Lettered Artists *and the* Languages of Empire

SUSAN VERDI WEBSTER

LETTERED ARTISTS *and the*

LANGUAGES OF EMPIRE

Painters and the Profession in Early Colonial Quito

UNIVERSITY OF TEXAS PRESS ◆ AUSTIN

Copyright © 2017 by the University of Texas Press

All rights reserved

Printed in the United States of America

First edition, 2017

Requests for permission to reproduce material from this work should be sent to:

 Permissions

 University of Texas Press

 P.O. Box 7819

 Austin, TX 78713-7819

 http://utpress.utexas.edu/index.php/rp-form

♾ The paper used in this book meets the minimum requirements of
ANSI/NISO Z39.48-1992 (R1997) (Permanence of Paper).

Library of Congress Cataloging-in-Publication Data

Names: Webster, Susan Verdi, 1959– author.

Title: Lettered artists and the languages of empire : painters and the profession
in early colonial Quito / Susan Verdi Webster.

Description: First edition. | Austin : University of Texas Press, 2017. |
Includes bibliographical references and index.

Identifiers: LCCN 2017005560 | ISBN 978-1-4773-1328-2 (cloth : alk. paper)

Subjects: LCSH: Art, Colonial—Ecuador—Quito. | Art, Ecuadorian—Ecuador—Quito. |
Painters—Ecuador—Quito. | Painting, Ecuadorian—Ecuador—Quito. | Painting,
Colonial—Ecuador—Quito.

Classification: LCC N6687.Q5 .W43 2017 | DDC 700.9866—dc23

LC record available at https://lccn.loc.gov/2017005560

doi:10.7560/313282

For my parents, Barbara D. Webster and Grady L. Webster,

who instilled in me the passion for, and the value of, research.

CONTENTS

ACKNOWLEDGMENTS

Many individuals, institutions, and organizations contributed to the realization of this book, and I owe to all an enormous debt of gratitude. In Quito, I am especially grateful to Ximena Carcelén for her unflagging support, counsel, and friendship over nearly twenty years of research trips, publications, exhibitions, symposia, and numerous other fruitful collaborative endeavors. Ximena opened many doors that might otherwise have remained closed to me, and her commitment to fostering research on Quito's colonial art and architecture contributed significantly to this book and to other publications. Over the same period, Drs. Christiana Borchart de Moreno and Segundo Moreno generously shared materials, publications, and ideas that contributed in important ways to my thinking about colonial Quito, always with great enthusiasm and wit. Similarly, I benefited from the kindness of Iván Cruz Cevallos, who graciously shared his thoughts and collections, many of which enriched this study in important ways.

I thank the following art and architectural conservators, curators, archivists, and collectors in Quito for their kind collaboration, many of whom went out of their way to assist in the research process: Ximena Carrión, Patricio Carvajal, Gaby Costa, Vicente Ramos, Arq. Héctor Vega, José Vera, Oswaldo and Marta Viteri, and Israel Zambrano. I am particularly grateful for the assistance and counsel of Arqs. Guadalupe Uria and Ángel Silva. Many thanks to the following friends and colleagues in Quito for their support: Marta Albán, Madre Inés María Arias, José Barrera, Judy Bustamante, Guillermo Bustos, Susana Cabeza de Vaca, Carmen Fernández-Salvador, Christoph Hirtz, Alexandra Kennedy Troya, Nancy Morán, Fray Agustín Moreno, Trinidad Pérez, and Rosemarie Terán Najas.

I am thankful to the many Quito museums and archives that generously opened their collections to me, especially the Archivo Nacional de Historia, Archivo Histórico del Banco Central, Archivo Histórico Metropolitano, Archivo del Ministerio de Relaciones Exteriores, Museo de Arte Colonial, Casa de la Cultura Ecuatoriana, Museo Jijón y Caamaño, Museo del Sitio La Florida, Instituto Nacional de Patrimonio Cultural del Ecuador, Convento de San Francisco, Convento de San Diego, Convento de Santo Domingo, Convento de San Agustín, Convento de la Merced, Monasterio de la Inmaculada Concepción, Monasterio de San Carlos, and the Monasterio de Santa Clara.

I gratefully acknowledge the support and guidance of Constanza Toquica Clavijo and the remarkable staff of the Museo de Arte Colonial and the Museo de Santa Clara in Bogotá. Many thanks to my dear colleagues Marta Fajardo de Rueda, José Luis Mumbru, and Juan Vitta, all of Colombia, for their inevitably stimulating conversation and counsel. I thank the Biblioteca Nacional and the Archivo General de la Nación in Bogotá, as well as the Archivo de Boyacá in Tunja, for making accessible their rich collections.

The staff at the Museo de América in Madrid kindly provided photographs and information, as did my colleagues, María Elena Alcalá and José Manuel Matilla. I am grateful for the assistance of Orieta Durandal at the Museo Colonial Charcas, Sucre, and Pedro Querejazu Leyton, both of Bolivia.

I owe a debt of gratitude to many friends and colleagues in the United States who supported and contributed in various ways to the realization of this study. Foremost, I thank Fredrika Teute for her sage and penetrating editorial comments and questions, all of which materially improved the book, although any errors are, of course, my own. I am grateful also to Elizabeth Hill Boone, Tom Cummins, Nancy Deffebach, Regina Harrison, Aaron Hyman, Thomas DaCosta Kaufmann, Kris Lane, Joanne Rappaport, Jeffrey Chipps Smith, Karen Stothert, and Suzanne Stratton-Pruitt. I thank my supportive colleagues in the Department of Art and Art History, the American Studies Program, and the Latin American Studies Program at the College of William and Mary. Kristin Wustholz of William and Mary's chemistry department and student Mary Matecki generously conducted pigment analysis on several samples of colonial Quito paintings, and Bill Hutton of the classical studies department assisted with Latin translations. Thanks also to Kevin Schrack for his professional work on plans and drawings. I thank Robert Devens and the staff of the University of Texas Press for shepherding the manuscript through to production.

I am deeply grateful to the following agencies and institutions for subventions that permitted the development and ongoing research for this project: John Simon Guggenheim Memorial Foundation, National Humanities Center, Fulbright Senior Specialist Program, American Philosophical Society, National Endowment for the Humanities, and the American Council of Learned Societies. A sabbatical leave from the College of William and Mary

allowed me to complete the research and the writing of the book. Research funds associated with the Jane Williams Mahoney Chair in Art History and American Studies and Kate Conley, dean of the College of Arts and Sciences at William and Mary, provided important travel, photographic, and technical support for the project.

None of this could have come to fruition without the unconditional support and always enthusiastic collaboration of Hernán L. Navarrete, *amor de mi vida*, who generously shared many travels and travails, long hours in the archives, challenging photographic conditions, and innumerable animated conversations about painters, paintings, and colonial worlds. His beautiful photographs enhance this volume, just as his love has immeasurably enhanced my life.

INTRODUCTION

Siempre la lengua fue compañera del imperio.
ANTONIO DE NEBRIJA, 1492

Translation is always a shift, not between two languages but between two cultures.
UMBERTO ECO, 2004

In 1599, a painter named Andrés Sánchez Gallque affixed a signature inscription to his now-famous triple portrait, *Francisco de Arobe and His Sons, Pedro and Domingo*, that reads, in its extended version, "Andrés Sánchez Gallque, native of Quito, made this" (*see plate 1*). Heralded as the first signed portrait in South America, its inscription has played a powerful role in the modern fascination with the painting, above all because it identifies the signer as a native Andean artist. Beyond its semantic content, however, the form—indeed, the very presence of the signature inscription—raises a series of intriguing questions about painters and the profession in early colonial Quito that are entangled with issues of education, languages, literacies, and graphic technologies. The circumstances that empowered Sánchez Gallque's signature inscription and its broader implications for painters and the profession in early colonial Quito constitute one of the overarching themes of this book.

Sánchez Gallque's lettered status was not unique to the profession. In fact, the vast majority of painters in early colonial Quito—most of whom were Andean—shared his ability to read and write. These artists dominated both the pen and the brush. In this regard, I pluralize Antonio de Nebrija's often-cited assertion that "language was always the companion of empire" in order to underscore the documentary equivalency of painting, writing, and other graphic systems.[1] I also call into question the singularity of Nebrija's "empire" by recognizing simultaneously the precontact authority of the Inca empire and its political and administrative continuities under Spanish colonial rule—the parallel but subordinate *república de los indios*—within which the power and agency of colonial Inca and other Andean groups were articulated on a local level. "Empire" is thus a relative and, in this study, emphatically plural term. In early colonial Quito, numerous Andean painters held

elite indigenous administrative posts, frequently bore the title of "master" and the honorific "Don," and established professional networks and dynasties within the urban geography of the city that bear greater affinities with pre-Hispanic moieties than with European-style artistic "workshops."

The multiplicity of languages—spoken, written, read, and painted—that characterized the lives and practices of Quito's early colonial painters are amply reflected in the documentary record. Scriptorial and pictorial documents, considered here as equivalent, constitute the evidentiary basis of this study. In addition to the information content that archival sources provide regarding the lives and professional activities of painters, I am concerned with the forms, materiality, and technologies of graphic practices that include painting and script and the consonances among them. The many signatures penned by painters are testimony to alphabetic literacy, yet their autographs simultaneously disclose mastery of sophisticated scribal conventions, just as their painted images reveal equally specialized knowledge of pictorial languages: the materials, technologies, and chemistry of painting, in addition to perspective, proportion, and iconography. Moreover, the languages and literacies possessed by painters were not solely imported, imparted, or imposed by Europeans; they drew upon the local and traditional as well as the foreign. As visual intermediaries and multifaceted cultural translators, painters harnessed a wealth of specialized knowledge to shape graphic, pictorial worlds for colonial audiences.

The inspiration for this study arose in response to a disjunction between the historiography and the archival record. The literature on painting in colonial Quito largely glosses over or ignores the first century of activity, between 1550 and 1650, emphasizing the overwhelming anonymity of painters—the *voz del anonimato*—and the paucity of extant works.[2] The lack of archival research on the painters of this period has resulted in a historiography of painting in colonial Quito focused on subject matter, style, and iconography. Historians repeat the same handful of names, to which they attribute many works, with little context and often without citations or documentary evidence.[3] Legends and myths abound in the literature.

The dearth of archival research on painters in early colonial Quito stands in stark contrast to the remarkable wealth of documentary evidence regarding these artists, their profession, and the art market that I have collected over the years in numerous local and foreign archives. Despite the fact that Quito painters rarely signed their works, the vast majority signed their names to notarial contracts. Hundreds of archival documents record the names, activities, and artistic commissions of more than fifty painters who were active between 1550 and 1650. These sources, largely notarial contracts, afford an admittedly circumscribed and mediated but nonetheless revealing vision of the social circumstances and professional practices of Quito's early colonial painters.[4]

Traditional approaches have sought to unify Quito's art history along a linear, positivist trajectory of development in which the artistic torch is passed

from each of the few known early painters, from Juan de Illescas through Andrés Sánchez Gallque, and ultimately to Miguel de Santiago in the second half of the seventeenth century. These and several other known painters are cast as progenitors and practitioners of the so-called "Quito School" of painting, a nomenclature that supposes and imposes the existence of a unified formal or stylistic corpus. To cite José Gabriel Navarro's metaphor, these artists were seen as forming links in a chain of artistic development in a tidy march that explained, applauded, and justified the abundant work of the renowned late seventeenth-century painter Miguel de Santiago, moving inexorably toward the "modern" painters of the post-independence period.[5]

Painters in the second half of the seventeenth century, particularly Miguel de Santiago, have been accorded far more attention in the literature than those who came before. Indeed, Santiago, who was traditionally assumed to be Spanish or mestizo, has long been heralded as the premier painter of the century and labeled the "Apelles of America." The patient archival work of the Spanish art historian Ángel Justo Estebaranz has revealed that Santiago was, in fact, born of Andean parents, and his studies have contributed a wealth of new knowledge about the artist, his contemporaries, the profession, and the art market in the second half of the seventeenth century.[6] The present study departs from Justo Estebaranz's work in its exploration of the languages and literacies of painters even as it complements and more broadly contextualizes the Spanish author's publications by establishing the identities, professional practices, and historical context for the preceding generations of painters.

The present study suggests that the professional activities, mobility, and trajectories of painters in this early period were far more unruly and nonlinear than previous art histories would have us believe. Prior histories typically acknowledge the relatively few extant early colonial paintings in a rush to discuss the more amply documented, iconographically rich, and abundant work of Miguel de Santiago and the later seventeenth-century painters. Underpinning the traditional linear stylistic and iconographic approach is the power, control, and agency accorded to the Spanish and Creole friars who reportedly initiated and orchestrated the development of painting in early colonial Quito. Although it is likely that the Franciscan *colegios* and the Dominican confraternities served as formative institutions that fostered some of Quito's many indigenous painters, traditional narratives do not adequately account for the local and transient European painters in this early period. Nor do they consider the independent agency of the native painters who constituted the majority, who signed contracts for artistic commissions, or who worked for the open market in the later sixteenth and early seventeenth centuries.

The history and human geography of Quito plays a significant role in the story of its painters. Established in 1534, the colonial city of Quito was the center of an important Spanish *audiencia* (royal judicial court) in the northern region of the Viceroyalty of Peru. Nestled in a high Andean valley

at the foot of the volcano Pichincha, Quito boasted ample natural resources and a year-round temperate climate. In the early colonial period, Quito burgeoned as a major mercantile center of production and trade, second only to Lima and Potosí, importing and exporting raw and manufactured goods on regional and global levels.[7] Indeed, large quantities of locally produced as well as foreign paintings, polychrome sculptures, and other artworks passed through the hands of Quito's merchants and marketplaces during this period.[8]

The urban fabric of the city also expanded dramatically during this time. By 1600 Quito housed nearly a dozen growing monasteries and convents, six parish churches, several hermitages, and a cathedral, all in a population of approximately ten thousand, which by 1650 expanded to some fifty thousand inhabitants.[9] The majority of colonial buildings extant today—all of which were extensively adorned with paintings, polychrome sculpture, and elaborate multimedia altarpieces and furnishings—were constructed during the late sixteenth and seventeenth centuries. The flourishing urban economy thus supported and attracted large numbers of skilled painters and artisans, some of whom were regional and, to a lesser extent, European immigrants. More recently, Quito was the first city to be named a UNESCO World Heritage Site, owing to its remarkable wealth of colonial art and architecture.

The early colonial city of Quito stands out for its distinctive circumstances and characteristics among contemporary Latin American urban centers. Although, in terms of population, Quito ranked among the secondary colonial Spanish American cities, the city and its surrounding five leagues of jurisdiction had an overwhelming indigenous majority during this period. Unlike many comparable urban centers, Quito sustained a relatively small African community; thus, it is not surprising that its painters and artisans were principally of indigenous ancestry.[10] Despite its size, Quito's demographic composition appears to align it more closely with many of the medium-sized provincial cities of the period, such as Cuzco or Sucre, which had similarly high proportions of Andean inhabitants. Yet the history of painters and painting in early colonial Quito does not replicate that of the better-documented and more widely known city of Cuzco; instead, the northern city followed a trajectory based on its particular demographic and sociopolitical circumstances.

Like colonial Cuzco, however, colonial Quito was built on the site of an Inca settlement. Some forty years before the Spanish invasion, Quito was a northern outpost of the empire conceived as "another Cuzco" and "a second city after Cuzco" that, according to some, replicated the Inca capital's "sacred geography."[11] Although Inca rule was relatively short in the north, Quito nonetheless emerged as a power center within the empire owing to its status as the seat of Atahualpa, the last Inca sovereign. After Atahualpa's demise, his sons were placed under the tutelage of the religious orders, one of whom, Francisco Atahualpa (Francisco Topatauchi Inca, known as "the Auqui"), continued the dynasty in Quito in a position of relative power, pre-

siding over his expansive residence and lands in a southern sector of the Spanish colonial city. During the early colonial period, the Atahualpa residence was an epicenter of artistic activity and a magnet for dynasties of Andean painters, whose residences were clustered around the "houses of the Auqui."[12] At the same time, Quito was home to a variety of autochthonous, non-Inca groups whose members included numerous painters and several painting dynasties, as well as a smaller number of European and Creole painters who plied their trade with relative independence. The present study maps Quito's documented painters within the social and political geography of the early colonial city.

This book is foremost about painters, their mastery of languages and literacies, and the circumstances under which they practiced their trade in early colonial Quito. Part I explores the nature of the painting profession, shifting between considerations of pre-Columbian and early colonial contexts that include the education and training of particularly Andean painters; the materials, sources, and market for paintings; the range of objects and venues to which painters applied their talents; and the titles, hierarchies, and structure of the trade. In the absence of an official painters' guild, chapter 4 explores alternative frameworks and modes of professional organization.

Part II employs extensive and largely unpublished archival evidence to examine the lives and professional activities of successive generations of Andean, Creole, and European painters, many of whom are introduced here for the first time. These chapters shift the traditional art-historical focus on the product to emphasize the painters, the materials, and the profession and to explore the circumstances and the circulation of people and images in terms of broader networks of social relationships, markets, and mobility. Painting contracts, however, are considered in detail, alongside extant signed or otherwise documented works, many of them unpublished. Two monographic chapters examine representatives of the early and the later generations of painters, Andrés Sánchez Gallque and Mateo Mexía, reconstructing their lives and work to the extent that the documents permit, and analyzing signed and dated canvases. The appendix contains selected transcriptions of artistic contracts representing the nature and spectrum of painting commissions during this period. By establishing the identities and examining the professional lives of Quito's first generations of painters, this study demonstrates the ways that they mastered and deployed languages and literacies to obtain power and status in the early colonial city.

PART I

Contexts

Lettered Painters and the Languages of Empire

Among the other things that the Inca kings invented for the good government of their
empire was to order that all of their vassals learn the language of the court—which is
today called: "the general language"—for the teaching of which they placed Inca teachers
in each province to instruct the elite.

EL INCA GARCILASO DE LA VEGA, *Comentarios reales*, 1609[1]

And if they have crucifixes, images of Our Lady or of the saints, lead them to understand
that such images are a form of writing that represents and leads to the understanding of
that which it represents, and that they should be greatly venerated.

FRAY PEDRO DE LA PEÑA, Diocesan Synod of Quito, 1570[2]

In 1582, Francisco Atahualpa—son of the former Inca ruler and Quito's most
powerful native lord—and his son Alonso purchased at a local shop "a quire
of paper" and "an Arte de Antonio," the famed Latin grammar written by
Antonio de Nebrija.[3] Some seventeen years later, the painter Andrés Sán-
chez Gallque affixed his signature inscription beneath the Latin dedication
to his now-famous 1599 triple portrait, *Francisco de Arobe and His Sons, Pe-
dro and Domingo*, which states, "Andrés Sánchez Gallque, native of Quito,
made this" (*see plate 1*). Underscoring their Western-educated and accultur-
ated status, these Andean residents of Quito actively deployed an arsenal of
European literate technologies that included writing, reading, painting, and
Castilian and classical languages.

Francisco and Alonso Atahualpa engaged a notary to record their
purchases in a contract to which both father and son penned their names
(fig. 1.1). Francisco signed with the honorific "Don" and abbreviated his
first name using superscript letters. Alonso similarly identified himself as
"Don," inscribing his full name, "Alonso Atabalipa," in complex calligraphy
adorned with extensive flourishes, ligatures, and rubrics. The autographs of
both father and son employ scribal conventions and technologies; however,
Alonso's elegant, complex penmanship surpasses that of his father, display-
ing his mastery of more sophisticated calligraphic knowledge.

Similarly, when Sánchez Gallque inscribed his signature on the triple
portrait, he deployed a range of calligraphic forms, conventions, and prac-
tices, including abbreviations, ligatures, superscript, and flourishes that
make his inscription appear more like a code than a text (*see plate 2*). He
painted several additional texts on the canvas: the names and ages of the
subjects are rendered in Roman square capitals above their heads, and a

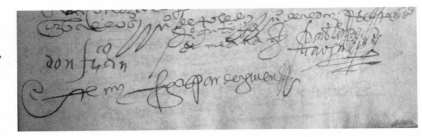

Latin dedication to the king of Spain, executed in elegant chancery script and framed in a strapwork cartouche, records that in 1599 Juan del Barrio y Sepúlveda, a Spanish judge of the *audiencia* of Quito, had the painting made at his own expense. The inscriptions lend the portrait a documentary quality that identifies and fixes the "exotic" subjects in time, reinforcing the impression that the artist painted them from life, and they simultaneously proclaim the artist's mastery of literate technologies that included scribal knowledge and calligraphic expertise.

While Francisco and Alonso Atahualpa represented the apex of the Andean sociopolitical hierarchy in early colonial Quito, Sánchez Gallque did not share their elite status, yet all three Andeans mastered European letters to their benefit. Visual studies and archival documents establish the lettered status of painters in early colonial Quito and bring into focus a set of interrelated scholarly issues of the colonial period: education, literacies, technologies, and graphisms. The consideration of these contexts reveals a more complicated and nuanced picture of the ways that Andean painters, in particular, acquired, appropriated, and manipulated literate technologies to claim status and authority in early colonial Quito.

Lettered Painters

Alphabetic literacy was not the norm in early colonial Quito, or for that matter, in the early modern world, and the ability of the Atahualpas and Sánchez Gallque to sign their names was not shared by most of the city's inhabitants. Yet neither alphabetic literacy nor knowledge of the Spanish language was required to file a notarial contract. In fact, a great many parties to notarial documents, irrespective of ancestry, lacked the ability to read and write; thus, a witness was asked to sign in their stead, and in the case of Andeans a native interpreter might be summoned to ensure that the client understood and authorized the contents of the document. Perhaps not surprisingly, painters served as interpreters and translators in the drafting of legal contracts. Such was the case in 1631, for example, when the Andean parties to a notarial document were assisted "by the language and interpretation of Lorenzo Ygnacio journeyman painter, *ladino* in the Castilian language and that of the Inca, who swore to its contents."[4] In Quito, very few early colonial artists

signed their names to paintings; however, in contrast to the general population, painters almost invariably signed their names to notarial documents, most with a manifestly practiced hand.[5]

The names of fifteen painters are recorded in notarial documents between 1580 and 1615—the period of Sánchez Gallque's professional lifetime. Four are European or Creole, and eleven are identified as Andean; it is noteworthy that Andeans constitute the majority (table 1.1).[6] Notaries invariably recorded as legal identifiers the ethnicity or ancestry of the parties involved, with the exception of Spaniards and Creoles, for whom no such designation was included. African, mulatto, or mestizo painters are not named in the records for this period.

Equally noteworthy is the fact that all but one of the recorded painters—European, Creole, and Andean—consistently signed their names to the more than fifty notarial documents in which they figured as principal parties. Indeed, only the Andean painter named Alonso was unlettered, asking witnesses to sign contracts in his stead. In a region where no alphabetic

Table 1.1. Painters in the documentary record, 1550–1615, by chronological first appearance

Name	Title(s)	Ancestry	Literacy
Juan de Illescas	Painter	Spanish	
Luis de Ribera	Painter, gilder, sculptor	Spanish	Signature
Francisco Gocial	Painter	Andean	Signature
Alonso	Painter	Andean	Unlettered
Andrés Sánchez Gallque	Master painter	Andean	Signature
Fray Pedro Bedón	Painter	Creole	Signature
Angelino Medoro	Painter	Italian	Signature
Pedro Torona	Painter	Andean	
Juan Chauca	Painter	Andean	Signature
Juan del Castillo	Journeyman painter, woodworker	Andean	Signature
Juan Ponce	Painter, gilder	Spanish	Signature
Bernabé Simón	Master painter	Andean	Signature
Domingo	Painter	Andean	Signature
Esteban	Painter	Andean	
Turocunbi	Painter	Andean	

Juan del
Castillo

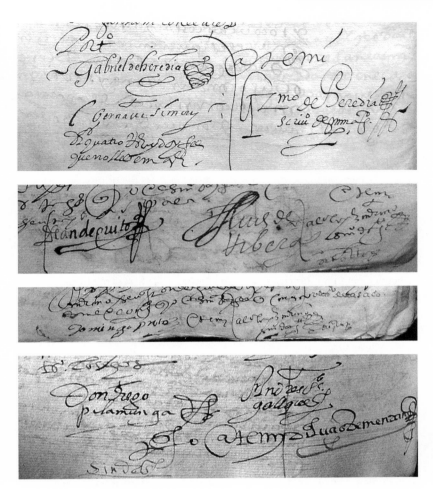

Figure 1.2a–h. Signatures of selected Andean painters, 1580–1615.

writing system was known prior to the European invasion, it might appear remarkable that virtually all of the early Andean painters signed their names to numerous legal documents. To the degree to which visibly assured signatures can be understood to demonstrate alphabetic literacy, painters in early colonial Quito possessed and actively employed the technology by inscribing their names on contracts (fig. 1.2a–h).[7] Most Andean painters, whether identified in the document as masters or simply as journeymen or practitioners of the art, autographed multiple contracts during the thirty-five-year period from 1580 to 1615. As signatories, they were the protagonists of these documents.

Yet it is not simply the fact of these signatures but their form that invites closer consideration. The majority display fluid penmanship, some use abbreviations with superscript letters, and several employ elegant ligatures (a glyph combining or linking two or more letters) in their autographs. All the painters append *rúbricas* (paraphs or terminal flourishes) to their signa-

tures—graphic marks that again align them with sophisticated scribal practices (fig. 1.2a–h). Distinctive *rúbricas* imbued signatures with individuality and graphic power that transcended alphabetic content and rendered them unique and ostensibly difficult to forge. The signatures of Quito's early painters present compelling evidence of Western education that went well beyond *primeras letras* (ABCs); indeed, they were not merely literate, they were also lettered.

Andean painters signed their names to nearly forty notarial documents during this period, underscoring the extent to which these artists had mastered Western alphabetic literacy and graphic conventions and simultaneously highlighting their ability to negotiate effectively the colonial bureaucratic system. Andeans comprised an elite group of literate, skilled professional painters in early colonial Quito—indeed, they were the majority—at a time when alphabetic literacy was not standard for either Andeans or Europeans, particularly among the artisan class. Sánchez Gallque and his indigenous contemporaries thus figured among the first generations of literate Andeans to constitute and foster the expansion of what Joanne Rappaport and Tom Cummins have termed the "indigenous lettered city."[8]

The Languages of Empire

When Atahualpa and his son purchased an "Arte de Antonio" and a quire of paper, they participated in larger trends and tendencies in the Hispanic world. The Spanish humanist and linguist Antonio de Nebrija's 1481 publication of the *Introductiones latinae*, the Latin grammar popularly known as the "Arte de Antonio," and his authorship of the first Castilian grammar, published in 1492, are closely allied with the expansion of Renaissance humanism, literacy, and empire. Nebrija's prologue to the Castilian grammar contains one of the author's most often-cited quotes: "siempre la lengua fue compañera del imperio" ("language always was the companion of empire"). As Ángel Rama, Walter Mignolo, and other modern scholars have observed, language—spoken, read, and written—was from the beginning of the colonial period inseparable from the Spanish imperial project in the Americas.[9]

Because the Spanish empire ran on paper, it required the creation and support of specialized *letrados* (lettered classes)—scribes, notaries, and other bureaucrats—to operate the institutions of state. As Rama noted, the masters of the letter were privileged classes, brokers, and translators who enforced the laws, regulations, and directives that ran the empire's vast machine.[10] Yet the language of graphic signs as the companion of empire encompassed and entangled pictorial images as well as alphabetic script, and it was also through painting and visual forms of representation that the power of Western graphism instructed, shaped, and controlled colonial experience. Colonial paintings, which incorporate text to a far greater extent than their peninsular Spanish counterparts, played an equally consequential colonizing

role in the implantation and maintenance of Christianity and the glorifica-
tion of the Spanish imperium. As visual intermediaries, early colonial artists
were the agents that instantiated and actualized this representational realm—
painters harnessed and wielded the pictorial language of empire.

Like the *letrados*, early colonial painters in Quito exercised power as a spe-
cial and privileged class of intermediaries who purposefully interpreted and
shaped visual experience for colonial audiences. In fact, painters were dou-
bly powerful, for they dominated both the brush and the pen—interpreting,
adapting, and manipulating Western technologies, images, and ideologies for
a colonial public that included educated and unlettered Europeans, Ande-
ans, Africans, and people from other parts of the world. That the majority of
Quito's early colonial painters were Andean—as undoubtedly were a host of
others who did not enter into the documentary record or whose documen-
tation has been lost—demonstrates that it was overwhelmingly indigenous
people who translated, interpreted, and crafted almost exclusively Christian
imagery for their varied colonial viewers. For these painters to be successful
in their profession, they must have received ample and thorough instruction
in a variety of European arts and technologies that included reading, writing,
and Christian doctrine, as well as painting and other graphic practices. They
may also have brought to bear non-European, local, and regional traditions
on the practices and the products of their profession.

Educating Painters in Early Colonial Quito

When Atahualpa and his son signed a notarial contract to record their pur-
chase of paper and a Latin grammar and Sánchez Gallque affixed his signa-
ture inscription to the triple portrait, they implemented a set of acculturated
practices, precepts, and technologies acquired under the auspices of early
colonial Western education in Quito—practices that friars, tutors, and other
educators instilled in a range of students. An assortment of educational ven-
ues and opportunities existed in Quito from the earliest years of its estab-
lishment, which extended from cost-free *doctrinas* and religious schools
run by local friars and priests to private tutors and "public" schools that
offered basic instruction for a fee. Among the earliest of these was a tuition-
free school established in the 1530s by the Mercedarian Order to teach "the
noble children of caciques," with a curriculum that included reading, writ-
ing, Christian doctrine, and Castilian and Quechua grammar.[11]

Independent educational ventures and instructors were also present in
Quito from the first decades of its foundation. For example, a mid-sixteenth-
century witness testified that "Juan Griego had a shop in the cathedral to
teach young boys of this city, and he taught Spaniards and Mestizos and
Indians the Christian doctrine and how to read and write."[12] Griego's ini-
tiative apparently was short-lived, and he seems to have moved on to teach
at one of the early *doctrinas*. In 1570, however, the precentor of the Cathe-

dral, Pedro de la Peña, contracted another independent professional teacher named Luis Remón "to teach grammar in this city so as to benefit students and people who want to learn the said science."[13] Unlike the schools and *doctrinas* run by the religious orders, other educational venues and instructors charged a fee for services, the average price of which was twelve pesos per year for instruction in reading and writing.[14]

Domingo de Orive's 1577 description of the city of Quito offers the most extensive early report on the number of local schools and the students who attended them. According to his account, Quito boasted "three schools where they teach the sons of [Spanish] citizens to read and write, and they have more than five hundred boys, there are another six [of] these [schools] in which the Indians are taught the things mentioned and to sing and other good and virtuous practices, such as Latin [*latinidad*] and how to make choir books."[15] Orive links the skills taught in local schools to the remarkable abilities of indigenous artisans, in particular, noting the existence of "many Indian professionals in all of the trades," and declaring that

> they practice with skill whatever thing they are taught and especially those who transcribe [*apuntan*] choir books and [who] practice other utilitarian professions, such that, in addition to being very beneficial to the republic, they live justly and they are diligent to the extent that they contribute to and assist their extended families [*deudos*] and poor friends, in both their sustenance and their taxes [*tributos*].[16]

It is particularly noteworthy that Orive's account singles out the activities of Andean students in the production of choir books, which typically incorporated text, musical notation, and painted illuminations. The skills with which indigenous students are credited in this regard suggest a predilection or predisposition toward multivalent forms of graphic and iconographic representation and communication.

Beyond *doctrinas* and other educational venues, members of the Quito elite relied on private tutors for the schooling of children. Such was the case with Francisco Atahualpa's son Alonso, who was educated by a private tutor, Martín de Moreta, in a range of European technologies and practices, which notably included drawing, as well as reading, writing, grammar, and musical arts. Moreta testified in Alonso's 1584 *probanza de méritos* (relation of merits and services to the crown) that he had known Alonso since his birth, and knew him very well, "because this witness taught him to read and write," adding that "don Alonso knows how to read and write, sing, dance, and play the vihuela [an early form of the guitar] and the zither and other instruments, and how to draw."[17] The graphic arts of writing and drawing, among other subjects, thus formed integral components of Alonso's private educational curriculum. Francisco Atahualpa had clearly ensured that his son was educated in Western forms of knowledge and letters. Indeed, Francisco was himself an early alumnus of the most important educational endeavor of the six-

teenth century in Quito: the Franciscan Colegio de San Juan Evangelista, later known as the Colegio de San Andrés.

Scholars have often assumed that Sánchez Gallque and other Andean artists were trained by the Franciscans in their famed Colegio de San Andrés, which was established in 1552 and continued to function in one form or another well into the seventeenth century. San Andrés has been promoted as the crucible of indigenous (and other) education in colonial Quito, and the genesis of the so-called Quito School of art that produced such notable painters as Andrés Sánchez Gallque.[18] Despite the fact that there is no documentary evidence linking the Colegio de San Andrés with any early Andean painters, the assumption in the literature has been that they learned their craft under the tutelage of the Franciscans. Nonetheless, there are a number of circumstantial reasons to surmise that this might have been so, not the least of which is the conspicuously lettered status of virtually all Quito's Andean painters. Moreover, the Colegio de San Andrés is the best documented, the longest-lived, and arguably had the greatest impact of any other educational endeavors of the period.

The Franciscan Colegio de San Andrés

The early Franciscan educational mission in Quito was spearheaded by the Flemish friars Jodoco Rique and Pedro Gocial, known as "Pedro Pintor,"[19] who arrived in 1534 and later established the first formal school for Andean and other students at their provisional monastery. Rique and Gocial had come to Quito from Spain via Nicaragua, where they reportedly met with the Franciscan friar Toribio de Motolinía—one of the famed "first twelve" Franciscans in New Spain who was intimately involved with the order's educational endeavors—and heard of the first Franciscan schools for indigenous students at San José de los Naturales and Santa Cruz de Tlatelolco in New Spain.[20] Indeed, early documents confirm that Quito's Franciscan *colegios* were modeled on their New Spanish predecessors.[21] Rique and Gocial were joined in the early 1550s by Fray Francisco de Morales, who supervised and reported on the status and educational practices of the first Franciscan school, the Colegio de San Juan Evangelista, which later became the Colegio de San Andrés.

The Spaces of San Andrés

Little remains of the physical spaces and buildings that constituted the early Franciscan establishment in Quito, although indications are that the first structures, including a chapel, a patio or cloister, and buildings housing the friars and the early *colegios*, occupied the southeast section of the now sprawling Franciscan complex (fig. 1.3).[22] The physical nature and architectural form of the *colegios* of San Juan Evangelista and San Andrés are

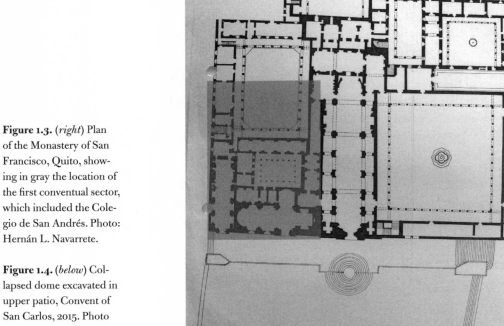

Figure 1.3. (*right*) Plan of the Monastery of San Francisco, Quito, showing in gray the location of the first conventual sector, which included the Colegio de San Andrés. Photo: Hernán L. Navarrete.

Figure 1.4. (*below*) Collapsed dome excavated in upper patio, Convent of San Carlos, 2015. Photo courtesy of Guadalupe Uria.

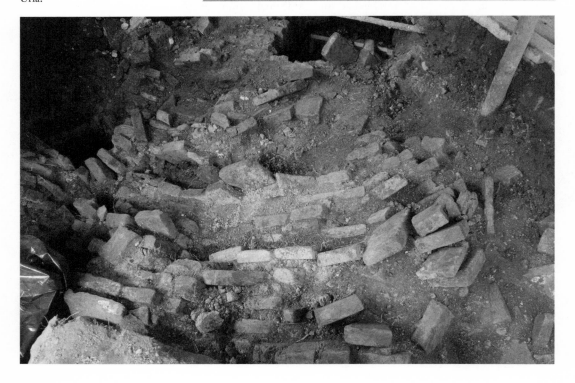

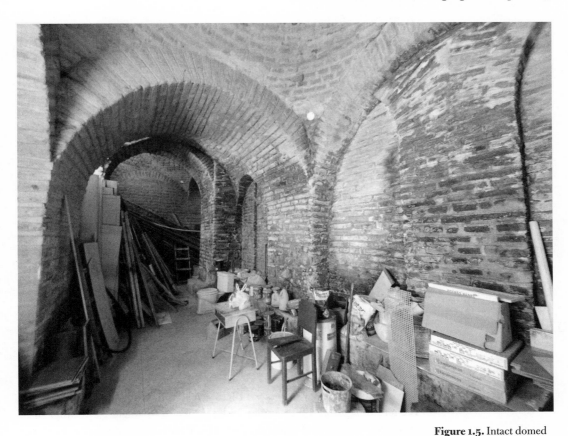

Figure 1.5. Intact domed bay, lower patio, Convent of San Carlos, 2015. Photo: Hernán L. Navarrete.

unknown, and there are no contemporary descriptions of the building(s). Indeed, the only direct reference to the early structures comes from Bishop Pedro de Oviedo's 1572 report: "in the city of Quito, alongside the Franciscan monastery, is a church with a building [*casa*] that they call the Colegio de San Andrés."[23] With the exception of the much modified sixteenth-century Capilla de Cantuña, which occupies the southeast corner, the remainder of this sector of the complex no longer belongs to the Franciscans—it is now the Convent of San Carlos, run by the Sisters of Charity of Saint Vincent de Paul.

Recent excavations in the main patio of San Carlos afford for the first time a vision of one of the important early Franciscan buildings.[24] Fragmented structures are revealed that include several semicollapsed pitched brick domes (fig 1.4), each measuring approximately 3.6 meters in diameter, in addition to semicircular arches, air ducts or chimneys, and flat brick surfaces suggesting walkways.

The domes uncovered in the main, upper patio correspond to and were once contiguous with a series of four intact and interconnected domed structures that opened onto the lower patio of the convent (figs. 1.5 and 1.6). Each domical space is sustained by four heavy brick arches set atop stone ashlar

foundations, constituting repeating modules that measure 3.6 meters square by 4.10 meters in height. The foundation level, height, diameter, and other measurements of the four intact domed spaces conform to those uncovered in the main upper patio, indicating that they originally were connected and formed a unified structure. Indeed, the existing four bays on the lower patio open onto to each other; however, their back or east arches were at some point filled with stone and brick to form walls (figs. 1.6 and 1.7). A test opening in one of these "walls" reveals open spaces (note in figure 1.7 the gloved hand emerging from within the aperture) combined with areas of fairly solid rubble fill, suggesting that the western section of the complex had been damaged and was subsequently filled in order to support later constructions above.[25] Indeed, a more recent two-story building sits atop these intact spaces.

Based on the current evidence, the original building as a whole appears to have occupied a square plan four bays wide by five deep with two lateral barrel-vaulted aisles to the north and south. The area of each sail-domed bay constituted 25 square meters, and each of the side aisles measures approximately 2.5 meters in width, for a total area of 625 square meters. Heavy brick arches supported twenty domical spaces and two vaulted, open-arched corridors running the length of the north and south sides, as indicated in the conjectural plan and isometric reconstructions (figs. 1.8 and 1.9). The building was originally open to the east, where the extant arched bays (all but one of which is now enclosed) faced the lower patio and the main plaza of San Francisco beyond. The foundation level, height, diameter, and other measurements of the intact vaulted bays conform to those uncovered in the upper patio, indicating that they originally were conjoined as a unified structure.

This building was almost certainly a *capilla abierta*, an open chapel wherein masses were celebrated that sheltered indigenous attendees, which also served as a space of education for early Franciscan colleges. Indeed, the form and plan of the building replicate those of the New Spanish Franciscan colleges of San José de los Naturales—founded by the Flemish Franciscan friar Pedro de Gante—and the Capilla Real in Cholula, both of which were initiated in the sixteenth century to serve as open chapels and spaces of indigenous indoctrination and education. Although San José de los Naturales was destroyed in the eighteenth century, early descriptions confirm that, at its height, it comprised a square plan made up of seven parallel and seven transverse bays capped either by barrel vaults or cupolas, faced with fourteen stone arches that opened onto a patio.[26]

Scholars point to the Capilla Real at Cholula, initiated around 1565 and reconstructed between 1590 and 1731, as a "faithful copy" of the earlier San José de los Naturales.[27] A 1581 plan of Cholula depicts the façade of the Capilla Real as a structure comprised of five domes set atop arched bays that open onto a forecourt or patio, located on the north side of the main Franciscan church (fig. 1.10). On the map, the Capilla Real bears a textual gloss—*cabila*—an Arabic term that was used to designate both the tribes of Arabs

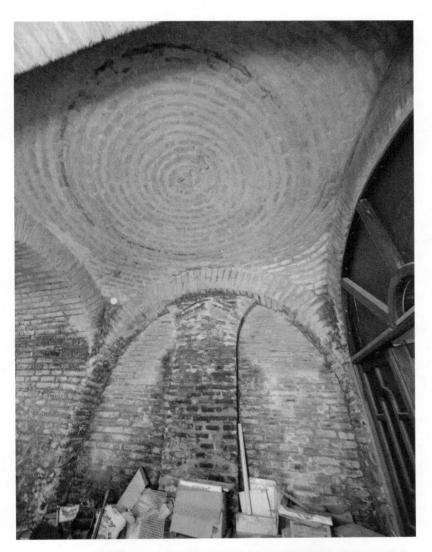

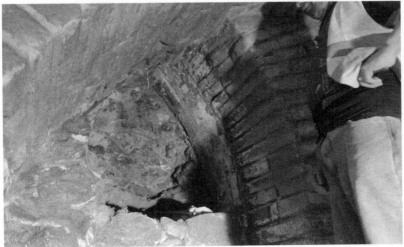

Figure 1.6. (*top*) Intact dome and later reinforced arch with filled wall, lower patio, Convent of San Carlos, 2015. Photo: Hernán L. Navarrete.

Figure 1.7. (*bottom*) Back wall of domed bay showing rubble fill beyond, lower patio, Convent of San Carlos, 2015. Photo courtesy of Guadalupe Uria.

Figure 1.8. (*right*) Conjectural isometric plan of multidomed structure within original sector of the Monastery of San Francisco, Quito. Drawing by Kevin Schrack.

Figure 1.9. (*below*) Conjectural isometric drawing of multidomed structure within original sector of the Monastery of San Francisco, Quito. Drawing by Kevin Schrack.

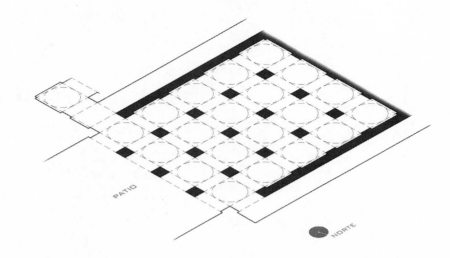

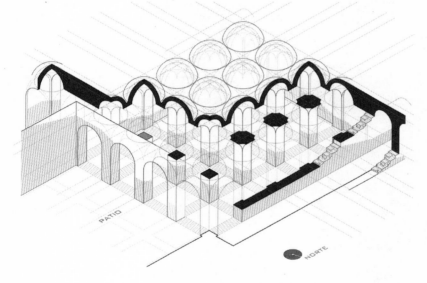

and Berbers in Spain and North Africa as well as the territories in which they were located. This structure is clearly marked as "Other" by the Spanish creators of the map, thereby equating it, and the indigenous people for whom it was constructed, with the Arabs or Moors whose cities and mosques dominated much of the Iberian Peninsula for nearly eight centuries. Indeed, the regular plan of the Capilla Real, with a forest of columns supporting domed vaults, strongly recalls the hypostyle mosques of medieval Spain. Although the arched façade of the Capilla Real is today enclosed, the structure still retains its square plan of modular domed spaces organized in open bays that now number seven by seven, with lateral aisles along the north and south (figs. 1.11 and 1.12).

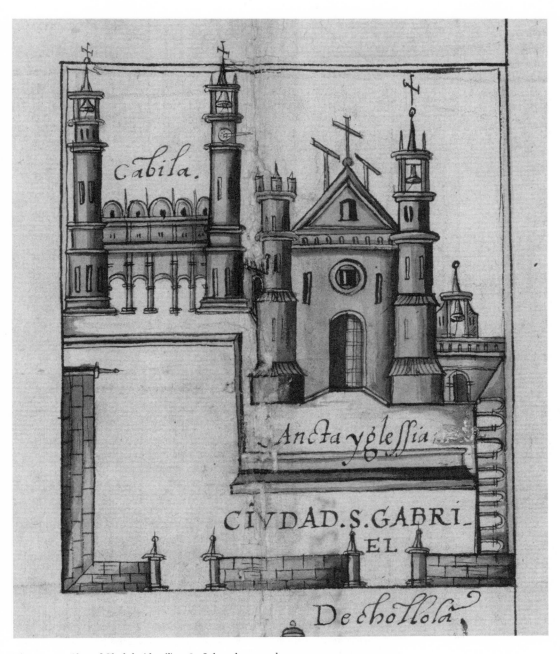

Figure 1.10. Plan of Cholula (detail), 1581. Ink and watercolor on paper, 31 × 44 cm. Photo courtesy of the Nettie Lee Benson Latin American Collection, University of Texas Libraries, the University of Texas at Austin.

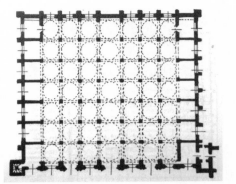

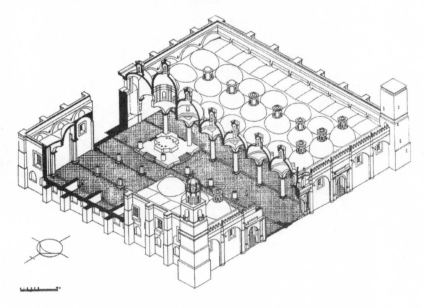

The Franciscans who extended their missionary reach into Quito cre-
ated an early open chapel in the Franciscan complex that imitated the New
Spanish models of San José de los Naturales and the Capilla Real at Cholula.
Indeed, the monastery at Quito was, during the first eighteen years of its exis-
tence, under the custody of the Franciscan Province of the Santo Evangelio
in New Spain. The Flemish Franciscans in Quito, Rique and Gocial, surely
received communications regarding the New Spanish foundations and *cole-
gios*.[28] Moreover, Rique and Gocial reportedly possessed knowledge of the
Franciscan *colegios* in New Spain, obtained in their meeting with the Fran-
ciscan author and educator Motolinía in Nicaragua. A 1552 letter requesting
"assistants and [construction] workers" written by Fray Francisco Morales,
Guardian of the Monastery of San Francisco in Quito, notes that "in Quito
we have begun a colegio in the form of those of New Spain [. . .] and we teach
in the manner of those of New Spain," suggesting the relationship of physical
construction as well as pedagogical practice.[29]

The materials, engineering, and construction of this massive building were not undertaken by a handful of friars; its realization depended upon the acquisition of construction knowledge and the manual labor of the indigenous population, specifically the students of San Andrés. Yet the exclusively European materials and technologies employed—bricks and mortar, semicircular arches, and sail vaults—required the specialized knowledge of an *albañil*. Three Spanish *albañiles* are documented in Quito from the 1550s, any or all of whom may have contributed to the construction of San Andrés. Among them, Alonso de Aguilar, documented in 1566 as the builder of the brick arches in the Cathedral,[30] is a particularly good candidate for the transmission of construction knowledge, based on three pieces of circumstantial evidence: from at least 1558, Aguilar's residence was located one block from the Colegio de San Andrés;[31] in 1569, he offered to supply *indios albañiles* for the brick and mortar construction of a main room and chimney in his neighbor's residence;[32] he maintained a family chapel and sepulcher in the Franciscan church, and in the 1570s sent one of his sons to join the Franciscan order.[33] Moreover, one of Aguilar's possessions, a 1552 Spanish edition of Sebastiano Serlio's *Third and Fourth Books of Architecture* in which he inscribed his name underscores his intimate knowledge of European building technologies.[34]

The choices made regarding the form and materials of San Andrés were both practical and symbolic. A regular plan of repeating bays composed of piers, semicircular arches, and sail vaults was a pragmatic solution to enclosing space during this early period. The relatively simple form and technology of the pitched brick sail vaults likely obviated the need for centering, and repeating modules could efficiently be added to expand and achieve the desired dimensions of the building. Yet the form and materials also conveyed symbolic values. In addition to its mosque-like plan, the building's exclusively brick construction—like the majority of Iberian mosques—ranked lower on the hierarchy of noble materials than did the finely dressed stone of the main Franciscan church that was built alongside it, underscoring the "otherness" of the indigenous population for whom it was intended.

If the recent archaeological discoveries at San Francisco in Quito have revealed the open chapel that served the Colegio de San Andrés, this structure would be the first and indeed the only of its kind in South America. The original square-plan brick building composed of multiple vaulted bays and lateral aisles was meant to serve the doctrinal and educational needs of the first Franciscan establishment and its students. Perhaps the identification and reassessment of this structure as the sixteenth-century open chapel and Colegio de San Andrés may help to rescue it from its ignominious twenty-first-century function as a bodega and restore at least some of its former dignity and rich historical import. It was within these arched and vaulted spaces that early generations of Andean and other students—among them Francisco Atahualpa—learned to read and write, together with a host of "practical" skills. Imparting Christian doctrine was certainly foremost among the

goals of the Franciscans, yet they also taught languages (Castilian, Latin, and Quechua), reading, and writing, in addition to music and manual arts, such as carpentry, masonry, and painting.

Students and the Curriculum

The Colegio de San Juan Evangelista was established in 1551–1552 to instruct Andeans, mestizos, and Spanish orphans "in the art of grammar just as in that of plainchant and organ music, and to read, write, and teach [*mostrar*] the Christian doctrine."[35] During San Juan Evangelista's relatively short existence (from 1551 to around 1559), two friars offered instruction to mostly adult pupils that included more than forty caciques from all regions of the *audiencia*. Francisco Atahualpa was certainly the foremost but by no means the only member of the first generation of Andeans educated by the Franciscans.[36]

In 1559–1560, the Franciscans expanded the institution and renamed it the Colegio de San Andrés, reportedly in honor of the patronage bestowed by the new viceroy, Andrés Hurtado de Mendoza.[37] Following the practices of the Franciscan colleges in New Spain, Quito's Colegio de San Andrés incorporated additional instructors and developed an expanded curriculum that educated Andeans, mestizos, and Spanish and Creole orphans in the manual as well as the linguistic and spiritual arts.[38] An oft-cited anonymous 1575 description of the Franciscan educational mission at San Andrés affords a vision of the range of training and technologies received by Andean students and others:

> Fray Jodoco taught (the Indians) to plow with oxen, to make yokes, plows and carts [. . .] how to count using Arabic and Castilian numbers [. . .] moreover he taught the Indians to read and write [. . .] and to play musical instruments, keyboards and strings, sackbuts and shawms, flutes and trumpets and cornets, and organ songs and plainchant [. . .] and because there was need in the land for mechanical trades, and because the Spaniards were not inclined to want to use the trades they knew; he taught the Indians all manner of professions, which they learned very well, so that they serve the whole land cheaply and at little cost, without the need of having Spanish tradesmen [. . .] from very perfect painters, and writers, and copyists of books: which incite great admiration at the great ability they possess and [the] perfection of the works produced by their hands.[39]

In addition to training an inexpensive workforce so that Spanish hands need not be sullied by manual labor, the Franciscans created a lettered *ladino* class of artisans, musicians, interpreters, and intermediaries who served them and their educational mission in a variety of ways. At the same time, they equipped generations of Andeans with a sense of mastery and power, in

addition to the knowledge, skills, and technologies to negotiate the colonial system to their own advantage and benefit.

The 1568 statutes of the Colegio de San Andrés describe additional aspects of the students and detail the professional skills, including the art of painting, which comprised the Franciscan curriculum:

> They brought together in the said college many sons of the elite and of caciques and lords and others that were not noble and mestizos from forty leagues around, where they instructed them in Christian doctrine and behavior, and also to read and write and sing and play all types of instruments, and Latin [*latinidad*] [. . .] many Indians of the said college have been taught many professions, as some of them are masons, carpenters, and medics [*barberos*], and others make tiles and bricks, and others are silversmiths and painters, whereby much good has come to this land.[40]

The numerous reports and chronicles that document the activities at San Andrés typically expound on the many and varied trade skills acquired by Andean students and their virtuoso practice of those professions. A 1647 account of the Colegio de San Andrés enumerates and comments on additional trades acquired by the students:

> In this said college the friars taught the Indians native to this province of San Francisco de Quito how to read and write and [practice] mechanical trades such as [those of] masons, carpenters, blacksmiths, shoemakers, tailors, singers, and painters, and all of the other trades and practices that these kingdoms enjoy were also taught to the sons of Spaniards by the friars in this college, to read and write, grammar, and good customs, in such a way that this Monastery was the first temporal and spiritual source in these kingdoms.[41]

Christian doctrine was unquestionably a priority of the Franciscan curriculum at San Andrés; however, two related and overlapping educational goals were language instruction and vocational training. Indeed, the friars needed skilled translators in the visual as well as the linguistic arts, and they also needed teachers.

Students and Teachers

Alongside spiritual conversion, alphabetic literacy, and vocational training, one of the overarching goals of the Franciscan schools was to convert their pupils into teachers who were then expected to return home to instruct their families and communities. Agustín Moreno published a 1564 list of the names of more than forty caciques from communities throughout the *audiencia* who were educated at the early Colegio de San Juan Evangelista,[42]

most of whom later returned to their communities to govern and teach in the *doctrinas*.[43] No known painters are among them, and no other account of students who attended the early colegio has yet been recovered.

At the later Colegio de San Andrés, the Franciscans continued their campaign to convert students into teachers. A 1568 report on San Andrés recorded that "by means of [the] Indians who know the Spanish language, the Indians who do not know the [Christian] doctrine may be taught."[44] This educational goal had the added advantage of producing an acculturated class of translators who could assist the relatively small numbers of friars at their *doctrinas* and missions in and beyond the city of Quito. At San Andrés, the success of the Franciscan educational initiative is demonstrated by the fact that, by 1568, Andeans constituted the majority of the teachers.[45]

Between 1568 and 1583, the names of nearly a dozen Andean instructors are recorded in the documents: Diego Gutiérrez Bermejo, Pedro Díaz, Juan Mitima, Cristóbal de Santa María, Juan Aña, Diego Guaña, Antonio Fernández, Martín Sancho, Diego Hernández, Miguel Omayón, Diego de Figueroa, and Alonso de Zámbiza.[46] Native instructors taught a range of subjects, including reading, writing, and music. For example, Diego Gutiérrez Bermejo and Pedro Díaz taught reading and writing, in addition to "singing, keyboards, and flute [. . .] shawm and [. . .] choir music"; Juan Mitima offered lessons in choir, "sackbut and flutes"; and Cristóbal de Santa María gave instruction in reading, singing, and playing various musical instruments.[47] Painting and other trades are not mentioned in documents associated with Andean instructors; however, they also may have offered training in the manual arts.

A particularly instructive example of a pupil-turned-teacher success story is that of Don Diego de Figueroa Cajamarca, cacique of the ethnic group of Huayacuntus, who was among the first generation of students to attend the Colegio de San Andrés. His name is listed among the students-turned-teachers in the 1568 report on San Andrés.[48] By 1575, he was deemed so conversant in doctrine, languages, and other arts that he was selected by the Franciscans to serve as master instructor of reading, writing, choir, and music, teaching these arts—along with Castilian grammar—to both Andean and Spanish pupils. He also served as *alcalde de doctrina* at the colegio, a post in which he enforced and assured the religious indoctrination of Andean and Spanish youth, teaching Christian doctrine in both Castilian and Quechua. Figueroa Cajamarca routinely preached sermons to the Andean community in the "language of the Inca."[49]

Figueroa Cajamarca's elite, acculturated, and lettered status, as well as his ability to instruct, organize, and lead Andean people, was in the 1570s recognized by the *real audiencia*, when he was appointed *alcalde de los naturales de la provincia de Quito*. In this capacity, Figueroa Cajamarca served also as a builder and general contractor when the *audiencia* charged him with organizing and overseeing the native labor to erect the parish church of San Blas and to complete the construction of a local convent. In 1574,

Figueroa Cajamarca was named *alcalde mayor de los naturales de la parro-quia de San Sebastián*, a post that included judicial as well as political power. Under this title, he established two new indigenous communities (*reduccio-nes*) associated with the parish of San Sebastián, for which he reportedly designed the plans and layout of streets, plazas, and lots.[50] In the 1570s and 1580s, Figueroa Cajamarca enjoyed a series of prestigious and well-remunerated political posts awarded by the *real audiencia*, including *alcalde mayor de las parcialidades de urin y anansaya de Quito*. When he died in the 1590s, the *audiencia* named yet another Andean graduate of the Colegio de San Andrés, Don Pedro de Zámbiza (cacique of the eponymous community), to replace Figueroa Cajamarca as *alcalde mayor*.[51] The high offices and titles held by Figueroa Cajamarca and Zámbiza exemplify the Franciscan goals at San Andrés to create an indigenous leadership class.

According to Waldemar Espinoza Soriano's analysis of the documents, the officeholders of *alcalde mayor de los naturales* were required to possess specific knowledge and skills, notably in the linguistic and lettered arts, even in calligraphy. A list of these abilities included:

> 1. That they know how to read and write. 2. That they understand the customary law. 3. That they are mindful of and effectively practice the Christian doctrine. 4. That they be skilled in the administration of civil and criminal justice. 5. That they dominate the Spanish language. 6. That they dress like elites of Castile. 7. That they be clearly faithful to the king. 8. That they must also have good handwriting [*caligrafía*].[52]

Among the many requirements of the post, it is of particular note that good calligraphy figured among more staple skills of reading, writing, and knowledge of Christian and legal doctrine.

Additionally, in the arena of music—another of the languages of empire—many of the Andean students trained at San Andrés went on to hold important and well-remunerated positions in the Cathedral and other churches as choirmasters, singers, and musicians. A 1573 account boasts, "from here [the Colegio de San Andrés] the land has been filled with singers and musicians."[53] The sixteenth-century Dominican friar Reginaldo de Lizárraga recounts with evident pride and hyperbole the story of a certain Andean man, Juan Bermejo, who parlayed the musical skills he acquired at San Andrés into a brilliant career as chapelmaster and organist at the Cathedral in Quito.[54]

While the documents name a number of the early students and several of those who later became teachers at the Colegio de San Andrés, no painters or artisans are recorded among them. Nonetheless, the visual and material evidence discussed below indicates that many among the early generations of Andean painters and other artisans likely acquired lettered status and learned their trades at the Franciscan school.

Instructional Materials and Methods

There is ample documentary evidence as to what was taught and who was teaching at the Colegio de San Andrés, as well as the admirable capabilities and successes of its alumni; however, far less information is available regarding how subjects were imparted and what materials were employed in the pedagogical process. Because the Colegio de San Andrés was modeled on the early Franciscan schools of New Spain, many of their teaching materials and methods were undoubtedly similar.[55]

As the Franciscan friar Diego de Valadés demonstrated with the engravings that accompany his 1579 *Rhetorica christiana*, the Franciscans in New Spain employed a range of pedagogical strategies, many of which depended on the use of visual images.[56] Valadés's often-reproduced engraving, the *Ideal atrio*, depicts many small groups of students being instructed by Franciscan friars, several of which employ visual images in their task (fig. 1.13). In a few prominent instances, friars point to large sheets or panels on which visual images are painted, including a depiction of God the Father creating the world, in order to convey their message.[57] Another of Valadés's engravings depicts a Franciscan friar instructing a large group of indigenous people by pointing to scenes depicting events from the Passion of Christ that are painted on a long canvas (fig. 1.14). Similarly, the Franciscans at Quito's Colegio de San Andrés employed visual images as pedagogical tools in various ways; indeed, one of the 1568 rules of the colegio declared: "they are taught [. . .] the meaning of the images that are in the churches."[58] Western visual literacy, achieved by educating the eyes of native people in representational imagery, taught new ways of seeing and understanding graphic and sculptural forms.

The 1568 statutes of Quito's Colegio de San Andrés record in some detail the Christian doctrine taught by Franciscans to their native charges. Thirteen points of doctrinal instruction that were imparted prior to baptism are laid out in the report, including

> the confirmation of their belief in only one creator God, punisher of evil and rewarder of the devout; the belief that God was incarnated in Christ for the salvation of the world; the agreement to live under natural law of God (instead of the sinful ways of their past), and that all sins would be pardoned upon receiving baptism. After this sacrament, the Franciscan catechism moved on to treat more complex doctrinal themes, such as the articles of faith, heaven, hell, purgatory, the trinity, the resurrection, and the eucharist.[59]

As Andrea Lepage has pointed out, the thirteen points of doctrinal pedagogy employed at the Colegio de San Andrés correspond to those depicted in Valadés's engraving of the *Ideal atrio*.[60] The Franciscans in Quito thus relied on visual images as an integral part of their pedagogical method and

Figure 1.13. Diego de Valadés, "Ideal Atrio," 1579. Engraving from *Rhetorica christiana* (Perugia, 1579). Photo courtesy of the Nettie Lee Benson Latin American Collection, University of Texas Libraries, the University of Texas at Austin.

they employed a host of related materials, objects, and instruments in their instruction at the colegio.

Among the few documentary references to teaching materials utilized at San Andrés are books of various sorts, writing materials, musical instruments, and sheet music. The 1568 statutes of the colegio mention an annual budget of one hundred pesos "for primers and books [so that] they can read, paper and ink so that they can write, and choirbooks [so that] they can sing."[61] A 1581 inventory of the colegio's possessions included "three shawms, five large folders of sheet music with motets by the Sevillian master Francisco Guer-

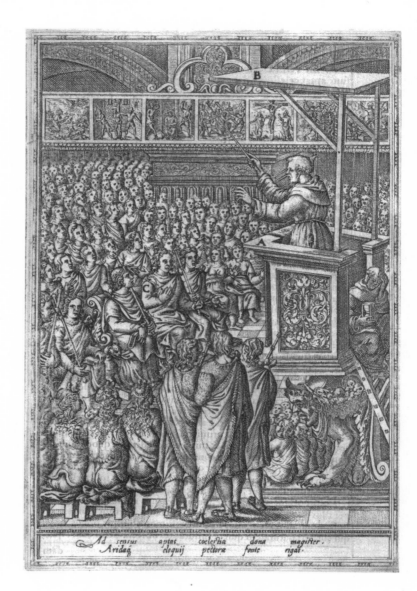

Figure 1.14. Diego de Valadés, "Preaching with Pictures," 1579. Engraving from *Rhetorica christiana* (Perugia, 1579). Photo courtesy of the Nettie Lee Benson Latin American Collection, University of Texas Libraries, the University of Texas at Austin.

rero, eight large folders of manuscripts, nine cloth costumes for dances, and a box of books in Castilian [*romance*] and primers for children."[62]

Sixteenth-century students in Quito and elsewhere typically were educated by means of *cartillas* (primers), often used as a catchall term for basic texts that instructed in reading, writing, and Christian doctrine, which could include catechisms, syllabaries, *libros de niños*, and other pedagogical manuals. [63] Many of these instructional books combined texts with engraved pictorial images. For example, the immensely popular and widely distributed *Cartilla para enseñar a leer* (Mexico City, 1569), attributed to the Franciscan friar Pedro de Gante, is illustrated with numerous printed religious images

that served as didactic and mnemonic devices, blending pictorial and alphabetic instruction. One of the first books produced in Lima upon the establishment of the printing press in 1584 was a *cartilla*, the *Doctrina christiana y catecismo para instruccion de los Indios* (1584), which was illustrated with engravings depicting the Trinity, the Coronation of the Virgin, the Last Supper, and other religious images, alongside historiated capitals and marginal adornments composed of Renaissance grotesques (fig. 1.15).[64] Indeed, several of these prints served as the basis for later seventeenth-century paintings in Quito.[65]

The specific *cartillas* employed by Franciscan and Andean instructors at the Colegio de San Andrés are unknown; however, teachers likely chose from among the many popular catechisms, primers, and manuals of various sorts that were imported and sold by the scores in the city during the sixteenth and

BREVE.

amar a Dios fobre todas las cofas, y a fu proximo como afsi mifmo.

Q.

Diospa llapa camachi cufcá fiminri cay yfcay manmi tucun. Diofta tucuy yma haycaclaya llifpa munanqui, runa macijquiclari quiquij quicla hina cuyan-qui.

ʡ.

Diòfanataque aronac páfca aca paya aroroquipi tucu. Diosáro chuyma cancabàta taque cuna, cauquifa llallifsina, haque macimafca huma quiquimahàma cuyahàta.

Fin del Catecifmo breue.

early seventeenth century. Although it is rarely possible to identify the specific texts based on the generic descriptions in the documents,[66] the abundance and availability of *cartillas* is nonetheless registered with great frequency. To cite just three examples, a 1585 purchase registered "three pesos' worth of *cartillas* at one-half peso the dozen";[67] a 1595 sale included "eight and one-half dozen large *cartillas* at one peso the dozen";[68] and a 1601 shop inventory listed "eleven dozen *cartillas* at two and one-half pesos the dozen, together with four dozen that have already sold."[69] Notarial documents provide ample evidence of the demand in Quito for instructional texts to teach and indeed to go beyond *primeras letras*.

Grammars are also noted in sales records, yet they are largely named as such, with one notable exception: Nebrija's Latin grammar, *Introductiones latinae* (1481), the "Arte de Antonio."[70] In addition to Francisco Atahualpa's abovementioned purchase of Nebrija's work, a 1601 Quito shop inventory records, among other volumes, "forty-eight artes de ant[oni]o at three pesos each,"[71] and a list of books imported to Quito in 1618 registers 137 copies of the "Arte de Ant[oni]o in boxes."[72] The 1618 recipient of those many volumes of Nebrija's Latin grammar was the merchant Gabriel Villán de Valdés, who served at the time as *mayordomo* of the Confraternity of the Vera Cruz in the Monastery of San Francisco and was closely associated with the Franciscan educational endeavors.[73] Indeed, as noted above, grammar and *latinidad* figured as pedagogical priorities at the Colegio de San Andrés, alongside reading, writing, and instruction in painting and other manual arts. Given their educational priorities and pedagogical methods, the Franciscans produced generations of lettered students equipped with a range of Western knowledge and abilities that exceeded the rudiments of ABCs.

The End of the Colegio de San Andrés?

Scholars have asserted that the Colegio de San Andrés operated only until the 1580s, when it was disbanded and given over to the Augustinian friars, who changed its name to San Nicolás de Tolentino.[74] Yet a series of notarial documents record the colegio's continued existence well into the seventeenth century. For example, in a 1604 account, Don Domingo Hernández was identified as "maestro de capilla del Colegio de San Andres."[75] The majority of seventeenth-century documents involving San Andrés, however, are *censos*, mortgages held by the colegio for which it gained an annual income. Eight *censos*, each specifying that they were made in favor of the Colegio de San Andrés, appear in the notarial record between 1604 and 1622, which together comprised substantial revenue.[76] Testamentary references to the Colegio de San Andrés also continue through the early seventeenth century.[77] Thus *censos* and other documents confirm the continued existence of the colegio during the first decades of the seventeenth century, even if they do not convey the precise form in which it functioned.

There are intimations, however, that the colegio may finally have ceased

to exist or that it underwent a drastic transformation sometime in the 1630s, perhaps in part related to its Andean charges. In 1632, a group of Andean *principales y naturales* (elites and natives) of the parish of San Roque, Don Felipe Vilca (governor), Antón Chachicha (*alcalde*), Francisco Cayllagua (carpenter), Clemente Quispe (painter), Esteban Rimache (blacksmith), and Mateo Ataurimache (painter), took into their own hands the education of young boys of their community. Each signed his name to a notarial contract hiring the choir- and schoolmaster Don Luis de la Torre to "teach the boys of the parish to read, write, and sing."[78] It is unclear whether the action taken by the Andean leaders of San Roque indicated or initiated the demise of San Andrés, or whether the group had other reasons for taking control over the education of their children. Indeed, during the 1620s, many of the same Andean parish leaders who later hired the schoolmaster were involved in a protracted lawsuit with the Franciscans over land claims in San Roque and beyond.[79] The Andean leaders of San Roque had learned well the Franciscan lessons, for they strategically employed acquired knowledge and alphabetic literacy to further their own interests—even counter to those of the Franciscans—just as they recognized and sought for their sons the power and privilege that alphabetic and other literacies conferred within the colonial city.

Questions and concerns regarding the nature, extent, and ramifications of Andean schooling percolated throughout the viceroyalty during the late sixteenth and early seventeenth centuries. There was growing anxiety in some circles regarding the degree to which Andeans should be educated, concerns about natives "knowing too much," and preoccupation about the ways that these technologies might be used to contest and undermine Spanish authority. In particular, manipulation of the legal system via notarial documents and a precipitous rise in lawsuits brought by Andean plaintiffs were fodder for authorities throughout the viceroyalty seeking to curtail, control, and otherwise circumscribe the education of indigenous people in Western letters.[80] In 1588, for example, Father Bartolomé Álvarez, a *doctrinero* in the Charcas region, railed against "indios ladinos" who employed their education to bring lawsuits and complaints against the priesthood:

> To grasp the [ladinos'] bad intentions look no further than to the designs of the Indian who wants to be a "letrado," but only to make lawsuits, without having the proper studies. If you were to ask him about Christian doctrine, he wouldn't know the law of God, or understand the catechism, or how to recite it [. . .] and try to raise a ladino son that does not know how to read and write, and he will turn Monterroso and the *leyes de La[s] Partidas* upside down just to do evil [. . .] The ladinos have not profited from the Spanish language or the Christian doctrine they have learned in the homes of priests, except to be worse than other Indians and interpreters of their own aims and our ruin.[81]

The specific texts mentioned by Álvarez are legal manuals that circulated widely in the early colonial period: Gabriel de Monterroso y Alvarado's *Practica civil y criminal, e instruction de escrivanos* (Valladolid: Francisco Fernández de Córdova, 1563) and Alfonso X "el Sabio's" *Siete Partidas* (ca. 1265; printed in numerous editions throughout the sixteenth century). In Quito, as in many early colonial urban centers, copies of the *Siete Partidas*, "Practica de Monterroso," and "Notas de Ribera para escribanos" (Diego de Ribera, *Escrituras y orden de partición de residencia, y judicial civil y criminal* [Granada: En casa de Antonio de Nebrija, 1561]), among other legal and scribal manuals, were imported and sold in substantial numbers.[82] To the consternation of Spanish authorities, literate Andeans reportedly took advantage of the widespread availability of such texts, employing them to the detriment of "social order."

In the 1620s, when Pablo José de Arriaga queried a Spanish priest about the lack of a school in his parish, the priest responded, "It wasn't worth having the Indians know how to read and write because knowledge of letters only served them for making lawsuits against their priests."[83] Indeed, complaints regarding Andean literacy and legal activism echoed throughout religious as well as civil realms during this period, appearing in confession manuals such as that of the parish priest Juan Pérez Bocanegra, who specifically warned Andean notaries to beware of employing their skills to commit offenses against God and the Spanish hierarchy.[84] Similarly, Viceroy Francisco de Toledo expressed concerns regarding the ability of Andeans to read books and employ their contents to challenge colonial authority, observing "It is not advantageous that profane books be brought to this kingdom because the Indians will receive bad example from them and many now know how to read."[85] Again, such "profane" books likely included legal and scribal manuals that offered instruction in the preparation of official documents such as lawsuits, complaints, and other bureaucratic forms, which were imported in significant numbers to Quito and elsewhere in the Andes.[86]

Felipe Guaman Poma de Ayala also referenced the distrust felt by parish priests when it came to lettered Andeans: "They soon throw the *indios ladinos* out of their parishes because, if they know how to read and write, they will file complaints against him."[87] Guaman Poma promoted the idea that all caciques should learn to read and write in order to draft legal petitions and complaints, yet he simultaneously warned of instances in which Andean elites were jailed, punished, and even executed for doing so.[88]

The alphabetic literacy of Andeans was, from a Spanish optic, perceived with some ambivalence. On the one hand, knowledge of Western letters was necessary for religious indoctrination, for the creation of a much-needed class of interpreters, and for a capacitated workforce. At the same time, native command of literate conventions was threatening and potentially disruptive to those in power, for those skills gave Andean people access to the law and the means for potentially refuting and overthrowing Spanish colonial dominion. The scales appear to have tipped in the last decade of the sixteenth and

early seventeenth centuries, when religious orders and others scaled back indigenous education, providing only the basics required to make them "good citizens" and workers.[89]

Following broader trends throughout the viceroyalty, the Franciscan educational mission in Quito changed course substantially during the seventeenth century to focus solely on the schooling and training of its own largely Spanish and Creole members. Shortly after midcentury, a new and different educational institution had replaced San Andrés: the Colegio de San Buenaventura, specifically designed for the training of Franciscan novices and friars. San Buenaventura reportedly occupied the buildings of the first Franciscan complex that included the earlier San Andrés, which by the latter part of the century had fallen into disrepair. In 1699, several Franciscan friars determined to rebuild the early structures in order to house "once again the Colegio de San Buenaventura, previously known as San Andrés."[90] Andean schooling and training in the spiritual, literary, and manual arts thus fell by the wayside at the Franciscan monastery, supplanted by an inward-turning educational focus on members of the order itself. The Franciscan abandonment of efforts to educate indigenous children is the backdrop against which the Andean parish leaders of San Roque in 1631 hired a schoolmaster to teach their children to read, write, and sing. Equally, their action registers a commitment to maintaining a legacy of learning within the native community.

Inca Languages of Empire

Western genres of education and alphabetic literacy were not the only forms of knowledge possessed by Francisco Atahualpa, Andrés Sánchez Gallque, and many of their early colonial Andean contemporaries. Despite the historiographical preoccupation with the "puzzling" lack of alphabetic writing as speech in pre-Columbian Andean cultures, painting and graphic forms of expression, information archiving, and record keeping abounded in the ancient Andes. Indeed, the Inca and other Andean polities possessed their own languages of empire. As Galen Brokaw has observed, the Western "alphabetic bias" has impeded our ability to understand the quipu (knotted-string recording device) and other forms of Andean knowledge production.[91] The sustained and expanding interest in deciphering the quipu often has overshadowed other forms of Inca and Andean pictorial, presentational, and recording practices, including painting. The Inca possessed a range of materially and graphically recorded forms of knowledge and information that did not replicate speech.

In Quito, Francisco Atahualpa serves as an example of the link between pre-Columbian and colonial Inca experiences and practices. Francisco was perhaps the most illustrious of the first generation of Andeans to be educated by the Franciscans in Quito.[92] In the mid-1530s, the fourteen- or fifteen-year-old Francisco was remanded to the care of the Flemish friar Jodoco Rique,

founder of Quito's Franciscan monastery.[93] In 1556, Rique testified that he had "for the last twenty years taught and indoctrinated him [Francisco Atahualpa] in the Catholic faith and had baptized him and has sustained him spiritually and corporeally."[94] Given his age when he became a ward of the Franciscans, Atahualpa undoubtedly possessed considerable prior knowledge and experience: he spent his childhood and much of his youth within the elite Inca system, and only as a teenager was he educated and indoctrinated by the Franciscans in Quito.

Although we know little of Francisco Atahualpa's early educational experiences and training before the Spanish invasion, colonial chronicles provide descriptions of the type of elite Inca education in which he had likely participated, even if they are mediated through a Spanish lens. To cite several particularly revealing examples, Fernando de Montesinos (1642) describes a school established in Paucaritambo by the Inca ruler Topa Cauri Pachacuti "in the style of a university, where nobles attended military training, and the boys were taught the way to count using quipos, adding diverse colors, which served as letters."[95] Martín de Murúa's early seventeenth-century manuscript describes in detail the special school in Cuzco designed for "sons of the principal Lords of the provincial governors and their closest relatives and others of their bloodline," where they were instructed in "all of the things that are required for them to become wise and experienced in government, politics, and war."[96] Four or five maestros taught boys of different ages in a four-year graduated curriculum, beginning with "the language of the Inca," and continuing to the study of religious practices and ceremonies, the use of quipus in administration, justice, and the recording of historical knowledge.

Garcilaso de la Vega (1609) offers perhaps the most detailed account of Inca elite education and its curriculum, albeit filtered through European norms: "Among other things that the Inca kings invented for the good government of their empire was to mandate that all of their vassals learn the language of the court—that which today is called: the 'general language'—for the teaching of which they established in each province Inca masters for those of privilege."[97] Garcilaso's chapter, "Of some laws that the king Inca Roca made and the schools that he established in Cuzco, and some of the things he said," draws on the Jesuit Blas Valera's account of Inca educational attitudes and practices:

> What Father Blas Valera, the great investigator of the Incas that he was, says about this King [Inca Roca] is, that he reigned for almost fifty years, and that he established many laws, among which the following are said to be the most principal. That it was unsuitable for the sons of the common people to learn the sciences, which belonged solely to the nobility, so that they do not become arrogant and dishonor the republic. That it was enough for them to simply be taught the trades of their fathers [. . .] he [Inca Roca] was the first to establish schools in the royal city of Cuzco, so that the wise ones [*amautas*] might teach what they knew

to the Inca princes and those of their royal blood and the nobility of the Empire, not by means of teaching them letters, because they did not have them, but by practice and by everyday use, and by experience, so that they might know the rites, beliefs, and ceremonies of their false religion, and so that they would understand the reason and basis of his laws and charters, and their number, and their true interpretation; so that they would achieve the ability to know how to govern, and they would become more urbane and more practiced in the arts of war; so that they would know the seasons and the years, and understand and recount histories by means of knots; so that they would know how to speak with elegance and aplomb, and know how to raise their children and govern their homes. They were taught poetry, philosophy, and astrology, the little of each science that they knew.[98]

The sons of nobles learned to speak the language of empire, and to "read" and recount it as registered in the knots of quipus and the colored additions that "served as letters." They were also instructed in religious beliefs and practices and political systems, which included the laws and forms of good governance so that they would obey and enforce the rules throughout the empire. Francisco Atahualpa and many of his contemporaries were likely instructed in these skills prior to being indoctrinated by the Spaniards; thus, Francisco and the first generations of elite Inca boys to be educated by the Franciscans in Quito filtered European knowledge and technologies through their earlier educational experiences in the Inca system.

And what of the training of painters and other specialized artisans under Inca rule? Garcilaso de la Vega writes that the best craftsmen were placed at the disposition of the Inca and his principal lords: "excellent craftsmen, such as silversmiths, painters, carpenters and masons, which in all of these trades the Inca had great masters, who, by virtue of being worthy of their service, were presented to the *curacas*."[99] According to Garcilaso, the Inca and his lords valued certain specialized trades above the ordinary, which included "special craftsmen, such as silversmiths, painters, potters, boatmen, accountants, and musicians, and also in the trades of weaving and building or constructing, who served the lords."[100] The Sapa Inca and other elites esteemed the work of these specialized artisans, who received special privileges because of their profession. These included exemption from taxation—a benefit that otherwise was extended only to the Inca nobility. Inca artists, including "painters," thus possessed specialized knowledge, occupied privileged positions, and shared some of the benefits enjoyed by the nobility.[101] Although mediated through a European lens, the chroniclers describe pre-existing systems of Inca education and related values that to some extent dovetailed with colonial missionary education and a need for artisans, musicians, and painters. References to Inca painters by Garcilaso de la Vega and other chroniclers pose a series of questions about the nature and practices of such professionals, as well as the materials and objects of Inca painting.

Quilca *and Colonial Andean Notions of Graphism*

Early colonial Quechua-Castilian dictionaries offer an approximation of the ways that Andean informants conceptualized and identified European things and practices, among them, painting. The works of the Dominican friar Domingo de Santo Tomás, *Lexicon, o Vocabulario de la lengua general del Peru* (1560), the anonymous *Vocabulario y phrasis en la lengua general de los indios del Peru, llamada quichua* (1586), and the Jesuit Diego González Holguín, *Vocabulario de la lengua general de todo el Peru llamada lengua Qquichua, o del Inca* (1608) record the terminology used to define a range of graphic materials and practices. These sources demonstrate that Andean notions regarding graphism and the recording of knowledge did not conform to European categories and nomenclatures. In each dictionary, the stand-alone Quechua term *quilca* (and its variant spellings) is defined as paper, letter, book, and script (among other things), thus associating it with European alphabetic writing materials and conventions. However, while the Castilian language employs separate and distinct terms for a range of graphic practices and forms, including "writing," "painting," and "embroidering," the Andean informants who worked with the early compilers of dictionaries made no such distinction among these and other concepts in the Quechua language. The Castilian terms and a host of others are translated in the early dictionaries as the same Quechua word: *quilca* (also spelled *quillca, quelca, quellca*).

Quilca forms the root word for a multiplicity of colonial Quechua terms. For example, in Domingo de Santo Tomás's *Lexicon*, *quilca* alone appears in the definitions of the following verbs: to design, draw up [*trazar*]; draw [*dibujar*]; paint; write; sculpt; dye with color; embroider with colors; and "paint with fire." Indeed, Domingo de Santo Tomás defines twenty-eight separate Quechua terms that employ *quilca* as the root word. González Holguín's later *Vocabulario* defines the Quechua verb *quilcani, gui* as "to paint or write in general" and "to embellish a work with colors in general," and *quellcani* or *qquellccacuni* as "to write, draw, paint," thus rendering virtually indistinguishable three actions that in European modes of thought constituted separate if related categories of graphic expression. González Holguín defines twenty-seven Quechua terms that employ *quilca* as a root word, which incorporate a similar range of materials and actions, from writing, drawing, painting, and printing to sculpting, dyeing, and embroidering or embellishing with colors. Whether the Spanish rendered the term too capacious or the Inca informants aggregated multiple graphic conventions under the same rubric, in contemporary dictionaries, writing, drawing, and painting, among other graphic practices, were thus entangled and effectively indistinguishable in the colonial lexicon for Quechua.

Colonial dictionaries also include terms that define the practitioners of *quilca*, which employ the term as a root plus *camayoc* (master or official practitioner). Domingo de Santo Tomás defines equally as *quilcacamayoc* the three separate Castilian terms for "painter" and "writer" and "drafts-

man." González Holguín's definitions operate in a similar manner, although he adds material-specific terms that render his translations more precise and nuanced. For example, he employs the words *riccha quellcaycamayok* for "painter," wherein *riccha* means "color or figure," and *rumiqquellcaycamayok* for "sculptor," wherein *rumi* means "stone or rocky ground," reserving *quellcacamayok* alone for "a scribe by trade or a great writer." Ultimately, all such practitioners are defined as the makers of meaningful graphic, often colored, marks on surfaces.

One of the first books published in South America, the 1584 *Doctrina christiana*, contains several appearances of the alternate spellings *quilca* and *quellca* in translations of religious texts and definitions in Aymara and Quechua, wherein the term is applied to the objects and practices of writing and painting. Although the Quechua *quellca* is not included in the "Vocabulario breve" for each language that constitutes the last section of the volume, the Aymara *quilca* is defined as: "Quilca, paper, book writing, letter, painting. Quilcatha to write, to paint."[102]

Felipe Guaman Poma de Ayala, in his "Nueva corónica" (ca. 1615), describes and illustrates a colonial *quilcaycamayoc* as a scribe at work in his study, characterizing the profession as an elite post that was held in great esteem by the colonial Inca (fig. 1.16).[103] Guaman Poma glosses his titles in Spanish as "escribano de cabildo" ("scribe of the council") and "escribano de quipo, cordel" ("scribe of the quipu, cord"), thus linking through text and image two principal recordkeeping technologies, quipus and script (*quilca*), with their practitioners. As Joanne Rappaport and Tom Cummins have observed, Guaman Poma's epistle is the quintessential colonial Andean example of the union of writing and drawing: "in the New Chronicle and Good Government, quilca is exemplified as an ambiguous term that enabled Guaman Poma to unite two non-Andean actions—drawing and writing—with the ancient accounts of knowledge."[104] Cummins concluded that "*Quilca* as a colonial Quechua term expresses both writing and drawing and denies a separation between them. They are the same act."[105]

Interestingly, González Holguín also includes definitions that employ *quilca* as a root word in relation to oral or verbal forms of communication that are associated with graphic practices. For example, *quellcarpayachini* is defined as "to dictate that which [one] is writing"; *quellcarpayani* is defined as "to write what is being dictated"; and the phrase *quellcar payachispa yachanini* is rendered as "to teach theology through dictation." Thus, *quilca* is also linked to oral forms of communication that were interpreted, translated, and recorded through graphic forms.

In early colonial Quito, Quechua loanwords figure only rarely among the archival documents; however, the term *quilca* makes notable appearances, indicating that it formed part of the local lexicon for some Andeans. In an undated document that is clearly an oral transcription of events that transpired in the mid-sixteenth century, the term *quilca* is employed on several occasions.[106] The person who wrote or dictated the document was the

Andean architect and builder Jorge de la Cruz, an Inca transplant from Guaclachiri (Huarochirí?) who had been brought by Spaniards to Quito soon after the establishment of the city. He and his son Francisco Morocho were closely allied with the Franciscans, for whom they worked for more than twenty years to build the "church and main chapel and choir of San Francisco."[107] Both men possessed alphabetic literacy, and were undoubtedly alumni of the Colegio de San Andrés.

Written in Castilian and signed with his name, Jorge de la Cruz's account employs some Quechua forms of expression, grammar, and syntax, and

one loanword appears repeatedly: *quilca*. Because this document sought to establish the legal basis for Andean ownership and title to land, *quilca* is used throughout to signal graphic records that include a last will and testament, a land title, and perhaps a drawing that constituted a plan of the landholding. The document recounts that when Jorge de la Cruz's Spanish *amo* (master), Diego de Tapia, made a deathbed will, he "left a *quilca* of all the lands and ranches of the said town of Lumbizi and of Cumbaya," and that document or plan was passed on to a certain Germán Alemán so that he "might have the *quilcas* of the lands."[108] The ambiguity of *quilca* in this document—title, drawing, testament—resonates with the aggregate Quechua meanings of the term found in colonial Quechua-Castilian dictionaries.

Galen Brokaw has convincingly argued that the reason the word *quilca* does not appear in the works of most early colonial chroniclers is because they translated the term supplied by native informants into Spanish words that more specifically defined the concept in separate European categories. According to Brokaw,

> Unlike the quipu, the various Andean objects and practices to which it [*quilca*] referred were easily translatable into a variety of other terms. Thus, in many cases where Spanish terms such as "pintura" (painting), "bordado" (embroidery), "escultura" (sculpture), and so forth appear in colonial documents in reference to indigenous Andean society, the original Quechua word from which they were translated was likely often *quilca* or a compound containing *quilca*, particularly in the case of references to "painting."[109]

Although we cannot know the precise pre-Hispanic meaning(s) of *quilca*, the term entered into the colonial lexicon in various interesting and revealing ways that were related to alphabetic writing, painting, and other graphic forms. The appearance of the term *quilca* in early colonial Quechua-Castilian dictionaries and in documents forms a web of meanings associated with graphic materials, technologies, and practitioners.[110] *Quilca* and its related concepts thus constituted an integral and often overlooked part of the colonial Andean languages of empire.

The common denominator that emerges from among the range of materials, actions, and results related to the term *quilca* in colonial dictionaries would seem to be the making of meaningful, visually distinctive marks on surfaces with expressive or communicative content (frequently involving color or the contrast of colors/light created by raised or incised and flat surfaces). The nexus of *quilca* and its derivative terms is the purposeful marking of surfaces with meaningful, communicative content.[111] *Quilca*, rather than constituting a form of "writing" in the Western sense, encompassed a range of expressive graphic forms and practices far beyond a narrow alphabetic or phonetic mode by including multiple mediums and manners of expression.

Chroniclers often mention the significant role played by color in Andean

graphic and social conventions. Indeed, as Gabriela Siracusano has observed, "In the case of Andean cultures, political, social, economic and religious practices reveal the presence of color as a key protagonist. Far from occupying a secondary or accidental role, the chromatic spectrum, rooted in daily life, functioned as a mechanism by which social status, commercial activity, or sacred presence could be identified."[112] The materiality of colors—powdered pigments derived from revered stone, metal, and organic sources—held signifying power that rendered the chromatic spectrum a potent vehicle of communication in the pre-Columbian Andean world. The frequent association of graphic practices involving color with *quilca* underscores the inherently discursive nature and function of pigments. The types and chromatic range of colors that the Inca applied to surfaces and objects are perpetuated in colonial Quechua notions of *quilca* as multifarious graphic forms of communication.

Quilca *and Inca Painted Objects*

Colonial chroniclers understood various examples of painted objects produced by the Inca as recording privileged information and histories associated with elite and specialized knowledge. Brokaw has argued that the Quechua word employed by the chroniclers' native informants to describe Inca applications of paint to wood panels, staffs, and woven textiles must have been "quilca."[113] These objects, Brokaw contends, were likely named and understood as *quilca* by the native informants who assisted the Spanish chroniclers in their collection of information. Beyond terminology, such painted objects point to a history among the Inca of recording, recounting, and retrieving knowledge via graphic, often colored, marks on surfaces—not an alphabetic or hieroglyphic language, nor in any sort of mimetic form, but perhaps a semiotic system of knowledge production. The chroniclers frequently describe Inca graphic practices as constituting specialized and privileged forms of knowledge production and recording.

Writing in the 1550s, Juan de Betanzos described numerous instances of what he termed "drawing and painting" among the Inca. He recounted, for example, that an unnamed lord of Cuzco "ordered much carved wood brought and many paintings made on wood" as offerings to the mummified body of Inca Yupanque's son.[114] Betanzos also recorded that Inca Yupanque himself designed bridges by "painting and drawing" them, although the precise material and graphic form of these images remains mysterious in his account. According to the chronicler, Inca Yupanque painted and drew the bridges, "showing the way he wanted to have them and how they were to be constructed. He was also drawing some roads that went from a town to those bridges and rivers. Since the meaning of these drawings was beyond the understanding of those lords [. . .] they asked him what he was drawing."[115] The Inca responded that they would know in good time. The Sapa Inca clearly possessed specialized and exclusive knowledge of graphic technolo-

gies, which might have been characterized as *quilca*, that were not apprehensible to all, even to his local lords.

In a similar vein, Pedro Sarmiento de Gamboa's 1572 account describes how the Inca Pachacuti commanded histories to be recorded on painted wood panels:

> After he had ascertained all that was most important about the events of their histories, he ordered all of it to be painted on large wood panels [*tablones*] and designated a great hall in the houses of the sun where the gilded panels were, which were like our libraries, and he elected learned men who knew how to understand and explain them. And no one was permitted to enter [the place] where these panels were kept other than the Inca or the historians with express permission from the Inca.[116]

The painted wood panels depicting "histories" of the Inca required specific knowledge and expertise to decipher, and those recorded accounts were so precious that access to them was restricted to the Sapa Inca and select historians.

Cristóbal de Molina, writing around 1575, also described the "library" of the Inca that was kept in the House of the Sun "called Poquen Cancha," reporting that it contained "the life [history] of each one of the Inca [leaders], their origins, and the lands that they conquered, painted in figures on some panels."[117] Similarly, the Spanish viceroy of Peru, Francisco de Toledo, wrote of "a wooden panel and quipos on which were recorded the histories of Pachacuti Inca and his son Topa Inca Yupanqui and Huayna Cápac, son of the said Topa Inca," and Martín Enríquez provided testimony regarding "a wooden panel of different colors by which the Inca judges understood the crimes that each delinquent had committed."[118]

Painted repositories of knowledge also took the form of wooden staffs to which colors were applied. In the 1580s, the chronicler Miguel Cabello Balboa described the creation of such an object associated with recordkeeping in his account of the death of Huayna Cápac in Quito: "Feeling himself close to death, he made his [last will and] testament, according to their customs, and on a long [wooden] staff (like a crosier) they applied stripes of different colors by which his last and final will was known and understood, after which it was given for safekeeping to the Quipo-camayoc (who was like our Scribe or Secretary)."[119] Here again, the verbal is transposed from one system of signs into another: Cabello Balboa understood the words of Huayna Cápac to be translated into patterns of color painted on a wooden staff, which was to be guarded by the keeper of quipus so that it could later be "read" and acted upon by the heirs of the Inca ruler. These colored graphic forms were effectively "coded"; their later interpretation and implementation was restricted to certain groups. However, broader audiences likely would have recognized the power encoded in these colored forms, even if those viewers did not understand their specific meaning.

In 1613, Juan de Santa Cruz Pachacuti Yamqui cited several instances of "painted staffs" [*palos pintados*] that functioned as repositories of knowledge and instruction. The first such mention occurs in his account of pre-Inca history, in which a "pilgrim" called Tonapa Viracochampacachan gave a staff painted with stripes that contained his teachings to the cacique Apo Tampo and his people: "so that on a single staff they received what he preached to them, marking with stripes [*rayando*] each chapter of the arguments."[120] In another instance, Pachacuti Yamqui recounted that Topa Ynga Yupanqui sent one of his elite administrators to inspect his fields and lands, "giving him his instructions in stripes painted on a wooden staff."[121] The chroniclers' accounts highlight the significant role of wooden objects painted in colors in the transmission of spiritual and symbolic ideals, as well as the more quotidian relay of instructions.

Inca histories, directives, and accounts reportedly were painted on textiles as well as wood. Sarmiento de Gamboa wrote that when Pachacuti's official inspectors returned to Cuzco, they brought with them "a description [painted] on some cloths of the provinces they had inspected."[122] Bernabé Cobo reported seeing in Cuzco a "history" that was "depicted on a tapestry cloth of cumbe, no less interesting and well painted than if it had been one of the very fine court textiles."[123] Perhaps the most famous colonial episode of painted textiles created by Inca artists occurred in the early 1570s, when the Spanish viceroy Francisco de Toledo commissioned Andean artists to produce four cloths depicting Inca histories and genealogies that he intended to send to the Spanish king.[124] The information painted on the textiles was subsequently discussed and validated by members of the indigenous elite and by Spaniards, who signed sworn statements as to its truth and validity. Here, colonial pictorial images created by Andean painters made truth claims, entering into the documentary record as visual historical evidence that could presumably be "read" and understood or acted upon by the Spanish king and his court.

Despite colonial reports of boards, staffs, and textiles painted in colors as containing accounts of histories, genealogies, testaments, and other sorts of information, we cannot know what these objects looked like, nor should the chronicler's accounts be interpreted as evidence that the precontact Inca employed representational painting or some form of hieroglyphic or graphic writing that replicated speech.[125] Yet the painted stripes of color and whatever form the histories and genealogies painted on textiles assumed were obviously more than decorative elements: they held signifying power for those who possessed the specialized and privileged knowledge required to "read" them. Pigments and colorants, applied as paint to specific surfaces, were vital syntactical components of the Inca lexicon of power.

The chroniclers' accounts of these precontact mediums and technologies are of particular significance for this study. Descriptions of Inca painted surfaces reveal them as repositories of knowledge, histories, instruction, and beliefs. Above all, though hardly mentioned, they were by implication

the products of professional activity and specialized knowledge of Andean painters—*quilcacamayocs* in colonial Quechua. Those Andean painters, pre-Columbian and colonial, were the skilled agents and intermediaries who perforce possessed the particular understandings and the technologies to translate the spoken language of power (Inca, viceroy, or king) into graphic, often colored, forms that could later be "read" by those equally knowledgeable and versed in the technology. Although they are rarely mentioned in the chronicles, these Andean painters occupied positions of power and prestige as the possessors and recorders of privileged knowledge.

Colonial Inca notions regarding *quilca* well might have been reified to some extent by the Franciscans, in particular, through an educational curriculum that included the specialized and closely related technologies of writing and painting. The sources, models, and pedagogical practices employed by the Franciscans to teach the languages of the Spanish empire to their native neophytes reinforced the semiotic links between writing, painting, and other graphic modes of communication. In great measure the colonial confluence of Inca and Spanish forms and practices speaks directly to the circumstances by which the majority of Andean painters signed their names, navigated colonial bureaucratic systems, and interpreted and translated European knowledge and histories into graphic and pictorial expression. Their ability to speak and indeed dominate the colonial languages of empire point to preexisting traditions and training in forms of graphic communication under the Inca empire.

The documentary and visual evidence presented in the following chapters explores the practices of Quito's early colonial painters, who, as skilled and empowered intermediaries, achieved measures of status and authority through their manipulation of graphic languages. These painters, irrespective of ancestry, operated in a professional realm that required prior training and specialized knowledge of materials, sources, procedures, and technologies. The materials and tools of their trade were available in abundance on the local market in Quito, in addition to a wealth of paintings, prints, and other objects that served as models for artistic production.

Materials, Models, and the Market

Quito in the late sixteenth and early seventeenth centuries was a rich emporium and a clearinghouse for imported, local, and regional goods. Merchandise of all sorts arrived overland from the northern ports of Santa Marta and Cartagena and from the regional port of Guayaquil, supplying imported goods for local consumers and for distribution to regional markets. Shops, markets, and warehouses offered an abundance of textiles, garments, tools, furnishings, foodstuffs, and works of art brought from far-flung areas of the globe. Piled high on shelves were bolts of Chinese and Mexican silks, damasks, and taffetas; muslins and canvas from India and Holland; colored velvets and brocades from Spain and Italy; lace, colored thread, silk ribbons, and kid gloves from Flanders; huge spools of thread from Portugal and Milan; felted and embroidered hats from northern Spain and Paris—all vying for attention amid piles of exotic and local foodstuffs, spices, oils, and wines, as well as tools, furnishings, and utensils of various sorts. A dizzying array of foreign and local goods was available in Quito's warehouses, shops, and plazas, including visual images and the materials required to produce them.

Imported artworks and related objects were purchased from wholesale merchants (*mercaderes*) of the Indies by local retailers (*tratantes*) and by the owners of *pulperías* (general stores). The earliest extant notarial volumes in Quito, dating from the 1560s, record dozens of such acquisitions intended for sale on the local market. Artists, patrons, and consumers in early colonial Quito could select from a variety of paintings, prints, illustrated books, small retablos or *oratorios* (private altarpieces), and polychrome sculptures, among many other items. These objects adorned churches, civic buildings, and private homes, and also served as sources and models for local artists.

In 1601, the extensive shop inventory of the wealthy Quito merchant Mar-

tín Durana was sold posthumously at public auction. Customers bid on a profusion of goods that included paintings and sculptures, printed images and books, and quantities of powdered pigments and other materials and implements associated with artistic production. The public auction of Durana's inventory documents the type of merchandise that had been available to Quito consumers for more than twenty very successful years at his shop, located on the main plaza of the city.[1] The local and imported objects, materials, and models of artistic production listed in the inventory illustrate the vibrancy of the art market in early colonial Quito. Indeed, Durana's inventory, together with numerous commercial accounts from the notarial records, illuminates a series of issues regarding artistic production and the market in early colonial Quito, from the acquisition and prices of paintings and painted objects to the availability of artistic sources and materials.

The Market for Paintings

Paintings in early colonial Quito were marketed in two principal spheres: an informal economy wherein ready-made paintings were sold in local shops or at public auction or commissioned verbally or by means of *vales* (informal receipts), and a formal economy wherein patrons and painters signed documents of artistic commission before a notary. Notarial contracts for paintings typically were undertaken when the magnitude of the work or its cost merited the expense of drafting a legal document, yet reasons of security and legal recourse were also factors in the filing of such documents. Artistic contracts usually were drawn up at the behest of the patron, who was required to pay the cost of the notary. Because the monetary value of individual paintings was quite low relative to that of sculpture or altarpieces, for example, works on canvas or panel often did not merit the expense of a notary.[2]

The 1601 public auction of Martín Durana's shop inventory illustrates the relatively low prices brought by paintings in early colonial Quito. According to the record of sale, two unframed paintings on canvas depicting the seasons (*los tiempos*) sold for a total of four pesos; a painting on canvas of Saint Anthony of Padua brought six pesos; a series of fourteen panel paintings depicting the apostles was purchased for thirty pesos; two panel paintings depicting Saint Dominic and Saint Roch sold for three pesos each; and two large panel paintings of the Virgin of the Rosary, one of which was embellished with gold, brought a total of thirty-six pesos. In this case, the prices of paintings ranged from two to approximately twenty pesos.

Several other items sold at the same auction afford useful comparison with the paintings: nine prints on paper (*estampas en papel*) brought one peso apiece; a wooden writing desk (*escritorio*) adorned with an image of the Immaculate Conception sold for sixty pesos; and one locally made piece of fine wool cloth (*cumbi*) intended for a mantle commanded twelve pesos. Even a locally made tablecloth (*sobremesa*) described as "ripped" (*rota*) sold for

three pesos—the same purchase price brought by each of the panel paintings of the two saints, and more than the value of two pesos apiece for the pair of canvas paintings depicting the seasons.[3] Clearly, paintings sold on the open market had a relatively low monetary value, and much of that value seems to have depended on size of the works and the cost of materials. Frames, which could sometimes cost as much or more than the painting itself, also factored into the cost of such works. However, as discussed in later chapters, the sums commanded by paintings sold at auction do not vary significantly from those of paintings commissioned before a notary.

While in most cases provenance is not specified in bills of sale, the relative cost of store-bought paintings as compared to locally commissioned works indicates that many of the former were imported. Although the subject matter of paintings is often summarily recorded in the documents, size and materials tend to constitute the primary descriptors and indicators of value. In the 1601 Durana auction, two panel paintings depicting Saint Dominic and Saint Roch sold for three pesos each, while two large panel paintings of the Virgin of the Rosary (one with gold embellishment) brought a total of thirty-six pesos.[4] Here, size and materials determined the difference in cost between the two pairs of paintings. On the other hand, sales records may be ambiguous as to the assignation of value, as in a 1566 contract, in which the merchant Diego de Castro purchased "eighteen canvases of large figures at five pesos each, and eight canvases of large figures at six pesos each."[5] No indication is given as to what these figures represented or why one group of large figures cost more than the other.

The subject matter and material composition of paintings are frequently mentioned in bills of sale. For example, in 1566 the local vendor Francisco López de Remuego sold a variety of goods to Juan de Angulo, which included "six canvases of figures of the virtues for sixty pesos."[6] A 1596 purchase of numerous artworks listed "one canvas depicting San Diego with another painting at his feet, at five pesos [. . .] another oil painting of Saint Michael at six and one-half pesos [. . .] two small canvases, one of the Magdalen and the other of Our Lady at one and one-half pesos."[7] In 1600, Miguel Heraso y Aldaz acquired a variety of paintings and sculptures that included "five tempera paintings on canvas for five pesos," in addition to "a large oil painting on canvas of San Diego [. . .] another large oil painting on canvas of the mystery of Christ [. . . and] another oil painting on canvas of the descent from the cross," for a total of sixty pesos.[8] In 1622, a canon of the Cathedral, Francisco de Mena y Arellano, paid a local merchant ten pesos apiece for "twenty-one canvases painted in oil of different images and histories."[9] Although no provenance is specified in the documents for the works mentioned above, the relatively high prices commanded by those sold in local shops indicates that they were likely imported.

Religious subject matter predominated during this period, yet as indicated by the paintings depicting seasons, virtues, and histories, secular imagery occasionally is registered in the documents, particularly in last wills and

testaments. The 1642 testament of Francisco de Urasandi, alongside numerous religious paintings, records "two landscapes on canvas" and "one canvas painting of monkeys playing cards and fighting and another framed [painting of] a single monkey."[10] References to portraits appear only occasionally. The 1638 testament of Juan Méndez Miño lists a series of portraits of emperors,[11] and the 1649 testament of the painter Salvador Marín mentions that a patron gave him "four portraits so that he would paint them," perhaps referring to the employment of engravings as models.[12] Secular and profane themes combine in the belongings of Don Antonio de Morga, former president of the *real audiencia*, sold at public auction in 1636, which included "ten portraits of family members and two of Spanish Kings [. . .] thirteen canvases depicting the Sibyls, four representing the Seasons and one [depicting] Cupid surrounded by young boys."[13] The 1566 testament of the silversmith Juan Mateo Mallorquín enigmatically lists a "canvas of judique [Judith?]," alongside the tools of his trade and several books in Castilian and Latin.[14]

The geographical origin of paintings is mentioned only rarely in the documents. In one intriguing example, Doña Ana de Prado acquired in 1596 "a feather image of Saint Paul made in Mexico," whose novel medium and origin warranted inclusion in the bill of sale.[15] Similarly, in 1600, two local merchants purchased goods that included "fourteen canvases of figures from Flanders at two pesos."[16] In 1595, the attorney (*procurador*) Antonio de Aguilar bought an impressive quantity of merchandise in the amount of 6,055 pesos, which comprised a range of goods imported from Mexico, China, Italy, Portugal, and Flanders, as well as a number of artworks, including

> one work depicting Christ for seven pesos [. . .] two painted capes from China at five pesos [. . .] one work representing Our Lady in ivory with her processional platform [*andas*] made of turned ebony at four pesos four tomines [. . .] two works representing San Juan in ivory with their processional platforms of turned ebony at four pesos four tomines [. . .] four ounces of color for oil [paint] at two pesos the ounce [. . .] one canvas depicting San Diego with another painting at his feet at five pesos [. . .] another oil painting of San Miguel at six and one-half pesos [. . .] two small canvases, one of the Magdalen and the other of Our Lady at one and one-half peso.[17]

In this instance, the ivory sculptures indicate Asian origin, while the source of the canvas paintings is unspecified; however, their inclusion amid a wealth of imported goods nonetheless suggests a foreign provenance.

Although testaments demonstrate that some of Quito's inhabitants possessed profane works, sales records indicate that the subject matter of paintings sold by local merchants was largely religious and that many were likely imported. Oil and tempera paintings on canvas and on wood were available on the market in a variety of sizes and at prices that ranged between two and twenty pesos; however, the average price for paintings overall appears to have

been between five and six pesos. The low cost of imported paintings might to a great degree have determined the prices for locally produced works.

Prints and Illustrated Books

The notarial record registers a brisk trade in prints and illustrated books, which were available in significant numbers and variety from the first decades of the city's establishment. Printed images supported private devotion and pedagogical interests and provided a rich reservoir of artistic sources and models for local painters. Indeed, many of the extant notarial contracts for paintings and altarpieces make reference to *estampas* (prints) provided by patrons to artists as models for the works they were to create. In a 1626 contract with the Andean painter Lucas Vizuete for two large paintings to adorn the main altar of the Cathedral, the patron instructed the artist to create the works "in accordance with the prints that he was given."[18] In 1630, the Andean painter Miguel Ponce signed a contract for twenty-seven paintings depicting the life of Saint Francis, in which the patron required that the works be created "following the other twenty-seven fine prints on paper that must serve as the model[s], according to and just as [the images appear] in them without omitting anything."[19] Additional examples of the use of prints in artistic commissions can be cited for Spanish and Creole, as well as Andean, artists in Quito throughout the colonial period.[20]

Bills of sale register the quantities and physical nature of prints available on the market. Prints on paper were sold individually, in small or large format, or as sheets of various dimensions that contained multiple images (*de a medio pliego*, *de a pliego*, or *de a seis pliegos*). On occasion, prints were characterized by quality, distinguishing *estampas finas* (fine prints) and *estampas de esplandor* (colored or illuminated prints) from the apparently unremarkable *estampas ordinarias*. Images printed in ink on textile supports, such as silk and taffeta, and on wood (*tabla*), appear occasionally on lists of merchandise.[21] Prints on paper figure prominently in a series of wholesale transactions between merchants in 1581, which demonstrate the active market for such images. In May of 1581, Jorge Seco paid two pesos "for fifteen prints *de a pliego*," which he acquired from the local merchant Hernando Rodríguez,[22] and Marcial de los Reyes bought from the same merchant "six prints *de a seis pliegos* at six tomines each."[23] In June of that year, Bartolomé Velázquez de Meneses paid "for fifteen prints *de a pliego*, four pesos [. . . and] for six large prints, three pesos,"[24] and in September, Juan Báez acquired "thirty prints on paper *de a seys pliegos* [. . . and] eighty prints *de a medio pliego*."[25] If the year 1581 is any indication, a great many prints of various dimensions circulated in the colonial city.

The transactions noted above were for the most part effected on the wholesale level between major Quito merchants; however, a number of retail records document the purchase of prints by individuals. In 1583, the broth-

ers Lorenzo and Juan de Escobar purchased "eleven large figures on paper [and] nine small prints" from a local *pulpería*;[26] in 1586, Juan de la Vega and his wife, Doña Ana de Ortega, bought a range of merchandise from shop-keeper Marcos de la Plaza that included "twenty-one prints that were given to Father Dionisio [at] one peso two reales and six granos";[27] and in 1596, Catalina Ramírez acquired "nine prints on paper," along with other devo-tional objects, from a local shop.[28] In 1600, the shopkeeper Miguel Heraso y Aldaz purchased a large number of artworks, among them "fifty illuminated prints at three pesos two tomines [. . .] fifty-seven papers of small prints for three pesos [. . .] eleven large papers of the said prints at five and one-half pe-sos [. . .] ten large maps at one peso each."[29] In 1601, the shopkeeper Miguel de Entrambasaguas acquired at public auction "nine prints on paper and wood panel," which he may have intended for his own use or for resale in his *pulpería*.[30]

Bills of sale in this early period rarely mention the subject matter or prov-enance of prints, and other types of documentary sources, such as testa-ments and dowries, offer equally few clues in this regard. Among the rare early documents to address subject matter is the enigmatic record of "three gypsy [*gitanas*] prints" in a 1581 bill of sale.[31] Another sale in the same year recorded "some papers with figures of the saints for one peso."[32] A 1601 record of public auction listed a series of prints that sold for thirty pesos, which constituted "fourteen panels representing the savior and Saint Paul and twelve apostles printed on yellow taffeta with adornment."[33] Despite these isolated examples, the subject matter of the vast majority of prints that flooded the local market is largely unremarked in the documents. The same holds true for provenance. In one rare example, the 1638 testament of Juan Méndez Miño recorded his possession of "four small Roman prints that cost eight pesos apiece," although "Roman" in this instance may reference style, not provenance.[34] The subject matter and origin of prints were documented far more frequently during the second half of the seventeenth century, even if the prints themselves were often created much earlier.[35]

Not all the printed images circulating in early colonial Quito were religious in nature. Playing cards (*naipes*) were ubiquitous and tremendously popular, and they figure in numerous early sales records.[36] *Naipes* arrived from Spain, Mexico, and Lima in stacks of separately printed black-and-white, recto and verso sheets that were later cut and pasted together [*retobado*] to form indi-vidual cards. A 1581 sale listed "five dozen mounted [decks] of playing cards [. . .] one dozen unmounted [decks] of playing cards."[37] Typically woodcuts, the recto images of *naipes* held the suits: clubs, cups, coins, and spades, the last cards of which depicted kings, queens, knights, and knaves. The verso sides ran a gamut of images that might include "portrait" busts of men, wom-en, or Moors, vases of flowers, decorative designs, or other motifs.[38]

Painters were involved with playing cards in various ways. The sellers and the purchasers of printed black-and-white sheets or decks of *naipes* often enlisted painters to adorn them with colors. Miguel de Benalcázar, mestizo

and *hijo natural* (out-of-wedlock son) of one of the city's conquistadors, re-
portedly made a living in the 1580s as a painter of *naipes*. Benalcázar was later
accused of sedition for painting subversive playing cards and was prohibited
from plying his trade.[39] Early colonial Quito was a wagering town, for the
notarial records are rife with *promesas de no jugar*, promissory agreements
signed by gamblers in which they legally vowed not to play cards or other
betting games for a certain number of years. In 1648, the master painter Juan
de Salinas signed such an agreement, in which he admitted that "because
gambling [with cards] has brought him much discredit [. . .] and diminution
of his belongings, he promises not to play cards for three years or pay two
hundred pesos to the Holy Inquisition."[40] The 1649 testament of the master
painter Salvador Marín lists a series of debts to people with whom he had
played cards and lost, as well as numerous possessions that he was forced to
pawn in order to pay off gambling debts.[41] Because of the widespread popu-
larity of *naipes* in early colonial Quito, their imagery may have been more
familiar to many people than other forms of printed images.

The prints and engravings that reached the Americas, particularly in the
early colonial period, were largely imported, originating from presses in a
variety of European countries, particularly the Flemish Plantin Press, which
had an office in Seville and held a monopoly on the book trade with Spain's
overseas viceroyalties dating from 1571. Yet printing presses were established
in New Spain in 1539, and in Lima in 1584; thus, some of the prints and
illustrated books that reached Quito in the late sixteenth and early seven-
teenth century originated in the Americas.[42] Indeed, the 1601 public auction
of Martín Durana's merchandise documents a particularly intriguing and
important set of materials: "seventy-six medium and small copper plates for
making prints and a wheel or press [*torno*]," which were sold to Miguel de
Entrambasaguas, a merchant whose shop was located on the main plaza of
the city.[43] These items suggest that perhaps not all of the prints on the market
in Quito were imported. Although the copper plates sold at auction might
already have been engraved in Europe or some other region (the document
does not specify their origin or give any indication of the presence of imag-
ery), by the first years of the seventeenth century there existed at least one
local source for the manufacture of printed images that may have played an
important role in shaping the city's artistic production.

Woodcuts and engravings also illustrated many of the books that circu-
lated in Quito during this period. These sources provide a better sense of
the imagery available to local artists than do the many citations of individual
prints and *pliegos de estampas*, whose subject matter is largely unidentified
in the documentation. The architect Alonso de Aguilar owned in 1577 an
edition of Serlio's *Third and Fourth Books of Architecture*, in which he in-
scribed his signature and the date. Subsequently, the carpenter and builder
Sebastián Dávila purchased the volume in 1585, in which he too penned a
dated inscription and signature. Both men constructed buildings in Quito
that employ Serlian forms, undoubtedly using the volume's many illustra-

tions as a guide.[44] Only rarely are books specified among the belongings of artists in their testaments, as in the 1566 testament of the local silversmith Juan Mateo Mallorquín, which notes his possession of "five books in Latin and Castilian."[45]

By contrast, the sales records of local merchants register a broad range of subjects, sizes, and titles of books in a number of languages that were available to consumers in early colonial Quito, many of which were imported in multiple copies. Devotional manuals, books of hours, breviaries, ceremonials, martyrologies, and other religious texts vied for attention on the shelves of local shops, alongside numerous copies of the popular Latin grammar of Antonio de Nebrija; texts by Latin authors such as Terence and Virgil;[46] the 1585 moralizing mythological study *Philosophía secreta de la gentilidad* by Juan Pérez de Moya; a variety of theatrical works (*comedias*); literary texts, especially those of Cervantes; legal manuals and treatises, such as Diego del Castillo de Villasante's 1544 *Las leyes de Toro glosadas*, Diego de Ribera's 1561 *Escrituras y orden de partición de residencia, y judicial civil y criminal*, and Alfonso "el Sabio" X's *Siete Partidas*; histories that included *The Battle of Roncesvalles* (Valencia, 1555), *Cisma de inglaterra* (probably Pedro de Ribadeneyra's *Historia ecclesiastica de la scisma del reyno de Inglaterra* [Amberes, 1594]), and the *Historia de Escocia.*[47]

Sales and public auction records registered a large number of books by title or by summary description, demonstrating the extensive and varied subject matter available in Quito. Many of these volumes included printed illustrations. Bills of sale do not always allow for the identification of the specific text; however, they occasionally indicate the presence of illustrations. Among the items in the 1601 auction of Durana's inventory were "six books, one of them a large book of architecture, and the five small ones in Latin."[48] A separate 1601 auction of merchandise belonging to the shopkeeper Marcos de la Plaza included an impressively long and varied list of volumes, among them "four missals, two of them large from Burgos at forty-five pesos, and the two quartos [with] fine engravings at thirty-two pesos."[49] Additional illustrated titles identified in this sale included "two flos santorum, the second and third part, and with another two that were sold."[50] The *Flos sanctorum* by Alonso de Villegas (1588, 1590–1594) and the similarly titled volume by Pedro de Ribadeneyra (1599) were published in several editions in Spanish and Italian prior to 1601, all of which contained illustrations of the life of the Virgin, Christ, and images of saints and martyrs.

Of particular note is a 1601 auction that included the relatively high sale price of "seven pesos for a book of the history of illustrious men, and another which already sold."[51] This description characterizes a number of sixteenth-century illustrated texts, such as the Italian Paulo Giovio's famous portrait books. Indeed, the sixteenth century witnessed a boom in the publication of biographies of famous men and women, including tomes on Roman emperors, philosophers, warriors, writers, artists, monarchs, and members of the clergy and the nobility. These volumes of "ilustres varones" typically includ-

ed engraved portraits of famous people alongside textual biographies extolling their virtues. Although determining with precision the specific books referenced in the 1601 auction record is not possible, the presence of these volumes nonetheless indicates that portrait books circulated and were likely used by painters in early colonial Quito.

A 1613 account of preparations for the exequies of Margarita de Austria directed the participating unnamed painters to produce twenty-seven life-size paintings of "the genealogy of the House of Austria, from Pipino I Duke of Brabant to the King Philip II," to be copied from the engravings in "a book composed by Juan Baptista Vrientino of Antwerp."[52] The portrait book employed by these local artists is Hadriani Barlandi's *Ducum brabantiae chronica*, published in Antwerp by the Plantin Press in 1600. This volume was illustrated with engraved portraits of the dukes and duchesses of Brabant, from Pipino I to Philip II, provided to the press by Ioan Baptista Vrients (*see figs. 3.2 and 3.3*). Illustrated volumes of the lives of the saints, the Virgin, and Christ, as well as those of famous men and women, afforded local artists visual compendia of sources for paintings.

Cartillas (primers) intended for instruction in reading and writing were abundant and popular items in local shops, and they often included printed images as pedagogical and memory devices, particularly devotional scenes that doubled as catechisms.[53] During the sixteenth century, thousands of *cartillas* illustrated with printed images were sent to the Americas, and others were produced in Mexico City and Lima, for the instruction of children and native neophytes.[54] *Cartillas* appear in Quito with great frequency in the sixteenth- and early seventeenth-century sales records.[55] The imagery depicted in *cartillas*, however rudimentary, was for neophytes a formative entry into the worlds of pictorial and alphabetic literacy. Indeed, illustrated *cartillas* constitute an important and often overlooked aspect of colonial visual culture.

Another type of book frequently imported and sold in Quito in large numbers contained neither text nor images: the *libro de memoria*. These small, pocket-sized volumes, familiar from Cervantes' stories, took two principal forms in the early modern period, both of which emphasized portability and efficiency.[56] One type was made of small slabs of stone, slate, ivory, or paper pages coated with a slick varnish, sometimes richly bound in wood, leather, or cloth, and often equipped with metal or bone styluses tipped with colored gemstones or coal, sticks of chalk, or ink pens crafted to write on their various surfaces. These forms shared the feature of erasure that enabled reuse: their surfaces were palimpsests to be wiped clean and reinscribed. A second category of *libro de memoria* was a small booklet of blank paper pages wherein the owner could record daily events, ideas, prices, obligations, or sketches and drawings and other details not to be forgotten.[57]

Libros de memoria are among the books most frequently for sale in early colonial Quito. Wholesale merchants imported them by the scores and a

broad range of individuals purchased them. Accounts of such sales under-
line the local accessibility, affordability, and popularity of *libros de memoria*.
In 1581, the retail consumer Marcial de los Reyes purchased "six *libros de
memoria* [at] two pesos two tomines."[58] In the same year, the local merchant
Hernando Ramírez inventoried "a dozen *libretes de memoria*" among the
stock in his *pulpería*,[59] and a 1601 sale included seventeen *libros de memo-
ria*.[60] A 1613 sale by the shopkeeper Juan de Alarcón highlights the personal
and highly portable virtues of such items: "twelve *libritos de memoria* at four
reales," followed immediately by "twelve carrying cases or pouches [*estuches
de faltriquera*] at ten reales."[61] Other sales of *libros de memoria*, some in-
cluding special carrying cases, occurred in Quito throughout the sixteenth
and early seventeenth centuries.[62] The buyers of *libros de memoria* likely
used them primarily for textual and numerical notes; however, they may also
have served the needs of artists. Regardless, the widespread presence of such
books points to a local habit of recordkeeping—textual, numerical, and per-
haps pictorial—that appears to have been fairly common.

Although no records of painters purchasing prints or illustrated books
have been recovered for this period, and the few extant testaments of such
artists rarely mention prints or books among their possessions, artistic con-
tracts and many extant paintings testify to the use of engravings as sources
and models for figure types, compositions, and iconographic themes. Qui-
to's painters copied, adapted, and transformed images from prints to serve
local needs. Yet above all, those artists translated small, typically black-and-
white images into large surfaces of vivid color through their own fabrication,
mixture, and application of a broad chromatic range of pigments and other
substances purchased on the local market.

The Materials of Painting

Demand for the raw materials and implements of painting and artistic pro-
duction ensured a steady supply on the local market. Painters and patrons
could select from among several types of supports: prepared wood panels,
stone or metal plates, and various qualities of textiles that included *ruán de
fardo*, *melinze*, and *cañamazo*, commonly used for easel paintings. A range of
local and imported powdered pigments, dyes, and inks were sold by weight
in local shops. Paintbrushes large and small were stocked by the dozens, as
were booklets of gold and silver leaf, together with quantities of *bol arménico*
(red bole), which served as the base for the elaborate gold and silver *esto-
fado* of polychrome statuary and other objects. Local shops carried a variety
of resins, gums, balsams, waxes, and lacquers, such as liquidambar (sweet
gum), *acíbar* (aloe), *copal* or *mirra* (resin incense), *menjuí* and *estoraque*
(aromatic balsams), and *lacre* (sealing wax), alongside different types of oils,
any of which might have proven useful to painters.[63] Because these materi-

als served multiple uses—in medicines, cooking, and textile manufacture, as well as artistic production—the intended function of such materials cannot always be determined with precision.

Painters who produced works for the open market, to be sold ready-made by themselves or by a merchant, had to acquire their own canvases or panels and other materials. Local shops sold wood panels, particularly cedar, suitable for painting as well as other uses. A 1601 shop inventory included "fifty-five large and small cedar panels."[64] Bills of sale record numerous examples of painters purchasing quantities of textiles, especially *ruán de fardo* and *melinze*, flat-weave fabrics usually made of linen or hemp that were typically employed as supports for painting.[65] In 1599, the painter Luis de Ribera purchased twenty *varas* of *ruán de fardo* from a local merchant, along with other textiles and merchandise.[66] The painter Mateo Mexía bought four *varas* of *ruán de fardo* from a local shopkeeper in 1612, and he made a larger purchase in 1620, acquiring an additional sixty-five *varas* of the textile along with eighty *varas* of *melinze*.[67] In 1622, the painter Juan Fonte purchased forty-seven *varas* of *ruán de fardo* from the merchant Pedro Sánchez de Olea,[68] and in 1628 the master painter Sebastián de Herrera bought fifty *varas* of the same fabric from a local shop.[69] The price per *vara* of *ruán de fardo* ranged between six and a half *reales* and one *patacón*, and a *vara* of *melinze* cost one *patacón*, three *reales*; thus, the textile support for paintings constituted a significant percentage of their cost.

For commissioned paintings, the patron typically was responsible for supplying the support but not the colors or other materials. In the 1630 contract between Miguel de Aguirre and the Andean painter Miguel Ponce to produce twenty-seven paintings, the patron agreed to supply fifty-four *varas* of canvas (*melinze*) and the requisite wooden stretchers, while Ponce was to provide all the pigments.[70] The general requirement that patrons supply the supports for paintings helps to clarify contracts such as Canon Mera y Arellano's 1619 purchase of twenty-one oil paintings in addition to "forty varas of ruán de fardo, at one patacon the vara," indicating that he planned to commission quite a large number of paintings, for which he would provide the canvas.[71] Above all, however, the patron's obligation to provide the textile support for commissioned paintings clarifies the many examples of painters purchasing large quantities of *ruán de fardo* and *melinze*: painters were also producing noncommissioned works for the open market.

The standard division of responsibility for materials recorded in painting commissions, in which the patron supplied the support and the painter provided the "colors," underscores a crucial aspect of the painter's profession: the possession of specialized chemical and scientific knowledge regarding the confection and application of pigments, binding and drying agents, and varnishes. Painters employed specific techniques and formulas to grind, mix, and suspend a range of vegetable, mineral, and animal pigments in oils, resins, glues, and other binders.[72] This acquired realm of professional knowledge enabled them to produce vivid and lasting chromatic effects on painted

surfaces. Painters were perforce masters of the chemistry of colors and materials.

The sales records and inventories of local retailers enumerate quantities of implements, pigments, and other materials related to the painting profession. In 1586, Diego de Lario bought more than one hundred small paintbrushes,[73] and in the same year, Diego de Benavides purchased "one hundred and thirty small brushes for painting," together with "a pound of *albayalde* [lead white] [. . .] two portions of *azul marinas* [ultramarine blue] [. . .] four ounces of *alumbre* [alum, used to fix pigments]," all of which were employed in the painting profession.[74] Lead white was imported from Spain and other regions in large amounts and figures frequently in the sales records in early colonial Quito.[75] A 1600 purchase by Miguel de Entrambasaguas included "one hundred and nineteen pounds of *albayalde* in a crate," in addition to "twelve pounds of *albayalde*" in a separate container.[76] Beyond lead white, the abundant sale of pigments, often called *colores*, *polvos*, or *tintas*, demonstrates the broad chromatic range available to local painters.[77] Indeed, unlike the documentary record for the later seventeenth century, in which sales records or even mention of pigments are extremely rare, such documentation abounds for the late sixteenth and early seventeenth century, as registered in table 2.1.[78]

In early colonial Quito, the provenance of colorants listed on formal sales records is mentioned only occasionally. Many were likely imported from Europe or from elsewhere in the Americas, yet other pigments were produced regionally and maintained an uninterrupted history of use dating from pre-Columbian times. The European origin of a pigment is noted in a 1581 bill of sale to the local merchant Hernando Ramírez, who received a shipment of goods that contained "six papers of colors from Flanders."[79] In 1566, the retailer Diego de Castro acquired "one-eighth [of a pound] of *grana de polvo*," a highly prized red colorant derived from the cochineal insect, which at the time might have been imported from Mexico or Central America or was produced in the *audiencia* of Quito.[80] A 1601 sale included "a box containing two pounds and two ounces of cochineal."[81] Another important colorant, indigo (*añil*), arrived in large quantities from Mexico and Nicaragua during this period and was employed by painters, as well as in the numerous local and regional textile workshops (*obrajes*) for dyeing wool to produce the distinctive and renowned blue Quito cloth (*paño azul*).[82] A 1598 sale of merchandise to the shopkeeper Gaspar Báez included "one hundred and ten ounces of indigo [*tinta añil*] from Nicaragua [. . .] at three and one-half pesos a pound."[83] Although early on, quantities of *añil* were imported, by 1595, indigo plantations existed in rural zones near Quito.[84] Nonetheless, archaeological evidence indicates that indigo was used by pre-Columbian cultures in the region from around 435 CE.[85]

Specifications of colors or pigments to be used in particular paintings are rare in the early colonial documents. A 1572 commission for the creation of eight illuminated choir books did stipulate the particular colorants that were

Table 2.1. Pigments and related materials in the archival record, 1550–1650

Pigment/material	Related color
Achiote (annatto)	Reddish orange
Albayalde (lead white)	White
Alumbre (alum)	Mordant; drying agent
Ancorca; ancorque (ochre)	Dark yellow
Añíl; índigo (indigo blue)	Blue
Azafrán (saffron)	Orange yellow
Azarcón (minium; red lead)	Red; reddish orange
Azul (azurite?)	Blue
Azul marina (lapis lazuli?)	Ultramarine blue
Azul subido (azurite)	Bright blue
Bermellón (vermilion)	Red
Bol arménico (red bole; red ochre)	Reddish brown adhesive substrate or pigment
Caparrosa (copper sulphates)	Reddish brown; blue-green; white (pigmented drying agent)
Cardenillo (verdigris)	Green
Cochinilla; grana (cochineal)	Intense red; carmine
Genulí (lead-tin yellow)	Yellow
Sombranetas; tierras naturales (umbers)	Earth colors
Tornasol (turnsole)	Translucent red; blue; purple
Urchilla; orquilla (orchil)	Violet; purple
Verde terra (green verditer; malachite)	Green

to be employed in their confection. The list includes gold leaf, as well as a range of pigments: vermilion, blue, violet, translucent blue/red, orange, and green (*bermellón, azul, orchilla, tornasol, azafrán,* and *cardenillo*) (see appendix, part a).[86] Another rare example, involving a single pigment, is a 1652 record of purchase by the Mercedarian monastery of "a pound of *achiote* to shade [*sombrear*] the rosettes of the coffered wooden ceiling of the cloister."[87] The plant pigment *achiote* (annatto) produced a deep reddish-orange tonality. *Achiote* was produced locally and had long been employed as a colo-

rant by pre-Columbian cultures in the northern Andes. Similarly, vermilion, a sulfide of mercury, had an extensive history of use in the pre-Columbian Andes and also may have been locally produced, for the mercury mines in the southern region of the *audiencia* were exploited extensively during the early colonial period.[88] The imported spice *azafrán* (saffron) served as a paint colorant in addition to its culinary and medicinal applications, and it often appears on lists of merchandise alongside pigments and materials associated with the painting profession.[89]

Two sales from the turn of the sixteenth century further illustrate the impressive quantities and variety of pigments available in Quito, note their costs, and indicate the extent of local consumption and demand. In 1600, two Quito merchants recorded their purchase of large amounts of pigments for resale on the local market that included

> seven pounds and four ounces of verdigris at eight pesos a pound [. . .] five pounds and fifteen ounces of azurite in four papers at twenty-two pesos a pound [. . .] another paper of *azul* [azurite?] with one pound and eleven ounces [at] twenty-two pesos a pound [. . .] two pounds and one-half ounce of fine malachite in two papers at twenty-two pesos a pound [. . .] two pounds of fine *colorado* [a reddish-orange color] called *azarcón* [minium] in one paper at four pesos a pound [. . .] one pound and eleven ounces of orchil [a violet colorant] in the form of a liquid balsam without Paper at two pesos [. . .] fifteen ounces of umbers [or earth pigments] at two pesos [. . .] one and a half pounds of *ancorque* [*ancorca*, yellow lake?] at two pesos [. . .] fourteen ounces of vermilion with paper at five pesos [. . .] one pound and seven ounces of lead yellow with paper at one peso and four tomines [. . .] two pounds and seven ounces of *albayalde de tetilla* [lead or vegetable white?] with paper at one peso and four tomines [. . .] forty-four pounds of red bole at four pesos four tomines.[90]

In addition to the remarkable range of pigments, the large amounts that were sold underscore the extent of local demand. While most of the colorants mentioned in this document were commonly used in Europe and throughout the colonial Americas, two deserve special mention for their relative rarity in the colonial Andean record. The nature and geographic origins of the dark yellow pigment *ancorca* are ill defined in the seventeenth-century artistic literature, and its appearance in the colonial Andes apparently is not documented outside of Quito at this time.[91] *Urquilla*, or orchil, a violet pigment derived from the fermentation of lichens of the family *Roccellaceae*, was produced in Malta and in the Canary Islands. This colorant is mentioned in seventeenth-century Spanish painting treatises, yet it rarely appears in the documents of the colonial Andes;[92] however, orchil was decidedly on the market in early colonial Quito.

The 1601 public auction of Martín Durana's shop inventory also listed

large quantities of colorants, although unfortunately not all are specified in the document:

> One hundred pesos [. . .] for three and one-half pounds of vermilion in a burlap [sack] and all of the other colors that were inventoried [. . .] one hundred seventy-nine pesos and five tomines for one hundred thirty-three pounds and two ounces of lead white with a box and burlap [sack] of one and one-quarter vara at one and one-half peso the pound sold to Miguel de Entreambasaguas [. . .] six arrobas and fifteen pounds of locally produced iron, copper, or zinc sulfate [*caparrosa*] in a pouch [. . .] one pound eight ounces and eight *adarmes* [approximately 14.4 grams] of verdigris in some papers.[93]

The large amount of pigments available for local retail is not necessarily an indication of the quantity of paintings being produced at the time, for many of these substances were employed in textile workshops for dyeing fabrics, and they also served medicinal, culinary, and other practical uses. Nonetheless, painters in early colonial Quito clearly had at their disposal large quantities and a wide range of colorants available for purchase from local shops, which they could acquire in relatively small amounts that did not likely merit formal written contracts. Some pigments undoubtedly were obtained locally, particularly those with an Andean tradition of use in painting and dyeing, while others were imported from Europe or other regions of the Americas. The imported status of many pigments is underscored in the work of Gabriela Siracusano, who notes additionally the complete absence of one colorant, *genulí* (lead yellow), in the palette of southern Andean painting, yet this pigment was available in 1600 on the market in Quito.[94] Nonetheless, pre-Columbian cultures of the northern Andes had engaged in long-distance trade with other regions of the Americas for centuries before the arrival of Europeans, particularly via *mindaláes* (a specialized class of long-distance traders in luxury goods), whose wares included spondylus, coca, gold, feathers, textiles, and perhaps pigments and dyestuffs.[95]

The gold and silver leaf that adorned paintings, altarpieces, sculpture, architectural elements, and other objects was an abundant commodity in early colonial Quito. The sixteenth century saw a veritable gold rush in the *audiencia*, as cargos of the precious metal from local mines and pre-Columbian objects plundered from tombs and huacas were registered before notaries in prodigious numbers.[96] Although it is possible that some amount of gold and silver leaf may have been imported, these materials were manufactured and sold locally by Quito's many silversmiths and *batihojas* (gold beaters), whose products were stocked by local merchants.[97]

The high monetary value of gold and silver generated records of artists and patrons buying or supplying quantities of gold and silver leaf for works of art. In 1597, the Spanish sculptor Diego de Robles purchased goods from a local merchant that included "one thousand six hundred sheets of gold

and silver leaf at thirty-two pesos and four tomines," which he undoubtedly planned to employ in an artistic commission.[98] In 1612, the painter Luis de Ribera received thirty thousand sheets of gold leaf produced by three local *batihojas*, which he was to transport to the port of Guayaquil "to gild his majesty's galleons."[99]

Both patrons and artists contracted with goldsmiths and *batihojas* to produce gold and silver leaf for specific artistic commissions. In a fairly typical example, the master silversmith Juan de Albear signed a contract in 1631 with the Augustinian friars to produce "two books of gold leaf each week" for an unspecified number of weeks to supply the needs of artists working in the monastery church.[100] In 1648, the gilder and painter Francisco Pérez Sanguino hired the *batihoja* Antonio Sánchez to accompany him to the southern town of Riobamba where he was to "produce the gold leaf to gild the altarpiece and tabernacle" of a local church.[101] Many of Quito's early painters were masters of overlapping skills, combining the materials and techniques of gilding with those of painting, applying them to easel and mural paintings, sculpture, furniture, galleons, and a range of other objects.

The Materials of Sánchez Gallque's Triple Portrait

In 2012, the Museo del Prado undertook a technical analysis of Sánchez Gallque's 1599 painting *Francisco de Arobe and His Sons Pedro and Domingo* (*see plate 1*); the museum analyzed pigment samples from seven areas of the painting, using gas chromatography and mass spectrometry to determine their chemical compositions.[102] A summary of the findings indicates that linen is used as the support, and the composition of pigments employed for the following colors present in the painting are identified as

> **white:** *albayalde* (lead white), *yeso* (gesso), and *carbonato cálcico* (calcium carbonate);
> **red:** *laca* (red lake), *tierras* (earth or mineral colors), and *bermellón* (vermilion);
> **yellow:** *oropimente* (orpiment);
> **orange:** *minio* (minium);
> **blue:** *azurita* (azurite) and indigo?[103]; and
> **black:** *carbón vegetal* (charcoal).[104]

These base pigments were combined and layered in a variety of ways to create the delicate chromatic range of the painted image.

The gold leaf applied to the facial ornaments, jewelry, and lettering of the painting, whose contents register 98 percent gold and 2 percent silver, was adhered to the surface with a drying oil after the painting was completed. Interestingly, the areas now covered by gold leaf were previously painted with orpiment, a bright yellow pigment used to simulate gold.[105] The existence of

orpiment beneath the gilded areas of the painting indicates that a change of opinion occurred after the pigment had been applied, and a subsequent decision was made to employ gold leaf. The inclusion of actual gold leaf made an explicit material point about the wealth of the Indies and the importance of subjugating its people in order to extract the precious metal.

Virtually all of the identified pigments could have been locally or regionally produced. Lead white, vermilion, minium, azurite, and indigo are registered in substantial quantities in the contemporary documents, and the pigments described in local documents as *sombranetas* likely correspond to the earth colors cited in the chemical analysis—all of which were used by pre-Columbian cultures in the region. *Laca*, or red lake, is a somewhat generic term for a translucent organic red pigment precipitated in a mordant, usually a metallic salt. The specific source of the *laca* is not identified in the Prado report, but could derive from a range of local organic materials that were traditionally employed as paints and dyestuffs in the pre-Columbian northern Andes, including *Relbunium* sp. (a red root related to madder), *Galium* sp. (a red root dye), or the sap or bark of certain native trees such as brazilwood.[106] Another red lake, cochineal, was a common pigment in Andean cultures from at least as early as 500 CE and was cultivated in what is today southern Ecuador.[107] Similarly, gesso, calcium carbonate, charcoal, azurite, vermilion, and minium had a long history of use prior to the arrival of the Spaniards, as did the applied gold leaf that adorns the painting. The earth or mineral colors (*tierras*), whose chemistry is not specifically identified, could undoubtedly have been obtained locally. Orpiment, an arsenic sulfide that occurs naturally in volcanic regions was also a local product; indeed, it is mentioned in the documentary record in Quito as early as 1565.[108]

Early colonial painters such as Sánchez Gallque were amply supplied with the colorants necessary to produce images with a rich chromatic range and high degree of visual impact—such as the portrait of Francisco de Arobe and his sons. Indeed, given the materials identified in the Prado report, it appears that Sánchez Gallque employed pigments that were locally or regionally produced, all of which enjoyed a long history of use by pre-Columbian Andean cultures. These colors were certainly familiar to and appropriate for a European audience accustomed to mimetic images, yet they might also have held additional layers of significance for colonial Andean viewers and for the painters that selected, prepared, and applied them.

Quito's early colonial painters had at their disposal a profusion of materials, sources, and models, and they mastered the specialized knowledge and skills required to produce the many images that adorned the city's ecclesiastical and secular buildings. Yet these artists did not apply their talents solely to traditional European forms such as easel and mural paintings. Painters engaged with a broad range of objects and genres—from miniatures to mediascapes—in their dialogue with colonial patrons and audiences.

The Objects of Painting

The art of painting in Quito or elsewhere in the Americas did not arrive with Europeans in the sixteenth century: painters and their profession had been active in the northern Andes for centuries. A multitude of graphic practices characterized these pre-Columbian cultures: paintings on buildings, rock formations, ceramics, wood, textiles, human bodies, and other supports are evident in the archaeological record and are described by early colonial chroniclers.[1] Many of the forms, materials, and techniques involved in pre-Columbian Andean graphic practices found continuity in the early colonial period.

Northern Andean Painted Objects

Contents in the living areas and shaft tombs dating from ca. 340 to 1505 CE at the La Florida archaeological site illustrate some of the range of pre-Columbian painting in the region.[2] Excavations of the site, located in what is now a northern sector of the city of Quito, have revealed a number of painted and/or dyed objects that combine utilitarian, ritual, and political functions. The shaft tombs contain the bodies, sumptuary goods, and offerings associated with high-status individuals. Ceramic vessels such as tall urns, bowls, and plates, many of which once contained offerings, are decorated in red slip painted with intricate black geometric designs and occasional schematic serpent, monkey, or bird forms. Jewelry and adornments include copper, gold, and gold-plated objects as well as shells, many of which were originally sewn as disks or bangles to the funerary vestments in an all-over pattern.[3] The metallic bangles applied across the surface of the vestments must once

have captured and reflected the light to scintillating visual effect with the movements of the wearer. The attached metal ornaments preserved the only remaining fragments of the cotton and camelid fiber textiles, which display a range of colors from cream, brown, and gray to reddish and bluish gray tonalities (*see plates 3 and 4*). The problematic condition of these fragments does not permit definitive conclusions to be drawn as to whether the textiles were painted or dyed; however, they nonetheless register the presence of a range of colors.[4]

Dyed and painted textiles, some adorned with metallic ornaments, have been recovered from archaeological sites in regions across the northern Andes. Textiles of the late Milagro style (ca. 1200–1550 CE) from Los Ríos province (southwest of Quito) often are covered with large silver bangles, and examples from northern Ecuador and southern Colombia are adorned with circular and star-shaped gold plaques.[5] Although painted textiles were common in precontact northern Colombia, references and examples are relatively rare for Ecuador. Still, these traditional forms are recorded the early colonial period in Quito and the highland region. In Domingo de Orive's 1577 description of Quito, he observed that indigenous women wore on their heads "certain small painted kerchiefs of cotton called *xoxonas*."[6] The 1560 testament of Doña Juana Farinango, *cacica* of Otavalo (north of Quito), included "a painted mantle made by natives of Pasto,"[7] and the early seventeenth-century will of Don Alonso Maldonado, cacique of Otavalo, listed Inca tunics of fine tapestry weave (*cumbi*) adorned "with stamped silver pieces (*camenteras y patenas de plata, marcadas, grandes y pequeñas*)."[8] The precontact associations and status-signifying power of painted textiles, and those ornamented with bangles of silver, gold, and other metals, found continuity in early colonial Andean vestments.

In the pre-Columbian northern Andes, pigments were applied to surfaces using a variety of tools that included brushes, cloth, feathers, fingers, and *sellos* (patterned stamps). *Sellos* were inherently graphic tools. Typically made from fired clay in cylindrical or planar forms, the face of the *sello* was carved with raised designs that could be coated with pigments or dyes, permitting the transfer of repeating colored graphic patterns to a range of supports that included textiles, ceramics, and the human body. The designs carried by *sellos* range from abstract, geometric patterns to figurative forms that include animals, birds, and humans (fig. 3.1). Thousands of *sellos* have been recovered in archaeological excavations throughout Ecuador, and their use is documented among numerous indigenous groups, from the Machalilla culture (ca. 1600 BCE to 950 CE) through the Jama-Coaque (ca. 350 BCE to 1530 CE), to the time of the Spanish invasion.[9] Jama-Coaque examples occasionally preserve vestiges of blue and red pigments.[10] The extensive production of *sellos* allowed the reproduction and widespread diffusion of an iconographic repertoire of motifs across many types of objects and surfaces.

Northern pre-Columbian ceramics were painted with designs made from an array of earth, mineral, and organic colors from opaque to iridescent,

Figure 3.1 Modern replicas of pre-Columbian *sellos* from Ecuador. Photo: Hernán L. Navarrete.

which were applied using techniques that included negative painting, *sellos*, rocker-stamping, and post-fired painting. In the northern Andes, the Inca painted ceramics in colors that included red, brown-red, orange-red, white, gray, black, cream, and cinnamon tones, typically rendered in geometric designs.[11] The chromatic range of pigments as well as designs allowed for nuanced cultural communication. In the Inca empire, colors and color combinations held culturally defined social and religious significance that are most evident in textiles and vestments. Crimson and related shades of red, as well as blue and white, were associated with royalty; white vestments were worn for important religious celebrations, such as Inti Raymi and solar rituals; and the combination of red and yellow colors was connected with lightning and associated deities.[12] Colors constituted an integral syntactical element of the Inca lexicon of power.

The pigments that produced specific colors themselves embodied sacred and significant meanings. Pre-Columbian Andean cultures possessed specialized technologies and knowledge required to extract and render into usable pigments and dyes the minerals and organic materials derived from the natural world. They had at their disposal a range of pigments (many of which also were used in Europe), including "vermilion, malachite, black charcoal, earth colors, orpiment, realgar, and a variety of lakes made from dyestuffs derived from vegetable or animal sources [. . . and] blue and green copper pigments."[13] In addition to their material application, colonial chroniclers noted the sacred and discursive functions of a number of these pigments and other materials. According to the 1584 *Doctrina christiana*, the first cat-

echism published in Lima, Andeans venerated certain metals, stones, and their derivatives, employing them in a variety of rituals and ceremonies:

> They adore and revere the metals that they call *Corpa*, adoring, kissing and making different ceremonies for them. Also the nuggets of Gold, or powdered Gold, and silver, or the foundries where the silver is smelted. Also the metal called *Soroche*. And Mercury: and the Vermilion made from Mercury that they call *Yehma*, or *Limpi*, is highly valued in diverse superstitions.[14]

Pablo José de Arriaga's 1621 account describes Andean rituals involving pigments that were "kissed" and blown onto "idols" and sacred objects:

> *Paria* is a powder of a reddish color, like vermilion, that they bring from the mines of Huancavelica, the metal from which mercury is derived, although it appears more like minium.
> *Binzos* are fine powdered [pigments] of a blue color. *Llacsa* is Green in powders or Stone like verdigris.
> *Carvamuqui* is a yellow powder. [. . .]
> Of all the abovementioned things, the powders of different colors that we mentioned, they offer [by] blowing softly, striping and marking the carved stones and the rest of the sacred objects [huacas] with the powders before blowing them on, and they also did the same with silver, [a] ceremony that in the Province of the Yauyos they call *Huatcuna*.[15]

Colors applied to surfaces as painted and powdered graphic marks similarly imbued those objects and bodies with numinous power. As Gabriela Siracusano has observed, "color operated as a vital category for the construction of a world in which the power of the sacred was not beyond but *within* the represented object itself."[16] Andeans perceived the sacred ontological status of stones and metals and their presence in colored pigments applied to objects and bodies.

Although we do not know whether the pigments described above were revered and used in similar ceremonial and symbolic acts by the autochthonous peoples of the northern Andes, these materials nonetheless were available and were employed widely in the region prior to the Spanish invasion. It is not difficult to imagine that, in the early colonial period, Quito's extensive population of Andeans continued to behold the numinous in pigments and metals, associating them with sacred practices and other traditional forms of social communication.

In Ecuador, ochre is among the earliest pigments to be identified in the archaeological record. A small ball of powdered ochre approximately eight thousand years old was recovered in excavations on the Ecuadorian coast, dating from the preceramic Las Vegas culture, and the pigment continued to

be employed by subsequent cultural groups.[17] The sulfides of mercury, vermilion, and minium—known as *red lead*—had long been used by cultures in the northern Andes as colorants employed in painting a variety of objects, as well as human bodies.[18] The rich mercury mines located in what became the south-central region of the *audiencia* of Quito (Cañar and Azuay provinces) had been exploited for centuries, and the extraction of vermilion and minium as well as mercury continued in the colonial period. Blue and green pigments derived from copper, malachite, and azurite were widely employed by pre-Columbian cultures to paint a range of objects.[19] The yellow pigment orpiment, an arsenic sulfide mineral common to volcanic regions, is mentioned in the documentary record regarding Quito as early as 1565, suggesting that it was used prior to the arrival of Europeans.[20]

Organic pigments and dyes also were common to the pre-Columbian cultures of the northern Andes. The extract of *achiote* (annatto) from the fruit of the *Bixa orellana* plant was mixed with grease and used to paint bodies, faces, and hair an opaque reddish-orange color, as today do the Tsáchila of Santo Domingo de los Colorados in Ecuador. *Achiote* also was employed for painting objects, including textiles, rock walls, and wood. A black tincture was extracted from the jagua fruit (*Genipa americana*), and a brown colorant was produced from the juice of an American walnut (*Juglandeas* sp.).[21] Cochineal, a scarlet pigment, was derived from scale insects that infested cacti native to tropical and subtropical South America.[22] Organic colorants made from the roots of *Relbunium* sp. and *Galium* sp., from the sap of certain plants, and from the bark of native trees, rounded out a spectrum of red lake pigments.[23] Gums, resins, and waxes, including *estoraque* (an aromatic balsam), *acíbar* (aloe), *sangre de drago* (*Croton urucurana Baillon* or *Calamus draco*), and *mopa mopa* or *barniz de Pasto* (*Elaeagia pastoensis Mora*), could be mixed with powdered pigments and used in the decoration of wooden objects and textiles.[24] Pre-Columbian peoples of the northern Andes possessed extensive knowledge of a range of organic and inorganic pigments, dyes, and binding agents about which we still know relatively little. Many of the regional pigments, materials, tools, and techniques continued to be used, sometimes under new nomenclature, in the early colonial period.

The Illustrated City: Early Colonial Objects of Painting

Painters in colonial Quito engaged in the production of painted objects that went well beyond those typically displayed in modern art museums or reproduced in art-historical texts. In addition to painting and gilding canvases, wood panels, stone and metal surfaces, sculpture, altarpieces, walls, and architectural elements, painters applied their skills to a still wider range of objects, from playing cards, choir books, and furniture to ecclesiastical furnishings, festival decorations, and theatrical scenery. These varied applications

of the painter's trade provide a backdrop to understanding their activities in creating what some today might consider the more "traditional" easel or mural paintings associated with the profession.

Several examples underscore the breadth of objects and type of work available to painters in early colonial Quito. As noted earlier, Miguel de Benalcázar, the *hijo natural* (out-of-wedlock son) of the conquistador Sebastián de Benalcázar, plied his trade during the sixteenth century as a painter of playing cards, a product that sold widely in the early colonial city.[25] Highlighting once again the interrelationship between painting and script, in 1572, Melchor de Alarcón, "writer of books" (*escritor de libros*), signed a contract with Fray Pedro de la Peña to produce for the Cathedral "eight choir books on vellum [. . .] in inks and colors," which were to include numerous painted and gilded illuminations (see appendix, part a).[26] None of the eight volumes was to contain less than one hundred folios, and they were to be completed within two years at a cost of two pesos per folio. Given the magnitude of the 1572 commission, Alarcón likely relied on assistant painter-scribes in the production of the choir books, and he may well have trained them himself.[27] A few years earlier, in 1568, a grammar instructor named Alarcón (first name unknown) was at the Colegio de San Andrés, where students learned to copy and illuminate choir books.[28]

Early colonial secular and ecclesiastical furniture in Quito often was painted and gilded with images. Gold leaf, *estofado* (sgraffito), and polychrome images decorated writing desks, chests, chairs, tables, picture frames, and other furnishings and architectural elements, although the names of the artists who adorned them are rarely registered. Such objects were not generally commissioned before a notary; most are registered in testaments. The 1632 testament of the silversmith Juan de Cazañas mentions articles of furniture (likely chairs) made of "six old *guadameçies* [tooled or embossed leather panels] with figures," indicating that the leather surfaces and figures were painted and perhaps gilded, as typically was the case with this artisanal form.[29] In 1586, Bartolomé de la Muela sold specialized merchandise to Diego de Tapia for his pharmacy business that included "twenty-four large apothecary boxes [to be] painted by a painter to the contentment of Diego de Tapia."[30] Further expanding the range of objects embellished by painters, in 1612, the Spanish painter Luis de Ribera traveled from Quito to the port city of Guayaquil to gild the galleons of the royal fleet.[31]

Gilders, as well as painters, were often contracted to decorate church furnishings using techniques that included polychromy and *estofado*, as well as gold leaf. In 1627, for example, the Spanish or Creole Marcos Velázquez, identified as a gilder, signed a contract with the *síndico* (administrator) of San Francisco in which he agreed to "gild to perfection the choir stalls of the said monastery of San Francisco from the screen above with the saints that are located on it, applying all the colors = carmine, [red] bole, blue and vermilion."[32] Extensive polychromy, as well as gilding, was clearly an integral

part of the commission. Velázquez's work is still extant in the choir loft of San Francisco in the rows of vividly colored saints and ornamentation that adorn the furnishings (*see plate 5*). In a 1636 contract between the Spanish or Creole Francisco Pérez Sanguino, identified as a gilder, and the Convent of the Immaculate Conception, the artist was enlisted to paint, gild, and apply *estofado* to the wooden pulpit of the church, and to paint flesh tones on all of the figures (*see plate 19*).[33] Although Pérez Sanguino is named as a painter in several other documents, in this contract he is identified only as a gilder, and he employed several assistants in this commission that likely included painters.

Beyond the more traditional objects and venues of the painter's craft, such artists also were enlisted to create ephemeral decorations for public celebrations and spectacles that included festivals, processions, royal exequies, and theatrical productions. These occasions, which might generally and profitably be termed "urban mediascapes," offered frequent, important, and highly visible opportunities for the involvement of painters in the creation of public ephemeral decorations for a wide audience.[34]

The confection of theatrical scenery and backdrops formed one aspect of painterly activity. In 1584, Alonso de Capilla, author of plays (*autor de comedias*), signed several contracts in the city of Tunja (Colombia) with the painter Pedro Rodríguez to create painted theatrical backdrops, called "retablos" (literally, "altarpieces") in the documents. These contracts are remarkably evocative of the range of the painter's craft. In July of 1584, the playwright and the painter agreed that

> Pedro Rodríguez is obligated to create and paint for the said Alonso de Capilla a retablo that Alonso de Capilla wants to have made and any other paintings that may be needed for his [theatrical] representations and not for anything else, and once the retablo is completed, he is obligated to help him assemble and disassemble it whenever necessary, and if Alonso de Capilla should require the help of Pedro Rodríguez for his representations [in margin: of the retablo], he is required to assist him and he is obligated to transport all the clothing that he is bringing along using the horses of Alonso de Capilla [. . .] until [we] arrive to the Ciudad de los Reyes [Lima].[35]

A second contract between the two parties, signed five months later in November of 1584, offers still more fascinating evidence, in which the painter, Pedro Rodríguez, forcefully asserts his skill and his professional status as an artist. Rodríguez was displeased with his previous assignments for the company, which he felt exceeded and compromised his professional status and obligations; thus, a subsequent document was drawn up that included specific language limiting the artist's responsibilities to the painting, mounting, and transporting of stage scenery. According to this contract,

> Alonso de Capilla declared that because he has had many deals and con-
> tracts with the painter Pedro Rodríguez, which include the salary that
> I was obligated to pay him for helping with the [theatrical] representa-
> tions and for painting the things that were necessary for them and the
> decorations that he has loaned, and having terminated the period of the
> previous contract between him and the painter Pedro Rodríguez, he
> still owes him one hundred and sixty-six pesos and five tomines and a
> thousand grains of smelted gold [. . .] which he must pay in the follow-
> ing form and manner [. . .] Pedro Rodríguez is obligated to [. . .] assist
> Alonso de Capilla for the period of one year in all of the representations
> that he mounts, in [?] just as in retablos, painting them and creating in
> them whatever is necessary, in the city of Tunja just as in all other places
> and spaces where Alonso de Capilla might travel over the said period of
> one year, [with] Alonso de Capilla providing him the things required for
> the painting of the retablos and plays, so that Pedro Rodríguez does not
> have to supply anything other than his hands and his work for the entire
> time, [and] Pedro Rodríguez does not have to do anything else, and
> Alonso de Capilla cannot occupy him in anything else other than solely
> the paintings and retablos, and taking care of arming and disarming
> [them], and in the plays, as mentioned, providing him all that is neces-
> sary for them, and at the same time, he is obligated to transport the said
> retablo and retablos using the horses that Alonso de Capilla provides,
> together with an Indian who will help him to load and unload in all the
> places and spaces where Alonso de Capilla might travel over the course
> of one year.[36]

Capilla essentially hired himself a portable painter to create, assemble, and disassemble multiple stage backdrops for his theatrical productions as they traveled through towns from Tunja to Lima, where they perforce would have passed through Quito en route.

No additional documents register Pedro Rodríguez's activities as a paint-er of theatrical scenery or other objects; however, in 1587 one "Pedro Ro-dríguez pintor" filed his last will and testament in Mérida, New Kingdom of Granada (today Venezuela), stating that he was a "native African from the border of Mazagán."[37] Now part of Morocco, Mazagán was a Portuguese outpost during the sixteenth century; thus, Rodríguez was likely of Luso-African ancestry. Chronological correspondences, together with elements of his will, indicate that Rodríguez is very likely the same person contracted by Capilla as a painter of stage scenery some years earlier. Among the belong-ings that Rodríguez listed in his will were quantities of powdered pigments and a large number of textiles related to the confection of clothing and paint-ings. Rodríguez's status as an "africano" probably accounts for Capilla's ini-tial attempts to take advantage of him as a general handyman.

Alonso de Capilla was a well-known Spanish actor and playwright whose pursuits are documented on the Iberian Peninsula in the 1570s and early

1580s. In Spain, numerous contracts trace Capilla's involvement in theatrical productions during this period, particularly in Seville, yet he disappears from the archival record there after the mid-1580s. Apparently, he immigrated to the New Kingdom of Granada, where he continued his theatrical endeavors in the northern Andes. Capilla's signature on the peninsular documents is a precise match with those on the Tunja contracts discussed here.[38] Both Capilla and Rodríguez are fascinating examples of skilled immigrants whose professional trajectories led them to the northern Andes, where they plied their trades as itinerant playwright and painter throughout the region.

Although Capilla and Rodríguez have yet to be located in Quito, a number of other itinerant theatrical companies made extended stops in the city during the early seventeenth century. Their productions likely employed sets and painted backdrops, whether or not they brought painters with them or hired local artists to produce stage scenery. In 1601, the *autores de comedias* Juan de Morales and Pedro Millán brought their theatrical company to Quito, where they purchased from a local merchant material for costumes and other items related to their profession.[39] Morales returned to Quito in 1610, and in 1618 formed a company with Francisco Jiménez, "maestro autor de obras," to stage *comedias* during a two-year period.[40] In that year, they hired eight actors to play a variety of roles. One of these, Juan Ladrón de Guevara, was to serve not only as an actor, juggler, and gymnast, but also as stage manager and jack-of-all-trades for the company, activities that may have included painting and mounting stage scenery.[41] The theatrical productions of Morales and Jiménez apparently played to rave reviews, for in 1619 the two authors renewed their contract with the actors, adding several new members, all of whom were to perform in plays held on "every Sunday and all the feast days of the year."[42] Although none of the actors who signed the documents is named as a painter, two of them, Francisco de Cazañas and Francisco Adame, were members of extended families of silversmiths and gilders.[43] Regardless, any of the numerous painters who plied their trade in early seventeenth-century Quito might have been enlisted to create backdrops and scenery for the productions of Morales and Jiménez and other itinerant theatrical companies.

Painters were similarly involved in the confection of imagery for the many festivals, celebrations, and royal exequies that were observed in early colonial Quito.[44] The names of painters that produced images for such occasions are rarely recorded in the documents; however, in 1647 the painter Bartolomé Marín was paid for designing and painting the ephemeral monument (*túmulo*) for the exequies of Prince Baltásar Carlos celebrated in the Church of La Merced.[45] Although this is the only reference to Marín, his work as a painter on the *túmulo* of the Mercedarian church exemplifies the opportunities afforded to such artists by the numerous public ceremonies, processions, and exequies.

The royal honors celebrated in 1599 to commemorate the death of Philip II offered another occasion for the participation of artisans and painters. For

the king's exequies, an elaborate *túmulo* was erected in the Cathedral, the construction and adornment of which involved carpenters, sculptors, architects, and artisans of various sorts, including painters. An early seventeenth-century description of the *túmulo* remarks on the status of the Andean and Spanish painters and describes the painted decorations of the monument and its surroundings in the Cathedral:

> All of the columns and their arches and the floor from the *túmulo* to the choir loft were covered with black mantles in all three of the naves [of the church], and each column had a black taffeta flag unfurled on its pole, and all of the columns were adorned with specially made paintings of all the cities of this district, which accompanied many other paintings of the royal coats of arms, and all this was made (or most of it) in the buildings of the city council, where the Corregidor lived, occupying in this [all] the Spanish and Indian painters that there were in the city.[46]

The *túmulo*, its numerous paintings, and the surrounding adornments were so elaborate and extensive that they required the collaboration of all local painters, the vast majority of whom were indigenous.

In 1603, Quito celebrated the 1601 canonization of the Dominican San Raimundo de Peñafort with festivities and public processions that involved guilds and confraternities, religious and civil dignitaries, and painters and other artisans. The religious orders mounted a procession of allegorical carts representing such themes as the Angelic Choir, Natural Law, and the Law of Grace. A contemporary account described the range of pictorial images deployed in the public spaces of the city:

> As backdrops for each cart, large painted canvases were commissioned: for the first, the starry sky and the figure of God the Father surrounded by familiar archangels; for the second, the scene of the Creation, of the Terrestrial Paradise and the holy patriarchs; for the third, which was in the form of a ship, the battle of Joshua and the fall of Jericho were depicted on each side, at the stern the giving of the tablets of the law on [Mount] Sinai, and, on the prow, the serpent suspended from the Cross; for the fourth, a backdrop was necessary on which was painted figures representing Christ, the Martyrs, and the Confessors.[47]

The paintings created for the allegorical carts were intricate and detailed in their designs. Diego Rodríguez Docampo in 1604 recounted with greater specificity the creation scene mounted on the second cart: "The back of the cart was adorned with paintings of the creation of the world and paradise with the tree of life with many golden apples suspended [from it] and Adam lying [beneath] it, and at the foot of the tree of the knowledge of good and evil was Eve speaking with the serpent that was wrapped around it."[48] Many of the human allegorical figures that accompanied this and other carts are described as "carrying painted images." On the aforementioned cart, the figure

of Enoch carried "the image of paradise painted on a wooden panel."[49] The cart representing "the Law" was painted the color green, symbolizing hope, and hanging from it were "some painted cloths with their depictions of the principal histories that transpired in the times of this law," which included the battle of Joshua, the fall of Jericho, and the giving of the tablets of the law on Mount Sinai.[50] The artists who painted the many backdrops and panels commanded a diversity of pictorial themes and capitalized on the professional opportunities afforded by such extensive public celebrations.

In addition to the carts, the streets of the city were decorated with ephemeral altars that held sculpted and painted images, richly caparisoned with baldachins and adorned with textiles of silk, damask, and taffeta. The Jesuits mounted a street altar containing a number of paintings that were specifically commissioned for the event.[51] The occasion of San Raimundo's canonization logically gave rise to a host of sculpted and painted images of the saint, many of which are located today in the Dominican monastery and other repositories throughout the city.

The 1613 royal exequies commemorating Queen Margarita of Austria involved a complex orchestration of processions, sermons, and musical performances around the focus of the event: the *túmulo*. On this occasion, a competition was organized in which prizes reportedly were offered to the artists who produced the best designs and images for the monument. Numerous unnamed master painters participated:

> The General also called for the reunion of all the most perfect and master painters [and] he ordered that they depict in human-scale figures on large canvases the descendants of the House of Austria, from Pipino the First, Duke of Brabant, to King Philip the Second our lord of felicitous memory, which are twenty-six [in number], and which they took great pains in painting, modeling them on prints from a book composed by Juan Baptista Vrientino of Antwerp dedicated to the serene princes Albert and Isabella, Dukes of Brabant, taking much time to make the copies similar to their originals, with the dress and clothing that each one used in their time, so alive and so perfectly finished that they are the best paintings in all of the kingdom.[52]

The twenty-seven paintings of the dukes of Brabant were arranged on the monumental *túmulo*, interspersed with sculptures of the cardinal and ecclesiastical virtues, skeletons, painted escutcheons, and a wealth of "hieroglyphs" and texts.

> All of the figures of the descendants of the House of Austria were set up all the way to the grille of the choir loft, and along the frieze above where they were hung many black and white candles were placed in candelabras, so that with the reflection of the lights they [the painted figures] looked like they were alive [. . .] they hung many paintings of the royal coat of arms [. . . and] they placed in the center a large painting of the

Figure 3.2 (*left*) Anonymous, *Pipinus I*, ca. 1600. Engraving. Adriaan van Baarland, *Ducum brabantiae chronica* (Antwerp: Plantin Press, 1600). Photo courtesy of the Folger Shakespeare Library, Washington, DC.

Figure 3.3 (*right*) Anonymous, *Philip II*, ca. 1600. Engraving. Adriaan van Baarland, *Ducum brabantiae chronica* (Antwerp: Plantin Press, 1600). Photo courtesy of the Folger Shakespeare Library, Washington, DC.

PIPINVS SENIOR BRABANTIÆ DVX I.

PHILIPPVS IIII. DVX BRAB. HISP. II. REX.

escutcheon of the city of Quito, and alongside they hung paintings of the coats of arms of all the cities and towns of this province.[53]

Among the panoply of elements described as adorning the *túmulo*, the twenty-seven life-size "portraits" of the dukes of Brabant stand out, not only because they are lauded as so lifelike and perfectly rendered, but also because the source of their imagery is identified by name. The book containing the engravings published by "Juan Baptista Vrientino de Antuerpia" (Joan Baptista Vrients [Vrintius, Vrints]) is the *Ducum brabantiae chronica*, authored by Adriaan van Baarland and published in 1600 at the Plantin Press in Antwerp.[54] Thirty-six engravings of the dukes of Brabant and the kings of Spain adorn the volume, twenty-seven of which illustrate the lineage of the Spanish kings from Pipinus I, son of Charlemagne (fig. 3.2), to Philip II of Spain (fig. 3.3).

Although the later disposition of the twenty-seven life-size paintings is unknown, they likely became adornments in another venue, serving as models themselves. Perhaps they hung on the walls of the *casas reales*, taking their place among the painted escutcheons of the House of Austria and the *audiencia* of Quito that similarly originated with the *túmulo*. They may subsequently have been redeployed in exequies, festivals, and other celebrations and, like the engravings, provided examples for local artists. The painters likely to have participated in the confection of the "portraits" were almost exclusively Andean, with the exception of the Spaniard Luis de Ribera and the Creole Fray Pedro Bedón. Among the possible painters were Andrés Sánchez Gallque, Bernabé Simón, Mateo Mexía, Felipe Guáman, Juan Chauca, Juan del Castillo, and Mateo Ataurimache, all of whose names are registered in the archives between 1600 and 1620 as actively working in Quito.

Indeed, the facial features, piercing gaze, and three-quarter pose of Philip II in the *Ducum brabantiae* find close correspondence in those of Francisco de Arobe in Sánchez Gallque's 1599 painting (*compare plate 1*). Given that Vrients acquired the plates from other sources prior to their publication in 1600, the images may well have been in circulation during the late sixteenth century.

Andeans participated in a variety of ways in the creation of urban mediascapes, although their contributions are infrequently mentioned in contemporary accounts. One remarkably detailed description of native vestments, adornments, and paraphernalia highlights an instance of massive Andean involvement and political agency. In 1631, the city of Quito celebrated news of the birth of Prince Baltásar Carlos, heir to the Spanish throne. A lengthy memorial sent to the king by authorities in Quito describes the month-long festivities, which included processions, bullfights, jousting (*juegos de cañas*), pyrotechnic displays, and a multitude of other amusements. At the very end, Andean participation took center stage.

On the final day, a mock battle was enacted between the "armies of the Inca, former king of this land in its gentility" and those of the "queen of Cochasqui," the leader of groups native to the *audiencia* of Quito.[55] The battle seems to have reenacted that of Yaguarcocha, the pre-Hispanic military confrontation between the invading army of the Inca ruler, Huayna Capac, and Quilago, the indigenous queen of Cochasquí (a region some fifty kilometers north of Quito) that is recounted in colonial chronicles.[56]

Parading in captained squadrons, each representing eight Andean ethnic groups called "naciones," which included "Quisingas, Gíbaros, Cofanes, Litas, Quixos, Incas, Niguas and Mangaches [. . .] more than four thousand natives [fully] armed according to their customs with slingshots, *chesos* [?], darts, bows and arrows, clubs, hatchets, lances, *macanas* [clublike swords], [and] heads of lions, tigers, and bears," they entered the main plaza of the city accompanied by "drums, flutes, and whistles and carrying [a large] quantity of banners and insignia on tall poles [topped] with feathers."[57] The squadrons of the Inca were accompanied by

> their women, with their earspools, diadems [*llautos*], silver discs and adornments, and a cart on which appeared a dense mountain artfully arranged with many animals, and both armies with their cargos of coca, *chicha*, and cotton, hot peppers and other foods of their customs [. . .] and on another cart there appeared the punishment of the *caciques* [P]ena and Jumande, which were those who rebelled in the province of the Quijos.[58]

The astonishment, frisson, and fascination of the narrator recording this display was likely shared by the audience as a whole, particularly as he described the entry of "four thousand armed Andeans" that

extended themselves across the entire plaza so gallantly that there was
nothing in any of these festivities that gave such great pleasure, because
in addition to seeing the extraordinary manner of the natives, there were
so many cloth tunics, and most of gold, fine velvets with gold trimming,
damasks, and many embroidered and others with their woven [decora-
tion], and the diversity of colors that they all possessed, and the feathers
in their hats, that they could shame the most fertile flowers or springtime
[itself] and never would those fields be able to bring together what was
seen here in such a small space.[59]

According to the description, color was a particularly powerful aspect of
the dress and adornment of the Andean participants. Finally, the author de-
scribes in some detail the actions and "performance" of the two groups of
indigenous militia and the subsequent victory of one side:

Both armies undertook their battles and assaults skillfully and with nota-
ble boisterousness and shouting to the sound of their instruments and
of the delightful [ones] from Spain until they triumphed and beheaded
the queen of Cochasqui, and the manner in which they sang their victory
was most amusing and much to witness, [for it] lasted for a period of
three hours, and if it had gone on any longer it would have seemed but a
short time, owing to the great and good [manner] in which they amused
and entertained, upon which they returned to their former order and
marched out of the plaza in the same concert and order in which they
had entered, and the festival continued until nighttime.[60]

Although this document does not make specific mention of painters in-
volved in aspects of the performance, the many native painters in the city
were very likely among the four thousand Andeans who participated in the
mock battle, or were at least present in the audience. From an Andean optic,
the performance was an opportunity for the public expression of ancestral
identities, symbols, and power, which ultimately reinforced contemporary
Inca dominance and authority over aboriginal groups in the colonial city.[61]
 The colonial city afforded a broad array of opportunities for the creation
of visual imagery that painters of primarily indigenous ancestry fulfilled. The
professional world in which they operated encompassed the entire urban
fabric of the city and its diverse affairs, bringing professional Andean paint-
ers, in particular, and their works into dialogue with a full range of patrons
and audiences. Painters mastered and deployed the specialized forms of
knowledge and materials required to address the manifold exigencies of co-
lonial mediascapes. Yet the practice and transfer of that knowledge depend-
ed on the internal organization and structure of the painting profession. Cir-
cumstances and features related to the organization and hierarchy of painters
and the profession may be glimpsed through the archival record; however, a
professional guild of painters is conspicuously absent in early colonial Quito.

CHAPTER 4

Painters and the Profession

The privileged knowledge and technologies of materials, colors, and chemistry—in addition to perspective, proportions, and iconography—were the purview of professional painters in the European tradition. As practitioners of the art, painters typically were organized in and subject to guilds that oversaw professional practices, enforced regulations and internal hierarchies, and jealously protected the interests and secrets of the trade.[1] Specialized knowledge was passed from masters to apprentices in a system that awarded the professional titles of journeyman and master only after years of practice and formal examination. The painters of early colonial Quito, however, were not organized within a guild structure, even though they frequently are named in the documents with the titles of "master" and "journeyman." Alternative forms of professional organization appear to have governed the professional lives and practices of the many painters that pursued their livelihood in the early colonial city.

Titles and Trades

The professional title of "painter" constituted a relatively fluid category in early colonial Quito. In the documentary record, titles indicating profession often varied to the extent that painters might be identified as practitioners of several different or additional trades, especially that of gilder, as well as those of sculptor and woodcarver (*entallador*). The documents often establish rank in accord with title; thus, the hierarchy of "master" (*maestro*) and "journeyman" (*oficial*) distinguish levels of professional status, knowledge, and skill, although many are identified simply as "painter." Of the fifty-nine

painters documented between 1550 and 1650, sixteen bore the title of "master" and five were identified as "journeyman painter."

Although most documented painters are identified as such by a single professional title, for those bearing multiple titles, that of painter is typically foremost in naming the artist; the designation of gilder, sculptor, or woodworker might appear as additional identifiers. For example, contracts related to the Spaniard Luis de Ribera invariably name him as "painter," while on a few occasions the title of gilder or sculptor is appended.[2] The Andean artist Juan del Castillo appears in bills of sale named only as a painter; however, in a 1606 contract for a group of sculptures, he is identified as both painter and woodcarver.[3] On the other extreme, several multifaceted artists carried a range of titles in different contracts. The Spanish or Creole Juan Fonte and the Andeans Antonio Gualoto and Cristóbal Faizán are identified variously as painter, gilder, sculptor, and woodcarver.[4] More rarely, artists primarily recorded as gilders, such as the Andean Diego Gualoto and the Spanish or Creole Francisco Pérez Sanguino, occasionally are identified as painters.[5]

The mutability of professional titles extends to artistic commissions involving a number of painters. The Andean painter Sánchez Gallque, for example, signed a 1592 contract as "yndio pintor" to create the main altarpiece of the church in Chimbo, a project that involved carpentry, joinery, sculpture, painting, and gilding. In this instance, the contract registers that Sánchez Gallque brought with him from Quito a group of Andean assistants (*oficiales*) skilled in the requisite arts.[6] The Spaniard Luis de Ribera, identified as "painter," signed a 1609 contract to polychrome and gild an altarpiece dedicated to Santa Ana in the Cathedral.[7] The magnitude of these contracts and the variety of professional abilities required to complete them make it clear that these painters did not undertake all aspects of the work themselves. As signatories to the contracts, they possessed the authority and connections to act as general contractors who provided their own teams of skilled assistants to realize major multimedia works such as altarpieces. At the same time, most painters practiced and indeed dominated multiple, related trades, accepting commissions for artistic enterprises that often went beyond simply the painting of images.

Similarly, artists identified exclusively as sculptors, carpenters and/or architects often were commissioned to produce carved altarpieces that included extensive painting, gilding, and *estofado*. Such was the case, for example, with the prolific Andean artist Juan Benítez Cañar, who appears variously as master architect, sculptor, joiner (*ensamblador*), and woodcarver—but never painter—and who signed at least nine contracts for the creation of carved, painted, and gilded altarpieces between 1615 and 1629.[8] Acting as general contractors, a range of Andean artists, including painters, commanded the power and authority to muster the materials and the manpower required to undertake major commissions involving a range of mediums, and to organize and direct the professionals possessed of the various skills to complete the job. Such masters whose names have been preserved in the notarial record

were almost exclusively Andeans who acted as sophisticated intermediaries between patrons and the artisan community, organizing and directing portable "workshops" of adept native assistants in the realization of extensive multimedia projects.

In other principal colonial urban centers, such as Mexico City and Lima, where official trade guilds protected and enforced professional categories and protocols, master artists frequently signed formal subcontracts with specialized artisans to undertake specific aspects of major commissions. In colonial Quito, such official subcontracts are extremely rare.[9] Subcontracting must have occurred, but it likely was handled verbally by those who wielded social and professional status within the artisan community and were capable of negotiating the lettered bureaucracy of notaries. The polyvalent context of titles, professions, and artistic commissions demonstrates the relative freedom with which painters, sculptors, and related professionals could operate to their advantage in the city, and the means by which many of those artists registered in the documentary record achieved and maintained power and authority within the community.

The fluidity of professional titles and the variety of professional practices in which early Quito painters were involved are not unusual in the colonial Americas, particularly in urban centers without related trade guilds to police and enforce professional boundaries. Because no official guilds of painters, gilders, sculptors, or woodworkers existed in early colonial Quito, such artists had autonomy in practicing multiple trades without professional conflict or legal reprisal.

Trade Guilds and the Professions

In urban centers throughout the colonial Americas, trade guilds based on European prototypes were established from an early date to benefit and regulate people, professional practices, products, and consumers. In the Spanish Americas, the city council acted as the ultimate controlling force, establishing *aranceles* (price limits) for good and services, approving guild regulations, and electing annually the *maestro mayor, alcalde y veedor* (head master, magistrate, and overseer) of each guild. The *maestro mayor* served as an intermediary between the city council and the tradesmen, enforcing guild regulations and overseeing training, production, and quality. Artisan guilds established rules regarding apprenticeship that involved several years of on-the-job training to gain the title of journeyman (*oficial*). After more years of practice, journeymen could acquire the title of master upon successful examination by the officially appointed *maestro mayor* of the trade.[10] Trade apprenticeships and professional examinations that specified the legal benefits and obligations of the parties involved typically were registered in formal contracts before a notary.

In colonial urban centers, the official guild structure afforded benefits to

its members in the form of legal recognition and social status, and it also served to control and limit local competition. Officially recognized guilds required all local professionals and newly arrived tradesmen to be examined and approved by the *maestro mayor y veedor*, and some excluded indigenous and African members or limited their status to that of *oficiales*.[11] By presenting their regulations to the city council for ratification and approval, guilds obtained official endorsement that protected the professional interests and legal rights of their members. Operating in tandem with the city council, trade guilds regulated and controlled the people, practices, prices, and quality of their products.

Painters' guilds, which sometimes incorporated the profession of gilders, were established in many colonial cities during the sixteenth and seventeenth centuries. In Mexico City, the guild of painters and gilders was formed, with *ordenanzas* (regulations), in 1557;[12] in Lima, with *ordenanzas*, in 1649;[13] in Cuzco, with *ordenanzas*, in 1649;[14] in Puebla de los Angeles, with *ordenanzas*, in the late seventeenth or early eighteenth century;[15] and in Santiago de Chile the guild of painters was recognized by the *cabildo* in 1659.[16] In other urban centers, such as Santa Fe de Bogotá and Potosí, painters' guilds were not officially instituted until the mid- to late eighteenth century,[17] while in some areas, such as the region that is today Venezuela, official trade guilds never found a foothold during the colonial period.[18] Frontier circumstances and indigenous majorities may to some extent account for the lack of painters' guilds in northern Andean cities.

Unlike many other colonial urban centers, Quito had no official guild of painters until the mid-eighteenth century.[19] The absence of a painters' guild for much of the colonial period, as well as that of sculptors, carpenters, and woodworkers (with the notable exception of silver- and goldsmiths), was one factor that decisively affected artistic practice and production in early colonial Quito. A variety of other artisan guilds, such as tailors, shoemakers, locksmiths, and tanners, were officially established in Quito by the 1570s.[20] *Maestros mayores* of the guild of silversmiths and that of gold beaters (*batihojas*) were not formally named by the *cabildo* until the first half of the seventeenth century; the earliest extant record of their election dates from 1639.[21] The guild of sculptors was not established until 1690, and from 1694 also incorporated carpenters among its ranks. Significantly, the first *maestro mayor* of the sculptors' guild named by the *cabildo* was the Andean master sculptor and carpenter Francisco Tipán, a post to which he was subsequently reelected for sixteen years.[22] This example underscores the prevalence of Andean artists and craftsmen in Quito and suggests that they engaged in alternative forms of professional organization during the early colonial period.

An official guild structure created a professional hierarchy of masters, journeymen, and apprentices whose ascent in the ranks depended upon training, skill, and examination. Yet in early colonial Quito, despite the absence of a formal guild, painters bearing the titles of journeyman and master

consistently are recognized. In many instances, the documents trace the rise in status of painters over time through a change in title from journeyman to master.[23] Without official guild organization and examination, how did painters attain these titles? Informal recognition of seniority and expertise may have played a role, in which years of professional practice and the leadership of family or community workshops naturally led to a designation of "master." Indeed, informal painting "workshops" or professional collaborations may have emulated some aspects of the official guild structure and its nomenclature, yet any control over the people and practices of painting appears to have rested with individuals, not with city authorities, councils, and official bureaucracies.

The lack of an official painters' guild explains the almost complete absence in the notarial record of apprenticeship contracts for painters. Indeed, for early colonial Quito, just one such contract has been recovered, and only two are known for the entire seventeenth century.[24] This lacuna is all the more glaring since hundreds of apprenticeship contracts for a wide range of other professions are present in the notarial record from the 1560s and throughout the seventeenth century.[25] The earliest known painting apprenticeship contract is a document from 1620 in which the Spanish or Creole master painter Felipe Díaz accepted the mestizo Juan López de Navarro as an apprentice to serve in his workshop for the period of one year "so that he can be taught the profession of painter."[26] The signatures of both Díaz and López de Navarro appear at the end of the document, suggesting that the latter was perhaps not a young boy at the time and implying that the arrangement may have been closer to that of hiring a workshop assistant. The virtual absence of apprenticeship contracts for painters in early colonial Quito speaks to the existence of informal professional collaborations and the incorporation of extended family members in the trade.

Logically, the lack of a painters' guild explains the dearth of formal examination records for painters during the sixteenth and seventeenth centuries. Trade examinations for many other professions are abundant in the notarial record, containing the questions posed to the journeyman, his responses, and his demonstration of the skills required to obtain the title of "master."[27] Although numerous Quito artists are identified as "master painter," no formal written record exists as to how their titles were attained.

At the same time, the city council may have played an indirect role that accounts for the absence of certain guilds, including that of painters. The power of the city council to control the prices and production of goods and services appears in some instances to have forced the establishment of particular guilds, whose members sought to protect their own professional interests. Dating from the 1530s, prior to the official establishment of guilds, the city council mandated a series of *aranceles* (price limits) on certain locally produced trade goods and services in response to complaints of excessive and irregular prices. Groups of tradesmen, including blacksmiths, tailors,

and hosiers, appealed and attempted periodically to negotiate the price limits throughout the late sixteenth and early seventeenth century, and finally staged a strike in 1650.[28]

Direct conflict between guilds and the city council had led in 1568 to the establishment of local *ordenanzas* regulating trade professionals that imposed harsh penalties for noncompliance. The *ordenanzas* required that the tailors, hosiers, blacksmiths, and shoemakers obey the *aranceles* established for their trades, and that their prices be publicly posted. Moreover, all guild professionals were subject to periodic review by an overseer appointed by the *cabildo* to determine their mastery of the trade, and all were required to provide a guarantor (*fiador*) who was obligated to pay damages in the case of defective, delinquent, or otherwise unsatisfactory products or services.[29] The tradesman's possession of a "public shop" (*tienda a la calle*) was the principal means by which the city council and the *maestros mayores y veedores* located, supervised, and enforced regulations. By implication, those professionals who did not operate a public shop—who individually contracted works produced in their homes or private workshops or who sold their wares through an intermediary or at a general store—operated outside the city council's realm of direct control.

While abundant notarial contracts register the rental and purchase of *tiendas a la calle* by a wide range of local tradesmen during this period, in only one instance is a painter recorded as owning a public shop. In 1599, the Spanish painter Luis de Ribera purchased a shop located next to his residence in the parish of Santa Barbara. Although Ribera may have sold paintings in the shop, this and subsequent documents make clear that he ran a *pulpería* (general store) that offered a range of products from textiles and foodstuffs to hardware and household implements.[30] With the possible exception of Ribera, painters in early colonial Quito did not sell their wares from their own public stores.

By curtailing what had been a laissez-faire economy, by establishing public order—*buen gobierno y policía*—the city council thus brought certain groups of professional tradesmen directly under its control, and from 1568 the *cabildo* essentially mandated the formation and maintenance of guilds and *aranceles* by naming annually the *maestros mayores y veedores* for numerous trades who would enforce the established *ordenanzas*. The roster of trades for these decades highlights those professions of particular importance to the city authorities at this time: tailors and hosiers, blacksmiths, shoemakers, hat-makers, embroiderers, farriers, and tanners.

Although the list of guilds approved and controlled by the *cabildo* expanded in subsequent decades to include additional trades, painters and gilders were not among them. A combination of several possible scenarios may account for the city council's lack of oversight with regard to painters. The vast majority of painters in early colonial Quito were Andean, and the small number of European and Creole practitioners of the art may have ren-

dered any official control unnecessary. Moreover, as noted above, paintings brought extremely low prices on the market; thus, the *cabildo* may have seen no fiduciary need to control and regulate the prices of such products. Additionally, there is little indication in the documentary record that painters operated public shops, despite the extensive documentary record of such establishments run by a wide range of local tradesmen. Painters appear to have operated almost exclusively as independent contractors or general contractors; thus, they escaped—by design or by accident—the control of the city council. Because most locally produced paintings were made to order, the almost uniformly lettered status of Quito painters enabled them to undertake written commissions by means of *vales* or formal notarial contracts, thereby obviating or circumventing the need for a public shop.

The absence of a painters' guild also may shed some light on the curious disjunction between the high percentage of painters in Quito who autographed notarial documents and the remarkably small number who signed their paintings. Of the thirty-six painters who signed numerous notarial documents between 1550 and 1650, only four inscribed their names on paintings that are today extant: Angelino Medoro, Andrés Sánchez Gallque, Mateo Mexía, and Juan de Salinas. Elsewhere in the colonial Americas, however, painters' guilds could enforce the requirement that officially recognized "masters" sign their works, as established for example in the *ordenanzas* of the Mexico City guild in 1681, and those of Puebla in the late seventeenth or early eighteenth century.[31] Although the official record of signature requirements by New Spanish guilds is later than the period in question for Quito, the informal practice may have much earlier origins, as evidenced by the many signed sixteenth-century paintings in New Spain.[32]

In Quito, the absence of a formally organized guild of painters afforded such artists great latitude in their professional pursuits, creating correspondingly informal economies of training, collaborative practices, and market values. At the same time, the lack of any official mechanisms of protection and control meant that those artists who were equipped with knowledge of the linguistic, textual, and legal procedures of the Spanish bureaucracy enjoyed decided advantages over those who did not. Given that Andeans constituted the overwhelming majority of painters in early colonial Quito, they likely operated in a manner similar to that documented for Andean sculptors, carpenters, and others in the building professions, wherein the indigenous community assumed almost complete control over people, processes, and production.[33] Yet the fact that most of the subject matter and the demand for paintings originated within a religious context also may have been a factor, for the Church controlled lay institutions in the form of confraternities, many of which limited their membership on the basis of ethnicity and/or professional affiliation. Membership in lay confraternities may have afforded painters a measure of the benefits that an official trade guild might otherwise have provided.

Confraternities

Lay confraternities were perhaps the only form of social organization ostensibly open to all members of society, even if some of them varied in terms of membership exclusivity. Trade guilds and confraternities were often linked during the colonial period. Guilds frequently established related confraternities as their "spiritual arm" in order to enjoy the benefits conferred by such groups, limiting their membership to the practitioners of a particular trade. In general, however, confraternity membership could be open or exclusive, admitting entry to all or limiting membership on the basis of profession, race, ethnicity, gender, or other social divisions.

Confraternities thus constituted another institutional option for the organization and mutual benefit of trade professionals and other groups in early colonial Quito, one whose control rested not with civil but with religious authorities. In many ways, the haven of a confraternity offered a viable and even desirable alternative to that of a guild. Confraternities afforded considerable social and spiritual advantages to their members, and offered an alternative to direct supervision and control by the city council. Established in devotion to a titular saint, advocation of the Virgin Mary, Jesus, or a biblical event, confraternities offered mutual aid to members, burial benefits, and spiritual benefits, such as prayers and masses for the dead, graces, and indulgences. Confraternities occupied side chapels in the churches of monasteries, convents, parishes, and the Cathedral, where they erected altarpieces and maintained communal images, objects, and utensils of devotion.

Governed by a set of rules agreed upon by the membership and ostensibly submitted to episcopal authorities for approval, confraternities were subject to the control of the Church. In addition to episcopal ratification of their regulations, they were required to maintain account books and inventories of corporate belongings that were subject to periodic review by religious authorities. The internal organization and hierarchy of confraternities were determined by the rules and the membership, who annually elected *mayordomos*, *priostes*, *síndicos*, and other variable leadership posts charged with the administration of the sodality. The opportunity thus existed for social status and advancement within the group by which members could attain positions of power and prestige. Moreover, confraternities organized masses and processions on feast days in which they carried their titular images on decorated platforms through the streets of the city. These groups, with their accompanying members adorned in special robes and carrying lighted candles, were thus highly visible within the community.

Confraternities typically established membership requirements as a part of their internal rules. While "open" confraternities existed throughout the city, they coexisted with numerous sodalities whose memberships were of an exclusive nature. Among several founded in the Cathedral during the sixteenth and early seventeenth centuries were Nuestra Señora de Alta Gracia, which limited its membership to "negros y mulatos"; the Santísimo Sacra-

mento, which excluded members not of Spanish blood; and that of Nuestra Señora de la Presentación, which admitted only Andeans.[34] Many of the confraternities established in churches of both the regular and the secular clergy limited membership on the basis of race and ethnicity, among other factors.[35]

At the same time, confraternities could also restrict their membership to the practitioners of a specific trade or related trades; indeed, as noted above, many functioned as spiritual extensions of established trade guilds. Guild-confraternities in early colonial Quito include Nuestra Señora de la Presentación, which restricted membership to Andeans in the textile profession;[36] Santa Catalina, limited to tailors;[37] Dulce Nombre de Jesús, scribes and notaries;[38] and San Pedro, members of the secular clergy.[39]

No confraternity dedicated to San Lucas (Saint Luke)—patron saint of painters—is recorded in Quito until the latter half of the seventeenth century. A late seventeenth-century sculpture of San Lucas holding a brush and palette, located in the Capilla de Cantuña of the Franciscan monastery, served as the titular image of this confraternity. The base of the sculpture bears an inscription that reads: "In the year 1668 this effigy of S. Lucas Evangelista was completed and it was made by Padre Carlos and renovated by Bernardo de Legarda its Administrator in the year 1762."[40] The 1672 testament of Doña Francisca Llagtapalla contains a clause recognizing a debt she owed to "the confraternity of san lucas founded in the monastery of san francisco of the natives," indicating that its membership was limited to Andeans.[41] That the Confraternity of San Lucas was established in the Capilla de Cantuña was not a coincidence, for the chapel had originally served the Colegio de San Andrés, where generations of Andeans and others were trained in literate and artistic skills.

In 1585, the silver- and goldsmiths attempted to found an exclusive confraternity dedicated to San Eloy in the main Franciscan church.[42] Although they were unsuccessful in that year, by 1602, their confraternity was officially established in the neighboring Mercedarian church, decades before the trade guild of gold- and silversmiths was constituted and officially recognized by the city council in 1639.[43] The 1585 rule book of the Confraternity of San Eloy indicates that its members were principally Spanish and Creole; on only one occasion are Andeans mentioned, precluding them from certain burial rights accorded to other members.[44] The fairly standard roster of administrative positions elected by confraternity members included the unusual post of *ensayador* (assayer), which illustrates the sodality's combination of professional concerns with spiritual pursuits.[45] Indeed, in early colonial Quito, it may have been more advantageous for the silver- and goldsmiths to congregate within a confraternity under ecclesiastical authority rather than be subject as a guild to the strict regulations and control of the city council.

Confraternities of trade professionals often were subdivided into separate groups of the same religious advocation on the basis of race and ethnicity. The confraternity of tailors and that of button-makers, for example, consti-

tuted three subconfraternities of Spaniards and Creoles, Andeans, and Africans.[46] In many instances, "mixed" confraternities of a single advocation, often located in the same monastery or convent, operated as distinct groups whose respective memberships were limited by their racial and ethnic identities. Such was the case, for example, with the Confraternity of the Vera Cruz in the Monastery of San Francisco, which in the 1580s broke into two groups along ethnic lines. One confraternity, the Vera Cruz de los Españoles, had its chapel and altar in the main Franciscan church, while the other, the Vera Cruz de los Naturales, was located in its own chapel, separate from the main church, the chapel later known as that of Cantuña.[47]

Because the chapel of the Vera Cruz de los Naturales occupied one flank of the original cloister that housed the Franciscan Colegio de San Andrés, it is tempting to imagine that the confraternity's membership incorporated a range of Andean artisans, including painters. Unfortunately, no membership rosters or rule book have been recovered for the Vera Cruz de los Naturales; however, documents confirm the names and professions of at least some of its members. A 1585 petition to the king was signed by several members of the Confraternity of the Vera Cruz de los Naturales, including Diego de Figueroa Cajamarca (*alcalde mayor de los naturales* and alumnus of the Colegio de San Andrés), Ventura de San Francisco (carpenter and builder), Alonso Barbero (barber/medic), and Juan Guanga (profession unknown).[48] Thus, membership in the Vera Cruz de los Naturales appears to have been open to Andeans of all trades, which undoubtedly included painters. In exclusively Andean confraternities, membership was occasionally limited on the basis of profession (as in the case of the *yndios tejedores*); however, the majority of Andean-only confraternities blended professions and gender, such as those of the Vera Cruz de los Naturales and Nuestra Señora del Rosario de los Naturales.

Extensive membership rosters are known, however, for one confraternity whose affiliates included a significant number of named Andean painters. The Confraternity of Nuestra Señora del Rosario was established in 1563 in the church of the Dominican monastery as a mixed group that included Spaniards and Andeans. In 1588, the Dominican friar and accomplished painter Pedro Bedón reorganized the confraternity into three distinct sodalities of Spanish, Andean, and African and mulatto members. Bedón served as chaplain to all three constituencies, often recording and signing the minutes, inventories, and expenditure records.[49] Bedón's pen-and-ink drawing of the Virgen del Rosario adorns the opening folio of the confraternity book (*see plate 13*), an image that reveals the friar's Mannerist stylistic formation.

Indigenous painters who were members of the Andean Confraternity of the Rosary between 1588 and 1592 included "Alonso Chacha, Andrés Sánchez Gallque, Cristóbal Naupa, Francisco Gocial, Francisco y Gerónimo Vilcacho, Juan José Vásquez, Sebastián Gualoto, Antonio y Felipe."[50] Several of them, notably Sánchez Gallque, Gocial, Gualoto, and Naupa, are named in the notarial record as painters, master painters, and gilders. Sánchez Gallque, in particular, occupied several prestigious posts in the confraternity hi-

erarchy.[51] However, painters were by no means the only professional group associated with this confraternity. Other members in the late sixteenth and early seventeenth century included the embroiderer (*bordador*) Diego Tutillo and the saddlemaker (*sillero*) Luis Paucar.[52] The Confraternity of the Virgen del Rosario de los Naturales was an exclusive group in terms of ethnicity, but not profession.

Bedón's Andean confraternity might well have served simultaneously as an "art school" or "workshop," given that so many of its members were painters and artisans of various other sorts. Indeed, in 1598, Bedón penned a telling formulation of his views on artistic practice, which he likely imparted to members of the confraternity, emphasizing the employment of art theory, practice, and imitation as the three pillars of painterly perfection. Bedón's text is overtly didactic in its intent, highlighting the rules of proportions, the mixing of colors, and the use of finished models that must be studied and employed for one to become an accomplished painter.[53] This text aligns Bedón with sixteenth-century European art theorists such as Francisco Pacheco and Giorgio Vasari, and conveys the friar's deep involvement with pedagogy in the visual arts. As members of the Confraternity of the Rosary, Sánchez Gallque and other painters likely received instruction in Bedón's three pillars, the last of which, reliance on models, indicates the use of prints and paintings as sources. In lieu of an official painters' guild, Bedón's Andean Confraternity of the Rosary may have served this role in a more informal fashion.

The lack of a painters' guild or an exclusive confraternity of painters was a double-edged sword. On the one hand such artists could practice their profession with a high degree of freedom, finding their own patrons and venues for sales, setting their own prices, and employing whatever materials and assistants they deemed fit—all in an unsupervised and unregulated economy. At the same time, however, painters lacked the protections and benefits that such official organizations afforded, which included strength in numbers, legal recourse as a group, protection against competition, and the establishment of set prices. Given this laissez-faire environment, the painters who attained professional and economic success were most likely those capable of independently negotiating the bureaucracy to their benefit, taking advantage of the Spanish colonial legal system, particularly notaries, to protect their interests and advance their causes. The notarial documents do not register all of the painters who undoubtedly plied their trade in early colonial Quito. They do, however, record those literate artists who were able to successfully harness and negotiate the bureaucratic system to their advantage.

Commissioning Paintings

Paintings were purchased from local artists in several ways: on the open market, by verbal agreement, and by filing a formal contract before a notary.

Compared to the price of a notary, for which the cost per page in this period ranged between one-quarter and one-half peso, a less expensive option for commissioning paintings was by verbal agreement or by means of informal *vales* (small handwritten receipts), the record of which was typically noted in the patron's account books of expenditures. The alternative to *vales* and verbal or formal contracts was sale on the open market. In addition to artworks available at public auctions, local merchants retailed "ready-made" works in their *pulperías* (general stores), which included both locally produced and imported paintings.

A number of variables were involved in a typical artistic contract filed before a notary: the size, form, and iconography of the work, the nature and variety of materials and who would supply them, the time frame for completion, the amount and schedule of payment, and the omnipresent "satisfaction" clause stipulating that the work must be well executed according to the approval of the patron and/or others knowledgeable in the art. Both artist and patron had a vested interest in establishing the requirements and responsibilities of each party with respect to the work, and a notarial contract served as powerful legal insurance.

It would be overly simplistic to assume that all artistic contracts filed before a notary were undertaken only for paintings of great monetary value or because the commission was for a "major" work of art. Indeed, artistic contracts often contain information that goes beyond the mere facts of the commission, affording intimations of social contexts, motivating circumstances, and special interests. A host of additional factors played into the decision to file an official contract before a notary, and artists as well as patrons had a stake in ensuring that the terms of the contract were met. Beyond the pecuniary value of the work commissioned, the requirement of a formal contract might indicate prior problems with the artist completing works or issues with the patron making the required payment. The Andean painter Alejandro de Ribera was taken to court and sentenced to prison because he had not completed a painting for which he had been paid.[54] Because neither Ribera nor his patron had filed a notarial contract for the work, the Andean artist found himself at the mercy of the court. Some painters clearly initiated and paid for contracts before a notary in order to protect their interests by documenting legally the terms of the commission. Andrés Sánchez Gallque and his brother Bernabé Simón registered an artistic contract before a notary in order to establish legally the patron's obligation to pay them for their work.[55] Without a formal guild of painters to protect their interests, artists were forced to watch out for themselves, and lettered painters had a decided advantage in their ability to negotiate the bureaucratic system.

Operating largely within an informal, unofficial, and relatively unregulated economy, painters in early colonial Quito had the leeway to negotiate their own terms, yet could find it more difficult to protect their interests. A painter's guild would have regulated professional practices, prices, and

production, acting on behalf of its members. Many painters lacked the legal recourse that notarial contracts might have offered, as well as the solidarity and professional protections that a formal guild structure might have provided. These circumstances, in addition to traditional Andean practices and networks, provide explanations for the lack of official regulation. Andean painters may to some extent have created their own organizational structure within native confraternities, and/or within parishes or barrios, collaborating on commissions, producing paintings for the open or retail market, and contributing to the production of extended family workshops. Under these circumstances, the profession of painting was not officially regulated by guilds and the city council in the early colonial period, and those painters whose documentary record extended into the formal, legal bureaucracy of notarial contracts are thus the exceptions to the rule.

Alternative Frameworks: Painters and Urban Geography

The lack of a painters' guild and the diffuse or mixed memberships of such artists in confraternities suggest that alternative principles of organization governed and shaped the professional lives and activities of Quito's early colonial painters. Other patterns of professional relationships and organization are revealed by mapping the distribution and concentration of painters' residences throughout the city.

The seven urban parishes of Quito were established in the sixteenth and early seventeenth century. Many of the parish divisions responded to and were physically reinforced by a series of deep ravines that traversed the city (fig. 4.1). The prestigious Cathedral parish of El Sagrario occupied the heart of the city, wherein principally Spanish and Creole citizens resided. The primarily indigenous parishes of San Sebastián and San Blas were among the earliest, established before 1573. The elite, mixed but initially Spanish and Creole parish of Santa Barbara was in existence by the 1580s, and the predominantly Andean parishes of San Roque, San Marcos, and the more rural Santa Prisca were established in the late 1590s and in the first decade of the seventeenth century.

Importantly, the parish of San Roque, which housed the majority of Andean painters, was the residence of the descendants of Atahualpa. San Roque was established in 1597 by annexing the western sector of the older parish of San Sebastián. By the turn of the sixteenth century, many of Quito's parishes were segregated on the basis of income, race, and ethnicity. Structural vestiges of traditional Inca sociopolitical organization were present in the parochial divisions of the city.[56] In particular, *ayllus*—traditional Andean ethnic and/or sociopolitical groups—are documented in the parishes during the early colonial period, testifying to the continued relevance of indigenous systems of authority, administration, and social organization.[57] The primarily native

Figure 4.1. Plan of Quito, ca. 1600, showing parish and *hanan/hurin* divisions. Drawing by Kevin Schrack after Minchom, *The People of Quito, 1690–1810* (Boulder, CO: Westview, 1994), 22.

parishes of San Roque, San Sebastián, and San Blas housed numerous caciques and *principales* and regularly named Andean *alcaldes* and *alguaciles* (chief constables) as parish administrative officials.

Overlaying the parochial map of colonial Quito was a larger spatial division carried over from Inca social organization that divided the city and indeed much of the *audiencia* into *hanan* (upper) and *hurin* (lower) moieties (*see fig. 4.1*).[58] Andean and Spanish authorities recognized and actively applied this form of imperial Inca sociospatial division to the geography of the city throughout the colonial period.[59] Indeed, the city council elected annually the *alcaldes mayores* (chief magistrates) and *alguaciles* of the *hanansayas* and *hurinsayas*, who typically were Andean caciques and *principales* from Quito and from the respective north and south sectors of the *audiencia*.

Hanan and *hurin* were complementary but unequal moiety divisions in which the lesser *hurin* was subjugated to the dominant *hanan*. The division of *hanan* and *hurin* Quito followed the length of the deep ravine that bisected the city center near the Cathedral, separating the southern *hanansaya* from the northern *hurinsaya*. The three southern parishes of San Roque, San Sebastián, and San Marcos thus constituted the more powerful *hanan* sector, while the northern parishes of Santa Barbara, San Blas, and Santa Prisca belonged to the complementary but lesser *hurin*.

The Ecuadorian historian Hugo Burgos Guevara, in his analysis of *hanan*

and *hurin* Quito during the colonial period, draws parallels between Cuzco and Quito, arguing that in Cuzco, the most recent conquerors of the city, the Inca, established their power center in the *hanan* sector of the city and relegated to the *hurin* half the subjugated autochthonous community. Burgos Guevara attempts to make a similar case for Quito in terms of foreign Inca conquerors and subjugated local Andean groups organized according to the *hanan/hurin* division, which he contends continued throughout the colonial period.[60] While such apparently stark distinctions between Inca conquerors, indigenous subjects, and colonial Spaniards threaten to over-simplify the human geography and historical development of the city, Burgos Guevara's argument is to some degree borne out in the documentary record related to painters and other artisans. A correlation between the non-Hispanicized surnames of Andean painters and the location of their residences supports the *hanan/hurin* division of the city, at least in the early colonial period. Surnames of painters that are identifiably Quechua from central Peru, and thus suggest Inca or colonial Inca ancestry, include Chauca, Guáman, Ataurimache, Quispe, and Chumbiñaupa. At least six painters of these surnames lived in San Roque, in *hanan* Quito. Among the non-Quechua local or regional surnames are Gallque, Gualoto, Boyolema, Sarango, Faizán, Cañar, Chaquinga, and Pillajo. Painters of these surnames, with only a few exceptions, resided in the *hurin* parishes of San Blas and Santa Barbara.

Within the larger *hanan/hurin* division, the urban residence patterns of painters indicate the existence of an alternative framework of family- and barrio-based professional organization within specific parishes. Because most notarial contracts employed parish of residence as an identifier, the many documents signed by Quito painters map the urban geography of their residences, disclosing significant concentrations of such artists in certain zones of the city and suggesting the existence of neighborhood collaboration and workshops. While the home of every painter cannot be located, a revealing picture emerges of the distribution and concentration of painters' residences in early colonial Quito.

Of the forty-four painters whose residences can be documented, twenty-two lived in the largely Andean parish of San Roque; ten in the predominantly Andean parish of San Blas; five in the mixed parish of Santa Barbara; five in the mixed parish of San Marcos; one in the predominantly Andean parish of San Sebastián; and two in the prestigious Cathedral parish of El Sagrario, where most residents were elite Spaniards or Creoles. The residences of fourteen painters are not specified. Some of these artists, particularly Europeans and Creoles, likely rented their homes, while others were itinerant. Most European artists stayed only a short time in Quito before moving on to seek their fortunes in Lima or elsewhere.[61]

The majority of Andean painters owned homes and land in the parishes of San Roque and San Blas, while with only a few exceptions non-Andean painters lived in the somewhat mixed parishes of Santa Barbara, San Marcos, and El Sagrario. Moreover, the majority of artists with the title of "master

painter" were Andeans, a total of twelve, while only seven Spanish or Creole painters bore that title. The highest number of artists identified as "master painters," a total of ten, lived in the parish of San Roque, with two in Santa Barbara, two in San Blas, and one in San Marcos. The overwhelming majority of painters and master painters in early colonial Quito owned residences in the parish of San Roque, within the dominant *hanansaya* moiety.[62]

This concentration is revealing, for San Roque housed the traditional seat of Inca power, embodied in the residence and lands of Atahualpa and his heirs, and it also stood in close proximity to the Franciscan monastery and its Colegio de San Andrés (*see fig. 4.1*).[63] Even accounting for the inevitably changing demographics of the city over the span of a century—immigration, intermarriage, shifting alliances—a majority and indeed growing concentration of Andean painters and master painters resided in the parish of San Roque throughout the early colonial period.

The urban geography of artists' residences indicates the existence of an alternative framework for professional organization in which painters operated within family-, barrio-, or *ayllu*-based artistic communities. Tracing the residence patterns according to parish and *hanan/hurin* spatial divisions highlights the concentrations and physical proximity of painters within the urban geography of the city. Within this context, the lives of Quito's early colonial painters, Andean and European alike, may be charted, from their homes, families, and neighborhoods to their economic activities, professional practices, and artistic production.

PART II

Painters

CHAPTER 5

First Generations, ca. 1550–1615

The earliest recorded painters in colonial Quito are European immigrants who arrived in the 1530s and 1540s, although little documentary or pictorial evidence exists regarding their activities. The first is the Flemish Franciscan friar Pedro Gocial, cofounder of the Franciscan Colegio de San Juan Evangelista. Reginaldo Lizárraga, who lived in Quito in the 1550s, identified Gocial as a painter, calling him "Pedro Pintor."[1] Yet beyond Lizárraga's account, nothing is known of Gocial's practice of painting or of his works. Similarly, the Spanish painter Juan de Illescas was in Quito in the early 1550s; however, he departed the city for Lima in 1553 or 1554, and it is unclear whether he ever returned.[2] Illescas possessed a house in the central Cathedral parish of Quito, which he bequeathed to his son (who was also a painter).[3] No evidence of Illescas's artistic production has been identified in Quito. Far more documentary evidence exists for the few European immigrant painters who chose to stay in Quito, such as the Spaniard Luis de Ribera.

Creole painters enter the documentary record in the 1580s. Although notaries did not distinguish between Spaniards and Creoles, testaments and other biographical documents permit the identification of several Creole painters, such as the Sevillian Juan Ponce and the Dominican friar-painter Pedro Bedón. In the art-historical literature, some early Creole inhabitants of Quito have been mistakenly or without documentary evidence named as painters. A case in point is that of the Spanish *encomendero* Captain Juan Sánchez de Jérez Bohórquez, whom Navarro identified as a painter based on the misreading of a document.[4] Unfortunately, Sánchez de Jérez Bohórquez continues to be cited in the literature as a painter.[5]

Dating also from the 1580s, Andean painters enter the documentary record, named by notaries who used the terminology of ancestry to identify

indigenous and other non-Spanish individuals. Andeans constituted the majority of painters, although several appear only as references in documents concerning other people and events. A number of these artists migrated to Quito from other regions of the *audiencia* to learn or ply their trade. In contrast to the European and Creole painters, for whom an extensive historiography exists, little has been published on the Andeans, and many are introduced or detailed here for the first time. Ample documentation survives regarding the lives and artistic commissions of many Andean painters, even if only a few of their paintings can be identified.

Overall, the number of extant paintings that can be documented for European, Creole, and Andean artists in the sixteenth century is so small that their impact on the history of art in Quito is difficult to assess in any qualitative fashion. However, the archival record sheds new light on the social lives and professional practices of painters and the dynamics of patronage and

Table 5.1. Painters in the documentary record, 1550–1615, by chronological first appearance

Name	Title(s)	Ethnicity	Literacy	Residence
Juan de Illescas	Painter	Spanish		Cathedral
Luis de Ribera	Painter, gilder, and sculptor	Spanish	Signature	Sta. Barbara
Pedro de Vargas	Painter	Spanish	Signature	
Francisco Gocial	Painter	Andean	Signature	S. Roque
Alonso	Painter	Andean	Unlettered	S. Marcos
Andrés Sánchez Gallque	Master painter	Andean	Signature	S Roque
Fray Pedro Bedón	Painter	Creole	Signature	S. Marcos
Angelino Medoro	Painter	Italian	Signature	S. Marcos
Pedro Torona	Painter	Andean		
Juan Chauca	Painter	Andean	Signature	S. Roque
Juan del Castillo	Journeyman painter, woodworker	Andean	Signature	S. Roque
Juan Ponce	Painter, gilder	Spanish	Signature	
Bernabé Simón	Master painter	Andean	Signature	S. Roque
Domingo	Painter	Andean	Signature	
Esteban	Painter	Andean		S. Blas
Turocunbi	Painter	Andean		

the art market in early colonial Quito. The painters considered individually below are those for whom substantial documentary and/or pictorial evidence exists.

Urban Geography of the First Generations of Painters

Within the broad urban spatial divisions of *hanan* and *hurin* Quito, the majority of early painters for whom residences can be documented lived in the parishes comprising the *hanan* moiety division: San Roque and San Marcos. The parish of San Roque boasted the highest number of painters, a total of five—all of whom were Andean—while San Marcos counted three. In contrast, *hurin* Quito housed one Spanish or Creole painter in the parish of Santa Barbara and one Andean painter in San Blas (table 5.1). Although the residence of the Spanish painter Juan de Illescas is documented in the prestigious Cathedral parish near the main plaza, it has not been possible to establish its location within one of the *hanan/hurin* divisions. Regardless, Andean spatial divisions were functionally irrelevant to most Spanish residents. However, this distribution was very significant for Andean painters, who predominated in the *hanan* half of the city and were concentrated in the parish of San Roque. Only a few Andean, European, and Creole painters were scattered among the other parishes.

Although the small number of documentable painters in this sample might appear to preclude any broad conclusions regarding painters, parishes, and traditional Inca spatial divisions, in fact, the urban distribution of painters' residences documented here illuminates as well as establishes the foundations for those of the later generations of Quito painters.

European and Creole Painters of the Sixteenth Century

In addition to friar-painters such as the Flemish Franciscan Pedro Gocial, the Spanish Jesuit Pedro de Vargas, and the Creole Dominican Pedro Bedón, a number of secular immigrant painters plied their trade in sixteenth-century Quito. The city was merely a way station for most of these European artists; few stayed more than one or two years before moving on to Lima or elsewhere in search of greater opportunities. Of these early generations, only the Spaniard Luis de Ribera and the Creole Pedro Bedón made Quito their permanent home, even if each painter traveled periodically to other Andean regions for extended stays.

Indeed, throughout the colonial period, European artists and builders working in Quito were frequently invited, lured, or ordered to Lima by viceregal authorities, much to the consternation of Quito's city council.[6] Particularly in the sixteenth and early seventeenth centuries, the city council resorted to offering land grants to entice European artists and builders to

remain in the city, where their services were in high demand. Such was the case, for example, with the Spanish painter Luis de Ribera, who in 1584 was awarded by the *cabildo* a generous parcel of land in Mira (north of Quito) with the hope that he would stay and work locally.[7] In this instance, the city council was successful in obtaining Ribera's permanent residence; however, other immigrant painters, such as the Spaniard Juan de Illescas and the Italian Angelino Medoro moved on to develop their careers in Lima, and the Jesuit painter Pedro de Vargas was relocated by his superiors from Quito to Potosí.

Pedro de Vargas (in Quito ca. 1587–1591)

The Spanish Jesuit painter and gilder Pedro de Vargas reportedly arrived in Peru in the early 1570s, learned the arts of painting and gilding in Lima, and entered the Jesuit order in that city in 1575. He collaborated with the Italian Jesuit painter Bernardo Bitti in Lima and Cuzco, where he sculpted and built altarpieces and adorned them with gilding, polychromy, and *estofado*.[8] Around 1587 or 1588 his superiors sent him to Quito, where he spent nearly four years, departing the city for Potosí in late 1591.[9] Vargas came to Quito in the company of a group of Jesuit brothers sent to establish the city's first Jesuit church and college. These Jesuits initially were housed in the parish church of Santa Barbara, where they reportedly organized a school to teach Latin that enrolled some one hundred students.[10]

Little is known of Vargas's activities as a painter in Quito, and only one local canvas has been attributed to him. Rejecting prior attributions to Mateo Mexía and Angelino Medoro, Mesa and Gisbert attributed to Vargas the stunning monumental painting, *Immaculate Conception with Jesuit Saints* (*see plate 6*), which today hangs in the Chapter Room of the Cathedral, dating it to around 1591.[11] In addition to documenting his presence in Quito in the late 1580s to 1591, the Bolivian art historians support their attribution by noting that Vargas typically included on his paintings "in the manner of a signature the 'IHS' characteristic of the Jesuit order," pointing to the presence of "this same acronym on the 'Inmaculada' in Quito."[12] In fact, no "IHS" is to be found on the Quito painting; however, another favored Latin motto of the Jesuits is inscribed beneath the crescent moon of the Virgin: "AMDG," the acronym for "Ad maiorem Dei gloriam" ("For the greater glory of God").

The Bolivian authors date the painting to 1591 and identify the two accompanying haloed Jesuit saints as Luis Gonzaga and Estanislao de Kotska. If these identifications are correct (for neither saint bears any identifying attribute), the said Jesuits were beatified in 1605, fourteen years later than Mesa and Gisbert's proposed dating of the painting. The Bolivian authors date to the 1590s a subsequent work by Vargas in La Paz, the *Virgin Surrounded by Jesuit Saints*, pointing out that the artist specifically identified Estanislao de Kotska with a letter "B" for "beato" because he had not yet been canonized.[13] With respect to the Quito *Immaculate Conception with Jesuit Saints*,

Mesa and Gisbert's identification of the saints and the resulting chronologi-
cal disjunction calls into question their dating of the canvas and perhaps
even its authorship. If their circa 1591 date is correct, the *Immaculate Con-
ception with Jesuit Saints* is among the earliest paintings in Quito to employ
the elaborate technique of *brocateado*—the application of intricately applied
gold patterning and motifs that imitate gold brocaded fabric, embroidery,
and lace. This painting clearly belongs among the works of early painters
in Quito, and it must have served as a powerful inspiration and model for
subsequent generations of artists.

Angelino Medoro (in Quito ca. 1599–1600)

The Italian painter Angelino Medoro (Rome ca. 1567–Seville 1633) was pres-
ent briefly in Quito, for perhaps less than a year, before moving on to Lima.
Treatments of Medoro reveal a tangle of often-conflicting dates, accounts,
and suppositions that renders extremely difficult the recreation of a coher-
ent timeline or narrative for the artist. Nonetheless, Medoro left at least two
works in Quito that undoubtedly influenced local artists. His significance for
subsequent painters and painting in Quito makes important the artist's life
and work, prior to and including his brief sojourn in the city.

Medoro was born in Rome about 1567, where he reportedly learned and
practiced his trade. He may also have worked in Florence, in the style of High
Renaissance Mannerism, before traveling to Spain in the mid- to late 1580s.[14]
To judge from signed and dated work in Málaga, Medoro may have been in
that region in 1586.[15] He is documented later that year in Seville, where he
reportedly stayed for a few months and left at least one signed painting, the
Flagellation of Christ, also dated 1586.[16] It was likely in the same year that
Medoro departed for the Americas, arriving in 1587 at Cartagena or Santa
Marta.

Medoro's career in South America began in the New Kingdom of Grana-
da. He first established residence in the then-burgeoning city of Tunja (Co-
lombia) in 1587. Scholars have documented his work there between 1587 and
1598.[17] A monumental tempera painting on wood panel located in Tunja's
Dominican church, the *Virgen de la Antigua with Saints and Donors*, is fre-
quently published as the work of Medoro, and indeed bears all the hallmarks
of his style (*see plate* 7). The painting is unsigned, although it is inscribed with
the date 1587. Commissioned for the family chapel of Don Diego Hernández
Carballo and his wife, Doña Polonia de la Roa, their profile donor portraits,
hands clasped in prayer, appear at the Virgin's feet, accompanied by images
of Santiago el Mayor and San Francisco. Another early work by Medoro is
the dramatic *Annunciation* in the church of Santa Clara in Tunja, which is
signed and dated 1588 on the base of the Virgin's prie-dieu.

In establishing a terminus date for Medoro's tenure in Tunja, scholars
uniformly point to a series of paintings that he reportedly completed in 1598
for Captain Antonio Ruiz Mancipe as the last documented works by the art-

ist in that city. This date may well be erroneous, based on a misreading of the related documents. The paintings in question were created to adorn the patron's eponymous family chapel, the Capilla de Mancipe, originally dedicated to the Santa Cruz, located in Tunja Cathedral. Construction on the chapel was begun around 1569 by Ruiz Mancipe's father, Pedro Ruiz García. After his father's death, Ruiz Mancipe completed and decorated the family chapel, activities that must have taken place over quite a number of years.[18]

On 29 July 1598, Antonio Ruiz Mancipe drew up a document establishing a *capellanía* (chaplaincy) in the recently completed chapel, in which he recorded payment to a series of builders and artists for its construction and adornment, including masons, carpenters, blacksmiths, and painters. In this document, Ruiz Mancipe declared that he had paid Medoro for painting a series of works, which are enumerated as follows:

> I paid the painter Argelino [*sic*] Romano for the creation of an image made by his hand of Nuestra Señora de la Antigua, framed and gilded, which he made in this city of Tunja, one hundred and fifty pesos of twenty-carat gold.
> Moreover, I paid said Medoro Agelino [*sic*] for the creation of two large paintings, framed and gilded, one of the Agony in the Garden and the other of the descent from the Cross, which are [hanging] to either side of the altarpiece of the main altar of the stained glass, and for gilding the tribune and door of the choir loft and sacristy, escutcheon, and other things that he painted in the said Chapel, two hundred and fifty pesos of twenty-carat gold.[19]

The painting of the *Virgen de la Antigua* is no longer in situ, but it must have been very much like that of the same advocation produced by Medoro for the Dominican church, although without the specific accompanying saints and donor portraits.[20]

The canvas paintings of the signed and dated *Agony in the Garden* (*see plate 8*) and the *Descent from the Cross* (more properly a *Piedad*), which bears no visible signature or date, still occupy the chapel, displaying Medoro's precise linear and angular draftsmanship, his brilliant Mannerist chromatic range, and his delicate tenebrism. These two paintings have been dated to 1598, when Ruiz Mancipe declared that he had paid Medoro in his *capellanía* contract. However, the 1598 document clearly indicates that payments to the artists and the builders of the chapel were made over time in the past, not necessarily in the year that the chaplaincy was established. Moreover, scholars have not attended to the signature and date inscribed on a painted cartellino in the lower section of the *Agony in the Garden*. The painting is quite clearly dated 1587, more than ten years earlier, and contemporaneous with the *Virgen de la Antigua* in the Dominican church. Because the 1598 date has also been taken to designate the terminus of Medoro's residence in Tunja, and even though the accompanying painting of the *Descent from the*

Cross is neither signed nor dated, the 1587 date inscribed on the *Agony in the Garden* calls into question much of the chronology of Medoro's presence in Tunja, Bogotá, and, indeed, in the New Kingdom of Granada.

Beyond these three paintings, Medoro undertook other works in the Capilla de Mancipe. In addition to gilding the tribune and the choir and sacristy doors, the document mentions payment to Medoro for "an escutcheon [*escudo*] and other things that he painted."[21] Ulises Rojas cited a "coat of arms of the Ruiz Mancipe [family]" among the items that Medoro was commissioned to create for the chapel.[22] No family crest is today present in the chapel, although it would have been a typical and traditional inclusion for a wealthy, elite family. What "other things" might Medoro have painted for Ruiz Mancipe?

In this regard, two early twentieth-century accounts document the presence of a portrait of Captain Antonio Ruiz Mancipe in the family chapel. Writing in 1927, Luis Augusto Cuervo described a special exhibition held in Tunja that year, in which the Cathedral displayed, among other works, "the portrait of Captain Mancipe, in an attitude of prayer, a canvas of that time period, of delicate colorism and of irresistible attraction."[23] In a 1952 publication on the Capilla de Mancipe, Ulises Rojas observed that "until just a few years ago an oil painting of the founder was preserved in the chapel, on the bottom of which could be read: 'The Captain Antonio Ruiz Mancipe at the age of fifty-six years.' He is kneeling and in an attitude of supplication. This portrait is today kept in the chapter room alongside the cathedral."[24] Remarkably, Rojas reproduced in his article a murky but somewhat legible black-and-white photograph of the portrait in question (fig. 5.1). No longer present in the chapel or the chapter room, its whereabouts are unknown. To judge from the illustration in Rojas's article, the painting is clearly contemporaneous with the construction and decoration of the chapel: it is a Mannerist work that bears numerous similarities to the donor portraits in Medoro's 1587 *Virgen de la Antigua*. The portrait of Ruiz Mancipe is apparently unsigned and undated, but the age of the sitter is inscribed on the canvas as "fifty-six." A 1595 document in which Captain Antonio Ruiz Mancipe testified as a witness establishes that he was sixty years old in that year, thus making it possible to date the Ruiz Mancipe portrait to around 1591.[25] Given the date, the patron, the similarities between the portrait and those of the donors in the 1587 *Virgen de la Antigua*, together with Mancipe's account of having paid Medoro for painting "other things" in the chapel, it is extremely likely that Medoro was the author of the portrait.

In view of the confusion of published dates regarding Medoro's execution of the works in Tunja and in the Mancipe chapel, this new information transforms the traditional chronology for the painter. The date on this portrait strongly indicates that Medoro remained in Tunja until at least 1591, but not necessarily until 1598.

In addition to signed and documented works by Medoro in Tunja, a number of other paintings are almost certainly by his hand, and several others

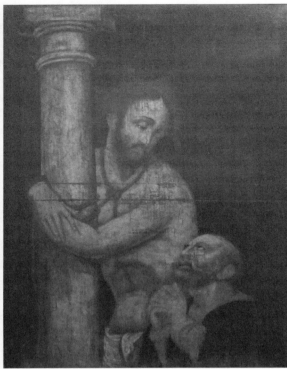

Figure 5.1. (*left*) Angelino Medoro, *Portrait of Antonio Ruiz Mancipe*, ca. 1591. Oil and tempera on canvas? Location unknown. Photo after Rojas, "La Capilla de los Mancipes," *Boletín de Historia y Antigüedades* 26 (1952): 564.

Figure 5.2. (*right*) Angelino Medoro (attrib.), *Señor de la columna*, s. XVI. Oil on canvas, 1.08 × .08 m. Museo del Banco de la República, Bogotá. Photo: Hernán L. Navarrete.

may be relatively contemporary and later copies. Some of these works relate directly to images produced later in Quito, making them important to consider at this juncture. Foremost among those attributable to the Italian painter are two panel paintings depicting *Christ at the Column with the Repentant Saint Peter*, a devotional scene more commonly known as the *Lágrimas de San Pedro* (Tears of Saint Peter).[26] One of these panels is located in Tunja Cathedral, where it occupies the apex of a retablo to the left of the main altar (*see plate 9*), thereby rendering inaccessible any view of the lower section where a signature might appear. The other panel of the same subject occupies a similar position on an altarpiece in the Church of San Francisco.[27] The theme of repentance seems to have held particular appeal in the northern Andes, for numerous versions and copies exist in Tunja, Bogotá, Quito, and elsewhere in the region.

These panels, and many contemporary or subsequent copies, often depict in typical Mannerist fashion two related scenes: in the foreground, Christ tied to a column looks down upon the kneeling figure of Saint Peter, who weeps with hands clasped in repentance for having denied Him. The architecture behind the saint opens to reveal a scene of Peter's denial in the deep background, illuminated before the leaping flames of a fireplace. Simplified versions of the theme, which also are frequent in the northern Andes, omit the background scene of the denial to focus solely on the emotional in-

teraction between Peter and Christ. For example, an unsigned canvas paint-
ing of this scene in the Museo del Banco de la República, Bogotá, identi-
fied as the work of Medoro, highlights only the figures of Christ and Peter
against a background cast in complete darkness (fig. 5.2). Such scenes were
intended to provoke emotions of penitence in the viewer, and their emphasis
on confession, repentance, prayer, and forgiveness may have held particular
potency for clergy instructing native neophytes in these practices, which may
account for the widespread popularity of the theme throughout the region.

According to the literature, Medoro also painted works in Bogotá, al-
though no signed paintings are reportedly present in the city. An unsigned
tempera painting on cedar panel, the *Coronation of the Virgin*, now in the
collection of the Museo de Arte Colonial in Bogotá, is undoubtedly by his
hand, but other local attributions to Medoro are less convincing.[28] Again,
the many attributions and chronologies are so confused that it is difficult to
achieve any coherent sense of what Medoro might have produced in Bogotá,
and when he might have been in residence there.[29] Even the date and loca-
tion of Medoro's marriage to Lucía Pimentel, *hija natural* of Alonso Gutiér-
rez Pimentel, a powerful Bogotá region *encomendero*, is questionable. Many
sources locate their marriage in Bogotá in either 1588 or 1589, while other
reports assert that they were wed in Tunja or in Quito. Sources vary even as
to his wife's first name, some calling her Lucía, others Luisa.[30] A review of
Medoro's chronology, together with documents recovered in Quito, serves
to clarify at least some of the issues in question.

Given the general confusion in the literature regarding chronology, it is
only possible to say that Medoro and his wife, Lucía Pimentel, accompanied
by their three young daughters, probably departed Tunja or Bogotá to travel
south toward Quito sometime in the mid-1590s. Medoro may have worked
for a time in the town of Cali, which lies along the route to Quito. The poly-
chromy of a stone sculpture of the *Virgen de los Remedios* in Cali has been
attributed to Medoro.[31] A canvas painting in the same city, depicting Christ
seated at the base of a column, bears the inscription "Medorus Angelinus
Romanus Faciebat," and is reportedly dated 1599. However, there is no prov-
enance to indicate whether the painting was produced in Cali or acquired
elsewhere.[32] On his long southward journey from Bogotá, Medoro and his
family stayed for a time in the town of Popayán, which at the time formed part
of the *audiencia* of Quito.

Heretofore, the only evidence of Medoro's presence in Quito has been
the existence of two of his paintings in the city. Even then, because of the
confusion over his tenure in Tunja, whether he ever was in Quito has been
questioned.[33] Mesa and Gisbert characterize Medoro's stay in Quito as "one
of the most obscure aspects of his biography," and posit several possible sce-
narios that might explain the presence in Quito of two paintings by Medoro:
he may have sent them from Tunja; he brought them to Quito on an earlier
trip and returned to Tunja before 1598; "or, what is most probable, that he
was never in Quito."[34]

Although the extant documentation regarding Medoro's visit to Quito is hardly voluminous, three contracts bear witness to his stay in the city, none of which were drawn up in his presence. All three are dated in 1601, one in August and two in September. Never previously published, these documents disclose details about the artist, his family and professional ties, his economic status, and his activities in Quito.

On 19 August 1601, Doña Lucía Pimentel, "legitimate wife of the painter Medoro Angelino [. . .] hija natural of Alonso Gutiérrez Pimentel, who was a resident of the city of Santa Fe," drew up her last will and testament before a notary public in Quito.[35] Noting that she was "sick in body but healthy in free will," she requested that upon her death she be interred in the church of Santo Domingo in Quito. She declared her marriage to Medoro, noting that they received no dowry whatsoever, yet she subsequently mentioned several expensive items of jewelry that she pawned in Quito, included an extensive inventory of her belongings, and referenced a stipend provided for her sustenance by one Curcio Romano, to whom she had also entrusted her possessions.

The lengthy inventory of Lucía Pimentel's belongings reveals a wealth of costly clothing made of silks, taffeta, damask, and velvets, embellished with lace, embroidery, and gold fringe; lavish gold jewelry set with emeralds and pearls; a host of silver utensils and household items; and three African slaves, one of whom she had recently sold for fifty *patacones*. No paintings or other works of art are recorded in the inventory, with one possible exception: "twenty-five patacones [. . .] for a *lámina* [metal plate] of Juan de Munoa Ronquillo—that she collected from him."[36] The term "lámina" typically referred to a sheet of metal that was often engraved or painted with images, a technology that was particularly popular in Italy and Flanders; thus, it is likely that Pimentel sold a painting on metal—perhaps by Medoro—to Muñoa Ronquillo, a wealthy local notary and patron of an important chapel in the church of Santo Domingo.[37] At least one copper *lámina* painted by Medoro is known to survive, *Sacred and Profane Love* (also called *Triunfo del Amor Divino*), which is signed and dated 1601 (Barbosa-Stern Collection, Lima).[38] The very substantial price of twenty-five *patacones* suggests that the *lámina* sold by Pimentel was something more than simply a sheet of metal, and that it may well have been painted.

The inventory indicates specifically which items Lucía Pimentel had in her possession in Quito, and which were in Riobamba, a town several hundred kilometers south of Quito on the route to Lima. The location of the majority of household items listed on the inventory, as well as a substantial amount of clothing and jewelry, are designated as being in Riobamba, suggesting that Medoro and Pimentel had lived in that city at some point. Other items are clearly marked *acá* (here) or *aquí en casa* (here at home). Pimentel also mentions in her testament that she leaves to "Eugenia my oldest daughter all of the headdresses and jewels that I have in a coffer that is in Riobamba, which are five headdresses and a pearl necklace with gold pieces and

charms [*mermelletas*]."[39] Medoro might have produced works in Riobamba, but the city was completely destroyed by an earthquake in 1797 and was later rebuilt on a new site some twenty kilometers away.

Lucía Pimentel left bequests to various people and institutions in Quito, and she designated as universal heirs her three daughters, Eugenia, Inés, and lastly Ana, "who I have in Popayán," as well as her husband, Angelino Medoro. Among the witnesses to the document were two Dominican friars, Gaspar Martínez and Enrique Rosero, one of whom signed for Pimentel because she was unlettered. A close connection with the Dominicans in Quito is signaled throughout Pimentel's testament, and the document implies that she lived near the Monastery of Santo Domingo in the parish of San Marcos.

Less than a month later, on 4 September 1601, an Italian named Curcio Romano went before a notary in Quito to transfer a power of attorney that he held for Angelino Medoro, identified as a "painter of sculpture" (*pintor de ymaginería*).[40] The original power of attorney, drawn up in Lima by Medoro in May of 1601 and transcribed in this document, gave Curcio Romano complete legal authority to act on his behalf. Whether illness or other reasons precluded her travel, the document makes clear that Lucía Pimentel did not want to join her husband, for Medoro states that, despite his previous letters and entreaties, she had "made many excuses" for not undertaking the journey to Lima. Thus, Medoro "gives power of attorney" to Romano

> so that he can bring my wife dona Lucia Pimentel to this city [of Lima], and that [he] equip and provide everything necessary [for the journey], and if she does not want to come of her own volition, he can force her by means of judicial order—and in the case that she does not want to come, he must ensure that my wife is deposited and retired [*recogida*] to the convent of the nuns of Santa Clara in the said city, where she is to remain until I decide that she may leave.[41]

If Pimentel determined to enter the convent, Medoro agreed to pay for her sustenance each year. He also directed that Romano "bring to me in this said city [of Lima] two daughters of mine and hers, and spend on them everything that is necessary—one of them is named Eugenia, eight years old, and the other Inés, who is around six years [old]."[42] The third daughter, Ana, remained in Popayán. Additionally, Medoro gave Romano explicit permission and directions to sell all of Lucía Pimentel's possessions and bring the funds to him in Lima. Romano registered this document with a notary in Quito specifically in order to transfer Medoro's power of attorney to a local lawyer, Juan Díaz Redondo, who was to assume all the obligations contained therein. Romano's transmission of authority indicates that he was preparing to depart Quito and that Lucía Pimentel had elected not to accompany him.

Years later, in 1610, Medoro declared before a notary in Lima that he had been married first to Lucía Pimentel, who had died the year before; thus, Pimentel lived for nearly a decade after the marital rift described above, likely in

Quito, until her death in 1609.[43] It is possible that, in the end, Lucía Pimentel consented to travel to Lima; after all, she stood to lose her two daughters and her worldly possessions if she chose to stay in Quito. On the other hand, as directed by her husband and enforced by Romano or the attorney Díaz Redondo, she may have entered a local convent in Quito, which might account for the lack of any public documents involving her after 1601, either in Quito or in Lima. Perhaps she followed Medoro's demand and joined the Convent of Santa Clara; however, the Poor Clares were recently established in Quito in 1596, and by 1601 still offered only rudimentary and inhospitable lodgings.[44] The logical choice for a convent at the time would have been that of the Immaculate Conception, the oldest nunnery in Quito, established in 1577, which was equipped with buildings, furnishings, and a small church.[45] The fate of Lucía Pimentel remains to be determined, for after 1601 she is not recorded in Quito or in Lima; however, the documents indicate that her two daughters did travel to live with their father in the viceregal center. Eugenia later married the Lima silversmith Pedro Negrillo, and in 1610 their younger daughter entered the Convent of Santa Clara in Lima with the religious name Inés de la Concepción.[46]

Just six days after filing the power of attorney, on 10 September 1601 in Quito Curcio Romano registered a debt owed by Medoro to Doña Micaela Suárez for the substantial amount of 445 *patacones 2 reales*.[47] Romano furnished a partial payment, leaving the debt at 233 *patacones 3 reales*, offering as collateral (described as *empeñadas*) a number of costly pieces of jewelry that included "a large golden lizard with a twisted tail that has twenty large emeralds [. . .] a gold *agnus dei* in a round frame with illuminated panels with a Savior of the World on one side and on the other a Holy Mary with three ovals of emeralds."[48] Romano was clearly carrying out the directives of Medoro's power of attorney, for these items are listed on the inventory of Lucía Pimentel's belongings.[49] Again, in this transaction, Romano indicates that he was preparing to travel to Lima immediately, whereupon he would inform Medoro of the remaining debt.

And just who was Curcio Romano? Although these contracts establish that he was a resident of Lima, not Quito, they are silent as to his profession. He was undeniably a trusted emissary, friend, and confidante of Angelino Medoro and, to judge from his name, he too was Italian. Curcio Romano is rather an unusual name; indeed, it is that of a legendary ancient Roman, Marcus Curtius, also called Curzio Romano (Curcio in Spanish), whose tale is told by several classical authors, including Plutarch and Pliny the Elder, as well as the sixteenth-century Valencian composer and writer Lluís del Milá in his popular book *El cortesano* (1561). Curcio Romano was also the alias of Vincencio Botanelli, an Italian actor and *autor de comedias* who plied his trade in Spain during the 1570s, and who, in the early 1580s, became subdirector of the itinerant acting troupe led by the famed Italian playwright Ganassa (alias Alberto Naselli).[50] Perhaps not coincidentally, Curcio Romano

disappears from the documentary record in Spain by 1582, and, although the Italian actor and playwright has not been proven to be the same person operating in Quito and Lima in 1601, given the correspondence of name and dates, the likelihood is high. Much like the immigrant and itinerant Spanish actor and playwright Alonso de Capilla, Romano also was associated with a painter. Possibly, in Lima, if Romano still plied his theatrical trade, he might have enlisted Medoro's assistance with stage sets and scenery.

The employment of a literary alias, or "pen name/stage name," that appears to have been common among Italian playwrights and actors may also have extended to painters. Angelino Medoro's name contains the intriguing conjunction of those of the two protagonists in Ludovico Ariosto's famous love poem *L'Orlando Furioso*, the maiden Angelina and the "Saracen" King Medoro of Cathay.[51] In his badly damaged 1631 testament, filed in Seville, Medoro reveals that he was the "legitimate son of Angelino Meros [surname redacted in the original] and of Paloma Pomp . . . [illegible in the original], citizens of Rome."[52] The lack of correspondence between surnames raises the possibility that he had adopted an alias.

The notarial record sheds at least some light on the "obscure" Quito period in Medoro's career. By 1601, he and his wife had amassed a substantial fortune in clothing, jewelry, and other belongings; he and his wife had separated, with Medoro moving south to Lima, and his wife apparently remaining behind in Quito; and his presence in Quito suggests additional explanation for two works by his hand there.

Medoro left one signed and dated work in Quito: a monumental canvas painting of a coat of arms that bears the inscription in saturated red paint: "Medorus Angel Romanus fecit 1592" (*see plates 10 and 11*). The date of this painting has perplexed scholars, leading some to assume that Medoro must have made a trip from Tunja to Quito that year and then returned to the northern city, and prompting others to suggest that he might have sent the painting to Quito.[53] A hybrid of these hypotheses might be that Medoro simply brought it with him from Tunja when he was en route to Lima in the second half of the 1590s, or, in view of the last year in which Medoro can be documented in Tunja—1591—it is conceivable that he and his family made the long journey south, with stops in Cali and Popayán, in time to paint the escutcheon in Quito and date it 1592; however, there are alternative scenarios.

This canvas painting of a family coat of arms is relatively unusual as a stand-alone subject, particularly in view of its large dimensions: 6.2 feet high by 5.4 feet wide. Family crests and noble coats of arms often were sculpted in architectural settings, painted on smaller canvases, on portraits and on parchment folios, or emblazoned in rich fabrics and gold on heraldic banners. However, a monumental canvas painting focused solely on a family crest is a relative rarity. Although the painting most closely approximates a heraldic banner (*repostero*), the reasons for its creation on painted canvas in massive proportions is unclear, even as it might suggest the outsized ego of

the patron. Whatever the reason, the painting was clearly intended for an ample interior space such as a sepulchral chapel that glorified the lineage of its patron and family members.

In the early twentieth century, the painting is identified as "un escudo no-biliario antiguo." However, without explanation or justification, and perhaps because the painting is located in Quito's Dominican monastery, Navarro and many subsequent authors retitled it the "Escutcheon of the Aza Family," or "The Escutcheon of Juana de Aza," the mother of Santo Domingo de Guzmán, founder of the Dominican order.[54]

Such a heraldic painting would not have been created for the Domini-cans in Quito; instead, it was more likely commissioned by a secular patron to glorify his lineage. Given that, in 1598, Antonio Ruiz Mancipe recorded having paid Medoro for an "escutcheon and other things" painted for the Capilla de Mancipe in Tunja, and no escutcheon exists today in that chapel, then the Quito painting may well be the same as that referenced by Mancipe. Perhaps the painting was rejected or for some reason could not be displayed in the chapel and Medoro subsequently took it with him as a "calling card" or example of his work when he traveled south to Quito.[55]

A less plausible scenario, but one nonetheless worth considering, is the possibility that a local patron in Quito commissioned the painting or pur-chased it ready-made. Medoro and his wife were closely associated with the Dominican monastery in Quito precisely at the time that Juan de Muñoa Ronquillo (to whom Medoro's wife sold a *lámina* in 1601) was setting about decorating his family chapel in the Dominican church. Perhaps Muñoa Ron-quillo commissioned or purchased the painting for display in his family cha-pel, thereby accounting for its presence in the Dominican collection. In any case, family crests for Ruiz Mancipe and Muñoa Ronquillo that might clarify the issue have not been located, leaving open the question of heraldic iden-tification.

The scrolling strapwork frame of the crest is painted in vibrant hues of orange and gold, and its surfaces are covered in illusionistic fish or serpent scales (*see plate 10*). The fictive frame, with its stylized female mask at the top, grotesque satyr-like mask at the bottom, and the seated figures of young boys that sustain it, strongly recalls the framing and masks typically employed by sixteenth-century Italian and northern European artists, such as the engrav-ings executed by Tobias Stimmer for the Italian Paulo Giovio's famed por-trait books, particularly the *Elogia virorum bellica virtute illustrium* (Basel, 1575–1577).

The figures, strapwork frame, and escutcheon emerge luminously from the penumbra of the background, highlighting the striking Mannerist hues and chromatic combinations on the shield and the surrounding foliage. The heraldic emblems and devices contained within the crest include, on the left side, a floriated cross (cross fleury) painted in saturated red (gules, *gulas*) against the gold background of a shield, surrounded by eight irregularly ar-ranged gold castles against a blue ground. Another red cross fleury is re-

<p></p>

peated atop the helmet that crowns the escutcheon. Indeed, the two floriated crosses and Medoro's signature inscription are the only elements of the composition executed in an intensely saturated red hue. The right half of the crest is segmented into four quadrants in which two triads of scallop shells (*conchas*, *veneras*) alternate with two emblems of a wild boar at the base of a tree.

The heraldic symbols on the crest bear little or no resemblance to the Aza family coat of arms. Neither the crest of the maternal line of Juana de Aza, nor that of Guzmán, the saint's paternal line, share any significant elements with Medoro's escutcheon.[56] The Aza crest does include a cross fleury and scallop shells; however, they form a completely different configuration and are surrounded by eight *calderas* (cauldrons), not eight castles, as in Medoro's painting.

A second painting in Quito attributed to Medoro, the *Virgin and Child with Saints Peter, Paul, Jerome, and Francis* (*see plate 12*), is located in the Convent of the Immaculate Conception. This large canvas has suffered extensive damage and paint loss, and while it may once have borne a signature inscription, no visible vestiges remain. This work certainly is Medoro's, for it bears all the characteristics of the artist's style.[57] There are striking chromatic similarities between this work and Medoro's 1592 painting in Santo Domingo, together with the fact that the postures and disposition of the cherubs crowning the Virgin are repeated in those of the young boys sustaining the escutcheon in the 1592 painting.[58] Most importantly, the selection of the four saints depicted in the painting bears special relevance for the nuns of the Immaculate Conception and the city of Quito. The Convent of the Immaculate Conception was founded in Quito by the Franciscan order, and soon thereafter came under the auspices of the Cathedral Chapter, thus linking the painted images of Saint Francis and the episcopal saints Peter and Paul respectively to those patrons.[59] Saint Jerome was at this time the principal patron of the city of Quito, which maintained a chapel and images dedicated to him in the Cathedral.[60] Accordingly, the saints depicted in this work respond to local devotions and patronage, suggesting that the painting was made specifically for the Convent of the Immaculate Conception in Quito.

A more intriguing line of inquiry is how the painting might have entered the collection of the Conceptionist nuns. Although no provenance exists, recall that in 1601 Lucía Pimentel was confronted with the choice of joining Medoro in Lima or being remanded to the Convent of Santa Clara. She appears to have remained in Quito, since her presence is not indicated in Lima in any of the documents concerning Medoro. Medoro documented her death in 1609 (although without mentioning where it occurred), and it is likely that she continued to live in Quito until her demise.[61] As opposed to the rudimentary conditions at the recently established Convent of Santa Clara in Quito, that of the Immaculate Conception, founded in 1577, boasted in 1602 four buildings, more than one hundred nuns and novices, and a small but serviceable church.[62] Perhaps, rather than joining Santa Clara, Pimen-

tel instead entered the Convent of the Immaculate Conception, offering as part of her dowry the *Virgin and Child with Saints Peter, Paul, Jerome, and Francis* painted by Medoro. Indeed, Medoro had promised to pay her an annual stipend if she entered the convent, and it was not unusual for artists to barter their labor in exchange for dowries to enable family members to enter convents. In 1637, for example, the master woodworker (*ensamblador*) Juan Marín signed a contract to construct the main altarpiece of the conventual Church of the Immaculate Conception in Quito, in which he exchanged more than half the payment—four thousand of seven thousand *patacones*—for "the dowry of his two daughters so that they can enter the convent and take the veil."[63] For whatever reason, Medoro's painting has over the centuries been the object of contemplation and inspiration for nuns, novices, and congregants in the Convent of the Immaculate Conception. However brief Medoro's stay in Quito, the city is the repository for two of his works, whose characteristics likely served as models for local painters.

Luis de Ribera (active in Quito 1582–1622)

In contrast to the other early painters, a wealth of archival evidence exists regarding the life and professional activities of the Spanish artist Luis de Ribera.[64] He is the only documented European immigrant painter of the first generations to remain in Quito for the extent of his professional lifetime. More than fifty contracts spanning the painter's forty-year career in the city record not only his professional activities as an artist, but also his entrepreneurial pursuits as an investor, moneylender, landholder, and the owner of a *pulpería* (general store). Although Ribera almost invariably is named as a painter in the documents, and he was involved in a number of major artistic commissions during his lifetime, his varied artistic activities appear to have constituted the lesser of his professional interests. Ribera signed his name to the many notarial contracts in which he was involved, yet no signed paintings or other works by the artist are known, and the artistic commissions documented here, with perhaps only one exception, apparently have not survived.

Despite scholarly claims that Ribera arrived in Quito from Spain or Mexico, either with Juan de Illescas or with the sculptor Diego de Robles, no evidence has surfaced to corroborate these assertions.[65] In fact, Ribera lived and worked in the city of Tunja prior to his arrival in Quito, for a recently recovered document indicates that he sold his house there some time before 1580; he is not documented in Quito until 1582.[66] Like other itinerant immigrant artists, among them Angelino Medoro, Ribera arrived first to the New Kingdom of Granada and established residence for a time in the city of Tunja. The documents do not disclose his reasons for leaving Tunja, although it is probable that he, like other immigrant European artists, sought greater opportunities offered in the viceregal center.

Ribera's first recorded artistic commission is linked to lands that he encountered en route from Tunja to Quito. In 1584, the *cabildo* of Quito ratified

Ribera's ownership of a tract of land called Quisnamira on the outskirts of the town of Mira, some 180 kilometers north of Quito on the main road to Pasto, Popayán, Bogotá, and Tunja. Ribera bartered his talent as a painter with the local caciques in exchange for land, specifying that

> to the said Luis de Rivera is adjudicated one-half caballería of land for a vineyard and plantation on the outskirts of the town of Mira, on the warm side, where it appears that the caciques and Indians of Mira have given it to him in payment for a certain painting for the church of the said town, as it appears on their petition and a certain guarantee that the Indians presented.[67]

Ribera's work was requested by Andeans in Mira, where it was placed in a local church for a primarily indigenous audience, and where it would have been viewed by native painters. At this early date, Ribera parlayed his labor as a painter of altarpieces into land investments that would render harvests of wine and produce, a practice that he would continue throughout his time in Quito. For reasons that likely included the almost complete lack of European painters in Quito, and thus a desire to keep Ribera in the region, in the same year, the city council substantially augmented his holdings in Mira, awarding him six *caballerías* of land bordering his previous acquisition.[68] Indeed, the painter would continue to invest in land throughout his career in Quito.[69]

Ribera lived with Isabel Muñoz, his wife, in a two-story, tile-roofed residence in an elite sector of the parish of Santa Barbara, home to mainly Europeans and Creoles. He and Muñoz had at least two offspring, daughters who married Spanish or Creole men associated with the silver- and goldsmith trade, skills related to the painting profession.[70] Ribera also owned the building next door to his residence, out of which he ran a *pulpería* that offered local and imported merchandise, including textiles, clothing, foodstuffs, wine, tools, and perhaps paintings and other works of art.[71] Clearly a wealthy man, over the course of his career Ribera bought and sold numerous properties in Santa Barbara and other parishes, as well as country estates in Pomasque, Yaruquí, and other nearby rural communities.[72]

Ribera's involvement in a variety of entrepreneurial activities likely limited the attention he paid to less remunerative endeavors such as painting, and may to some extent explain the relative scarcity in the notarial record of painting contracts involving the artist. Perhaps he sold or bartered his own work and that of others at his *pulpería*, thereby obviating the need for notarized contracts. In all of the notarial documents to which Ribera was party, he invariably appears with the title of "painter" (and more rarely as gilder or sculptor); never does that status change to become "master painter," as it did with some of the Andean and other European and Creole artists. Given these circumstances, the practice of painting appears to have been one of Ribera's lesser professional priorities, although the title remained part of his official identity throughout his lifetime. Ribera's signature, replete with expansive

flourishes, appears on each of the documents to which he was party (*see fig. 1.2f*).

During Ribera's nearly forty-year tenure in the city of Quito, only six artistic commissions involving the artist have been recovered, several of which have been previously published in part or as attributions. As noted above, some time prior to August 1584, Ribera bartered his skill as a retablo painter to the Andean community in the northern town of Mira in exchange for one-half *caballería* of good farmland.[73] Further indication of Ribera's tendency to barter his work appears in a 1598 contract for the sale of a ranch in the nearby community of Cumbayá. The painter sold the land, with farming implements and draft animals, to one Blas Díaz, noting that the acquisition came with "the rights to twenty silver pesos that I [Ribera] have paid with the creation of some large candlesticks [*ciriales*] for don Pedro governor of Cumbayá, who is obligated to pay me for them in the work of *mitayos* [corvée laborers] on the said plantation."[74] *Ciriales*, tall processional candlesticks, typically were made of silver worked over a carved wooden core; however, in this case it is likely that Ribera was responsible for gilding and painting as well as carving the wooden candlesticks. In addition to the ranch, Ribera traded to its owner the payment in *mitayo* labor owed him for the confection of *ciriales* for an Andean governor, from whom the buyer of the land would have to collect.

Ribera only once appeared with the title of "gilder," in a 1595 contract for the purchase of merchandise from a local shopkeeper, yet like many painters of his time, he practiced both arts in the adornment of sculptures, altarpieces, and other objects.[75] In one of the most charmingly evocative documents concerning the decorative arts, Ribera acknowledged in 1612 the receipt of thirty thousand sheets of gold leaf with which he was to travel to the port city of Guayaquil "to gild his majesty's galleons."[76] Conjuring up images of golden figureheads, bowsprit, and stern ornamentation, his charge demonstrates the extent to which "painters" such as Ribera mastered various mediums in the adornment of a wide range of objects.

Ribera is known primarily as a painter of statuary who collaborated with the renowned Spanish immigrant sculptor Diego de Robles on a number of images. In this regard, Ribera and Robles's authorship of the famed miracle-working sculpture of the Virgin of Guápulo and other "miraculous" images of the Virgin, following the claims of Juan de Dios Navas, has been elaborated in the scholarship. Referencing the early twentieth-century publications of Carlos Sono and Julio Matovelle, Navas states that in 1586 Robles and Ribera were commissioned by Cristóbal López, the *mayordomo* of the Confraternity of the Virgin of Guadalupe, to carve and polychrome a sculpture of the Virgin "that must be in all manner possible an exact copy of the most celebrated image of Our Lady of Guadalupe, venerated in the mountains of this name [in Spain]," noting that Ribera was paid the sizeable sum of 460 pesos for the polychromy and gilding.[77] Navas subsequently introduces a rather tenuous argument for dating the sculpture to 1584, rather than 1586.[78] As a result,

more recent scholars have repeated this information, employing the names of the patron, artists, and confraternity, the advocation of the sculpture, the payment, and one or the other of the execution dates cited by Navas.[79] The sculpture of Our Lady of Guadalupe was reportedly housed in the Church of Guápulo, a small sanctuary located some ten miles from Quito.

A formal contract for the sculpture of the Virgin in Guápulo does exist in the notarial record, although none of the above-cited authors or any subsequent scholars refers to it. The contract, signed in 1586 by Ribera, Robles, and the patron, Cristóbal López, makes no mention of the Virgin of Guadalupe or a confraternity of her name.[80] If this contract is the subsequently much-transformed and embellished source of the published information, it corroborates, while it amends and corrects, the scholarly record.

In the 1586 contract, a man named Cristóbal López, identified only as such and not associated with a confraternity, commissioned Ribera and Robles to create

> an image of Our Lady of the Rosary with the Child Jesus, very well made and finished and gilded as it should be in all perfection, and it must be seven palms [high] with the base in conformity with the [image] that is in the cathedral of this city [. . .] and for the creation of the said image they must be paid one hundred fifteen silver pesos to Luis de Ribera and to Diego de Robles one hundred twenty-five pesos [. . .] and they must present it finished, adorned with *estofado* and engraved in the view of practitioners of the trade and they also must make the platform on which it is taken out in processions.[81]

The patron was clearly concerned with obtaining a high-quality sculpture of the Virgin of the Rosary that imitated a statue in Quito's Cathedral, which was to be carried in public processions. The total cost of the sculpture was 240 pesos, of which the painter Ribera received the lesser percentage of 115, while the sculptor Robles was paid 125. Nonetheless, the compensation for each artist is roughly commensurate and it indicates the high value placed on the work of both painter and sculptor—an attitude that was not generally prevalent in Quito, where painters often earned far less for their work than sculptors.

The contract does not specify that the sculpture was intended for a confraternity, although it might be inferred from the inclusion in the contract of a processional platform, nor does it link the patron in any way with a confraternity. The commission does not mention the advocation of Guadalupe; it refers only to an image of the Virgen del Rosario. Whether this contract is for the sculpture that subsequently became known as the Virgin of Guadalupe, or Guápulo, after the name of the sanctuary in which it was located, cannot be determined from the document; however, its advocation as the Virgen del Rosario may later have been augmented with the localizing nomenclature of Guápulo. The assumption that the sculpture was intended for a confrater-

nity lacks a source, with some making the leap to identify Cristóbal López
as the *mayordomo* of the Confraternity of the Virgin of Guápulo. However, it
remains to be determined whether the sculpture in this contract, created by
Ribera and Robles, was in fact the image that became known as the Virgin of
Guápulo.[82] Any evidence that could be gathered from the original sculpture
was destroyed by fire in the 1830s.

Ribera and Robles collaborated on at least one additional sculpture of the
Virgin. In the same year of 1586, the two artists signed a contract with Gaspar
Manuel, "citizen [and] encomendero of the city of Loja," to create

> a sculpture of Our Lady of the Rosary in the following form and manner
> [. . .] it must be of cedar with the Baby Jesus in her arms, of the size, [?]
> and manner of the sculpture that is in the Monastery of Santo Domingo
> of this city, with its crown and base and with its seraphim on the said
> base, of seven palms in height [. . .] and moreover, once the sculptor
> has finished it, the said Luis de Ribera must gild it and apply *estofado* in
> such a way that the clothing of the image is covered with roses and sera-
> phim, and with the base and the strong wooden box, so that the image
> must be finished in all perfection in the view of knowledgeable people
> and practitioners [of the art] [. . .] the image must be completed and fin-
> ished and gilded and packed in the said box.[83]

López agreed to pay Ribera and Robles a total of 220 pesos for the finished
sculpture, and the contract records down payments made to each artist: Ri-
bera received only 20 pesos, while Robles was given 50, again underscoring
the higher valuation of sculpture over painting (see appendix, part b).

Again, the sculpture was to represent the Virgin of the Rosary, in this
instance imitating a statue of the same name located in Quito's Dominican
monastery.[84] The patron stipulated the material (cedar), the size and accou-
terments as well as the images and details of the painted and gilded surfaces,
and included language intended to ensure its high quality. From the mention
of packing it in a "strong wooden box," the patron intended to transport
the sculpture a substantial distance, undoubtedly to the town of Loja, some
seven hundred kilometers to the south. All three men inscribed their signa-
tures at the end of the contract.

Scholarly fabrication surrounds the creation of the "miraculous" sculp-
ture of the Virgen del Cisne in Loja, as well. Matovelle figures among the
principal sources of many of later accounts, although he stops short of at-
tributing the Loja sculpture to Ribera and Robles. According to Matovelle,
the sculpture of the Virgin of Guadalupe in the Church of Guápulo had be-
come so famous for its fervent devotees and its miracle-working powers that
a group of "Indians" from the town of Cisne (near Loja) traveled to Quito
and, with "great effort and sacrifice" obtained a close copy of the famed im-
age, which they brought back to Cisne and placed "in a rustic hut."[85] Navar-
ro, Vargas, and others subsequently attributed or asserted authorship of this

sculpture to Ribera and Robles, recounting and embellishing the tale told by Matovelle and emphasizing "Indian" initiative and patronage.[86] The 1586 contract cited here strongly suggests that the sculpture in Loja that came to be known as the Virgen del Cisne was indeed the work of Ribera and Robles; however, it was not commissioned by "Indians," but by a wealthy Spanish *encomendero*.

In the years following Ribera's 1586 commissions, there are only three artistic contracts, two of which include the *ciriales* for the Andean governor of Cumbayá and the gilding of his majesty's galleons. Not until 1609— nearly a quarter century after his collaboration with Robles—does another formal artistic contract involving Ribera appear. In that year, Ribera signed a contract with the dean of the Cathedral Chapter, Don Francisco Galavis, to paint an altarpiece dedicated to Saint Anne for one of the newly completed side chapels in the Cathedral.[87] According to their agreement, Ribera was to proceed "from the model that has been signed by him and by the said dean, and according to its design and with the following conditions [. . .] that the said altarpiece have on its upper portion a wooden panel painted in oils with an image of Christ with Our Lady and the Magdalen and Saint John."[88] In addition to this scene of the crucifixion, Ribera was to paint several panels with images of saints and polychrome the niche for a sculpture in the round of Saint Anne to be placed. The wording suggests that the structure of the altarpiece and the freestanding sculptures were already complete; thus, for his labors as a painter, Ribera received the sum of 180 pesos.

Ribera continued to live and work in the parish of Santa Barbara well into the seventeenth century. Over the course of his long career, he amassed a substantial fortune that included houses, lands, and a public shop. A self-identified painter throughout his career, he may have bartered his artistic talents (as he did on two occasions) to further his acquisition of real estate. He was involved in a range of entrepreneurial activities in addition to painting, and he undertook artistic commissions that principally involved the polychromy of sculpture and altarpieces.

Juan Ponce (active 1606)

Only two documents regarding the Sevillian painter Juan Ponce are known: his 1606 testament and a codicil filed the same year.[89] These documents name him as a "pintor y dorador," native of Seville, the son of Bartolomé Oyos and Leonora Martínez. They also reveal Ponce's close ties with the Franciscans and indicate that he worked for them on at least one artistic project. Indeed, Ponce requested in his testament that his body be clad in the Franciscan habit and interred in the Church of San Francisco in Quito. The series of masses and prayers to be said for him at the church were to be paid for from "thirty pesos that the monastery owes me for my work."[90]

Ponce's possessions registered in his testament indicate that he was fairly well off and also suggest his itinerancy. Among his belongings were 130 sil-

ver pesos, numerous articles of clothing, a wooden caparisoned bed, sheets, blankets, pillows, and traveling gear (backpacks, saddle, bridle, and spurs), as well as the "tools of my trade and the other items that might appear to be mine."[91] Ponce noted, perhaps with regard to his profession, that he "owes eight pesos to an 'yndio de la loma' in payment for a sculpture [*ymagen*]."[92] Neither the testament nor the codicil mention a house or land among his possessions, signaling that his accommodations in Quito were rented, not owned.

In a codicil filed three days later, Ponce directed that his belongings and the "colors and tools of his profession" be sold at public auction. The proceeds were to be used to finance work on the altarpiece of the Church of San Francisco, and to support his *hijo natural*, also named Juan, and his Andean mother, Magdalena Pablo. Importantly, Ponce instructed the executor of his testament, Marcos de la Plaza, *síndico* (financial administrator) of the Monastery of San Francisco, to use some of the proceeds "to enroll his son in the College [of San Andrés]."[93] Juan Ponce's scrawled and unsteady signature on both documents likely testifies more to his state of health than to his lettered status (*see fig. 1.2d*).

Ponce's Sevillian origins surely facilitated his immigration to the Americas in search of professional opportunity and wealth. Indeed, he may have been related or apprenticed to an earlier Sevillian gilder, also named Juan Ponce, who was closely involved in the transatlantic slave trade.[94] In the early sixteenth century, this Juan Ponce, *dorador*, rented a house on Sierpes Street in Seville.[95] The 1606 testament of Juan Ponce in Quito demonstrates that he did not bear the surname of either of his parents; however, it was commonplace at the time for apprentices to assume the surname of their professional masters.

A series of references to a late sixteenth-century gilder named Juan Ponce de León, who traveled the Andean region to work on altarpieces in Cuzco, Lima, and Potosí, might be the same individual who filed his 1606 testament and codicil in Quito. If so, the 1582 contract that Ponce de León signed to create the main altarpiece for the Mercedarian church in Cuzco "is one of the most explicit undertaken in Cuzco."[96] An excerpt from this lengthy description specifies the nature and expectations of Ponce de León's work on the altarpiece:

> The entire altarpiece must be gilded, well covered in well burnished gold, the only things not to be gilded are the said faces and feet and hands, and then the whole altarpiece must be painted with patterns, applying to the gold the colors and patterns that each element requires to make it a good work, especially on the friezes and columns and festoons and cornices and capitals and borders, placing on the said colors good and ornate patterns . . . designs that should be handsome and artistic. . . .[97]

Juan Ponce mastered a range of artistic practices and techniques. Although a definitive link has not been established between the two Juan Ponces, the Cuzco artist's abilities as a painter and gilder, as well as his peripatetic professional life, bear a close resemblance to those of the Quito Juan Ponce. The itinerancy of skilled artists like Ponce and others in the early generations of painters appears to have been a frequent condition among Europeans who sought ever more fruitful opportunities in the larger cities and viceregal centers. These artists left behind works that cross-fertilized artistic production in cities and towns along their routes.

Fray Pedro Bedón (ca. 1556–1621)

The mobility of European artists in the northern Andes echoes to some extent that of the Creole Dominican friar and painter Pedro Bedón. Despite his many travels, however, Bedón's roots were unquestionably planted in the city of Quito, to which he always returned after extended journeys. The son of wealthy and pious landowners in Riobamba, Bedón was first educated by the Dominicans in Quito, and in 1577 his superiors sent him to Lima to continue his religious training under the Dominicans at the Universidad de los Reyes, where he remained for ten years.[98] During this time, Bedón was ordained and was appointed to several important posts, including instructor of novices (*maestro de novicios*) and professor of philosophy. He also served as chaplain of the Confraternity of the Rosary, which he organized into separate groups of Spaniards and Andeans. Reportedly in Lima, Bedón learned and first practiced the art of painting under the tutelage of the Italian Jesuit artist Bernardo Bitti, who had arrived there in 1575.[99]

By 1586 Bedón had returned to Quito, where he continued his studies and occupied teaching positions in the Dominican college/seminary that included serving as a professor of the Quechua language. In 1588, he assumed the position of chaplain of the Confraternity of the Rosary, which had been established in the Dominican church since 1563, and, as he had in Lima, Bedón reorganized it along ethnic and racial lines, creating three distinct sodalities for Spaniards, Andeans, and Africans, each of which maintained separate chapels in the Dominican church.[100] Bedón's famed brush and ink image of the Virgin of the Rosary (*see plate 13*) adorns the frontispiece of the 1588 confraternity book, visually documenting his mastery of Bitti's angular Mannerist stylistic forms and composition.

Between 1593 and 1598, Bedón undertook an extended journey to visit Dominican establishments in the northern part of the *audiencia* of Quito and in the New Kingdom of Granada. In Bogotá, Bedón taught theology in the Dominican monastery, where he also reportedly established or fostered the Confraternity of the Rosary. According to an early eighteenth-century account, in 1594 Bedón executed mural paintings in the refectory of the Dominican establishment in Bogotá (destroyed in 1647), and later that same year in the refectory of the Dominicans in Tunja (not extant), where he also

founded a Confraternity of the Rosary.[101] Although he was in Tunja at the Dominican Chapter meeting in August of 1594,[102] his sojourn in the city was short, only four months in 1594, rather than the four years, according to some scholars, that he "studied under" or "had been a student of Medoro in Tunja."[103] Their stays in that city might not have coincided at all, although Bedón likely saw Medoro's works in Santo Domingo, the Cathedral, and other local churches. Furthermore, Medoro's whereabouts are uncertain between 1591, the date of his last documented painting in Tunja, and circa 1599, when he and his family arrived in Quito. Still, Medoro and Bedón might have encountered each other on their travels from Tunja to Quito, possibly in Popayán, where both are recorded in 1598.

By March 1598, Bedón was back in Quito, having spent time along the way in the Dominican establishment at Popayán and other monasteries. Returning to his duties as chaplain of the Cofradía del Rosario de los Naturales, in April of that year Bedón penned his theory of artistic practice:

> Three things, he wrote, are necessary for he who wishes to have perfect knowledge of something, which are art, practice, and imitation: art—or theory—in order to teach the rules and perspectives; practice in order to acquire the technical ability, and imitation so as to have the models before one's eye. This is clearly apparent in the skilled painter, who, in order to acquire perfection in his art, needs in the first place to know the general rules of painting and proportions that must be practiced in the mixing of colors, in order to obtain those that are appropriate to the images that he wishes to paint; in the second place, the exercise [of the art], because if it is not practiced, one will never become a painter; in the third place, the finished models, in which can be seen the application of the rules.[104]

The overtly didactic intent of this text is indicative of Bedón's deep involvement with artistic pedagogy, and he may well have instructed the Andean painters and other artisans who were members of the Confraternity of the Rosary in these and other professional practices.[105] Bedón's roles at the Dominican institution, together with his artistic training, pedagogical interests, and painterly pursuits, equipped him to propagate Western artistic ideals, forms, and practices in Quito and across a broad territorial range.

By mid-1598, Bedón had been elected prior of the Dominican Monastery in Quito, precisely at the time that the new church was under construction. In subsequent years, as vicar general and as provincial of the order, Bedón dedicated himself to supporting that building campaign and to founding new Dominican establishments in Quito and elsewhere. During this time, he traveled to other regions of the *audiencia*, where he established Dominican monasteries in Ibarra and Riobamba.[106]

Bedón's labors as promoter of the construction of the Dominican monastery church in Quito and founder of Dominican establishments in and be-

yond the city were recognized and commemorated by the inclusion of his portrait in a 1620s mural painting on the chancel arch of the newly completed church of Santo Domingo in Quito (*see plate 14*). Here, Bedón is depicted with rosary in hand and traveling hat at his feet, kneeling before an image of the Virgin of the Rosary, accompanied by a portrait of the builder of the church, Sebastián Dávila, and by Dominican saints.[107] The only other, and indeed the final, pictorial image of Bedón is his death portrait of 1621.[108]

In addition to the ink and wash drawing of the Virgen del Rosario in the 1588 confraternity volume, two extant paintings can be documented as the work of Bedón, among a host of attributions. A seventeenth-century account records that Bedón painted a mural depicting the Virgin of the Rosary (known as the *Virgen de la Escalera*) in the stairwell of the Dominican retreat.[109] The mural was removed from the wall in the early twentieth century and transferred to canvas. In the process it suffered losses and deformation and has been subject to extensive consolidation, restorations, and repainting during the past century. As a result, the present image is by no means an adequate guide to Bedón's capacity as a painter or his style. In terms of iconography, Bedón adapted and transformed an engraving by the Italian printmaker Giacomo Franco to create a Dominican genealogical tree with the Virgin of the Rosary in the center, from which branches unfurl that support half-length figures of Dominican saints. The tree trunk springs from the supine figure of Saint Dominic of Guzmán.[110] Bedón's modified iconography of the Dominican genealogy was reiterated time and again by Quito painters during the colonial period, testifying to its local relevance and longevity.

A second work by Bedón illustrates his artistic versatility. Among the illuminated capitals in the folios of a 1613 choir book in the Dominican collection in Quito are two that bear the initials APB designed as a device (*see plate 15*). Bedón signed several missives with the name "Fray Pedro Bedón de Agüero," using both of his father's surnames, and he does not appear to have employed that of his mother; thus, these may well be his initials.[111] Like many of the other illuminations in the book, these incorporate fanciful and grotesque profile heads whose pointed caps make them appear to emerge like flowers from the entwined foliage and letter forms. Both illuminations incorporate the same color scheme and are set against a minutely stippled background, features present in a number of other illuminations in the volume, similarly suggesting the hand of Bedón. Yet several other artists clearly were involved in the confection of the many meticulously detailed painted and gilded illuminations, and it would not be surprising to learn that Bedón enlisted a number of the Andean painters in the Confraternity of the Rosary in the creation of this massive choir book containing over one hundred folios. The skill and concentration required to execute these minutely rendered designs that combine scribal and pictorial techniques, together with the fact that a number of them are copies of engravings or illustrations that appear in another choir book in the collection, likely made the undertaking of the illuminations an instructive and collaborative task for local painters.[112] The

features of persistent practice and copying finished models are in concert with Bedón's stated directives regarding artistic practice. Bedón was able to wield his authority by setting down guiding principles that supported artists and artistic production in Quito.

In the absence of a guild of painters, Bedón's contemporaries frequently sought his opinion and assessment of works of art, making him a kind of de facto *maestro mayor y veedor* of painters and artists. This status is evidenced in a number of artistic contracts that required the work to be executed "to the satisfaction of fray Pedro Bedón," even when those works were not located in Dominican establishments and were not necessarily paintings. In 1601, Pedro de Léniz, *mayordomo* of the Confraternity of the Vera Cruz, located in the Franciscan church, signed a contract with the sculptor Antonio Fernández for a statue of the Ecce Homo, in which he stipulated that the work must be done "to the contentment of fray Pedro Bedon [. . .] and of the officials of the said confraternity [of the Vera Cruz]."[113] An artistic arbiter as well as instructor, Bedón's influence extended even to the surname of an early seventeenth-century Andean painter named Francisco Bedón, which he almost certainly adopted in homage to the Dominican friar.[114]

A multitude of paintings in Quito and elsewhere have been attributed to Fray Pedro Bedón, but none are signed or otherwise documented as his work. The examples described above—an ink and wash drawing on paper, a damaged mural painting, and miniature choir book illuminations on parchment—are so varied in medium, function, and date that they render any characterization of Bedón's "style" extremely difficult and indeed counterproductive to assess. While they speak to his versatility as a painter, Bedón's extant documented works preclude any coherent assessment of his formal and stylistic influence on early colonial art in Quito. Instead, Bedón's contributions lie in his recorded theory of art, his pedagogical proclivities, and his role as chaplain of the Confraternity of the Rosary. His leadership undoubtedly exerted a substantial impact on painters and the profession, particularly Andeans, in early colonial Quito.

The First Generations of Andean Painters, 1580–1615

The earliest Andean painters appear in the documentary record in Quito in the 1580s. Most were likely born under Spanish rule in the 1550s and 1560s, and their careers often stretch into the first decades of the seventeenth century. Because the birthdates of these artists are unknown, the "first generations" of painters considered here are those who are documented in the archival record between 1580 and 1615, employing the recorded professional lifetime of the Andean painter Andrés Sánchez Gallque as a means of grouping his contemporaries. The inclusive dates provided below for individual Andean painters reference only the period in which they were active, as reflected in the notarial record.

In addition to the Europeans and Creoles discussed above, nine documented Andean painters fall within the category of Sánchez Gallque's contemporaries, the majority of whom lived in the parish of San Roque (see table 5.1). Like Sánchez Gallque, the Andean painters of San Roque were lettered artists: every one who was a party to a notarial contract signed his name to it. Indeed, among all Andean painters who were party to notarial contracts during this period, only one, Alonso "yndio pintor," notably a resident of San Marcos, was unlettered. The resident painters of San Roque might have chosen to live close to the monastery of San Francisco and the Colegio de San Andrés, either as former students or beneficiaries of patronage.

For a number of these painters, there is only limited information about their professional practices, even as their identities and in some cases certain aspects of their lives are recorded. Often, all that remains in the written record is a single contract or reference that is frequently unrelated to their profession. The sole reference to "a painter [named] Turocunbi" appears in the 1614 testament of Martian Anda Pucalloni, who recorded that the painter owed him "a shirt [made] of damask from Castile."[115] The Andean painter known as "Esteban yndio pintor" appears only in a 1610 contract for the purchase of land in the parish of San Blas made by his wife, Joana Guallichicomen, who named her husband and his profession as part of her legal identity.[116] Similarly, the sole record of "Domingo yndio pintor," identified as a native of Riobamba and resident of Quito, is a 1608 contract in which he promised to repay a debt, on which he inscribed his signature (*see fig. 1.2g*).[117]

In other instances, the only recorded reference to a painter is related to an artistic commission. In 1602, the Andean members of the Confraternity of San Bartolomé registered payment of "one patacón and one and one-half bushels [of grain]" to "Pedro Torona *yndio pintor* for the creation of a sculpture of San Bartolomé."[118] The Andean journeyman painter and woodworker Juan del Castillo is identified as an "yndio oficial pintor y entallador" in a 1606 commission to create "a [sculpture of] Christ crowned [with thorns] with his tormentors [*sayones*] for the processional platform, all for sixty reales" for the Confraternity of the Vera Cruz, established in the Monastery of San Francisco.[119] Castillo's accomplished signature is inscribed on this contract, replete with ligatures and rubric (*see fig. 1.2b*). Two additional documents locate his residence in the Miraflores sector near the Franciscan Recoleta de San Diego in the parish of San Roque in 1604 and register his acquisition of adjoining land there in 1608. In these, too, Castillo is identified with the sole title of "yndio pintor."[120]

The only example of an unlettered Andean painter is that of the above-mentioned "Alonso pintor yndio ladino," who in 1586 contracted to purchase a half-lot of land in the parish of San Marcos, and requested that a witness sign in his stead because he did not know how.[121] Although he was unlettered, the designation "yndio ladino" indicates that Alonso could speak the Castilian language. It is possible that Alonso "pintor yndio ladino" may

be the painter Alonso Chacha, who was recorded as a member of the Do-
minican Confraternity of the Rosary two years later, in 1588.[122] Perhaps not
surprisingly, a number of the earliest recorded Andean painters appear to
have been associated in one way or another with the Franciscan Colegio de
San Andrés and/or with the Dominican Confraternity of the Rosary.

Four artists, Francisco Gocial, Juan Chauca, Bernabé Simón, and Andrés
Sánchez Gallque—all of whom lived in the parish of San Roque—command
a far greater number of notarial contracts than other Andean painters of this
period. Indeed, the documents regarding Sánchez Gallque are so rich and
extensive that his life and work are considered in the following chapter. To
the extent that the documents permit, the lives and professional activities of
the other three Andean painters are discussed in detail below. The paren-
thetical dates introducing each painter refer to the inclusive dates in which
they are documented in the archival record.

Francisco Gocial (active 1585–1599)

The first Andean painter in the documentary record is Francisco Gocial,
whose Christian name and surname link him with the Franciscans and the
Flemish friar Pedro Gocial, cofounder of the Franciscan *colegios* and known
by some as "Pedro Pintor."[123] Like Francisco Bedón, Gocial's given name
indicates links to the Franciscans, while his surname makes specific homage
to Fray Pedro Gocial. In 1585, the city council awarded Gocial "pintor" (first
name omitted) legal title to a *marca de hierro* (branding iron mark) "to brand
his livestock." The design of Gocial's personal brand, which appears as the
letter "F" (for Francisco) with a scalloped line that connects the lower bar of
the letter to the base, is drawn in the margin of the document (fig. 5.3, num-
ber 65).[124] The symbol could have been crafted by Gocial or provided by
the city council, although one might suspect that he created his own design.
Regardless, Gocial's branding iron mark (reminiscent of the "painting with
fire" definition of *quilca*) constituted yet another graphic form of communi-
cation that was harnessed by colonial Andeans to protect their legal interests
and rights. Gocial was a resident in the parish of San Roque, and he also was
for some time a resident of Riobamba. He was among the painters listed as
members of the Confraternity of the Rosary in its 1588 rule book, although
what years his name was registered in the volume are uncertain.[125]

Figure 5.3. *(facing page)*
Branding iron marks, late
sixteenth century. Number 65
belonged to Francisco Gocial.
After *Libro de proveimientos
de tierras, cuadras, solares,
aguas, etc., por los Cabil-
dos de la Ciudad de Quito,
1583–1594.* Transcr. Jorge
A. Garcés (Quito: Archivo
Municipal, 1941), 61.

A glimpse of Gocial's professional activities appears in two 1590s docu-
ments, even if they fail to mention specific works. In 1596, the Spanish *albañil*
Alonso Muñoz gave power of attorney to a lawyer in Quito to collect money
that was owed him by "Francisco yndio pintor," identified as a resident of
Riobamba.[126] A subsequent promissory note signed in 1599 by Francisco
Gocial in Riobamba certifies that the Andean painter was indeed Gocial. He
agreed to pay the vicar general the debt that he owed Alonso Muñoz, for
which he had been condemned and imprisoned.[127] Gocial's practiced signa-
ture, employing abbreviations, superscript, and rubric, adorns the end of this

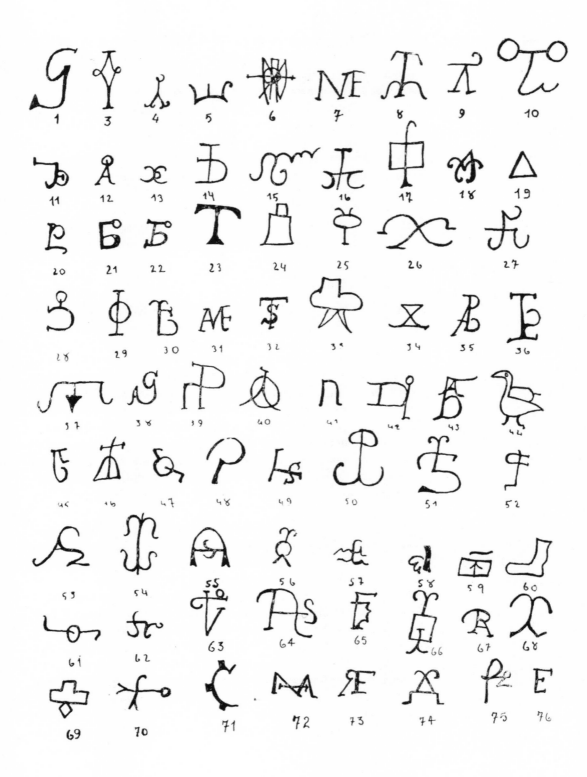

document, bearing witness to his mastery of literate European graphic technologies (*see fig. 1.2c*) as well as of credit transactions. A later marginal note appended to the contract indicates that in 1600 the vicar general acknowledged Gocial's repayment of the debt "by means of his own work," implying that the artist made compensation by creating paintings. Because of the late eighteenth-century earthquake that destroyed the city, Gocial's works are no longer extant in Riobamba.[128]

As an active, lettered Andean painter, Gocial was enmeshed in legal and economic networks in both Quito and Riobamba, where he resided and undertook artistic commissions during the early colonial period. His links with Franciscan and Dominican missionaries and artistic campaigns in Quito and beyond, and his residence among other Andean painters in San Roque, made him a particularly influential artistic intermediary and interpreter.

Juan Chauca (active 1603–1615)

The Andean painter Juan Chauca has a particularly rich documentary record that reveals many of the circumstances of his life and professional activities, although specific artistic commissions are not mentioned. Chauca's surname bespeaks Quechua ancestry from central Peru. The circa 1582 register of indigenous residents in Quito's parish of San Sebastián names the "*ayllo* of Juan Chuaca" as that of the "Indians of Don Francisco Ynga (i.e. the 'Auqui') who are settled next to his house."[129] Chauca is here identified as the leader or *principal* of an indigenous *ayllu*—a sociopolitical unit—within the parish. Indeed, the location of Chauca's domicile in the parish of San Sebastián, in the sector that in 1597 became San Roque, highlights one of the epicenters of Andean artistic activity in early colonial Quito: the neighborhood surrounding the residence of Don Francisco Atahualpa (the Auqui), son of the last Inca ruler.

That Chauca was favored by local Inca nobility is evidenced in a section of Francisco Atahualpa's 1582 testament, in which he declared, "in order to discharge my conscience and because I owe him a debt for having served me in his profession of carpenter, [I give] to Juan Chauca yndio one and one-half plots of land in the place where the said yndio has his houses, and also seventy Castilian sheep."[130] Following the imperial Inca tradition, Juan Chauca had served the principal descendant of the Inca ruler by means of his specialized knowledge, in his profession as a carpenter and perhaps also as a painter, marking him as a member of an elite indigenous artisan class.

Juan Chauca was the son of Francisco Chauca, an Andean blacksmith, who in 1605 occupied the prestigious post of native *alcalde* (chief magistrate) of the parish of San Roque.[131] In 1602, Doña Beatriz Ango, widow of Francisco Atahualpa, declared in her testament that she owed "to Francisco Chauca yndio a piece of land [the equivalent of] one lot alongside the houses in which I reside [in the parish of San Roque]."[132] Thus, both Francisco and his son Juan Chauca occupied indigenous leadership posts in their parish,

and they lived in houses that were directly adjacent to the center of traditional Inca power.

A 1603 document involving both father and son affords an intriguing glimpse into the status and professional activities of the Chaucas and the local exchange economy. On 23 June 1603, Juan Chauca signed a promissory note to repay fifty pesos that he had borrowed to purchase "Castilian and locally made clothing" because "I need to dress myself and [acquire] other things necessary for the adornment of my person." Chauca promised to reimburse the merchant in six months "with the proceeds of my profession and the fruits of my lands."[133] Like Francisco Gocial, Francisco Bedón, and Luis de Ribera, Juan Chauca sought ways to pay without specie, compensating debts through the work of his hands and his profession.

Chauca's loan apparently required substantial backing, for his father, Francisco Chauca, signed as his guarantor, and both father and son offered specific properties and possessions as collateral: "The principal [debtor] Juan Chauca offers as collateral some houses that I have in this said city in the parish of San Roque bordered by [the] houses of Francisco Chauca and of Pedro Quispe, and I the aforementioned Francisco Chauca, guarantor, mortgage the forge of my profession [together] with all of the tools."[134] The document also contains a list of the merchandise that they acquired:

> For eight varas of *ruán de fardo* at two pesos, sixteen pesos
> For nineteen pounds of iron, nineteen pesos
> For eight varas of *cachas* [cloth from Cachas, near Otavalo?] at one peso
> and four tomines, twelve pesos
> For one hoe, three pesos.[135]

Some of the materials that Juan Chauca acquired were clearly intended to serve his profession as a painter, since *ruán de fardo* typically was used as a support for paintings, and the hoe was obviously destined to support his agricultural enterprise. The eight *varas* of "cachas" likely refer to a more refined, locally produced textile, which was intended for the garments that Juan Chauca would use "to dress himself."[136] As a blacksmith, Chauca's father must have been the one acquiring the nineteen pounds of iron. The practiced signatures of both father and son, which employ fluid lettering, superscript, and rubrics, appear at the end of the document (*see fig. 1.2a*).

In 1617, Chauca sold a thatch house and land on his own property to the Andean, mestizo, or Creole painter Mateo Mexía and donated an adjoining plot of open land to the Andean painter Mateo Ataurimache.[137] Based on the neighboring properties described in these and other documents, Chauca's land was bordered by descendants of the Inca elite and by other native artisans, including Andrés Sánchez Gallque, his brother Bernabé Simón, and the Andean architect and builder Francisco Morocho, all in the neighborhood surrounding the house and lands of Atahualpa's heirs.[138] Chauca's 1617 sale and donation of land adjoining his own ensured that his closest

neighbors would be painters, a move that may have marked the initiation or consolidation of a collaborative professional enclave.

In a final document, Chauca declared before a notary in 1620 that he previously had purchased property in San Roque with monies from and on behalf of Leonor Alarcón *yndia*.[139] Chauca's action is of particular significance, for he used his lettered status and knowledge of Spanish colonial law on behalf of an Andean woman who, for whatever reason, was herself unable to make the purchase. Chauca formally bought it in his name, and then legalized her ownership in a subsequent notarial document, thereby circumventing the law in favor of Alarcón. Andean artists like Chauca, through their negotiations and contracts, their economic transactions and professional relations, established networks and operational knowledge that allowed them to shape and manipulate the colonial system.

Bernabé Simón (active 1608–1625)

The Andean painter Bernabé Simón, although the brother of Andrés Sánchez Gallque, entered into the archival record far less often. In the first decades of the seventeenth century, Simón's residence was located in the parish of San Roque on land adjoining that of his brother and, as noted above, surrounded by the homes of elite Inca artisans near the residence of the heirs of Atahualpa.[140] Like his brother, Simón owned a tract of farmland in the nearby indigenous community of Zámbiza, which he purchased in 1624 from Lorenzo Gocial, "yndio ladino."[141] The two brothers collaborated on at least one major painting commission. Because this commission is entwined with that of Simón's more famous brother, it is considered in greater detail in the following chapter on the life and work of Sánchez Gallque.

Conclusions

To the degree that they can be traced in the notarial record, Sánchez Gallque's contemporaries appear almost uniformly to have achieved a measure of success, status, and economic prosperity as a result of their professional activities, regardless of their origins or ancestry. The majority of these painters possessed their own houses and properties in Quito, as well as lands in nearby communities. The Andean painters lived almost exclusively in the native parish of San Sebastián, in the sector that in 1597 became that of San Roque, occupying residences near or adjacent to those owned by the heirs of Atahualpa. The European and Creole painters were either transients or renters in Quito, with the notable exceptions of Fray Pedro Bedón and the Spaniard Luis de Ribera, who resided and ran a *pulpería* in the primarily European and Creole parish of Santa Barbara. These artists were able to make a good living through their profession, and many elevated their economic as well as professional status over the course of their careers. Moreover, they

were literate. Of those painters who were principal parties to notarial con-tracts, all but one, irrespective of origin or ancestry, signed his name to the documents.[142] This ability allowed them to take advantage of and manipulate the Spanish colonial system to their own ends. Sánchez Gallque and his con-temporaries thus constituted an elite group of lettered, skilled professional painters in colonial Quito at a time when alphabetic literacy was not the norm for either Andeans or Europeans, particularly among the artisan class. The biography of the principal Andean painter of the early generations, Andrés Sánchez Gallque, permits a closer examination of the implications of lettered status and artistic production for colonial Andeans in Quito.

Pintar la figura de la letra

Andrés Sánchez Gallque and the Languages of Empire

Andrés Sánchez Gallque is most renowned today for his captivating 1599 triple portrait *Don Francisco de Arobe and His Sons, Pedro and Domingo* (*see plate 1*), one of the most frequently cited and reproduced paintings in the modern literature on colonial South America. The painting has been extensively praised, parsed, and interpreted by twentieth- and twenty-first-century scholars and heralded as the first signed South American portrait.[1] Modern authors express surprise and delight not only with the persuasive illusionistic power of the painting, the mesmerizing appearance of its subjects, and the artist's impressive mastery of the genre, but with the fact that the artist chose to sign and date his work, including a specific reference to his Andean identity. Indeed, the artist's signature and accompanying inscription appear to play as great a role in the modern fascination with the image as does the visual magnetism of the portrait itself.

The canvas is inscribed with the abbreviation "ADR SHS GALQ nl. de qto f.," in its extended version, "Andrés Sánchez Gallque, native of Quito made this" (*see plate 2*). The 1599 date appears above the signature in a cartouche following a textual dedication to King Philip III, in which Juan del Barrio y Sepúlveda, a Spanish judge of the *audiencia* of Quito, avows that he commissioned the painting at his own expense. Further enhancing the documentary quality of the portrait, the names and ages of the subjects are inscribed above the head of each figure. Other attractions include the secular subject matter of the image—an arresting group portrait created at a time when most paintings were religious in nature—and the extraordinarily dignified, commanding presence of the mulatto (Afro-indigenous) subjects clad in a striking combination of Andean and European dress with adornments of local, Mexican, and Chinese silks, damasks, taffetas, and gold.[2] To which may be added the

artist's confection of the painting in local and regional pigments and materials that communicated traditional Andean associations and meanings. Text and image, identities and ancestries, local and global economies appear to merge seamlessly in the portrait. On the strength of this work alone, Andrés Sánchez Gallque has come to represent in the modern literature the genesis of colonial Andean painting.

Rightly, much has been made of this group portrait. Its visually compelling subjects, the expression of powerful Afro-indigenous alliances, its implications for the emergence of Andean artists as active agents in colonial South American history, and the rich historical context of its production have inspired extensive scholarly commentary and analysis. The painting has been particularly attractive to modern scholars, owing to the abundantly documented historical circumstances surrounding its creation. The portrait was commissioned by Juan del Barrio y Sepúlveda, whose diplomatic and military efforts led to the (temporarily) successful "pacification" of the indigenous and Afro-indigenous peoples of Esmeraldas (a region on the north coast of present-day Ecuador). Intended for the king of Spain, the painting served as a visual complement to an extensive textual report documenting the success of the Spanish campaign in Esmeraldas.[3] In this context, Sánchez Gallque's signature inscription on the painting could appear designed to play directly into the political aims of his patron, standing as an additional exemplar of the "pacification" of non-Europeans in the *audiencia* of Quito and their ability to adopt "good customs." The painting was, after all, a visual document meant for the Spanish king.

Given the amply documented circumstances under which the painting was created, surprisingly little is known about its author. Until recently, Sánchez Gallque's life, social circumstances, artistic practices, and professional activities have remained almost completely obscure—a rather ignominious legacy for an artist whose work has been the subject of so much discussion. The great twentieth-century Ecuadorian art historian José Gabriel Navarro characterized Sánchez Gallque as "the missing link in the chain of art history in Quito [. . .] the natural-born founder of Ecuadorian art," and "a great overlooked artist who merits immortality."[4] In fact, it was Navarro who in 1929 rediscovered this painting in the collection of the Museo Arqueológico in Madrid, recognized its historical significance, and identified its author as a native of Quito.[5] Yet in Navarro's history of Ecuadorian painting, published posthumously in 1991, he offered only a question and a hypothesis regarding the identity of the artist: "But who was Sánchez Gallque? He may have been of the family of Juan Sánchez de Xerex Bohorquez [. . .] son of the Spaniard Juan Sánchez de Xerex, one of the first conquistadors and one of the first wealthy citizens of Quito."[6] Though Sánchez Gallque identified himself as indigenous in his inscription on the 1599 painting, Navarro sought to link him with an elite family of Spanish conquistadors. Complicit in the scarcity of documents regarding Sánchez Gallque's life and work is a progressive teleology in historical writing that privileges dominant hierarchies and cultures.

Historiography for Sánchez Gallque

All but the most recent literature offers little information about Sánchez Gallque's life and work beyond the circumstances of his 1599 painting. Yet a range of documentary sources exist that shed light on the artist's social circumstances, professional practices, painting contracts, and artistic self-image. The evidence reveals a more complicated and nuanced picture of Sánchez Gallque as an Andean who engaged and manipulated literate technologies to claim status and agency in early colonial Quito.

Sánchez Gallque was clearly an accomplished painter, and he was also a conspicuously lettered artist. To explain this, the historical assumption has been that Sánchez Gallque first learned the art of painting at the Franciscan Colegio de San Andrés in Quito, although without any documentary evidence to substantiate this claim. The documents discussed below provide the evidence of the painter's association with the Franciscan monastery and support the hypothesis that he may have been educated at the Colegio de San Andrés.

The earliest published documentary reference to Sánchez Gallque identifies him in 1588 as a member of Fray Pedro Bedón's Cofradía del Rosario de los Naturales in the Dominican church.[7] That Sánchez Gallque may have practiced or perfected his practice of the art of painting under or in collaboration with Bedón is suggested by the presence of his name and signature on the register of the confraternity, alongside those of other Andean painters and artisans.

With respect to the relationship between Sánchez Gallque and Bedón, one small but perhaps telling bit of evidence involves signatures. Sánchez Gallque employed a specialized European convention in his signature on the 1599 triple portrait: he rendered an abbreviation of his first name as a visual device, in which three letters (ADR) are interwoven to form an independent design, as shown in plate 2. In a similar fashion, Bedón appears to have signed his name as a device, in this case employing initials (APB), in a 1613 choir book illumination (*see plate 15*).[8] Beyond basic alphabetic literacy, the convention of abbreviating and transforming selected letters of a word into a design is a special and learned technique, one that is quite rare among artist's signatures in colonial Quito. Thus, its employment by both Bedón and Sánchez Gallque may well underline an association between the two. Yet Sánchez Gallque's inscription on this 1599 painting suggests more than just an elegant statement of authorship. Its formal techniques and graphic configurations link the painter with sophisticated scribal conventions and practices.

Sánchez Gallque occupied several important offices in the Cofradía del Rosario de los Naturales between 1588 and 1615. His continued involvement in the brotherhood indicates that he enjoyed a degree of status and authority among its members. In 1590 he supervised the Holy Week procession of the Virgen de Dolores; in 1605 he served as *prioste* (steward) of the confraternity

Figure 6.1. Signature of Sánchez Gallque, *Denial and Repentance of Saint Peter*, 1605. Photo courtesy of the Museo Colonial Charcas, Sucre, Bolivia.

alongside Diego Tutillo and Luis Paucar; and in 1615 he was again named steward of an unspecified feast-day observance.[9] His 1588 inscription in the rule book and the 1615 record of his service as feast-day steward serve as temporal brackets for the period in which Sánchez Gallque was professionally active in the city of Quito. The notarial and pictorial evidence concerning the artist also falls within this timeframe.

The visual and contextual preoccupation with *Don Francisco de Arobe and His Sons, Pedro and Domingo* has to a great degree overshadowed the existence of a second signed and dated work by Sánchez Gallque. A small panel painting, *Denial and Repentance of Saint Peter* (*see plate 16*), now in the Museo Colonial Charcas in Sucre, Bolivia, bears the inscription "A͠DRES FAC. EN Qto 1.605" ("Andrés made this in Quito 1605") (fig. 6.1). This diminutive painting was first identified as the work of Sánchez Gallque in 1960 by the Bolivian art historians José de Mesa and Teresa Gisbert.[10] Since then, relatively few scholars have discussed or noted the existence of this work.[11]

Familiar from Medoro's renderings of the theme, Sánchez Gallque's painting is organized in a bipartite composition that follows European Mannerist formulae in which scenes of both the denial and the repentance of Saint Peter are depicted. The illuminated foreground is dominated by the figure of Christ at the column and the kneeling figure of the repentant Peter. Recessed in deep shadow above Peter is a scene of the saint's denial of

Christ, located before a large fireplace replete with leaping flames. The emotional emphasis of the painting is repentance, one of the spiritual practices highlighted by missionaries who attempted to teach native neophytes to feel remorse and atone for transgressions. The painting seems intended to both instruct and provoke a penitential response.

In some ways, it is difficult to believe that the same artist painted the triple portrait of the Arobes and the *Denial and Repentance of Saint Peter*. The diminutive size and meticulously detailed figures of the latter painting link it more closely with choir book illuminations, such as those produced by students at the Colegio de San Andrés, than with the artist's large and imposing triple portrait. Differences in scale, materials, patronage, and intended function between the two works may to some extent account for the formal and stylistic disjunction. Even the six years that separate the paintings in time do not seem enough to explain the pronounced dissimilarities between them in their treatment of color, perspectival space, and the human figure. Both works employ Mannerist stylistic features and coloration, elegant gestures, and elongated hands and fingers, but the powerfully lifelike quality of the figures in the large oil-on-canvas triple portrait looks nothing like the highly stylized, iconic, and inward-turning devotional image on wood panel. In the end, given that both works are signed by Sánchez Gallque, we are left to conclude that he was a versatile painter capable of dramatically changing and adapting his style to correspond with the nature and demands of specific subjects and commissions.

Given that the theme of the repentance of Saint Peter was extremely popular throughout the northern Andes in the late sixteenth and early seventeenth centuries, many pictorial representations of it would have been available, some combining it with a subsidiary background scene of the saint's denial of Christ. The original source for Sánchez Gallque's panel, transmitted through paintings and prints, is a canvas by the Spanish artist Luis de Morales ("El Divino"), *San Pedro en lágrimas ante Cristo flagelado* (c. 1570), today in the Catedral de Nuestra Señora de la Real Almudena, Madrid (*see plate 17*). Although Morales's panel painting depicts only the scene of Peter's repentance, Sánchez Gallque replicates numerous of its elements in precise detail, in particular Christ's frontal embrace of the column, the delicately splayed disposition of his fingers, and the double cord and slipknot with which he is bound.[12] Sánchez Gallque also hews closely to Morales's painting in his depiction of Peter, who gazes up in sorrow at Christ, his hands clasped with fingers interlocked. Painted copies, drawings, or engravings of Morales's painting must have been brought to the Andes in the late sixteenth century, perhaps by Angelino Medoro, to whom are attributed several versions of the theme in the New Kingdom of Granada.[13] Sánchez Gallque followed a widely circulated model for his painting, yet he included the subsidiary scene of the denial, and he also elected to affix a signature inscription to his work.

On the basis of this signed and dated panel painting, Navarro assigned to

Sánchez Gallque authorship of two very similar works in Quito collections, one of which he termed "a replica" of the panel in Bolivia.[14] An early panel painting today in the collection of the Museo de Arte Colonial in Quito follows the same model employed by Sánchez Gallque, although it omits the background scene of the denial (*see plate 18*). A second panel painting of this theme, in the collection of the Carmelite convent of La Trinidad (known as Carmen Bajo) in Quito, which is attributed to the Italian painter Bernardo Bitti and dated circa 1600, similarly excludes the denial scene.[15] The prevalence of early colonial images of the repentance of Saint Peter testifies to its importance and popularity in early colonial Quito and elsewhere in the northern Andes. The subject was developed and transformed during the later seventeenth and eighteenth centuries in particularly visceral images of Christ at the column after the flagellation, which focus on Christ's lacerated and bleeding back, while scenes of Saint Peter's denial and repentance are relegated to the deep space of the background.[16]

Sánchez Gallque's small panel painting in Bolivia is of unquestionable import, for it confirms that the artist's signature on *Don Francisco de Arobe and His Sons, Pedro and Domingo* was not an exceptional case, not an inclusion demanded by the nature of the commission to highlight indigenous alterity and "pacification." Rather, the signature inscriptions on these two paintings record Sánchez Gallque's conscious control of literate conventions and his self-awareness as an artist in visibly marking and inscribing his identity as an expression of authorship.

Documented Artistic Commissions

In addition to the two extant paintings that Sánchez Gallque signed and dated, three contracts exist for works by the artist that are now lost or remain to be identified.[17] These commissions afford a broader perspective on the professional practices and status of this Andean painter and situate him as a respected painter and visual interpreter of religious imagery within colonial Andean and European communities.

The earliest and arguably most important work for which the contract has been identified predates Sánchez Gallque's 1599 triple portrait by some seven years; it is a 1592 commission to create the main altarpiece for the church of Santiago de Chimbo, a native community about one hundred kilometers south of Quito. This commission is particularly intriguing because both artist and patron were Andean and because they chose to employ the Spanish notarial system to record the contract (see appendix, part c).[18] This 1592 document is the earliest known artistic contract undertaken before a notary by an Andean painter in Quito.

In 1592, Andrés Sánchez "pintor" and Don Diego Pilamunga "cacique principal" of Santiago de Chimbo, signed a contract in which the artist agreed to travel to the town and produce the main altarpiece for the local

church.[19] The document spells out in detail the size, materials, structure, composition, and iconography of the altarpiece, for which Sánchez Gallque was to receive the impressive amount of twelve hundred silver pesos. This payment is all the more significant because Pilamunga agreed to provide the artist with the wood and nails required to construct the altarpiece, as well as his meals and other amenities during the time of production. In turn, Sánchez Gallque was to supply "all the gold and colors and the rest of the materials that might be needed," as well as his own team of native carpenters and assistants (*oficiales*).[20] The conditions of this contract indicate that Sánchez Gallque enjoyed an estimable reputation, and he possessed the status and authority to muster and command a group of professional Andean artisans in the realization of a monumental work.

Although the contract is very specific regarding the benefits and obligations of both parties, it is even more detailed in its adumbration of the formal, compositional, and iconographic features of the work itself. The height of the altarpiece was to be five *varas* (approximately fifteen feet) and the width three and one-half *varas* (approximately ten feet), with carved niches to house six sculptures in the round representing Santiago, the Virgin of Guadalupe, the crucified and the resurrected Christ, and two angels, in addition to high-relief sculptures of Saints Peter and Paul, Barbara, John the Baptist, Mary Magdalen, and various seraphim, together with painted panels depicting the Evangelists. The altarpiece was complex, elaborate, and expensive, and the contract specifies carefully the form, size, and location of each image, as well as the materials to be employed in creating each aspect of the work (see appendix, part c).[21]

Iconographic elements of the altarpiece have been linked to the specific choice of imagery with the patron's family and with local devotions, highlighting Andean appropriations and transformations of European prototypes.[22] Beyond the symbolic content of the altarpiece, the commission charged the painter Sánchez Gallque with the construction and the creation of the sculptures—in addition to applying the gilding and colors (which in the contract are rather summarily stated in comparison to the instructions for composition and iconography). Given the varied professional, material, and artistic requirements of the altarpiece as outlined in the commission, Sánchez Gallque was to serve as *maestro de obra* (general contractor) of the work. This role is expressed in the requirement that the artist supply his own team of native carpenters and assistants—circumstances that would come to be fairly common for Andean master artisans, particularly sculptors and builders, in seventeenth-century Quito.[23]

In addition to the substantial remuneration he received, this commission further underlines Sánchez Gallque's artistic status. By 1592, he commanded the professional authority to muster the teams of skilled native artisans that accompanied him on the job, in this case to a fairly distant site. Both artist and patron were in command of the literate and legal conventions of the process for entering into a formal contract before a notary. The signatures of Sán-

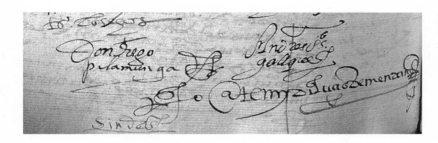

Figure 6.2. Signatures of Sánchez Gallque and Pilamunga, 1592. ANH/Q, Notaría 1a, vol. 3, 1588–1594, Diego Lucio de Mendaño, fol. 318r.

chez Gallque (who penned both surnames, abbreviating Sánchez to "ShS") and Pilamunga (who employed the honorific "don") are inscribed at the end of the document (fig. 6.2); both demonstrate experience with the form and assurance in using it. Whether Sánchez Gallque signed the altarpiece itself can only be a matter of speculation, for neither the colonial church nor the altarpiece in question are extant in Santiago de Chimbo.[24] The commission and the physical existence of the altarpiece at the end of the sixteenth century were expressions of Andean networks operating within a colonial setting, applying Spanish tools of empire to colonial Andean objectives.

A second documented work by Sánchez Gallque appears only as a brief indexed reference in a 1601 notarial volume. Many colonial notaries supplied *abecedarios* (in this context, alphabetized indexes of names and contracts) at the front of each volume to facilitate the consultation of specific documents. In this instance, the original 1601 index records a contract with Sánchez Gallque; however, the corresponding folios of the volume are missing. The brief entry notes that a contract between Pedro de Léniz, *mayordomo* (administrator) of the Cofradía de la Vera Cruz de los Españoles (located in the Church of San Francisco), and Andrés Sánchez "yndio pintor" should begin on folio 768 of the volume.[25]

Indeed, in the same year of Sánchez Gallque's commission, Pedro de Léniz, as *mayordomo* of the Cofradía de la Vera Cruz de los Españoles, embarked on a concerted decorative campaign for the confraternity chapel. Léniz was motivated by what he described as the confraternity members' lamentable lack of participation in the principal activity and devotion of the group, which was "that the Maundy Thursday of each Holy Week a general penitential procession [*de sangre*] must be made in atonement for the sins Committed against the majesty of god our lord."[26] According to Léniz, attendance was lagging because a new confraternity dedicated to the Soledad, which formed a part of the Spanish Confraternity of the Rosary at the Dominican monastery, was attracting all the members of the Vera Cruz during Holy Week. Léniz complained that "the penitents all go out in that [procession] and they leave that of the Vera Cruz, [which was] instituted for that purpose, alone and without any accompaniment."[27] As a result, and "in order to attract the faithful Christians" back to the Vera Cruz and its penitential activities, Léniz sent an envoy to Rome to obtain papal bulls recording

the special graces and indulgences granted to the confraternity members for their participation.

In addition to such spiritual inducements, Léniz believed that visual images would attract and energize the membership of the confraternity. In 1601, the same year that he commissioned the unspecified work from Sánchez Gallque, Léniz signed a contract with the Spanish or Creole sculptor Antonio Fernández to create a statue of the Ecce Homo for the confraternity chapel, in which he stipulated that the work was to be made "to the content of fray Pedro Bedon."[28] Even though it was under Bedón's tutelage that the "rival" confraternity of the Rosario and the Soledad was flourishing at the Dominican monastery, as a religious artist, his judgment was important enough to be registered as a requirement in the contract itself.

Five years later, Léniz commissioned yet another work for the confraternity chapel, this time a sculpture that was to be carried in the penitential processions of Holy Week. On 7 January 1606, the Andean artist Juan del Castillo "yndio oficial pintor y entallador" signed a contract with Pedro de Léniz, "to make for the said confraternity a Christ Crowned [with thorns] with the executioners for the processional platform [*paso*] all in sixty *reales* [. . .] the finished work will be submitted [in time] for Palm Sunday of the present year."[29] With the acquisition of these various images, Léniz sought to renovate and inspire devotion among the Spanish and Creole members of the confraternity through images commissioned from Andean painters and woodworkers.

The themes of the sculptures commissioned by Léniz, the crowning with thorns and the Ecce Homo, are directly related to the penitential devotions and processions of the Confraternity of the Vera Cruz, in which images of Christ's suffering and sacrifice at the hands of men were intended to provoke sentiments of sorrow and repentance in their viewers. During this time, the confraternity also possessed a set of processional sculptures representing Christ at the column with a figure of the repentant Saint Peter, which are still extant in the Monastery of San Francisco.

All told, in the first decade of the seventeenth century, Pedro de Léniz mounted a fervent campaign based on visual images and textual indulgences in order to retain and inspire the Spanish and Creole membership of the Confraternity of the Vera Cruz. Given the principal penitential focus of the confraternity, a painting depicting the denial and repentance of Saint Peter would certainly have been an appropriate image for its chapel. The lapse of four years between the unspecified 1601 contract with Sánchez Gallque and Pedro de Léniz and the painting of this subject signed by the artist in 1605 (*see plate 16*) is perhaps too long to propose a direct link between the two; however, the presence in Quito of two very similar contemporary paintings of the repentance of Saint Peter attributed to Sánchez Gallque suggests that the artist's contract with Léniz may well have been for an image of this subject.

With respect to this lost contract, that a confraternity composed of exclu-

sively Spanish and Creole members commissioned an Andean artist to pro-
duce a work for its chapel is noteworthy. The contract suggests that, perhaps
as a result of the painter's 1599 triple portrait commission, Sánchez Gallque
enjoyed a substantial measure of status and renown within the community.
Second, the principal activities of this confraternity were penitential and fo-
cused on the Passion of Christ. In light of Sánchez Gallque's signed painting
of the denial and repentance of Saint Peter in Bolivia and the presence in
Quito of two very similar paintings of the theme that are attributed to the
artist, his treatment of this subject would certainly have been appropriate for
the confraternity chapel.[30] The 1601 contract with Sánchez Gallque figured
among a number of artistic commissions undertaken in the early seventeenth
century by European or Creole and Andean artists at the behest of Léniz and
the Confraternity of the Vera Cruz, among them sculptures of the Crowning
with Thorns and the Ecce Homo.[31] That Léniz recruited Andean as well as
Creole artists to inspire renewed devotion among the Spanish and Creole
membership of the confraternity is significant.

A second artistic contract involving Sánchez Gallque points to another
as yet unidentified work. On 7 April 1608, Andrés Sánchez Gallque and his
brother Bernabé Simón, "maestros pintores yndios," signed their names to
a contract in which they agreed to produce a large painting depicting the
Adoration of the Magi for the Congregación de los Reyes Magos, a mestizo
confraternity established in the local Jesuit church. According to the docu-
ment, for the sum of fifty-eight pesos, the artists were to create a canvas that
depicted "Our Lady of the Kings, in which Saint Joseph and the three Kings,
and an angel, and a bull, and a donkey, and a camel, are painted in oil in very
good and vivid colors, of one and three-quarter [*varas*] in height."[32] Sánchez
Gallque and Simón were charged with bringing to life through vibrant colors
a large multifigural composition that would embody and inspire the devotion
of the mestizo confraternity members.

The form of this contract is atypical in that the two artists, at their own
initiative and cost, elected to document their commission before a notary,
while the patron's representative was present only as a witness. The brothers
recorded the legal nature and requirements of the commission, which might
otherwise have proceeded on a more informal basis, verbally or by means of
vales, small handwritten receipts that were often passed between buyers and
sellers in lieu of paying a notary to render a formal contract. That the two
Andean painters chose to seek out and pay for the notarial document empha-
sizes their knowledge of, and their ability to maneuver within, the Spanish le-
gal system, which theoretically would protect them should the patron default
on his part of the bargain. The signatures of Sánchez Gallque (who again
abbreviated "Sánchez" and omitted his second surname) and Simón (who
penned only his surname) are inscribed at the end of the document (fig. 6.3).

The Congregación de los Reyes Magos (also known as Our Lady of the
Kings) was an exclusively mestizo sodality that was established in the Jesuit
church in the 1590s. The Jesuits initially encountered difficulties in attract-

Figure 6.3. Signatures of
Sánchez Gallque and Simón,
1608. ANH/Q, Notaría 1a,
vol. 53, 1608, Alonso López
Merino, fol. 248v.

ing mestizos to join the confraternity; however, by the early seventeenth century the situation had improved markedly, with many new members added to the roster. Could the acquisition of paintings such as that commissioned in 1608 from Sánchez Gallque and Simón have encouraged this membership increase? According to a late seventeenth-century description, the mestizo congregation possessed a side chapel in the Jesuit church, the altarpiece of which was decorated with a large canvas depicting the Adoration of the Kings "painted by an Indian [who was] very skilled in this art."[33] The ethnicity and artistry of the painters who produced the work were still remembered at the end of the seventeenth century, even if their names had been forgotten.[34] The institutional memory of the painting's authorship also suggests that the work may have borne a signature inscription. Unfortunately, the *Adoration of the Magi* made by Sánchez Gallque and Simón is no longer in situ, and its whereabouts are unknown.[35]

Contracts and paintings establish Sánchez Gallque's ability and reputation as a painter, his mastery of literate and legal conventions, and his self-awareness as an artist. His signatures on those productions also indicate his status as an *indio ladino*, a member of an acculturated class of Andeans who spoke both native and Spanish languages and often wore elements of European clothing.[36] However, the descriptor "indio ladino" appears on only one of the more than a dozen documents to which Sánchez Gallque was party, although it was frequently employed by notaries to designate indigenous clients familiar with the language and the customs of Spaniards. Nonetheless, Sánchez Gallque's signatures and inscriptions register a level of alphabetic literacy that transcends *primeras letras*, as well as a familiarity with Spanish legal precepts, formulas, and procedures. The nature of the brush versus the pen may account for visual differences between Sánchez Gallque's signatures on paintings and those he recorded on documents. Nevertheless, the consistent employment of abbreviations and marks of suspension—indicators of scribal fluency—occur in both his written and painted signatures. These abilities not only attest to the artist's formal training, they also demonstrate his conscious domination of literate tools and practices.

Given the inclusive dates of Sánchez Gallque's documented professional activities (1588–1615), he was likely born in the 1550s, locating him within the first generations of Andeans raised under colonial rule. Well equipped with professional skills that included striking visual and alphabetic literacy, Sánchez Gallque consciously manipulated European cultural forms and technologies to his own benefit. Indeed, the artist moved capably and successfully within the socioeconomic matrix of the colonial city, where he identified and allied himself with the Andean community.[37]

Sánchez Gallque in His Place and Time

Andrés Sánchez Gallque was married to Barbara Sasticho (also spelled Sactichug in the documents), an Andean woman from Pomasque, not far from Quito, who was recognized by the 1630s with the honorific "Doña."[38] Their union produced two sons, Francisco Sánchez and Matheo Galquín (an interesting division of the father's surnames), both of whom are identified in the documents as painters. Francisco, the elder, bears the title of "Don" in documents from the 1630s, and is identified as "maestro pintor" in a document of 1638 that also names him as Sánchez Gallque's son and principal heir.[39] Like his father, Francisco signed with an elegant hand each notarial document to which he was a party. Unlike his father, he added to his name the honorific "Don" (fig. 6.4). As a pupil-become-teacher, Sánchez Gallque ensured that his sons acquired the skills of alphabetic and visual literacy, and they likely collaborated in his workshop.

Sánchez Gallque's brother, Bernabé Simón, was also a master painter, and he owned a house on a plot of land adjacent to that of his brother's family in the parish of San Roque.[40] The professional titles of Sánchez Gallque's sons and brother, both painters and master painters, together with the proximity of their homes in San Roque, suggest they operated a family workshop. Similarly, the two brothers owned adjacent tracts of land in the nearby native community of Zámbiza, lands that Simón augmented in 1624.[41] The fraternal interest in possessing property in Zámbiza hints that this town may have been their birthplace, to which they maintained ancestral ties even as they resided and pursued their profession in Quito.

The location of Sánchez Gallque and Simón's residences in the parish of San Roque also indicates the artists' social and political status. Indeed, they lived in a neighborhood of high-status Andeans with a concentration of

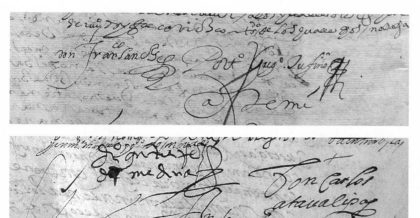

Figure 6.4. (*top*) Signature of Francisco Sánchez, 1638. ANH/Q, Notaría 1a, vol. 160, 1638, Diego Bautista, fol. 347r.

Figure 6.5. (*bottom*) Signatures of Sánchez Gallque and Carlos Atahualpa, 1602. AHN/Q, Notaría 6a, vol. 11, 1602, Diego Rodríguez Docampo, fol. 481v.

literate painters, and their homes were adjacent to the traditional seat of Inca authority. On 26 June 1602, Andrés Sánchez Gallque "yndio pintor" signed a contract with Don Carlos Atahualpa (grandson of Francisco Topatauchi Inca and great-grandson of the Inca ruler Atahualpa) showing that he had purchased for 220 silver pesos two plots of land in the parish.[42] According to Atahualpa, the properties in question were "bordered on one side by the lands of doña mençia my sister and by a ravine in the middle, with the lands of miraflores and with other lands that are mine."[43] The fluid signatures of Sánchez Gallque and Atahualpa (Ataualipa) appear at the end of the document (fig. 6.5).

At the time this contract was drawn up, Sánchez Gallque did not possess the full amount required to purchase the land; thus, he signed a promissory note with Atahualpa, registering a debt of 99 1/2 pesos to be repaid within the following year.[44] Nonetheless, the artist had at his disposal the resources for a down payment of more than half the substantial purchase price. A subsequent reference to the property appears in the 1608 testament of Doña Beatriz Ango, widow of Francisco Topatauchi Inca, who declared possession of lands in San Roque that were bordered by those of a number of native artists and builders, including Andrés Sánchez "pintor."[45] Sánchez Gallque and his brother Simón were thus closely associated with the descendants of Atahualpa, and surrounded by Andean artisans, in the Inca heart of colonial Quito.

It was on this property in San Roque that Sánchez Gallque and his family lived and practiced the art of painting, likely in collaboration with the artist's brother Simón, in the first decades of the seventeenth century. During this time, Sánchez Gallque acquired two additional lots close to his residence "near the convento of San Diego," although these were still without buildings in 1638, when one of the painter's sons and his widow used them as collateral to borrow 30 *patacones*.[46] In 1639, Barbara Sasticho, "widow of the deceased painter andres sanchez Gallque," sold the better part of these lots for the sum of 140 *patacones*, noting that an easement granting access to the property would be supplied by her relative (*deudo*), the Andean painter Cristóbal Chumbiñaupa, who owned adjacent lands.[47] In addition to his sons and his brother, Sánchez Gallque thus counted another painter among the members of his extended family in the parish, one who also resided on a neighboring property—all amid a larger group of Andean painters and artisans.

Sánchez Gallque's last will and testament has not come to light, and his genealogy is unknown. His distinctive second surname does not appear elsewhere in the notarial record, with one possible exception. Years after his death, in 1631, Doña Ana Tucto and Don Antonio Silquigua declared themselves before a notary to be the legitimate children and heirs of Don Mateo Yupanqui and Doña María Gualquín.[48] Because their mother's surname is so close to that of Sánchez Gallque's second surname and to that of his son, Matheo Galquín (whose first name also suggests a link to Yupanqui), one wonders whether the painter may have been related to the prestigious Yupanqui family. The Mateo Yupanqui referred to in this contract is the

grandson of the famed sixteenth-century native lord Mateo Yupanqui, the brother of Atahualpa. Such an illustrious familial association might clarify Sánchez Gallque's status in the community and the location of his residence and properties adjacent to those of Atahualpa's heirs. It might also in part account for the reason that Barrio y Sepúlveda commissioned him to undertake the portrait of Francisco de Arobe and his sons, adding yet another layer of significance to the "pacification" message of the triple portrait that the Spaniard intended.

The final living reference to Sánchez Gallque in the notarial record occurs in 1609.[49] In an intriguing contract dated 20 June 1609, Carlos Atahualpa sold to the parish church of San Roque "the portal of sculpted stone that I possess and [which] is installed in the houses that belonged to don Francisco auqui my grandfather that belong to me by donation from my grandmother doña beatriz ango."[50] The Andean representatives and officials of the parish church who purchased the portal included "andres sa[nche]z painter and don marcos and don fran[cis]co morocho and Francisco lisana and joan bazquez, indian parishioners of the said parish."[51] Sánchez Gallque signed his name to this document alongside those of elite Andean members of the parish, among them Marcos de la Cruz and Francisco Morocho, caciques *principales* of San Roque. The latter, a master carpenter and builder, served as *maestro de obra* in the construction of the Church of San Francisco for more than twenty years.[52]

Above all, this contract illustrates the continuity of Inca status and authority in its colonial Andean conjugation, undertaken at the initiative of the Andean elite, for the purchase ensured that the parishioners of San Roque would pass through Atahualpa's stone portal each time they entered the Christian church. Sánchez Gallque was instrumental in effecting this transaction. The artist is later documented in 1615 as *prioste* of the Cofradía del Rosario de los Naturales.[53] Sánchez Gallque's death therefore would have occurred sometime between 1615 and the first documented mention of his widow in 1633.

Sánchez Gallque's family continued to live in the parish of San Roque after his death; as late as 1643, their residence in San Roque is identified as that of "the heirs of the painter andres sa[nche]z."[54] His sons and brother likely continued to practice the family painting profession on that property well into the seventeenth century, linked within the network of Andean painters and artisans resident in the parish.[55]

Sánchez Gallque accumulated considerable wealth and prestige during his lifetime, perhaps in greater measure than most other Andean painters of his time. By the early seventeenth century, his title "master painter" indicated this elevated status, as did the location of his family residence and lands, so close to those of the heirs of Atahualpa and other elite indigenous families in the parish of San Roque. Although at present only two signed paintings by Sánchez Gallque are known, and only three contracts for works have been recovered, they indicate that his work was highly valued in and beyond the

city of Quito. His patrons represented a range of social, political, and religious identities, including an educated cacique, an elite Spanish judge of the *audiencia*, a confraternity of Spaniards and Creoles, and a confraternity of mestizos. His works adorned the churches of both regular and secular clergy, and one painting was sent to the king of Spain.

"Pintar la figura de la letra"

Sánchez Gallque's elegant signature inscription on his 1599 triple portrait, *Francisco de Arobe and His Sons, Pedro and Domingo*, has commanded considerable scholarly attention as a statement of authorship and ethnic identity (*see plate 2*). Indeed, its relatively large, black lettering, set against the opalescent background and located directly beneath the cartouche containing a textual dedication to the king of Spain, unquestionably commands the viewer's attention. Yet signatures convey more than maker's marks, and Sánchez Gallque's inscription on this painting is decidedly more than a straightforward declaration of authorship. Beyond its semantic content, the graphic forms, materiality, and technologies of Sánchez Gallque's autograph on this painting reveal much about the artist and the lettered status of Andean painters in early colonial Quito. His depicted text connects script, painting, and authority, disclosing Sánchez Gallque's manipulation and domination of European languages of power.

The sophisticated scribal forms and conventions employed by Sánchez Gallque on his 1599 triple portrait bespeak extensive training and knowledge of European literate technologies. The alphabetic and pictorial literacies that were priorities for the Franciscan educational mission at the Colegio de San Andrés supported a range of instructional materials and practices to teach reading, writing, and calligraphy. Indeed, early chroniclers highlighted in particular the mastery of script exhibited by the Andean pupils at San Andrés, emphasizing their remarkable ability to copy and create choir books and other illuminated ecclesiastical manuals that required sophisticated calligraphic knowledge.[56]

In the sixteenth century, *cartillas*, grammars, and syllabaries were commonly employed pedagogical tools for learning to speak and read; however, one very popular class of manuals served the specific pedagogy of writing. The sixteenth century marked the rise and proliferation of calligraphy manuals, "artes de escribir," which offered theoretical, material, and technical instruction accompanied by models for proper and elegant penmanship. Juan de Yciar's *Arte subtilissima, por la qual se enseña a escrevir perfectamente* (1550) followed and expanded upon Italian prototypes, and was the first to introduce modern calligraphy to Spain. Other popular Spanish writing manuals, such as Pedro de Madariaga's *Libro subtilissimo intitulado honra de escriuanos* (1565), Juan de la Cuesta's "Tratado de bien y perfetamente escrivir" (1570), and Francisco Lucas's *Arte de escrevir* (1577), followed suit, and

Figure 6.6. Sample pages from Juan de Yciar, *Arte subtilissima, por la qual se enseña a escrevir perfectamente*, 1550. John M. Wing Collection, Newberry Library, Chicago. Wing zw 540 .11642. Photo courtesy of the Newberry Library, Chicago.

were published in numerous editions during the sixteenth and seventeenth centuries.[57] As testimony to their stature, abilities, and pedagogical practices, Yciar and Lucas served as calligraphy instructors for Spanish princes, and all of the *pendolistas* (calligraphers) dedicated their manuals to Spanish kings and princes.[58]

Although calligraphy manuals were certainly exported to the Americas,[59] the specific texts are not identified in Quito's sixteenth- and early seventeenth-century sales accounts and inventories; however, many generically named manuals—which could admittedly comprise a range of topics—frequently appear in the records.[60] Moreover, sales records for large quantities of quill pens (*cañones de escribir*), ink, and writing paper are registered repeatedly in this period.[61]

The "artes de escribir" combine letterpress pages of theoretical, technical, and pedagogical text with numerous woodcut plates illustrating calligraphy models of various scripts, sample pages of abbreviations, monograms, epigrams, and learned Latin and vernacular quotations (fig. 6.6). Additionally, the authors typically provide detailed advice regarding the selection and preparation of quill pens, ink, and paper, and offer instruction on the correct ways to hold and manipulate the pen in order to create specific types of script.

In addition to theoretical and technical instruction, the authors of the sixteenth-century "artes de escribir" promote calligraphy as a liberal art through text, inscription, and imagery, casting elegant script as the practice and profession of cultured gentlemen, and equating it with painting and the

visual arts. They enlist four principal tactics to persuade and instruct the reader of these truths: rhetorical texts, pictorial images, heraldic devices, and signatures.

For Juan de Yciar, the practice of calligraphy was foremost a self-conscious medium of artistic expression. He reminds readers of his 1550 *Arte subtilissima* of the book's mechanical form of reproduction, emphasizing that, in contrast, calligraphy is a creation of "la viva mano" ("the living hand"). Yciar viewed calligraphy as a noble and virtuous pursuit, and his volume taught the skill of handwriting as a fine art and as a sophisticated technology for the management of empire.[62]

Juan de la Cuesta, whose manual is in part titled "la verdadera practica para la buena pintura y figura de la letra," repeatedly equates calligraphy with the arts of painting and drawing, exhorting students to "pintar la figura de la letra" ("paint the form of the letter") and reminding them that "buena letra es buen dibujo" ("good handwriting is good drawing").[63] Pedro de Madariaga, in his *Honra de escribanos*, associates proper penmanship with upward social mobility, avowing,

> But I do not want to recount now how many sons of carpenters and blacksmiths and others of that sort have risen in our times to become great Lords, and for how many good calligraphy has provided the illustrious start of their [new] lineage: because there are so many and they are so new [to the elite] that I would be stating here what the whole world [already] knows.[64]

Following Yciar, Madariaga advocates for the status of calligraphy as a liberal art, and repeatedly stresses in his text that honor, virtue, elevated social standing, and financial gain accrue to those who practice the art of good penmanship.[65]

The manuals of Yciar and Madariaga employ portraiture, signatures and monograms, and heraldic devices to make the case for the nobility of calligraphy, and thus of its practitioners. Yciar's 1550 edition of the *Arte subtilissima* incorporates two versions of pictorial self-representation. A portrait bust of the author, which appears among the first pages of the volume, depicts Yciar as a finely attired gentleman whose gaze directly and powerfully engages the spectator (fig. 6.7). Framing his image is a Latin text rendered in Roman square capitals that gives his name and age, twenty-five years, emphasizing its status as a *retrato en vivo* (portrait from life). A second image, Yciar's scribal portrait, adorns the frontispiece: set within an architectural pediment, Yciar is presented as an erudite gentleman scholar at work in his study, recalling images of the doctors of the Church and learned humanists (fig. 6.8). Clad in the same elegant attire, Yciar sits at a desk before an open volume on which he inscribes alphabetic letters with a quill pen. His portrait is framed by a Latin motto, flanked by two angels holding the "arms of the scribe" (the pen, knife, inkwell, compass, and square) and banners that proclaim "honor" and

Figure 6.7. (*left*) Portrait of Juan de Yciar, *Arte subtilissima, por la qual se enseña a escrevir perfectamente*, 1550. John M. Wing Collection, Newberry Library, Chicago. Wing zw 540 .11642. Photo courtesy of the Newberry Library, Chicago.

Figure 6.8. (*right*) Scribal portrait of Juan de Yciar, frontis, *Arte subtilissima, por la qual se enseña a escrevir perfectamente*, 1550. John M. Wing Collection, Newberry Library, Chicago. Wing zw 540 .11642. Photo courtesy of the Newberry Library, Chicago.

"glory." Directly beneath and on axis with Yciar's portrait is a heraldic shield, reinforcing his status as a gentleman of noble lineage. A second escutcheon appears on axis below the central text, in which the monogram of the engraver, Juan de Vingles (I.D.V. for "Iohannes de Vingles"), is inscribed within a crowned heart. A variety of escutcheons marked with the names or monograms of Yciar and Vingles are inserted in images throughout the manual, often accompanied by the "arms of the scribe" (fig. 6.8; *see also fig. 6.12*). The authors of script and image thus consistently mark their identity and authorship, highlighting the art and nobility of calligraphy.

In a similar manner, Madariaga, a disciple of Yciar and a university professor of calligraphy, opens his *Honra de escrivanos* with a half-length portrait of himself clad in courtly finery and holding in his left hand a small book that suggests the portable size of his own calligraphy manual (fig. 6.9). The portrait is framed by a Latin text that names him and gives his age as twenty-eight years, fixing the image in time and indicating that it was made from life. Madariaga is represented as an erudite and cultured gentleman, reinforcing the thrust of his text, in which he avows that good penmanship leads to financial reward and upward social mobility.[66]

While all of the "artes de escribir" include illustrative models of scripts

and lettering processes, those of Juan de Yciar and his student Francisco
Lucas contain the most elaborate, beautifully executed, and extensive num-
ber of woodcut plates. Authorship is abundantly evident in every plate: each
bears the signature of Juan de Yciar and the monogram or full name of the
artist that cut the plates, Juan de Vingles (the latter's monogram appears in
inventive forms and locations throughout the volume, including the ruffle of
Yciar's left shoulder in his author portrait) (fig. 6.7).[67] Signature inscriptions
appear in both Castilian and Latin, and include indicators of authorship that
range from *faciebat* and *scribiebat* to *escrivía* and *execudebat*, emphasizing
the primacy of manual artistic production—"la viva mano"—and counteract-
ing the nature of the mechanically reproduced volume. Similarly, Francisco
Lucas signed his name to and conscientiously dated each plate, employing
exclusively the Spanish term *escrivía* to indicate artistic creation (*see figs.
6.10 and 6.11*).

Calligraphy manuals overwhelmingly associate good handwriting ("hacer
buenas letras") and the capacity to master the proper scripts with cultured,
elite status, and the visible form of script served as a vehicle for the commu-
nication of power and prestige.[68] In addition to social status, however, the

sophisticated forms, models, and techniques illustrated in the "artes de escribir" present elegant and proper penmanship, "buenas letras," as a graphic revelation of interior character. In much the same way that physiognomy in portraiture was believed to express the subject's interior nature: one's handwriting, one's mastery of the correct form, design, and proportion of letters, expressed one's inner virtue and noble quality (*calidad*).

The pedagogy of script in early colonial Quito would have been grounded in these principles and values. The evidence suggests that Sánchez Gallque likely figured among the first generations of students educated at the Colegio de San Andrés, for his knowledge, techniques, and professional practices appear to follow closely the training and precepts of the Franciscans. Although we do not know which writing manuals the Franciscans employed at San Andrés, instruction in calligraphy formed an important aspect of their educational endeavor. Sánchez Gallque's manifestly practiced and elegant signatures, and those of other Andean painters likely trained at San Andrés, offer compelling visual evidence of writing instruction that transcended "primeras letras."

If we return once again to Sánchez Gallque's signature inscription on the 1599 triple portrait and view it against the backdrop of contemporary calligraphy manuals, the artist's painted declaration of authorship emerges as a tour de force of erudition, mastery, and self-presentation (*see plate 2*). Beyond simply claiming authorship, Sánchez Gallque carefully formulates, modulates, and crafts his inscription, deploying such a full range of graphic, calligraphic, linguistic, and scribal conventions that it takes on the dense and almost impenetrable appearance of a code.

In its extended form, the inscription reads: "Andrés Sánchez Gallque native of Quito made this," yet what the viewer sees and is required to decipher is a series of elegantly rendered abbreviations: "ADR S˜HS GAL˜Q nl. de qᵗᵒ f." In just seven abbreviated words, the artist combines four distinct types of calligraphic lettering, each group of letters executed in a different script. In the first line of the inscription, Sánchez Gallque's abbreviated first name, "ADR," employs Spanish *Letra Bastarda* capitals (fig. 6.10); that of his first surname, "SHS," uses Italianate *Grifo* or *Grifado* capitals (fig. 6.11)—note particularly the first capital *H* form; and his second surname, "GALQ," is inscribed in Roman square capitals with serifs (fig. 6.12). The second line of the inscription is rendered in lowercase *Bastarda pequeña*, or Spanish cursive.

Sánchez Gallque selected an abbreviated contraction for his first name and crafted it as an elegant ligature (a glyph combining two or more letters) that recalls monograms or ciphers: three *Letra Bastarda* capitals (ADR) are adorned with controlled flourishes, superimposed, and interwoven to form an independent design. He implemented a more traditional ligature in his second surname, in which the Roman square capital letters *A* and *L* are conjoined in "GALQ." The graphic forms of these letters, ligatures, and flourishes echo calligraphy manuals and the monograms or devices of contemporary European printmakers.

BASTARDA

El que me sigue no anda en tinieblas,
mas terna lumbre de vida. Estas pa-
labras son de Christo, con las quales so-
mos amonestados que imitemos su
sanctissima vida, y costumbre si que-
remos ser librados de la cequedad del
FRAN. LUCAS. coraçon

Aa ab bc cd d ee ff gg hh ii jl ll mm nn oo p
p q qrr ſſſſſ ſſſ ts ss tt vv uu xx yy zz ſp
A A BB CC DD EE FF G
G H HI I LL MM N
N OO PP Q QRR SS
TT VV XX YY ZZ &
Letra del Grifo que escreuia Fran. Lucas En
Madrid. Año De. M. D. LXXVII.

Sánchez Gallque abbreviated all but one word in the inscription, forming sigla that include superscript letters (q^to.), flourished tilde suspension marks to indicate omitted letters ("s~hs" and "gal~q"), and punctuation marks between words to signal abbreviations. His inscription culminates with a Latin abbreviation: "f.," either for *fecit* (made this) or for *faciebat* (was making this), learned forms often employed by contemporary European artists, although his "f." tellingly renders ambiguous the specific conjugation of the verb. The variety of scripts, superscripts, and flourishes, as well as the use of suspension and punctuation marks, have their origins in sixteenth-century calligraphy manuals—although in none of these cases are they exact copies: Sánchez Gallque internalized the forms, techniques, and practices, and he manipulated these technologies in his own way, to his own ends.

Sánchez Gallque's signature inscriptions on paintings are executed with a technology very different from that of pen-and-ink autographs written on paper. The artist imitated with brush and paint the natural flow, cut, and serif forms of the pen to create the pictorial illusion of script. This painted imitation of calligraphy, quite literally "pintar la forma de la letra," is far more technically demanding than that required by the natural manipulation of the quill pen's stiff and precise edge. Calculated to create the graphic illusion of pen-and-ink lettering, Sánchez Gallque's painted inscription is not an autograph in the traditional sense—he goes far beyond the types of signatures affixed to documents to create a stunningly varied and masterful pictorial rendering of his personal identity and authorship.

Sánchez Gallque's triple portrait is a tour de force of the genre, but his signature inscription matches that achievement in graphic and calligraphic terms: it is a compendium of his mastery of far more than "buenas letras." Sánchez Gallque's carefully selected graphisms, his rendering of scripts, ligatures, flourishes, scribal abbreviations, superscripts, and punctuation, effectively code his text, restricting its access and appreciation to only those members of the sophisticated, lettered world of scribes and cognoscenti, thereby locating himself among them. If language is the companion of empire, then Sánchez Gallque's signature inscription fluently and artfully proclaims that he harnesses and masters this language of power.

In this sense, the triple portrait also contains a self-portrait—a graphic self-representation designed to express the artist's interior nobility and virtue. With the painted inscription of a mere seven abbreviated words, Sánchez Gallque purposefully and eloquently displays his status as a sophisticated, lettered artist of "calidad," and stakes his claim to the world of the *letrados.* Yet, on another level, by demonstrating his possession of a privileged scribal system of communication, Sánchez Gallque simultaneously recalls *quilca* and the specialized graphic forms of knowledge transcription and transmission in the precontact Inca empire. Like his signature inscription, Sánchez Gallque's employment of local pigments and materials that embodied Andean principles similarly encoded his painting, even if—or perhaps because—

Figure 6.10. (*facing page, top left*) *Letra Bastarda,* Francisco Lucas, *Arte de escrevir,* 1580. Photo: Hernán L. Navarrete. John M. Wing Collection, Newberry Library, Chicago. Wing zw 540 .L96. Photo courtesy of the Newberry Library, Chicago.

Figure 6.11. (*facing page, top right*) *Letra del Grifo,* Francisco Lucas, *Arte de escrevir,* 1580. John M. Wing Collection, Newberry Library, Chicago. Wing zw 540 .L96. Photo courtesy of the Newberry Library, Chicago.

Figure 6.12. (*facing page, bottom*) *Letra pequeña bastarda* and *letra romana cuadrada,* Juan de Yciar, *Arte subtilissima, por la qual se enseña a escrevir perfectamente,* 1559. John M. Wing Collection, Newberry Library, Chicago. Wing zw 540 .I1642. Photo courtesy of the Newberry Library, Chicago.

its intended recipient would not be able to decipher their language. Sánchez Gallque's triple portrait and graphic self-portrait employ language-within-language to proclaim mastery and control over his own circumstances: "I am a native of Quito, and I made this."

Later Generations, 1615–1650

During the first half of the seventeenth century, many of Quito's monumental colonial buildings were adorned with a wealth of painting, sculpture, altarpieces, and other furnishings. Nearly a dozen churches, chapels, monasteries, convents, and retreats were completed, expanded, or rebuilt during this period, the interiors of which were elaborately decorated, requiring the labor and skill of a wide range of artisans, including painters. The dramatic expansion and adornment of the urban fabric is reflected in the large number of painters that enter the archival record during this period and in the correspondingly greater numbers of documented artistic commissions. Additional European and Creole painters figure among the later generations, yet Andeans continued to dominate the profession. In particular, Andean painters migrated to Quito from other regions of the *audiencia* seeking opportunities in the expanding urban center.

With one exception, the generations of painters of that followed Sánchez Gallque and his contemporaries are first documented after 1615, and most were likely born in the 1590s or in the first decades of the seventeenth century.[1] The later generations comprise a total of forty-three documented painters, as compared with fifteen in the first generations. These painters, many of whose professional lifetimes extend into the second half of the seventeenth century, were overwhelmingly Andeans. Table 7.1 registers thirty-three Andean painters, nine Spanish or Creole painters, and one of ambiguous ancestry.

Among the professional titles held by painters of this period, table 7.1 lists a total of fifteen as "master painter," a substantial increase over the early generations. Of these, nine are identified as Andean; five are Spanish or Creole; and the ancestry of one is ambiguous.[2] Four artists, all Andeans, are identi-

Table 7.1. Painters in the documentary record, 1615–1650, by chronological first appearance

Name	Title(s)	Ethnicity	Literacy	Residence
Mateo Mexía	Master painter	Andean? Mestizo? Creole?	Signature	S. Roque
Felipe Guaman	Painter	Andean	Signature	S. Blas
Mateo Ataurimache	Painter	Andean	Signature	S. Roque
Antonio Gualoto	Master painter, gilder, woodworker	Andean	Unlettered	S. Blas
Felipe Díaz	Master painter	Spanish or Creole	Signature	
Juan Fonte Ferreira	Master painter, gilder, sculptor	Spanish or Creole	Signature	
Felipe Sánchez	Painter	Spanish or Creole	Signature	
Clemente Quispe	Master painter	Andean	Signature	S. Roque
Lucas Vizuete	Master painter	Andean	Signature	S. Roque / Sta. Barbara
Sebastián de Herrera del Castillo	Master painter	Spanish or Creole	Signature	
Hernando de la Cruz	Painter	Creole	Signature	Cathedral
Francisco Cúpido	Painter	Andean		S. Roque
Miguel Ponce	Master painter	Andean	Signature	Sta. Barbara
Bernabé Boyolema	Painter	Andean		Sta. Barbara
Juan Gualoto	Painter	Andean	Signature	S. Blas
Diego Gualoto	Painter, gilder	Andean	Signature	S. Blas
Francisco Bedón	Painter	Andean	Unlettered	S. Blas
Roque Sarango	Painter	Andean		
Diego de Zúñiga	Master painter	Andean		S. Roque
Bernal de Zúñiga	Painter	Andean		S. Roque
Lorenzo Ignacio	Journeyman painter	Andean	Signature	S. Roque
Gerónimo Chumbiñaupa	Painter	Andean	Signature	S. Roque
Cristóbal Chumbiñaupa	Painter	Andean	Signature	S. Roque
Diego Lima Tandapaqui	Painter	Andean	Unlettered	S. Marcos
Andrés Bucial	Painter	Andean		S. Roque

Name	Title(s)	Ethnicity	Literacy	Residence
Marcos Velázquez	Gilder, painter	Spanish or Creole	Signature	
Francisco Pérez Sanguino	Painter, master gilder	Spanish or Creole	Signature	S. Roque
Francisco Sánchez	Master painter	Andean	Signature	S. Roque
Mateo Galquín	Painter	Andean		S. Roque
Salvador Marín	Master painter	Spanish or Creole	Signature	Sta. Barbara
Tomás de Zúñiga	Painter	Andean	Signature	S. Roque
Alejandro de Ribera	Painter	Andean	Signature	
Cristóbal Faizán	Journeyman painter, sculptor, gilder	Andean		Sta. Barbara
Felipe Méndez	Painter	Andean	Unlettered	S. Blas
Pedro Cañar	Painter	Andean		S. Marcos
Esteban Cáceres	Painter	Andean		S. Roque
Melchor Díaz	Master painter, sculptor	Andean	Signature	S. Blas
Garcia Chaquinga	Journeyman painter	Andean		S. Blas
Sebastián de Quirós	Master painter, gilder	Andean	Signature	S. Marcos
Gabriel Vásquez	Master painter	Andean	Signature	S. Roque
Gerónimo Vásquez	Painter	Andean	Unlettered	S. Sebastián
Juan de Salinas Vizuete	Master painter	Spanish or Creole	Signature	
Francisco Pillajo	Journeyman painter	Andean	Unlettered	S. Blas

fied as "journeyman painter." Again, in the absence of a painters' guild, the preponderance of Andean journeymen and master painters points to the existence of an alternative form of professional organization within the Andean community in which standard European terms for designating rank were employed.

The number of artistic commissions, payment records, and signed paintings increased significantly during this period. Twelve painters account for twenty-nine extant contracts, payment records, and signed paintings between 1615 and 1650. Six of these artists are identified as Andean, five as Spanish or Creole, and one, Mateo Mexía, is of uncertain ancestry.

The majority of painters documented in Quito during the first half of the seventeenth century were lettered artists who signed their names to contracts with a sophisticated and elegant hand. As evidenced in table 7.1, of the thirty-two painters who were principal parties to notarial contracts, only six were unlettered, less than 20 percent.[3] Significantly, the percentage of unlettered painters in the later generations more than doubled from that of the earlier painters, wherein only one in twelve, or 8 percent, was unlettered. In the later period, every one of the unlettered painters was Andean. Statistically, these proportions indicate a decline in literacy among Andean painters in the later generations that may be related to the closure or transformation of the Colegio de San Andrés or the relative inaccessibility or high cost of education. The rise in unlettered painters also suggests that more such artists were engaging with the legal system. The decline in literacy may also be linked to broader trends in the viceroyalty, wherein Spanish civil and religious authorities sought to "dumb down" and control access to education for Andeans, complaining that they would only use this knowledge to engage in lawsuits and otherwise undermine the social order.

Nonetheless, the evidence demonstrates that, during the first half of the seventeenth century, the majority of painters signed their names to legal documents. Those that did so almost invariably penned their names with a practiced hand, and many employed sophisticated rubrics, abbreviations, ligatures, and other scribal conventions that demonstrate knowledge far exceeding "primeras letras."

Mapping the Urban Geography of Painters

The number and distribution of painters' residences expanded dramatically during the first half of the seventeenth century, infiltrating additional parishes and exhibiting growing concentrations in those with already established communities of painters. Just as the early generations of painters were concentrated almost exclusively in the dominant *hanan* parish of San Roque, the later generations demonstrate a continued expansion in that zone. The *hanan* parishes of San Marcos and San Sebastián saw smaller but nonetheless substantial increases in the number of painters as well. One painter, the Jesuit Hernando de la Cruz, resided in the Jesuit Compañía, located on the *hanan* side of the Cathedral parish. The *hurin* parishes of San Blas and Santa Barbara also experienced significant growth, each more than doubling in the number of painters recorded for the earlier generations. Table 7.1 lists the parishes for painters whose domiciles are indicated in the documentary record, leaving the column blank for those whose residences are unknown.

Notaries typically identified the parish of residence of Andeans who were parties to legal contracts, while that of Spaniards and Creoles was not recorded. The few contracts in which Spanish or Creole painters purchased or rented houses establish their locations; however, the domiciles of the major-

ity of such painters are unknown. Of the three European or Creole painters for whom residences are recorded, one lived in the Cathedral parish, one in Santa Barbara, and the other in San Roque. The only painter of ambiguous ancestry also lived in the parish of San Roque.

By contrast, the parish of residence for thirty-one of the thirty-three Andean painters is recorded, providing an ample vision of their urban distribution. In *hanan* Quito, the parish of San Roque continued to house the majority of Andean painters during the first half of the century, boasting fifteen of the thirty-one such painters for whom domiciles are registered. The parish of San Marcos added three Andean painters to its community, and San Sebastián, which in 1597 had lost all of its painters to San Roque when the latter parish was established, housed one Andean painter in this later period.

The parishes of *hurin* Quito also saw a substantial rise in the numbers of Andean painters in residence. San Blas added nine during this period, a significant increase over the single such painter recorded for the earlier generations. Similarly, the parish of Santa Barbara, formerly the home of a single Spanish painter, expanded to include four Andean painters within its borders. Overall, the documentation from the first half of the seventeenth century demonstrates that San Roque retained its primacy as the dominant residential parish for Andean painters. San Blas harbored a growing concentration of Andean painters, and Santa Barbara, San Marcos, and San Sebastián established smaller enclaves.

The geographic expansion and growing concentrations of painters during the first half of the seventeenth century had implications for the lives and professional activities of the later generations of painters. Given the large number of Andean painters whose residences are known, viewing them through the *hanan/hurin* lens affords an additional and important perspective on the urban geography of such artists. Mapping the distribution of painters throughout the city discloses familial and proximal relationships that suggest collaborative professional endeavors, locates concentrations of lettered painters, and highlights the geographical proximity of painters' residences to monumental religious buildings that were completed and decorated during this time.

The Painters of *Hanan* Quito: The Parishes of San Roque, San Marcos, and San Sebastián

The dominant *hanan* half of colonial Quito included the southern parishes of San Roque, San Marcos, and San Sebastián, and extended far to the south, reaching past Riobamba and beyond Cuenca. The documentation that forms the basis for table 7.1 traces a number of family dynasties of painters in the parish of San Roque. Indeed, many of the painters recorded in this parish represent fathers, sons, brothers, and other relatives of painters from earlier generations. Most bear Quechua surnames from central Peru, underscoring

the convergence of painters of Inca ancestry in the southern half of the city, particularly in the parish of San Roque.

The Painters of San Roque

During first half of the seventeenth century, San Roque substantially expanded its primacy as the parish housing the majority of urban painters. All but one of the painters in this parish were Andean. The generational continuity of painters and extending webs of familial relationships were unquestionably significant factors in the increased numbers and concentration of such artists in the parish. In many instances, the family members and successive generations of painters followed in the profession. This was so with the sons, brother, and brother-in-law of Andrés Sánchez Gallque, as well as a host of other Andean families of painters. Although familial surnames were not consistently maintained within the Andean community in Quito, a significant number of genealogical relationships among painters may be traced in the documentary record. This is especially evident in San Roque, where, in addition to the offspring of painters from the first generations who practiced the profession, the Chumbiñaupa, Zúñiga, and Quispe families produced successive generations of painters in the seventeenth century. However, surnames are not always indicators of family ties; documentation can often confirm or disprove such links, and occasionally provides important evidence of extended family members associated with the painting trade who might not otherwise be recognized as such.

San Roque housed the majority of artists who bore the title of "master painter," in addition to the vast majority of lettered painters in early colonial Quito. Eleven painters inscribed their signatures—the total number of those in the parish who were parties to notarial documents. Put another way, every painter from San Roque who was party to a notarial document was lettered. By contrast, literacy varied among the relatively small number of painters in the other *hanan* parishes: San Marcos housed one lettered and one unlettered painter, and the only painter recorded in San Sebastián was unlettered.

This panorama indicates that something significant in terms of alphabetic literacy was happening in the parish of San Roque. Certainly the earlier generations of painters in that parish were lettered, and they likely acquired literate technologies at the nearby Franciscan Colegio de San Andrés. Following the Franciscan tradition of converting pupils into teachers, the lettered painters of San Roque may have instructed their sons or sent them to educational institutions. Indeed, the Andean community of San Roque was notably active with regard to education, perhaps beyond what even the Franciscans had envisioned. Perhaps also the painters and artisans whose homes surrounded the residence of Atahualpa exemplified continuities between elite, precontact Inca specialized technologies of graphic communication and Western systems of letters and pictorial representation.

Two examples underscore the latter points and simultaneously highlight

the power of language wielded by the Andean painters of San Roque. A 1631 declaration made by Doña Ana Tucto, daughter of Don Mateo Yupanqui and resident of San Roque, registers that the text had been recorded "by means of the language and interpretation of Lorenço Ygnaçio journeyman painter, *ladino* in the Castilian language and that of the Inca, who swore [the truth of] its contents to the said Doña Ana Tucto."[4] Ignacio inscribed his signature at the end of the document. It is particularly noteworthy that an Andean painter from San Roque served as an interpreter, reader, and reviewer of a notarial document in the service of an unlettered Andean registrant.

As mentioned in chapter 1, a second example illustrates the recognition and appropriation by Andean painters and artisans of San Roque of the power that Western education in letters afforded. In 1632, a group of Andean "principales y naturales" of the parish, Don Felipe Vilca, governor, Antón Chachicha, *alcalde*, Francisco Cayllagua (carpenter), Clemente Quispe (painter), Esteban Rimache (blacksmith), and Mateo Ataurimache (painter), took control over the education of young boys in their community. In that year, each signed their name to a notarial contract in which they hired the choir- and schoolmaster Don Luis de la Torre to "to teach the boys of the parish to read, write, and sing."[5]

In the first half of the seventeenth century, San Roque housed two principal, although interrelated, enclaves of painters. The domiciles of one group were clustered around the residence of the descendants of Atahualpa, located in the northern sector of the parish nearest the Monastery of San Francisco and the city center. The largest number of painters, however, possessed homes in the southwestern neighborhood of Miraflores near the Franciscan Recoleta de San Diego, a more rural zone on a flank of the volcano Pichincha. Construction of the Recoleta de San Diego in the first decade of the seventeenth century and its subsequent decoration undoubtedly contributed to the cluster of painters and artisans in the surrounding neighborhood.[6]

AT THE RESIDENCE OF ATAHUALPA

The elite barrio surrounding the lands and residence of the descendants of Atahualpa continued to be an epicenter for Andean painters and artisans in the first half of the seventeenth century. Although an abundance of documentation exists for the majority of painters who resided in this neighborhood, for a few, such as the Andean painter Francisco Cúpido and the Andean master painter Gabriel Vásquez, their existence and residences appear only tangentially in the archival record.[7]

During this period, Andrés Sánchez Gallque continued to live in San Roque with Barbara Sasticho, his Andean wife, and their painter sons, Francisco Sánchez and Matheo Galquín, in a house that adjoined the lands and residence of the Atahualpas. After Sánchez Gallque's death, sometime before 1633, his wife and sons continued to reside there into the late 1630s.[8] Despite the fact that Sánchez Gallque's son, Francisco Sánchez, bore the title of "master painter," and his brother that of "painter," no evidence of artistic

commissions for either has been found. With Sánchez Gallque's death, his family seems to have hit upon hard times, for in 1633 they sold a *caballería* of land in Zámbisa, and in 1638 they mortgaged their house and property in San Roque "in order to supply our needs."[9] In 1639, Sacticho and her sons sold a vacant plot of land that they owned in San Roque, near the Franciscan Recoleta de San Diego.[10] The transaction discloses that Sacticho was a relative of the Andean painter Cristóbal Chumbiñaupa, whose land bordered the plot that she sold.[11]

Sánchez Gallque's brother, Bernabé Simón, lived in a neighboring house, at least until 1625.[12] Although no record indicates Simón's artistic commissions beyond the 1608 painting on which he collaborated with his brother, he appears to have fared well enough economically, for in 1624 he purchased a tract of land in the nearby town of Zámbiza.[13] Simón inscribed his competent signature and rubric on the documents to which he was party (*see figs. 1.2e and 6.3*).

The Andean painter Mateo Ataurimache lived with his wife, Barbara Chumbibilca, near the Atahualpa residence on land adjacent to the homes of numerous Andean artists, including the architect and builder Don Francisco Morocho and the painter Mateo Mexía. Ataurimache had received the land in 1617 as a donation from the painter Juan Chauca.[14] Ataurimache also occupied important political posts in the parish. He is named as "cacique principal de San Roque" in several later documents, where he bought and sold land, as well as in the nearby Andean community of Oyumbicho.[15] A lettered artist, Ataurimache was among the painters and artisans of San Roque who signed his name to the 1632 contract hiring a schoolteacher to instruct the boys of the parish.[16] Despite his identification as a painter in numerous documents, Ataurimache's artistic production has not been discovered in any contracts.

AT THE RECOLETA DE SAN DIEGO

In the early 1630s, the Andean painters and brothers Gerónimo and Cristóbal Chumbiñaupa shared a tile-roofed house in the parish of San Roque that fronted the plaza of the Franciscan Recoleta de San Diego.[17] In 1633, Gerónimo Chumbiñaupa acquired his own tile-roofed house with an orchard in the parish, located near that of his brother, purchasing it for the impressive sum of four hundred *patacones* from the Andean mason Francisco Landa.[18] In the 1640s, the brothers again bought homes in the same parish that represented substantial financial investments.[19] In the 1670s, Cristóbal Chumbiñaupa was recorded as a prestigious "veinte y quatro" in the Cofradía del Rosario in the Dominican Convent of Santa Catalina, an elite membership status that involved greater obligations and higher dues.[20] Although no painting commissions have been recovered for either brother, their business as professional artists appears to have been quite lucrative.

The Chumbiñaupas were lettered artists who navigated easily the Spanish colonial bureaucratic world, often employing it to their advantage and to

Figure 7.1. Signature of Cristóbal Chumbiñaupa, 1647. ANH/Q, Notaría 1a, vol. 186, 1647, Diego Bautista, fol.170v.

Figure 7.2. Signature of Gerónimo Chumbiñaupa, 1632. ANH/Q, Notaría 1a, vol. 142, 1632, Gerónimo de Heredia, fol. 402v.

that of their community. In 1621, Gerónimo Chumbiñaupa signed his name alongside those of other Andean painters and artisans in the parish of San Roque to a power of attorney in a successful lawsuit that they brought against the Spaniard Francisco Sánchez Benítez for dispossession of community lands in the parish.[21] The assured signatures of each painter appear on the various contracts to which they were party, demonstrating the employment of sophisticated abbreviations, diacritical and suspension marks, and rubrics (figs. 7.1 and 7.2).

CLEMENTE QUISPE (ACTIVE 1623–1638)

Another important family of Andean painters and artisans in San Roque was the Quispe clan, whose surname links them with Inca and central Peruvian origins, many of whom resided in the neighborhood of the Recoleta de San Diego.[22] Several members of the extended Quispe family occupied important sociopolitical posts in the parish of San Roque. Pedro Quispe "yndio herrero" served as "alcalde de la parroquia de San Roque" from 1598 through the first decade of the seventeenth century.[23] Pedro's brother, the Andean master painter Clemente Quispe, was governor of the parish in the mid-1630s, and his son Alejandro Quispe and grandson Isidro Quispe succeeded him in that post.[24]

Clemente Quispe "yndio pintor" first appears in the documentary record in 1623 when he signed a contract to rent three *caballerías* of land in the indigenous community of Puembo.[25] His residence in San Roque is first mentioned in a 1629 contract, in which "Clemente quispe yndio ladino en lengua castellana maestro pintor" purchased a thatch house and land in the

neighborhood of the Franciscan Recoleta de San Diego for 260 *patacones*.[26] Quispe lived with Francisca Çisa, his Andean wife, and other members of his extended family, including Esteban Cáceres "yndio pintor," to whom Quispe was related by marriage.[27] Moreover, Quispe's niece, María Pasña, was married to the painter Mateo Mexía, although their residence was not located in the same sector of San Roque.[28] In 1638, Quispe's immediate neighbors were elite Andean artisans, including the master carpenter and architect Don Francisco Morocho, the carpenter Francisco Cayllagua, and the carpenter Pedro Paucar, all of Inca ancestry.[29] To the north, their lands bordered those of the descendants of Atahualpa, sited between the Recoleta de San Diego and the Franciscan monastery, thus linking Quispe to the center of traditional Inca authority in Quito.

Among other elite members of the parish of San Roque, Clemente Quispe was also a signatory to the 1631 contract in which the Andean parishioners of San Roque hired a schoolmaster to teach their children.[30] Clemente, like other members of his family, autographed each notarial document to which he was party (fig. 7.3). The Andean painter Francisco Quispe, who signed and dated the large canvas known as the *Passion of Christ* (1668) that hangs today in the Franciscan Museo Fray Pedro Gocial, was undoubtedly a member of the Quispe family of painters in San Roque.[31]

THE ZÚÑIGA DYNASTY

During the seventeenth century in San Roque, the Zúñiga family constituted another extended clan of Andean painters and artisans of various sorts. In 1631, the Andean master painter Don Diego de Zúñiga lived with his son Tomás de Zúñiga—also a painter—in a sector of the parish near the Franciscan Recoleta de San Diego.[32] Don Diego's younger brother, the painter Don Bernal de Zúñiga, was another patriarch of the Zúñiga dynasty of painters, and both of his sons were painters, as well. Don Bernal lived with his wife, Doña Francisca Llagtapalla, in San Roque near his brother and the Franciscan Recoleta de San Diego.

Llagtapalla's extraordinarily rich 1672 testament lays out much of the

Zúñiga family genealogy, and reveals important aspects of her husband's professional career. Llagtapalla declared that she and the deceased Don Bernal had raised two sons, Don Sebastián de Zúñiga and Don Josef de Zúñiga, both of them painters, in addition to Doña Catalina Llagtapalla, and a grandson, Blas de Zúñiga. She also confirmed that the painter Don Diego de Zúñiga was her husband's older brother. The honorific titles of "Don" and "Doña" held by many of its members underscore the elite status of the Zúñiga family. Linking her family to a confraternity traditionally associated with painters, Llagtapalla confessed she owed money to the "confraternity of Saint Luke of the natives [*naturales*], founded in the monastery of San Francisco."[33] This is the earliest known reference to the Confraternity of Saint Luke, which occupied a side altar in the Franciscan Capilla de Cantuña—the chapel that had once served the Colegio de San Andrés.

No formal contracts or extant works are known for Bernal de Zúñiga; however, Llagtapalla's testament portrays in great detail her husband's professional career and workshop. She adumbrated a series of finished and unfinished works that remained upon his death, demonstrating that he was a prolific painter of canvases and panels as well as a sculptor and painter of statuary, and she referenced a large set of prints that he used as models. She also described some of the tools of her late husband's trade, which she bequeathed to her sons:

My deceased husband told me in life that both brothers, my sons, should have the stone for grinding pigments, and I declare this to be the case [. . .] I declare that I possess a painted holy image of Our Lady of the Rosary that measures one and one-half varas in height [. . .] I declare that I inherited from my deceased husband a small image of Our Lady of the Angels painted on wood panel [. . .] a medium-sized holy image of the advocation of Our Lady of Oyacachi sculpted in the round of three-quarters of a vara in height that is yet to be gilded and painted with flesh tones, which I inherited from my husband [. . .] seven picture frames and six small wood panels ready to be painted [. . .] ninety-six old and new engravings, large and small, of different images [. . .] one small sculpture of Saint Joseph = and another small sculpture of Saint Anthony = and another small sculpture of Saint Francis—that remains to be finished [. . .] three unfinished wood panels, two of them somewhat wide and the other narrow [. . .] six pieces of uncarved wood [. . .] one piece of cedar for sculpture that cost twelve reales.[34]

This inventory of Don Bernal's workshop indicates a highly productive center of both painting and sculpture, in which his sons and extended family members were undoubtedly involved, with a trove of engravings that served as artistic models.

Llagtapalla locates the family residence in San Roque, near the Francis-

can Recoleta de San Diego, adjacent to the home of her nephew Don Tomás de Zúñiga. He, too, was an Andean painter, son of the painter Diego de Zúñiga. In a 1633 contract, Don Tomás is identified as an "yndio pintor ladino," when he and his Andean wife, Doña María Mencia, sold three blocks of land in the nearby indigenous community of Tumbaco.[35] In 1684, Don Tomás signed a notarial document transferring property in the parish of San Roque to his nephew, Sebastián de Zúñiga.[36] In this document, Don Tomás stated he was "the eldest and legitimate son of Don Diego de Zúñiga, my deceased father, natives of the town of Tumbaco and residents of the parish of San Roque."[37] Don Tomás avowed that he made the transfer of property with the agreement of his sons, Don Pedro, Don Ventura, and Don Antonio de Zúñiga, all of whom signed the document. At least one of Don Tomás's sons was an artisan: Ventura de Zúñiga is identified as a master sculptor in several documents, and he continued to live and practice his trade in the parish of San Roque well into the final decade of the seventeenth century.[38]

Two additional Andean painters lived in the parish of San Roque near the Recoleta de San Diego: Mateo Mexía and Lucas Vizuete. Mexía's record and extant paintings form the subject of the following chapter. Vizuete is the only Andean painter of this or indeed of any earlier generation who is documented as moving his residence from one parish to another. In the 1620s, Vizuete lived in San Roque near the Recoleta de San Diego, and in 1632 he purchased a house in the parish of Santa Barbara. Because Vizuete resided for most of his career in Santa Barbara, his life and work are considered below in the section that focuses on the parishes of *hurin* Quito.

FRANCISCO PÉREZ SANGUINO (1633–1659)

The only documented Spanish or Creole painter to live in San Roque during this period, and indeed, one of the few such painters for whom a parish of residence can be established, was Francisco Pérez Sanguino. Prior to 1643, Pérez Sanguino lived for some time in a substantial residence in the neighborhood of the Recoleta de San Diego. In that year he sold the house and land for the considerable sum of 450 *patacones*.[39] Where he lived after selling his house is unknown, although he was active in the city of Quito until at least 1659.

In all but the earliest document related to Pérez Sanguino he is identified as a "master gilder." Indeed, all of Pérez Sanguino's artistic contracts and payment records involve the gilding of altarpieces, furnishings, and architectural elements, a number of which included painting, polychromy, and *estofado*. Only the earliest document involving Pérez Sanguino identifies him as a "painter," yet this contract records a loan of 102 *patacones* that he made to the painter Juan Fonte (who appears with the title of gilder in other documents), suggesting that the two may have collaborated on painting commissions.[40] All subsequent documents identify Pérez Sanguino as either a "gilder" or "master gilder." That gilding was his principal profession is further under-

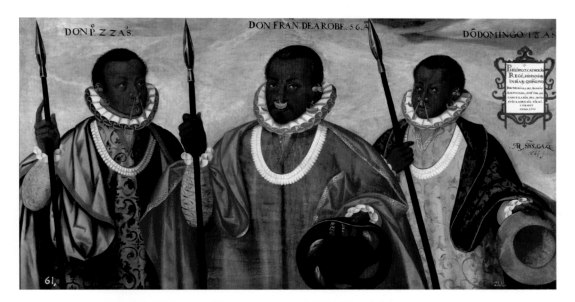

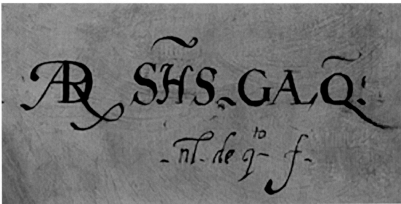

Plate 1. (*top*) Andrés Sánchez Gallque, *Francisco de Arobe and His Sons, Pedro and Domingo*, 1599. Oil with gold on canvas, 92 × 175 cm. Museo de América, Madrid. Photo: Courtesy of the Museo de América, Madrid.

Plate 2. (*bottom*) Detail of Sánchez Gallque's signature inscription, *Francisco de Arobe and His Sons, Pedro and Domingo*, 1599.

Plate 3. (*above*) Textile fragment from La Florida tombs, 220 CE-640 CE. Dyed and/or painted cotton and camelid fiber. Museo del Sitio La Florida, Quito. Photo: Hernán L. Navarrete.

Plate 4. (*right*) Textile fragment from La Florida tombs, 220–640 CE. Dyed and/or painted cotton and camelid fiber. Museo del Sitio La Florida, Quito. Photo: Susan V. Webster.

Plate 5. Marcos Velázquez, polychromy of choir loft seats, 1636. Church of the Monastery of San Francisco, Quito. Photo: Hernán L. Navarrete.

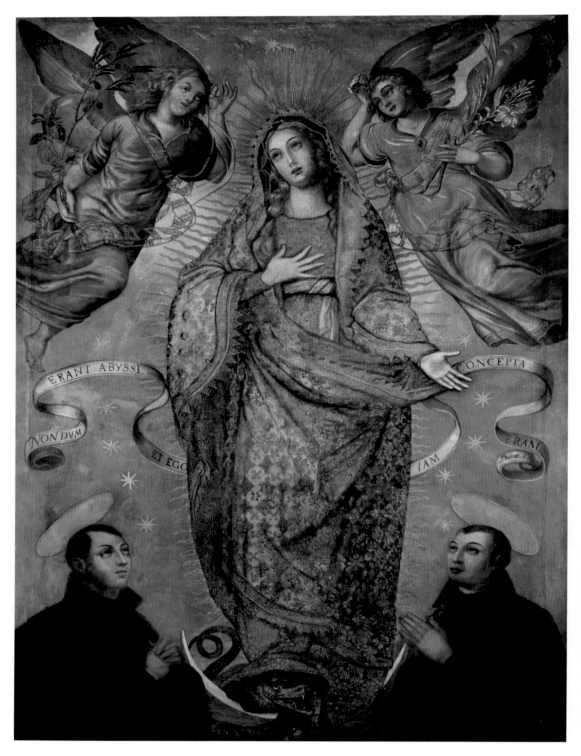

Plate 6. Pedro de Vargas (attrib.), *Immaculate Conception with Jesuit Saints*, ca. 1591. Oil on canvas, 2.48 x 1.47 m. Cathedral of Quito. Photo courtesy of Judy Bustamante.

Plate 7. Angelino Medoro (attrib.), *Virgen de la Antigua with Saints and Donors*, 1587. Oil and tempera on wood panel, 2.50 x 2.00 m. Church of the Monastery of Santo Domingo, Tunja, Colombia. Photo: Hernán L. Navarrete.

Plate 8. (*facing page*) Angelino Medoro, *Agony in the Garden*, signed and dated 1587. Oil and tempera on canvas, 2.12 × 1.34 m. Cathedral of Tunja, Colombia. Photo: Hernán L. Navarrete.

Plate 9. (*above*) Angelino Medoro (attrib.), *Christ at the Column with the Repentant Saint Peter*, late sixteenth century. Oil and tempera on wood panel. Cathedral of Tunja, Colombia. Photo: Hernán L. Navarrete.

Plate 10. Angelino Medoro, *Coat of Arms*, signed and dated 1592. Oil on canvas, 1.89 x 1.65 m. Monastery of Santo Domingo, Quito. Photo: Hernán L. Navarrete.

Plate 11. (*facing page*) Signature of Medoro on *Coat of Arms*. Photo: Hernán L. Navarrete.

Plate 12. Angelino Medoro (attrib.), *Virgin and Child with Saints Peter, Paul, Jerome, and Francis*, late sixteenth/early seventeenth century. Oil on canvas, 1.76 x 1.66 m. Convent of the Immaculate Conception, Quito. Photo: Hernán L. Navarrete.

Plate 13. Pedro Bedón, *Virgin of the Rosary*, ca. 1588. Pen, ink, and wash on laid paper. "Reglas de la Cofradía del Rosario." Location unknown. Photo courtesy of Thomas B. F. Cummins.

Plate 14. Anonymous, *Portraits of Fray Pedro Bedón and Sebastián Dávila*, ca. 1620s–1630s. Mural painting. Church of the Monastery of Santo Domingo, Quito. Photo: Hernán L. Navarrete.

Plate 15. Pedro Bedón (attrib.), choir book illumination, ca. 1613. Oil and tempera with gold on parchment. Monastery of Santo Domingo, Quito. Photo courtesy of Thomas B. F. Cummins.

Plate 16. Andrés Sánchez Gallque, *Denial and Repentance of Saint Peter*, signed and dated 1605. Oil and tempera on panel, 29.5 x 22 cm. Museo Colonial Charcas, Sucre, Bolivia. Photo courtesy of the Museo Colonial Charcas, Sucre, Bolivia.

Plate 17. Luis de Morales, *Saint Peter in Tears Before the Flagellated Christ*, ca. 1570. Oil on panel, 73 × 55 cm. Photo courtesy of the Catedral de Nuestra Señora la Real de la Almudena, Madrid.

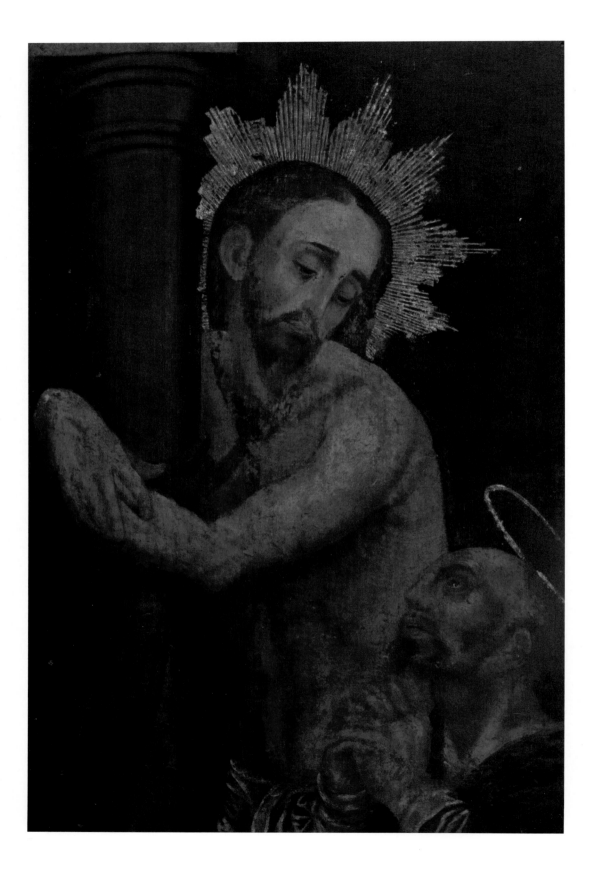

Plate 18. (*facing page*) Anonymous, *Repentance of Saint Peter*, late sixteenth or early seventeenth century. Oil and tempera with gold on panel, 0.67 x 0.44 m. Museo de Arte Colonial, Quito. Photo: Hernán L. Navarrete.

Plate 19. (*above*) Francisco Pérez Sanguino, pulpit, 1636. Gilded and polychrome wood with *estofado*. Church of the Convent of the Immaculate Conception, Quito. Photo: Hernán L. Navarrete.

Plate 20. Antonio Gualoto, altarpiece, 1650s. Gilded and painted wood. Lower cloister, Monastery of La Merced, Quito. Photo: Hernán L. Navarrete.

Plate 21. (*facing page*) Antonio Gualoto, putti and Franciscan tertiaries, 1654. Mural painting with gold leaf. Crossing arch, Church of the Monastery of San Francisco, Quito. Photo: Hernán L. Navarrete.

Plate 22. Anonymous, *Saint Dominic Curing a Sick Man*, mid-seventeenth century. Oil on canvas, 2.21 X 2.91 m. Monastery of Santo Domingo, Quito. Photo: Hernán L. Navarrete.

Plate 23. Anonymous, *Miracle of Saint Dominic Curing the Cardinal's Nephew*, mid-seventeenth century. Oil on canvas, 2.19 × 2.36 m. Monastery of Santo Domingo, Quito. Photo: Hernán L. Navarrete.

Plate 24. (*facing page*) Lucas Vizuete(?), *Saint Teresa of Avila*, ca. 1629? Oil on canvas, 101 × 85 cm. Location unknown. Photo courtesy of the Instituto Nacional de Patrimonio Cultural del Ecuador.

Plate 25. (*above*) Anonymous, *Saint Teresa of Avila*, nineteenth century? Oil on canvas, 90 × 60 cm. Church of the Convent of the Immaculate Conception, Quito. Photo: Hernán L. Navarrete.

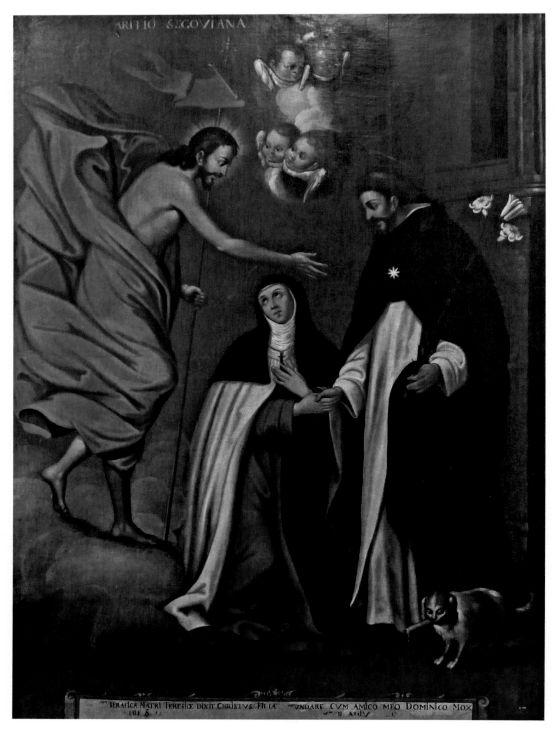

Plate 26. Juan de Salinas Vizuete, *Apparition of Jesus and Saint Dominic to Saint Teresa of Avila*, signed and dated 1648. Oil on canvas, 1.76 x 1.16 m. Convent of Santa Clara, Quito. Photo: Hernán L. Navarrete.

Plate 27. Mateo Mexía, *Saint Francis and Tertiaries*, signed and dated 1615. Oil and tempera with gold on canvas, 255 × 203 cm. Museo Fray Pedro Gocial, Monastery of San Francisco, Quito. Photo: Hernán L. Navarrete.

Plate 28. (*facing page*) Mateo Mexía (attrib.), *Triumph of the Risen Christ*, early seventeenth century. Oil and tempera with gold on canvas, 249 x 163 cm. Museo Jijón y Caamaño, Pontificia Universidad Católica del Ecuador, Quito. Photo courtesy of Judy Bustamante.

Plate 29. (*top*) Detail of donor portraits, *Triumph of the Risen Christ*. Photo: Susan V. Webster.

Plate 30. (*bottom*) Detail of female donor portrait, *Triumph of the Risen Christ*. Photo: Susan V. Webster.

Plate 31. Mateo Mexía, *Saint Michael Archangel*, signed and dated 1615. Oil and tempera with gold on canvas, 252 × 203 cm. Monastery of San Francisco, Quito. Photo: Hernán L. Navarrete.

Plate 32. Mateo Mexía (attrib.), *Annunciation*, early seventeenth century. Oil and tempera with gold on canvas, 248 × 203 cm. Monastery of San Francisco, Quito. Photo: Hernán L. Navarrete.

Plate 33. Detail of *Annunciation*. Photo: Susan V. Webster.

Plate 34. (*facing page*) Anonymous, *Virgin of the Rosary with Saints*, second half of the seventeenth century. Oil with gold on canvas, 165.5 × 103 cm. Museo Fray Pedro Bedón, Monastery of Santo Domingo, Quito. Photo: Hernán L. Navarrete.

Plate 35. Anonymous, *Virgin Tota Pulchra with Augustinian Saints*, second half of the seventeenth century. Oil with gold on canvas, 0.82 x 1.00 m. Recoleta de San Diego, Quito. Photo: Hernán L. Navarrete.

lined by a 1636 contract in which Pérez Sanguino "maestro dorador" accepted Pedro Gutiérrez as an apprentice in the trade for a period of four years.[41]

Pérez Sanguino's first documented artistic commission illustrates the range of media in which he worked. In a 1636 contract to gild and polychrome the newly constructed pulpit and sounding board (*abat-voix*) for the conventual Church of the Immaculate Conception, the artist declared he had been hired to "apply the gold, red bole, sgraffito, and flesh tones on the figures, and fully finish it in a manner that is very well done in all respects, providing everything that is needed for the work," for which the nuns were to pay him 230 *patacones*.[42] The magnificent original pulpit specified in this contract still exists in the Church of the Immaculate Conception. Numerous monochromatic layers of overpaint have recently been removed from the pulpit during restoration, revealing the delicate chromatic range, gilding, and intricate *estofado* created by Pérez Sanguino in 1636 (*see plate 19*).

Pérez Sanguino was the protagonist of the contract, for his name alone appears in the preamble, where the patron's name typically would be included. This rather unusual procedure suggests that the artist brought the commission before a notary to stake his legal claim to the agreement and to the remuneration it entailed. As a result, he was responsible for paying the cost of the document. Nonetheless, the signature of the abbess, Doña Magdalena de Santa Marta, appears at the end of the document alongside that of Pérez Sanguino, making her the second party to the agreement, even if she was unwilling to pay for the notarized contract.

Pérez Sanguino, like many artists who obtained substantial commissions, depended on the collaboration of apprentices, assistants, and/or professional colleagues to facilitate his work. In the contract of 1636, dated just two months before the commission for the pulpit, when Pérez Sanguino "maestro dorador" took on an apprentice, Pedro Gutiérrez, he stipulated that Gutiérrez was "to serve [him] [. . .] in the said profession for a period of four years [. . .] and if he labors consistently for four years and does not attain the title of journeyman, Francisco Pérez Sanguino is obligated to pay him what a journeyman of the said art would command."[43] In a 1648 contract, Pérez Sanguino hired the master goldbeater Antonio Sánchez "to travel to the town of Riobamba [. . .] and there Antonio Sánchez must produce at his own cost and expense all the beaten gold that Francisco Pérez Sanguino might require to gild the altarpiece and tabernacle for which he has contracted with the nuns of the said town."[44] Both artists signed their names to the contract. This commission is yet another example of the mobility of Quito artists and the demand for their work throughout the *audiencia*.

By the 1650s, Pérez Sanguino had returned from Riobamba, and a series of accounts from the Mercedarian monastery in Quito document his work in the cloister in the early years of that decade. The 1654 payments to Francisco Pérez "dorador" include 750 *patacones* "for gilding the wooden ceiling panels [*artesones*] of the cloister and the picture frames, out of the 3,000

[*patacones*] for which he is contracted," in addition to 67 *patacones* "for gilding and applying sgraffito [*estofado*] to the altarpiece of the Tota Pulchra in the cloister."[45] The final references to Pérez Sanguino demonstrate his continued work in the Mercedarian cloisters into 1659, when he is registered in the account book in April and May of that year.[46]

Overall, the elite painters of *hanan* Quito lived principally in the parish of San Roque in residences clustered around two landmarks, the residence of the descendants of Atahualpa and the Franciscan Recoleta of San Diego. This parish also housed the majority of master painters in the city, most of whom lived near the Atahualpa residence in their own, often expensive, tile-roofed houses with gardens and orchards. Several elite painters resided in similar homes in the neighborhood of San Diego, yet many of the artists in this barrio owned more humble abodes. Their concentration around San Diego suggests not only a close relationship with the Franciscans, but professional associations with the Recoleta de San Diego precisely during the time when its buildings were completed and elaborately adorned with mural and easel paintings, altarpieces, and other painted and gilded furnishings. The documented painters of San Roque were uniformly and conspicuously lettered artists who penned their names using sophisticated scribal forms and conventions. Painters in San Roque were organized in extended family networks that approximated traditional Andean *ayllus* as well as European guilds, in which professional skills and literacies were handed down to subsequent generations of artisans.

The Painters of San Marcos and San Sebastián

The other parishes included within the *hanan* half of the city, San Marcos and San Sebastián, registered a far smaller number of painters than did San Roque, although each marked an increase during this period. Given that the Monastery of Santo Domingo, which housed Bedón's Confraternity of the Rosary, was included within the parish of San Marcos, one might expect to encounter numerous painters in residence there. However, this is not the case: only three painters—all Andeans—are recorded as residents of San Marcos during this time, a small increase over the earlier period. In the case of San Sebastián, only a single painter appears for this period, as opposed to none for the earlier generations. Only one of the four painters recorded for these parishes was lettered, even as two of the four were identified in the documents as "maestros pintores."

The parish of San Marcos was the residence of the Andean master painter and gilder Sebastián de Quirós and the Andean painters Pedro Cañar and Diego Lima Tandapaqui, all of whom lived near the Monastery of Santo Domingo. In a 1644 contract, Sebastián de Quirós "yndio maestro pintor" purchased his home in San Marcos for 180 *patacones*.[47] Quirós signed his name to the contract with a competent, if a bit shaky, hand (fig. 7.4). An even more

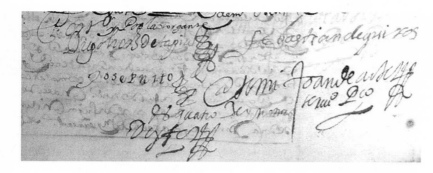

Figure 7.4. Signature of Sebastián de Quirós, 1644. ANH/Q, Notaría 5a, vol. 35, 1644, Juan de Heredia, fol. 340v.

fleeting glimpse is caught of the Andean painter Pedro Cañar. In 1638, Elena Yumipansa, "widow of Pedro Cañar yndio pintor," sold part of the land associated with her residence in San Marcos.[48] Perhaps not coincidentally, the land in question bordered that owned by the Andean painter Diego Lima Tandapaqui. The only contractual reference to Lima Tandapaqui is a 1632 document identifying him as an "yndio pintor," in which he agreed to serve as *mayordomo* of a merchant convoy to Caracas organized by the trader and *obraje* (textile workshop) owner Miguel de Aguirre. Lima Tandapaqui was unlettered, and asked a witness to sign the contract on his behalf.[49]

The parish of San Sebastián harbored the residence of only one painter of the later generations, in spite of the fact that this principally indigenous parish was older and more populous than that of San Roque. During the 1640s, the Andean master painter Gerónimo Vásquez, a regional immigrant from the indigenous community of Saquisilí, south of Quito, lived in San Sebastián with his wife Beatriz Annaquilago in a thatch house that had "four rooms roofed with tile," which he sold for 128 pesos in 1651.[50] The specified location of Vásquez's residence places it near the border between the parishes of San Sebastián and San Roque.[51] A witness signed the document of sale on his behalf, since Vásquez was unlettered.

The Cathedral Parish: Hernando de la Cruz (ca. 1592–1646)

The biography of the Creole Jesuit painter Hernando de la Cruz is chronicled by a number of seventeenth- and eighteenth-century authors, although no civil documents register his activities in Quito.[52] According to the Jesuit chronicler Pedro de Mercado, Cruz was born around 1592 of Spanish parents in Panama, learned the art of painting in Lima, and in 1622 entered the Jesuit Order in Quito. Diego Rodríguez Docampo's 1650 account praised Cruz's superior abilities as a painter, "as can be seen in the canvases and paintings in the Church of La Compañía."[53] Writing in the 1690s, the Jesuit Jacinto Morán de Butrón lauded Cruz's talents as a painter with evi-

dent hyperbole, avowing "He was exquisite in this art, and when he applied brush to canvas, he had already visualized [the design] through meditation and prayer. His labors produced all of the paintings that adorn the church, hallways and rooms."[54] Similarly, the Jesuit Juan de Velasco, writing of Cruz around 1774, rhapsodized "that the many paintings with which he enriched the church and the college were and are the greatest marvels of art and the most incalculable treasure."[55]

In addition to avowing that Cruz was responsible for most of the painted decoration in the Jesuit church and college, both Morán de Butrón and Mercado identify specific paintings by his hand. Morán de Butrón's evocative account records that Cruz was "directed by God"

> to paint two very large canvases that are today beneath the choir of our church: on the epistle side of the main altar, he placed a [painting] of hell with horrendous, strange and severe punishments [suffered by] the sinners, who whimper and weep, condemned to their misfortune for eternity. On the other side, which is that of the gospel, he placed [a painting of] the Resurrection of the predestined, and the possession that they are given of the unending pleasure to see God as the inheritors of his Glory. He painted them with such delicacy, liveliness, and skill that his hand was unquestionably guided by one more powerful, indeed, these two canvases have been such effective preachers that their mute voices have caused prodigious conversions [among the people].[56]

Today, nineteenth-century copies have replaced Cruz's paintings, and the whereabouts of the originals are unknown.[57] Mercado also described Cruz's paintings of heaven and hell, in addition to a work by his hand located in the sacristy, a canvas depicting Saint Ignatius offering his heart to the Holy Trinity.[58] According to Morán de Butrón, Cruz taught the art of painting to several of the Jesuit novices, including an Andean youth, and directed a group of painters in what might be described as a workshop.[59] If this was the case, then Cruz's pedagogy as well as his works must have exerted an influence on generations of Quito painters.

Yet, in *hanan* Quito, the presence of numerous dynasties of Andean painters in the parish of San Roque characterized the professional organization and production of such artists. Their houses were clustered principally around the residence of Atahualpa's descendants. These painters were not the result of European dominance and training as much as the evolution of an elite artisanal system within colonial Andean social structures. To the extent that genealogies and the documentary evidence permit, painters of central Peruvian, Inca ancestry dominated the painting profession in this half of the city. That the Creole Jesuit Hernando de la Cruz is given much emphasis as an eminent painter and teacher in contemporary as well as colonial histories speaks to the comfortable ways that he was perceived as fitting within a European narrative of education and accomplishment.

The Painters of *Hurin* Quito: The Parishes of San Blas and Santa Barbara

The *hurin* spatial division of colonial Quito, which occupied a lesser yet complementary status to that of *hanan* Quito, included the northern parishes of San Blas, Santa Barbara, and Santa Prisca, and extended north beyond Otavalo. Painters are recorded as residents in only the first two parishes. These artists were not associated with the Inca elite. Many of the surnames of Andean painters in the *hurin* parishes are non-Quechua, autochthonous, or regional in origin, particularly in the parish of San Blas. In comparison with *hanan* Quito, a large percentage of the painters of *hurin* Quito were unlettered.

The Painters of San Blas

Second only to the parish of San Roque, that of San Blas experienced the greatest increase in painters during the first half of the seventeenth century. A total of nine are recorded in the parish during this period, all of them Andean. Intergenerational families again explain much of the growth in the number of painters resident in San Blas. In contrast to the parish of San Roque, however, that of San Blas harbored one principal painting dynasty during this period. The Gualoto clan of painters grew in numbers to include three immediate family members and several apparently related by marriage, thus constituting the majority of such professionals living in San Blas. Moreover, the Gualotos were clearly elite members of the parish, for most are identified in the documents with the honorific title of "Don."

A number of other painters—all of them Andean—are recorded in the parish; however, most count only a single reference in a document to which they were not party or figure in a single document that establishes their residence in San Blas. The only document known for García Chaquinga is a 1643 contract in which he is recorded as an "yndio oficial pintor" purchasing land in San Blas.[60] A single document identifies the unlettered Andean painter Don Felipe Méndez as a resident of San Blas, the son of Felipe Méndez and Doña Marta Pillapaña.[61]

The existence of extended families of painters and other professional relationships is traceable in the documents related to San Blas. In 1616, Felipe Guaman "yndio pintor ladino en la lengua española" signed his name to a notarial document as witness to a sale of land in San Blas, in which he was identified as a resident of the parish.[62] Highlighting the generational continuity of the profession, years later, in 1671, Juan Guaman "yndio pintor" sold part of this land, which he had inherited from his father, Felipe Guaman.[63] Two contracts dated in the 1630s record the activities of Francisco Bedón "yndio pintor" and resident of San Blas. Both involve purchases on credit in which Bedón offered as collateral his thatch house and land in San Blas.[64] Bedón's surname associates him with the Creole painter Fray Pedro Bedón,

perhaps owing to collaboration or mentorship in the Cofradía del Rosario de los Naturales at Santo Domingo. Of these four painters, only Felipe Guaman was lettered. Indeed, of the eight painters from San Blas recorded as principal parties to notarial documents, only half could sign their names.

In contrast to these scattered references, the Gualoto family of painters dominates the documentation for San Blas during this period, although most members of their clan were unlettered. The earliest mention of a painter with the Gualoto surname appears in the 1588 rule book of the Cofradía del Rosario de los Naturales, which lists one Sebastián Gualoto as a member.[65] This is the only reference to Sebastián Gualoto, and his parish of residence is not specified. On the other hand, for the seventeenth century, the undisputed patriarch of the Gualoto family in San Blas was Don Antonio Gualoto, who is variously identified as a master painter, gilder, and woodworker (*ensamblador*) as well as "cacique de San Blas." The long and productive career of Antonio Gualoto, and those of several of his immediate family members and descendants, is amply documented.

ANTONIO GUALOTO (ACTIVE 1620–1671)

Antonio Gualoto was a versatile artist who principally was a gilder and painter of altarpieces, and secondarily a painter of canvases and panels. His patrons included several confraternities as well as members of the regular clergy. Many of his documented works were created for the Augustinian and Mercedarian churches, located on the *hurin* side of the Cathedral parish. Yet his work frequently took him well beyond the *hurin* half of the city and the parish boundaries of San Blas. In the 1620s Gualoto appears with the title of "Don" in official documents, and with those of "maestro dorador y pintor" and "maestro ensamblador." Unlike the majority of Quito painters, particularly those who held the title of "Don" and "master," Antonio Gualoto remained unlettered throughout his long career.

Don Antonio's archival record begins in the 1620s, when Catalina Tanbiacha "yndia" donated property in the parish of San Blas to the Confraternity of Nuestra Señora de los Remedios, which maintained a chapel in the Augustinian church. According to the contract, Tanbiacha made the contribution so that the confraternity could sell the land, and "with the proceeds the confraternity's altarpiece can be gilded and painted, and so that don Antonio Gualoto *yndio* master gilder and painter may be paid according to the contract that the *mayordomos* made with him."[66] No mention is made of Tanbiacha's relationship to Gualoto; however, her unequivocal support of the painter is evident in the document. A prior agreement or contract for Gualoto to create the altarpiece had obviously been made, and Tanbiacha meant to ensure that he would be paid for his work.

Gualoto is identified as a "maestro ensamblador" in a 1635 contract with the *mayordomos* of the Confraternity of Nuestra Señora de Gracia, also established in the Augustinian church, to "gild the altarpiece of the confraternity," which was dedicated to its Marian advocation.[67] A clause in the contract

stipulated that "the gold and all the other materials and assistants must be supplied by Antonio Gualoto, without obligating the *mayordomos* to provide him anything else."[68] In this instance, Gualoto supplied a guarantor, Antonio Sánchez "maestro batihoja" (master gold-beater), who backed his completion of the project. For his material and labor costs, Gualoto received three hundred pesos. Sánchez signed the contract. The unlettered Gualoto did not.

To judge from his multiple professional titles, Gualoto was a versatile, multitalented artist able to undertake and direct a range of artistic commissions. The protean nature of his professional persona is reflected in a series of payments made to him in the 1650s and 1660s by the Mercedarian Order. Gualoto received periodic remuneration from the Mercedarians during this time, including thirty pesos for gilding, polychroming, and applying *estofado* to a sculpture of the Virgin "Tota Pulchra"; another thirty pesos as partial payment for gilding an altarpiece belonging to a *doctrina* of the order in the Valley of Chillo; and four pesos for restoring the gold leaf on an altarpiece dedicated to San Ramón.[69] In addition to such relatively minor commissions, Gualoto reaped substantial financial gain for his work as a painter and gilder of several important altarpieces in the Mercedarian monastery.

In 1651, the Mercedarian account book recorded 420 *patacones* paid to "don Antonio Gualoto for gilding three altarpieces in the cloister, with his gold, and colors, and also for gilding three sculptures for the said altarpieces and for painting the canvases that adorn them."[70] The account book additionally registered a payment of 2 *patacones* to the notary who drew up the contract for the altarpieces, indicating that the commission had been legally recorded for the patron's benefit. Several of these altarpieces are still extant in the Mercedarian cloister, although many of the original sculptures and paintings that once adorned them have been removed or replaced (*see plate 20*).

In 1664, the Mercedarian account book recorded payment to Gualoto for another major work, although it is not specifically identified. This entry provides a sense of the materials and processes involved in Gualoto's project:

> For one thousand seven hundred pesos that were given to the lieutenant Lorenzo de Salazár for one thousand eight hundred and twenty-one books of gold [leaf] that he provided, and for four hundred and thirty-six pesos that were paid to don Antonio Gualoto from 7 January of the year sixty-four = and the said don Antonio also received eight pounds of red bole in forty-four pesos that were given by a devotee, and now don Antonio is only owed twenty pesos according to the contract.[71]

The large quantity of gold leaf and the substantial remuneration that Gualoto received for this work suggest its major proportions, perhaps the main altarpiece of the Mercedarian church or the gilding and polychromy of the *artesonados* (coffered ceilings) in the church or cloisters.[72]

Gualoto's most spectacular and remunerative work was executed for the church of the Franciscan monastery. In the only documented instance of a named painter commissioned to create mural paintings, in June of 1654, the Franciscans drew up a notarial contract with Don Antonio Gualoto "yndio maestro dorador" in which he agreed to

> gild and paint two altarpieces that are located in the church of the said monastery together with the three arches of the crossing, and the said arches must be completed to match the finished arch in the said [crossing of the] main chapel by the end of the coming [month of] September [. . .] for one thousand and nine hundred pesos.[73]

According to the contract, Gualoto was required to supply "the gold and all of the expenses of materials and assistants," while the Franciscans agreed to provide daily meals for the master painter alone, as well as "the prepared wooden scaffolds for gilding and painting the said altarpieces and arches."[74] As was often the case in major contracts with Andean master painters, the artist was responsible for taking care of his own: Gualoto paid the salaries and provided the meals for his team of Andean assistants.[75]

Although the two transept altars referenced in the contract are no longer in situ, the vivid mural paintings that adorn the arches of the crossing have been recovered from beneath gilded panel overlays that protected them over the centuries (*see plate 21*). Each of the murals depicts complex, repeating compositions involving multitudes of wingless putti who tumble, sport, and clamber across the full expanse of the arch, groups of which bear oval "portraits" of male and female Franciscan tertiary saints, popes, and monarchs in illusionistic gilded frames. Interestingly, the uniformly dark skin and hair coloration of the putti suggest that the artist may have intended to depict them as Andeans whose entangled yet collaborative actions work in concert to support, sustain, and present to the viewer the framed Franciscan tertiaries. These paintings establish iconographic continuity with the series of eighteen paintings depicting Franciscan tertiary monarchs and dignitaries created by anonymous artists around 1607.

Unlike the majority of Andean painters and even some members of his extended family, Antonio Gualoto was unlettered—the fifteen notarial contracts to which he was party consistently register his request that a witness sign for him because he did not know how. Unlettered status notwithstanding, Don Antonio built a small empire in San Blas, and he consistently received major and minor artistic commissions throughout his lifetime. Over the course of his professional career, Don Antonio purchased significant tracts of land in the parish of San Blas, all of which adjoined and augmented the property on which his residence was located.[76] He also created sculpted as well as painted, gilded, and polychromed works for most of the major churches in Quito, from those of San Francisco, San Agustín, and la Merced to the extramural sanctuary Church of Guápulo.

Don Antonio Gualoto fostered a dynasty of painters and artisans in the parish of San Blas. Although the genealogy of the Gualoto family is not entirely recovered, it is likely that Don Juan Gualoto, identified in the documents as an "yndio pintor," was related to Don Antonio. In 1630, Don Juan bought an expensive tile-roofed house in the parish of San Blas next door to the property of Antonio Gualoto.[77] Similarly, the Andean gilder Diego Gualoto was almost certainly a member of the dynasty for, although his residence is unknown, he was associated with at least one artistic commission involving other artisans from San Blas with the Gualoto surname.[78] Yet another extended family member was the painter Don Francisco Gualoto. He is registered in 1656 with the title of "cacique principal de San Blas," associated with the Andean sculptor Lázaro de Paz.[79] In addition to their numbers in the seventeenth century, painters, gilders, silversmiths, and sculptors of the surname Gualoto populate the documentary record throughout the eighteenth and into the nineteenth centuries, and those for whom residences can be established lived in the parish of San Blas.[80]

DIEGO GUALOTO (ACTIVE 1639)

The Andean painter Diego Gualoto is identified variously with the title of "pintor" and/or "dorador," and with the honorific "Don." The only documented artistic commission involving Don Diego is a contract that he signed in 1639 as "yndio dorador" to gild and polychrome the main altarpiece of the Church of Guápulo, located in a nearby indigenous community to the northeast of San Blas. The Spanish or Creole painter and gilder Juan Fonte Ferreira is included in the commission as both guarantor and collaborator. According to the contract, Gualoto and Fonte Ferreira "jointly declare that together we are obligated to gild an altarpiece for the church of Our Lady of Guadalupe and to apply *estofado*, and paint, and enameling and to finish it in all perfection according to the orders given us by Juan González Gordillo, to his satisfaction and that of other practitioners of the said art."[81] As the principal contractor, Don Diego Gualoto was to be paid 230 pesos, and the patron would provide all the materials required to complete the job. It is interesting to observe that Don Diego was the protagonist and agent of

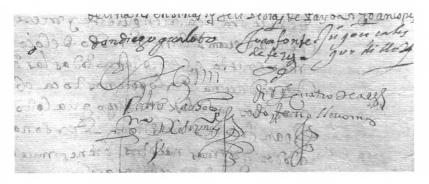

Figure 7.5. Signatures of Diego Gualoto and Juan Fonte Ferreira, 1639. ANH/Q, Notaría 1a, vol. 162, 1639, Pedro Pacheco, fol. 183v.

this commission, and he was designated to receive full payment, while Fonte Ferreira appears as a lesser collaborator and guarantor of the job's successful completion. Both artists signed their names to the contract alongside that of the patron, with Gualoto notably including the honorific "Don" as a part of his autograph (fig. 7.5).

Because the main altarpiece of the Church of Guápulo was destroyed by fire in the nineteenth century, we have no extant record of Diego Gualoto's work. The only remaining evidence as to how that work might have appeared is a late seventeenth-century ex-voto painting by Miguel de Santiago, *Curación de una enferma durante la misa*, in which the main altarpiece of Guápulo is depicted.[82] In the early eighteenth century, Cristóbal Gualoto "oficial pintor," likely related to the family in San Blas, also created work for the Church of Guápulo, perhaps with a proprietorial sense of responsibility.[83]

MELCHOR DÍAZ (ACTIVE 1637–1683)

Another Andean painter of San Blas, Melchor Díaz, merits particular mention not only because he appears frequently in the documents, but also because he is identified as a master painter and a master sculptor. Díaz is first referenced as an "yndio escultor" in 1637 when he acquired land in the rural indigenous community of Quinche for forty *patacones*.[84] When he sold the land in 1648, he was identified in the contract as an "yndio maestro escultor," testifying to his rising professional status.[85] In 1641 Díaz bears the title of "maestro pintor" in a contract for the purchase for ninety *patacones* of an additional five blocks of land bordering his residence in San Blas.[86] It was likely not a coincidence that, in 1649, the Andean journeyman painter Francisco Pillajo bought "one bottom-floor room of a house, roofed in tile, with a patio" in San Blas that adjoined the residence of Melchor Díaz, therein identified as "yndio escultor."[87] The close proximity described in the document implies that the two artists were involved in professional collaboration. Melchor Díaz was lettered; Francisco Pillajo was not.

Díaz appears to have worked for the Mercedarian friars in the 1650s. A number of payments in 1651, 1652, and 1655 to "don Melchor escultor" are entered in Mercedarian account books for a series of works that included mounting and painting the *artesonado* in the cloister, repairing the frames of paintings, and "sculpting the heads, hands, and feet of Our Father San Pedro Nolasco and San Ramón."[88] The only painter or sculptor with the first name "Melchor" to appear in the notarial record during the 1640s and 1650s is the Andean painter and sculptor Melchor Díaz. The "don Melchor escultor" who worked for the Mercedarians and Díaz are likely one and the same.

The Painters of Santa Barbara

Of the eight *hurinsaya* painters whose residences were in parishes other than San Blas, five lived in Santa Barbara, four of whom were Andean. Because

the Andean painter Lucas Vizuete moved from San Roque to Santa Barbara in 1632, his residence in the latter parish is considered here. One member of the earlier generations of painters, the Spaniard Luis de Ribera (discussed in chapter 5), continued to reside in the parish until at least 1619, although he is not counted among the artists in this section.

Documentation regarding the five painters in Santa Barbara ranges from a single legal proceeding for the Andean painter Bernabé Boyolema to over twenty contracts for the Spanish or Creole painter Salvador Marín, while references to the Andean painters Miguel Ponce, Lucas Vizuete, and Cristóbal Faizán fall somewhere in between. Not all of the documents are illuminating in terms of their professional practices, although they occasionally reveal surprises. The only archival record of Boyolema is a 1629 legal agreement reached between Alonso Pillajo and his wife Magdalena and Bernabé Boyolema "yndio pintor morador en la parroquia de Santa Barbara," in which the couple agreed to drop charges against the painter for having "corrupted" their daughter María.[89]

MIGUEL PONCE (ACTIVE 1629–1633)

Only three documents record the activities of the Andean master painter Miguel Ponce. In 1629, Miguel Ponce "yndio pintor natural de Yaruqui" purchased for forty-two *patacones* a vacant half-lot of land in Santa Barbara from the Andean silversmiths Juan Guallazamen and Andrés Laguacuna.[90] Ponce's origins in the nearby indigenous community of Yaruquí mark him as yet another example of a regional immigrant painter to Quito, among the many who contributed to the increasing numbers of such artists in the first half of the seventeenth century. In two subsequent contracts from the 1630s, Ponce has become "master painter," indicating his professional ascent. A lettered painter, Ponce signed his name to each of the contracts in question, employing elegant calligraphy with serifs, cedilla, and rubric (fig. 7.6).

Based on two notarial contracts for paintings, Ponce engaged in various types of commissions, from mass production to complex altarpiece. In 1630, Miguel Ponce "yndio ladino pintor" signed a contract with Miguel de Aguirre, the owner of a textile *obraje* and mills in the nearby communities of Pomasque and Cumbayá, for the creation of twenty-seven canvases measuring two *varas* high by one *vara* wide that were to depict

> the life of Saint Francis in accord with twenty-seven fine engravings on paper that must serve as models, [everything] just like and according to the images on them, without anything lacking [. . .] well painted with vivid colors and a fine brush, to the contentment of the said Miguel de Aguirre and people knowledgeable [in the art].[91]

The painter was to supply only the pigments, and Aguirre agreed to provide "fifty-four *varas* of *melinze* and the wooden stretchers required for the paintings." Ponce received three hundred *patacones* "for his labor, art, and time

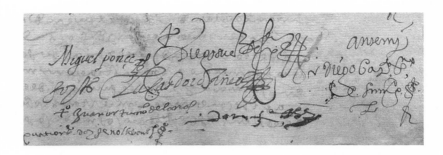

in creating them."[92] The careful detail with respect to the quality of colors and precision of the brush, as well as the stock phrase regarding "expert opinions," underscore the patron's determination to obtain high-quality images. Both Ponce and Aguirre inscribed their signatures at the end of the document. Aguirre, who sent merchandise and perhaps artworks by convoy for sale in Caracas in 1632 under the supervision of another Andean painter, might have intended these paintings for sale in a distant market.

In a major commission of 1633, Miguel Ponce "yndio ladino en la lengua española maestro pintor" signed a contract with the *priostes* and *mayordomos* of the Confraternity of Santa Catalina, an exclusive sodality composed of tailors that was located in the Mercedarian church, to produce the altarpiece for their chapel (see appendix, part e). Corporate patronage is explicit in this contract: the *priostes* and *mayordomos* agreed to the payment "in the voice and name of the said confraternity." Ponce was to provide "everything necessary, including gold, silver, colors, manufacture, and assistants," and

> for the canvases that he must paint, he confesses having received from the priostes and mayordomos of the said confraternity four varas and two-thirds of canvas for the niches, which must be those on the bottom = and [in] the three that are above [must be] the Virgin of Guadalupe in the middle, and on either side Saint Peter Nolasco and Saint Raymond = and above on the frontispiece the holy Trinity, and at the foot of the altarpiece Mary Magdalen, and on the two small paintings above [images of] Saint Teresa of Jesus and Saint Juana, all well gilded and finished [to the content] of the priostes and mayordomos of the said confraternity and [of] people knowledgeable in the art.[93]

Ponce received 250 *patacones* for painting these numerous canvases and for gilding the altarpiece. His signature appears on the contract alongside that of one of the *priostes* of the confraternity.

CRISTÓBAL FAIZÁN (ACTIVE 1635–1649)

Cristóbal Faizán was another regional immigrant to Quito. He came from the town of Lita (Esmeraldas) in the northern part of the *audiencia*, and may

subsequently have divided his time between Quito and the southern city of Cuenca.[94] In 1635, Cristóbal Faizán "yndio oficial pintor" purchased for ninety *patacones* a small vacant lot near the Mercedarian monastery in Quito, bordering the ravine that descends from the flanks of the volcano Pichincha.[95] The apparent location of the land actually places it in the Cathedral parish, very close but not within the boundaries of Santa Barbara, in a fairly rural and somewhat inhospitable zone. Again underlining the range of professional practices in which painters engaged, Faizán is identified in a 1649 contract as an "yndio oficial dorador y escultor." By this time, he had increased his power of acquisition, for he significantly expanded his landholdings in the same sector by purchasing additional terrain behind the Mercedarian monastery for the substantial sum of 110 pesos.[96] Faizán did not sign his name to either of the above-cited documents, yet neither makes reference to a witness signing in his stead.

SALVADOR MARÍN (ACTIVE 1633–1671)

The painter in Santa Barbara for whom the greatest amount of documentation exists is the Spanish or Creole artist Salvador Marín. More than twenty notarial contracts record Marín's activities between 1633 and 1671, including the purchase, rental, and sale of houses and land, in addition to loans, powers of attorney, artistic contracts and, perhaps most importantly, his last will and testament. Marín was a prolific artist who also engaged in real estate speculation and other investments, and he was a self-confessed inveterate gambler.

Indeed, the earliest document concerning Marín is a loan he took out for unspecified reasons, a pattern that continues throughout his well-documented career. In 1633, Salvador Marín "journeyman painter, resident in Quito, over twenty-five years old," borrowed 110 *patacones* from Don Pedro de Carvajal, a priest from the northern community of Cayambe, which he agreed to repay in ten months' time.[97] By 1639, Marín had married Doña Augustina de Cárdenas, whom he later claimed "brought him nothing as a dowry," and they were living in a rented thatch-roof house in the parish of Santa Barbara that cost thirty pesos per year.[98]

In 1649, ill and bedridden, Salvador Marín—now identified as a "maestro pintor"—drew up his last will and testament, one of the few such documents extant for painters in early colonial Quito.[99] He asked that his body be interred in the Mercedarian church, acknowledged his marriage to Doña Augustina de Cárdenas, and noted that they had produced no children. He also recorded a lengthy list of pawned items and people to whom he owed money, citing various gambling debts, including a 120-peso debt to Don Pedro Bohórquez, "who lent me money, which I gambled and lost by gambling with him and with other people."[100] In a similar fashion, Marín described a large number of paintings in various states of completion that he "owed" to numerous clients.

Marín's will contains an extensive account of his professional activities, from which it is evident that, unlike many of his contemporaries, Marín was

almost exclusively a painter of canvases. The descriptions of the paintings in Marín's workshop due to patrons in 1649 are worth recording in full:

> I declare that Father fray Fran[cis]co de la Puebla gave me six p[es]os for a painting on canvas and I direct that he be given the said canvas in whatever state it might be found
>
> I declare that Joan Ambrosio Negroto gave me fifteen p[es]os to pay for a canvas that I am making for him, [and] I direct that if he pays seven p[es]os more he be given the canvas in its present state
>
> I declare that don Fernando de Vera y Flores brought four portraits for me to paint [which were] commissioned for forty p[es]os of which he has given me ten patacones. I direct that an assessment be made of what has been completed on the paintings and the remaining money owed by the said don Fernando be collected and that he [then] be given the said canvases
>
> I declare that I have in my possession twelve small canvases and two large [ones] that are for don M[arti]n de Fuenmayor [and] I direct that they be given to him
>
> I declare that I owe don Felipe de Berguete [*sic*] ten pesos for a work that I was supposed to make for him which I have not done [and] I direct that he be paid from my estate
>
> I declare that the said don Felipe de Beruete [*sic*] owes me ten remaining pesos from the cost of a canvas that I made for him, which are compensated by the costs cited above
>
> I declare that I have in my possession six prepared canvases that belong to Antonio de la Chica [and] I ask that they be returned to him
>
> I declare that I have in my possession two canvases for Martin de Ayala that are sketched out [*en bosquexo*] [and] I direct that they be given to him.[101]

Marín had twenty-seven paintings in various stages of completion, commissioned by both secular and religious patrons. The subject matter of the paintings is not mentioned, with the notable exception of the four portraits commissioned by Fernando de Vera y Flores. Contracts for or references to the commission of portraits are extremely rare for this early period, and their production by Marín is likely a testament to his talents and abilities as a painter. Moreover, Vera y Flores was a particularly distinguished and wealthy patron of the type likely to request a series of portraits; he had served as mayor (*corregidor*) and governor of the northern town of Ibarra and its region, and he owned one of the finest houses on the main plaza of Quito.[102]

Among the witnesses who signed Marín's 1649 testament were two contemporary painters, Juan de Salinas and Simón de Valenzuela. The former, a Spanish or Creole master painter, was also an inveterate gambler. He filed an official *promesa de no jugar* before a notary in 1648, swearing under oath that he would not gamble for a period of three years or pay a whopping fine

to the Santa Inquisición.[103] The other artist, Simón de Valenzuela, who was of African ancestry, lived in Santa Barbara and was an early member of the workshop associated with the Andean painter Miguel de Santiago in the mid-1650s. Valenzuela's professional career spans the second half of the seventeenth century; thus, he is not included among the painters considered here.[104] Importantly, however, the presence of these two painters as witnesses to Marín's testament points to the existence of professional community collaboration in Santa Barbara that predates the documented 1654–1656 formation of Miguel de Santiago's workshop.[105]

Marín's account of the many paintings in his workshop again underscores the important point that the majority of paintings in early colonial Quito were informally commissioned by word or by *vale*, and that notarial contracts for such works were relatively rare. Had Marín's testament been lost or remained unknown, scholars might draw a completely different picture of the artist based on the two extant notarial documents that record his artistic commissions. The first of these, a brief record of payment to Marín, appears among the judicial accounts of the *real audiencia*, which in the late 1640s registered that a portion of the five-hundred-peso fine imposed on Don Pedro Leal Gil Negrete was used to pay a series of beneficiaries that included compensating "the Master Painter Salvador Marín for the canvases of Saints Peter and Paul for the Royal Chamber."[106]

The second document is an artistic contract for three paintings that Marín created in 1654 for the Dominican order in Quito. On September 23rd of that year, Salvador Marín "maestro pintor" signed his name to a contract in favor of the prior, general administrator [*procurador general*], and friars of the Monastery of Santo Domingo, in which he agreed to paint "three canvases depicting the history of Saint Dominic of the same size as the others that are being made, to the content and satisfaction of the said prior, and he must work on them in this monastery and complete them by the last day of this coming month of November of the present year."[107] Marín received seventy *patacones* for three canvases, and although the contract does not specify who was to supply the materials, the directive that the artist must paint them in the monastery suggests that the Dominicans would provide everything required to produce them. Additionally, Marín was "obligated not to take on any other commissions during the time that this work is being done," indicating that the Dominicans were well aware of the high level of activity in the painter's workshop, and perhaps also of his tendency to leave works incomplete.[108]

According to the contract, Marín's canvases were to form part of a series of paintings that was already underway. Today, the Dominican monastery houses four large seventeenth-century paintings depicting the life and acts of Saint Dominic that once constituted part of a more extensive series, which are evidently the work of several different artists. Marín cannot be the author of two of these canvases because the donor inscriptions that they bear place them much later in the seventeenth century than Marín's 1654 commission.[109] However, a second pair of canvases, *Saint Dominic Curing a*

Sick Man and *Miracle of Saint Dominic Curing the Cardinal's Nephew* (*see plates 22 and 23*), may date from an earlier period, and appear to have been painted by the same hand. The two paintings share approximately the same dimensions and, like the others in the series, each bears a legend inscribed across the bottom of the canvas. The text on both paintings is almost completely effaced, leaving the question open as to whether one or both of these canvases might be the work of Marín. However, each painting contains at least one clue: *Saint Dominic Curing a Sick Man* bears a large painted family crest, and the *Miracle of Saint Dominic Curing the Cardinal's Nephew* is inscribed "this canvas was given by Manuel [?] [Mariano?] Benavides" ("dio este lienzo Manuel [?] [Mariano?] Benavides"). These clues suggest that heraldic and genealogical study might provide the names and dates during which these patrons lived. Were these commissions the only information available regarding Marín's artistic production, he would likely be seen as a painter of solely religious images.

Marín did not succumb to the illness that he suffered when he filed his 1649 testament; in fact, he lived for more than twenty productive years thereafter. Like many of his contemporary Spanish and Creole painters in the 1630s through the 1650s, Marín rented rather than bought his residence and other properties. In 1651 he leased a small farm on the outskirts of Quito for four years,[110] and in 1653 he signed a contract with Juan Ortuño de Larrea to rent from him "the upstairs room in my house, in which he presently lives, [together] with two rooms on the first floor and the garden, for a period of four years" for the price of 30 pesos per year.[111] Although the contract does not specify the location of the house, members of the Ortuño de Larrea family owned residences in Santa Barbara during the seventeenth century.[112] The following year, in 1654, Salvador Marín "maestro pintor" signed yet another rental contract for a four-year term, this time for a small farm, an orchard, and a *tejar* (tile factory) in Guanacauri (the hill enclosing the north side of the city, known as San Juan) for the rather steep price of 125 pesos per year.[113] In an entrepreneurial fashion, Marín expanded his economic base with these suburban rentals to incorporate agriculture and tile production, although given the large number of paintings with which he was engaged at the time of his 1649 testament, it is likely that he hired others to run those businesses.

Marín's various professional and business interests brought him a fortune in later years. He signed a series of five contracts for the purchase of land and houses in the 1660s and early 1670s, and he transitioned from renting to buying houses and land, either outright or via mortgages. In 1665, he acquired two vacant plots in the heights of Santa Barbara, and the following year he bought a very expensive stone two-story, tile-roofed house on adjacent land for which he paid fifteen hundred pesos.[114] As the contract for Marín's house indicates, the painter Simón de Valenzuela owned one of the neighboring residences. This physical proximity again suggests collaboration between the two artists and perhaps also with Lucas Vizuete and/or Miguel de

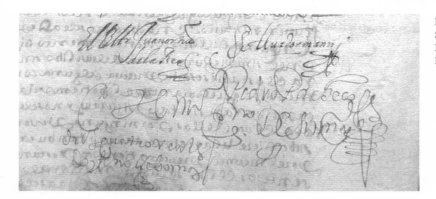

Figure 7.7. Signature of Salvador Marín, 1653. ANH/Q, Notaría 1a, vol. 197, 1653, Pedro Pacheco, fol. 65v.

Santiago, both of whom resided in the parish of Santa Barbara at this time. The final document involving Marín is a 1671 contract for the purchase of additional land adjoining his own in Santa Barbara.[115] A lettered artist, Marín penned his elegant signature, replete with flourishes and rubrics, to all the documents in which he was involved (fig. 7.7). Marín's long and successful career exemplifies the social and economic mobility available to painters in mid-seventeenth-century Quito.

LUCAS VIZUETE (ACTIVE 1626–1657)
The Andean painter Lucas Vizuete is best known as the father of Miguel de Santiago, renowned painter of the second half of the seventeenth century.[116] Vizuete may have immigrated to Quito from the town of Cotacache, an Andean community near Otavalo in the north of the *audiencia*, for he inherited land in that community from his father, Hernando Capaco.[117] As noted above, Vizuete occupies the relatively unusual position of being the only Andean painter to move from one parish to another, in this case across the *hanan/hurin* line. He lived first in the parish of San Roque during the 1620s and moved to Santa Barbara in the 1630s, where he resided for the remainder of his career.

In a 1626 sale of land near the Recoleta of San Diego, one of the properties is cited as the "houses of Lucas yndio pintor."[118] As discussed below, a 1629 document records the participation of "Lucas yndio pintor" in the creation of a side altar for the conventual Church of the Immaculate Conception.[119] These references to "Lucas yndio pintor" are extremely likely to be Lucas Vizuete, for no other painter named Lucas is named in the archival record for these decades. The documents in question locate Vizuete's early residence in the parish of San Roque. By 1632, however, Lucas Vizuete "yndio pintor" was living in Santa Barbara where he purchased vacant land adjoining that of the residence that he inhabited with Francisca Mendiola, his Andean wife, and their daughter, Leonor Vizuete.[120] Mendiola had inherited a house and land in Santa Barbara, which was probably the reason for Vizuete's move to the parish.[121] Their residence in Santa Barbara was next to that of Juana

Ruiz, the Andean woman with whom Vizuete produced an *hijo natural*, the painter Miguel de Santiago.[122]

One witness to the contract for Vizuete's 1650 sale of inherited land in Cotacache was the Andean painter Bernabé Lobato, who was active in the second half of the seventeenth century and was associated with Miguel de Santiago's workshop. In fact, Lobato was Vizuete's grandson, born to his daughter Leonor; thus, Vizuete gave rise to successive generations of Andean painters in his son, Miguel de Santiago, and his grandson, Bernabé Lobato.[123] Seen in this light, Vizuete would appear to have initiated a professional dynasty in the parish of Santa Barbara, for both his son and grandson were productive painters who lived and worked in the parish during the second half of the seventeenth and early eighteenth centuries.

Vizuete's first documented painting contract is a major 1626 commission for the main altarpiece of Quito Cathedral. In that year, Lucas Vizuete "yndio pintor" signed a contract with the Spanish cleric Andrés Farfán de los Godos "mayordomo de la fábrica de la catedral" in which he agreed to paint

> two large canvases that must be nailed into their frames, and on one canvas he must paint the Nativity of our lord Jesus Christ and on the other the Adoration of the Three Kings according to the prints provided to him by Andrés Farfán [. . .] he must include in the two works all of the figures that are present in the prints, and good colors, and they must be well finished and well done to [Farfán's] content within three months [. . .] so that they may be placed on the main altar of the cathedral.[124]

Following the typical requirements of such contracts, Vizuete was to supply all of the required pigments. For his labor he received a total of eighty *patacones*, rather a low price for such large, complex, and prestigious works (see appendix, part d). Vizuete's distinctive signature and rubric adorn this contract, and all of the others to which he was party (fig. 7.8).

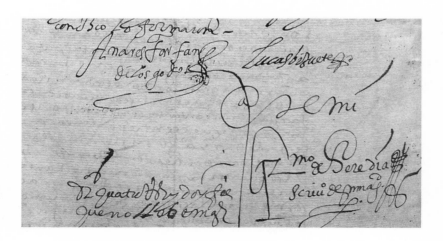

Figure 7.8. Signature of Lucas Vizuete, 1626. ANH/Q, Notaría 1a, vol. 117, 1626, Gerónimo de Heredia, fol. 842v.

That Vizuete received in 1626 a prestigious commission for the main altar of the Cathedral testifies to his skill and status as a painter, all the more so because it occurred at an early stage in his career. The dimensions of Vizuete's paintings are not cited in the contract; however, given their intended location on the main altar, they must have been quite large canvases. Moreover, their subject matter required that numerous figures be organized into complex compositions. Unfortunately, these paintings are no longer present in the collections of the Cathedral.[125]

A 1726 inventory of the Cathedral holdings listed a variety of elements dispersed from the "old main altarpiece." Among them were "four canvases, two large, and two arched, one of the Nativity and the other of the Adoration of the Kings, and the other of Saint Michael, and the last of the Visitation of my Lady Saint Anne," the first pair of which almost certainly refer to Vizuete's 1626 paintings.[126] Lamenting the loss of the majority of objects in the Cathedral collection over the years, Navarro observed,

> The only one [of the lost works] of which there is any record is the Adoration of the Shepherds, which is in the British Museum [. . .] It was acquired fifty or sixty years ago by Mr. Ludovico Soderstrom, a Swede in the service of the British Crown, which named him as Consul to Quito [. . .] Through negotiation with the canons of the Cathedral, this man obtained the canvas of the Adoration of the Shepherds and donated it to the British Museum. We possess a postcard, on the back of which is written that the canvas is from Quito and that its authorship by either Velázquez or Zurbarán was the subject of extensive debate among the experts, who determined that the latter attribution was most likely.[127]

The titles of "Nativity" and the "Adoration of the Shepherds" are often interchangeable, particularly when such works are paired with the "Adoration of the Kings"; thus, it is likely that the painting of the "Nativity" commissioned from Vizuete is the same "Adoration of the Shepherds" given by Soderstrom to the British Museum. If the painting in question is indeed the work of Vizuete, the debate between "experts" as to whether the canvas was by Velázquez or Zurbarán (with emphasis on the latter) affords a tantalizing insight into Vizuete's style of painting, indicating that he manipulated the tenebrist language of Baroque naturalism then prevalent in Seville. Numerous paintings of this genre were produced in Quito in the first half of the seventeenth century, notably the death portrait of Fray Pedro Bedón in the collection of Santo Domingo, and this stylistic language clearly informed the later works of Miguel de Santiago.[128]

A second commission involving Vizuete sheds further light on the question of his painting style. In 1629, Pedro de Cepeda, nephew of Saint Teresa of Ávila, acquired a side chapel in the conventual Church of the Immaculate Conception. To adorn his chapel, Cepeda recorded the purchase of "a completed altarpiece made to house a sculpture of Saint Teresa," which included

payments of 420 *patacones* to the sculptor Antonio de la Torre, and 30 *pata-cones* to "lucas pintor."[129] Since no other painter named Lucas appears in the documents between the 1620s and 1660, Cepeda's "lucas pintor" was very likely Lucas Vizuete.

The monumental altarpiece dedicated to Santa Teresa still exists in the Church of the Immaculate Conception in the location designated in Cepeda's contract, although most of its original paintings and the sculpture of the saint that occupied the principal niche have been replaced with others. However, in the early twentieth century, the highest niche of the altarpiece held a tenebrist painting depicting Teresa seated at her desk, which appears to date from the seventeenth century (*see plate 24*). In 1960, Navarro published a photograph of this painting, which was still in situ when the Instituto de Patrimonio Nacional inventoried the church in 2006.[130] In light of Vizuete's 1626 Cathedral commission, it is telling that Navarro attributed the Saint Teresa to the "Escuela Sevillana" on the basis of its naturalism and tenebrist stylistic features. The painting subsequently was replaced by a later work that does not fit within the original space (*see plate 25*). If the earlier canvas originally formed part of the 1629 altarpiece dedicated to the saint, it would constitute yet another known painting attributable to Lucas Vizuete, although the present location of this work is unknown.

Although Vizuete was identified simply as an "yndio pintor" in his 1626 commission for the Cathedral, by the 1640s the documents indicate that he had risen to the status of "master painter."[131] Despite his professional ascendance, no major artistic commissions for Vizuete are found in the notarial records after 1626, even though many other types of contracts document his life during this period. In addition to his likely work on Cepeda's altarpiece in the Church of the Immaculate Conception, only one subsequent document regarding Vizuete's artistic activities appears in the archival record. An expenditure book in the Mercedarian monastery records that, in 1652, "lucas pintor" was paid three pesos "for retouching and repairing the paintings in the cloister."[132]

In spite of his designation as "maestro pintor," Vizuete's fortunes appear to have declined over the years. Between 1642 and 1657, Vizuete and Mendiola sold a total of five parcels of land and took out at least one substantial loan. In 1642 they sold a half-lot in Santa Barbara to Gabriel Yunquita "yndio";[133] in 1650 they sold a small plot in the same parish to the Andean sculptor Lázaro Páez;[134] in 1652 Vizuete sold the land in Cotacache inherited from his father;[135] and in 1656 Vizuete and his family sold land and a small thatch house in Santa Barbara to Bartolomé Lema, "yndio frutero."[136] Additionally, Vizuete and family signed a notarial contract in 1656 for a loan of 112 pesos from Isabel Gómez.[137] His death occurred sometime between 1657 and 1662, for in the latter year Francisca Mendiola filed a notarial contract in which she was identified as the "widow of Lucas Vizuete yndio maestro pintor."[138] Vizuete's legacy continued in the work of his painter son and grandson, Miguel de Santiago and Bernabé Lobato.

The *hurin* half of Quito was populated by a majority of Andean paint-ers. The non-Hispanicized surnames of most Andean painters in this zone indicate autochthonous or regional ancestry, particularly in the parish of San Blas. The documents underscore the extent of the powerful painting dynasty of Gualoto artists in San Blas, and indicate the development of professional and familial painting collaborations in the parish of Santa Barbara. Overall, the painters of *hurin* Quito emerge as a less cohesive, scrappy, disparate set of men in comparison to those of *hanan* Quito. Nevertheless, the Gualotos were able to consolidate their position, and Vizuete created an artistic house.

Painters of Unspecified Residence

For a number of painters, their parish of residence is not indicated in the records. In the case of Andeans, residences are largely unspecified only be-cause they were not principal parties to the notarial documents; however, this is not generally the case for Spanish or Creole artists. Despite their identification as *vecinos*, *residentes*, or *moradores* of Quito, Spanish or Cre-ole artists constitute the majority of those for whom a parish of residence is unidentified, suggesting that at least some were itinerant and/or that their lodgings were rented, not owned. Nonetheless, these painters were involved in numerous significant artistic commissions that merit close consideration.

Juan Fonte Ferreira (active 1621–1652)

The Spanish or Creole artist Juan Fonte Ferreira (whose signatures occa-sionally exclude his second surname) principally has an identity as a gilder, though he is titled "painter" and "gilder and painter" in some contracts, and in others as "master sculptor and gilder." Yet in virtually all documents from the 1620s Fonte Ferreira bears the title of "painter." It is not until the 1630s that the professions of "gilder" and "sculptor" are added, suggesting that he not only acquired additional trade skills over time, but that he came to recog-nize the greater financial rewards afforded by professional diversification as practiced by many of his contemporaries.

The majority of Fonte Ferreira's artistic contracts involve the gilding and painting of altarpieces, yet like many of his contemporaries, he certainly en-gaged in a variety of smaller artistic tasks that went largely unrecorded. One documented example appears in the 1625 testament of the goldsmith Ventura de Gaviria, noting "that the painter Juan Fonte has my sculpture of the sleep-ing baby Jesus on a base, which I gave him to adorn, and I gave him one peso to gild it."[139] Fonte Ferreira had business interests that went beyond paint-ing, including half-ownership of a local *pulpería*, which he acquired in 1629, and through which he may also have furthered his artistic profession.[140]

Fonte Ferreira's first major artistic commission involved gilding the altar-piece of the Confraternity of the Immaculate Conception, established in the

Franciscan church. In 1631, the *mayordomos* of the confraternity undertook with Fonte Ferreira "maestro pintor y dorador"

> to gild an altarpiece that is finished and made of wood, which is today installed in the altar and chapel of the said confraternity, providing all and the full amount of the gold required for the said work and gilding [. . .] and he also must gild the tabernacle, which must be made of wood so that it can be placed on the altarpiece.[141]

The confraternity agreed to provide all the gold leaf, and to pay Fonte Ferreira for his labors the sum of three hundred *patacones*. The painter autographed the official document "Joan Fonte," although in several later documents he signed with both surnames. Nonetheless, the signatures clearly were inscribed by the same hand.

In February 1638, Juan Fonte was subcontracted by the Spanish or Creole gilder Gabriel Vázquez to work on an altarpiece for an unspecified patron and location. Fonte's stated obligations included gilding and painting

> an altarpiece of five *varas* in height and three *varas* wide with its tabernacle gilded and painted with all of the paintings required for the entire body [of the altarpiece], and in the upper panel a canvas of the ascension of our Lord with the eleven apostles and Our Lady and the Holy Spirit, and in the upper portion the full figure of God the Father, and in the center box a Saint Ursula with the eleven thousand virgins, which is to be inside the niche, and to either side four angels and a sculpture in the round of Saint Christine of one *vara* in height with its gilding and sgraffito, and the said altarpiece must be completely gilded with pure gold [*oro limpio*] with some enameling [*esmaltes*] wherever it may be required.[142]

Vázquez agreed to provide all the required gold leaf and to pay Fonte Ferreira sixty-five pesos for what appears to have been extensive and complex painting and gilding. For the patron of the work not to be involved in the contract is relatively unusual, nor is the intended location of the altarpiece mentioned. In fact, Vázquez was almost certainly acting as a middleman in this contract. In 1637, Melchor Báez Martínez had commissioned an altarpiece of exactly the same dimensions and iconography from Pedro de Olivas "oficial ensamblador," which was intended for his family chapel in the conventual church of Santa Catalina.[143] This is clearly the same altarpiece that Fonte Ferreira was commissioned to paint and gild the following year. The contract between Fonte and Vázquez is a relatively rare example of artistic subcontracting undertaken before a notary, which was by no means the norm in early colonial Quito.

In March of 1638, Fonte Ferreira was commissioned by the nuns of the Convent of the Immaculate Conception to gild the main altarpiece of their

church. The master sculptor Antonio de la Torre served as Fonte Ferreira's guarantor for this contract, suggesting that the former was the sculptor of the altarpiece, and that Torre collaborated with and/or had recommended Fonte Ferreira as the appropriate gilder and painter. The contract follows the fairly standard format and set of requirements for such a job:

> The said Juan Fonte must gild the main altarpiece of the conventual church, and he must supply at his own cost the gold and all of the materials and colors that might be necessary for the work, and he must pay for the assistants and paintings and everything else that might be required, to the contentment and satisfaction of the abbess and of people knowledgeable in the said art, except for the six large paintings, which he does not have to paint nor provide anything for them.[144]

This was a monumental altarpiece, and Fonte Ferreira was paid the equally monumental sum of nineteen hundred pesos for its confection. It is interesting that Fonte Ferreira was not selected to paint the six large easel paintings that would dominate the retablo. Perhaps, despite his diversification, he was still viewed principally as a gilder and decorator, and not therefore as the most desirable painter of large, independent canvases or panels. Fonte autographed the contract using both surnames.

Felipe Sánchez (active 1623)

The Spanish or Creole painter Felipe Sánchez signed a 1623 contract for a series of paintings that involves Juan Fonte Ferreira. In that year, the merchant Juan de Cáceres commissioned Felipe Sánchez "pintor" and Juan Fonte "pintor," the latter again acting as guarantor, to create sixteen oil paintings on canvas depicting the twelve apostles, Jesus, and the Virgin Mary, each of one *vara* in height.[145] Fonte Ferreira is presented as a collaborator on the commission, although Sánchez is designated to receive the entire payment: three and one-half pesos per painting, for a total of 56 pesos. This was a modest price, especially in view of the fact that the artists were required to supply all the materials. Nonetheless, this 1623 contract is the earliest known in Quito for an *apostolado* series, although they would become more common later in the seventeenth century.[146] Each of the three parties signed the contract.

Juan de Salinas Vizuete (active 1648–1673)

Along with Andrés Sánchez Gallque and Mateo Mexía, the Spanish or Creole painter Juan de Salinas Vizuete is the only artist for whom signed and dated paintings are extant during the first half of the seventeenth century. In 1648 Salinas Vizuete signed his name to *Apparition of Jesus and Saint Dominic to Saint Teresa of Avila* (*see plate 26*). No official contract for this painting has been recovered, and no other works by Salinas Vizuete have been identi-

fied. The few extant documents regarding Salinas Vizuete identify him as a "maestro pintor." They also note his gambling habit in the 1640s,[147] and they record his failed attempt to hire a painting apprentice in 1673.[148]

Salinas Vizuete's painting *Apparition of Jesus and Saint Dominic to Saint Teresa of Ávila* is signed and dated "Juan de Salinas 1648," omitting his second surname. This canvas is a relatively rare depiction of one of Saint Teresa's many spiritual visions, experienced in Segovia when she was attempting to establish monasteries throughout the peninsula of her newly reformed order, the Discalced Carmelites. In a text describing her stay in Segovia in 1574, she wrote of visiting the "cave" or chapel of Saint Dominic, the place in which the saint performed his acts of penitence and self-mortification. Kneeling in prayer before a sculpture of Saint Dominic, Teresa experienced a vision in which the saint himself appeared at her left. When she asked why he chose to appear on her left side, Dominic responded, "because the right-hand side is for my Lord" ("porque la mano derecha es de mi Señor"). In that moment, Teresa saw Christ appear to her right, and he said to her "Be pleased with my friend" ("Huélgate con mi amigo"), whereupon Dominic took Teresa's hand and promised to help and support her in the foundation of her order.[149] Although one might suppose the patron of this work to be associated with the Carmelite or Dominican orders, the painting hangs today (without provenance) in the chapter room of the Franciscan Convent of Santa Clara. Salinas Vizuete's parish of residence is unknown; however, he was associated with several painters in Santa Barbara, including Salvador Marín and Simón de Valenzuela, and his second surname suggests a connection to the Andean painter Lucas Vizuete.

Alejandro de Ribera (active 1635–1648)

Two documents record the activities of the Andean painter and regional immigrant Alejandro de Ribera, who is not documented living in a specific parish but who conducted a land transaction that reveals underlying links to painters in Santa Barbara. In a 1635 document, Alexandro de Ribera "*yndio ladino* journeyman painter, native of the town of Cotacachi [. . .] resident in this city of San Francisco of Quito" sold three blocks of land in Cotacachi to one Agustín de Cisneros "yndio."[150] Ribera penned his scrawled but nonetheless competent signature, replete with rubric, to the contract (fig. 7.9). This rather unassuming, conventional contract of sale actually contains several intriguing details. First, Agustín de Cisneros is the name of the painter Miguel de Santiago's son, and also of the grandfather of his wife, Andrea Cisneros y Alvarado.[151] Second, as discussed above, the family of Miguel de Santiago's father, Lucas Vizuete, was from Cotacache. These links, tenuous as they are, suggest familial relationships between Ribera, Vizuete, and Miguel de Santiago.

In 1648, Ribera's activities as a painter had an adverse effect on his fortunes. In that year, Juan Álvarez Moreno posted bail for "Alexandro de Ri-

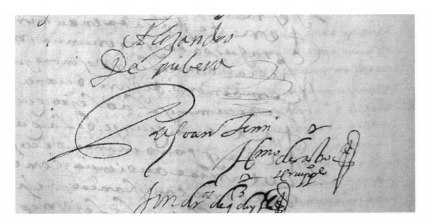

Figure 7.9. Signature of Alejandro de Ribera, 1635. ANH/Q, Notaría 5a, vol. 18, 1634–1635, Gerónimo de Castro, fol. 181v.

vera *yndio* painter, imprisoned in the public jail as a result of legal action brought by Juan Suáres Sores for eighty pesos [. . .] which he gave to the said *yndio* for some paintings."[152] This evidence reaffirms the protection that legal notarial documents of commission conferred, particularly for artists, because in this case no such document had been filed. As a result, Ribera found himself at the mercy of his patron, and landed in jail.

Overall, the number of documented painters in Quito increased significantly between 1615 and 1650, and they were somewhat more widely distributed throughout the city. The urban geography of painters' residences demonstrates growing numbers and concentrations of painters in the *hanan* parish of San Roque, and in the *hurin* parish of San Blas. In general, these divisions are reflected in the non-Hispanicized surnames of Andean painters, in which Quechua surnames from central Peru predominate in the *hanan* half, and autochthonous or regional surnames in the *hurin*. By contrast, the residences of Spanish and Creole painters were scattered throughout the parishes or are unspecified in the documents, in some cases owing to their status as transients or renters. The number of Andean painters increased substantially in the three parishes of San Roque, San Blas, and Santa Barbara. Moreover, the physical proximity of Andean painters in these parishes, many of whom were bound by family ties, suggests that these extended kin groups may in some ways have operated as informal trade guilds, although on their own terms.

For the most part, Quito's many painters appear to have made quite a good living by means of their trade, even if the prices of paintings and related works remained relatively low during this period. Painters often bartered their work, particularly for land, suggesting that paintings were a fungible commodity. Many painters owned houses and land, above all the Andeans; many possessed additional agricultural terrain in nearby communities; and a number speculated in real estate and other business ventures. Despite the relative decline in alphabetic literacy during this period, the majority of painters were nonetheless conspicuously lettered artists who effectively har-

nessed and negotiated the Spanish colonial legal and bureaucratic system to their advantage.

Painters undertook a broad spectrum of artistic commissions for religious and secular patrons, for resale on the open market, for export to other regions, and some traveled to undertake commissions in distant parts of the *audiencia*. Their contracts and extant works range from canvas, panel, and mural paintings to polychrome and gilded statuary, altarpieces, and church furnishings. Patrons typically provided the supports for paintings, while artists were largely responsible for supplying the pigments and gold leaf—materials that required specialized knowledge to create and employ. Many contracts specify the use of prints as models, relying on the painters to translate, adapt, and transform small black-and-white images into large-scale coloristic works by means of their specialized knowledge, skills, and techniques.

The few extant signed or documented paintings of this period do not permit any overarching conclusions to be drawn regarding the artistic styles and proclivities of the later generation of Quito painters, except that they appear to have varied significantly among artists and dynasties. Far from presenting a unified vision of a theoretical "Quito School" of painting, their stylistic pluralism suggests that painters and their works might more fruitfully be considered individually or in terms of extended family production. The exception is Mateo Mexía, for whom several signed and dated as well as securely attributed paintings are extant that have made him an outlier in the art-historical literature precisely because of his distinctive "style" and approach to painting.

CHAPTER 8

Mateo Mexía and the Languages of "Style"

The problem with the painter Mateo Mexía is that his work has not been perceived as fitting neatly into a Western evolutionary scheme of the development of painting in seventeenth-century Quito—it does not logically and stylistically set the stage for the Baroque naturalism of Miguel de Santiago and other painters of the latter half of the century.[1] Mexía is named frequently in the literature and his works are often illustrated, yet he does not figure prominently in histories of colonial Ecuadorian art, and little has been published regarding his life and work. Despite the existence of two signed and dated paintings by Mexía and at least two additional canvases that can be securely attributed to him, he has not been the subject of extensive scholarly interest and publication. To date, the only monographic study of Mexía is a 1960 article by José de Mesa and Teresa Gisbert that attempted to establish and evaluate his oeuvre through stylistic attributions and secondary sources.[2] Dubbing him "the strangest painter of the period," the authors observed that Mexía's artistic "personality does not fit with his era; he looks for inspiration in the past, in Spanish painting of fifty years earlier."[3] Indeed, most scholars have characterized Mexía's painting style as "archaic," "Gothic," "Byzantine," "mystical," and otherwise anachronistic, which to a great degree accounts for the fact that he has been largely overlooked as a worthy or fruitful art-historical subject.[4] Yet Mexía's apparent stylistic "peculiarities" are precisely what make his paintings and his life worthy of closer examination: his technical and artistic versatility and his distinctive pictorial idiom mark him as one of the most intriguing painters of his time.

Based on a stylistic analysis of Mexía's paintings, Mesa and Gisbert concluded that he "must be a Spanish master, but one having a marked archaic tendency."[5] Others also believed that Mexía must have been of peninsular

ancestry, again basing their assessment solely on the visual appearance of his paintings.[6] Commenting on Mexía's training and professional status, José María Vargas observed, "in San Francisco there are two paintings that bear the names of Mateo Mexía and Francisco Quispe that are respectively dated 1615 and 1668. They were undoubtedly secondary assistants in the workshops of some good master [painter]."[7] Moreover, Mesa and Gisbert conjectured that, since all the artist's known paintings were related to the Franciscan order, "Mexía himself may have been a Franciscan priest, or at least a Franciscan Tertiary."[8] The lack of documentary evidence regarding Mexía has forced scholars to speculate on the basis of visual and circumstantial evidence alone as to the painter's ancestry, his artistic formation, and even his religious affiliation.

Yet Mexía registered a range of his personal and professional activities in more than twenty notarial documents over the fifty years between 1612 and 1662. These contracts extend from the purchase of merchandise, houses, and land, to lawsuits, loans, and artistic commissions. Taken together, they contain pertinent information on Mexía's relationship to the Andean community, his social and economic status, aspects of his education and professional training, and the contemporary market for his work. While the documents may clarify and establish some things about Mexía's life, they also reflect some of the incertitude that has characterized him in the historiography of painting in early colonial Quito.

Mexía's ancestry is ambiguous. His ethnicity is not specified in the notarial contracts, a typical indication that he was Spanish or Creole; however, in one noncontractual instance he is identified as an "yndio pintor."[9] The form of racial or ethnic classification employed by colonial notaries relied more on social markers such as language, dress, and visible signs of social standing than it did on skin color or phenotype.[10] Whatever his personal history, it appears that Mexía largely "passed" as non-Andean in the colonial bureaucratic world. In this regard, Mexía's classification as "yndio" in a lawsuit that he brought against two Andean brothers may well have been to his legal advantage.[11] Mexía's ambiguous, shifting socioethnic status in the documentary record hints at his ability to negotiate the system to his benefit.

In addition to racial or ethnic identification, notaries also employed place of origin and/or place of residence as a sociocultural identifier. A 1630 document from Riobamba identifies Mexía as a "native of Riobamba," while a 1652 contract from Quito names Mexía and his wife as "natives of Puembo," a small indigenous community east of the capital.[12] Mexía may have found shifting his place of origin expedient or advantageous in accord with the nature and circumstances of each case, and he may well have been a regional immigrant to Quito. In a number of contracts from the 1610s and early 1620s, Mexía is identified as a "morador" (inhabitant) of Quito, indicating that it was not his place of origin.[13] A 1630 contract names him a "vecino" (citizen) of Riobamba.[14] However, in several—but not all—later documents, the nomenclature changes to identify him as a "vecino" of Quito, a category usually

reserved for Spaniards or Creoles.[15] Mexía's changing "residence identity" suggests a pattern in which he is identified as a "vecino" in contracts involving Andean parties, and as "morador" when the parties are non-Andean. Such patterns of alteration again hint at Mexía's capacity to negotiate the colonial bureaucratic system to his advantage. Irrespective of his residential, ancestral, or geographic origins, Mexía spent most of his long professional career in Quito, with one notable hiatus, for his activities in the city consistently appear in the records during each of the decades between 1612 and 1662.

Mexía identified closely with the Andean community, which may account for some of the ambivalence in the documents regarding his ancestry and sociocultural status. Early in his career he lived with María Pasña, his Andean wife, in a thatch-roofed house in the parish of San Roque, purchased in July of 1617 from the Andean painter Juan Chauca. Mexía's domicile was surrounded by the homes of numerous Andean artisans and painters—Chauca, Andrés Sánchez Gallque, Mateo Ataurimache, and others, and by the residence of the descendants of Atahualpa.[16] Employing a tactic used often by "indios ladinos" and others in the notarial record, in November of 1617 Mexía filed an official statement before a notary declaring that he had purchased the property from Chauca with the money of his wife, María Pasña, and that it legally belonged to her.[17] Mexía thus appears to have manipulated the notarial system to ensure that his wife obtained legal title to the property, even though, for whatever reason, she had been precluded from making the initial legal purchase.

María Pasña came from an elite Andean family of artisans in San Roque. Her father, Pedro Quispe, was a blacksmith who served for a number of years as *alcalde* of San Roque, and her uncle was the master painter Clemente Quispe, who resided in the same neighborhood in San Roque.[18] Clemente Quispe was among the elite Andean signatories from the parish of San Roque who had contracted in 1632 to hire a schoolmaster to teach the boys of the parish to read, write, and sing.[19] Pedro, Clemente, and other members of the Quispe family owned land and houses in San Roque, as well as extensive terrain in the nearby indigenous community of Puembo.[20] Similarly, Mexía and Pasña owned a substantial tract of land in Puembo and the neighboring community of Pifo.[21]

By 1628, Mexía had acquired additional property in San Roque. His house is described in documents as "roofed in tiles and thatch," registering improvements that increased its status and value. In subsequent decades, Mexía and his wife bought and sold land and houses in the parish and in nearby native communities, highlighting the professional and economic success that he, as an artist, achieved in his lifetime.[22] Dating from the 1630s, Mexía's professional title shifts in the documents from "pintor" to that of "maestro pintor," underscoring his ascendant status and prominence in the trade.[23] Like the majority of painters considered in this volume, Mexía signed his name with a consistent and practiced hand that included flour-

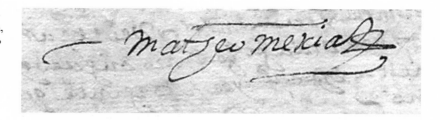

ishes and rubrics to each of the more than twenty notarial documents that recorded his activities (fig. 8.1).

Many of Mexía's contracts involved his purchase of merchandise from local shops. In most cases the artist was acquiring textiles for the production of paintings. Indeed, the earliest document involving Mexía is a 1612 contract that he cosigned with Juan Monroy, *clérigo de menores órdenes*, who also served as his guarantor when they purchased 150 *varas* of velvet and four *varas* of *ruán de fardo* from a local merchant.[24] The merchant required Mexía, the protagonist of the purchase, to provide a guarantor, perhaps because of his youth or because he was unknown to the seller, yet the painter staked his legal claim by inserting himself into the contract rather than relying on Monroy to make the purchase. The division of the goods is not clear, but the *ruán de fardo* likely was intended for Mexía's professional use. Less than four years later Mexía signed the two large paintings, *Saint Francis and the Tertiaries* and *Saint Michael Vanquishing the Demon*, which hang in the Monastery of San Francisco. Again, in October, November, and December of 1620, Mexía made a series of purchases from local merchants that were almost exclusively textiles used in the confection of paintings: eighty *varas* of *melinze*, sixty-five *varas* of *ruán de fardo*, and another twelve *varas* of *ruán de fardo*.[25] The quantities of textiles that he purchased in these instances conform to his professional practices and artistic commissions; Mexía's extant and documented paintings are canvases of very large dimensions. At the same time, his continued acquisition of textiles associated with painting indicates that he was producing for the open market, since patrons typically supplied the supports for commissioned works.

Artistic Contracts

Based on the documentary outline of Mexía's fifty-year professional career and on his extant paintings, he was a successful and prolific artist; however, only two artistic contracts are documented for him in the archives. The first of these reveals that Mexía produced canvases for patrons who intended to resell them on the open market. On 12 May 1622, Mateo Mexía "pintor" signed a contract with the merchant Juan Cit Moscoso to create in two months' time "nine canvases of just over one *vara* in height, on which must

be painted four good images of the most holy trinity and five of the ecce homo with [Pontius] pilate."[26] The paintings were valued at the modest price of two and one-half *patacones* apiece, for a total payment of twenty-two *patacones* and four *reales*.[27] In this case, the contract was drawn up at the behest of the patron, who was recorded as present at the signing; however, Mexía was the protagonist of the document, for he had previously received full payment for the as yet unfinished works, and the formal contract was undertaken to document his legal responsibility to complete the commission. The circumstances of this contract suggest that Mexía had not complied in due time with a previous (likely verbal) agreement between patron and artist. Mexía's signature, and not that of the patron, is inscribed at the end.

Although the nine paintings were to some extent stock images made for resale on the open market and may not be directly comparable to unique, highly specialized commissions, they nonetheless illustrate once again the generally low pecuniary value placed on paintings in early colonial Quito. Yet it is instructive at this relatively early stage in Mexía's career to compare this commission with those of his contemporaries. For example, in this 1622 contract, Mexía received two and one-half *patacones* for each of nine paintings measuring just over one *vara* in height, for a total of twenty-two *patacones*, four *reales*. In 1608, Andrés Sánchez Gallque and Bernabé Simón had been paid fifty-eight *pesos* for a painting measuring one and three-quarter *varas* commissioned by a confraternity of mestizos in the Jesuit church—more than double the amount paid to Mexía for all nine paintings combined. This disparity probably reflects the nature of each commission, as well as the different level of experience that each artist possessed at the time of the commission, for Mexía was of a younger generation than Sánchez Gallque and Simón, and did not yet bear the title of "master painter." Yet even the twenty-seven paintings depicting the life of Saint Francis commissioned from the Andean painter Miguel Ponce in 1630, which may have been destined for sale on the open market, commanded just over eleven pesos apiece, for a total of three hundred pesos.

A more contemporaneous comparison is the contract signed in 1623 between the merchant Juan de Cáceres and the Spanish or Creole painter Felipe Sánchez for a series of sixteen paintings depicting the apostles, each of one *vara* in height, for which he was to supply "all the colors and canvases."[28] For his labor, Sánchez received three and one-half *patacones* per painting, quite a low price considering that the artist provided all materials. Yet less than a year before, Mexía had earned only two and one-half *patacones* per painting for canvases of comparable dimensions. Again, this contract falls early in Mexía's career and he would later receive major commissions that brought substantial remuneration.

A second, and in this case major, artistic contract required that Mexía relocate to the town of Riobamba. This involved preparations for a journey that would take him away from Quito for an extended time. In April 1628, Mateo Mexía "maestro pintor" and his wife, María Pasña, rented their house in San

Roque to the Andean Manuel Silva for a period of four years, charging him twenty-two *patacones* per year, plus annual payment of the mortgages they held on the residence.[29] Less than two years later, in January 1630, Mateo Mexía "maestro pintor" and *vecino* of Riobamba signed a contract with fray Juan de Escobar, prior of the local Monastery of San Agustín, to create twelve large paintings for the main altarpiece of the Augustinian church. The paintings were to range in size from three by two and one-half *varas* to one *vara* square, and Mexía was to undertake the work in the following manner:

> All twelve pictures of the Saints must be painted on canvas with their borders made so that they fit [into the designated spaces], and some of them of low relief, cornices, and frontispieces and crowning elements [all] painted in perspective, [and] additionally it is ordered that they be painted in all sculptural perfection [*perfección de escultura*] and to the content of the said Prior and according to the account of the Saints that he provides and in the form of painting and sculpture . . . and I must provide all of the colorants and paints at my expense, and the manufacture and the costs of mounting [the paintings on the altarpiece] . . . and the prior will supply all of the wood for the paintings.[30]

Based on the published transcription of the contract, in addition to painting twelve large canvases, Mexía also was required to polychrome the relief sculpture and architectural elements of the altarpiece. The published source for this document does not record the amount of payment received by Mexía; however, this important commission undoubtedly brought him substantial remuneration, and therefore must have justified relocating his family to Riobamba for a four-year stay.

Mexía and Pasña moved back to Quito some time before 1638, when they purchased for 250 *patacones* a thatch-roofed house and land in the parish of San Roque, located on the plaza of the Franciscan Recoleta de San Diego.[31] Presumably they continued to receive rental income from their other house in the parish. The following year they sold a plot of vacant land in San Roque, and in the 1550s and 1560s they sold additional tracts of their landholdings in the rural indigenous communities of Puembo and Pifo.[32] At the same time, Mexía both lent and owed significant sums of money, and in 1662 he gave power of attorney to the painter Miguel de Santiago to seek and receive funds in compensation for a prior debt.[33] This final contract signed by Mexía indicates that not only did he know and enjoy the trust of the contemporary painter Miguel de Santiago, but that he may have been too sick or infirm to collect the debt himself. Given Mexía's signed 1615 paintings, the artist was likely born in the early 1590s, which in 1662 would make him more than seventy years old.

Mexía emerges from the documents as a lettered artist who skillfully managed and manipulated the literate arts and the bureaucratic system to his benefit and that of his family. He identified and was closely allied with the

Andean community, owning houses and land in the parish of San Roque and nearby indigenous communities. Mexía made quite a good living as an artist, he rose in status during his career from "painter" to "master painter," and his command of the art of painting brought him substantial and significant patronage. In seventeenth-century Quito and beyond, Mexía's work was appreciated and in demand.

Extant and Attributed Paintings

Scholarly characterizations of Mexía's painting style as "antiquated" focus principally on his use of applied gold decoration and to a lesser degree on painted inscriptions, hierarchies of scale, and his mixture of temporally distinct pictorial styles. Indeed, Mexía's eclectic combination of styles, materials, and techniques is the defining characteristic of his approach to painting, and it was precisely this aspect that rendered his work difficult for earlier art historians to classify within a Western evolutionary model of artistic development. The fact that Mexía often employed sixteenth-century European engravings as models also contributes to the perceived "archaic" appearance of his work; however, the painter adapted, transformed, and reinterpreted European prints in varied and significant ways. By attending closely to Mexía's signed and attributed paintings, we can see his creative blend of sources, approaches, and technologies as emerging from the colonial Andean context of the early seventeenth century, as did many other aspects of his life.

Mexía's signed and dated painting, *Saint Francis and Tertiaries*, located in Quito's Franciscan monastery, depicts the saint surrounded by members of the Franciscan Third Order of Penitence, known as tertiaries (*see plate 27*).[34] The artist painted his signature inscription, "Mateo Mexia fecit 1615," in the lower left sector of the canvas, adjoining and curving slightly below the shaft of a gilded scepter (fig. 8.2). His painted signature follows closely the form of his written name on documents (fig. 8.1). Unlike Sánchez Gallque, Mexía inscribed his signature in the same manner regardless of medium, function, or intended audience. Although Mexía, like Sánchez Gallque, crafted his painted signature to imitate the strokes of a pen, unlike his contemporary, Mexía seems to have viewed his autograph on paintings and on documents in the same way, as static markers of identity and authority.

The Ecuadorian art historian José Gabriel Navarro relegated Mexía to a footnote in a 1925 publication, scoffing that "Among the paintings in the lower cloister [of San Francisco] there is a particularly bad one that represents Saint Francis surrounded by many saints and monarchs of the Third Order. It bears the following signature: Mateo Mexía made this [in] 1616. Without a doubt, [he was] one of the many painters of the old school of Quito."[35] Navarro here employs the phrase "old school" (*escuela antigua*) in a disparaging manner, yet he does not elaborate on this or on the reasons that he considers Mexía's painting to be "particularly bad." Again, Navarro's

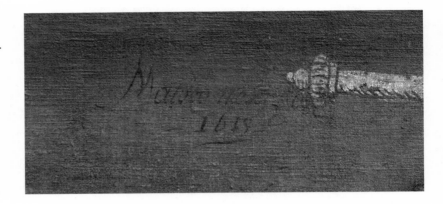

perception of Mexía's style as retardataire seems to have shaped his appraisal of the painting.

Saint Francis and Tertiaries is a summa of the distinctive features of Mexía's approach to painting and an illustration of the reasons his style has been considered in the literature as "antiquated," "mystical," "archaic," and even "particularly bad." The monumental and complex multifigural composition dramatically combines text and image, representational figures and symbolic forms, Mannerist elongations and medieval hierarchies of scale, illusionistic space and flat applied gold leaf. The manner in which Mexía incorporates, blends, and interprets these features has led art historians to regard his work as backward-looking during a period in which the move toward Baroque naturalism, embodied in the work of the painter Miguel de Santiago in the second half of the seventeenth century, was the evolutionary standard in the literature. Indeed, Mesa and Gisbert concluded that Mexía's style was essentially a dead end: "As regards the influence of Mexía on the later Quiteña school of painting, there is only one example, a 'Virgen de la Merced.'"[36] Yet the imposition of a Western evolutionary model of stylistic development is largely misguided in terms of its application to colonial Quito, as elsewhere in the Americas, where hosts of individual, local, and contextual factors exerted great influence over artistic production.

Mexía's liberal application of gold to embellish a range of elements across the painted surface contributes to a scholarly perception of his style as old world and old school. Unlike a number of his contemporary artists, never once is Mexía identified in the documents with the title of "gilder," yet he obviously mastered the same techniques used by such professionals on sculpture and other objects. Orpiment, a pigment that convincingly imitated gold, was available on the market in Quito, yet in this painting Mexía and/or his patrons elected to employ actual gold rather than an illusionistic simulacrum.[37] Mexía was not the first to do this. In addition to the circa 1591 *Immaculate Conception with Jesuit Saints* attributed to the itinerant Jesuit artist Pedro de Vargas, among Quito painters, Sánchez Gallque originally

painted with orpiment the gold facial ornaments on his 1599 triple portrait, and a subsequent decision was made to apply gold leaf over the pigment, rendering the adornments more palpable and imbuing them with greater visual potency.[38]

In Mexía's work, the exacting, labor-intensive, and expensive technique of gilding and applying painted gold patterns to the pictorial surface is not restricted to crucial iconographic elements or to heavenly splendor, but is delicately and intricately applied to all manner of things, from lettering, escutcheons, haloes, and crowns, to the edging and ornamentation of garments, cushions, and the attributes of saints. Myriad passages of gold capture and reflect light across the painted surface, animating the scene and exciting the eye of the spectator. One need only imagine the painting in a dim chapel, illuminated by flickering oil lamps and candles, to grasp the powerful visual effect that the gilded elements exerted on the perception of the viewer. The visible materiality of gold in Mexía's painting also embodied powerful symbolic associations for both European and Andean audiences.

Mexía incorporated gold into his paintings by using several different techniques. He applied it to the painted surface as flat areas of gold leaf, and he employed gold paint, made by grinding gold leaf into a fine powder, suspending it in oil, resin, or glue, and painting freehand designs on the surface with a brush. The latter method often created the effect of slight relief, giving body and palpable mass to the gold embellishments. Another technique used by Mexía is known as *brocateado*, the creation of brocaded or embroidered effects, in which gold paint was brushed on freehand or applied using stamps to create repeating patterns and designs such as those seen on draperies. Although a definitive assessment is not possible, in some instances Mexía appears to have used stamps or *sellos* to create the repeating ornaments that adorn draperies in his paintings, highlighting the employment of a technique and visual effects common to the textiles and ceramics of pre-Columbian cultures in the northern Andes.

Just as the pre-Columbian textiles from elite tombs at La Florida in Quito and elsewhere in the northern Andes often were covered with applied gold or other metallic bangles that captured and reflected the light to scintillating effect, so do Mexía's golden painted and perhaps stamped designs shimmer across the surface of painted draperies. Several specific ornamental motifs are repeated in at least three paintings attributed to Mexía, underscoring his reuse of the same design or pattern-making tool. Moreover, in some instances the edges of the ornamental designs are soft and slightly irregular, suggesting the use of a *sello*. Using *sellos* in the colonial period to apply gold designs to painted surfaces suggests a link with the pre-Hispanic past that is made not through iconography, but by technique and visual effect.

The applied gold ornamentation and designs liberally employed by Mexía in *Saint Francis and Tertiaries* are techniques that are associated in the literature with eighteenth-century painting.[39] This assumption engendered a standardized approach to dating Quito paintings in which works bearing

the *brocateado* technique typically were classified as eighteenth century, or the claim was made that the gold applications were eighteenth-century additions to paintings created in an earlier period.[40] This is decidedly not so with Mexía's *Saint Francis* canvas, which incorporates texts painted atop many gold leaf applications and also employs *brocateado*. Similarly, Sánchez Gallque's 1599 triple portrait displays applications of gold leaf on the facial ornaments of the sitters, and it is highly unlikely that an eighteenth-century peninsular Spanish artist took it upon himself to add these to the painting. In light of these two Andean painters' works, the scholarly supposition that all Quito paintings exhibiting *brocateado* and/or applied gold ornamentation are either eighteenth-century works or were retrofitted with gold in that century should be qualified and reevaluated.[41]

Another aspect of Mexía's work that contributes to its scholarly characterization as "archaic" is the abundant inscription of texts throughout the image. These are painted in black letters on the surface of gilded rays and applied as gilt lettering to dark passages of the painting, conjuring images of Gothic and Renaissance paintings filled with scrolling banderoles of lettering and textual glosses. Mexía included a range of exclusively Latin phrases, all appropriately rendered in Roman square capitals, a type of lettering known in the calligraphy manuals of Juan de Yciar and others as "letras latinas" from the "Alphabetum Latinorum." Mexía's texts include sophisticated abbreviations, ligatures, and flourishes. In the celestial sphere, the artist applied gilt and painted lettering that, from the viewer's perspective, is either right-side-up or inverted, as though some phrases should be read from above, a practice that was particularly common in sixteenth- and early seventeenth-century European engravings.

The monumental, hieratic figure of Saint Francis forms the axis of Mexía's painting, his arms outstretched in *imitatio christi*, stigmata on full display (*see plate 27*). Above his shimmering gold halo appear the gilded words "PATER PENITENTIVS," in lettering that incorporates abbreviations, ligatures, and scrolling adornments. Saint Francis stands atop a globe that bears in applied gold lettering the phrase: "CONCVLCAVIT MVNDVM ET QUE SUNT M˜V[N]DI" ("He trampled the earth and the things which are of the earth"), emphasizing the saint's renunciation of worldly pursuits. At the base of the globe are two pairs of crowns and scepters arranged on cushions, presumably placed there by the monarchs who kneel to either side. Along the bottom register of the painting a partially effaced inscription in applied gold leaf reads: "ET PENITENTIVS [. . .] TERTIVS," underscoring the penitential focus of Francis and the Third Order.

Francis's outstretched arms sustain the ample cloak of his habit, beneath which he protects flocks of Franciscan tertiaries who gaze up at him in attitudes of prayer. The facial features of the male and female figures show little variation in physiognomy or expression. Mexía conveys the notion of multitudes by the repeated sameness and anonymity of faces in the crowd; figures are distinguished only by their dress and attributes. The male figures assem-

bled on Francis's left incorporate numerous tertiary kings and saints, many of whom wear gilded crowns, while gilded, laureled aureoles hover in space above the group. In the foreground kneel Saint Louis King of France (patron of the Third Order of Penitence) with his crucifix and mantle adorned with gilded fleur-de-lis, and Saint Roch, who gestures to his wound and is accompanied by his dog. To Francis's right is a gathering of female tertiary queens and saints, including Saint Elizabeth of Hungary (patroness of the Third Order, often paired with Saint Louis), holding a cross and flagellant whip, and Saint Clare, who bears lilies, a cross, and a gold filigree coffer or pyx. Gilded haloes combining leaves and four-petaled flowers hover over the female assembly. Rupturing the illusionism of pictorial space, two gilt escutcheons of the Franciscan order—one bearing the crossed arms of Francis and Christ, and the other the Five Wounds—are superimposed on the picture plane over each of the figural groups.

The monumental form of Francis's body conjoins earthly and heavenly spheres in this work. Above his outstretched arms the figures of the heavenly Trinity are arranged in blazes of opulently gilded celestial glory. To the saint's right, the seated figure of Christ holds a cross in one hand and in the other the Franciscan knotted penitential cord, which winds across the upper sector of the canvas, linking each member of the Trinity. The dove of the Holy Spirit, outstretched wings trailing gilded shafts of light, crowns the head of Saint Francis. To the saint's left, the seated figure of God the Father sustains the globe in one hand and grasps the penitential cord in the other.

Once again shattering the pictorial illusionism of the painting, explosions of gilded undulating and staccato rays emanate from both Father and Son, many bearing inscribed Latin texts that record chants and lauds. For example, the text painted on one of the rays that emerges from God the Father reads: "EGO AUTEM IN DOMINO GAUDEM" ("But I rejoice in the Lord"), the refrain of a Latin chant from the feast of the Holy Name of Jesus. Indeed, so many texts adorn the gilded rays of Father and Son, and emerge also from the Holy Spirit, inscribed upside down as well as right-side-up, that spectators are as overwhelmed with the word-content as they are with the golden resplendence, the complex figural composition, and the many symbolic elements of the painting. Ample time is required to "read" this image, yet each figure, textual inscription, and conjunction of gilded glories combine to exalt Christ, Francis as a type of Christ, and his tertiary followers that practice penitence, humility, and renunciation of the material world. This painting is intended to visually transport and inspire as well as instruct its viewers.

The complex composition, axial organization, frozen iconic poses, hierarchies of scale, stylized anonymous faces, and above all the liberal application of illusion-shattering gold leaf and lettered texts to the painted surface constitute the hallmarks of Mexía's style—elements that led to his characterization in the literature as an "archaizing" painter. Irrespective of his reportedly retardataire tendencies, Mexía inventively and masterfully mixed forms, styles, and techniques from different chronological periods and geographical

origins. In many ways, this painting seems more like a finely crafted manuscript illumination expanded to a monumental scale, with all the subtleties and myriad details of a miniature writ large. Indeed, many of the techniques he employs, the application of gold leaf and *brocateado*, lettering, and intricate detail are typical of such miniatures, suggesting that Mexía likely practiced and perhaps acquired these skills in the production of illuminated manuscripts.[42] Some of these effects may also derive from an as yet unidentified European engraving that served as the source of the composition, for all of Mexía's other signed and attributed paintings are based on prints. Mexía's distinctive stylistic characteristics permit the attribution of at least two unsigned works to his hand.

Saint Francis and Tertiaries is closely related in style, composition, and scale to a painting now in the Museo Jijón y Caamaño of the Pontificia Universidad Católica del Ecuador in Quito, *Triumph of the Risen Christ* (*see plate 28*). This canvas is attributed to Mexía by several authors, who are surely correct in their assessment, to the extent that the painting is often published without qualification as his work.[43] *Triumph of the Risen Christ*, however, is not signed or dated, and no contract or payment record is known for the painting. The lower section of the canvas has suffered extensive paint loss, precisely in the area where a signature might once have appeared. Beyond bearing all the hallmarks of Mexía's style, the composition, iconography, and dimensions of this work strongly indicate that it served as a companion piece to *Saint Francis and Tertiaries*.

Like the figure of Saint Francis, the monumental form of the resurrected Christ occupies the central axis of the painting, linking the assembled groups of people with the celestial beings. His hands display the stigmata; the right is raised in the gesture of the benediction, and the left embraces the cross. The figure of Christ rises tall above the crowds, forming the Trinity with figures of the Holy Spirit and God the Father aligned above his head, each radiating beams of gilded glory that pervade the upper portion of the canvas. Hosts of cherubim, seraphim, and musical angels further animate the divine realm.

Emphasizing the events of the Passion, Christ embraces a tall cross bedecked with the *arma christi*—the lance, sponge of vinegar, flagellant whip, rope, and crown of thorns. He is flanked by legions of followers representing all walks of life: saints, monarchs, popes, bishops, cardinals, friars, nuns, and secular men and women. With several notable exceptions, the stylized, anonymous facial features of the figures are repeated throughout the crowd; social identity again is ascribed through dress, attributes, and adornment. Saints Peter and John the Baptist occupy the foreground to Christ's left, and to his right kneels the Virgin Mary, dressed in blue and red garments adorned with gold *brocateado* designs that precisely repeat those on Christ's robes.

Behind and to the left of the Virgin kneels a man clad in contemporary secular attire, with *cuello de lechuguilla* and ruffled sleeves, his hands clasped in prayer. In contrast to the generic faces of the crowd, his visage is distinctly a

portrait, and his disposition that of a traditional donor figure (*see plate 29*).[44] He speaks in the form of a (partially effaced) serpentine flow of gilded letters that unfurl and coil toward the Virgin Mary and Christ. This speech scroll is a supplication from the Litany of Saints: "Omnes sancti Dei intercedite Pro nobis" ("All ye holy elect of God, intercede for us"), a prayer to the Triune God seeking mercy and delivery from evil. This individual likely underwrote the cost of the painting, yet any textual indication of his identity has been lost along with the pictorial surface on the lower register of the canvas.

Mexía's tendency toward ambiguity is again revealed in this painting by the fact that three other figures in the assembly display distinctly portrait-like features. The facial characteristics of the Virgin Mary are so particular and individualized that she seems unquestionably to be a portrait, yet she is clad in the traditional blue mantle and red dress of the Virgin, and even the gold designs on her garments link her with Christ. Her proximity to the donor figure and his gilt speech scroll, however, suggest that she might easily be his wife. The viewer's perception of her image thus tacks back and forth from in-dividual persona to divine personage, challenging any singular identification. From the viewpoint of Western Christianity, rendering a portrait of a secular individual as the Virgin Mary might well have been considered problematic or even heretical. For Mexía and his patron(s), this visibly heterodox image apparently did not pose a problem.

Directly above, and indeed framing the Virgin with her body, stands a female figure clad in historical garb whose visage is also quite distinct from those of the crowd. Her identity is similarly ambiguous. On the one hand, she appears to represent Saint Anne, mother of the Virgin, and on the other, her facial features mark her as a specific person. On the opposite side of the canvas, a woman with conspicuously individualized facial features and hairstyle, wearing secular clothes and lavish jewelry that includes a neck-lace, earrings, and jeweled, feathered hair adornments, is painted just above Saints John and Peter (*see plate 30*). She appears to be yet another member of the donor's family; indeed, she shares specific facial traits with the "por-trait" of the Virgin Mary. The four individualized figures are also linked by the fact that each gazes outward into space in an unfocused manner; unlike other members of the assembly, they do not "see" with their eyes the figure of Christ, but seem to imagine him in the celestial glory that they one day hope to join.

The Argentine art historian Héctor Schenone was the first to observe that this painting employs as its source an early seventeenth-century print by the French engraver Juan de Courbes (1592–c. 1641), who worked in Madrid between 1620 and 1640.[45] Courbes's undated engraving *Cristo Salvador y Redentor* (fig. 8.3), or perhaps an earlier print on which it may have been based, is clearly the model employed in *Triumph of the Risen Christ*.[46] In the engraving, the monumental form of Christ holding the cross connects the earthly and heavenly realms, flanked by two groups of figures, with the Vir-gin Mary and Saint Peter kneeling in the foreground to either side. However,

Figure 8.3. Juan de Courbes, *Christ the Savior and Redeemer*, early seventeenth century. Engraving, 142 × 90 mm. Real Academia de Bellas Artes de San Fernando, Calcografía, Madrid. Photo courtesy of José Manuel Matilla.

Mexía has made a number of significant and intriguing changes to the print, including the reversal of the figural groups, their notable expansion in numbers, and the addition of the donor figure(s) as well as the musical angels and numerous cherubim in the celestial realm. Unlike the print, Mexía's painted figure of Christ fully embraces the cross with his left arm, and his gaze has been reoriented downward to focus on the Virgin Mary kneeling to his right.

Mexía's painting includes additional instruments of the Passion adorning

the cross, and curiously, the artist painted the sun and the moon surrounded by stars at its base—an unusual location for these symbols, which typically appear in the heavens of crucifixion and Marian scenes. Perhaps most notably, Mexía has omitted the serpent and skull upon which Christ tramples, placing the focus instead on the celestial bodies beneath his feet. Indeed, unlike the engraving, Mexía has removed the entire scene to the celestial realm. Extensive paint loss along the lower register has made it difficult to see that the full expanse of ground on which Christ stands and the figures kneel is in fact a firmament strewn with gilt stars, thereby establishing this assembly as the elect, chosen by Christ to reside with him in the heavens. The painting thus emphasizes Christ's role as judge and redeemer, and it highlights in particular the penitential practices associated with the instruments of the Passion that afford Christ's followers salvation and eternal life in heaven.

In contrast to *Saint Francis and Tertiaries*, this painting includes few texts; indeed, the donor's speech scroll (which is Mexía's invention) and the INRI of the cross are the only textual elements visible in the painting. The lowest register of the canvas, apparently cut down and now largely devoid of painted surface, may once have included a textual inscription, perhaps that of Courbes's print. The engraving bears Latin text from Matthew 25:34 on the lower register, which reads "VENITE BENEDICTI PATRIS MEI, POSSIDETE PARATVM / VOBIS REGNU[M] A CONSTITVTIONE MV[N]DI" ("Come, you blessed of my Father, inherit the kingdom prepared for you from the creation of the world"). The full passage from Matthew 25 from whence this phrase is taken locates the image within the larger context of the Last Judgment:

> When the Son of Man comes in his glory, and all the angels with him, then he will sit on the throne of his glory. All the nations will be gathered before him, and he will separate people from one another as a shepherd separates the sheep from the goats, and he will put the sheep at his right hand and the goats at the left. Then the king will say to those at his right hand, "Come, you holy elect of my Father, inherit the kingdom prepared for you from the creation of the world" [. . .] Then he will say to those at his left hand, "You that are accursed depart from me into the eternal fire prepared for the devil and his angels."

Neither the painting nor the engraving visually references the separation of the flock, the judgment, or the eternal fire of the devil. The text in Courbes's engraving focuses on the rewards of the elect on Judgment Day, reassuring followers of Christ that they will stand at his side in the heavens. Through his selections and additions, Mexía emphasizes in *Triumph of the Risen Christ* the instruments of the Passion associated with the expiation of sins and the penitential practices that lead to eternal salvation. The iconography of the painting, as well as its composition and scale, associate it closely with *Saint Francis and Tertiaries*.

Another large canvas in the Franciscan collection, *Saint Michael Archangel* (*see plate 31*), is attributed to Mexía by authors who apparently did not no-

tice that the painting is in fact signed and dated "Matheo Mexia fac[ie]b[at] 1615," even if the text is partially effaced (fig. 8.4).[47] This canvas appears also to have formed a companion piece to the works discussed above. *Saint Michael* has suffered even more damage than the other two; extensive paint loss renders large areas of the canvas support visible across the surface, revealing the typical primer of red ochre (*almagre*) used by Mexía in this, as in his other works. Despite its somewhat ruinous state, Mexía's signature elements are nonetheless visible in this work, among them the celestial explosions and scattering of applied gold leaf, the use of *brocateado* and texts, the focus on a monumental axial figure, and the Mannerist elegance of gesture and pose.

The source for this painting is a 1584 engraving of Saint Michael Archangel by the Flemish printmaker Jerome Wierix, after a work by Martin de Vos (fig. 8.5).[48] Mexía reversed but nonetheless maintained the composition of the engraving, hewing to the precise form and gesture of the demon beneath Michael's feet, the number and placement of cherubim above his head, and the text that reads "QVIS VT DEVS" ("Who [is] like God," a translation of the Hebrew name "Michael") inscribed within the applied gold sunburst that surrounds the archangel's upstretched right hand.

However, Mexía introduced two significant additions that expand and transform the iconography of the image. First is a set of scales—not present in the Wierix print—suspended from the archangel's right hand, establishing an explicit visual link between Michael and the Last Judgment. While the Wierix print focuses on Michael as "like God" in his triumph over the demon, Mexía's inclusion of the scales adds another layer of meaning by emphasizing the archangel's role as "like God" in the weighing of souls and the choosing of the elect at the Last Judgment. The second addition is the tall spear in the archangel's left hand, which accompanies the martyr's palm seen in the engraving. The spear again associates the figure of Michael in this painting with that of the Redeemer in *Triumph of the Risen Christ*, whose tall spear of Longinus angles between Him and the cross laden with the *arma christi*, although in the Saint Michael, the spear also relates to justice and punishment. Indeed, Mexía appears to have reversed the archangel's pose in Wierix's print so as to reiterate that of Christ in the *Triumph* canvas.

With respect to the Wierix print, Mexía simultaneously translated the figure, stance, and facial features of Saint Michael into his own elegant idiom, liberally applying gold leaf and *brocateado* throughout the surface. The archangel's robes are edged in lacy *brocateado* and adorned with gold painted, four-petaled flower designs with teardrop pearls suspended from each, and his breastplate is painted with swirling, intricate gold patterns. Michael's outspread wings are tipped, outlined, and veined in gold, as are numerous other elements across the canvas, including the scaly skin of the demon, the wings of the cherubim, the patens of the scales, the shaft of the spear, and the archangel's shimmering aureole.

In iconography, technique, composition, and scale, *Saint Michael Archangel* is closely associated with *Saint Francis and the Tertiaries* and *Triumph of*

Figure 8.4. (*top*) Detail of Mexía's signature on *Saint Michael Archangel*. Photo: Susan V. Webster.

Figure 8.5. (*bottom*) Jerome Wierix (after Martin de Vos), *Saint Michael Triumphing Over the Dragon*, 1584. Engraving, 291 X 202 mm. Bernard F. Rogers Collection, 1935.149, Art Institute of Chicago. Photo: © The Art Institute of Chicago.

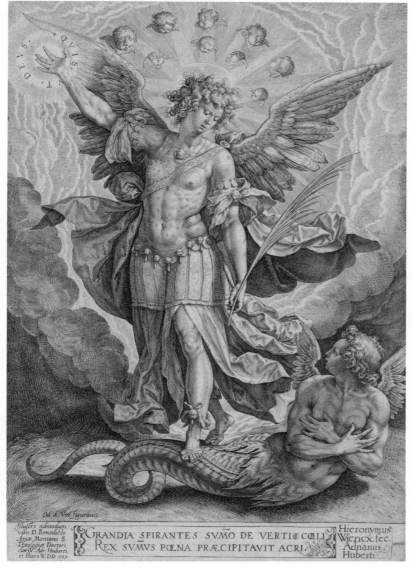

the Risen Christ. Taken together, these three paintings of Christ, Francis as a type of Christ, and Michael as like Christ appear to have constituted the core of an altarpiece that belonged to the Franciscan Third Order, whose central message promoted penitence and the practices of the tertiaries as the path to redemption and eternal life.

A large canvas of the *Annunciation* (*see plate 32*) in the collection of San Francisco is also quite rightly attributed to Mexía by several authors, and it too may be linked with the three canvases discussed above.[49] This painting incorporates Mexía's elegant figures and stylized facial types, along with an abundance of applied gold embellishments, celestial shafts of light, *brocateado*, gilded textual inscriptions, and attention to intricate detail. Indeed, the four-petaled flower motif that adorns the robes of the Archangel Gabriel is repeated on Saint Louis's mantle in Mexía's *Saint Francis and Tertiaries* and on Michael's mantle in *Saint Michael Archangel*, highlighting the links between these paintings. Mesa and Gisbert have pointed out the striking similarity between the form and rendering of Gabriel's wings in the *Annunciation* and those of the archangel in *Saint Michael*.[50] Moreover, Gabriel raises his right hand to the heavens in precisely the same form and gesture employed by Jesus in the *Triumph of the Risen Christ*, and similar musical angels and cherubim populate the heavens in each scene. Alongside the formal, technical, and stylistic affinities, the physical dimensions of the *Annunciation* are almost exactly equivalent to those of the three paintings discussed above, strongly suggesting that it served as a companion piece to the others.

Like most of Mexía's paintings, the *Annunciation* is based on a European print: a 1578 engraving by the German-born Dutch printmaker Hendrik Goltzius, after a design by Martin de Vos (fig. 8.6). Yet again, the Quito painter introduced changes and adaptations that bring the scene to vivid, dramatic life. Mexía reproduced the form and gesture of the archangel in the engraving down to the precisely furling folds of the drapery and the placement of its foot on the bank of clouds. The furnishings, such as the chair and the prie-dieu, are copied literally from the print, even to the form of the winged grotesque creature and cherub head that decorate the latter. However, Mexía edged, embellished, and highlighted all of these and other elements in applied gold leaf and *brocateado*.

Mexía adapted and transformed the Goltzius print in several significant ways: by reducing the number of figures and furnishings, by tilting up the floor and raising the spectator's viewpoint, and by closing off the deep space recession, bringing forward the pilaster and back wall of the architecture, thereby rendering the scene enclosed and intimate. The distant window pictured in the print is here brought close to reveal a cloudy dawn sky and a seemingly mountainous Andean landscape beyond. Mexía located at a greater distance the heavenly glory, cherubim, and musical angels, enabling him to highlight the descent of the dove of the Holy Spirit, which is absent in the Goltzius print. He also transformed the position and gesture of the

Figure 8.6. Hendrik Goltzius (after Martin de Vos), *Annunciation*, 1594. Engraving, 21.3 x 28.6 cm. Metropolitan Museum of Art, New York. Artwork in the public domain. Photo courtesy of the Metropolitan Museum of Art, New York.

Virgin to draw her closer and into more direct alignment with the archangel, covering her head with a mantle, and rearranging her pose and gesture to that of prayer. Mexía included a curtained bed behind the Virgin, not present in the Goltzius engraving but derived from other Northern prints of the Annunciation. Other additions include the liberal scattering of roses and small four-petaled flowers across the expanse of tile floor, and the transformation of the traditional vase of white lilies into an array of various types and colors of flowers tipped in gold. Overall, the changes introduced by Mexía work to render the scene more visually powerful yet exquisitely intimate.

Above all, however, it is Mexía's liberal, delicate, and intricate application of gold leaf and *brocateado* to numerous elements across the surface of the painting that captures the attention and imbues the image with divine splendor, elegance, and optical potency (*see plate 33*). The gilded blaze of heavenly glory that descends behind Gabriel flashes out in shimmering solid and stippled rays, illuminating the archangel's gilded wings and the interior space, casting a deep shadow beneath the cloud on which he stands. All manner of forms, texts, and objects are rimmed, tipped, embroidered, and spangled with gold leaf, from the lavish robes of the figures to the furnishings, the prie-dieu and the cover of the Virgin's book, and even to the window bars. While the *brocateado* of the draperies is realized with gold paint, other elements, including the chair behind the Virgin, are rendered in solid panels of applied, burnished gold leaf that illuminate the directionality of the heavenly explosion of light that accompanies Gabriel.

Gilded text scrolls connect the figures of Gabriel and the Virgin, engaging them in the canonical conversation: "AVE GRATIA PLENA D[OMIN]N[U]

s, TECVM" ("Hail, full of grace, the Lord is with you"), to which the Virgin responds in gilt lettering that shifts in orientation with the flow of the scroll, "ECCE ANCIL[L]A D[OMI]NI FIAT MIHI SECUNDUM VERBVM TVVM" ("Behold the handmaid of the Lord, be it done unto me according to your word"). Mexía supplies this gilded dialogue, which is not present in the Goltzius print, in Roman square capital letters that incorporate abbreviations, suspension marks, and leafy flourishes. Additionally, he paints text using the same lettering in black on the open pages of the book placed before the Virgin. This text, the traditional communion antiphon for Advent, from Isaiah 7:14–15, does not lie flat on the fictive pages, but undulates and in part appears to stand up from their surfaces—perhaps to render the words more easily read (albeit upside down) by the viewer.[51] The text incorporates numerous ligatures, abbreviations, and ampersands, and its final lines are smaller and squeezed into the remaining space of the page. Mexía omits in his painting the Hebrew text that marks the heavenly sphere in the Goltzius print.

Although no signature is visible on the *Annunciation*, Navarro published it as signed and dated 1615, perhaps confusing it with *Saint Francis and Tertiaries*. However, he correctly observed that the subject of the Annunciation was rare in early colonial Quito, pointing out that "not one single picture like this is known in sixteenth-century Quito painting," thereby classifying Mexía's canvas as "the first of its type."[52] In his brief discussion of Mexía, Navarro attempted to link the painter's style to the work of the fifteenth-century Spanish artist, Pedro Berruguete, again underscoring the tendency of scholars to view Mexía's work as archaic and Gothic.

Saint Francis and Tertiaries, Triumph of the Risen Christ, Saint Michael Archangel, and the *Annunciation* have not previously been linked as companion pieces; however, Mesa and Gisbert associated Mexía's *Saint Francis and Tertiaries* with a series of near life-size paintings of Franciscan tertiary kings and queens that are also located in the Franciscan monastery collection. Eighteen paintings in this series exist in the Franciscan collections. One of them, *King Alfonso of Portugal*, is dated 1607 (fig. 8.7), eight years before the 1615 date of *Saint Francis and Tertiaries*.[53] Mesa and Gisbert attribute the series of tertiary monarchs to Mexía, while others have assigned them to Sánchez Gallque or another of his contemporaries.[54] Regardless, several different hands are at work in this large series of paintings.

Scholars have posited that the series of tertiary monarchs formed part of a grand altarpiece in which Mexía's *Saint Francis and Tertiaries* occupied the central location.[55] Given their related themes, compositions, and dimensions, Mexía's *Saint Francis and Tertiaries, Triumph of the Risen Christ, Saint Michael Archangel*, and the *Annunciation* may together have occupied the central panels of an altarpiece. The lower register likely comprised *Saint Francis* and the *Annunciation*, whose subjects are represented in the earthly sphere, with *Triumph of the Risen Christ* and *Saint Michael* respectively above them in the celestial realm.[56] Set within the larger architectural structure of an altarpiece, the paintings were likely separated by carved columns

Figure 8.7. Anonymous, *Alfonso of Portugal*, dated 1607. Oil and tempera on canvas, 143 × 85 cm. Monastery of San Francisco, Quito. Photo: Hernán L. Navarrete.

and niches occupied by sculptures—perhaps including a sculpted scene of the crucifixion or another moment of Christ's Passion. This hypothetical arrangement would seem to exclude on the basis of sheer dimensions the eighteen earlier paintings of tertiary monarchs and popes, although they may have hung in file along the side walls of a church or large chapel. Regardless, the altarpiece containing the four paintings must itself have constituted a massive structure.

The fact is, however, that no documents substantiate the existence of a Franciscan Third Order in Quito during the period in which Mexía created *Saint Francis and Tertiaries*. Indeed, the first documented reference to

its existence appears in the late seventeenth century. Navarro, in particular, combed the archives for information regarding the Franciscan Third Order and was perplexed by the complete lack of any documentary evidence regarding a dedicated chapel or even its presence in San Francisco prior to the 1670s.[57] Moreover, given the 1615 date on two of the four related paintings, such a large altarpiece could hardly have been housed in the main Franciscan monastery or church, which was in precisely that decade undergoing major construction, reconstruction, and reorientation.[58] This conundrum lies beyond the scope of the present study; however, it suggests that Mexía's four related paintings, and perhaps the series of tertiaries, were created not for the Franciscan Third Order but for another Franciscan-related establishment. One possibility is the Confraternity of the Vera Cruz of Spaniards, which had occupied a large chapel in the Monastery of San Francisco since the sixteenth century.[59] The emphasis on penitential practices as a means to salvation and the image of the risen Christ with the cross and the *arma christi* would have been appropriate images for the Confraternity of the Vera Cruz. Moreover, the tertiary saints and monarchs would serve as heroes and models for the confraternity members on their path to redemption. Yet the chapel location of the Vera Cruz was similarly in flux during this decade.

A more likely possibility is that Mexía's paintings and the tertiary series were created for the newly constructed Franciscan Recoleta de San Diego, which was completed in the first decade of the seventeenth century as a place of spiritual retreat for members of the order.[60] Today, four paintings of the tertiary series are inset into the side walls of the massive apse in the church of San Diego, surrounded by vast empty spaces that could easily accommodate the entire group. Mexía's four paintings may have occupied the main altar of the church, accompanied by sculpted images, set within a monumental carved altarpiece.

In this regard, the identity of the donor family depicted in *Triumph of the Risen Christ* could clarify the original location of the works, for they were undoubtedly wealthy benefactors of the Franciscans. A particularly likely candidate is the prosperous local merchant Marcos de la Plaza and his wife, Beatriz de Hinojosa y Cepeda, a second cousin of Saint Teresa of Ávila, who were especially close and fervent supporters of the Franciscans. In 1599, Plaza donated from his extensive ranch in Miraflores the original plot of land for the construction of the Recoleta de San Diego, to which he added more terrain in 1602, and in 1642 his widow Beatriz de Hinojosa donated the additional land that constituted the plaza of the complex.[61] Envisioning Plaza as the donor figure in *Triumph of the Risen Christ*, accompanied by portraits of his wife Beatriz and their daughters, Ana and Juana (*see plates 29 and 30*) is plausible.[62] There is little doubt, however, that Marcos de la Plaza and Beatriz de Hinojosa y Cepeda are portrayed as the donors accompanying the figure of San Diego depicted in the recently recovered mural painting that adorns the central niche above the main portal of the Franciscan Recoleta church (fig. 8.8). Unfortunately, the nature of the fresco medium, surface damage, and repainting make it difficult to establish physiognomic similari-

Figure 8.8. Anonymous, *San Diego de Alcalá with Donors*, early seventeenth century. Mural painting. Recoleta de San Diego, Quito. Photo: Hernán L. Navarrete.

ties between these figures and the donor portraits in Mexía's *Triumph of the Risen Christ*. Without additional documents, the relationship is speculative between possible donors, the Franciscan Third Order, the painted series of tertiaries, and Mexía's canvases of *Saint Francis and Tertiaries*, *Triumph of the Risen Christ*, *Saint Michael Archangel*, and *Annunciation*.

As the documents and extant paintings demonstrate, an audience and a market for Mexía's style of painting existed in early colonial Quito. The artist's liberal employment of gold leaf and *brocateado* in his paintings created a shimmering splendor on their surfaces that held unquestionable contemporary appeal. Far from anachronistic, Mexía's varied contemporary audiences likely experienced the reflective gilded surfaces and patterns on several levels in accord with different cultural, visual, and symbolic traditions. While the abundance of gold underscored generalized economic and spiritual con-

cepts of value across cultures, for Andean audiences the material presence of gold, particularly as applied in repeating patterns, evoked additional layers of associations and meanings. The abundant presentation of gold recalled traditional forms of elite Andean power and authority, from ornaments and textile adornments of precious metals worn by indigenous leaders throughout the Andes, to gold as a material embodiment of Inti, the sun deity of the Inca.

In fact, the penchant for gilded imagery in colonial Quito did not abate with the rise of the more naturalistic paintings produced by Miguel de Santiago and his workshop during the second half of the seventeenth century; paintings like Mexía's continued to be produced concurrently with those exhibiting Baroque naturalism. Indeed, numerous paintings displaying many of the characteristics of Mexía's artistic vocabulary, particularly the employment of applied gold leaf and *brocateado*, were created throughout the seventeenth century. These images coexisted and shared the market with canvases produced in the relatively naturalistic idiom of Miguel de Santiago and his workshop. In this regard, Mexía's style of painting thrived in the seventeenth century, inspiring other painters and devotional audiences.

Among the many examples of seventeenth-century paintings that could be cited, two may serve here as examples of the continued production, predilection, and market for canvases employing extensive gold leaf and *brocateado* elements. The anonymous artist of a large canvas from the second half of the seventeenth century, *Virgin of the Rosary with Saints* (*see plate 34*), in the collection of Santo Domingo, incorporated gold painted and perhaps stamped designs and details throughout the image. The Virgin's crown is crafted in densely filigreed gold studded with painted gemstones, an array of gilded amulets, charms, and jewelry adorn her dress, and her mantle is edged in elaborate *brocateado*. Similarly, the garments of the Christ child are decorated with large gold motifs, and the central elements of his headband and cross are outlined in gold. Other gilded passages include the edging of the garments of the angels and saints, their haloes, and the triple tassels suspended from the multiple rosaries depicted throughout the image.

The artist of the *Virgin of the Rosary with Saints* employed European prints as a model, for he adapted and reinterpreted the traditional form and iconography of the Virgen de los Desamparados (patroness of Valencia, Spain), here transformed to embody the advocation of the Virgin of the Rosary.[63] This painting likely once belonged to the Cofradía del Rosario de los Naturales, established in 1588 under the tutelage of Fray Pedro Bedón, which maintained its chapel in the church of Santo Domingo throughout the colonial period.

A second example is an anonymous canvas from the second half of the seventeenth century, the *Virgin Tota Pulchra with Augustinian Saints* (*see plate 35*), in the collection of the Franciscan Recoleta de San Diego. This work might convincingly be attributed to a follower of Mateo Mexía or to the artist himself—especially considering that the painter's long career extended into the 1660s. Indeed, the thick, angular folds of the Virgin's mantle echo

those of the archangel in the *Annunciation* attributed to Mexía, as do the facial features of the figures, and the form of the Virgin's halo is the same in each painting—composed of delicately alternating straight and undulating gilt rays. In the *Tota Pulchra*, however, the *brocateado* has become far more ample, elaborate, and intricate, completely covering the Virgin's dress in lush webs of gold floral designs, and thickly bordering her star-spangled mantle. The saints bear gold haloes studded with colored gems, their jewelry and habits edged in gold and *brocateado*. Several symbols of the litanies are similarly highlighted in gold, as is the apple beneath the Virgin's feet. The painter of this canvas may have employed European engravings, in particular Raphael Sadeler's 1605 *Immaculate Conception*, as models for the composition.

Mexía may well have been the author of the *Tota Pulchra*. Upon his return from his commission for the Augustinians in Riobamba, he purchased in 1638 a house on the plaza of the Franciscan Recoleta de San Diego, where he lived for the rest of his career. Although geographical proximity is not an indicator of authorship, finding later works by Mexía's hand in the Recoleta de San Diego would not be surprising. Perhaps it is only coincidence that this painting depicts two Augustinian saints, Augustine and Nicholas of Tolentino. Regardless, if this painting is not the work of Mexía, it was certainly executed by a follower who recognized the demand for Mexía's compelling style of intricately gilded pictorial imagery.

Ambiguity and the Languages of "Style"

Mexía's apparent "ambiguities," in his life as in his work, were of his own invention. He was an intermediary of his own making who mixed, translated, and transformed languages, technologies, and appearances to his own ends. The painter's shifting ancestry and sociocultural status, his manipulation of literate and legal conventions, and his constant and close association with the Andean community are testimony to his capacity to successfully navigate and shape his place in the colonial city.

Mexía was an innovative translator and interpreter of Christian religious imagery for a broad and varied colonial audience. He developed and promoted a distinctive pictorial language of his own invention based on mixtures of materials, techniques, sources, and styles, to create paintings that were much appreciated and in demand during his lifetime, even if their contexts are lost to twentieth-century art historians. Nonetheless, those scholars recognized without a doubt Mexía's distinctive stylistic vocabulary, and had no difficulty attributing a number of paintings to the artist.

Mexía's ability to transform engraved print sources into massive canvases of complex compositions that seamlessly meld Renaissance and Mannerist styles, text and image, representational figures and symbolic forms, and pictorial illusionism and two-dimensional gold surfaces eloquently demonstrates his enormous creative capacity. In a larger sense, his approach also

reflects the permeability and interrelationships among the arts of painting, gilding, and polychromy of all manner of objects that was pervasive in early colonial Quito. Through his skillful and innovative mixture of material, technical, and stylistic languages, Mexía transcended individual sources and translated them into his own distinctive, personal artistic idiom. Mexía's success as a painter during his lifetime demonstrates that his particular pictorial language spoke to viewers in ways that moved, instructed, and inspired them. He established and popularized an inventive artistic style whose elements were emulated by followers and persisted throughout the seventeenth century and indeed to the end of the colonial period.

Final Considerations

Around 1615, the colonial Andean author and artist Felipe Guaman Poma de Ayala dedicated an image in his "Nueva corónica" to the office of colonial Andean painters (fig. 9.1). He pictured two native artists holding bowls of paint and a brush, collaborating in the polychromy of a sculpted image of the crucified Christ. Guaman Poma glossed his drawing with the following text: "Painter. The skilled craftsmen painter, sculptor, woodcarver, embroiderer, [in the] service of god and the holy church."[1] Although Guaman Poma does not employ it in the above-cited quote, the colonial Andean term *quilca* nonetheless reverberates throughout his text, recalling the range of Andean graphic practices defined and translated in the early dictionaries of Domingo de Santo Tomás and González Holguín. Indeed, *quilca* is in many ways a more efficient and effective term to characterize the manifold activities of Quito's early colonial Andean painters, who dominated the brush and the pen, frequently bore the titles of *escultor* and *entallador*, possessed the privileged knowledge of pigments and materials, and applied their talents to a broad spectrum of objects in multiple venues. Their multifarious practices do not fit neatly within the narrow Western category and definition of "painter."

Quito's early colonial painters, Andeans and Europeans alike, were masters of multiple languages and literacies. Unfettered by a guild structure that would have narrowed, regularized, and circumscribed their professional practices, these painters dominated pluralistic forms of artistic production and operated on a broad public stage. The Western pictorial illusionism registered on canvases, panels, and mural paintings represents only one facet of the painterly repertoire manipulated by these artists, yet these forms traditionally have constituted the focus of art-historical inquiry. The invention of

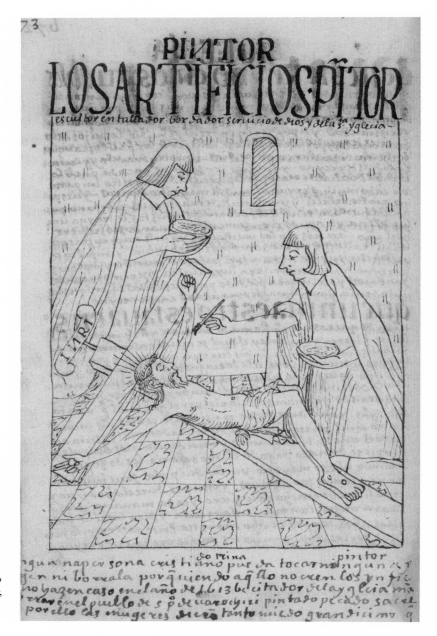

Figure 9.1. Felipe Guaman Poma de Ayala, "Pintor," ca. 1615. Ink on laid paper. Photo courtesy of the Royal Library, Copenhagen, Denmark, ms. GKS 2232 40.

the "Quito School" by twentieth-century art historians posited and sought to impose the vision of a stylistically and formally unified corpus of painting that emulated European models and followed a similar evolutionary trajectory. This approach has at its core a narrow, modern definition of the "appropriate" objects and forms of painting and the profession, conjoined with a positivist evolutionary vision of artistic development over time. Far from presenting a unified corpus, painting in early colonial Quito exhibited an un-

ruly diversity of forms, styles, materials, techniques, and practices that defy singular definition or characterization. Indeed, this very diversity may well be its defining feature.

The visual evidence contests and contradicts the linear, evolutionary models of art-historical development that earlier scholars sought to trace and impose. Beyond the myriad objects to which painters applied their talents, the few extant canvas and panel paintings that can be linked to specific artists of this period illustrate the concomitance of multifarious forms and styles. The two extant works signed by Sánchez Gallque bear little resemblance to one another in terms of subject, style, coloration, medium, and scale; indeed, they hardly appear to have been executed by the same painter, yet from another optic, they exhibit the tremendous painterly versatility of the artist. Indeed, *Francisco de Arobe and His Sons, Pedro and Domingo* displays heterogeneity on multiple levels: from its subject, author, patronage, and intended recipient to its visible mix of text and image, and European, Andean, and African dress, adornment, and accouterments. Sánchez Gallque's selection and application of locally produced pigments and materials that embodied traditional meanings for Andean audiences imbues the painting with another layer of significance. Similarly, the temporal coexistence of Mateo Mexía's visibly mixed and reportedly "retardataire" style with the Baroque naturalism of Miguel de Santiago and others, and the continued production of works that incorporated Mexía's brand of elaborate *brocateado* and related techniques throughout the seventeenth century, underscore the multiplicity of professional practices as well as the diversity of audiences in early colonial Quito.

Much of the historiography of painting in Quito has been bound by a progressive teleology of Western art and thereby misses hidden layers of significance and communication embedded in representational systems produced by colonial Andean painters. The specialized technologies of painting and the materiality of painted objects—the concealed levels of complex preparation, the numinous sources and substances of pigments and their chromatic associations, the physicality and reflective brilliance of gold leaf, the shimmering repeated patterns of *brocateado*—suggest layered forms of communication that include Andean to Andean linkages within Inca and Spanish empires. The convergence of representational, scriptorial, coloristic, and material languages in early colonial paintings reveals strata that intersect and simultaneously operate on other planes for different audiences. Graphic forms of communication, rendered in powdered colors, gold, and other materials, thus incorporated European subject matter and iconography within a more capacious signifying realm. For Quito's Andean majority—painters and audiences alike—plural empires and languages converged in graphic painted images that were doubly charged with significance.

Graphic relationships extend also to the web of legal, economic, and kinship associations expressed through but not necessarily controlled by the colonial bureaucratic archive. Notarial documents carry the traces of these

painters, from signatures indicating alphabetic literacy, scribal sophistication, and mastery of the colonial legal system; to malleable surnames that reference underlying familial and professional networks; to land transactions that index kinship affiliations; to titles that mark rising status and multifaceted professional skills; to economic exchanges that involve paintings as payment. Yet their traces on documents and presence in the archives simultaneously obscure a realm of intentions and activities not committed to paper.

Human geography and demography on both a local and regional scale affected the context in which Quito's early painters lived and worked. Part of the story of Quito's early painters belongs within the larger context of contemporary colonial urban centers. Both Lima and Cuzco established a painters' guild in 1649, while painters in Bogotá and Potosí did not form an official guild until the eighteenth century. In sixteenth- and seventeenth-century Quito, the absence of such a guild opened up a broad field of professional practices, opportunities, and potential pitfalls that undoubtedly contributed to the heterogeneity of painting and the trade. By and large, this variegated scenario owes to the fact that the majority of Quito's early painters were Andeans, who brought distinctive local and regional traditions and perspectives to bear on the practices as well as the products of the profession. The urban geography of Quito's Andean painters, in particular, demonstrates the efflorescence of professional dynasties—indeed, empires—in certain parishes of the city, which experienced continued expansion throughout the century. Superimposed on the parochial map, the *hanan* and *hurin* division of the city reveals the concentrations and dominance of colonial Inca painters over those of autochthonous ancestry.

This study has attempted to recount human stories by reintroducing to the historical record, to the extent that documents permit, facets and glimpses of the lives and professional practices of the more than fifty painters who plied their trade in early colonial Quito. Although they are recounted and refracted principally through the prism of official documents, these accounts nonetheless disclose the power and authority wielded by Quito's artists in shaping visual worlds for a colonial audience. Yet painters shaped their own worlds, as well, through their domination of lettered technologies, by which they negotiated and manipulated the colonial bureaucratic system to their advantage and to that of their family members and community. The sophisticated, calligraphic signatures of the many painters who autographed notarial documents proclaim their identities as well as their status as *letrados* in a largely unlettered society. The traces and marks that they left on paper and on painted surfaces implicate a web of mostly invisible underlying practices, traditions, and relationships.

The languages, literacies, and specialized knowledge mastered and leveraged by early colonial painters, the majority of whom were Andeans, enabled them to carve out spaces of success in the socioeconomic matrix of the city. To the degree that the documents permit us to know, Andeans and Europeans alike made a good living from their trade that enabled them to el-

evate their professional status, obtain honorific and administrative titles, own houses and land, and engage in other entrepreneurial activities. As skilled visual intermediaries and interpreters, Quito painters and their works communicated to multiple audiences, and were in high demand locally and regionally. The languages of empire wielded by Quito's painting dynasties and individual painters shaped their professional practices and informed their creation of the multivalent and heterogeneous visual landscape of the early colonial city.

Selected Transcriptions of Painting Contracts

A. Melchor de Alarcón, Choir Books, 1572

The following contract, dated 1572, shows Melchor de Alarcón, "escritor de li-bros," agreeing to produce eight illuminated choir books for the Cathedral Chapter. Source: AHBCE, JJC .00195, 1562–1572, Jacome Freile, fols. 14r–16r.

En la ciudad de quito a diez y siete dias del mes de março de mill e qui[nient]os y setenta y dos años en presencia de mi es escriu[an]o y t[estig]os El muy Ill[ustr]e R[everendisi]mo p[adr]e maestro don ffray Pedro de la peña obispo deste obispado y el chantre don diego de salas y el can[onig]o gomez de tapia como dean y cabildo desta santa iglesia y dixeron q[ue] por quanto en la santa iglesia de Esta ciudad ay grande falta de libros para ofiçiar los ofiçios diuinos y al presente esta en esta ciudad Melchor de alarcon clérigo escritor de libros con el qual an tratado de que escribiese ocho libros en pergamino para esta santa iglesia con çiertas condiciones por ende los d[ich]hos señores y el d[ic]ho Melchor de alarcon que estaua ansi mismo presente dixeron que son convenidos y conçertados en que el d[ic]ho Melchor de alarcon escriua los d[ic]hos ocho libros de canto en pergamino con las condiciones y en la manera siguiente—

Primeramente en los Pergaminos que an de lleuar los libros sean de buen cuerpo y limpios y sin graça o manteca lo qual comúnmente sale en los pergaminos graças por medio do dizen el cerro o espinazo y los tales pergaminos no son nada porque en poco tiempo dispide la letra que En los tales pergaminos se escriue y que los tales pergaminos no sean lanternados ny manchados—

que no lleuan ni tengan Rotura ni agujero y si lo tubieren que los tapen y rremien-den como es costumbre de suerte que aya fealdad que la letra y Punto sea del tamaño y grueso de la muestra de felix namqz—

que los renglones sean de seis en plana y de m[edi]a bara de largo digo que [?] plana sea y lleue seys rrenglones sin el punto—

que la letra vaya Recogida conforme al /fol. 14v/ Punto de aRiba y que no lleue

mas espacio de silaba a silaba de confforme a los puntos de mancha que el espacio de letra y la neuma de los puntos benga todo justo—

que desde el pie del rrenglon Postrero de la margen de abajo hasta la primera Regla del canto de la rregla de arriba tenga tres quartas

que las margenes todas quatro vayan en su perffiction y cuenta y medida

que las tintas y colores asi de bermellon como de azul orchilla o tornasol con que los d[ic]hos libros se hizieren sean bien templados y que no desdigan jamas—

que los principios de las historias del principio de los cuerpos de los libros sean quadrados de dos rrenglones E dos pautas de lebreas y de dos colores con el oro q[ue] pidiera la tal yluminaçion y las margenes de la tal letra se hiziere lleuen sus lazos E yluminaçiones y vaya la tal letra pulidamente yluminada—

que si en el cuerpo del libro cayere alguna fiesta de la vocaçion de la iglesia u otra fiesta prinçipal y le pidieren que haga otra estra como la del prinçipio del libro que sea obligado a hazerla—

que todas las demás ffiestas haga al prinçipio de la tal fiesta Vna letra quadrada de dos colores que hay en la librea con en la yluminaçion q[ue] tome un rrenglon y una paeta—

que todas las demás letras sean de una color unas azules y otras coloradas—

que las letras de los versos bayan enbiadas rrabiscadas y metidas de açafran y cardenillo—

/fol. 15r/ en el espacio que ay en los Renglones de entre silaba y silaba por causa de la neuma de los puntos vayan virgulados—

yten que se le a de dar q[ue] haga hasta ocho libros y en cada cuerpo de libro no lleue menos de çien fojas ni mas de çiento y veinte—

que la madera En que esta el cuerpo se enquadernare sea morocha en rrezia y enjuta y lleue En los pies y cabeças su cola de milano por que no tuerca—

que el cuero En que el tal libro se enquadernare sea de venado bien curtido y lleue la carnaza affuera—

que cada tabla de libro lleue nueue escudos de metal sin las maniguetas segun es uso y costumbre—

que las tales guarniçiones sean de metal y abiertos digo labrados segun se suelen hacer y los clauos sean del d[ic]ho metal—

que el hilo con que se cosieren los tales quadernos sea de hilo de cáñamo o de lino—

que la solffa [sic] de los quadernos sea de macho y hembra y el egrudo con que se pegare que no haga cuerpo y no se despuegue y vayan los lomos de los quadernos delgados en que no hagan cuerpo—

que cada cuerpo lleue en prinçipio del libro y al fin tres o quatro fojas blancas que no yendo la obra conforme a estas condiçiones sobre d[ic]has las tome [?] y el ofiçial que la hiziera y tornea [?] otra [?]—

yten se le a de dar Por cada hoja dos p[eso]s de plata corri[ent]e marcada y por ellos a de dar hechos y acauados los libros y enquadernados /fol. 15v/ E guarnecidos E iluminados con d[ic]ho es En las condiciones d[ich]as—

yten que a de dar hechos los d[ic]hos libros en la manera d[ic]ha dentro de dos a[ñ]os syguientes—

yten que se le a de pagar en tres pagos yguales la primera luego la otra terçia este al cabo del primer año y luego que diere escriptos los çinco cuerpos la otra terçia este al cauo de los dos a[ñ]os o tres [. . .]

yten que a de dar ffiadores q[ue] pagaran lo q[ue] el d[ic]ho melchor de alarcon
obiere rre[cibi]do o y no cumpliere y escribiere en d[ic]hos libros—

yten se le a de dar p[ar]a cada hoja dos p[atacon]es de plata corriente marcada y
por ello a de dar hechos y acauados los d[ic]hos libros encadernados [*sic*] e guarne-
zidos E iluminados como d[ic]ho es en las condiciones arriba d[ic]has—

yten en la manera que d[ic]ha se concertaron y conbinieyeron y consertaron y los
d[ich]hos señores dean E cabildo obligaron los bienes y rrentas de la santa iglesia y
fabrica della de pagar al d[ic]ho melchor de alarcon lo q[ue] demandare en los d[ic]
hos libros a dos pesos de plata corri[ent]e cada vna hoja con que a de dar los d[ic]
hos libros Enquadernados e guarnezidos seg[u]n d[ic]ho es y se conze[rtaro]n en las
d[ic]has condiciones ya declarado / y el d[ic]ho melchior de alarcon se obligo de dar
fechos y y acauados los d[ic]hos libros seg[u]n y de la man[er]a q[ue] va declarado
en las d[ic]has condiciones en el d[ic]ho tiempo por el d[ic]ho preçio / es tanbien
cond[ici]on q[ue] lo q[ue] se a de escreuir y apuntar en los d[ic]hos libros son todo
El santoral asi tocante a mysas como a las oras del dia conforme al rrezar sevillano
como de lo declarare El prelado della yg[lesi]a—

yten todas las misas de los [?] de apostoles / un mártir / muchos mártires / un con-
fesor / muchos confesores doctores y perlados / yten vna virgen / muchas vírgenes
/ y de continentes / y asi y mismo la del t[iem]po pas [?] /fol. 16r/ cual tocante a las
d[ic]has ystorias y reconocym[ient]os todas las mysas del t[iem]po ansi dominicales
como feriales / yten todo lo tocante a las d[ic]has comunes como esta d[ic]ho arriua
en las oras del dia syn capitulas ny oraciones ni otra cosa superflua—

yten En un cuerpo o mas todos los quiries necesarios / glorias / credos / sanctus
/ y anus dei / conforme sienpre a lo sevillano quitando lo superfluo / y prosas solas
[*sic*] las de navidad que comiença letabundos & en la de rresurreçion que comiença
victe me & en la del espirito santo que comiença sanctis spiritus y no otra /

yten y no ouiere conplim[ient]o a lo d[ic]ho [?] d[ich]os libros este obligado a
escreuirlo en rrecto del salterio y los demas que mandare por el d[ic]ho prelado—

E con las d[ic]has condiciones se obligaron el d[ic]ho melchor de alarcon de dar
fechos y acauados los d[ic]hos libros como en las d[ic]has condiciones y en cada
una dellas y para ello se obligo el d[ic]ho melchor de alarcon su persona E bienes
muebles E rrayzes sus de[rech]os y actiones eclesiasticos y seglares avidos E por
aver [. . .]

[signatures and rubrics]
fr[ay] p[edro] ep[iscop]us quitensis
M[elch]or de alarcon

B. *Diego de Robles and Luis de Ribera, Virgin of the Rosary, 1586*

In the following contract, dated 1586, Diego de Robles and Luis de Ribera agree
to create a polychrome sculpture of the Virgin of the Rosary for Gaspar Manuel,
encomendero of Loja. Source: AHBCE, JJC .00196, 1586, Francisco de Corcuera, fols.
1118r–1119r.

En la çiudad de s[an] fran[cis]co del quito en once dias del mes de setiembre de
mill y qui[niento]s y ochenta y seis años Por ante mi el pres[en]te scriu[an]o pu[bli]
co y del cab[ild]o desta çiudad e t[estig]os yusoescriptos pareçieron presentes gas-

par manuel v[ecin]o encomendero de la çiudad de loxa de la una parte E de la ottra luis de rriuera pintor y diego de rrobles escultor v[ecin]os de esta çiudad I dixeron que por quantoEl d[ic]ho gaspar manuel se a concertado con los susod[ic]hos de q[ue] le ayan de hazer una hechura de ymagen de n[uest]ra s[eñor]a del rrosario en la fforma e manera sig[uien]te—

Primeram[en]te q[ue] la d[ic]ha hechura de ymagen a de ser de sedro con su nino jesus en los braços del tamaño y fforma e manera que esta la ymagen del conuento de s[eño]r santo domingo desta d[ic]ha çiudad con sus coronas y peanas E con sus çeraffines en la d[ic]ha peana de altura de siete palmos encargo la qual d[ic]ha ymagen esta ya debastada y la bio al contento de la fforma de ella El d[ic]ho gaspar manuel y ansimismo acauada de poner en perffiçion el dicho escultor el dicho luis de rribera la a de dorar y pintar de manera que el rropage de la dicha ymagen baya con sus rrosas y seraffines y con su peana e caxa de madera fuerte de manera que la dicha ymagen aya de estar acauada en toda perffiçion y a bista de personas y offiçiales que lo entiendan y que pueda yr segura y sin peligro a la parte adonde quisieren como no sea ffuera destos rreynos la qual hechura de ymagen hecha y acauada y dorada y ecaxada en la dicha su caxa e sin que sea nesessario poner en ello mas costa ni manos las puedan lleuar y la an de /fol. 1118v/ dar ffecha y acauada denttro de dos meses cumplidos primeros siguientes ambos a dos por el todo y por la hechura de la d[ic]ha ymagen en la manera que dicho es el dicho gaspar Manuel le a de dar y pagar dozientos y beynte p[eso]s de plata para en quenta de lo qual el dicho gaspar manuel les dio y Pago en presençia de mi el dicho escriu[an]o al dicho diego de rrobles çincuenta p[eso]s y al dicho luis de rribera beynte y dellos se dieron por contentos y pagados a toda su voluntad y el rresto se le a de pagar acauada la dicha hechura de ymagen y enttregada y no la dando y entregando al dicho tienpo y plaço el dicho gaspar manuel pueda comprar ottra hechura de ymagen de n[uestr]a s[eñor]a en la parte que la hallare y de la manera que quisiere y Por lo que costare con solo su simple juramento los pueda executar a ambos a dos juntamente y a cada uno de ellos ynsolidum por el todo por el principal y por mas todas las costas danos y menoscauos que se rrecreçieren y el dicho gaspar manuel se obligo ansimismo de que dando y entregandole la dicha ymagen al dicho tienpo y plaço dara y pagara çiento y çinquenta p[eso]s de plata de plata [*sic*] corriente marca[da] que son cunplimiento de los dichos dosçientos y beynte p[eso]s de la dicha plata y cada uno de las dichas partes por lo q[ue] les toca y tocan puede obligaron sus personas e bienes muebles y rrayçes auidos y por auer [. . .] /fol. 1119r/ y los dichos otorgantes que yo el scriu[an]o doy fee que conozco y los firmaron siendo t[estig]os fran[cisc]o arias de albarado y fran[cis]co de s[an]ta maria y martin bedon v[ecino]s [. . .]

[signatures and rubrics]
Gaspar Manuel
D[ie]go de Robles
Luis de Ribera

C. *Andrés Sánchez Gallque, Chimbo Altarpiece, 1592*

This contract between Don Diego Pilamunga and Andrés Sánchez ("pintor"), dated 1592, shows the latter man agreeing to create the main altarpiece of the church at Chimbo. Source: ANH/Q, Notaría 1a, vol. 3, 1588–1594, Diego Lucio de Mendaño, fols. 317v–318v.

Conçierto Entre don di[eg]o pilamunga y andres sanchez pintor

En la ciudad de san fran[cis]co del quito de los rreynos del peru a treçe dias del
mes de nou[iembr]e de mill E quin[ien]tos E noventa e dos años ante mi E; presente
escriuano y testigos de yuso escritos pareçieron presentes de la una parte don diego
pilamunga cacique prencipal del pueblo de Santiago de chimbo Estante al presente
En esta çiudad y de la otra andres sanchez pintor rresidente En esta d[ic]ha çiudad
E dijeron que ellos son conçertados convenidos E ygualados En esta manera de que
el d[ic]ho andres sanchez se obligaua e obligo de yr al d[ic]ho pueblo de santiago
con su persona adonde a de asistir con ella para haçer y que hara para la yglesia
del d[ic]ho pueblo un tavernaculo de çinco baras de alto y de ancho tres y media
conforme a la traça que En presençia de mi El presente escriuano la vio el d[ic]ho
andres sanchez En el qual d[ic]ho tavernaculo a de auer y llebar al pie del una caxa
E gueco de vara y media de alto En que a de estar un Santiago de bulto que [??] el
d[ic]ho gueco y luego Ençima de la otra caxa grande de dos baras se llene En que a
destar nuestra señora de guadalupe con el niño jesus En brazos y a de ser de bulto y
luego Ençima un frontespiçio de bulto de medio rreliebe y luego Ençima del d[ic]ho
frontespiçio otra caxa con sus rremates a los lados y en ella una resurreçion de bulto
y luego Ençima de la d[ic]ha resurreçion un cristo de bara y media de alto dorada la
cruz lo que fuere En ella menester y a los lados de la d[ic]ha resurreçion a de auer
Encada lado su angel de bulto y en las quatro caxas que quedan a los lados conforme
a la d[ic]ha traça a de auer En cada caxa su santo En la una san pedro y en la otra san
Pablo y En la otra san ju[a]n bautista y en la otra santa Barbara y estas ymagenes y
huecos an de ser de medio rreliebe conforme a como Estan En el tabernaculo de la
yglesia mayor desta çiudad y en los rremates del d[ic]ho tabernaculo arriua a de auer
los rremates conforme a como Estan pintados En la d[ic]ha traza y al pie del d[ic]
ho tabernaculo a de auer un tablero largo del d[ic]ho ancho de tres baras y m[edi]a
En el qual a de auer En el m[edi]o santa maria madalena /fol. 318r/ hechada con su
cristo En la mano la qual a de ser de m[edi]o reliebe y El cristo de bulto y a cada lado
de las d[ic]has caxas a de auer sus colunas con sus molduras conforme a la d[ic]ha
traza de manera que junto a las caxa[s] colunas en los atrauesanos que haçe la d[ic]
ha traza a de auer sus serafines de medio rreliebe de manera que quede acabado El
d[ic]ho tabernaculo a gusto y contento del d[ic]ho don diego pilamunga conforme
a la d[ic]ha traza El qual d[ic]ho tabernaculo y bultos del a de ser dorado y colores
y donde fuere menester lleuar plata se le a de agregar y le a de dar acauado del todo
y puesto En el altar de la d[ic]ha yglesia dentro de año y m[edi]o que corre desde el
prinçipio del año venidero de nouenta e tres y El d[ic]ho andres sanchez a de poner
carpinteros y ofiçiales y El oro y colores y todos los demas materiales que fueren
menester y necessarios para haçer y acabar el d[ic]ho tabernaculo = y El d[ic]ho don
diego pilamunga se obligo por rrazon de haçer el d[ic]ho andres sanchez El d[ic]ho
tabernaculo segun d[ic]ho es de le dar E pagar mill E doçientos pesos de plata cor-
riente E marcada o en rreales nueue al peso pagados como fuere hacienda El d[ic]ho
tabernaculo le yra dando plata para en quenta del y poniendolo a las Espaldas desta
escriptura para que aya cuenta E rrazon En ello y lo que faltare de pagar acauado
que le haya El d[ic]ho andres sanchez y le aya asentado de manera que no tenga mas
que haçer En el se lo dara pagara luego sin dilaçion alguna y mas le a de dar toda la
madera que ouiere menester y lleuare El d[ic]ho tabernaculo sin que el d[ic]ho an-
dres sanchez ponga cosa della y para su comida En todo el tienpo que estubiese En el
trauajo del d[ic]ho tabernaculo le a de dar doçe fanegas de maiz y doçe carneros y los

biernes le dara de comer lo que En la tierra obiere y las cuaresmas a de comer El d[ic]
ho andres a su costa y la cena que ouiere menester para su casa y para en quenta de
los d[ic]hos mill E doçientos pe[s]os le a dado y pagado al /fol. 318v/ d[ic]ho andres
sanchez setenta pe[s]os de plata corr[ien]te Enmarcada el qual se dio por contento y
entregado dellos por auer los rreceuido del d[ic]ho don diego pilamunga en quenta
de la d[ic]ha cantidad y porque la entrega dellos al presente no pareçio para dar
fee del rrenuncio las leyes de la non numerata pecunia y las demas de que se pueda
aprouechar y se obligo de que hasta auer acauado El d[ic]ho tabernaculo no saldra
del d[ic]ho pueblo de sant[iag]o adonde el a de yr haçer y para el cumplimiento E
seguridad de los que En esta escriptura se contiene y en ella se declara cada uno por
lo que les toca por ser anbos yndios ladinos y de rrazon y que Entre Entranbos sean
conçertados por entenderlo se obligaron con sus personas E bienes muebles rraiçes
auidos E por auer [. . .] otorgaron ansi ante mi El d[ic]ho Escriuano y lo firmaron de
sus nonbres a los quales doy fee que conoz[co] siendo t[estig]os fran[cis]co sanchez
y al[ons]o de aldas y Sebastian mendez rresidentes En esta corte y mas a de poner
El d[ic]ho don d[ieg]o pilamunga En El d[ic]ho tabernaculo todos los clauos que
fueren menester y lleuare para haçerle y asentarle.

[signatures and rubrics]
don Diego Pilamunga
Andrés S[ánc]hes Gallque
ante my di[eg]o lucio de Mendaño

D. Lucas Vizuete, Easel Paintings, 1626

In the following contract, dated 1629, the "yndio pintor" Lucas Vizuete agrees with
Andrés Farfán de los Godos to produce two paintings for the main altar of the cathe-
dral. Source: ANH/Q, Notaría 1a, vol. 117, 1626, Gerónimo de Heredia, fols. 842r–842v.

En la ciudad de san Francisco del quito a beinte y un dias del mes de agosto
de mill y seisçientos y beinte y seis años ante mi el escriu[an]o de su mag[esta]d
y t[estig]os parecieron andres farfan de los godos presuit[er]o y mayorodomo de
la fabrica de la cathedral desta d[ic]ha ciudad de la una p[ar]te y de la otra lucas
bizuete yn[di]o pintor rressidente en esta d[ic]ha çiudad de la otra y dixeron que
son combenidos y concertados en esta manera que el d[ic]ho lucas bizuete yn[di]
o se obliga a pintar dos lienços grandes que se le an de entregar clauados en sus
marcos y en el un lienço a de pintar el nasçimiento de nuestro señor jesuchristo y
en el otro la adoraçion de los tres reyes magos conforme a las estampas que se le
dieren por el dicho andres farfan presuitero en las quales d[ic]has dos hechuras a
de poner todas las figuras que tengan las d[ic]has estampas y buenas colores y las a
de dar y entregar acauadas y bien hechas y a contento den [sic] dentro de tres meses
cumplidos primeros siguientes de oy dia a la f[ec]ha de esta escriptura para que se
pongan en el altar mayor de la d[ic]ha yglessia cathedral de esta d[ic]ha çiudad y a
de poner a su costa las colores necessarias en los d[ic]hos dos lienços por el qual
trauajo y ocupaçion y colores se le an de dar y pagar al d[ic]ho lucas bizuete ochenta
patacones de a ocho rreales pagados en esta manera los quarenta patacones dellos en
rreales de contado de que se da el d[ic]ho lucas bizuete del d[ic]ho andres farfan por
contento y entregado a toda su boluntad y porque el entrego dellos de presente no
pareçe por estar ya fecho rrenun[ci]o la excep[ci]on de la pecunia leyes de las entre-

gas y pagas y pruebas dellos y los quarenta patacones rrestantes se los a de pagar el d[ic]ho andres farfan acabados que sean las d[ic]has dos hechuras y el d[ic]ho lucas bizuete se obliga a haçer y entregar acabadas las d[ic]has dos hechuras y el d[ic]ho andres farfan /fol. 842v/ a la paga de los d[ic]hos quarenta p[es]os de a ocho rreales al cumplim[ien]to y paga de lo que d[ic]ho es obligaron el d[ic]ho lucas bizuete su perss[on]a y ambos todos sus bienes muebles y rrayçes d[erech]os y acçiones auidos y por auer [. . .] estando presentes por t[estig]os pedro velasquez presui[ter]o Gabriel de Heredia y Fernando de obando v[ecin]os de esta d[ic]ha çiudad y los otorgantes que yo el escriu[an]o doy fee conozco lo firmaron

[signatures and rubrics]
Andrés Farfán de los Godos
Lucas Bizuete
ante mi Ger[oni]mo de Heredia, scriu[an]o de su mag[esta]d

E. Miguel Ponce, Altarpiece and Paintings, 1633

In this contract, from 1633, the Confraternity of Santa Catalina of the tailors' guild arranges to have the "yndio maestro pintor" Miguel Ponce create an altarpiece and paintings for its chapel in the church of La Merced. Source: ANH/Q, Notaría 1a, vol. 148, 1633–1634, Juan del Castillo, fols. 270v–272r.

En la c[iuda]d de ssan fran[cis]co del quito a beinte y tres dias del mes de mayo de mill y seiscientos y treinta y tres años ante mi el escriuano de su magestad y testigos ynfraescriptos pareçio pressente miguel ponze yndio ladino en la lengua española maestro pintor natural de esta c[iuda]d a quien doy fe que conozco y dixo que sse obligaua y obligo dar acabado de todo punto el rretablo de la cofradia de los sastres de santa catalina virgin y martir que esta fundada en el monasterio y comuento de nuestra señora de la m[erce]d desta c[iuda]d poniendo en la d[ic]ha obra todo lo nessesario asi de oro y plata colores y manifactura y ofiçiales dentro de tres meses cumplidos primero siguientes que corren y se quentan desde oy dia de la f[ec]ha de esta y para los lienssos que sse a de pintar confiessa aber rreseuido de los priostes y mayordomos de d[ic]ha cofradia quatro varas y dos terçias de cotencie para los que los que [sic] an de ser los dos de abaxo = los gloriosos san joan bautista y san bueno [sic] = y las tres de arriua la madre de dios de guadalupe en medio y a los dos lados san p[edr]o nolasco y san rramon = arriba en el frontispiçio la santisima trinidad y al pie del rretablo la magdalena y en los dos cartellillos de arriba ssanta tereza de jesus y santa joana todo bien obrado y acauado de los priostes y mayordomos de la d[ic]ha cofradia y de personas que entienda del arte dentro del d[ic]ho termino so pena de que /fol. 271r/ si no lo diera acabado al d[ic]ho plazo pueda ser compelido a ello por todo rrigor de derecho por que sse a concursada la d[ic]ha obra con joan ortuño de larrea prioste y joseph ximenes de albarran y tomas fernandes mayordomos de la d[ic]ha cofradia en dusientos y quarenta y cinco patacones de a ocho rreales para cuya quenta rresciuio de los susod[ic]hos en mi presençia y testigos cient patacones de a ocho rreales de que doy fee yo el d[ic]ho escriuano = y lo rresatante que son çiento y quarenta y cinco patacones despues de aber acabado la d[ic]ha obra sin escusa ni dilaçion alguna a satisfaçion de d[ic]hos mayordomos como queda rreferido——

y estando pressentes a esta escriptura los d[ic]hos joan ortuño de larrea prioste

joseph ximenes de albarrasin y tomas hernandes de mayordomos de d[ic]ha cofradia auiendolo oido y entendido dixeron que en boz y en nombre de la d[ic]ha cofradia la açeptaron segun y como por el d[ic]ho miguel ponze ba declarado y expeçificado sin le eçeptar ni rretirar bos alguna y por lo que a ellos toca se obligaron a pagar al d[ic]ho miguel ponze yndio y a quien su poder causa viere por la d[ic]ha rrazon los çiento y quaren /fol. 271v/ ta y cinco patacones de a ocho rreales al plazo que ba d[ic]ho dando el susod[ic]ho acabado de todo punto el d[ic]ho rretablo y pinturas sin dilacion ni escusa alguna y a ello anbas partes cada una por lo que le toca y ban obligados en esta escriptura obligaron sus perssonas e bienes muebles y rraizes derechos y acciones de ellos y los d[ic]hos prioste y mayordomos los bienes y rrentas de la d[ic]ha cofradia = para cuyo cumplimiento paga y satisfacion e execuçion dieron poder cumplido a todas qualesquier justiçias e juezes del rrey nuestro señor de esta d[ic]ha ciudad y en especial y sseñaladamente a los sseñores oidores alcaldes deste corte juezes de prouincia corregidor y su lugarteniente de ella a cuyo fuero e jurisdiction sse sometieron y rrenunciaron el suyo propio domicilio y vezindad y la ley si combenerit de jurisdiction omnium judicum poder a que qualquiera de d[ic] has justiçias /fol. 272r/ les condene compela y apremie a lo que d[ic]ho es como por sentencia passada en autoridad de los ajusgada cerca de lo qual rrenuncia con todas qualesquiera leyes fueros y derechos de su fabor y las quinta y sexta titulo quinze de la quinta partida y la ley que prohiue general rrenunciacion de leyes en cuyo testimonio y firmessa lo otorgaron ante mi el d[ic]ho escriuano de su magestad y su rreseptor desta d[ic]ha ciudad siendo testigos ssebastian de aguilar y fran[cis]co de cubas y gregorio dias presentes y los otorgan ante yo el escriuano doy fee conozco lo firmaron de sus nombres

[signatures and rubrics]
Miguel ponçe
prioste juan ortuno de larrea
tomas hernandez
joseph de albarrasin
Joan del Castillo escriu[an]o de su mag[esta]d

GLOSSARY

advocation: Used in art history texts to mean "dedication," "devotional type," or "type of devotional patron" (Virgin of the Rosary, of Guadalupe, etc.).

albañil: Professional builder, especially in brick, who constructed, renovated, and repaired buildings.

alcalde: Magistrate or mayor.

alcalde mayor: Indigenous magistrate designated annually by colonial municipal authorities.

alguacil: Constable, law enforcer.

aranceles: Tariffs established by a municipality to regulate commerce.

artesonado: Elaborately carved, pieced, and inlaid coffered wooden ceilings that were often painted and gilded.

audiencia: A major judicial and administrative entity legally subordinate to a viceroyalty.

ayllu: Andean kinship group or community.

barrio: Neighborhood or zone of an urban center.

batihoja: Gold or silver beater who produced sheets of metal leaf.

brocateado: Elaborate patterning applied to the surfaces of paintings in gold or silver paint or leaf.

caballería: A varying unit of land measurement, which in sixteenth-century Quito could range between 11.28 and 16 hectares.

cabildo: City council, ecclesiastical council, or council governing an indigenous community.

cacique, *cacica*: Male or female hereditary ruler and member of the native nobility.

cartilla: Primer or instruction book for learning to read and write.

censo: Mortgage or financial obligation assumed on property in exchange for loans or for religious reasons.

comedia: Theatrical play or production.

curaca: Quechua language equivalent of cacique. Male or female hereditary ruler and member of the native nobility.

doctrina: School for religious indoctrination.

dorador: Gilder.

encomendero: Holder of a royal tribute grant of native labor.

entallador: Woodcarver, woodworker.

ensamblador: Joiner, woodworker.

escultor: Sculptor.

estampa: Print, engraving, woodcut.

estofado: Sgraffito—that is, the creation of brocaded patterns, typically on sculpture, by scratching through painted surfaces to reveal gold and silver leaf beneath.

hanan/hurin (*hanansaya/hurinsaya*): Quechua terms for the "upper" and "lower" moiety division common to Inca socio-spatial organization.

hijo/a natural: Out-of-wedlock son or daughter.

ladino: An indigenous person who could speak Spanish and was familiar with Spanish customs.

letrado: A member of the lettered class who typically studied at a university and occupied a high status in the social and legal hierarchy.

maestro: Master, teacher.

maestro de obra: General contractor, usually a master of the trade.

mayordomo: Majordomo, administrator.

melinze (also spelled *melinge*, *melinçe*, *melinje*): A flat-weave textile from Flanders (Malines) usually made of linen and/or cotton that commonly served as a support for painting, among other functions.

mestizo: An individual identified or self-identifying as of mixed indigenous and European ancestry.

natural: Native.

obraje: Workshop, usually a textile workshop.

oficial: Journeyman of a particular trade and/or assistant to a master of the trade.

ordenanzas: Legal rules, regulations, bylaws.

patacón: A silver or gold coin, divisible into eight or nine *reales* (slang for peso).

peso: A silver or gold coin equivalent to a *patacón*, divisible into eight or nine *reales*.

primeras letras: ABCs.

principal: A member of the native nobility; lesser in status than a *cacique*.

prioste: An official post, usually within a confraternity, responsible for overseeing religious utensils and celebrations.

procurador: A legal representative or attorney who filed papers on behalf of clients for presentation at court and to other authorities.

promesa de no jugar: A legal agreement to desist from gambling, usually for a period of three to four years, the contravention of which carried a stiff financial penalty.

pulpería: General store.

quipu: Quechua term for an Andean device consisting of knotted fiber cords used to record information.

quilca: Quechua term that in the colonial period encompassed a range of graphic forms and practices, including writing, painting, sculpting, and embroidery.

reducción: A planned indigenous town to which Andeans were relocated by colonial authorities.

república de los españoles: An administrative and judicial entity administered by Spaniards that governed Spaniards, Creoles, Africans, and other castes.

república de los indios: An administrative and judicial entity that governed native people in which Andeans named by Spanish authorities occupied administrative posts.

retablo: Altarpiece, retable.

ruán de fardo: A flat-weave textile from France (Rouen) similar to sackcloth typically made of linen and/or cotton commonly used as a support for painting, among other functions.

sello: A stamp or seal bearing designs or symbols.

síndico: Financial administrator of a monastery, convent, confraternity, or other religious organization.

vale: A small paper receipt or promise of payment exchanged in a transaction between buyer and seller.

vara: A unit of measurement approximately equivalent to three feet.

NOTES

Introduction

1. The term "documentary equivalency" derives from visual culture studies and in particular from pioneering investigations of graphic pluralism in the Americas. See especially Elizabeth Hill Boone and Walter Mignolo, eds., *Writing without Words: Alternative Literacies in Mesoamerica and the Andes* (Durham, NC: Duke University Press, 1994); Elizabeth Hill Boone and Gary Urton, eds., *Their Way of Writing: Scripts, Signs, and Pictographies in Pre-Columbian America* (Washington, DC: Dumbarton Oaks, 2011); Matt Cohen and Jeffrey Glover, eds., *Colonial Mediascapes: Sensory Worlds of the Early Americas* (Lincoln: University of Nebraska Press, 2014); and the special issue on graphic pluralism in the Americas edited by Frank Salomon and Sabine Hyland, *Ethnohistory* 57, no. 1 (Winter 2010).

2. For the catchphrase *voz del anonimato* and the majority of Quito's colonial painters as anonymous, see José María Vargas, *Patrimonio artístico ecuatoriano* (Quito: Editorial Santo Domingo, 1965), 14–16; Filoteo Samaniego, "Determinantes del primer arte hispanoamericano," in *Arte colonial de Ecuador, siglos XVI–XVII*, ed. José María Vargas (Quito: Salvat, 1985), 25–28.

3. The many important twentieth-century publications of José María Vargas and José Gabriel Navarro typically approach Quito painting chronologically, based on stylistic features, inserting the few known names of painters and attributing a host of works to these artists. Vargas is generally inconsistent in terms of citing his sources; Navarro fares somewhat better in this regard. More recently, several innovative studies of Quito painting have been published. See especially Suzanne Stratton-Pruitt, ed., *The Art of Painting in Colonial Quito* (Philadelphia: Saint Joseph's University Press, 2012), which adopts a thematic "virtual catalog" approach; and *Arte quiteño más allá de Quito: memorias de un seminario internacional* (Quito: FONSAL, 2010), which largely identifies works by Quito artists in Europe and the Americas on the basis of style and technique.

4. Archival documents by no means tell the whole story, and they surely omit many painters who never registered their activities before a notary or whose contri-

butions were not otherwise recorded. Certainly, colonial documents have their own set of problematic issues, yet as Karen Graubart has succinctly observed, "while we must make allowances for the mediations of the state and its agent, the notary, wills and other notarial documents can give us access to parts of the social structure not otherwise open to view." Graubart, *With Our Labor and Sweat: Indigenous Women and the Formation of Colonial Society in Peru, 1550–1700* (Stanford, CA: Stanford University Press, 2007), 23. Similarly, Joanne Rappaport and Tom Cummins view notarial contracts as among the least problematic of colonial documents: "Contracts are the form of document least susceptible to generic manipulation, given their brevity and highly formulaic character." Rappaport and Cummins, *Beyond the Lettered City: Indigenous Literacies in the Andes* (Durham, NC: Duke University Press, 2012), 128.

5. José Gabriel Navarro, *Artes plásticas ecuatorianas* (Mexico City: Fondo de Cultura Económica, 1945), 159–160. Navarro laments the lack of earlier "links in the historical chain," observing that "[a] partir de Miguel de Santiago, la historia del arte se concatena fácilmente." He then points to the felicitous rediscovery of Andrés Sánchez Gallque as "el anillo que faltaba a esa cadena histórica" that leads directly to Miguel de Santiago. See also Navarro, "Un pintor quiteño y un cuadro admirable del siglo XVI en el Museo Arqueológico Nacional," *Boletín de la Real Academia de la Historia* 94 (1929): 465–468.

6. Ángel Justo Estebaranz, *El pintor quiteño Miguel de Santiago (1633–1706): su vida, su obra y su taller* (Seville: Universidad de Sevilla, 2013), 28–29, 41–46. The "Apelles of America" sobriquet is referenced on page 29. See also Ángel Justo Estebaranz, *Miguel de Santiago en San Agustín de Quito* (Quito: FONSAL, 2008); Justo Estebaranz, "El obrador de Miguel de Santiago en sus primeros años: 1656–1675," *Revista Complutense de Historia de América* 36 (2010): 163–184; and Justo Estebaranz, *Pintura y sociedad en Quito en el siglo XVII* (Quito: Pontificia Universidad Católica del Ecuador, 2011).

7. John Super, "Partnership and Profit in the Early Andean Trade: The Experience of Quito Merchants, 1580–1610," *Journal of Latin American Studies* 2 (1979): 265–281.

8. For the importation of artworks and related materials from Europe and other regions of the Americas, see chapter 2. For the extensive exportation of locally produced painting and sculpture, see especially *Arte quiteño más allá de Quito*.

9. Quito's population in 1600 expands to around thirty thousand if the surrounding communities within the five-league jurisdiction of the city are included. Kris Lane, *Quito 1599: City and Colony in Transition* (Albuquerque: University of New Mexico Press, 2002), 1; John Leddy Phelan, *The Kingdom of Quito in the Seventeenth Century: Bureaucratic Politics in the Spanish Empire* (Madison: University of Wisconsin Press, 1967), 49.

10. Although demographic and census data is incomplete, Quito certainly possessed a substantial indigenous majority during the sixteenth and early seventeenth centuries. Martin Minchom points out that "the city's racial mix was largely Indian-White," emphasizing the fact that the small African population of Quito "marks a real difference with nearly all other major Spanish American urban centers." Minchom, *The People of Quito, 1690–1810: Change and Unrest in the Underclass* (Boulder, CO: Westview, 1994), 50. See also Lane, *Quito 1599*, 3–4.

11. Many colonial chroniclers state that the Inca conceived of Quito as a "new" or a "second" Cuzco. According to Pedro Cieza de León, Topa Inca commanded that

"Quito was to be the second city after Cuzco." Quoted in Catherine Julien, *Reading Inca History* (Iowa City: University of Iowa Press, 2000), 157. Juan de Betanzos recorded that Atahualpa intended to "build a new Cuzco" in Quito. Betanzos, *Narrative of the Incas*, trans. Roland Hamilton and Dana Buchanan (Austin: University of Texas Press, 1996), 233. For Quito as replicating Cuzco's sacred geography, see Frank Salomon, *Native Lords of Quito in the Age of the Inca: The Political Economy of North Andean Chiefdoms* (Cambridge: Cambridge University Press, 1986), 174; Hugo Burgos Guevara, *El guamán, el puma y el amaru: formación estructural del gobierno indígena en el Ecuador* (Quito: Abya Yala, 1995), 262–296.

12. See chapters 5 and 7 herein.

Chapter 1: Lettered Painters and the Languages of Empire

1. "Entre otras cosas que los reyes Incas inventaron para buen gobierno de su imperio, fue mandar que todos sus vasallos aprendiesen la lengua de su corte—que es la que hoy llaman: 'lengua general'—para cuya enseñanza pusieron en cada provincia maestros Incas de los de privilegio." El Inca Garcilaso de la Vega, *Comentarios reales* (Lisbon: Pedro Crasbeeck, 1609), book 7, chap. 3.

2. "y si tuvieren crucifixos, ymagenes de n[uest]ra Señora o de los sanctos, les den a entender que aquellas ymagenes Es una manera de escriptura que rrepresenta y da a entender a quien representa, y que las an de tener En mucha beneraçion." Archivo General de Indias (hereafter AGI), Patronato, 189, R.40, "Pedro de la Peña, obispo de Quito: sínodo de aquella diócesis," 1570, fol. 20r.

3. "una mano de papel" and "un Arte de Antonio." Archivo Histórico del Banco Central del Ecuador (hereafter AHBCE), JJC .00194, 1580–1586, Gaspar de Aguilar, fols. 841r–842r. A "mano de papel" is a quire of paper, equivalent to twenty-five sheets or one-twentieth of a ream. For Nebrija's "Arte de Antonio" as designating specifically his Latin grammar, see Walter D. Mignolo, "Nebrija in the New World: The Question of the Letter, the Colonization of Amerindian Languages, and the Discontinuity of the Classical Tradition," *L'Homme* 32, nos. 122/124 (1992), 192–195.

4. "por la lengua e ynterpretaçion de Lorenço ygnaçio official pintor ladino en la lengua castellana y del ynga que juro ser la contenida." Archivo Nacional de Historia, Quito (hereafter ANH/Q), Notaría 6a, vol. 40, 1631, Juan Martínez Gasco, fols. 122r–123r. The principal parties to this document were the Andeans Doña Ana Tucto and Constanza Ñusta. For Andean *lenguas* and interpreters, see especially José Carlos de la Puente Luna, "The Many Tongues of the King: Indigenous Language Interpreters and the Making of the Spanish Empire," *Colonial Latin American Review* 23, no. 2 (2014): 143–170.

5. Each of the artists discussed below signed multiple notarial documents over the years, and the form of their respective signatures is consistent throughout. For the question of ambiguous or falsified signatures, see Joanne Rappaport and Tom Cummins, *Beyond the Lettered City: Indigenous Literacies in the Andes* (Durham, NC: Duke University Press, 2012), 202–208; and Kathryn Burns, *Into the Archive: Writing and Power in Colonial Peru* (Durham, NC: Duke University Press, 2010), 74–82, 91–92, 116–117.

6. Susan V. Webster, "Of Signatures and Status: Andrés Sánchez Gallque and Contemporary Painters in Early Colonial Quito," *The Americas* 70, no. 4 (2014): 603–644. Table 1 leaves blank the signature capability of three artists who were not principal parties to notarial contracts and thus were not required signatories. The

undoubtedly literate Spanish Jesuit artist Pedro de Vargas is not included here because he is not recorded in any local notarial documents.

7. As Rappaport and Cummins have rightly observed, native signatures on notarial documents can be ambiguous or problematic because the meaning of a signature or the rationale for signing one's name was not culturally fixed for Andeans. Among their examples are multiple signatures executed by the same hand on a single document, as well as instances of individuals signing one document and in another case claiming that they did not know how to sign. Rappaport and Cummins, *Beyond the Lettered City*, 203. In Quito, the majority of Andean painters included in the present study signed their names to more than one notarial document in a consistent form, often before different notaries. This regularity strongly suggests that their signatures were not falsified or supplied by others.

8. Rappaport and Cummins, *Beyond the Lettered City*, 113–151.

9. Ángel Rama, *La ciudad letrada* (Hanover, NH: Ediciones del Norte, 1984); Walter Mignolo, *The Darker Side of the Renaissance: Literacy, Territoriality, and Colonization* (Ann Arbor: University of Michigan Press, 1995); Byron E. Hamann, *The Translations of Nebrija: Language, Culture, and Circulation in the Early Modern World* (Amherst: University of Massachusetts Press, 2015).

10. Rama, *La ciudad letrada*, chap. 3.

11. Roswith Hartmann and Udo Oberem, "Quito: un centro de educación de indígenas en el siglo XVI," in *Contribuçiões à Antropologia em homenagem ao Professor Egon Schaden* (São Paulo: Fundo de Pesquisas do Museu Paulista, 1981), 106. There is no known roster of students for the Mercedarian school, nor has any detailed documentation regarding its activities been recovered.

12. "Juan Griego tenía tienda de enseñar muchachos en la iglesia cathedral de esta ciudad e mostraba a españoles e mestizos e indios la doctrina cristiana e a leer y escribir." Hartmann and Oberem, "Quito," 108.

13. "que lee grammatica en esta ciudad para que sea aprouechados los estudiantes y personas que quisieren oyr la d[ic]ha ciencia." AHBCE, JJC .00195, 1565–1566, Jácome Freile, fols. 336r–336v.

14. "Estatutos y reglamentos del colegio de San Andrés, 1568," transcribed in Agustín Moreno, *Fray Jodoco Rique y Fray Pedro Gocial: apóstoles y maestros franciscanos de Quito, 1535–1570* (Quito: Abya Yala, 1998), 295. "Que en esta tierra hay muchos españoles que no tienen para sustentar sus hijos y pagar a un maestro por cada año doce pesos que es lo que en esta tierra se da por cada año que enseña un español a leer y escribir."

15. "tres escuelas donde se avezan a leer y a ezcriuir los niños hijos de vezinos y en ellas avra de quinientos muchachos para arriba, hay otros seis [de] estas [escuelas] en que se avezan los yndios a lo que esta dicho y a cantar y otros exercicios buenos y virtuosos como es latinidad y hazer libros de canto." Archivo del Ministerio de Relaciones Exteriores (AMRE/Q), Quito, G.1.2.6, Papeles de Quito, s. XVI, expte. 20, "Expediente en que se inicia un memorial de Domingo de Orive, en nombre del Cabildo de Quito, para que se le de testimonio de la descripcion de la ciudad y sus terminos que presenta 1573," 1577, 258.

16. "muchos indios oficiales en todos los oficios [. . .] que usan con destreza cualquier cosa a que se ponen y principalmente los que apuntan libros de canto y usan otros oficios útiles de manera que, demás de ser muy provechosos en la república, viven en justicia y ellos son muy aprovechados de manera que favorecen y ayudan a sus deudos y amigos pobres, así para su sustentación como para pagar sus tributos."

Quoted in *Relaciones Histórico-Geográficas de la Audiencia de Quito*, transcr. Pilar Ponce Leiva, (Quito: MARKA and Ediciones Abya Yala, 1992) 1:256.

17. "porque este testigo le enseño a leer y escriuir [. . .] don Alonso sabe leer y escriuir cantar danzar y tañer bihuela citara y otros instrumentos y debujar." Archivo General de Indias (hereafter AGI), Lima 472, "Provança de don Alonso Atagualpa," fol. 209r. Transcribed in Udo Oberem, *Notas y documentos sobre miembros de la familia del Inca Atahualpa en el siglo XVI* (Guayaquil: Casa de la Cultura Ecuatoriana, 1976), 157.

18. See for example Vargas, *Patrimonio artístico*, 5–10; *Los siglos de oro en los virreinatos de América, 1550–1700* (Madrid: Museo de América, 1999), 170. For perspectives and debates regarding the *escuela quiteña*, see José Gabriel Navarro, *Contribuciones a la historia del arte en el Ecuador* (2d ed. Quito: FONSAL, 2006) 1:14, 45–54; José María Vargas, *El arte quiteño en los siglos XVI, XVII y XVIII* (Quito: Imprenta Romero, 1949), 205–210; José María Vargas, *El arte ecuatoriano* (Quito: Editorial Santo Domingo, 1964), 161–170; Carmen Fernández-Salvador and Alfredo Costales Samaniego, *Arte colonial quiteño: renovado enfoque y nuevos actores* (Quito: FONSAL, 2007), 71–122; Jorge Guerrero, "El arte ecuatoriano de la colonia (1600–1800)," *Revista de América* 10, no. 30 (June 1947): 335–338.

19. Reginaldo de Lizárraga, "Descripción breve de toda la tierra del Perú, Tucumán, Río de la Plata y Chile," in *Descripción colonial, libro primero* (Buenos Aires: Librería La Facultad, 1916), 173. Lizárraga lived in Quito during the 1550s and had firsthand acquaintance with the Franciscan friars.

20. Moreno, *Fray Jodoco Rique*, 11.

21. A 1552 report written by Fray Francisco Morales, Guardian of the Monastery of San Francisco in Quito, declared that the Quito *colegios* were modeled on those of New Spain. Cited in Marcellino da Civezza, *Storia universale delle missioni francescane* (Rome: Tipografia Tiberina, 1857–1895), 7:88; Hartmann and Oberem, "Quito," 109.

22. José Gabriel Navarro cites a general description of the early Franciscan establishment written by the late nineteenth- and early twentieth-century Ecuadorian priest and historian, Federico González Suárez: "Delinearon los conquistadores, dice González Suárez, una de las plazas de la ciudad delante del convento y le señalaron indios para que se ocuparan en la construcción de la nueva fábrica. Ésta, al principio, fue una choza humilde a uno de los extremos de la plaza: los padres construyeron primero su iglesia, sencilla y pobre, en el punto donde ahora está el templo de San Buenaventura, pues la iglesia grande y el convento tardaron más de un siglo en terminarse." Navarro, *Contribuciones* 1:57.

23. "en la ciudad de Quito, junto al convento de San Francisco, esta una yglesia con una casa que se llaman el Colegio de San Andrés." Transcribed in Hugo Burgos Guevara, *Primeras doctrinas en la real audiencia de Quito, 1570–1640: estudio preliminar y transcripción de las relaciones eclesiales y misionales de los siglos XVI y XVII* (Quito: Abya Yala, 1995), 14.

24. Excavations were undertaken by the Instituto Metropolitano de Patrimonio, under the leadership of Guadalupe Uria Cevallos and Ángel Silva, to effect moisture abatement along the south wall of the principal Franciscan church. Although, for practical reasons, the entire patio was not completely excavated, several large areas, together with smaller *pozos de cateo*, were dug throughout the eastern half.

25. Today, an extensive two-story building sits atop much of the early domed brick structure.

26. John McAndrew, *The Open-Air Churches of Sixteenth-Century Mexico* (Cambridge, MA: Harvard University Press, 1965), 376, 385; George Kubler, *Arquitectura mexicana del siglo XVI* (Mexico City: Fondo de Cultura Económica, 1982), 376–379; Francisco de la Maza, "Fray Pedro de Gante y la capilla abierta de San José de los Naturales," in *Retablo barroco a la memoria de Francisco de la Maza*, ed. Diego Angulo Iñiguez (Mexico City: UNAM, 1974), 43–52; John F. Moffitt, *The Islamic Design Module in Latin America* (Jefferson, NC: McFarland, 2004), 153–154.

27. McAndrews, *Open-Air Churches*, 400–411; Kubler, *Arquitectura mexicana*, 378–379. Subsequent New Spanish open chapels built on a square or rectangular plan in a multiple-bay format include Jilotepec, Etzatlán, and Toluca.

28. Agustín de Vetancurt, *Chronica de la Provincia del Santo Evangelio de México: quarta parte del Teatro Mexicano* (Mexico City, 1694), 24–25.

29. "en quito hemos come[n]cado un collegio a [la] forma de nueva España," AGI, Quito 81, N.6. "y se enseñan al modo de Nueva España." Cited in Civezza, *Storia universale*, 7:88; Hartmann and Oberem, "Quito," 109.

30. Marcos Jiménez de la Espada, "Relaciones geográficas de Indias: Perú," in *Biblioteca de autores españoles* (Madrid: Ediciones Atlas, 1965), 183:99.

31. Federico González Suárez, *Historia general de la República del Ecuador* (Quito: Imprenta del Clero, 1892), 3:299.

32. AHBCE, JJC .00195, 1562–1567, Jácome Freile, fol. 91r.

33. José María Vargas, *Historia del Ecuador: siglo XVI* (Quito: Pontificia Universidad Católica del Ecuador, 1977), 107.

34. This volume is held in the Biblioteca Nacional de Colombia. Aguilar's inscription reads: "este libro es de al[ons]o de aguilar v[ecin]o de quito lo compro el año 1577 por mas lo costome veinte p[es]os [. . .] ." See also Susan V. Webster, *Quito, ciudad de maestros: arquitectos, edificios y urbanismo en el largo siglo XVII* (Quito: Abya Yala, 2012), 119–122.

35. "ansi en el arte de la gramatica como el de canto llano e de organo y a leer y escriuir y mostrar la doctrina xptiana." AGI, Quito 46, N.4, "Informaciones: Fray Francisco Morales," 1557, fol. 2r.

36. It is obviously no coincidence that Atahualpa's Christian name is "Francisco," for he was "baptized and raised" by Fray Jodoco Rique, the founder of the Franciscan establishment in Quito and promoter of its educational mission. Civezza, *Storia universale*, 7:88; Hartmann and Oberem, "Quito," 115. Similarly, Andrés Sánchez Gallque's Christian name is linked to the Colegio de San Andrés. Hartmann and Oberem report on a number of the first generation of Andean students who received instruction at San Juan Evangelista and San Andrés (115–119), and Moreno includes a list of the names of more than forty caciques from all regions of the *audiencia* who were educated by the Franciscans in the early years. Moreno, *Fray Jodoco Rique*, 278–279.

37. Benjamín Gento Sanz, *Historia de la obra constructiva de San Francisco* (Quito: Imprenta Municipal, 1942), 19.

38. Men and boys of African descent are not mentioned as pupils in any of the documents; indeed, the only reference to persons of African descent in relation to the school appears in a 1558 account that designates the proceeds from the public auction of an African slave for the financial support of the Colegio de San Andrés. Archivo Metropolitano de Historia, Quito (hereafter AMH/Q), "Oficios o cartas al Cabildo de Quito por el rey de España o el virrey de Indias, 1554 a 63," fols. 58v–60r.

39. "Fray Jodoco enseñó (á los Indios) á arar con bueyes, a hacer yugos, arados i carretas [. . .] la manera de contar en cifras de Guarismo y Castellano [. . .] además enseñó á los Indios á leer i escrivir [. . .] i tañer los instrumentos de música, tecla i cuerdas, salabuches i cheremias, flautos i trompetas i cornetas, i el canto de órgano i llano [. . .] i que havian de ser menester los oficios mecanios [sic] en la tierra, i que los Españoles no havian de querer usar los oficios que supiesen; enseñó á los Indios todos los géneros de oficios, los que deprendieron mui bien, con los que se sirve á poca costa i barato toda aquella tierra, sin tener necesidad de oficiales españoles [. . .] hasta mui perfectos pintores, i escritores, i apuntadores de libros: que pone gran admiración la gran habilidad que tienen i perfeccion en las obras que de sus manos hacen." Quoted in Francisco María Compte, *Varones ilustres de la Orden Seráfica en el Ecuador*, 2d ed. (Quito: Imprenta del Clero, 1885) 1:25–26.

40. "se juntaron en el dicho colegio muchos hijos de principales e caciques e señores e de no principales y mestizos de cuarenta leguas a la redonda a donde se les enseña la doctrina Cristiana e pulicia y asi mismo a leer y escribir y cantar y tañer todo genero de instrumentos y latinidad [. . .] se les an enseñado en el dicho colegio a muchos indios muchos oficios como son albañiles y carpinteros y barberos e otros que hazen teja y ladrillos y otros plateros e pinteros [sic] de onde ha venido mucho bien a la tierra." Quoted in Hartmann and Oberem, "Quito," 112; Moreno, *Fray Jodoco Rique*, 291–293.

41. "En este dicho colegio enseñauan los rreligiosos a los yndios naturales deesta prouincia de San Fran[cis]co de quito a leer y escrebir y oficios mechanicos como son albañiles carpinteros herreros sapateros sastres cantores pintores Y todos los demas oficios y policia que gosan estos rreynos asimesmo enseñauan los rreligiosos en este colegio a leer y a escrevir, gramatica y buenas costumbres a los hijos de los españoles de manera que este Combento fue la primera fuente en lo temporal y spiritual deestos rreynos." *Descripción inédita de la Iglesia y Convento de San Francisco de Quito* [1647] (Lima: Talleres Tipográficos de "La Tradición," 1924), 8.

42. Moreno, *Fray Jodoco Rique*, 278–279. The caciques represented a range of communities throughout the recently established *audiencia* of Quito.

43. Hartmann and Oberem, "Quito," 118–119.

44. "[los] yndios que saben la lengua española mediante los quales se puede enseñar a los yndios q[ue] no saben la doctrina." Quoted in Andrea Lepage, "El arte de la conversion: modelos educativos del Colegio de San Andrés de Quito," *Procesos: Revista Ecuatoriana de Historia* 25, no. 1 (2007): 50.

45. Hartmann and Oberem, "Quito," 114–115; Lepage, "El arte de la conversion," 65; Moreno, *Fray Jodoco Rique*, 270–271.

46. Hartmann and Oberem, "Quito," 114–115.

47. "cantar, tañer tecla e flauta [. . .] chirimias y [. . .] canto de organo [. . .] sacabuche y flautas." Hartmann and Oberem, "Quito," 114–115, 119.

48. Hartmann and Oberem, "Quito," 114n3.

49. Waldemar Espinoza Soriano, *Etnohistoria ecuatoriana, estudios y documentos* (Quito: Abya Yala, 1999), 20–21; Hartmann and Oberem, "Quito," 116.

50. Espinoza Soriano, *Etnohistoria ecuatoriana*, 20–23; Hartmann and Oberem, "Quito," 116.

51. AGI, Quito 26, N.15, "Petición de Pedro de Zámbiza, indio y cacique de Zámbiza"; Espinoza Soriano, *Etnohistoria ecuatoriana*, 31–33.

52. "1. Que supieran leer y escribir. 2. Que conocieran el derecho consuetudinar-

io. 3. Que estuvieran percatados y practicaron eficientemente la doctrina Cristiana. 4. Que fueran peritos en la administración de la justicia civil y criminal. 5. Que dominaran el idioma español. 6. Que se vistieran como hidalgos de castilla. 7. Que fueran notoriamente fieles al rey. 8. Que inclusive tuvieran buena caligrafía." Paraphrased in Espinoza Soriano, *Etnohistoria ecuatoriana*, 33.

53. "de aquí [el Colegio de San Andrés] se ha henchido la tierra de cantores y tañedores." Quoted in Hartmann and Oberem, "Quito," 113. See also Robert Stevenson, "Música en Quito," *Revista Musical Chilena* 16, nos. 81–82 (1962): 172–194.

54. Lizárraga, *Descripción colonial*, 174. Lizárraga wrote with evident hyperbole, "Conocí en este collegio un muchacho indio llamado Juan, y por ser Bermejo de su nacimiento le llamaban Juan Bermejo, que podia ser tiple en la capilla del Sumo Pontífice; este muchacho salió tan diestro en el canto de órgano, flauta y tecla, que ya hombre lo sacaron para la iglesia mayor, donde sirve de maeso de capilla y organista; deste he oido decir (dése fe a los autores) que llegando a sus manos las obras de Guerrero, de canto de órgano, maeso de capilla de Sevilla, famoso en nuestros tiempos, le enmendó algunas consonancias, las cuales venidas a manos de Guerrero conoció su falta."

55. For a more extensive comparison of pedagogy in the New Spanish Franciscan establishments, the Colegios de San José de los Naturales and Santa Cruz de Tlatelolco, with the Colegio de San Andrés, see Lepage, "El arte de la conversion," 48–56.

56. Diego de Valadés, *Rhetorica christiana* (Perugia, 1579), 207, 211.

57. See also the late sixteenth-century text by the Franciscan friar, Gerónimo de Mendieta, *Historia ecclesiástica indiana* (Mexico City: Editorial Porrúa, 1980), 249–250. Mendieta described the Franciscan use of paintings in religious instruction: "Hacian pintar en un lienzo los artículos de la fe, y en otro los diez mandamientos de Dios, y en otro los siete sacramentos, y lo demas que querian de la doctrina cristiana. Y cuando el predicador queria predicar de los mandamientos, colgaban el lienzo de los mandamientos junto á él, á un lado, de manera que con una vara de las que traen los alguaciles pudiese ir señalando la parte que queria. Y así les iba declarando los mandamientos. Y lo mismo hacia cuando queria predicar de los artículos, colgando el lienzo en que estaban pintados [. . .] Y no fuera de poco fruto si en todas las escuelas de los muchachos la tuvieron pintada de esta manera, para que por allí se les imprimiera en sus memorias desde su tierna edad."

58. "[s]e les enseña [. . .] lo que significan las imágenes que están en las iglesias." Quoted in Moreno, *Fray Jodoco Rique*, 292.

59. "la confirmación de sus creencias en un solo Dios creador, castigador del mal y de recompensas para los piadosos; el creer que Dios fue encarnado en Cristo para la salvación del mundo; el aceptar vivir de acuerdo a la ley natural de Dios (en vez de las formas pecaminosas de su pasado), y que todos los pecados serían perdonados tras recibir el bautismo. Después de este sacramento, el catecismo franciscano abordaba temas doctrinales más complejos como los artículos de la fe, el cielo, el infierno, el purgatorio, la trinidad, la resurrección y la eucaristía." Lepage, "El arte de la conversion," 51. For a complete transcription of the 1568 statutes and rules of San Andrés, see Moreno, *Fray Jodoco Rique*, 267–297.

60. Lepage, "El arte de la conversion," 52.

61. "para cartillas y libros que lean, papel para que en él escriban y tinta y libros en que canten." Hartmann and Oberem, "Quito," 110; Moreno, *Fray Jodoco Rique*, 293.

62. "tres chirimías, cinco cartapacios de música con motets del maestro sevillano

Francisco Guerrero, ocho cartapacios de manuscritos, nueve vestidos de bayeta para danzas y una caja de libros de romance y cartillas para niños." José María Vargas, *Historia de la cultura ecuatoriana* (Quito: Casa de la Cultura Ecuatoriana, 1965), 25.

63. Augustín Escolano, dir., *Historia ilustrada del libro escolar. Del Antiguo Régimen a la Segunda República* (Madrid: Fundación Germán Sánchez Ruipérez, 1997); Víctor Infantes and Ana Martínez Pereira, eds., *De las primeras letras: cartillas españolas para enseñar a leer de los siglos XV y XVI* (Salamanca: Universidad de Salamanca, 2003); Víctor Infantes, "De cartilla al libro," *Bulletin Hispanique* 97, no. 1 (1995): 33–66; Víctor Infantes, "La imagen gráfica de la primera enseñanza en el siglo XVI," *Revista Complutense de Educación* 10, no. 2 (1999): 73–100; José Torre Revello, "Las cartillas para enseñanza a leer a los niños en América Española," *Thesaurus* (Boletín del Instituto Caro y Cuervo, Bogotá) 15, nos. 1–3 (1960): 214–234; Pedro Rueda Ramírez, "Las cartillas para aprender a leer: la circulación de un texto escolar en Latinoamérica," *Cultura Escrita & Sociedad* 11 (2010): 15–42; Monique Alaperrine-Bouyer, *La educación de las élites indígenas en el Perú colonial* (Lima: Instituto Francés de Estudios Andinos, 2007), 186–193.

64. *Doctrina christiana y catecismo para instruccion de los Indios, y de las demas personas, que han de ser enseñadas en nuestra sancta Fé* (Lima: Antonio Ricardo, 1583). A 1584 edition of this volume held by the Bibliothek des Ibero-Amerikanisches Instituts Preußischer Kulturbesitz in Berlin bears on its frontispiece the handwritten inscription "Pertenece a la Misión de Quito."

65. For example, a large painting of the Trinity in the collection of the Monastery of San Agustín, signed "Chiriboga" and dated 1660, employs the distinctive configuration of the Trinity seen in the 1584 engraving from the *Doctrina christiana*, with Father and Son holding the dove between them. The engraved profile bust of Jesus from the same volume served as the basis for several seventeenth- and eighteenth-century Quito paintings. Imagery from the 1584 *Doctrina christiana* was reused in seventeenth-century Lima publications.

66. Pedro José Rueda Ramírez, "La circulación de libros desde Europa a Quito en los siglos XVI–XVII," *Procesos: Revista Ecuatoriana de Historia* 15 (2000): 3–20; Rueda Ramírez, "Cartillas para aprender a leer," 15–42; Roger Chartier, "Lectores y lecturas populares: entre imposición y apropiación," *Co-Herencia* 4, no. 7 (2007): 103–117; María Isabel González del Campo, "Cartillas de la Doctrina Cristiana, impresas por la Catedral de Valladolid y enviadas a América desde 1583," in *Evangelización y teología en América (siglo XVI)* (Pamplona: Universidad de Navarra, 1990) 1:181–193; Ernesto de la Torre Villar, "Estudio crítico en torno a los catecismos y cartillas como instrumento de evangelización y civilización," in *Fray Pedro de Gante, Doctrina Christiana en lengua mexicana* (Mexico City: Centro de Estudios Históricos Fray Bernardino de Sahagún, 1981), 13–103.

67. "tres pesos de cartillas a medio p[es]o docena." AHBCE, JJC .00194, 1580–1589, Gaspar de Aguilar, fol. 1534v.

68. "ocho docenas y media de cartillas grandes a peso la d[ozen]a." AHBCE, JJC .00200, 1595–1597, Diego Bravo de la Laguna, fol. 129r.

69. "onze docenas de cartillas a dos pesos y medio [la] dozena con quatro dozenas que se vendieron." ANH/Q, Notaría 1a, vol. 18, 1601, Francisco García Durán, fol. 24v. In 1581, Gaspar de Olmedo purchased "tres libros pa[ra] muchachos" from a local shop, which were likely primers of some sort. AHBCE, JJC .00194, 1580–1589, Gaspar de Aguilar, fol. 436r.

70. Mignolo, *Darker Side*, 49.

71. "quarenta y ocho artes de ant[oni]o a tres p[es]os cada uno," ANH/Q, Notaría 1a, vol. 18, 1601, Francisco García Durán, fol. 24v.

72. AGI, Contratación, 1165, N.2, R.1, fols. 26r–27r; Rueda Ramírez, "La circulación de libros," 19.

73. ANH/Q, Notaría 1a, vol. 118, 1627, Diego Rodríguez de Ocampo, fols. 448v–450v. The shipment of 1,299 books received by Villán de Valdés included, among other titles, 135 "Oratorios" by Fray Luis de Granada, 180 "Perfectos christianos"; 16 "contentus mundi" by Fray Luis de Granada; 12 "flos sanctorum de Martín de Roa"; 8 "Notas de Ribera para escribanos"; 8 "Practica de Monterroso" (for *escribanos*); and 8 "cursos de Arte de Murcia la llana," in addition to scores of plays by Lope de Vega. See AGI, Contratación, 1165, N.2, R.1, fols. 26r–27r; Rueda Ramírez, "La circulación de libros," 19–20. A 1608 shipment of books to Quito, intended for "fray Pedro despinosa [*sic*] de la orden de San Francisco," included collections of sermons, religious texts, and "2 Manual [de] coro de St. Francisco," many of which were certainly intended for didactic purposes, perhaps in the Colegio de San Andrés. Rueda Ramírez, "La circulación de libros," 15–16.

74. See, for example, Piedad and Alfredo Costales, *Los agustinos, pedagógos y misioneros del pueblo (1573–1869)* (Quito: Abya Yala, 2003), 91–96; Vargas, *Patrimonio artístico*, 120; Moreno, *Fray Jodoco Rique*, 284; Sonia Fernández Rueda, "El Colegio de Caciques de San Andrés: conquista espiritual y transculturación," *Procesos: Revista Ecuatoriana de Historia* 22 (2005): 21. José Gabriel Navarro nonetheless believed that San Andrés continued to operate until at least 1675, although he cited no evidence in support of this claim. Navarro, "La influencia de los franciscanos en el arte quiteño," *Academia: Boletín de la Real Academia de Bellas Artes de San Fernando* 5 (1955–1957), 74.

75. ANH/Q, Notaría 1a, vol. 34, 1604, Alonso Dorado de Vergara, fols. 1298r–1298v.

76. AHM/Q, "Censos en favor del Cabildo," 1584–1630, fol. 94r–94v; ANH/Q, Notaría 1a, vol. 39, 1605, Alonso Dorado de Vergara, fol. 1378r; ANH/Q, Notaría 6a, vol. 19, 1612, Diego Rodríguez Docampo, fol. 325r; ANH/Q, Notaría 6a, vol. 25, 1617–1619, Diego Rodríguez Docampo, fol. 196r; ANH/Q, Religiosos, caja 1, expte. 26-2-1619, n.p.; ANH/Q, Notaría 1a, vol. 93, 1620–1621, Álvaro Arias, fols. 184r, 193r–196v; ANH/Q, Notaría 1a, vol. 100, 1622–1624, Álvaro Arias, fol. 321v.

77. See, for example, the 1606 codicil of the painter Juan Ponce, who instructed the executor of his will, Marcos de la Plaza, *síndico* of the Monastery of San Francisco, to sell the tools of his trade and "procure meter en el Colegio [de San Andrés] al d[ic]ho su hijo." ANH/Q, Notaría 1a, vol. 43, 1606, Alonso López Merino, fols. 468r–468v.

78. "enseñar a leer escreuir y Cantar a los muchachos de la d[ic]ha parroquia." ANH/Q, Notaría 1a, vol. 138, 1631–1632, Diego Bautista, fols. 204r–204v. Luis de la Torre is not identified as *yndio*; however, he is described as "natural del pueblo de Mira," suggesting indigenous ancestry.

79. Archivo General de la Orden Franciscana en el Ecuador (hereafter AGOFE), 7.2, Titulos de tierras, aguas, III, fols. 3r–18v; ANH/Q Notaría 1a, vol. 94, 1621, Álvaro Arias, fols. 568r–568v. For increased numbers of lawsuits brought by Andean plaintiffs in seventeenth-century Quito, see Diana Bonnett, *El Protector de Naturales en la Audiencia de Quito, siglos XVII y XVIII* (Quito: FLACSO, 1992), 45–134.

80. For the purported "dangers" of Andean education and literacy, see Alaper-

rine-Bouyer, *La educación*, 25–31; Pierre Duviols, *La lutte contre les religions autoch-tones dans le Pérou colonial: "l'extirpation de l'idolâtrie" entre 1532 et 1660* (Lima: IFEA, 1971), 326–329; John Charles, *Allies at Odds: The Andean Church and Its In-digenous Agents, 1583–1671* (Albuquerque: University of New Mexico Press, 2010), 13; Bruce Mannheim, *The Language of the Inka since the European Invasion* (Austin: University of Texas Press, 1991), 75–77; Regina Harrison, *Sin and Confession in Co-lonial Peru: The Spanish-Quechua Penitential Texts, 1560–1650* (Austin: University of Texas Press, 2014), 230–231; and Alcira Dueñas, *Indians and Mestizos in the "Let-tered City": Reshaping Justice, Social Hierarchy, and Political Culture in Colonial Peru* (Boulder: University Press of Colorado, 2010), 17–19 and passim.

81. Partly translated and quoted in Charles, *Allies at Odds*, 13, and partly quoted in Harrison, *Sin and Confession*, 230–231.

82. A 1618 shipment of books received in Quito included, among other titles, eight "Notas de Ribera para escribanos"; eight "Practica de Monterroso" (a legal manual for *escribanos*); and eight "cursos de Arte de Murcia [de] la llana." AGI, Contratación, 1165, N.2, R.1, fols. 26r–27r. Among other legal manuals, multiple copies of Diego del Castillo de Villasante's 1544 *Las leyes de Toro glosadas* are recorded among the imports and sales in early colonial Quito. ANH/Q, Notaría 1a, vol. 18, 1601, Francisco García Durán, fol. 24v.

83. Quoted in Charles, *Allies at Odds*, 38.

84. See Harrison, *Sin and Confession*, 230–231; Charles, *Allies at Odds*, 40n71. Kathryn Burns discusses the implications of the fourteen questions "that should be asked of Indian notaries" in Bocanegra's confessional manual. Burns, "Making In-digenous Archives: The Quilcaycamayoc of Colonial Cuzco," *Hispanic American Historical Review* 91, no. 4 (2011): 679–680.

85. Translated in Charles, *Allies at Odds*, 31.

86. Pedro Rueda Ramírez, "Las redes comerciales del libro en la colonial: 'per-uleros' y libreros en la Carrera de Indias (1590–1620)," *Anuario de Estudios America-nos* 71, no. 2 (2014): 457, 463. For additional complaints regarding native literacy, and for scribal manuals sold in Lima, see Rappaport and Cummins, *Beyond the Lettered City*, 126–127, 291 n25.

87. "[A] los yndios ladinos luego le manda echar de su doctrina porque, ci saue leer y escriuir, le pondrá capítulos." Felipe Guaman Poma de Ayala, "El primer nueva corónica y buen gobierno" (ca. 1615), 609.

88. Burns, "Making Indigenous Archives," 672.

89. For a more extensive analysis of the debates regarding indigenous education in the Viceroyalty of Peru, see Alaperrine-Bouyer, *La educación*, 31–33.

90. "de nuevo el Colegio de San Buenaventura, llamado antes San Andrés." Fran-cisco María Compte, *Varones ilustres de la Orden Seráfica en el Ecuador: desde la fundación de Quito hasta nuestros días* (Quito: Imprenta del Gobierno, 1883), 59–60.

91. Galen Brokaw, "Semiotics, Aesthetics, and the Quechua Concept of *Quilca*," in *Colonial Mediascapes*, ed. Matt Cohen and Jeffrey Glover (Lincoln: University of Nebraska Press, 2014), 167–169.

92. Francisco was not the only Inca to be educated by the Franciscans in the first years of their establishment in Quito. Prior to the Spanish invasion, the Inca Ata-hualpa had sent his young son Francisco from Cajamarca to Quito in the company of four thousand Andeans. The documents indicate that he was later remanded to the Franciscans in Quito, along with his brother Carlos, and in all likelihood with Mateo

Inca Yupanqui, the brother or half-brother of the Inca Atahualpa. See Oberem, *Notas y documentos*, 33.

93. The date of Francisco Atahualpa's birth has been established as circa 1520, making him approximately fourteen or fifteen when he entered the custody of Fray Jodoco Rique. Tamara Estupiñán-Freile, "El testamento de Don Francisco Atagualpa," *Miscelánea Histórica Ecuatoriana* 1, no. 1 (1988): 35.

94. "desde veynte años a esta parte lo a ençeñado y doctrinado en la fe catolica y lo bautizo e lo a sustentado spiritual e corporalmente." Transcribed in Oberem, *Notas y documentos*, 129.

95. "a modo de uniuersidad, donde los nobles atendían a los erçicios de la miliçia, y a los muchachos se les enseñaua el modo de contar por los quipos, añadiendo diuersos colores, que siruieron de letras." Transcribed in Sabine Hyland, *The Quito Manuscript: An Inca History Preserved by Fernando de Montesinos* (New Haven, CT: Yale University Press, 2007), 130.

96. "hijos de los Curacas prinsipales de los gouernadores de las Prouincias y de los parientes mas çercanos y de otros de su linaje [. . .] todas las cosas por donde abian de benir a ser sabios y experimentados en gouierno, politico y en la guerra." Martín de Murúa, *Historia general del Piru: Facsimile of J. Paul Getty Museum Ms. Ludwig XIII 16* (Los Angeles: Getty Research Institute, 2008), fols. 248v–249r.

97. "Entre otras cosas que los reyes Incas inventaron para buen gobierno de su imperio, fue mandar que todos sus vasallos aprendiesen la lengua de su corte —que es la que hoy llaman: 'lengua general'— para cuya enseñanza pusieron en cada provincia maestros Incas de los de privilegio." Garcilaso de la Vega, *Comentarios*, book 7, chap. 3.

98. "De algunas leyes que el Rey Inca Roca hizo y las escuelas que fundó en el Cozco, y de algunos dichos que dijo [. . .] Lo que el Padre Blas Valera dice, como gran escudriñador que fue de las cosas de los Incas, dice de este Rey [Inca Roca], es que reinó casi cincuenta años y que estableció muchas leyes, entre las cuales dice por más principals las que siguen. Que convenía que los hijos de la gente común no aprendiesen las ciencias, las cuales pertenecían solamente a los nobles, porque no ensorberbecesien y amenguasen la república. Que les enseñasen los oficios de sus padres, que les bastaban [. . .] [Inca Roca] fue el primero que puso escuelas en la real ciudad del Cozco, para que los amautas enseñasen las ciencias que alcanzaban a los príncipes Incas y a los de su sangre real y a los nobles de su Imperio, no por enseñanza de letras, que no las tuvieron, sino por práctica, y por uso cotidiano, y por experiencia, para que supiesen los ritos, preceptos y ceremonias de su falsa religion y para que entendiesen la razón y fundamento de sus leyes y fueros y el número de ellos y su verdadera interpretación; para que alcanzasen el don de saber gobernar y se hiciesen más urbanos y fuesen de mayor industria para el arte militar; para conocer los tiempos y los años y saber por los nudos las historias y dar cuentas de ellas; para que supiesen hablar con ornamento y elegancia y supiesen criar sus hijos, gobernar sus casas. Enseñábanles poesía, filosofía y astrología, eso poco que de cada ciencia alcanzaron." Garcilaso de la Vega, *Comentarios*, book 4, chap. 19.

99. "excelentes oficiales, como plateros, pintores, carpinteros y albañiles, que de todos estos oficios tenían los Incas grandes maestros, que por ser dignos de su servicio, se los presentaban los curacas." Garcilaso de la Vega, *Comentarios*, book 5, chap. 7.

100. "especiales Oficiales, como eran Plateros, y Pintores, y Olleros, y Barqueros, y Contadores, y Tañedores; y en los mismos Oficios de Teger, y Labrar, ò Edificar,

avia Maestros para Obra Prima, y de quien se servian los Señores." Garcilaso de la Vega, *Comentarios*, book 5, chap. 9.

101. See Garcilaso de la Vega, *Comentarios*, book 5, chap. 9, in which he describes specialized artisans, including painters, as "presentados," that is, exempt from paying tribute.

102. "Quilca, papel, libro scriptura, carta, pintura. Quilcatha escriuir, pi[n]tar." *Doctrina christiana, y catecismo para instrucción de indios* (Lima: Antonio Ricardo, 1584), 82v.

103. Guaman Poma, "Primer nueva corónica," fols. 814–818.

104. Joanne Rappaport and Tom Cummins, "Between Images and Writing: The Ritual of the King's *Quillca*," *Colonial Latin American Review* 7, no. 1 (1998): 7–32.

105. Tom Cummins, "The Uncomfortable Image: Words and Pictures in the *Nueva corónica i buen gobierno*," in *Guaman Poma de Ayala: the Colonial Art of an Andean Author*, exhibition catalog (New York: Americas Society, 1992), 59.

106. AGOFE, Sección 7.1, Tierras, leg. 7, "Relación de las tierras de Lumbizi y de Cumbaya," fols. 13r–17v.

107. "iglesia y capilla mayor y coro de San Fran[cis]co." AGOFE, Sección 10.4, Varios, doc. 10–86, "Pago del trabajo, de más de 20 años en la iglesia, a Jorge de la Cruz y su hijo con unas tierras de encima de las canteras, hecho por el padre Jodoco con la voluntad del Cabildo de aquel tiempo," ca. 1632, fol. 86r.

108. "dexo una quilca de todos las tierras y estancias del d[ic]ho pueblo de lumbizi y de Cumbaya [. . .] tenga las quilcas de las tierras." AGOFE, Sección 7.1, Tierras, leg. 7, "Relación de las tierras de Lumbizi y de Cumbaya," fols. 14v–15r.

109. Brokaw, "Semiotics," 172.

110. For studies focusing specifically on *quilca*, see especially Brokaw, "Semiotics"; Rappaport and Cummins, "Between Images and Writing," 7–32; Carlos Radicati di Primeglio, "El secreto de la quilca," *Revista de Indias* 44, no. 73 (1984): 11–60; Raúl Porras Barrenechea, "Quipu i quilca (Contribución histórica al studio de la escritura en el antiguo Perú)," *Revista del Museo e Instituto Arqueológico* 13–14 (1951): 19–53.

111. Indeed, these condensed definitions coincide with Elizabeth Boone and Walter Mignolo's broad, inclusive redefinition of nonalphabetic "writing" in the pre-Columbian Americas: "the communication of relatively specific ideas in a conventional manner by means of permanent, visible marks." Elizabeth Hill Boone and Walter Mignolo, *Writing without Words: Alternative Literacies in the Americas* (Durham and London: Duke University Press, 1994), 15.

112. "En el caso de las culturas andinas, las prácticas políticas, sociales, económicas y religiosas revelan la presencia del color como un protagonista clave. Lejos de ocupar un papel secundario o accidental, el espectro cromático, instalado en la vida cotidiana, funcionaba como un dispositivo que permitía identificar un status social, movimientos comerciales, o la presencia de la sacralidad." Gabriela Siracusano, "'Copacabana, lugar donde se ve la piedra preciosa': imagen y materialidad en la región andina," paper presented at the conference *Los estudios de arte desde América Latina: arte y religión*, Salvador de Bahía, 2003, n.p. http://www.esteticas.unam.mx/edartedal/PDF/Bahia/complets/siracusano_bahia.pdf.

113. Brokaw, "Semiotics," 172–176.

114. Betanzos, *Narrative of the Incas*, 114.

115. Betanzos, *Narrative of the Incas*, 74–75, 85.

116. "después que tuvo bien averiguado todo lo más notable de las antigüedades

de sus historias, hízolo todo pintar por su orden en tablones grandes, y deputó en las Casas del Sol una gran sala, adonde las tales tablas, que guarnecidas de oro estaban, estuviesen como nuestras librerías, y constituyó doctores que supiesen entenderlas y declararlas. Y no podían entrar, donde estas tablas estaban, sino el inca o los historiadores, sin expresa licencia del inca." Pedro Sarmiento de Gamboa, *Historia de los Incas* (Madrid: Ediciones Miraguano and Polifemo, 2001 [1572]), 49.

117. "la vida de cada uno de los yngas y de las tierras que conquistó, pintado por sus figuras en unas tablas y qué origen tuvieron." Cristóbal de Molina, "Relación de las fábulas y ritos de los Incas" [ca. 1575], in *Fábulas y mitos de los incas*, ed. Henrique Urbano and Pierre Duviols (Madrid: Historia 16, 1989), 49–50.

118. "una tabla y quipos donde estaban asentadas las edades que hubieron Pachacuti Inca y Topa Inca Yupanqui su hijo y Huayna Cápac hijo del dicho Topa Inca [. . .] una tabla de diferentes colores, por donde los jueces incaicos entendían la pena que cada delincuente tenía." Quoted in Radicati, "El secreto de la quilca," 41–42.

119. "sintiéndose cerca a la muerte hizo su testamento, según entre ellos era costumbre, y en una vara larga (a manera de báculo) fueron poniendo rayas con distintos colores en que se conocía y entendía su última y postrimera voluntad, con lo cual le fue dada en guarda del Quipo-camayoc (que era como entre nosotros el Escribano o Secretario)." Miguel Cabello Balboa, *Obras* (Quito: Editorial Ecuatoriana, 1945), 1:367.

120. "de modo que en un palo recibieron lo que les predicaba, señalandoles y rayando cada capítulo de las razónes." Quoted in Brokaw, "Semiotics," 201n60.

121. "dándole su comisión en rayas de palo pintado." Juan de Santa Cruz Pachacuti Yamqui, *Relación de antigüedades de este reyno del Perú* (Mexico City: Fondo de Cultura Económica, 1995 [1613]), 85.

122. Sarmiento de Gamboa, *The History of the Incas by Pedro Sarmiento de Gamboa 1572*, ed. Brian S. Bauer and Vania Smith (Austin: University of Texas Press, 2007), 149.

123. "dibujada en una tapicería de cumbe, no menos curiosa y bien pintada como si fuera de muy finos paños de corte." Quoted in Radicati, "El secreto de la quilca," 44.

124. For accounts and sources regarding painted textiles, see especially Brian Bauer and Jean-Jacques Decoster, "Introduction: Pedro Sarmiento de Gamboa and *The History of the Incas*," in Sarmiento de Gamboa, *History of the Incas*, 16–18.

125. For scholars who have used these accounts to argue for lost Inca writing systems, see for example Porras Barrenechea, "Quipu i quilca," 19–53; Radicati di Primeglio, "El secreto de la quilca," 42; Victoria de la Jara, *Introducción al estudio de la escritura de los inkas* (Lima: Instituto de Investigación y Desarrollo de la Educación, 1975); Jara, "La solución del problema de la escritura peruana," *Arqueología y Sociedad* 1 (1970): 27–35; Jaime Salcedo Salcedo, *Los jeroglíficos incas: introducción a un método para descifrar tocapus-quilca: estudio del Quero 7511 del Museo de América de Madrid* (Bogotá: Universidad Nacional de Colombia, 2007).

Chapter 2: Materials, Models, and the Market

1. ANH/Q, Notaría 6a, vol. 10, 1601, Diego Rodríguez Docampo, fols. 445r–474v. For the privileged location of Martín Durana's shop, see *Libro de proveimientos de*

tierras, cuadras, solares, aguas, etc., transcr. Jorge A. Garcés (Quito: Imprenta Municipal, [16–17 c.] 1941), 158–159.

2. For the generally low monetary value of paintings in later seventeenth-century Quito, see Justo Estebaranz, *Pintura y sociedad*, 96–114.

3. ANH/Q, Notaría 6a, vol. 10, 1601, Diego Rodríguez Docampo, fols. 450r–474v. One interesting item at this auction, which sold for one hundred pesos, was "tres libras y media de bermellon en un cañamazo y todas las demas tintas que se inventariaron." Ibid., fol. 464v. Although these *tintas* were likely intended for dyeing textiles, they were also employed in the confection of paint. For the multiple uses of pigments, see especially Gabriela Siracusano, *El poder de los colores: de lo material a lo simbólico en las prácticas culturales andinas, Siglos XVI–XVIII* (Buenos Aires: Fondo de Cultura Económica de Argentina, 2005), 138–139, 144–145.

4. ANH/Q, Notaría 6a, vol. 10, 1601, Diego Rodríguez Docampo, fols. 450r–474v.

5. "diez y ocho lienços de figuras grandes a cinco pesos cada uno, mas ocho lienços de figuras grandes a seis pesos cada uno." AHBCE, JJC .00195, 1565–1566, Jácome Freile, fols. 841r–843r.

6. "seys lienços de figuras de virtudes a sesenta pesos." AHBCE, JJC .00195, 1565–1566, Jácome Freile, fols. 817r–817v.

7. "un lienço de la hechura de san diego con ottra Pintura a sus pies en cinco pessos [. . .] otro lienço de san miguel al olio en seis Pessos y medio [497r] [. . .] dos lienços Pequeños uno de la madalena y ottro de nuestra señora a pesso y medio" [498r]. AHBCE, JJC .00200, 1595–1597, Diego Bravo de la Laguna, fols. 493v–500v.

8. "cinco lienzos al temple a cinco pesos [. . .] un lienzo grande de San diego al olio en seis pesos [. . .] otro lienzo grande al olio del misterio de Xpo [. . .] otro lienzo al olio del deçendimy[n]to de la cruz." ANH/Q, Notaría 1a, vol. 16, 1600, Alonso Lopez Merino, fols. 88v–89v; Lane, *Quito 1599*, 264n23.

9. "Veynte y Un lienços de pinzel al olio de diferentes ymajines e historias—al olio, en dozientos y diez patacones de a ocho." ANH/Q, Notaría 6a, vol. 26, 1619, Diego Rodríguez Docampo, fols. 686r–687r.

10. "dos payzes en liensso" and "un lienso de pintura de monos jugadores a los naipes y peleadores y otro mono suelto en moldura." ANH/Q, Notaría 1a, vol. 171, 1641–1643, Gerónimo de Montenegro, fols. 261r–261v.

11. ANH/Q, Notaría 1a, vol. 97, 1621–1640, Diego Suárez de Figueroa, fol. 376v.

12. "quatro rretratos para que se los pintase." ANH/Q, Notaría 6a, vol. 55, 1649, Gaspar Rodríguez, fol. 21r.

13. "diez retratos de familiares y dos de los Reyes de España [. . .] trece lienzos que representaban a las Sibilas, cuatro que figuraban las Estaciones y un Cupido rodeado de Niños." Vargas, *El arte ecuatoriano*, 50–51.

14. "un cajon de platero con todas sus herramientas y unos fuelles taz y martillo y el dho taz y martillo y un peso con sus pesas esta y lo tiene en su poder Xpoval Sanchez platero [. . .] y un lienço de judique [. . .] cinco libros en Latin E rromance." AHBCE, JJC .00195, 1562–1567, Jácome Freile, fols. 851r–853v. The meaning of "judique" is not entirely apparent; however, paintings with this subject identification are listed in Iberian inventories of the period. See Antonio Méndez Casal, "El pintor Alejandro de Loarte," *Revista Española de Arte* 12, no. 4 (December 1934): 189–192, in which Loarte's testament lists "un lienzo de dos varas y tercio de judique [. . .] declaro que tengo hecho para el jurado Ramón Rodríguez de Esparza, vecino de Toledo, una judique con el cuadro dorado de oro bruñido." When Loarte's pos-

sessions were sold at public auction, both paintings were listed as "un lienzo de la judique" (p. 192). Méndez Casal interprets "judique" as the Old Testament heroine Judith (p. 189).

15. AHBCE, JJC .00202, 1596, Alonso Dorado de Vergara, fols. 1058r–1062r. "una ymagen de Pluma de el S[eño]r San Pablo echa en mexico." This is the only example of the renowned Mesoamerican and colonial New Spanish technique of *arte pluma-rio* to appear in the early Quito documents.

16. "catorce lienços de figuras de flandes a dos pesos." ANH/Q, Notaría 1a, vol. 13, 1600, Alonso Dorado de Vergara, fols. 196v–1107r.

17. "una hechura de un Xpo en siete pesos [. . .] dos mantas de la china pintadas a cinco pessos [. . .] una hechura de nra senora de marfil con sus andas de ebano torneadas en quatro pesos quatro tomines [. . .] dos hechuras de san joan de marfil con sus andas de euano torneadas a quatro pesos quatro tomines [. . .] quatro onças de color Para azeite a dos pesos onça [. . .] un lienço de la hechura de san diego con ottra Pintura a sus pies en cinco pessos [. . .] otro lienço de san miguel al olio en seis Pessos y medio [. . .] dos lienços Pequeños uno de la madalena y ottro de nuestra señora a pesso y medio." AHBCE, JJC .00200, 1595–1597, Diego Bravo de la Laguna, fols. 493v–500v.

18. "conforme a las estampas que se le dieron." ANH/Q, Notaría 1a, vol. 117, 1626, Gerónimo de Heredia, fols. 842r–842v. See the full transcription in the appendix, part d.

19. "conforme a otras veinte y siete estampas finas de papel que an de ser el modelo, segund y como en ellas sin que falte cossa ninguna de ellas." ANH/Q, Notaría 1a, vol. 137, 1630, Diego Rodríguez Docampo, fols. 822v–824r.

20. For later seventeenth-century examples, see especially Justo Estebaranz, *Pintura y sociedad*, 191–240; Justo Estebaranz, "La influencia de los grabados europeos en la pintura quiteña de los siglos XVII y XVIII," in *La multiculturalidad en las artes y en la arquitectura* (La Palmas de Gran Canaria: Consejería de Educación, Cultura y Deportes de Canarias y Anroart Ediciones, 2006), 1:305–310.

21. For additional examples of prints on textiles and wood panels (*tablas*), see ANH/Q, Notaría 6a, vol. 10, 1601, Diego Rodríguez Docampo, fols. 449r, 452r: "diez patacones en rreales que se rremataron una estanpa en tafetan blanco y la hechura de un nino jessus [. . .] nueue pesos de la d[ic]ha plata en que se rremataron nueue estampas en Papel y tabla en entrambasaguas"; [fol. 452r] "treinta pessos en que se rremataron catorze tablas de hechuras del saluador y san pablo y doze apostoles en estanpa de tafetan amarillo con orladora."

22. AHBCE, JJC .00194, 1580–1586, Gaspar de Aguilar, fols. 310v–311v. "por quinze estanpas de a pliego dos pesos."

23. AHBCE, JJC .00194, 1580–1586, Gaspar de Aguilar, fols. 323r–324v. "seis estampas de a seis pliegos a seis tomines una quatro pesos 4 tomines."

24. AHBCE, JJC .00194, 1580–1586, Gaspar de Aguilar, fols. 319v–321r. "por quinze estampas de a pliego quatro pesos [. . .] por seis estampas grandes tres pesos."

25. "treynta estampas de papel de a seys pliegos [. . .] ochenta estampas de a medio pliego." AHBCE, JJC .00194, 1580–1586, Gaspar de Aguilar, fol. 517r.

26. "honze papeles de figuras grandes [y] nuebe estanpas pequenas." AHBCE, JJC .00194, 1580–1586, Gaspar de Aguilar, fols. 1209r–1210v.

27. "veynte y un estampas que dio al P[adr]e Dionysio un peso dos rr[eale]s y seis granos." AHBCE, JJC .00196, 1586, Francisco de Corcuera, fols. 656r–660r.

28. "nueue estampas en papel." AHBCE, JJC .00202, 1596, Alonso Dorado de Vergara, fol. 1097r.

29. "cincuenta estampas de esplandor a tres pesos y dos tomines [. . .] cincuenta y siete papeles de estampas pequeñas por tres pesos [. . .] honze papeles grandes de las dhas estampas en cinco pesos y medio [. . .] diez mapas grandes a peso cada." ANH/Q, Notaría 1a, vol. 16, 1600, Alonso López Merino, fols. 88v–89v.

30. "nueue estampas en Papel y tabla." ANH/Q, Notaría 6a, vol. 10, 1601, Diego Rodríguez Docampo, fol. 449r.

31. "por tres estampas gitanas medio peso." AHBCE, JJC .00194, 1580–1586, Gaspar de Aguilar, fol. 409r. It is unclear whether "gitanas" refers to the subject matter or to some other aspect of the prints.

32. "unos papeles de figuras de santos en un peso." AHBCE, JJC .00194, 1580–1586, Gaspar de Aguilar, fols. 184r–184v.

33. "treinta pessos en que se rremataron catorze tablas de hechuras del saluador y san pablo y doze apostoles en estanpa de tafetan amarillo con orladora." ANH/Q, Notaría 6a, vol. 10, 1601, Diego Rodríguez Docampo, fol. 452r.

34. ANH/Q, Notaría 1a, vol. 97, 1621–1640, Diego Suárez de Figueroa, fol. 376v. The term "Romano" was employed frequently in this period to mean *estilo a lo romano*; that is, High Renaissance or Mannerist style images.

35. See Justo Estebaranz, *Pintura y sociedad*, 196–204.

36. According to Lane, in the late sixteenth century, Juan de Herrera held a monopoly on the production and sale of playing cards in Quito, which were offered at ten *reales* per deck. Lane, *Quito 1599*, 265–266n24.

37. AHBCE, JJC .00194, 1580–1586, Gaspar de Aguilar, fol. 622r. "cinco docenas de naypes rretobados [. . .] una docena de naypes por rretobar." Among many other examples, the 1601 public auction of Durana's shop inventory included "tres baraxas de naypes," indicating that previously cut and glued decks of cards could also be purchased on the market. ANH/Q, Notaría 6a, vol. 10, 1601, Diego Rodríguez Docampo, fol. 458v.

38. For illustrations and a discussion of sixteenth-century playing cards in Lima, see Ricardo Estabridis Cárdenas, *El grabado en Lima virreinal: documento histórico y artístico (siglos XVI al XIX)* (Lima: Fondo Editorial Universidad Nacional Mayor de San Marcos, 2002), 80–91.

39. Jorge Salvador Lara, *Quito en la poesía del periódo hispánico: discurso de incorporación del académico correspondiente* (Quito: Editorial Ecuatoriana, 1970), 11. For more on Benalcázar as a painter of playing cards, see Federico González Suárez, *Historia general de la República del Ecuador* (Quito: Imprenta del Clero, 1892), 3:117.

40. "por quanto el jugar ha sido de mucho descredito [. . .] y disminucion de sus uienes [. . .] hace promessa de no jugar por tiempo de tres anos [. . .] o pagara a la Santa Ynquicission doscientos pesos." ANH/Q, Notaría 1a, vol. 188, 1648, Pedro Pacheco, fols. 131r–131v.

41. ANH/Q, Notaría 6a, vol. 55, 1649, Gaspar Rodríguez, fols. 20r–23v. On widespread card playing, compulsive gambling, and related debts, see Lane, *Quito 1599*, 165, 265–266n24.

42. For the history of printing and printmaking in New Spain, see especially Manuel Romero de Terreros, *Grabados y grabadores en la Nueva España* (Mexico City: Editorial Ars, 1948). For Lima, see especially Estabridis Cárdenas, *El grabado en Lima*.

43. "setenta y seis Laminas de cobre medianas y pequenas para estampas y el torno." ANH/Q, Notaría 6a, vol. 10, 1601, Diego Rodríguez Docampo, fols. 445r–474v. For the location of Miguel de Entrambasaguas's shop on Quito's main plaza, see *Libro de proveimientos*, 159.

44. This Serlio volume, *Tercero y quarto libro de architectura de Sebastian Serlio boloñes* (Toledo: Casa de Iuan de Ayala, 1573) is located in the Biblioteca Nacional de Colombia, Colección de Libros Raros y Curiosos, RG3996. See also Ramón Gutiérrez and Graciela Viñuales, "San Francisco de Quito," *Trama* 1 (1977): 36–38; Susan Verdi Webster, "Art, Identity, and the Construction of the Church of Santo Domingo in Quito," *Hispanic Research Journal* 10, no. 5 (2009): 430–434; and Webster, *Quito, ciudad de maestros*, 119–124. Aguilar inscribed the volume thusly: "este libro es de al[ons]o de aguilar v[ecin]o de quito comprolo año 1577 por mas lo costome veinte p[es]os."

45. "cinco libros de Latin E rromance." AHBCE, JJC .00195, Jácome Freile, 1565–1566, fols. 851r–853v.

46. "dos garibayes quinze terencios y begilios." AHBCE, JJC .00194, 1580–1586, Gaspar de Aguilar, fols. 1209r–1210v. The historian Esteban de Garibay (1533–1600) is the only Spanish author included in this particular purchase.

47. Most of these titles may be found in ANH/Q, Notaría 1a, vol. 18, 1601, Francisco García Durán, fols. 20r–30r. For "un libro del suceso de la batalla de ronçesballes [a] tres pesos y medio," see AHBCE, JJC .00196, 1586, Francisco de Corcuera, fol. 1225v.

48. "seis libros el uno grande de arquitetura y los çinco pequenos de latin." ANH/Q, Notaría 6a, vol. 10, 1601, Diego Rodríguez Docampo, fol. 450r. "siete pesos de la d[ic]ha Plata en que se rremataron seis libros el uno grande de arquitetura [*sic*] y los çinco pequenos de latin."

49. "quatro misales los dos grandes de burgos a quarenta y cinco pesos y los dos de quarto [con] estanpas finas a treinta y dos pesos." ANH/Q, Notaría 1a, vol. 18, 1601, Francisco García Durán, fol. 24r.

50. "dos flos sanctorum seg[un]da y tercera p[ar]te y con otros dos q[ue] se uendieron." ANH/Q, Notaría 1a, vol. 18, 1601, Francisco García Durán, fol. 24v. Both Alonso de Villegas and Pedro de Ribadeneyra published volumes entitled *Flos sanctorum* in the late sixteenth and early seventeenth centuries. Alonso de Villegas, *Flos sanctorum segunda parte y Historia general: en que se escrive la vida de la Virgen sacratissima Madre de Dios [. . .] y la de los sanctos antiguos que fueron antes de la venida de nuestro Saluador* (Zaragoza: Casa de Simon de Portonarijs, 1586), contains illustrations of the life of the Virgin and the Passion of Christ. The third part of Villegas's volumes (Toledo: Juan y Pedro Rodríguez, 1588), as well as the many seventeenth-century editions of the *Flos santorum* of Pedro de Ribadeneyra, is illustrated with a number of images of saints and martyrs.

51. "siete pesos por un libro historia de ylustres barones y con otro que se uendio." ANH/Q, Notaría 1a, vol. 18, 1601, Francisco García Durán, fol. 24v.

52. "la descendencia de la casa de Austria desde pipino primero duque de brabantia hasta el Rey Don felipe segundo [. . .] un libro que compuso Juan baptista Vrientino de Antuerpia." Quoted in Vargas, *El arte ecuatoriano*, 236–237.

53. For *cartillas* that included religious images, see especially González del Campo, "Cartillas de la Doctrina Cristiana."

54. For example, according to Estabridis Cárdenas, in 1580 the Cromberger press in Seville produced a single order of two thousand "cartyllas de enseñar a leer" intended for the Americas. Estabridis Cárdenas, *El grabado en Lima*, 32.

55. For examples of the sale of scores of *cartillas* in early colonial Quito, see AHBCE, JJC .00194, 1580–1586, Gaspar de Aguilar, fol. 1534v; AHBCE, JJC .00200, 1595–1597, Diego Bravo de la Laguna, fol. 129r; and ANH/Q, Notaría 1a, vol. 18, 1601, Francisco García Durán, fol. 24v. For *cartillas* and their associated imagery in Spain and New Spain, see especially Roger Chartier, "Lectores y lecturas populares: entre imposición y apropiación, *Co-Herencia* 4, no. 7 (2007): 103–117; María Isabel González del Campo, "Cartillas de la Doctrina Cristiana, impresas por la Catedral de Valladolid y enviadas a América desde 1583," in *Evangelización y teología en América (siglo XVI)* (Pamplona: Universidad de Navarra, 1990), 1:181–193; Pedro Rueda Ramírez, "Las cartillas para aprender a leer: la circulación de un texto escolar en Latinoamérica," *Cultura Escrita & Sociedad* 11 (2010): 15–42; Carmen Castañeda García, "Libros para la enseñanza de la lectura en la Nueva España, siglos XVIII y XIX: cartillas, silabarios, catones y catecismos," in Carmen Castañeda García, Luz Elena Galván Lafarga, and Lucía Martínez Moctezuma (eds.), *Lecturas y lectores en la historia de México* (Mexico City: CIESAS, 2004), 35–66. For colonial Peru, see especially Víctor Infantes and Ana María Pereira, *De las primeras letras: cartillas españolas para enseñar a leer del siglo XVII y XVIII* (Salamanca: Universidad de Salamanca, 2003); Torre Revello, "Las cartillas," 214–234.

56. For *libros de memoria*, see especially Roger Chartier, *Inscribir y borrar: cultura escrita y literatura (siglos XI–XVIII)* (Buenos Aires: Katz Editores, 2006), 48–60; Antonio Castillo Gómez, *Entre la pluma y la pared: una historia social de la escritura en los siglos de oro* (Madrid: Akal, 2006), 61–70.

57. Castillo Gómez mentions a 1509 peninsular account that describes two *libros de memoria* as "dos libros de dibuxar." Castillo Gómez, *Entre la pluma y la pared*, 64.

58. "seis libros de memoria dos pesos dos tomines." AHBCE, JJC .00194, 1580–1586, Gaspar de Aguilar, fols. 323r–324v.

59. "una docena de libretes de memoria." AHBCE, JJC .00194, 1580–1586, Gaspar de Aguilar, fols. 350v–351v.

60. ANH/Q, Notaría 1a, vol. 18, 1601, Francisco García Durán, fols. 20r–30r.

61. "doze libritos de memoria a quatro rr[eale]s [. . .] doze estuches de faltriquera a diez rr[eale]s." AHBCE, JJC .00206, 1613, Francisco de Zarza, fols. 24r–25r.

62. For additional examples, see ANH/Q, Notaría 1a, vol. 18, 1601, Francisco García Durán, fol. 28r.

63. For a 1586 purchase of *acíbar* and *mirra*, alongside a list of pigments including *albayalde* and *azul marinas*, see AHBCE, JJC .00196, Francisco de Corcuera, 1586, fols. 919r–925r. For liquidambar, which appears in sales and inventories with great frequency, see AHBCE, JJC .00194, Gaspar de Aguilar, 1580–1586, fol. 613r. For *estoraque*, see AHBCE, JJC .00194, Gaspar de Aguilar, 1580–1586, fols. 350v–351v; ANH/Q, Notaría 1a, vol. 13, 1600, Alonso Dorado de Vergara, fols. 1096v–1107r. For *lacre*, see AHBCE, JJC .00194, Gaspar de Aguilar, 1580–86, fol. 1534r; ANH/Q, Notaría 5a, vol. 1, 1599–1600, Juan de Briñas, fols. 652r–654r.

64. "cinquenta e dos tablas de çedro grandes y pequenas." ANH/Q, Notaría 6a, vol. 10, 1601, Diego Rodríguez Docampo, fol. 461v.

65. *Ruán de fardo* and *melinze* (also spelled *melinçe, melinxe, melinge, melinje*) were among the most common supports for painting in the sixteenth and seventeenth centuries. See Rocío Bruquetas, *Técnicas y materiales de la pintura española en los Siglos de Oro* (Madrid: Fundación de Apoyo a la Historia del Arte Hispánico, 2002), 233–246. *Ruán*, a type of textile associated with the French city of Rouen,

is defined as a fine, flat-weave textile made from linen or wool. *Ruán de fardo* may translate roughly as sackcloth. *DICTER: diccionario de la ciencia y de la técnica del Renacimiento* (Ediciones Universidad de Salamanca), http://dicter.usal.es/.

66. ANH/Q, Notaría 1a, vol. 10, 1598, Francisco García Durán, fols. 783v–784v.

67. ANH/Q, Notaría 1a, vol. 73, 1611–1612, Alonso Dorado de Vergara, fols. 1518r–1518v; and ANH/Q, Notaría 1a, vol. 91, 1619–1620, Gerónimo Heredia, fols. 781r–781v.

68. ANH/Q, Notaría 1a, vol. 98, 1621, Gerónimo de Heredia, fols. 118r–118v.

69. ANH/Q, Notaría 5a, vol. 10, 1628, Gerónimo de Castro, fols. 451r–451v.

70. ANH/Q, Notaría 1a, vol. 137, 1630, Diego Rodríguez Docampo, fols. 822v–824r. "y el dicho miguel de aguirre a de dar al dicho miguel ponze çincueta y quarto Varas de melinze y bastidores nesçesarios para la pintura."

71. "quarenta Varas de rruan de fardo, a rrazon de a Un patacon, cada Vara." ANH/Q, Notaría 6a, vol. 26, 1619, Diego Rodríguez Docampo, fol. 68r.

72. For painter's formulas and techniques in eighteenth-century Quito, see the treatise on painting written by the artist Manuel Samaniego in José María Vargas, *Manuel Samaniego y su Tratado de Pintura* (Quito: Editorial Santo Domingo, 1975), 39–113. Although Samaniego penned his treatise in the last quarter of the eighteenth century, many of the artistic practices and formulas he recorded were likely traditional ones employed by earlier Quito painters.

73. AHBCE, JJC .00196, 1586, Francisco de Corcuera, fols. 925v–931r. Diego de Lario is not named as a painter in the documentary record.

74. "ciento y ttreynta pinzelitos de pintar [. . .] una libra de abayalde [sic] [. . .] dos maços de azul marinas [. . .] quatro onzas de alumbre." AHBCE, JJC .00196, 1586, Francisco de Corcuera, fols. 919r–925r. Diego de Benavides is not named as a painter in the documentary record.

75. For the export of *albayalde* from Seville, see José María Sánchez and María Dolores Quiñones, "Materiales pictóricos enviados a América en el siglo XVI," *Anales del Instituto de Investigaciones Estéticas* 95 (2009): 45–67.

76. "ciento y diez y nueue libras de albayalde en un cajon Tosco [. . .] doze libras de albayalde." ANH/Q, Notaría 1a, vol. 13, 1600, Alonso Dorado de Vergara, fols, 1050v–1051r.

77. For pigments and the symbolic role of colors in central and southern colonial Andean painting, see Gabriela Siracusano, *El poder de los colores: de lo material a lo simbólico en las practices culturales andinas, siglos XVI–XVIII* (Buenos Aires: Fondo de Cultura Económica, 2005); Gabriela Siracusano, "Polvos y colores en la pintura barroca andina. Nuevas aproximaciones," *Actas del III Congreso Internacional del Barroco Iberoamericano* (Sevilla, 2001): 425–444; Pedro Querejazu Leyton, "The materials and techniques of Andean Painting," in *Gloria in Excelsis: The Virgin and Angels in Viceregal Painting of Peru and Bolivia*, 78–82 (New York: Center for Inter-American Relations, 1986); José de Mesa and Teresa Gisbert, *Historia de la pintura cuzqueña* (Lima: Banco Weise, 1982), 1:266–269. For pigment analysis of paintings from the central and southern colonial Andes, see especially Alicia Seldes et al., "La paleta colonial andina: química, historia y conservación," in *Actas del X Congreso de Abracor* (Sao Paulo, 2000): 155–164; Alicia Seldes et al., "Blue Pigments in South American Painting (1610–1780)," in *Journal of the American Institute of Conservation* 38, no. 2 (1999): 100–123; Alicia Seldes et al., "Green, Red, Yellow Pigments in South American Painting (1610–1780)," *Journal of the American Institute of Conservation* 41, no. 3 (2002): 225–242. For the importation of European pigments, see Sánchez and Quiñones, "Materiales pictóricos," 45–67.

78. Ángel Justo Estebaranz laments the almost complete lack of documentary references in the later seventeenth century to pigments and the other materials of painting and their costs. Justo Estebaranz, *Pintura y sociedad*, 133.

79. "seis papeles de tintas de flandes." AHBCE, JJC .00194, 1580–1586, Gaspar de Aguilar, fols. 350v–351v. Among the other items included in Ramírez's purchase were "tres libras de estoraque [liquidambar] [. . .] quatro mill aguas marinas [?] [. . .] treinta y tres botijas de azeyte."

80. AHBCE, JJC .00195, 1565–1566, Jácome Freile, fols. 834r–836v. "una ochava de grana de polvo." Cochineal was used in the pre-Columbian northern Andes as early as 500 CE. Anne Pollard Rowe, "Introduction," in *Costume and History in Highland Ecuador*, ed. Anne Pollard Rowe (Austin: University of Texas Press, 2011), 9. Andrés Gutiérrez Usillos documents early colonial production of cochineal in Loja (southern Ecuador) and presents a case for pre-Columbian cultivation in the region. Gutiérrez Usillos, *Dioses, símbolos y alimentación en los Andes: interrelación hombre-fauna en el Ecuador prehispánico* (Quito: Abya Yala, 2002), 280–281. For the general history of cochineal in the Americas, see especially Elena Phipps, *Cochineal Red: The Art History of a Color* (New York: Metropolitan Museum of Art, 2010).

81. "doze libras y dos onças de cuchinilla con caxeta." ANH/Q, Notaría 6a, vol. 10, 1601, Diego Rodríguez Docampo, fols. 455v–456r.

82. See, for example AHBCE, JJC .00198, 1586–1587, Francisco de Corcuera, fol. 209r: "dos quintales de tinta de añir que de vos compre en seiscientos pessos y quatro tomines"; AHBCE, JJC .00203, 1598–1599, Alonso Dorado de Vergara, fols. 422v–423r: "çiento y diez libras de tinta añil de Nicaragua"; ANH/Q, Gobierno, caja 2, 1599–1608, expte. 1, fol. 76r: "200 libras de tinta anir de Puerto Viejo." The large quantities of indigo recorded in these sales indicate the high demand for the colorant in the local textile workshops that produced Quito's famed *paños azules*. Local production of indigo was underway by the 1590s; however, it likely did not meet the demand of the many *obrajes*. See Lane, *Quito 1599*, 185.

83. "çiento y diez libras de tinta anil de nicaragua que me bendio y entrego a tres pesos y medio cada libra." AHBCE, JJC .00203, 1598–1599, Alonso Dorado de Vergara, fols. 422v–423r.

84. Lane, *Quito 1599*, 185. Ynés de Alarcón owned a textile *obraje* in the nearby indigenous community of Pelileo, where in 1595 she cultivated three fields of indigo (*yerba de tinta*).

85. The earliest evidence of indigo used as a dye was recovered from textiles in the Nariño province (today southern Colombia), which date from 435 to 797 CE. See Anne Pollard Rowe, "Evidence for Pre-Inca Textiles," in Rowe, *Costume and History*, 63.

86. AHBCE, JJC .00195, 1562–1572, Jácome Freile, fols. 14r–16r.

87. "una libra de achiote p[ar]a sonbrear los florones del artezon del claustro." Archivo Histórico de la Orden Mercedaria de Ecuador (hereafter AHOME), C. VI, 6.4, 1644–1656, "Libro de gastos," fol. 256v.

88. On the mercury mines of Azogues in the colonial period, see especially Juan Chacón Z., *Historia de la minería en Cuenca* (Cuenca: Universidad de Cuenca, 1986).

89. For example, a 1605 sales list of merchandise registered "otra onça de ynsençio [sic] y una de almaciza un pesso y un tomin—por una onça de albayalde un tomin—por tres onças de asafran que llebo Pedro de rrobles siete pessos y medio." ANH/Q, Testamentarias, caja 1, 1588–1628, expte. 4, 7-X-1605, fol. 9r. See also the ap-

pendix, part a. For a 1679 painting contract specifying the use of *azafrán*, see Mesa and Gisbert, *Historia de la pintura cuzqueña* 1:268–269.

90. "siete libras y quatro onças de cardenillo a ocho pesos libra [. . .] cinco libras y quinze oncas de azules subidos En quatro papeles a veinte y dos pesos libra [. . .] otro papel de açul con una libra y onze onças veinte y dos pesos libra [. . .] dos libras y m[edi]a onça de verde terra fino en dos papeles a veinte y dos pesos libra [. . .] dos libras de colorado fino llamado açarcon en vn papel a quatro pesos libra [. . .] una libra y onze onças de Urchilla como estoraque nezo sin Papel a dos pesos libra [. . .] quinze onças de sombranetas a dos pesos onça [. . .] libra y m[edi]a de ancorque a dos pesos [. . .] catorze onças de bermellon con papel a cinco pesos [. . .] una libra y siete onças de genuli con papel a peso y quatro tomines [. . .] dos libras y siete onças de albayalde de tetilla con papel a peso y quatro tomines [. . .] quarenta y quatro libras de bol armenico a quatro pesos quatro tomines." ANH/Q, Notaría 1a, vol. 13, 1600, Alonso Dorado de Vergara, fols. 1097v–1108v. Most of the pigment terms employed in this document are defined and discussed in Zahira Veliz, *Artist's Techniques in Golden Age Spain* (Cambridge: Cambridge University Press, 1986); and Sánchez and Quiñones, "Materiales pictóricos." In addition to the South American sources cited above, see Nicholas Eastaugh et al., *Pigment Compendium: A Dictionary and Optical Microscopy of Historical Pigments* (Amsterdam, Boston, London: Butterworth-Heinemann, 2013), 18.

91. Veliz, *Artist's techniques*, 196–197 n4.

92. See Veliz, *Artist's techniques*, 198n11; Eastaugh et al., *Pigment Compendium*, 167, 289; Karen Diadick Casselman, *Lichen Dyes: The New Sourcebook* (2d ed., Mineola, NY: Dover Publications, 2001), 8–9; Sánchez and Quiñones, "Materiales pictóricos," 52, 62–63.

93. "çient pesos [. . . por] tres libras y media de bermellon en un cañamazo y todas las demas tintas que se ynbentariaron [. . .] çiento y setenta y nueue pessos y çinco tomines en que se rremato en miguel de entreambasaguas çiento y treinta y tres libras y doce oncas de albayalde con un caxon y cañamazo de una bara y una quarta a un pesso y medio cada libra [. . .] seis arrouas y quinze libras de caparrosa de la tierra en una Petaca [. . .] una libra y ocho onças y ocho adarmes de cardenillo en unos papeles." ANH/Q, Notaría 6a, vol. 10, 1601, Diego Rodríguez Docampo, fols. 445r–474v.

94. Siracusano, *El poder de los colores*, 41–130. The author notes that the pigment *genulí* occasionally appears in bills of sale in the southern Andes; however, its employment in colonial paintings has not yet been documented.

95. See for example Tamara Bray, "Ecuador's Pre-Columbian Past," in Carlos de la Torre and Steven Striffler (eds.), *The Ecuador Reader: History, Culture, Politics* (Durham, NC: Duke University Press, 2008), 19–22.

96. For gold mining, production, and plundering in late sixteenth-century Quito, see especially Lane, *Quito 1599*, 116–145.

97. For example, in 1621, Miguel Daza purchased "libros de oro y plata batida" at a local shop. AHBCE, JJC .00207, 1621–1622, Diego Suárez de Figueroa, fol. 603r.

98. "un mill y seisçientos panes de oro e plata en treinta e dos pesos y quatro tomines." ANH/Q, Notaría 1a, vol. 9, 1597–1598, Gaspar de Aguilar, fols. 167r–168r.

99. "para el Dorado de los galeones de Su mag[esta]d." ANH/Q, Notaría 6a, vol. 19, 1612, Diego Rodríguez Docampo, fol. 213v.

100. "dos libros de oro batido cada semana." ANH/Q, Notaria 6a, vol. 40, 1631, Juan Martínez Gasco, fols. 422r–423v.

101. "producir el oro batido para dorar el retablo y sagrario." ANH/Q, Notaría 1a, vol. 189, 1648–1649, Juan García Moscoso, fols. 95r–95v.

102. M. D. Gayo and Maite Jover, Museo del Prado, Dirección Adjunta de Conservación y Restauración, Reporte No. 00069, 3 de mayo de 2012, 1–10. I am grateful to Andrés Gutiérrez Usillos for kindly sharing with me a copy of this report.

103. According to the Prado report, the proportion of this blue pigment was not enough to determine precisely its origin; however, the microscopic analysis suggests "que pudiera ser índigo." Gayo and Jover, Museo del Prado, 4.

104. Gayo and Jover, Museo del Prado, 10.

105. Gayo and Jover, Museo del Prado, 5.

106. Rowe, "Evidence for Pre-Inca Textiles," 63, 65; Ana Roquero, "Identification of Red Dyes in Textiles from the Andean Region," Textile Society of America Proceedings (2008), paper 129, http://digitalcommons.unl.edu/tsaconf/129.

107. Rowe, "Introduction," in Rowe, *Costume and History*, 9; Gutiérrez Usillos, *Dioses, símbolos y alimentación*, 280–281.

108. Siracusano, *El poder de los colores*, 122n251. For orpiment in Quito, see also Antoine-François de Fourcroy, *Elements of Natural History and Chemistry* (London: C. Elliot and T. Kay, 1790), 2:187.

Chapter 3: *The Objects of Painting*

1. For regional painted ceramics, see especially Tamara Lynn Bray, *Los efectos del imperialismo incaico en la frontera norte* (Quito: Abya Yala and MARKA, 2003), 75–93; Albert Meyers, *Los Incas en el Ecuador: análisis de los restos materiales* (Quito: Abya Yala, 1998); Daniel Klein et al., *Ecuador: The Secret Art of Pre-Columbian Ecuador* (Milan: 5 Continents Editions, 2007). For regional painted and incised rock art, see especially Tamara L. Bray, "Rock Art, Historical Memory, and Ethnic Boundaries: A Study from the Northern Andean Highlands," *Andean Archaeology* 2 (2002): 333–354; Diego González Ojeda, "Rock Art Investigations in South Ecuador," in *Rock Art Studies—News of the World III*, ed. Paul Bahn, Natalie R. Franklin, and Matthias Strecker (Oxford: Oxbow Books, 2008), 274–279. For colored and painted textiles, see especially Chantal Caillavet, *Etnias del norte: etnohistoria e historia de Ecuador* (Quito: Abya Yala, 2000), 243–245; Chantal Caillavet, "'Como caçica y señora desta tierra mando . . .' Insignias, funciones y poderes de las soberanas del norte andino (siglos XV–XVI)," *Bulletin de l'Institut Français d'Etudes Andines* 37, no. 1 (2008): 67–68; Rowe, "Evidence for Pre-Inca Textiles," 49–69; Karen Olsen Bruhns, "Vestimentas en el Ecuador precolombino," *Arqueología del Área Intermedia* 4 (2002): 35–36; Joan S. Gardner, "Pre-Columbian Textiles, Los Ríos Province, Ecuador," *National Geographic Society Research Reports* 18 (1977): 334–340; Joan S. Gardner, "Textiles precolombinos del Ecuador," *Miscelánea Antropológica Ecuatoriana* 2 (1982): 9–23. For tattoos and body painting, see especially Olaf Holm, "El tatuaje entre los aborígenes prepizarrianos de la costa ecuatoriana," in *Lanzas silbadoras y otras contribuciones de Olaf Holm al estudio del pasado del Ecuador*, ed. Karen Stothert (Guayaquil: Banco Central del Ecuador, 2001) 1:272–296; and Bruhns, "Vestimentas en el Ecuador," 20–21.

2. For the dating of the tombs at La Florida, see María del Carmen Molestina Zaldumbide, "El pensamiento simbólico de los habitantes de la Florida (Quito-Ecuador)," *Boletin de l'Institut Français d'Etudes Andines* 35, no. 3 (2006): 380. For

the initial La Florida excavations, see Leon G. Doyon, "Tumbas de la nobleza en La Florida," in *Quito antes de Benalcázar*, ed. Ivan Cruz Cevallos (Quito: Centro Cultural Artes, 1989), 51–66.

3. Molestina Zaldumbide, "El pensamiento simbólico," 388.

4. Suzette J. Doyon-Bernard, "La Florida's Mortuary Textiles: The Oldest Extant Textiles from Ecuador," *Textile Museum Journal* 32–33 (1994): 89, 94–95. For additional examples of Quito-area textiles adorned with metal plaques, see Gardner, "Textiles precolombinos del Ecuador," 10, 14–16.

5. Rowe, "Costume in Ecuador," in Rowe, ed., *Costume and History*, 56–57, 63, 65.

6. "traen en las cabezas [las mujeres] unos paños pequeños y pintados de algodón que llaman xoxonas." Salomon, *Native Lords*, 85, 226n20.

7. Caillavet, "'Como caçica y señora,'" 67–68.

8. Lynn A. Meisch, "Colonial Costume," in Rowe, *Costume and History*, 108.

9. For *sellos* in pre-Columbian Ecuador, see Tom Cummins, Julio Burgos Cabrera, and Carlos Mora Hoyos, *Arte prehispánico del Ecuador: huellas del pasado, los sellos de Jama-Coaque* (Guayaquil: Museos del Banco Central del Ecuador, 1996); Emilio Estrada, *Arte aborígen del Ecuador: sellos o pintaderas* (Quito: Edición Universitaria, 1959); Constanza di Capua, "Consideraciones sobre una exposición de sellos arqueológicos," *Antropología Ecuatoriana* 2–3 (1984): 79–103; Isabel Clerc de Cuenca, "Sigilografía colombina: estudio de sellos de las zonas arqueológicas Quimbaya-Calima y del litoral pacific Colombo-Ecuatoriano," *Universitas Humanística* 33, no. 33 (1991): 38–45.

10. Cummins, Burgos Cabrera and Mora Hoyos, *Arte prehispánico*, 48.

11. See for example Betty Meggers, *Ecuador* (New York and Washington: Frederick A. Praeger, 1966), 58, 67–68, 95–96, 155; Bray, *Los efectos del imperialismo*, 88.

12. Elena Phipps, "Inca Garments and Seventeenth-Century Colonial Documents," *Dyes in History and Archaeology* 19 (2003): 52–54.

13. Ricardo Estabridis Cárdenas et al., "Materials and Techniques in Viceregal Painting and Sculpture in Lima—16th and 17th Centuries," *Art Technological Source Research* (Lisbon: ICOM-CC, 2011), 5.

14. "adoran y reverencian los metales que llaman, Corpa, adoranlas besandolas y haziendoles diferentes ceremonias. Item las pepitas de Oro, o Oro en polvo, y la plata, o las huayras donde se funde la plata. Item el metal llamado Soroche. Yel Azogue: y el Bermellón del Azogue que ellos llaman, Yehma, o Limpi es muy preciado por diversas superstitiones." Quoted in Siracusano, "'Copacabana,'" n.p.

15. "Paria es polvos de color Colorado, como el bermellón, que traen de las minas de Huancavelica, que es el metal de que se saca el azogue, aunque mas parece a zarcon.

Binzos son polvos de color azul muy finos. Llacsa es verde en polvos ó en piedra como cardenillo.

Carvamuqui es polvo de color amarillo.

(. . .) De todas las cosas sobredichas, los polvos de colores diferentes que dijimos ofrecen soplando como las pestañas, rayendo y señalando las conopas, y las demás huacas con los polvos antes de soplallos, y lo mismo hacen también con la plata, la cual ceremonia en la Provincia de los Yauyos llaman Huatcuna." Siracusano, "'Copacabana,'" n.p. Siracusano identifies *paria* and *llimpi* as vermilion, *zarcon* as minium, *binzos* as azurite; *llacsa* as verdigris or malachite; and *cavamuqui* as arsenic sulfate.

16. "el color funcionó como una categoría vital para la construcción de un mundo

en el que el poder de lo sagrado no estaba más allá del objeto representado sino *en* el objeto mismo." Siracusano, "'Copacabana,'" n.p.

17. Olaf Holm, "El pasado vive aún . . . ," in *Lanzas silbadoras y otras contribuciones de Olaf Holm al estudio del pasado del Ecuador*, ed. Karen Stothert (Guayaquil: Banco Central del Ecuador, 2001), 1:63.

18. The colonial chronicler José de Acosta described Inca production of *bermellón*: "los ingas, reyes del Pirú, y los indios naturales de él, labraron gran tiempo las minas de azogue, sin saber del azogue ni conocelle, ni pretender otra cosa sino este minio o bermellón que ellos llaman Llimpi, el cual preciaban mucho [. . .] que es para pintarse o teñirse con él los rostros y el cuerpo suyo y de sus ídolos." Quoted in Siracusano, *El poder de los colores*, 104. See also Sánchez and Quiñones, "Materiales pictóricos," 57.

19. Numerous chroniclers describe the pre-Hispanic use of malachite and azurite, blue and green copper pigments. See Ricardo Estabridis Cárdenas et al., "Materials and Techniques," 5.

20. Siracusano, *El poder de los colores*, 122n251.

21. Holm, "El tatuaje," 276; Siracusano, *El poder de los colores*, 126–129; Bruhns, "Vestimentas en el Ecuador," 20–21.

22. For cochineal in South America, see especially Siracusano, *El poder de los colores*, 83–98.

23. For these and other red lake pigments used in the pre-Columbian Andes, see Roquero, "Identification of Red Dyes."

24. For the uses of *sangre de drago* as a colorant and/or binding agent, see Siracusano, *El poder de los colores*, 73–74, 124–126. For *mopa mopa* or *barniz de Pasto*, see Rappaport and Cummins, *Beyond the Lettered City*, 106–111; Alvaro José Gómez Jurado Garzón, "El mopa-mopa o barniz de Pasto, comercialización indígena en el period colonial," *Estudios Latinoamericanos* 22–23 (2008): 82–93; and Ellen J. Pearlstein, Emily Kaplan, Ellen Howe, and Judith Levinson, "Technical Analyses of Painted Inka and Colonial Qeros," *Objects Specialty Group Postprints* 6 (1999): 94–111. For other resins, gums, and varnishes native to South America that were used by painters, see Siracusano, *El poder de los colores*, 68–76.

25. Federico González Suárez, *Historia general de la República del Ecuador* (Quito: Imprenta del Clero, 1892), 3:117. Imported playing cards were printed in black ink, and painters apparently supplemented their income by illuminating them with a variety of colors. Items registered on a 1581 list of merchandise sold in a local shop included "cinco docenas de naypes rretobados [. . .] una docena de naypes por rretobar." AHBCE, JJC .00194, 1580–1586, Gaspar de Aguilar, fol. 622r. The Biblioteca Nacional de España (hereafter BNE) conserves examples of painted and unpainted playing cards printed in Toledo in 1584. See BNE, Colecciones Especiales, Materiales Gráficos, R/41420; R/41421. For *naipes* in early colonial Peru, see Estabridis Cárdenas, *El grabado en Lima*, 80–90.

26. "ocho libros de canto en pergamino [. . .] de tintas e colores." AHBCE, JJC .00195, 1552–1572, Jácome Freile, fols. 14r–16r. Among the detailed requirements of production, the illuminations are described in the following manner: "que los principios de las historias del principio de los cuerpos de los libros sean quadrados de dos rrenglones e dos pautas de lebreas y de dos colores con el color q[ue] pidiere la tal yluminacion y las margenes de la tal letra se hiziere lleuen sus lazos e yluminaciones y vaya la tal letra pulidamente yluminada" (fol. 14v). See appendix, part a.

27. In an additional example, in 1579, the Cathedral Chapter purchased for eighty

pesos an illuminated choir book "de kiries, glorias y credos y santos y oficios de difuntos en pergamino apuntado y encuadernado" that was made by Francisco Muñoz "escriptor de libros." *Colección de documentos sobre el Obispado de Quito, 1546–1583*, transcr. Jorge A. Garcés (Quito: Talleres Tipográficos Municipales, 1946), 441.

28. Moreno, *Fray Jodoco Rique*, 271, 283.

29. "seis guadameçies biejos de figuras." ANH/Q, Notaría 1a, vol. 138, 1631–1632, Diego Bautista, fols. 337r–339v.

30. "veinte y quatro caxas grandes de botica pintadas de pintor al contento del d[ic]ho Diego de Tapia." AHBCE, JJC .00194, 1580–1586, Gaspar de Aguilar, fols. 1801r–1801v.

31. ANH/Q, Notaría 6a, vol. 19, 1612, Diego Rodríguez Docampo, fol. 213v.

32. "dorar en perfecçion el assiento del coro del d[ic]ho conuento de san Francisco hasta la rrexa de arriua con los santos que estan en ella poniendo los colores = carmin bol, açul, y vermellon." ANH/Q, Notaría 1a, vol. 119, 1627, Diego Rodríguez Docampo, fols. 685r–686v.

33. ANH/Q, Notaría 1a, vol. 154, 1636, Diego Bautista, fols. 369r–369v. See chapter 7.

34. I have borrowed the useful term "mediascapes" from Matt Cohen and Jeffrey Glover, eds., *Colonial Mediascapes: Sensory Worlds of the Early Americas* (Lincoln: University of Nebraska Press, 2014).

35. "pedro rrodriguez se obliga de hazer y pintar a el dho alonso de capilla un rretablo que el dho alonso de capilla quiere hazer y otras quales quier pinturas que uviere menester para sus rrepresentaciones y no para otra cosa y acabado el dho rretablo todas las vezes que fuere necesario se obligo de ayudallo a armar y desarmar y si el dho alonso de capilla tuuiere necesidad de ayuda de pedro rro[drigu]ez para sus rrepresentaciones [en margen "del dho rretablo"] se obligo de ayudalle y se obligo de ayudar a mudar en los caballos del dho alonso de capilla la rropa que el lleba [. . .] hasta llegar a la ciudad de los rreyes." Archivo Histórico de Boyacá, Tunja (hereafter AHB/T), Protocolos, 1584, vol. 41, fols. 189v–190r, 256v–258r.

36. "dijo el d[ic]ho alonso de capilla que por quanto el ha tenido muchos tratos y contratos con el d[ic]ho pedro rr[odrígue]s pintor asi de el salario que hera obligado a le pagar porque le ayudase en las rrepresentaciones y a le pintar cosas necessarias a ella y decoro que el a prestado y fençidas sus quentas de los dichos dares y tomares entre el y el d[ic]ho pedro rrodrigues pintor le rresta y queda debiendo ciento y sesenta y seis pesos y cinco tomines y mill granos de oro fundido [. . .] que le a de dar e pagar en la forma e manera que yra declarado [. . .] el dho pedro rr[odrígue]s pintor se obliga [que . . .] durante un ano hasta ser cumplido a de ayudarle al d[ic]ho alonso de capilla en las rrepresentaciones que hiziere asi de [?] como de rretablos pintandolos e haziendo en ellos lo que fuere necessario asi en la ciudad de tunja como en todas las partes e lugares donde el dho alonso de capilla fuere y el tubiere el dho tiempo de un ano dandole el dho alonso de capilla las cosas necessarias para la d[ic]ha pintura de los d[ic]hos rretablos e comedias porque el d[ic]ho pedro rr[odrígue]s no a de poner otra cosa mas de tan solamente sus manos e trabajo e en todo entred[ic]ho tiempo el d[ic]ho pedro rr[odrígue]s no a de hazer ottra ni a de ocupar el d[ic]ho alonso de capilla en ottra cosa mas de en tan solamente de las d[ic]has pinturas e rretablos e quedando a cargas e descargas y en las d[ic]has comedias como esta d[ic]ho dandole lo necessario para el d[ic]ho hefeto y ansimismo se obliga de llebar a su cargo el d[ic]ho rretablo e rretablos en los caballos que del d[ic]ho alonso de capilla diere por el d[ic]ho hefeto dandole un yndio que le ayude a cargar e descargar en

todas las partes e lugares donde fuere el d[ic]ho alonso de capilla fuere [sic] durante el tiempo de un ano." AHB/T, Protocolos, 1584, vol. 41, fols. 256v–258r.

37. "natural Africano de las fronteras de mazagan." AGI, Contratación, 5578, N .21, "Bienes de difuntos: Pedro Rodríguez."

38. Capilla is documented here for the first time in the New Kingdom of Granada. For Capilla and his signature on documents in Spain, see Luis Astrana Marín, *Vida ejemplar y heroica de Miguel de Cervantes Saavedra con mil documentos hasta ahora inéditos y numerosas ilustraciones y grabados de la época* (Madrid: Instituto Editorial Reus, 1948), 3:310, 313, 317. In 1579, 1580, and 1581, Alonso de Capilla represented *comedias* in Seville, including one entitled "La libertad de Roma por Mucio Scévola" (317). For Capilla in Spain, see Carmen Sanz Ayán and Bernardo J. García García, "El 'oficio de representar' en España y la influencia de la *comedia dell'arte* (1567–1587)," *Cuadernos de Historia Moderna* 16 (1995): 496; Carmen Sanz Ayán, "Las compañías de representantes en los albores del teatro áureo: la agrupación de Alonso Rodríguez (1577)," in *Mira de Amescua en candelero*, ed. Agustín de la Granja (Granada: Universidad de Granada, 1996), 2:460–465; Piedad Bolaños Donoso, "Nuevas aportaciones documentales sobre el histrionismo sevillano del siglo XVI," in *La comedia*, ed. Jean Cavanaggio (Madrid: Casa de Velázquez, 1995), 132–133.

39. ANH/Q, Notaría 1a, vol. 18, 1601, Francisco García Durán, fols. 83r–85r, 98v–99r.

40. ANH/Q, Notaría 1a, vol. 87, 1616–1619, Diego Suárez de Figueroa, fols. 866r–867r. The contract between Morales and Jiménez notes that, "por q[uan]to los suso-dichos han tratado de hazer comedias en esta dicha çiudad y otras p[ar]tes que les paresciere y p[ar]a Ello tienen tratado con algunas pers[on]as," it was agreed that they would form a company for two years and provide the "vestidos y demas apara-tos a las personajes en las comedias."

41. ANH/Q, Notaria 1a, vol. 87, 1616–1619, Diego Suárez de Figueroa, fols. 867v–868r. Jiménez commissioned Ladrón de Guevara to work for the company for one year, for which he was to be paid the impressive sum of two hundred pesos per month, in addition to his meals, and "doçe pares de çapatos." Ladrón de Guevara's role was to "seruir asi de personajes en las comedias que hiziere como en jugar de manos y hazer bueltos en todas las p[ar]tes y ocasiones que El d[ic]ho fran[cis]co ximenez le mandare" (fol. 867v). The other seven actors, hired under a different con-tract, were Antonio Negrete, Francisco Adame, Juan Izquierdo, Andrés de la Cuesta, Francisco de Cazañas, Luis de Castro, and Carlos Reynaldos. ANH/Q, Notaría 1a, vol. 87, 1617–1619, Diego Suárez de Figueroa, fols. 866r–867r.

42. "todos los domingos y fiestas del año." ANH/Q, Notaría 1a, vol. 86, 1616–1619, Alonso Dorado de Vergara, fols. 657v–658r.

43. For the Cazañas family of silversmiths and gilders, see ANH/Q, Notaría 1a, vol. 43, 1606, Alonso López Merino, fols. 4v–7v. The notarial record in Quito contains abundant documents related to the Cazañas family dating from the late sixteenth throughout the seventeenth century. For the Adame family of silversmiths and gild-ers, see ANH/Q, Notaría 1a, vol. 211, 1663–1665, Tomás Suárez de Figueroa, fols. 38v–41v.

44. For festivals, royal exequies (funerals), and celebrations in colonial Quito, see Carlos Espinosa Fernández de Córdova, "La mascarada del Inca: una investigación acerca del teatro politico de la Colonia," *Miscelánea Histórica Ecuatoriana* 2 (1960): 6–39; Alexandra Kennedy Troya, "La fiesta barroca en Quito," *Anales del Museo de América* 4 (1996): 137–152.

45. Navarro, *Contribuciones*, 2:53. Navarro cites the Archivo Mercedario, Libro de Sacristía, fol. 52v: "Dieronsele a bartolome marin pintor doce patacones por la trasa y pintura del túmulo." Perhaps Bartolomé Marín was related to the documented painter Salvador Marín, active between 1633 and 1671. See chapter 7.

46. "todos los pilares y sus arcos y el suelo desde el túmulo al Coro cubierto de mantas negras por todas las tres naves, y en cada pilar una bandera negra de tafetán desplegada en su asta, y adornados los pilares con cuadros hechos a propósito de todas las ciudades de este Distrito, que acompañaban otros tantos cuadros de las armas Reales que todo se obró (o lo más) en las casas de Cabildo donde el Corregidor vivía ocupando en estos los pintores españoles e indios que había en la Ciudad." Garcés, *Colección de documentos*, 67. Philip II died in 1598, yet notice was not received in Quito until the following year.

47. "como fondo de cada carro se mandó pintar en grandes lienzos: para el primero, el cielo estrellado y la figura del Padre Eterno rodeado de arcángeles conocidos; para el segundo, la escena de la Creación, del Paraíso Terrenal y los santos patriarcas; para el tercero, que fue en forma de barco, la batalla de Josué y la caída de Jericó que se puso a los flancos, en la popa la entrega de las tablas de la Ley en el Sinaí y, en la proa, la serpiente suspensa de la Cruz; para el cuarto hubo necesidad del fondo sobre el que se destacaban las figuras representativas de Cristo, los Mártires y Confesores." Quoted in Navarro, *La pintura en el Ecuador*, 53–54. For the canonization festivities of San Raimundo in Quito, see Lizardo Martín Herrera Montero, "Entre el Santo y el Rey: los festejos realizados en Quito en el año de 1603 por la canonización de San Raimundo de Peñafort," MA thesis, Universidad Andina Simón Bolívar, Sede Ecuador, 2003; Lizardo Martín Herrera Montero, "La canonización de Raimundo de Peñafort en Quito. Un ritual barroco entre la exhibición y el ocultado," *Procesos: Revista Ecuatoriana de Historia* 32 (2010): 5–30. Rodríguez Docampo's 1604 account is found in AGI, Quito, 17, N.35, 1604, "Fiesta de San Raimundo."

48. "al derredor del carro estaba adornado con pinturas de la creacion del mundo y plantado el paraiso con el arbol de la vida yvan pendientes muchas manzanas dorados yva adan recostado en el y al pie del arbol de la ciencia del bien y el mal hyva eva hablando con la serpiente que estaba revuelta en el." Herrera Montero, "Entre el Santo y el Rey," 91.

49. "la imagen del paraíso pintado en una tabla." Herrera Montero, "Entre el Santo y el Rey," 91.

50. "unos paños pintados con sus representaciones de las historias principales que se vivieron en los tiempos de esta ley." Herrera Montero, "Entre el Santo y el Rey," 91.

51. Herrera Montero, "Entre el Santo y el Rey," 81.

52. "hizo asimismo el general juntar todos los maestros pintores y a los mas perfectos hordeno que en quadros grandes sacasen en figuras del tamaño de un honbre la decendencia de la casa de austria desde pipino primero duque de brabantia hasta el Rey Don felipe segundo nuestro señor de felice memoria que son veinte y siete los quales se esmeraron tanto en la pintura de ellos sacandolos de estampas de un libro que compuso Juan baptista Vrientino de Artuerpia deregida a los serenisimos principes alberto e ysabel duques de brabantia en que gasto mucho tiempo por sacar los traslados semejantes a suhs originales con los bestidos y rropajes que cada uno en su tiempo usaron tan al bivo y tan perfectos y acabados que son los mejores quadros que ay en todo este Reyno." Vargas, *El arte ecuatoriano*, 236–237. Vargas transcribes

the full account of the "Relación de las exequias de la reina Margarita de Austria" on pp. 235–259. His source is a letter sent in 1613 by authorities in Quito to the Spanish court.

53. "se seguían hasta la reja [del coro] todas las figuras de la descendencia de la casa de Austria y en el friso de encima donde estaban colgados se pusieron muchas candelas sobre sus candeleros de blanco y negro que con la reberberacion de las luces parecian que estaban bivos [. . .] se pusieron muchos quadros de las armas reales [. . .] se pusieron en medio las armas de la ciudad de quito en un quadro grande y por los lados asimismo en sus quadros las demas de todas las ciudades y billas desta provincia." Vargas, *El arte ecuatoriano*, 244.

54. The copper plates used to produce the engravings in this volume were not the work of Joan Baptista Vrients; he had purchased twenty-five of them from the Antwerp dealer Peeter Baltens, and later employed the Italian engraver Antonius de Succa to expand their number to thirty-six. A French edition was published in 1603, and a Dutch edition in 1606. See Dirk Imhof, *Jan Moretus and the Continuation of the Plantin Press* (Leiden: Koninklijke Brill, 2014), 44.

55. "exercitos del ynga rrey que fue de esta tierra En su gentilidad [. . .] rreyna de cochasqui." Archivo Privado de Iván Cruz, Quito (hereafter APIC/Q), Títulos y ordenanzas, "Relaçion de las çelebres y famosas fiestas Alegrias y demostraçiones que Hiço la muy noble y muy leal çiudad de san fran[cis]co del quito en el piru, al dichosisimo y feliz naçimiento del prínçipe despaña don baltasar Carlos [. . .] del año de 1631," fols. 88r–92v.

56. See for example the transcription of Fernando de Montesinos's version of this historical event in Hyland, *Quito Manuscript*, 151–153.

57. "quisingas, gibaros, cofanes, litas, quixos, yngas, niguas, y mangaches [. . .] mas numero de quatro mil naturales armados a su usança de hondas, chesos, dardos, arco y flechas, porras, hachuelas, chuquis, macanas, caueças de leones, tigres y osos [. . .] "tambores, flautas y pitos y portando banderas E ynsignias cantidad de astas largas con plumeria." APIC/Q, Títulos y ordenanzas, "Relaçion de las çelebres y famosas fiestas . . . del año de 1631," fol. 91v.

58. "sus damas con sus oregeras llautos patenas de plata y bisçaletes y vn carro En que benia vn monte espeso artifiçiosamente compuesto con mucha caça de todos animales y ambos Exerçitos con sus bagajes de coca chicha y algodon AGI y otras comidas de su modo [. . .] y en otro carro yba El castigo de los caciques pena y Jumande que fueron los que se alçaron En la prouinçia de los quijos." APIC/Q, Títulos y ordenanzas, "Relaçion de las çelebres y famosas fiestas . . . del año de 1631," fol. 91v. Peña and Jumande were caciques in the territory of the Quijos who, in the late sixteenth century, armed a successful rebellion against the Spaniards that frustrated their colonizing campaign.

59. "estendieronse por toda la plaça tan galanamente que no vbo En todas estas fiestas cosa al pareçer de mayor agrado porque demas de de uer El extraordinario modo de los naturales fueron tantas las camisetas de tela y la mas de oro finos Terçio pelos con pasamaneria de oro damascos y muchas bordadas y otras de sus tegidos, y la diuersidad de colores que todas tenian y la plumeria de sus sombreros que podian afrentar la mas fertil flores o primabera y ninguna En sus campos llegara adjuntar lo que aqui se bio En tan pequeno espaçio." APIC/Q, Títulos y ordenanzas, "Relaçion de las çelebres y famosas fiestas. . . del año de 1631," fol. 91v.

60. "hiçieron ambos Exerçitos sus peleas y acometimientos diestramente con

notable algaçara y griteria al son de sus ynstrumentos y de los delicosos de espana hasta llegar a bençer y degollar la rreyna de cochasqui y El modo de cantar su vitoria fue de mayor graçia y mas de uer duro esto por espaçio de tres oras y si mucho mas durara pareçiera vn pequeno rrato por lo mucho y bien que diuertio y entretubo con que boluieron a salir marchando de la plaça por el mismo orden y conçierto con que entraron y se prosiguio la fiesta hasta la noche." APIC/Q, Títulos y ordenanzas, "Relaçion de las çelebres y famosas fiestas. . . del año de 1631," fols. 91v–92r.

61. Scholars have interpreted this "historical reenactment" of the triumph of Inca forces over the autochthonous Queen of Cochasquí and her regional troops from a Western perspective, as a display intended to reduce the ethnic diversity of all Andeans to "savages" subject to Spanish dominion. See Espinosa Fernández de Córdova, "La mascarada del Inca," 22; Kennedy Troya, "La fiesta barroca," 145–146. Nonetheless, Kennedy Troya astutely notes that the Inca in this representation did not render up his power to the Spanish monarch, but stood triumphant before the local audience.

Chapter 4: Painters and the Profession

1. For colonial painters' guilds and the protection of trade secrets, see especially Rogelio Ruíz Gomar, "El gremio y la cofradía de pintores en la Nueva España," in *Juan Correa: su vida y su obra, cuerpo de documentos*, Elisa Vargas Lugo et al., eds. (Mexico City: UNAM, 1991), 3:205–215.

2. Among the fifty notarial documents to which Ribera was party, in only three instances was the additional title of gilder or sculptor appended to his name. In a 1595 purchase of merchandise at a local shop, he is named as a gilder. AHBCE, JJC .00202, 1595, fol. 32v. In two 1599 documents related to his purchase of a public shop, he bears the title of painter and sculptor. ANH/Q, Notaría 1a, vol. 10, 1598, Francisco García Durán, fols. 782r–783v, 783v–784v.

3. Juan del Castillo, "yndio oficial pintor y entallador," was commissioned by the Confraternity of the Vera Cruz to create a group of processional sculptures. ANH/Q, Notaría 6a, vol. 15, 1605–1606, Diego Rodríguez Docampo, fols. 38v–39r. In other documents, he bears only the title of "yndio pintor," none of which are artistic commissions. ANH/Q, Notaría 1a, vol. 29, 1603, Diego Lucio de Mendaño, fols. 150r–151v; ANH/Q, Notaría 1a, vol. 58, 1608–1609, Diego Lucio de Mendaño, fols. 241v–242v.

4. Among the seventeen notarial contracts involving Juan Fonte, he is identified as a painter in twelve; as a painter and gilder in three; as a gilder in one; and as a sculptor and gilder in one. The fifteen contracts involving the Andean artist Antonio Gualoto variously identify him either singly or in combination as painter, gilder, and woodcarver. Contracts involving the Andean artist Cristóbal Faizán follow a similar pattern, interchangeably or in combination naming him as painter, gilder, and/or sculptor.

5. For Diego Gualoto, see ANH/Q, Notaría 1a, vol. 162, 1639, Pedro Pacheco, fols. 182r–183v. Francisco Pérez Sanguino is titled a gilder in six documents; however, a 1633 contract names him as a painter. ANH/Q, Notaría 1a, vol. 147, 1633, Gerónimo de Heredia, fols. 675r–675v.

6. ANH/Q, Notaría 1a, vol. 3, 1588–1594, Diego Lucio de Mendaño, fols. 317v–318v. This contract is considered in greater detail in chapter 6. See also the appendix, part c.

7. ANH/Q, Notaría 1a, vol. 60, 1609, Alonso López Merino, fols. 364v–365r.

8. Webster, *Quito, ciudad de maestros*, 24–27.

9. For examples of artistic subcontracts in Lima, see Emilio Harth-Terré and Alberto Márquez Abanto, "Pinturas y pintores en Lima virreinal," *Revista del Archivo Nacional del Perú* 27 (1963): 104–218.

10. The typical trajectory from apprenticeship through journeyman to master, as well as regional adaptations and variations on the Spanish peninsular model in the colonial northern Andes, is outlined in Jesús Paniagua Pérez, "La enseñanza professional en el mundo colonial: la enseñanza y desarrollo de los oficios," *Historia de la Educación Colombiana* 8, no. 8 (2005): 77–115.

11. Manuel Carrera Stampa, *Los gremios mexicanos: la organización gremial en Nueva España, 1521–1861* (Mexico City: EDIAPSA, 1954), 223–243; Ricardo Temoche Benítes, *Cofradías, gremios, mutuales y sindicatos en el Perú* (Lima: Editorial Escuela Nueva, 1987), 66–67.

12. Manuel Toussaint, *Pintura colonial en México* (Mexico City: Universidad Autónoma de México, 1990), 220–223; Ruíz Gomar, "El gremio," in Vargas Lugo et al., *Juan Correa*, 3:206.

13. Antonio San Cristóbal, "Gremios de plateros y doradores limeños del siglo XVII," *Revista Sequilao* 3 (1993): 21–31; Harth-Terré and Márquez Abanto, "Pinturas y pintores," 137–147; Mesa and Gisbert, *Historia de la pintura cuzqueña*, 1:137–138, 309–311. For the formation of Lima's official painters' guild as the result of a lawsuit, see Gabriela Siracusano, "Para copiar las 'buenas pinturas', problemas gremiales en un estudio de caso de mediados del siglo XVII en Lima," in *Memoria del III Encuentro Internacional sobre Barroco: manierismo y transición al barroco*, 131–139 (Pamplona: Fundación Visión Cultural/Servicio de Publicaciones de la Universidad de Navarra, 2011).

14. Mesa and Gisbert, *Historia de la pintura cuzqueña* 1:137–138, 309–311; Francisco Javier Pizarro Gómez, "Identidad y mestizaje en el arte barroco andino: la iconografía," in *Barroco, Actas do II Congresso Internacional* (Porto: Departamento de Ciências e Técnicas do Patrimonio, 2001), 199.

15. Efraín Castro Morales, "Ordenanzas de los pintores y doradores de la ciudad de Puebla," *Boletín de Monumentos Históricos* 9 (1989): 4–9.

16. Julio Alemparte, "La regulación económica en Chile durante la colonia (II)," *Anales de la Facultad de Ciencias Jurídicas y Sociales* 2, nos. 6–7 (1936): 77.

17. For Bogotá, see Laura Liliana Vargas Murcia, *Del pincel al papel: fuentes para el estudio de la pintura en el Nuevo Reino de Granada (1552–1813)* (Bogotá: ICANH, 2012), 41.

18. Jorge F. Rivas, "Breves comentarios sobre le oficio del pintor en Venezuela, 1600–1822," in *De oficio pintor: arte colonial venezolano* (Santiago de los Caballeros de Mérida: Centro León, Fundación Cisneros, 2007), 23.

19. Gloria Garzón, "Situación de los talleres; gremios y artesanos: Quito, siglo XVIII," in *Artes "académicas" y populares del Ecuador*, ed. Alexandra Kennedy Troya (Quito: Abya Yala, Fundación Paul Rivet, 1995), 19; Susan Verdi Webster, "Masters of the Trade: Native Artisans, Guilds, and the Construction of Colonial Quito." *Journal of the Society of Architectural Historians* 68, no. 1 (March 2009): 13–16; and Webster, *Quito, ciudad de maestros*, 9–16. In its annual meeting on January 1 or 2, Quito's city council officially named the *maestro mayores y veedores* of each recognized guild.

20. Archivo Metropolitano de Historia (hereafter AMH/Q), Actas del Cabildo de Quito, 1573–1574, fol. 156r. The city council established *aranceles* for a number of trade commodities decades before the official recognition of guilds by the election of

maestros mayores. See Isabel Robalino, *El sindicalismo en el Ecuador*, 2a ed. (Quito: Ediciones de la Pontificia Universidad Católica del Ecuador, 1992), 37–38.

21. *Libro de Cabildos de la ciudad de Quito, 1638–1646*, transcr. Jorge A. Garcés (Quito: Imprenta Municipal, 1960), 30:29. The volumes of the *Actas del Cabildo* between 1617 and 1638 are lost.

22. AMH/Q, Actas del Cabildo de Quito, 1691–1697, fol. 75v, 121r; Webster, "Masters of the Trade," 14–15.

23. For example, in the 1620s, the Spanish or Creole painter Juan Fonte appears in the documents as *pintor* and *oficial pintor*, and by the 1630s he bears the title *maestro pintor y dorador*. ANH/Q, Notaría 1a, vol. 109, 1624–1629, Diego Lucio de Mendaño, fols. 101v–102v; and ANH/Q, Notaría 5a, vol. 17, 1633, Gerónimo de Castro, fols. 445r–445v. In the 1630s, the Spanish or Creole painter Salvador Marín appears with the title of *oficial pintor*, and by the 1640s he is consistently named as *maestro pintor*. ANH/Q, Notaría 1a, vol. 147, 1633, Gerónimo de Heredia, fols. 578r–578v; and ANH/Q, Notaría 1a, vol. 191, 1649, Pedro Pacheco, fols. 70r–70v.

24. ANH/Q, Notaría 1a, vol. 92, Diego Suárez de Figueroa, 1620–1624, fol. 50r. This contract is discussed below. The other seventeenth-century painting apprenticeship contract was rendered invalid, and the document was left incomplete in the notarial volume. See Susan Verdi Webster, "La presencia indígena en el arte colonial quiteño," in *Esplendor del Barroco Quiteño/Himmel aus Gold: Indianischer Barock aus Ekuador*, ed. Ximena Carcelén (Quito: FONSAL, 2010), 41.

25. Apprenticeship contracts for a variety of trades are abundant in the notarial record from an early date. For example, in 1586, an Andean woman from the town of Chimbo placed her son as an apprentice to the Quito silversmith Francisco Gutiérrez for an eight-year period, "para que le enseñe el officio de platero." AHBCE, JJC .00196, 1586–1587, Francisco de Corcuera, fols. 620v–621r. For a wealth of apprenticeship contracts in other artisan professions, see Webster, "Masters of the Trade," 14.

26. "para que le enseñe El ofi[ci]o de pintor." ANH/Q, Notaría 1a, vol. 92, 1620–1624, Diego Suárez de Figueroa, fol. 50r; Webster, "La presencia indígena," 41. The only other extant seventeenth-century apprenticeship contract for painting was drawn up in 1673 between the Spanish or Creole master painter Juan de Salinas Vizuete and Pedro Jiménez de la Vega, for a period of six years to teach the latter the art of painting as well as "good customs." This document is incomplete and bears the rubric "no pasó." ANH/Q, Notaría 1a, vol. 231, 1670–1673, Tomás Suárez de Figueroa, fol. 357v.

27. Official trade examination records (*cartas de exámen*) for many professions abound in the notarial record. See for example ANH/Q, Notaría 1a, vol. 18, 1601, Francisco García Durán, fols. 227v–228v (*sastre*), 229r–229v (*zapatero*), 407r–407v (*sombrerero*); ANH/Q, Notaría 1a, vol. 23, 1602–1604, Francisco García Durán, fols. 570r–570v (*curtidor*); ANH/Q, Notaría 1a, vol. 30, 1604, Francisco de Zarza Monteverde, fols. 243r–243v (*sillero guarnicionero*); ANH/Q, Notaría 1a, vol. 49, 1606–1608, Francisco García Durán, fols. 428r–428v (*tintorero*), 429r–429v (*tintorero*); ANH/Q, Notaría 1a, vol. 67, 1610–1614, Juan García Rubio, fols. 302r–303r (*herrador*); ANH/Q, Notaría 1a, vol. 175, 1643–1650, Diego Rodríguez Urbano, fols. 99r–99v (*batihoja*).

28. Robalino, *El sindicalismo*, 37–39.

29. The 1568 *ordenanzas* are transcribed in ANH/Q, Gobierno, caja 4, 1658–1666, expte. 8-IV-1660, fols. 22r–23v.

30. ANH/Q, Notaría 1a, vol. 10, 1598, Francisco García Durán, fols. 782r–783v. Ri-

bera's activities as a painter and owner of a public shop are considered in the following chapter.

31. The 1557 regulations of the painters' guild in Mexico City make no mention of the requirement for master painters to sign their works; however, the 1681 guild regulations make explicit reference to this obligation. Clara Bargellini links the requirement to commercial interests, to the "exclusive rights" of master painters to sell their works and those of the *veedores* (who were often one and the same) to defend those rights. Clara Bargellini, "Consideraciones acerca de las firmas de los pintores novohispanos," in *El proceso creativo: actas del XXVI Coloquio Internacional de Historia del Arte*, ed. Alberto Dallal (Mexico City: Universidad Autónoma de México, 2006), 204–205. For a transcription of the *ordenanzas* of the painters' guild in Puebla, which required that masters sign their works "con su nombre y apellido," see Castro Morales, "Ordenanzas de pintores y doradores," 7.

32. See Abelardo Carrillo y Gariel, *Autógrafos de pintores coloniales* (Mexico City: Universidad Autónoma de México, 1953).

33. See Webster, "Masters of the Trade," 13–16.

34. For Nuestra Señora de Alta Gracia, see Archivo Histórico de la Catedral de Quito (hereafter AHC/Q), "Libro de los muy Ill[ustr]es señores Dean y Cab[il]do Desta S[an]ta yglesia Cathedral," Libro 4, 1583–1594, "Sobre la capilla de los mulattos," fol. 237v. For the Santísimo Sacramento, see AHBCE, JJC, primera serie, 17/10, "Ynstituçiones de la Cofradía del Santísimo Sacramento (1543), fols. 172r–177v, transcribed in Susan V. Webster, *Arquitectura y empresa en el Quito colonial: José Jaime Ortiz, Alarife Mayor* (Quito: Abya Yala, 2002), 127–132. For Nuestra Señora de la Presentación, see Jorge Moreno Egas, "La cofradía de tejedores de Nuestra Señora de la Presentación," *Revista del Instituto de Historia Ecclesiástica Ecuatoriana* 13 (1993): 105–124.

35. The sixteenth-century confraternities located in the Jesuit church included those of Nuestra Señora de los Reyes (mestizos); El Salvador (*morenos y pardos*); and El Niño Jesús ("el resto de los indios"). Minchom, *People of Quito*, 84.

36. Moreno Egas, "La cofradía de tejedores," 105–124. This confraternity was located in the Cathedral.

37. ANH/Q, Notaría 1a, vol. 87, 1617–1619, Diego Suárez de Figueroa, fols. 934r–936v. This confraternity was founded in the church of the Mercedarian monastery during the late sixteenth century, and purchased a side chapel there in 1618.

38. Archivo Histórico de la Orden Dominicana en el Ecuador (hereafter AHODE), legajo 13, fols. 177r–ff. This volume contains the 1599 *acta de fundación* and rules of the confraternity, which established its altar dedicated to San Jacinto in the Dominican church. Founding members included Francisco García Durán, *escribano de cabildo y público*; Juan de Briñas Marrón, *escribano del número*; Diego Rodríguez Docampo, *escribano del número*; and Pedro de Robles, *escribano de provincia*.

39. Archivo de la Parroquia del Sagrario (hereafter APS/Q), "Libro de los Hermanos de la cofradía de San Pedro," 1633.

40. "El año de 1668 se acabó esta efigie del Señor S. Lucas Evangelista y la hizo el Padre Carlos y la renovó Bernardo de Legarda siendo su Síndico el año de 1762."

41. "la cofradia de san lucas fundada en el combento de san fran[cis]co de los naturales." ANH/Q, Notaría 5a, vol. 80, 1685–1687, Francisco Dionisio de Montenegro, fol. 214v.

42. AGOFE, Legajo 2.2, expte. 2.6, "Cofradía de plateros de San Eloy." The Ca-

thedral Chapter rejected the silversmiths' petition to found the confraternity in the Church of San Francisco, citing as reasons the superabundance of confraternities in the city, and the fact that confraternity members neglected to attend masses and feast days in their parish churches in favor of the churches of the regular clergy, where their chapels were located. AHC/Q, Libro 4, 1583–1594, "Libro de los muy Ill[ustr]es señores Dean y Cab[il]do Desta S[an]ta yglesia Cathedral," fols. 126v–127r.

43. Jesús Paniagua Pérez, "La cofradía quiteña de San Eloy," *Estudios Humanísticos. Geografía, Historia, Arte* 10 (1988): 200.

44. AGOFE, Legajo 2.2, expte. 2.6, "Cofradía de plateros de San Eloy," fol. 3r.

45. AGOFE, Legajo 2.2, expte. 2.6, "Cofradía de plateros de San Eloy", fol. 3v.

46. Joel L. Monroy, *El Convento de la Merced de Quito de 1617–1700* (Quito: Editorial Labor, 1932), 204–206. These sodalities were located in the Mercedarian church.

47. Susan V. Webster, "The Devil and the Dolorosa: History and Legend in Quito's Capilla de Cantuña," *The Americas* 67, no. 1 (July 2010): 18–21.

48. AGI, Quito 23, N .4, "Los diputados de la Vera Cruz piden merced," n.p.

49. José María Vargas, *Nuestra Señora del Rosario en el Ecuador* (Quito: Artes Gráficas Señal, 1983), 45–51.

50. Vargas, *El arte ecuatoriano*, 33. Vargas repeated this list in many of his publications, often with the addition, omission, or variation in spelling of names.

51. Both Vargas and Navarro posited the "art school" role of the confraternity. Vargas, *Nuestra Señora del Rosario*, 53; José Gabriel Navarro, *La pintura en el Ecuador del XVI al XIX* (Quito: Dinediciones, 1991), 33.

52. Diego Tutillo is named as an embroiderer in various notarial documents, including ANH/Q, Notaría 6a, vol. 19, 1612, Diego Rodríguez Docampo, fols. 343v–344v. José Gabriel Navarro identifies the trade practiced by Luis Paucar as that of saddlemaker (*sillero*). Navarro, *La pintura en el Ecuador*, 33.

53. Vargas, *Patrimonio artístico*, 68. See also chapter 5 of this volume.

54. ANH/Q, Notaría 1a, vol. 175, 1643–1650, Diego Rodríguez Urbano, fol. 329r.

55. ANH/Q, Notaría 1a, vol. 53, 1608, Alonso López Merino, fol. 248v.

56. On the nature and formation of parishes in Quito, see especially Minchom, *People of Quito*, 22–27; Lane, *Quito 1599*, 1–3.

57. For *ayllus* in Quito, see especially Salomon, *Native Lords*, 168–169.

58. On the *hanan* and *hurin* moiety divisions in Quito, see especially Salomon, *Native Lords*, 174–177; Minchom, *People of Quito*, 23–27.

59. The *hanan/hurin* division was still employed by the city council in the 1830s. See Burgos Guevara, *El guamán*, 276–277.

60. Burgos Guevara, *El guamán*, 266–269.

61. The European painters Juan de Illescas and Angelino Medoro moved on to Lima. The Spanish painter and gilder Juan Ponce rented his domicile in Quito, for neither his 1606 testament nor a codicil filed in the same year register his ownership of houses or land. ANH/Q, Notaría 1a, vol. 43, 1606, Alonso López Merino, fols. 461r–462v, 468r–468v.

62. Within the *hanan/hurin* divisions, colonial *ayllus* existed in various parishes, especially in San Roque. See Salomon, *Native Lords*, 144–148, 167–169, 174–180; and Manuel Espinosa Apolo, *Insumisa vecindad: memoria política del barrio de San Roque* (Quito: Quito Eterno, 2009), for *ayllus* and the *padrón* of 1582.

63. For the colonial history of San Roque, see especially Espinosa Apolo, *Insumisa vecindad*, 15–118; and Minchom, *People of Quito*, 210–233.

Chapter 5: First Generations, ca. 1550–1615

1. Reginaldo de Lizárraga, "Descripción breve," 173.

2. Harth-Terré and Márquez Abanto, "Pinturas y pintores," 114. See also AGI, Indiferente, 1964, L. 10, "Licencia de pasajeros a Juan de Illescas para pasar a Nueva España," fol. 363v. For Illescas in New Spain, see Guillermo Tovar de Teresa, *Pintura y escultura en Nueva España (1557–1640)* (Mexico City: Grupo Azabache, 1992), 54; Toussaint, *Pintura colonial en México*, 37. Toussaint published a document in which Juan de Illescas is identified as "pintor y dorador." According to Carmen Fraga González, it is possible that Juan de Illescas and his sons traveled to New Spain via the Canary Islands, where they may have practiced their profession for a time; however the very early dates of the 1520s and early 1530s that Fraga González cites do not coincide with the period during which Illescas worked and was twice examined by the painter's guild in Córdoba, Spain, in the 1530s and 1540s, as documented by Harth-Terré and others. Carmen Fraga González, "Emigración de pintores andaluces en el siglo XVI," *Anales de la Historia del Arte* 4 (1994): 577–581.

3. Illescas the Elder was apparently in Quito long enough to acquire a house, yet only a single document in the Quito archives attests to his presence: his house was next door to a residence purchased in 1586, identified as "lindero con casas de Juan de Yllescas pintor." Yet his was no ordinary house: it was located in the very heart of the city, in the same block as the Cathedral, and the house next door was sold to the wealthy local merchant Marcos de la Plaza for an eye-popping five thousand pesos, marking it as one of the most expensive residences in the city. AHBCE, JJC .00196, 1586, Francisco de Corcuera, fols. 1122v–1124r. Illescas stated in his testament of 1575, filed in Lima, that he possessed a house in Quito, "que está en la calle de la Plaza junto a las casas de don Lorenzo de Estupiñán," which he bequeathed to his son, Juan de Illescas the Younger, who was also a painter. Harth-Terré and Márquez Abanto, "Pinturas y pintores," 116. There is no documentary evidence that any heirs claimed the property.

4. José Gabriel Navarro names Captain Juan Sánchez de Jérez Bohórquez (born in Pasto around 1568) among the early painters of Quito, a reference that is restated by subsequent authors. Navarro's identification of Sánchez de Jérez Bohórquez as a painter is based on a 1610 letter to the king of Spain, in which the captain reportedly requested permission "de pintar un cuadro en el que se representaría a él mismo arodillado ante su magestad, en actitud de entregar una carta." Navarro, *La pintura en el Ecuador*, 32. Navarro apparently misread the text, for the 1610 letter to which he refers makes it clear that the author did not himself intend to paint a canvas; rather, he requested permission to include the aforementioned imagery on his coat of arms and heraldic banners (*reposteros*). The text in question reads: "que en sus armas y rreposteros, en un quartel dellas pueda poner el rretrato de su Mag[esta]d, y al sup[lican]te de rodillas con la carta en que descubrio el motin y alçamiento de quito." AGI, Quito, 28, N .25, "El capitán Juan Sánchez de Jérez Bohórquez pide mercedes," fol. 2r. Juan Sánchez de Jérez Bohórquez may thus be removed from the roster of painters in early colonial Quito.

5. See for example Fernando Jurado Noboa, *Migración internacional a Quito entre 1534 y 1934* (Quito: Sociedad de Amigos de la Genealogía, 1989), 860; José de Mesa and Teresa Gisbert, "The Painter, Mateo Mexía, and His Works in the Convent of San Francisco de Quito," *The Americas* 16, no. 4 (1960), 386; Luis Roberto Al-

tamira, *Córdoba: sus pintores y sus pinturas (siglos XVII y XVIII)* (Córdoba: Imprenta de la Universidad, 1951), 2:191–192.

6. For example, early in the first decade of the seventeenth century, the president of the *real audiencia* of Quito awarded ten *caballerías* of land to the immigrant Spanish mason and builder Juan del Corral in an effort to encourage him to remain in the city. Nonetheless, in 1607 Corral was enticed to Lima with the promise of constructing a major bridge and other important buildings. See Webster, *Quito, ciudad de maestros*, 36–38.

7. *Libro de proveimientos*, 102.

8. Vargas does not figure among the archival documents in Quito; however, a series of letters written in the late 1580s and early 1590s to his superior in Rome document aspects of his stay in the city. For Vargas's biography, see José de Mesa and Teresa Gisbert, *Bitti, un pintor manierista en Sudamérica* (La Paz: Universidad Mayor de San Andrés, 1974).

9. Mesa and Gisbert, *Historia de la pintura cuzqueña*, 1:64.

10. José Jouanen, *Historia de la Compañía de Jesús en la Antigua provincia de Quito, 1540–1774* (Quito: Editorial Ecuatoriana, 1941), 48–58.

11. Mesa and Gisbert, *Historia de la pintura cuzqueña*, 1:64.

12. "a manera de firma, la sigla "IHS" característica de la orden jesuita [. . .] esta misma sigla en la 'Inmaculada' de Quito." José de Mesa and Teresa Gisbert, *El manierismo el los Andes* (La Paz: Unión Latina, 2005), 76.

13. Mesa and Gisbert, *Historia de la pintura cuzqueña*, 1:65.

14. The most complete biographies of Medoro are those of José de Mesa and Teresa Gisbert, "El pintor Angelino Medoro y su obra en Sudamérica," *Anales del Instituto de Arte Americano e Investigaciones Estéticas* 18 (1965): 23–47, and the updated and somewhat revised version published in Mesa and Gisbert, *El manierismo en los Andes*, 87–104. The present discussion of Medoro's early years in Italy, Spain, the New Kingdom of Granada, and the *audiencia* of Quito draws upon and augments the work of Mesa and Gisbert.

15. Agustín Clavijo García, "Pintura colonial en Málaga y su provincia," in *Andalucía y América en el siglo XVIII: actas de las IV Jornadas de Andalucía y América* (Sevilla: Escuela de Estudios Hispano-Americanos, 1985) 2: 92–93.

16. Martín Soria, *La pintura del siglo XVI en Sudamérica* (Buenos Aires: Instituto de Arte Americano e Investigaciones Estéticas, 1956), 74–75. This work is apparently one of those now in Málaga. For Medoro's final years in Seville, see also Fuensanta Arenado, "Nuevos datos sobre el pintor Angelino Medoro," *Archivo Hispalense* 60, no. 84 (1977): 103–112. For Medoro's work elsewhere in Spain, see José de Mesa y Teresa Gisbert, "Dos dibujos inéditos de Medoro en Madrid," *Arte y Arqueología* 1 (1969): 19–27.

17. For Medoro in the New Kingdom of Granada, see Santiago Sebastián López, "Angelino Medoro policromó una imagen en Cali," *Archivo Español de Arte* 36, no. 142 (1963): 137–138; Santiago Sebastián López, "Nueva pintura de Angelino Medoro en Bogotá," *Cuadernos de Arte Colonial* 1 (1986): 105–106; Luis Alberto Acuña, "Angelino Medoro, pintor andariego," *Revista de la Academia Colombiana de Historia Eclesiástica* 4, nos. 15–16 (1969): 325–329; Mesa and Gisbert, *El manierismo en los Andes*, 87–92.

18. Ulises Rojas, "La Capilla de los Mancipes," *Boletín de Historia y Antigüedades* 26 (1952), 559.

19. "Item, pagué a Argelino [sic] Romano pintor por la hechura de una imagen

del puñal de Nuestra Señora de la Antigua, guarnecida de madera y dorada que le hizo en esta ciudad de Tunja, ciento y cincuenta pesos de oro de veinte kilates.

Item, pagué más al dicho Medoro Agelino [*sic*] por la hechura de dos lienzos grandes guarnecidos y dorados, el uno de la Oración del Huerto y el otro del descendimiento de la Cruz que están a los lados del retablo del altar mayor de las vidrieras, y dorar la tribuna y puerta del coro y sacristía, escudo y otras cosas que se pintaron en la dicha Capilla, doscientos y cincuenta pesos de oro de veinte kilates." Gabriel Giraldo Jaramillo, "Fundación de la Capellanía de los Mancipes," *Repertorio Boyacense* 70 (1924): 1109. This document contains an accounting of the payments that Ruíz Mancipe made to carpenters, masons, blacksmiths, gilders, and painters during the entire period of the construction and decoration of the chapel. All told, Ruíz Mancipe claimed to have invested in the project the impressive amount of 6,130 gold pesos.

20. Medoro's paintings of the *Virgen de la Antigua* were among many copies of this devotional image that were created throughout the colonial Americas, the original of which, a late Gothic painting, is located in Seville Cathedral. See Enrique Valdivieso, *Historia de la pintura sevillana, siglos XIII al XX*, 2nd ed. (Seville: Ediciones Guadalquivir, 1992), 23; Magdalena Vences Vidal, "El culto a la Virgen de la Antigua en las diócesis hispanoamericanas," in *América Latina: las caras de la diversidad* (Mexico City: UNAM, 2006), 253–272. What appears to be another version of Medoro's *Virgen de la Antigua*, depicted with Saints Francis and Augustine, was stolen in 2004 from the Jesuit church of San Ignacio in Tunja. This painting might be the one referenced in Ruiz Mancipe's account of payment to Medoro, particularly because the patron professed special devotion to Saint Augustine in his 1598 *capellanía* contract. Giraldo Jaramillo, "Fundación de la Capellanía," 1102, 1105. The Jesuits were not established in Tunja until 1620 (although the church that they came to occupy dates from 1610); thus, this *Virgen de la Antigua* could not have been made for the Church of San Ignacio, and must have been moved there from some other location, again, perhaps the Capilla de Mancipe. For an image of the painting, see Olga Isabel Acosta Luna, "A su imagen y semejanza: un retrato de la Virgen de la Antigua en Bogotá," *Quiroga, Revista de Patrimonio Iberoamericano* 3 (2013): 20.

21. Giraldo Jaramillo, "Fundación de la Capellanía," 1109.

22. "escudo de armas de los Ruíz Mancipe." Ulises Rojas, *Escudos de armas e inscripciones antiguas de la ciudad de Tunja* (Santa Fe de Bogotá: Talleres de la Cooperativa Nacional de Artes Gráficas, 1939), 181.

23. "el retrato del capitán Mancipe, en actitud de orar, lienzo de la época, de colorido delicado y que atrae irresistiblemente." Luis Augusto Cuervo, "Exposición de arte antigua en Tunja," *Boletín de Historia y Antigüedades* 16, no. 190 (1927): 612.

24. "[h]asta hace algunos años se conservó en la capilla un óleo de su fundador, al pie del cual se lee: 'El Capitán Antonio Ruiz Mancipe de edad de 56 años.' Está arrodillado y en actitud supplicatoria. Este retrato se guarda hoy en la casa capitular contigua a la iglesia cathedral." Rojas, "La Capilla de los Mancipes," 564; Rojas, *Escudos de armas*, 181.

25. AGI, Santa Fe, 128, N. 8, "Informaciones: Bartolomé Villagómez Campuzano," fol. 3r. The recording of an individual's age in the early colonial period was often couched in somewhat equivocal terms; thus, the document in question registers Captain Antonio Ruiz Mancipe's age in 1595 as "sesenta años poco mas o menos." The date of the portrait should therefore be established as circa 1591.

26. See Alfonso Pérez Sánchez and Ana Sánchez-Lassia de los Santos, *Las lágri-*

mas de San Pedro en la pintura española del Siglo de Oro (Bilbao: Museo de Bellas Artes de Bilbao, 2000).

27. Mesa and Gisbert believe that the painting in the Franciscan church is the work of Medoro. Mesa and Gisbert, *El manierismo en los Andes*, 90. Several other paintings of Christ at the Column with the repentant Saint Peter hang in Tunja's churches. One example, executed on canvas, in the church of San Laureano, appears to be a later copy, despite the local legend recounting that Medoro's signature appears on the verso. We were unable to examine the back of the painting. Another example, in the church of the Convento de Santa Clara el Real, also appears to be a later copy.

28. For illustrations and the attribution to Medoro of the *Coronation of the Virgin* in the Museo de Arte Colonial, Bogotá, see Sebastián López, "Nueva pintura de Angelino Medoro," 105–106; Mesa and Gisbert, *El manierismo en los Andes*, 91.

29. For a range of examples, see Mesa and Gisbert, *El manierismo en los Andes*, 91–92. Mesa and Gisbert identify and illustrate a painting of a "Santo desconocido" in the collection of the Museo de Arte Colonial in Bogotá as by the hand of Medoro (p. 91). This painting, *Saint Lucius King of Britain*, has recently been attributed to the Sevillian artist Francisco Pacheco. See Susan V. Webster, "A British King in Colonial Bogotá: A Portrait of Saint Lucius Attributed to Francisco Pacheco," *Source: Notes in the History of Art* 34, no. 4 (2015): 48–55.

30. Various dates for Medoro's marriage in Bogotá are cited in the literature, and some authors claim that he married Lucía—or Luisa—Pimentel, either in Tunja or in Quito; however, the preponderance of authors date the wedding to 1589, and cite Bogotá as the location. For example, Mesa and Gisbert establish a 1589 date for the wedding in Bogotá. Mesa and Gisbert, *El manierismo en los Andes*, 90. Arenado dates the wedding in Bogotá to 1588. Arenado, "Nuevos datos," 104.

31. Sebastián López, "Angelino Medoro policromó," 137–138; Santiago Sebastián López, *Arquitectura colonial en Popayán y Valle del Cauca* (Cali: Biblioteca de la Universidad de Valle, 1965), 30; Gustavo Arboleda, *Historia de Cali* (Cali: Carvajal, 1956), 1:144, 348. See also José de Mesa and Teresa Gisbert, *Escultura virreinal en Bolivia* (La Paz: Academia Nacional de Ciencias de Bolivia, 1972), 62, in which the authors document two sculptures polychromed by Medoro in Cali.

32. See *Arquidiócesis de Cali, 1910–2010: un alba iluminada* (Bogotá: Cargraphics S.A., 2010).

33. "[u]no de los puntos más oscuros dentro de la biografía de Medoro es su estancia en la Audiencia de Quito; prácticamente los únicos datos que existen son dos cuadros suyos." Mesa and Gisbert, *El manierismo en los Andes*, 92.

34. "o lo más probable, que nunca estuviera en Quito." Mesa and Gisbert, *El manierismo en los Andes*, 92.

35. "muger legitima de medoro angelino pintor [. . .] hija natural de al[ons]o gutierrez Pimentel v[ecin]o que fue de la ciudad de santa fee." ANH/Q, Notaría 1a, vol. 18, 1601, Francisco García Durán, fols. 521r–523v.

36. "beynte y çinco patacones de a ocho rreales de una lamyna de Juan de munoa ronquillo—que cobro del susodicho." ANH/Q, Notaría 1a, vol. 18, 1601, Francisco García Durán, fol. 522r. If the *lámina* was in fact painted, the rather ambiguous phrase "una lamyna de juan de munoa ronquillo" might refer either to a portrait of the recipient or to a painted scene.

37. A series of 1637 documents record aspects of Muñoa Ronquillo's chapel in Santo Domingo, the altarpiece of which was painted and gilded by the Spanish or

Creole artist Gabriel Vázquez (not to be confused with the Andean master painter Gabriel Vásquez). ANH/Q, Notaría 5a, vol. 22, 1637, Gerónimo de Castro, fols. 137r–138r, 143r–144r, 145v–148v; ANH/Q, Notaría 6a, vol. 49, 1637, Juan Martínez Gasco, fols. 48v–49r.

38. The subject of Medoro's painted *lámina* is modeled on a 1595 engraving by Jerome Wierix. See Clara Bargellini, "La pintura sobre lamina de cobre en los virreinatos de la Nueva España y del Perú," *Anales del Instituto de Investigaciones Estéticas* 74–75 (1999), 81.

39. "[E]ugenia mi hija mayor todas las tocas y joyas que tengo en un cofre q[ue] Esta en rriobamba q[ue] son cinco tocas y una gargantilla de perlas y pieças de oro y mermelletas." ANH/Q, Notaría 1a, vol. 18, 1601, Francisco García Durán, fol. 521v.

40. ANH/Q, Notaría 1a, vol. 19, 1601, Francisco García Durán, fols. 545v–548r. Medoro's identification in this document as a "pintor de ymaginería" is revealing, for it reinforces the abovementioned attribution to him of the polychromy of two sculptures in Cali.

41. "para que puede traer E traiga a esta d[ic]ha ciudad a la d[ic]ha dona luçia Pimentel mi muger y la abie y despache de todo lo necessario y no queriendo venir de su voluntad le pueda apremiar y apremie a ella por justiçia—y En caso que no quiera benir haga que la d[ic]ha mi muger se deposite y rrecoja en el monasterio de las monjas de santa clara de la d[ic]ha çiudad donde este hasta que sea mi voluntad salga del." ANH/Q, Notaría 1a, vol. 19, 1601, Francisco García Durán, fols. 545v–546r.

42. "me traera a esta d[ic]ha çiudad [de Lima] dos ninas hijas mias y suyas y gastar con ellas todo lo necessario—que la una de ellas se llama Eugenia de hedad de ocho anos y la otra ynes de hasta seis anos." ANH/Q, Notaría 1a, vol. 19, 1601, Francisco García Durán, fol. 546r.

43. Mesa and Gisbert, *El manierismo en los Andes*, 94; Harth-Terré and Márquez Abanto, "Pinturas y pintores," 133, 193.

44. For the founding document of the Convent of Santa Clara, see ANH/Q, Notaría 6a, vol. 5, 1596, Diego Rodríguez Docampo, fols. 590v–596r. For its impoverished status and lack of adequate buildings in 1603, see AGI, Quito, 84, N .62, "Fr. Luis Núñez de Villavicencio pide una merced para las clarisas."

45. For the Convent of the Immaculate Conception around 1600, see Silvia Ortiz Batallas, ed., *Desde el silencio de la clausura: el Real Monasterio de la Limpia Concepción de Quito* (Quito: Instituto Metropolitano de Patrimonio, 2014), 26–40.

46. Harth-Terré and Márquez Abanto, "Pinturas y pintores," 194; Arenado, "Nuevos datos," 106, 108. Their third daughter, Ana, who was left behind in Popayán on the journey south, apparently never came to live with either parent. Medoro declared in his 1631 testament, filed in Seville, that they left Ana in Popayán as a baby because she was sick, in the care of a *beata* whose name he could not recall, and he was unaware as to whether she was alive or dead. Arenado, "Nuevos datos," 108–109.

47. ANH/Q, Notaría 1a, vol. 18, 1601, Francisco García Durán, fol. 533r–533v.

48. "un lagarto de oro con la cola torcida grande que tiene veinte esmeraldas grandes [. . .] un anus dei de oro con cerco rredondo con las chapas yluminadas con un saluador del mundo a un lado y al otro una santa maria con tres obalos de esmeraldas." ANH/Q, Notaría 1a, vol. 18, 1601, Francisco García Durán, fol. 533r–533v.

49. ANH/Q, Notaría 1a, vol. 18, 1601, Francisco García Durán, fol. 522r. "un lagarto cayman con sus esmeraldas—de oro [. . .] un anus dei de oro con sus esmeraldas—con beriles."

50. For Curcio Romano, alias Vicencio Botanelli, and his theatrical career in

Spain, see Hugo Rennert, *The Spanish Stage in the Time of Lope de Vega* (New York: Hispanic Society of America, 1909), 461, 479, 581; Luis Astrana Marín, *Vida ejemplar y heróica de Miguel de Cervantes Saavedra con mil documentos hasta ahora inéditos y numerosas ilustraciones y grabados de la época* (Madrid: Instituto Editorial Reus, 1948), 3:315; Emilio Cotareli y Mori, "Noticias biográficas de Alberto Ganasa, cómico famoso del siglo XVI," *Revista de Archivos, Bibliotecas y Museos* 12 (1908): 50, 52; and Sanz Ayán and García García, "El 'oficio de representar,'" 485–487.

51. Emilio Harth-Terré noticed the relationship between Medoro's name and those of the protagonists in Ariosto's poem, proposing "¿No era esto un sobrenombre escogido por el pintor?" Harth-Terré and Márquez Abanto, "Pinturas y pintores," 133.

52. "hijo legitimo de Angelino Meros [apellido tachado en el original] y de Paloma Pomp . . . [ilegible] vecinos de Roma." Arenado, "Nuevos datos," 103. Chichizola Debernardi reads the names of Medoro's parents on this document as "Angelino de Meres (el apellido está tachado en el original) y de Paloma Pompeoto (?), vecinos de la ciudad de Roma." He also includes a complete transcription of Medoro's 1631 will and testament. José Chichizola Debernardi, *El manierismo en Lima* (Lima: Pontificia Universidad Católica del Perú, 1983), 128, 232–236.

53. Soria, *La pintura del siglo XVI*, 75; Mesa and Gisbert, *El manierismo en los Andes*, 92.

54. José Gabriel Navarro, *Guía artística de Quito* (Quito: La Prensa Católica, 1961), 116; Navarro, *La pintura en el Ecuador*, 33; José María Vargas, *Historia de la Iglesia en el Ecuador durante el patronato español* (Quito: Editorial Santo Domingo, 1962), 187; Mesa and Gisbert, *El manierismo en los Andes*, 92; Luis Nieri Galindo, *Pintura en el Virreinato del Perú* (Lima: Banco de Crédito del Perú, 1989), 152.

55. In this regard, it bears mentioning that Antonio Ruiz Mancipe was the subject of scandal in Tunja, for he had produced five *hijos naturales* with an Andean woman from his family's *encomienda* in Toca and had brought them all to live in his grand house in Tunja—a scandal that erupted into a lawsuit over the family inheritance between Ruiz Mancipe and his younger brother Pedro. Antonio Ruíz Mancipe emerged the winner, but at the cost of his reputation. See Rojas, "La Capilla de los Mancipes," 561–562.

56. For images of the coat of arms of the Aza and Guzmán families in Caleruega, Spain, birthplace of Santo Domingo de Guzmán, see Venancio D. Caro, *Caleruega, cuna de Santo Domingo de Guzmán* (Madrid, 1952), 1. For the Aza escutcheon, also described as "cruz flordelisada con veneras en sus extremos, rodeada de calderas," documented in 1255, see Salvador Andrés Ordax, "El monasterio cisterciense de Villamayor de los Montes (Burgos)," *Boletín del Seminario de Estudios de Arte y Arqueología* 58 (1992): 295. See also Pedro Blas Valverde Ogaller, "Manuscritos y heráldica en el tránsito a la modernidad: el libro de armería de Diego Hernández de Mendoza" (PhD diss., Universidad Complutense de Madrid, 2001), 1171–1172, 1199–1200.

57. Several scholars have made compelling arguments for the attribution of this work to Medoro. See Mesa and Gisbert, "El pintor Angelino Medoro," 31; José María Vargas, *Arte quiteño colonial* (Quito: Imprenta Romero, 1945), 49; Vargas, *Patrimonio artístico*, 195; Soria, *La pintura del siglo XVI*, 75.

58. The support used in each painting is also the same: "mantelillo veneciano," which has distinctive raised geometric designs in the weave. See Ortiz Batallas, *Desde el silencio*, 368–369.

59. Vargas, *Patrimonio artístico*, 186–187; Ortiz Batallas, *Desde el silencio*, 27.

60. In 1600, for example, city council members decided to commission a smaller sculpture of their patron, Saint Jerome, specifically for use in processions, "porque la imagen de bulto que hay está en la capilla que esta ciudad tiene en la iglesia Catedral y es muy grande, de manera que no se puede llevar en la procession." AMH/Q, Libro de Cabildo, 1600–1602, tomo 1, vol. 13, fol. 261r.

61. Harth-Terré and Márquez Abanto, "Pinturas y pintores," 133. Chichizola Debernardi transcribes this document in *El manierismo en Lima*, 226–229.

62. Ortiz Batallas, *Desde el silencio*, 32–33, 175.

63. "la dote de sus dos hijas para que entren en el convento y tomen el velo." ANH/Q, Notaría 6a, vol. 49, 1637, Juan Martínez Gasco, fols. 22v–24v.

64. Material from this section on Luis de Ribera was previously published in Webster, "Of Signatures and Status."

65. See especially Navarro, *La pintura en el Ecuador*, 31–32; José María Vargas, *Historia del arte ecuatoriano* (Quito: Editorial Santo Domingo, 1963), 32. Juan de Illescas could not have collaborated with either Luis de Ribera or Diego de Robles, as some have written, since he had departed Quito for Lima long before the arrival of the latter artists. Stratton-Pruitt, *The Art of Painting in Colonial Quito*, 4; Navarro, *La pintura en el Ecuador*, 31–32.

66. A 1580 notarial document from Tunja registering the sale of a house in that city by Blas de Oliberas to the carpenter Melchor Hernández records that its previous owner was "Luis de Ribera pintor." With regard to the house, the complete phrase reads: "Segun que yo los hube y Conpre [las casas] de luis de rribera pintor que residio En esta d[ic]ha ciudad." AHB/T, Protocolos, vol. 29, 1580, fols. 189r–190r. For Quito, the earliest document involving Ribera is a 1582 contract that he signed as a witness. AHBCE, JJC .00194, 1580–1586, Gaspar de Aguilar, fol. 849v.

67. "al dicho Luis de Rivera se le proveyó media caballería de tierra para viña y huerta en término del dicho pueblo de Mira, en lo caliente, donde parece habérsela dado y señalado los caciques e indios de Mira en pago de cierta pintura de un retablo para la iglesia del dicho pueblo, como parece por su petición y cierto recabdo que presentó de los indios." *Libro de proveimientos*, 102–103.

68. *Libro de proveimientos*, 102.

69. Ribera subsequently expanded his terrain near Mira, purchasing in 1586 an additional *caballería* of neighboring land. AHBCE, JJC. 00196, 1586, Francisco de Corcuera, fols. 1057r–1058r.

70. Their daughter Bernarda de Ribera was married to an Italian gilder, Francisco Napolitano. ANH/Q, Notaría 1a, vol. 6, 1594–1599, Diego Lucio de Mendaño, fols. 269r–274r. Ana de Ribera, another of their daughters, wed Blas de Caçaña, a member of an important family of gold- and silversmiths. ANH/Q, Notaría 1a, vol. 60, 1609, Alonso López Merino, fols. 136r–137v.

71. For Ribera's houses in Santa Barbara and his purchase of the neighboring house and shop, as well as the range of merchandise offered in his *pulpería*, see AHBCE, JJC .00202, 1596–1597, Francisco de Corcuera, fol. 32v; ANH/Q, Notaría 1a, vol. 10, 1598, Francisco García Durán, fols. 782r–783v; and ANH/Q, Notaría 1a, vol. 17, 1601, Alonso López Merino, fols. 421v–422v.

72. See ANH/Q, Notaría 1a, vol. 27, 1603, Alonso Dorado de Vergara, fols. 1104r–1110r, 1110r–1110v, 1111r–1111v, 1111v–1119v; ANH/Q, Notaría 1a, vol. 23, 1602–1604, Francisco García Durán, fols. 142v–144v; ANH/Q, Notaría 1a, vol. 35, 1605, Alonso

López Merino, fols. 351r–353r; ANH/Q, Notaría 1a, vol. 60, 1609, Alonso López Merino, fols. 136r–137v, 434v–436v; and ANH/Q, Notaría 1a, vol. 71, 1611–1612, Alonso Dorado de Vergara, fols. 282v–284v.

73. *Libro de proveimientos*, 102–103.

74. "el derecho de veynte pesos de plata que tengo pagados en la hechura de unos ciriales a don pedro gouernador de cumbaya que esta obligado de me los pagar en jornales de mitayos para la lauor de la d[ic]ha estancia." AHBCE, JJC .00203, 1598–1599, Alonso Dorado de Vergara, fols. 476r–477r.

75. Ribera is identified as a "dorador" in AHBCE, JJC .00202, 1595, Alonso Dorado de Vergara, fol. 32v.

76. "para el dorado de los galeones de su mag[esta]d." ANH/Q, Notaría 6a, vol. 19, 1612, Diego Rodríguez Docampo, fol. 213v.

77. "que fuese en lo possible trasunto exacto de la celebérrima Imagen de Nuestra Señora de Guadalupe, venerada en la sierra de este nombre." Juan de Dios Navas, *Guápulo y su santuario, 1581–1926* (Quito: Imprenta del Clero, 1926), 50–51. The Virgin of Guadalupe in Extremadura, Spain, to which the quote refers, in fact, was a "black Madonna," while the Virgin of Guápulo was not.

78. Navas, *Guápulo y su santuario*, 52.

79. Vargas, *El arte ecuatoriano*, 32; Navarro, *La pintura en el Ecuador*, 31; José Gabriel Navarro, *La escultura en el Ecuador durante los siglos XVI, XVII y XVIII*, 2nd ed. (Quito: TRAMA, 2006), 190; Ximena Escudero de Terán, *América y España en la escultura colonial quiteña* (Quito: Ediciones del Banco de los Andes, 1992), 52; Gabrielle G. Palmer, *Sculpture in the Kingdom of Quito* (Albuquerque: University of New Mexico Press, 1987), 22–24; Stratton-Pruitt, *The Art of Painting*, 4.

80. AHBCE, JJC .00196, 1586, Francisco de Corcuera, fols. 1072v–1073v.

81. "una hechura de ymagen de n[uest]ra s[eñor]a del rrosario con su niño Jesus muy bien ffecha acauada y dorada en toda su perfficion como deue ser y ha de ser de siete palmos con la peaña conforme a la que esta en la ygleçia mayor desta çiudad [. . .] y por la hechura de la dicha ymagen les ha de dar y pagar çiento y quince p[eso] s de Plata al dicho luis de rribera y al dicho diego de rrobles çiento y beynte y çinco p[eso]s [. . .] y la han de dar acauada estoffada y grauada a bista de offiçiales y ansimismo an de hacer unas Pariguelas rrajas en que baya en las procesiones." AHBCE, JJC .00196, 1586, Francisco de Corcuera, fol. 1072v.

82. See for example Julio Matovelle, *Imágenes y santuarios de la Virgen Santísima en la América Española, señaladamente en la República del Ecuador* (Quito: Editora de los Talleres Salesianos, 1910), 324; José María Vargas, *Arte religioso ecuatoriano* (Quito: Casa de la Cultura Ecuatoriana, 1956), 98.

83. "vecino encomendero de la ciudad de Loja [. . .] una hechura de ymagen de n[uest]ra s[eñor]a del rrosario en la fforma e manera sig[uien]te [. . .] a de ser de sedro con su nino jesus en los braços del tamano [?] e manera que esta la ymagen del conuento de s[eñ]or santo domingo desta d[ic]ha çiudad con sus coronas y peana y con sus ceraffines en la d[ic]ha peana de altura de siete palmos en largo [. . .] y ansimismo acauada de poner en perffiçion el dicho escultor el dicho luis de rribera la a de dorar y pintar de manera que el rropage de la dicha ymagen baya con sus rrosas y seraffines y con su peana e caxa de madera fuerte de manera que la dicha ymagen aya de estar acauada en toda perffiçion y a bista de personas y offiçiales que lo entiendan [. . .] la qual dicha hechura de ymagen hecha y acauada y dorada y encaxada en la dicha su caxa." AHBCE, JJC .00196, 1586, Francisco de Corcuera, fols. 118r–119r.

84. The Confraternity of Nuestra Señora del Rosario was established in Quito's Dominican monastery in 1563 and, according to the 1650 account of Diego Rodríguez Docampo, its titular sculpture was reportedly an "imagen de bulto que se trajo de España al principio de la fundación." Vargas, *Nuestra Señora del Rosario*, 45, 54.

85. "en una rústica choza." Matovelle, *Imágenes y santuarios*, 521.

86. Navarro, *La escultura en el Ecuador*, 2nd ed., 193–194; Vargas, *Patrimonio artístico*, 462–464; Vargas, *El arte ecuatoriano*, 31; Escudero de Terán, *América y España*, 52. None of the scholars cites the contract or other documentary evidence.

87. ANH/Q, Notaría 1a, vol. 60, 1609, Alonso López Merino, fols. 364v–365r.

88. "del modelo que queda firmado de el y del d[ic]ho dean y de la traza de [e]l y con las condicyones siguientes [. . .] que el d[ic]ho tabernaculo lleba en lo alto un xpo en el tablero de [e]l pintado con n[uestr]a s[eñor]a y la Magdalena y s[an] joan al olio en tabla." ANH/Q, Notaría 1a, vol. 60, 1609, Alonso López Merino, fol. 364v.

89. For Ponce's testament and codicil, see ANH/Q, Notaría 1a, vol. 43, 1606, Alonso López Merino, fols. 461r–462v, 468r–468v.

90. "treinta pesos que me deue el conbento de mi trauajo." ANH/Q, Notaría 1a, vol. 43, 1606, Alonso López Merino, fol. 461v.

91. "herramientas de mi officio y lo demas que paresciere ser mio." Ibid.

92. "deuo ocho p[eso]s a un yndio de la loma de q[uen]ta de una ymagen." Ibid.

93. "procure meter en el Colegio [de San Andrés] al d[ic]ho su hijo." ANH/Q, Notaría 1a, vol. 43, 1606, Alonso López Merino, fol. 468v.

94. Antonio Muro Orejón, *Documentos para la Historia del Arte en Andalucía: pintores y doradores*, vol. 8 (Seville: Laboratorio de Arte, 1935), 14. It was not unusual for artistic apprentices to assume the surnames of their masters.

95. Juan Miguel Serrera Contreras, "El eje pictórico Sevilla-Lisboa, siglo XVI," *Archivo Hispalense* 76, no. 233 (1993): 144–145.

96. "es uno de los más explícitos realizados en el Cuzco." Mesa and Gisbert, *Historia de la pintura cuzqueña*, 1:53–54. The subsequent activities of Juan Ponce in Potosí, as traced by Mesa and Gisbert (citing Mario Chacón), locate him in that city until 1607, the year after the Juan Ponce in Quito filed his testament and codicil. It may be that the Potosí Juan Ponce is not the same person as the artist they documented working in Lima and Cuzco. Additional research is required to clarify the identities of these eponymous painter-gilders. For a 1581 contract with Ponce in Cuzco, see Jorge Cornejo Bouroncle, *Derroteros de arte cuzqueño: datos para una historia del arte en el Perú* (Cuzco: Ediciones Inca, 1960), 161–164. For Juan Ponce's Andean apprentice, Francisco Rincón, see Emilio Harth-Terré, *El indígena peruano en las bellas artes virreinales* (Cuzco: Editorial "Garcilaso," 1960), 46.

97. "Se ha de dorar todo el dicho retablo, bien cubierto y bien bruñido el oro, que solamente se ha de dejar de dorar los dichos rostros y pies y manos y luego se ha de estofar toda la dicha obra metiendo sobre el oro los colores y labores que en cada cosa requiere y pide la buena obra, especialmente en los frisos y columnas y los festones y cornisas y capiteles y remates y hacer sobre las dichas colores, las labores, de buena y vistosa obra . . . esgrafiados que sean galanes y artísticos . . ." Transcribed in Mesa and Gisbert, *Historia de la pintura cuzqueña*, 1:53.

98. The most complete biography of Bedón is still that of José María Vargas, *Biografía de Fray Pedro Bedón, O.P.* (Quito: Editorial Santo Domingo, 1965).

99. Soria, *La pintura del siglo XVI*, 46; Vargas, *Biografía de Fray Pedro Bedón*, 76.

100. The original source for Bedón and the Confraternities of the Rosary is Juan

López, *Quinta parte de la historia de Sto. Domingo y de su Orden de Predicadores* (Valladolid: Juan de Rueda, 1622), 439.

101. Vargas quotes a 1701 account of Bedon's mural paintings. Vargas, *Biografía de Fray Pedro Bedón*, 52.

102. Ulises Rojas, *Corregidores y justicias mayores de Tunja y su provincia desde la fundación de la ciudad hasta 1817* (Tunja: Imprenta Departamental de Boyacá, 1962), 210–211.

103. Alberto E. Ariza, "Santo Domingo de Tunja (Precisiones y rectificaciones)," *Apuntes: Revista de Estudios sobre Patrimonio Cultural* 15 (1978): 31–33. "había sido alumno de Medoro en Tunja." Santiago Londoño Vélez, *Arte colombiano: 3.500 años de historia* (Bogotá: Villegas Editores, 2001), 96. For similar claims, see Rodrigo Gutiérrez Viñuales, "La pintura y escultura en Hispanoamérica," in *L'Arte Universale*, Joan Sureda, ed., (Milan: Jaca Book, 2008), 1; Camilo Mendoza Laverde, "Restauración de las pinturas murals de Santo Domingo de Tunja," *Apuntes: Revista de Estudios sobre Patrimonio Cultural* (1976), 81.

104. "Tres cosas, escribió, son necesarias para el que quiere tener conocimiento perfecto de un asunto, a saber, el arte, el ejercicio y la imitación. El Arte—o teoría—para enseñar las reglas y orientaciones; el ejercicio para adquirir la habilidad práctica, y la imitación para tener a la vista los modelos. Esto aparece claro en un pintor perito, el cual, para adquirir a perfección en su arte, necesita, en primer lugar, conocer las reglas generales de la pintura y la proporción que debe guardarse en la mezcla de colores, para obtener los apropiados a las imágenes que se quieren pintar; en segundo lugar, el ejercicio, porque si no se lo practica, nunca se llegará a pintar; en tercer lugar, los modelos acabados, en los cuales se pueda advertir la aplicación de las reglas." Quoted in Vargas, *Patrimonio artístico*, 68. Vargas cites a similar quote attributed to Bedón that contains slightly different wording in his *Historia de la cultura ecuatoriana*, 62; and *Biografía de Fray Pedro Bedón*, 60. The manuscript source is the rule book of the Confraternity of the Rosary, current location unknown.

105. Navarro, *Artes plásticas ecuatorianas*, 168. Filoteo Samaniego claims that Tomás del Castillo signed his name to the death portrait of Fray Pedro Bedón; however, no signature is visible today. Samaniego, "Determinantes del primer arte hispanoamericano," 26. Navarro speculated that Bedón might have taught the Dominican Creole friar Tomás del Castillo the art of painting; however, no documentary or pictorial evidence remains to confirm this hypothesis.

106. Vargas, *Biografía de Fray Pedro Bedón*, 65–76.

107. The anonymous mural painting was probably executed in the 1620s, after Bedón's death in 1621, to commemorate his contributions to the Church and the order. See Webster, "Art, Identity," 417–438.

108. For a reproduction of Bedon's death portrait, see Samaniego, "Determinantes," 26; Vargas, *Biografía de Fray Pedro Bedón*, 103.

109. Bedón founded the Recoleta de la Peña de Francia in 1600, and during the first decade of the seventeenth century he reportedly painted a mural cycle in the cloister representing scenes from the life of the Blessed Enrique Susón (now lost) and another mural in the stairwell depicting the Virgin of the Rosary (now transferred to canvas). Navarro, *La pintura en el Ecuador*, 39.

110. Héctor Schenone, *Santa María* (Buenos Aires: Universidad Católica Argentina, 2008), 381.

111. See, for example Karen Vieira Powers, *Prendas con píes: migraciónes indí-*

genas y supervivencia cultural en la Audiencia de Quito (Quito: Abya Yala, 1994), 73n114.

112. For example, one of the choir book artists employed an engraving by the Jesuit Jerome Nadal, the *Death of Lazarus* from the *Evangelicae historiae imagines* (Antwerp, 1595), as the model for a full-folio painted scene; however, the Quito artist transformed Lazarus into a pontiff, asleep in bed, and replaced the subsidiary background scene in the print with an image of a Dominican and a Franciscan friar sustaining a church building that threatens to topple. This adaptation of the Nadal print converts it to depict the dream experienced by Pope Honorius III, who had denied permission to found the Dominican order, in which he saw the Lateran church toppling, and Saint Dominic struggling to hold it upright. As a result, Honorius reversed his opinion, and the Dominican order was officially recognized. A large canvas painting in the Dominican collection in Quito repeats the scene of Honorius's dream, with minor changes, and bears the textual dedication of Gaspar de Luna, judge (*oidor*) of the *real audiencia*. Stratton-Pruitt reproduces this painting, attributing it to Francisco Albán and workshop, and dating it to 1783–1788; however, Gaspar de Luna served as judge in the 1680s and 1690s, and the painting itself does not appear to date from the eighteenth century. Stratton-Pruitt, *The Art of Painting*, 258–259.

113. "al contento del padre frai pedro bedon [. . .] y de los oficiales de la d[ic]ha cofradia." ANH/Q, Notaría, 6a, vol. 10, 1601, Diego Rodríguez Docampo, fols. 558r–559r.

114. ANH/Q, Notaría 1a, vol. 135, 1630, Gerónimo de Heredia, fols. 183r–183v. In this document, Francisco Bedón *yndio pintor* and his wife María Chuchichug purchased merchandise from a local shopkeeper.

115. "un pintor Turocunbi [. . .] una camiseta de damasco de castilla." ANH/Q, Testamentarias, caja 1, 1588–1627, expte 10-XII-1614, fol. 1v.

116. ANH/Q, Notaría 1a, vol. 66, 1610, Alonso Dorado de Vergara, fols. 1077r–1078r.

117. ANH/Q, Notaría 1a, vol. 53, 1608, Alonso López Merino, fol. 212r. Domingo signed the document "Domingo pintor."

118. "pedro torona yndio pintor, por la hechura del bulto de San Bartolome [. . .] un patacon y una fanega y media [de granos]." AHBCE, ADQ 14.11.1, "Libro de Cofradía de S. Bartolomé," fol. 10v. Italics mine.

119. "un christo coronado con los sayones del paso todo en sesenta rreales." ANH/Q, Notaría 6a, vol. 15, 1605–1606, Diego Rodríguez Docampo, fols. 38v–39r.

120. ANH/Q, Notaría 1a, vol. 29, 1603, Dionisio de Mendaño, fols. 150r–151v; ANH/Q, Notaría 1a, vol. 58, 1608–1609, Diego Lucio de Mendaño and Álvaro Arias, fols. 241v–242v.

121. AHBCE, JJC .00194, 1580–1586, Gaspar de Aguilar, fols. 1799v–1800v.

122. Vargas, *Patrimonio artístico*, 68.

123. Lizárraga, *Descripción breve*, in *Descripción colonial*, 173. Lizárraga lived in Quito during the 1550s and was personally acquainted with the Franciscan friars. See also Moreno, *Fray Jodoco Rique*, 39.

124. The original manuscript in which this transaction is recorded has been lost. A transcribed volume published in 1941 copied all of the branding iron marks awarded by the city council to a single page, in which Gocial's mark is reproduced. See *Libro de proveimientos*, 61. This Gocial "pintor" cannot be the Franciscan friar Pedro Gocial, since the latter was born around 1497–1498 and died around 1570. Moreno, *Fray Jodoco Rique*, 39–40.

125. Vargas, *Patrimonio artístico*, 68. Vargas lists all Andeans identified as painters who were members of the confraternity "a partir de 1588," the date on which the rule book was inaugurated; however, members continued to be recorded in this volume until at least the second or third decade of the seventeenth century.

126. ANH/Q, Notaría 1a, vol. 5, 1596–1597, Diego Bravo de la Laguna, fols. 501v–502r.

127. ANH/Q, Gobierno, caja 2, 1599–1608, expte. 1, Notaría de Riobamba, fols. 466r–467r. According to the document, the monies owed by Gocial to the vicar general "son por rrazon y de Resto de dueda de mayor quantia que yo el dho principal deuia por escrip[tur]a publica ortogada en favor de alonso muñoz albanir por la qual fuy Presso y executado ante el pres[en]te escriuano ynfraescripto."

128. Alfredo Costales Samaniego published documents involving an indigenous painter called "Francisco José Gocial," who in 1620 was a resident of the town of Chambo, near Riobamba. Reportedly, this Gocial was commissioned in 1643 to paint and gild the main altar of the Augustinian church there. Despite the link with Riobamba, the 1643 date for Francisco Gocial would have put him in his late seventies when he undertook the Riobamba commission. Costales Samaniego, "El arte en la Real Audiencia de Quito: artistas y artesanos desconocidos de la 'Escuela Quiteña,'" in Fernández-Salvador and Costales Samaniego, *Arte colonial quiteño*, 220–221. Costales Samaniego's study provides incomplete and incorrect citations and dates for this artist, and for many of the others considered in his text. His work should be employed with caution.

129. Salomon, *Native Lords*, 168, 172.

130. "por descargo de mi conciencia e por que le tengo cargo de haberme servido de oficio de carpintero, a Juan Chauca yndio solar y medio adonde tiene sus casas el d[ic]ho yndio con mas setenta ovejas de Castilla." AHBCE, JJC .00194, 1580, Gaspar de Aguilar, fols. 1036v–1040v. For a transcription of Francisco Atahualpa Inca's 1582 testament, see Estupiñan-Freile, "El testamento."

131. ANH/Q, Notaría 1a, vol. 37, 1605, Alonso Dorado de Vergara, fol. 252v.

132. "a Francisco Chauca yndio un pedaço de tierra de un solar junto las casas de mi morada [in the parish of San Roque]." ANH/Q, Notaría 1a, vol. 22, 1602, Alonso López Merino, fols. 272v–274r.

133. "ropa de Castilla y de la tierra [. . .] yo tengo neçesidad de me vestir y otras cosas menesterosas Para el ornato de mi persona [. . .] con q[ue] Proçediere de mi oficio y frutos de mis sementeras." ANH/Q, Notaría 1a, vol. 27, 1603, Alonso Dorado de Vergara, fols. 1021r–1023r.

134. "obligo Joan chauca Prinçipal [deudor] unas casas que tengo en esta d[ic]ha çiudad en la parroquia de san rroque linde con casas de françisco chauca y de pedro quispe e yo El d[ic]ho fran[cis]co chauca fiador ypoteco la fragua de mi ofiçio con todas las herramientas." ANH/Q, Notaría 1a, vol. 27, 1603, Alonso Dorado de Vergara, fols. 1022v–1023r.

135. "Por ocho baras de rruan de fardo a dos p[es]os Diez y seis Pesos
Por diez y nueue libras de açero diez y nueue pesos
Por ocho baras de cachas a Peso y quatro tomines doçe pesos
Por un açadon Tres Pesos." ANH/Q, Notaría 1a, vol. 27, 1603, Alonso Dorado de Vergara, fol. 1022v. During the colonial period, the denomination "tomín" was equivalent to "real." Eight tomines or reales typically equaled one peso or patacón.

136. Cachas was the name of a small textile-producing community in the Otavalo region north of Quito. Another possibility may be *caxas* cloth (the pronunciation is

similar), a very fine *cumbi* style alpaca textile produced in the southern region of the *audiencia* of Quito to the Peruvian zone around Cajamarca. See Eduardo Almeida, *Apuntes etnohistóricos del Valle de Pomasque* (Quito: Abya Yala, 1994), 61–62.

137. ANH/Q, Notaría 1a, vol. 88, 1617–1618, Alonso Dorado de Vergara, fols 304r–305v, 306r–307v.

138. AMH/Q, "Censos en favor del Cabildo," 1584–1630, fol. 101v.

139. ANH/Q, Notaría 1a, vol. 92, 1620–1624, Diego Suárez de Figueroa, fols. 118v–119r.

140. ANH/Q, Notaría 1a, vol. 112, 1625–1626, Diego Bautista, fols. 126v–127v.

141. ANH/Q, Notaría 5a, vol. 5, 1617–1618, Gerónimo de Castro, fols. 242v–243r; ANH/Q, Notaría 1a, vol. 107, 1624, Gerónimo de Heredia, fols. 775r–776v. Lorenzo Gocial's surname and his *ladino* status indicate yet another link to the Franciscan friar Pedro Gocial.

142. With the exception noted above, each of the artists discussed in this section signed multiple notarial documents over the years, and the form of their respective signatures is consistent throughout. For the issue of ambiguous or falsified signatures on Andean notarial documents, see Rappaport and Cummins, *Beyond the Lettered City*, 202–208; and Burns, *Into the Archive*, 74–82, 91–92, 116–117. Notarial documents are not without their potentially slippery features; as Rappaport and Cummins have observed, however, "contracts are the form of documentation least susceptible to generic manipulation, given their brevity and highly formulaic character." *Beyond the Lettered City*, 128.

Chapter 6: Pintar la figura de la letra

Portions of this chapter were published previously in two distinct articles: Webster, "Of Signatures and Status; and "'Pintar la figura de la letra': Andrés Sánchez Gallque y la lengua del imperio," in *VIII Jornadas Internacionales de Arte, Historia y Cultura Colonial* (Bogotá: Ministerio de Cultura de Colombia, 2014), 54–81. These studies are combined, augmented, and reconfigured here within a new context.

1. The most substantive analyses of Sánchez Gallque's 1599 painting are found in Tom Cummins, "Three Gentlemen from Esmeraldas: A Portrait Fit for a King," in *Slave Portraiture in the Atlantic World*, eds. Agnes Lugo–Ortiz and Angela Rosenthal (Cambridge: Cambridge University Press, 2013), chap. 4; Tom Cummins, "Don Francisco de Arobe and His Sons Pedro and Domingo," in *The Arts in Latin America, 1492–1820*, org. Joseph J. Rishel and Suzanne Stratton-Pruitt (Philadelphia: Philadelphia Museum of Art; New Haven, CT: Yale University Press, 2006), 418; and Andrés Gutiérrez Usillos, "Nuevas aportaciones en torno al lienzo titulado 'Los mulatos de Esmeraldas.' Estudio técnico, radiográfico e histórico," *Anales del Museo de América* 20 (2012): 7–64. For detailed investigations of the painting's patronage and historical context, see Adam Szászdi, "El trasfondo de un cuadro: 'Los Mulatos de Esmeraldas' de Andrés Sánchez Gallque," *Cuadernos Prehispánicos* 12 (1986–1987): 93–142; Lane, *Quito 1599*, 22–51; John Leddy Phelan, *The Kingdom of Quito in the Seventeenth Century: Bureaucratic Politics in the Spanish Empire* (Madison: University of Wisconsin Press, 1967), 7–10; and Rappaport and Cummins, *Beyond the Lettered City*, 36–39.

2. The subjects wear both European and Andean articles of clothing, including indigenous tunics (*uncus*) and mantles worn over European buttoned shirts with

ruffled sleeves and Spanish *cuellos de lechuguilla* (ruffled collars). Francisco and Domingo hold European-style hats. Szászdi notes that the materials of their clothing figure among the expenses incurred by Barrio y Sepúlveda, which included Chinese silks, damasks, and taffetas, as well as colored silks from Mexico. Szászdi, "El trasfondo," 136. Gutiérrez Usillos cites a 1606 document that mentions the "camisetas de tamanese y ficcadas y mantas" that were given to the Arobes in Quito, documents the gold facial ornaments and shell necklaces as characteristic of the native people of Esmeraldas, and reiterates Cabello de Balboa's 1583 claim that the metallurgy for producing lances with iron tips was introduced to the region by Africans. Gutiérrez Usillos, "Nuevas aportaciones," 29–35.

3. Szászdi, "El trasfondo"; Charles Beatty Medina, "El retrato de los cimarrones de Esmeraldas," in *Ecuador–España: historia y perspectivas*, eds. María Elena Porras and Pedro Calvo-Sotelo (Quito: Embajada de España en el Ecuador, Archivo Histórico del Ministerio de Relaciones Exteriores, 2001), 18–21; Lane, *Quito 1599*, 22–51; Cummins, "Three Gentlemen." The success of the mission was short-lived, for by 1605 many communities in Esmeraldas had rebelled and rejected Spanish rule. Conflicts continued throughout the first decades of the seventeenth century. See Gutiérrez Usillos, "Nuevas aportaciones," 22; and Charles Beatty Medina, "Caught between Rivals: The Spanish–African Competition for Captive Indian Labor in the Region of Esmeraldas during the Late Sixteenth and Early Seventeenth Centuries," *The Americas* 63, no. 1 (2006): 125–132.

4. "el anillo que faltaba de la cadena histórica del arte quiteño [. . .] fundador nato del arte ecuatoriano" and "un gran artista ignorado que merece la inmortalidad." Navarro, *Artes plásticas ecuatorianas*, 164, 166; Navarro, "Un pintor quiteño," 449.

5. Navarro, "Un pintor quiteño."

6. "Pero, ¿quien era Sánchez Gallque? Era tal vez de la familia de Juan Sánchez de Xerex Bohorquez [. . .] hijo del español Juan Sánchez de Xerex uno de los primeros conquistadores y de los primeros y ricos vecinos de Quito." Navarro, *La pintura en el Ecuador*, 34.

7. Vargas, *El arte ecuatoriano*, 33.

8. Vargas, *Patrimonio artístico*, 68; Rappaport and Cummins, *Beyond the Lettered City*, 208–209. Vargas and others identify the initials APB on this choir book illumination as those of Fray Pedro Bedón. As noted in the previous chapter, the friar's patrilineal surnames were Bedón de Agüero, and he was known to sign letters using both these surnames. See Vargas, *Biografía de Fray Pedro Bedón*, 18–20.

9. Navarro, *La pintura en el Ecuador*, 33. Luis Paucar is identified in this document as a saddlemaker (*sillero*). Diego Tutillo appears in contemporary documents as an embroiderer (*bordador*). ANH/Q, Notaría 6a, vol. 19, 1612, Diego Rodríguez Docampo, fols. 343v–344v.

10. Mesa and Gisbert, "The Painter," 387. Pedro Querejazu Leyton reads the date on the inscription as 1609. Querejazu Leyton, "El arte quiteño y ecuatoriano en la Audiencia de Charcas y en Bolivia," in *El arte quiteño más allá de Quito* (Quito: FONSAL, 2010), 239. The correct date of 1605 is cited by Mesa and Gisbert, "The Painter," 387; Navarro, *La pintura en el Ecuador*, 45; and Cummins, "Three Gentlemen," 128. Although Sánchez Gallque did not inscribe his first name as a device in this painting, he nonetheless employed a sophisticated form of abbreviation used by scribes and notaries: the N in "ANDRES" is removed and replaced by a suspension sign (tilde) indicating the omission (A˜DRES), he used superscript letters in his abbreviation "Q^to," and the abbreviation "FAC." for the Latin *faciebat* (was making this).

11. Navarro, *La pintura en el Ecuador*, 35; Querejazu Leyton, "El arte quiteño," 239; Cummins, "Three Gentlemen," 128–129. Some authors make no mention of the signed 1605 painting in Bolivia, while others treat Sánchez Gallque's triple portrait as the only known work by the artist. For the latter case, see Elizabeth P. Benson, *Retratos: 2,000 Years of Latin American Portraits,* exh. cat. (New Haven, CT: Yale University Press, 2004), 115; and Gutiérrez Usillo, "Nuevas aportaciones," 27. Several authors cite an additional work reportedly by Sánchez Gallque, located in a Chilean collection: a small painting titled *Inocencia*. However, the painting is unsigned, and the reasons for its attribution to Sánchez Gallque are unclear. See Navarro, *La pintura en el Ecuador*, 36.

12. For Morales's painting and related works, see Pérez Sánchez and Sánchez-Lassia de los Santos, *Las lágrimas de San Pedro*, 17, 34–35.

13. Mesa and Gisbert, *El manierismo en los Andes*, 90; Nieri Galindo, *Pintura en el Virreinato*, 152. The Museo del Banco de la República in Bogotá possesses a large canvas painting of the *Lágrimas de San Pedro* (called *El señor de la columna*), which is unsigned but is identified and listed as the work of Angelino Medoro (*see fig. 5.2*). http://www.banrepcultural.org/coleccion-de-arte-banco-de-la-republica/obra/el -señor-de-la-columna.

14. For an illustration of one of these works, see Navarro, *La pintura en el Ecuador*, figure 12. Navarro attributed but did not describe the replica panel, although he subsequently attributed to Sánchez Gallque and described at great length a series of paintings depicting Franciscan tertiary monarchs, none of which are signed by the artist or otherwise documented as his work. Navarro, *La pintura en el Ecuador*, 35–38.

15. Stratton-Pruitt, *The Art of Painting*, 6.

16. See, for example, the illustrations of this theme reproduced in Stratton-Pruitt, *The Art of Painting*, 6; and Navarro, *La pintura en el Ecuador*, 45, 147.

17. José María Vargas published one of these contracts in 1978, and the others have only recently come to light. Vargas, "Andrés Sánchez Gallque," *Revista de la Universidad Católica* 4, no. 19 (1978): 25; Webster, "Of Signatures and Status," 614–618.

18. For additional discussion of the contract, see Vargas, "Andrés Sánchez Gallque," 25; Lepage, "El arte de la conversión," 66–73; Lane, *Quito 1599*, 237n2; and Webster, *Quito, ciudad de maestros*, 29.

19. ANH/Q, Notaría 1a, vol. 3, 1588–1594, Diego Lucio de Mendaño, fols. 317v–318v.

20. "todo el oro y colores y todo lo demas materiales que fueren menester." ANH/Q, Notaría 1a, vol. 3, 1588–1594, Diego Lucio de Mendaño, fol. 318r.

21. ANH/Q, Notaría 1a, vol. 3, 1588–1594, Diego Lucio de Mendaño, fols. 317v–318r.

22. For this analysis, see Lepage, "El arte de la conversión," 66–73.

23. "El d[ic]ho andres sanchez a de poner carpinteros y oficiales." For *maestros de obra*, see Susan Verdi Webster, "Vantage Points: Andeans and Europeans in the Construction of Colonial Quito," *Colonial Latin American Review* 20, no. 3 (2011), 303–330.

24. Lepage, "El arte de la conversión," 66.

25. ANH/Q, Notaría 6a, vol. 10, 1601, Diego Rodríguez Docampo, n.p.

26. "que los jueves S[an]tos de cada semana S[an]ta se haga de noche una general Proçession de Sangre en peniten[ci]a de los pecados Cometidos contra la mag[esta] d de dios n[uest]ro s[eño]r." ANH/Q, Notaría 6a, vol. 10, 1601, Diego Rodríguez Docampo, fols. 330r–331r.

27. "en ella van todos los penitentes y dejan a la de la Vera Cruz ynstituyda para este fin sola y sin ningund acompañamiento." Ibid., fol. 330v.

28. ANH/Q, Notaría 6a, vol. 10, 1601, Diego Rodríguez Docampo, fols. 558r–559r. "una figura de un xpo excseomo en Pie y desnudo de estatura de siete palmos de alto con su peana de madera ynclinada la caueca al cielo en la bestidura en Las manos [. . .] en tiempo y espacio de quatro meses [. . .] a contento del padre frai pedro bedon [. . .] y de los oficiales de la dha cofradia [. . .] a de dar y pagar nouenta pessos De Plata." Fernández's ethnicity is not specified in this contract, indicating that he was Spanish or Creole. His signature appears at the end of the document.

29. "de hazer para la d[ic]ha cofradia un christo Coronado con los sayones del paso todo en sesenta rreales [. . .] la qual hechura dara acauada para el domingo de rramos de este presente ano." ANH/Q, Notaría 6a, vol. 15, 1605–1606, Diego Rodríguez Docampo, fols. 38v–39r. The amount of "sixty reales" cited in this passage was corrected subsequently in the document to read "sixty patacones," a much more realistic value for the works. Juan del Castillo inscribed his elegant signature on the abovementioned document (*see fig. 1.2b*).

30. Navarro, *La pintura en el Ecuador*, 35.

31. In 1601, the same year as the lost contract with Sánchez Gallque, the confraternity commissioned a sculpture of the Ecce Homo from the Spanish or Creole artist Antonio Fernández. ANH/Q, Notaría 6a, vol. 10, 1601, Diego Rodríguez Docampo, fols. 558r–559r. In 1606, the confraternity contracted the Andean sculptor Juan del Castillo "yndio oficial pintor y entallador" to create processional sculptures representing Christ crowned with thorns and the figures of his tormentors (*sayones*). ANH/Q, Notaría 6a, vol. 15, 1605–1606, Diego Rodríguez Docampo, fols. 38v–39r. During the seventeenth century, the confraternity possessed a set of processional sculptures representing Christ at the column with a figure of the repentant Saint Peter, further highlighting this subject as one of its principal devotions. The sculptures can be seen today in the Monastery of San Francisco.

32. "una ymagen y hechura de n[uest]ra s[eño]ra de los rreyes donde esta s[an]t josef y los tres Rreyes magos y un angel y un buey y un asno y un camello de pincel al olio de muy buenos y bibos colores de una y tres quartas de alto." ANH/Q, Notaría 1a, vol. 53, 1608, Alonso López Merino, fol. 248v.

33. "pintado por un indio muy diestro en este arte." Jouanen, *Historia de la Compañía*, vol. 1, 72.

34. Jouanen does not cite his source for this information; however, this section of his text draws on Manuel Rodríguez's *El Marañon y Amazonas* (Madrid, 1684) and unspecified seventeenth-century documents from the Jesuit archives.

35. When the Jesuits were expelled from Quito in 1767, their possessions were distributed among numerous churches in the city and throughout the lands administered by the *audiencia*.

36. The category "ladino" was neither fixed nor neutral, although bilingualism was a principal feature. As Rappaport and Cummins and others have observed, "ladino was a slippery classification" that could include mestizos and others, and could also possess negative connotations. *Beyond the Lettered City*, 39–44. See also Rolena Adorno, "Images of *Indios Ladinos* in Early Colonial Peru," in *Transatlantic Encounters: Europeans and Andeans in the Sixteenth Century*, ed. Kenneth J. Andrien and Rolena Adorno, (Berkeley: University of California Press, 1991), 232–270.

37. Webster, "Of Signatures and Status," 619–624.

38. ANH/Q, Notaría 1a, vol. 147, 1633, Gerónimo de Heredia, fols. 166r–168v; ANH/Q, Notaría 1a, vol. 160, 1638, Diego Bautista, fols. 346r–347r.

39. ANH/Q, Notaría 1a, vol. 147, 1633, Gerónimo de Heredia, fol. 166r; ANH/Q, Notaría 1a, vol. 160, 1638, Diego Bautista, fols. 346r–347r. A 1633 document in which Sánchez Gallque's widow, Barbara Sactichug, and her two sons, Don Francisco Sánchez and Matheo Galquín, sold one *caballería* of land in Zámbiza, specifies their identities, familial relationship, and honorific titles, as well as their title to the land. ANH/Q, Notaría 1a, vol. 147, 1633, Gerónimo de Heredia, fol. 166r. A 1638 document records that Sánchez Gallque's widow and her son Francisco signed a promissory note to repay the sum of thirty *patacones* to an indigenous woman, Beatriz Cusichimbo, and again specifies their identities, titles, and familial relationship. ANH/Q, Notaría 1a, vol. 160, 1638, Diego Bautista, fol. 346r.

40. ANH/Q, Notaría 5a, vol. 5, 1617–18, Gerónimo de Castro, fols. 242v–243v; ANH/Q, Notaría 1a, vol. 112, 1625–1626, Diego Bautista, fol. 126v. The reference to Bernabé Simon's property in San Roque appears in a 1625 document concerning the sale of another plot of land in the parish by Marcos de la Cruz "cacique principal de la parroquia de san roque." ANH/Q, Notaría 1a, vol. 112, 1625–1626, Diego Bautista, fol. 126v.

41. ANH/Q, Notaría 1a, vol. 107, 1624, Gerónimo de Heredia, fols. 775r–776v; ANH/Q, Notaría 1a, vol. 147, 1633, Gerónimo de Heredia, fol. 166r.

42. AHN/Q, Notaría 6a, vol. 11, 1602, Diego Rodríguez Docampo, fols. 480r–481v.

43. "que lindan por una parte con tierras de dona mençia mi hermana y quebrada en medio con tierras de miraflores y con otras mias." Ibid., fol. 480r.

44. ANH/Q, Notaría 6a, vol. 11, 1602, Diego Rodríguez Docampo, fols. 482r–483r.

45. ANH/Q, Notaría 1a, vol. 53, 1608, Alonso López Merino, fols. 593v–594r.

46. ANH/Q, Notaría 1a, vol. 160, 1638, Diego Bautista, fols. 346r–347r. Pesos and *patacones* were the silver coins of highest value during the colonial period, and were equivalent in weight and value. Each could be divided into eight (or more rarely nine) *reales*. See Tamara Estupiñan Viteri, *Diccionario básico del comercio colonial quiteño* (Quito: Ediciones del Banco Central del Ecuador, 1997), 262.

47. "biuda muger que fuy de andres sanchez Gallque pintor difunto." ANH/Q, Notaría 1a, vol. 163, 1639, Diego Bautista, fols. 198r–200v. Barbara Sasticho's relative, the painter Cristóbal Chumbiñaupa, lived in a tile-roofed house on an extensive property that adjoined the plaza of the Recoleta de San Diego in the parish of San Roque. ANH/Q, Notaría 1a, vol. 186, 1647, Diego Bautista, fols. 170r–170v. Cristóbal's brother, the Andean painter Gerónimo Chumbiñaupa, acquired in 1632 and 1633 a house, garden, and a substantial piece of property alongside that of his brother, for which he paid the impressive price of four hundred pesos for the house alone. ANH/Q, Notaría 1a, vol. 142, 1632, Gerónimo de Heredia, fols. 401r–402v; ANH/Q, Notaría 1a, vol. 147, 1633, Gerónimo de Heredia, fols. 468r–470v. Their houses and landholdings indicate that the Chumbiñaupas made quite a good living from their profession. As noted in the previous chapter, it is likely that the painter "Cristóbal Naupa" cited by Vargas as a member of the Cofradía del Rosario de los Naturales is the same painter who appears in these documents as Cristóbal Chumbiñaupa. Vargas, *El arte ecuatoriano*, 33.

48. ANH/Q, Notaría 6a, vol. 40, 1631, Juan Martínez Gasco, fols. 122r–123r.

49. Waldemar Espinoza Soriano, "La vida pública de un príncipe Inca residente en Quito, siglos XV y XVI," *Boletín del Instituto Francés de Estudios Andinos* 7, nos. 3–4 (1978): 1–31; and Burgos Guevara, *El guamán*, 244.

50. "la portada de piedras labradas que tengo y esta armada En las casas que fueron de don Francisco auqui mi abuelo que me pertenezcan por donaçion que me hizo doña beatriz ango mi abuela." ANH/Q, Notaría 5a, vol. 3, 1609, Gerónimo Pérez de Castro, fols. 473v–475r. For a more extensive discussion of this contract, see Webster, "Vantage Points," 314–315; and Webster, *Quito, ciudad de maestros*, 50–51.

51. "andres sa[nche]z pintor y don marcos y don fran[cis]co morocho y Francisco lisana y joan bazquez yndios parroquianos della d[ic]ha parroquia." ANH/Q, Notaría 5a, vol. 3, 1609, Gerónimo Pérez de Castro, fol. 474r.

52. Webster, *Quito, ciudad de maestros*, 76–77.

53. Navarro, *La pintura en el Ecuador*, 33.

54. ANH/Q, Notaría 1a, vol. 173, 1643, Diego Bautista, fol. 108r. On 14 March 1643, Miguel de Fletes sold a plot of land in San Roque to Beatriz Sánchez (was she related to Sánchez Gallque?), which was bounded by that of "los herederos de andres sa[nche]z pintor i de juan bazquez i de don marcos." ANH/Q, Notaría 1a, vol. 173, 1643, Diego Bautista, fol. 108r. This document, in conjunction with others, makes it clear that the land owned by "Don Marcos," who was undoubtedly Marcos de la Cruz, cacique *principal* of San Roque, bordered the properties owned by the heirs of Sánchez Gallque and Bernabé Simón.

55. These artists constitute another of Navarro's "missing links" in the chain of Quito's early colonial painters that the historian fervently hoped would lead to the power and authority of the most renowned Quiteño painter of the second half of the seventeenth century, Miguel de Santiago. For Miguel de Santiago in the history of colonial painting in Quito, see especially Navarro, *La pintura en el Ecuador*, 66–97; Vargas, *Patrimonio artístico*, 113–120; Justo Estebaranz, *Miguel de Santiago*; and Justo Estebaranz, *El pintor quiteño*.

56. See the 1577 account of Domingo de Orive in *Relaciones Histórico-Geográficas*, 1:256.

57. Ana Martínez Pereira, "Los manuales de escritura de los Siglos de Oro: problemas bibliográficos," *Litterae: Cuadernos sobre Cultura Escrita* 3–4 (2003–2004): 133–160; Aurora Egido, "Los manuales de escribientes desde el Siglo de Oro [Apuntes para la teoría de la escritura]," *Bulletin Hispanique* 97, no. 1 (1995): 67–94; Jessica Berenbeim, "Script after Print: Juan de Yciar and the Art of Writing," *Word & Image: A Journal of Verbal and Visual Enquiry* 26, no. 3 (2010): 231–243.

58. Egido, "Los manuales de escribientes," 76–82.

59. José Torre Revello, "Algunos libros de caligrafía usados en México en el siglo XVII," *Historia Mexicana* 5, no. 2 (1955): 220–227.

60. ANH/Q, Notaría 1a, vol. 18, 1601, Francisco García Durán, fol. 24r.

61. AHBCE, JJC .00195, 1552–1571, Jácome Freile, fols. 790r–795r, 833v–834v; 837rv; 833r–834r; AHBCE, JJC .00207, 1621–1622, Diego Suárez de Figueroa, s.f.; ANH/Q, Notaría 1a, vol. 18, 1601, Francisco García Durán, fols. 24r, 27v; ANH/Q, Notaría 1a, vol. 13, 1600, Alonso Dorado de Vergara, fols. 1099v, 1105v.

62. Berenbeim, "Script after Print," 231.

63. Juan de la Cuesta, "Tratado de bien y perfetamente escrivir, assi de la verdadera practica para la buena pintura y figura de la letra, como de los aditamentos y particularidades, necessarias para la escritura," in *Libro y tratado para enseñar leer y escrevir* (Alcalá, 1589), 25, 38, 39, 42, 45.

64. "Pero no quiero contar agora cuantos hijos de carpinteros y herreros, y otros de este jaez han subido en nuestros tiempos a grandes Señores, y a cuantos ha sido illustrísimo principio de su linaje la buena pluma: por que hay tantos y son tan frescos

que diría aquí lo que todo el mundo sabe." Pedro de Madariaga, *Libro subtilísimo titulado honra de escribanos* (Valencia: Juan de Mey, 1565), 35v.

65. Carol D. Harllee, "Pull Yourself Up by Your Inkwell: Pedro de Madariaga's *Honra de Escribanos* (1565) and Social Mobility," *Bulletin of Spanish Studies* 85, no. 5 (2008): 545–567; Egido, "Los manuales de escribientes," 80.

66. For Madariaga, see Abraham Esteve Serrano, "El 'Libro subtilissimo intitulado honra de escrivanos' de Pedro de Madariaga," in *Homenaje al Prof. Muñoz Cortés* (Murcia: Universidad de Murcia, Facultad de Filosofía y Letras, 1977), 151–163; Rafael Malpartida Tirado, "Confluencia de modalidades dialogales en la *Honra de escribanos* de Pedro de Madariaga," *Lectura y Signo* 1 (2006): 105–124; Harllee, "Pull Yourself Up," 545–567.

67. Henry Thomas, "Juan de Vingles (Jean de Vingle), a Sixteenth-Century Book Illustrator," *The Library* 18, no. 2 (1937): 121–156.

68. Berenbeim, "Script after Print," 231.

Chapter 7: Later Generations, 1615–1650

1. The painter Mateo Mexía is first documented in 1612, and he signed and dated two canvases in 1615. Nonetheless, he is included among the later generations because his professional career developed over the first half of the seventeenth century. Mexía's life and work form the subject of chapter 8.

2. Mexía may well have been mestizo; however, none of the documents identify him as such, despite the fact that notaries frequently employed the term during this period. Such soci[racial categories appear to have become more fluid and unstable as visible indicators of ethnicity or ancestry grew more difficult to identify. Ethnicity came to be asserted and proclaimed by means other than physical appearance, and "passing" became more common among those of varied ancestry. Unless the notary had direct knowledge of the ancestry of the person in question, dress, speech, and literacy became the factors employed to legally "identify" the individual. On "passing," see especially Joanne Rappaport, *The Disappearing Mestizo: Configuring Difference in the Colonial New Kingdom of Granada* (Durham, NC: Duke University Press, 2014), 29–60.

3. Table 7.1 lists unlettered status only for those painters who were party to contracts and requested that a witness sign in their stead because they did not know how. Painters who were not the principal party to contracts and therefore not required to sign are indicated by a blank space in the "literacy" column.

4. "por la lengua e ynterpretaçion de Lorenço ygnaçio ofiçial pintor ladino en la lengua castellana y del ynga que juro ser la contenida a la dha dona ana tucto." ANH/Q, Notaría 6a, vol. 40, 1631, Juan Martínez Gasco, fols. 122r–123r.

5. "enseñar a leer escreuir y Cantar a los muchachos de la d[ic]ha parroquia." ANH/Q, Notaría 1a, vol. 138, 1631–1632, Diego Bautista, fols. 204r–204v.

6. The Recoleta of San Diego was founded in 1597 and constructed in the first decade of the seventeenth century. The complex was adorned with elaborate *artesonado* ceilings, numerous altarpieces, and extensive mural paintings. See Alexandra Kennedy Troya and Alfonso Ortiz Crespo, *Convento de San Diego de Quito: historia y restauración* (Quito: Banco Central del Ecuador, 1982), 26–37.

7. For the Andean painter Francisco Cúpido in San Roque, see ANH/Q, Notaría 1a, vol. 121, 1627–1628, Diego Bautista, fols. 403r–403v; ANH/Q, Notaría 1a, vol. 154, 1636, Diego Bautista, fols. 100v, 128v–129v. For the Andean master painter Gabriel

Vásquez, a native of Saquisilí and resident in San Roque (not to be confused with the Spanish or Creole *batihoja* and silversmith Gabriel Vázquez), see ANH/Q, Notaría 1a, vol. 185, 1647–1649, Francisco de Atienza, fols. 355r–356r.

8. For documents related to Don Francisco Sánchez, "pintor" and "maestro pintor," and Matheo Galquín, "pintor," sons of Sánchez Gallque, see ANH/Q, Notaría 5a, vol. 15, 1632–1633, Gerónimo de Castro, fols. 494r–494v; ANH/Q, Notaría 1a, vol. 147, 1633, Gerónimo de Heredia, fols. 166r–168v; ANH/Q, Notaría 1a, vol. 160, 1638, Diego Bautista, fols. 346r–347r.

9. "para suplir nuestras necesidades." ANH/Q, Notaría 1a, vol. 160, 1638, Diego Bautista, fols. 346r–347r.

10. ANH/Q, Notaría 1a, vol. 163, 1639, Diego Bautista, fols. 198r–200v.

11. ANH/Q, Notaría 1a, vol. 163, 1639, Diego Bautista, fols. 198r–200v. Barbara Sasticho, "viuda de Andres Sanchez Gallque pintor difunto," sold two plots of land near her residence in San Roque to Antón Talabera, noting that, "y porque no hay calle para entrar a las tierras, me obligo darsela por la tierra de Cristobal Chumbinaupa pintor, *mi deudo*, desde la dha calle a las dhas tierras, que por ella pueda pasar un caballo cargado." Italics mine.

12. For the location of Bernabé Simón's residence in the elite indigenous neighborhood near the residence of the descendants of Atahualpa, see ANH/Q, Notaría 5a, vol. 5, 1617–1618, Gerónimo de Castro, fol. 242v–243r; ANH/Q, Notaría 1a vol. 112, 1625–1626, Diego Bautista, fols. 126v–127v.

13. ANH/Q, Notaría 1a, vol. 107, 1624, Gerónimo de Heredia, fols. 775r–776v.

14. ANH/Q, Notaría 1a, vol. 88, 1617–1618, Alonso Dorado Vergara, fols. 306r–307v.

15. ANH/Q, Notaría 1a, vol. 121, 1627–1628, Diego Bautista, fol. 145r; ANH/Q, Notaría 1a, vol. 121, 1627–1628, Diego Bautista, fol. 145r–145v; ANH/Q, Notaría 1a, vol. 121, 1627–1628, Diego Bautista, fols. 257r–257v; ANH/Q, Notaría 1a, vol. 174, 1643–1645, Francisco Atienza, fols. 175r–177v.

16. ANH/Q, Notaría 1a, vol. 138, 1631–1632, Diego Bautista, fols. 204r–204v.

17. ANH/Q, Notaría 1a, vol. 142, 1632, Gerónimo de Heredia, fols. 401r–402v. Alejo Guanolima, "yndio tejedor," and his son, Lorenzo Díaz, "yndios ladinos," sold for 280 *patacones* to Gerónimo Chumbiñaupa "yndio pintor" "medio solar de tierra y una cassa de teja [. . .] en el barrio de San diego y parrochia de San rroque [. . .] por la frente con la plaçeta de la yglesia del comu[en]to de San diego." That Cristóbal and Gerónimo were brothers is registered in ANH/Q Notaría 1a, vol. 186, 1647, Diego Bautista, fols. 170r–170v. In this document, Cristóbal sold land in San Roque "que hube de Geronimo chumbinaupa mi hermano."

18. ANH/Q, Notaría 1a, vol. 147, 1633, Gerónimo de Heredia, fols. 468r–470v.

19. ANH/Q, Notaría 4a, vol. 2, 1647, Diego Hernández, fols. 4r–5v.

20. Archivo del Monasterio de Santa Catalina (hereafter AMSC/Q), "Limosna de cofradías," 1645–ca.1700, fol. 15v.

21. ANH/Q, Notaría 1a, vol. 94, 1621, Álvaro Arias, fols. 568r–568v. Other Andean signatories included Domingo Rimache (*herrero*), Juan Punga (*herrero*), Gaspar Domínguez (*sastre*), Francisco Cayllao [Cayllagua] (*carpintero*), Don Marcos de la Cruz, and his father Jorge de la Cruz (*albañil, arquitecto*), who brought the lawsuit "por nos y por todos los yndios de la parrochia de san Roque."

22. For the genealogy of the elite Quispe clan in Quito, see Fernando Jurado Noboa, *Diccionario histórico genealógico de apellidos y familias de origen quechua, aymara y araucano (Ecuador)* (Quito: Temístocles Hernández, 2002), 168–169.

23. ANH/Q, Notaría 1a, vols. 18–19, 1601, Francisco García Durán, fol. 187r; ANH/Q, Notaría 1a, vol. 10, 1598, Diego Bravo de la Laguna, fol. 126r. Several years earlier, in 1587, the city council recognized the *marca de hierro* (branding iron mark) belonging to Pedro Quispe. *Libro de proveimientos*, 140.

24. Jurado Noboa, *Diccionario histórico*, 168.

25. ANH/Q, Notaría 1a, vol. 103, 1623, Gerónimo de Heredia, fols. 563r–563v.

26. ANH/Q, Notaría 1a, vol. 128, 1629, Gerónimo de Castro, fols. 616v–620v. The property is described as "poco mas de medio solar de tierra con vna casa cubierta de paja y su guerta y unas paredes nuebas para hazer otra casa y toda la madera de bigas tixeras magueyes esteras texa y ladrillo necesario para hazerlo."

27. ANH/Q, Notaría 1a, vol. 160, 1638, Diego Bautista, fols. 533r–535v.

28. For María Pasña as the daughter of Pedro Quispe, niece of Clemente Quispe, and wife of Mateo Mexía, see ANH/Q, Notaría 1a, vol. 154, 1636, Diego Bautista, 254v–255v. The location of Pasña and Mexía's residence relative to that of Clemente Quispe is established in this document.

29. For the *linderos* that locate Clemente Quispe's residence, and those of the other elite Andean artisans, alongside lands of the descendants of Atahualpa, see ANH/Q, Notaría 1a, vol. 138, 1631–1632, Diego Bautista, fols. 19v–20r.

30. ANH/Q, Notaría 1a, vol. 138, 1631–1632, Diego Bautista, fols. 204r–204v.

31. For an illustration, see Navarro, *La pintura en el Ecuador*, 19. In 1732, an Andean journeyman sculptor named Alexandro Quispi (an alternate spelling of Quispe), age twenty-four, was recorded on the census of the parish of San Roque as the legitimate son of Pedro Quispi and Jacinta Sánchez, living with his parents in their own house in the neighborhood of the Recoleta de San Diego. He is almost certainly one of the descendants of Clemente, Pedro, or Francisco Quispe. ANH/Q, Indigenas, caja 45, 1732–1733, expte. 11-III-1732, fol. 1v.

32. AHBCE, JJC .00208, 1621–1622, Juan del Castillo, fols. 210v–212r. This document records the sale of land in San Roque between two Andeans unrelated to Zúñiga; however, like most contracts of this type, it specifies the names of those whose land bounded the parcel in question (*linderos*). In this case, the *linderos* included "Diego de Zúñiga maestro pintor."

33. "cofradia de san lucas fundada en el combento de san fran[cis]co de los naturales." ANH/Q, Notaría 5a, vol. 80, 1685–1687, Francisco Dionisio de Montenegro, fol. 214v. The phrase "el combento de san fran[cis]co de los naturales" refers to the separate chapel known at the time as that of the Vera Cruz, where the Andean Confraternity of the Vera Cruz was established. The chapel is now known as that of Cantuña. See Susan V. Webster, "The Devil and the Dolorosa: History and Legend in Quito's Capilla de Cantuña," *The Americas* 67, no. 1 (2010): 1–30.

34. "el d[ic]ho mi marido difunto me Dixo en Vida que una piedra de moler colores de pintura tubiesen entre ambos hermanos los d[ic]hos mis hijos y asi lo declaro [. . .] declaro que tengo una s[an]ta ymajen de n[uest]ra s[eño]ra del rrosario en lienço de bara y media de alto [. . .] declaro que herede del d[ic]ho mi marido difunto una ymajen pequeña de n[uest]ra s[eño]ra de los angeles en tabla [. . .] Vna santa Ymagen su adbocaçion de n[uest]ra s[eño]ra de oyacachi mediana de bulto de tres quartas de alto por dorar y encarnar la qual erede del d[ic]ho mi marido [. . .] siete molduras y seis tablitas por pintar [. . .] nobenta y seis estanpas nuebas y biejas chicas y grandes de diferentes pinturas [. . .] una hechura de san joseph pequeño en bulto = mas otra de s[a]n ant[oni]o pequeño = mas otra hechura de s[a]n fran[cis]

co pequeño - por acabar de escultar [. . .] tres tablas por labrar las dos algo anchas y la una angosta [. . .] seis maderas por labrar [. . .] un trosso de sedro para escultura q[ue] costo doçe rreales. " ANH/Q, Notaría 5a, vol. 80, 1685–1687, Francisco Dionisio de Montenegro, fols. 214r–217r.

35. ANH/Q, Notaría 1a, vol. 145, 1632–1633, Álvaro Arias, fols. 435v–437v.

36. ANH/Q, Notaría 5a, vol. 80, 1685–1687, Francisco Dionisio de Montenegro, fols. 218r–220v.

37. "hijo mayor y legitimo de Don Diego de Suniga mi p[adr]e difunto naturales del pueblo de Tumbaco y rresidentes en la parrochia de san rroque." ANH/Q, Notaría 5a, vol. 80, 1685–1687, Francisco Dionisio de Montenegro, fol. 218r.

38. In 1672, Don Ventura de Zúñiga "yndio escultor" purchased a thatched house and land in San Roque near the Franciscan Recoleta de San Diego. ANH/Q, Notaría 5a, vol. 64, 1672, Juan de Arce, fols. 105v–106r. Decades later, in 1698, Don Ventura de Zúñiga, "maestro escultor," acquired an additional residence in the same sector of the parish. ANH/Q, Notaría 1a, vol. 279, 1698, Antonio López de Urquía, fols. 21r–22v.

39. ANH/Q, Notaría 1a, vol. 174, 1643–1645, Francisco Atienza, fols. 190r–191v.

40. ANH/Q, Notaría 1a, vol. 147, 1633, Gerónimo de Heredia, fols. 675r–675v.

41. ANH/Q, Notaría 6a, vol. 48, 1636, Juan Martínez Gasco, fols. 620v–621r.

42. "poner el oro bol estof[ad]o y encarnar las figuras, y darlo acauado y muy bien obrado de todo punto poniendo todos lo demas neces[ari]o para ello." ANH/Q, Notaría 1a, vol. 154, 1636, Diego Bautista, fols. 369r–369v.

43. "a seruir [. . .] En el d[ic]ho ofiçio por tiempo y espaçio de quatro años [. . .] y si asistiere durante los d[ic]hos quarto años y no le diere ofiçial se oblige el d[ic]ho francisco perez sanguino a pagarle lo que un ofiçial del d[ic]ho arte ganare." ANH/Q, Notaría 6a, vol. 48, 1636, Juan Martínez Gasco, fols. 620v–621r.

44. "de yr desde luego a la villa de Riobamba [. . .] y en ella el d[ic]ho antonio sanchez a de labrar a su costa y expensas todo el oro batido que el d[ic]ho francisco perez sanguino hubiere menester para dorar el rretablo y sagrario que tiene consertado con las monjas de la d[ic]ha villa." ANH/Q, Notaría 1a, vol. 189, 1648–1649, Juan García Moscoso, fols. 95r–95v. Although the order of nuns that commissioned Pérez Sanguino is not specified, the only convent of nuns in Riobamba during the seventeenth century was that of the Immaculate Conception. See Rosemarie Terán Najas, ed., *La antigua Riobamba: historia oculta de una ciudad colonial* (Riobamba: Municipio de Riobamba, 2000), 38, 53, 57, 67–70.

45. "por dorar los artesones del claustro y molduras de los liensos a q[uen]ta de tres mill en q[ue] esta consertado [. . .] por dorar y estofar el retablo del claustro de la tota pulcra." AHOME, C. VI, 6.4, 1644–1656, "Libro de gastos," fols. 243v, 263r.

46. José Gabriel Navarro, "Datos tomados del archivo de la Merced," no. 2, Año de 1654, fols. 181r, 183v, unpublished manuscript in the collection of Ximena Carcelén; Navarro, *Contribuciones* 2:28.

47. ANH/Q, Notaría 5a, vol. 35, 1644, Juan de Heredia, fols. 340r–340v.

48. ANH/Q, Notaría 1a, vol. 161, 1638–1639, Juan de Peralta, fols. 40v–42r. For Diego Lima [Tandapaqui], see ANH/Q, Notaría 1a, vol. 143, 1632, Diego Rodríguez Docampo, fols. 530v–532r.

49. ANH/Q, Notaría 1a, vol. 143, 1632, Diego Rodríguez Docampo, fols. 530v–532r. Miguel de Aguirre owned an *obraje* in the nearby town of Pomasque, and undoubtedly intended to sell his wares in Caracas for export abroad. Lima's involvement suggests that Aguirre may have sold paintings, as well. In 1630, just two years before

the contract with Diego Lima, Miguel de Aguirre commissioned the Andean painter Miguel Ponce to create twenty-seven paintings of the life of San Francisco, which he also may have intended to sell outside of Quito. ANH/Q, Notaría 1a, vol. 137, 1630, Diego Rodríguez Docampo, fols. 822v–824r.

50. ANH/Q, Notaría 1a, vol. 194, 1651, Pedro Pacheco, fols. 412r–413v.

51. This property bordered "por debajo con el tejar de los jesuitas," whose buildings were located at the base of the hill known as the Panecillo, very near the parish border with San Roque. ANH/Q, Notaría 1a, vol. 194, 1651, Pedro Pacheco, fol. 412v. Vásquez is identified here as "maestro pintor yndio natural de saquisili."

52. For seventeenth-century biographies of Hernando de la Cruz, see Diego Rodríguez Docampo, "Descripción y relación del estado eclesiástico del Obispado de San Francisco de Quito [1650]," in *Relaciones Histórico-Geográficas*, 2:278; Jacinto Morán de Butrón, *La Azucena de Quito, que broto el florido campo de la Iglesia en las Indias Occidentales de los Reynos del Perú* (Madrid: Imprenta de Don Gabriel del Barrio, c. 1724), 259–268; Pedro de Mercado, *Historia de la Provincia del Nuevo Reino y Quito de la Compañía de Jesús* [late 17 c.] (Bogotá: Biblioteca de la Provincia de Colombia, 1957), vol. 3. For modern biographies, see especially Vargas, *Arte colonial*, 150–153; Teresa López de Villarino, *La vida y el arte del ilustre panameño Hernando de la Cruz S. J., 1591 a 1646* (Quito: La Prensa Católica, 1950).

53. "como se ve en los lienzos y cuadros que están en la Iglesia de la Compañía." Rodríguez Docampo, "Descripción y relación," 278.

54. "Era primoroso en este arte, y cuanto dibuxaba el pincel en el lienço, lo ideaba antes con la meditación, y oración. A su trabajo se deben todos los lienços que adornan la Iglesia, los transitos, y aposentos." Morán de Butrón, *La Azucena de Quito*, 262.

55. "que los muchísimos cuadros con que su diestro pincel enriqueció el temple y el Colegio Máximo fueron y son el mayor asombro del arte y el más inestimable tesoro." Juan de Velasco, quoted in Vargas, *Arte colonial*, 151.

56. "pintasse dos lienços muy grandes que están oy debaxo del Coro de nuestra Iglesia: en el que cae al lado de la Epistola del Altar mayor, puso un Infierno con horrendous, estraños, y rigurosos castigos de los miserables que gimen, y lloran obstinados por toda una eternidad su desventura. A otro lado, que es el del Evangelio, puso la Resurreccion de los predestinados, y la possession que se les dá de vna inacabable dicha de ver á Dios herederos de su Gloria. Pintólos con tanto primor, viveza, y diestra mano, que sin duda se la guíaba otra mas ponderosa, pues han sido estos dos lienços dos Predicadores tan eficaces, que sus mudas voces han causado conversiones prodigiosas." Morán de Butrón, *La Azucena de Quito*, 263–264.

57. For the copies of Cruz's paintings executed by Alejandro Salas in 1879, see Vargas, *El arte quiteño*, 122; Mireya Salgado Gómez, Carmen Fernández-Salvador, and Melissa Moreano, *Estructuración del orden social colonial en la región de Quito: Quito en el siglo XVII* (Quito: Museo de la Ciudad, 2007), 76. Vargas illustrates a detail of the painting depicting hell in *Arte colonial*, 150.

58. Vargas, *Arte colonial*, 150.

59. Morán de Butrón, *La Azucena de Quito*, 262–263. Morán de Butrón recounts that Cruz "siempre tuvo muchos discipulos, que publicaban con sus vidas las enseñanças del Maestro. Siempre que estaban ocupados en pintar servia uno de Lector leyendo vn libro spiritual, ò el mismo Hermano les hablaba cosas pertenecientes à sus almas, valiendose de la pintura para introducer el temor, y amor à Dios."

60. ANH/Q, Notaría 5a, vol. 33, 1643–1644, Juan de Heredia, fol. 40v.

61. ANH/Q, Notaría 1a, vol. 154, 1636, Diego Bautista, fols. 437v–439v. A document of 1598 records the scribal apprenticeship of the elder Felipe Méndez to the notary Diego Rodríguez Docampo, in which it is clear that Méndez penned the entire document. This is curious in light of the younger Méndez's unlettered status, indicating that his father did not teach him or see that he learned to read or write. ANH/Q, Notaría 6, vol. 9, 1598, Diego Rodríguez Docampo, fols. 761r–176v.

62. ANH/Q, Notaría 1a, vol. 86, 1616–1619, Alonso Dorado de Vergara, fol. 225v.

63. ANH/Q, Notaría 5a, vol. 63, 1670–1671, Joseph de Cabrera, fols. 98v–99r. Juan Guaman declares in this document that "el d[ic]ho pedaço de tierra le cupo entre quatro hermanos por herençia de Phelipe guaman su padre difunto." Interestingly, unlike his father, Juan Guaman was unlettered, and requested that a witness sign the contract on his behalf.

64. ANH/Q, Notaría 1a, vol. 135, 1630, Gerónimo de Heredia, fols. 183r–183v; ANH/Q, Notaría 1a, vol. 147, 1633, Gerónimo de Heredia, fols. 555r–555v.

65. Vargas, *Patrimonio artístico*, 68. Vargas does not specify the year(s) in which Gualoto was recorded as a member of the confraternity.

66. "para que con su prosedido se pueda dorar y pintar El rretablo que tiene la d[ic]ha cofradia y pagar a Don antonio gualoto yndio maesso dorador y pintor segun el conzierto que tienen hecho los mayordomos con el susodicho." ANH/Q, Notaría 5a, vol. 11, 1619–1620, Gerónimo de Castro, fol. 1340v.

67. "dorar un rretablo de la d[ic]ha coffradia que tienen armado," ANH/Q, Notaría 6a, vol. 47, 1635, Juan Martínez Gasco, fols. 1197r–1198r. The Augustinian monastery in Quito was dedicated to Nuestra Señora de Gracia.

68. "El oro y todos los demas materiales y ofiçiales los a de poner El d[ic]ho don antonio gualoto sin que los d[ic]hos mayordomos tengan obligacion de darle otra cossa." ANH/Q, Notaría 6a, vol. 47, 1635, Juan Martínez Gasco, fols. 1197v.

69. AHOME, C. VI, 6.4, 1644–1656, "Libro de gastos," fol. 256v. "Pagaronsele a don ant[oni]o gualoto dies p[esos] a q[uen]ta de 32 q[ue] se le aze de dar Por dorar estofar y encarnar la vir[ge]n de la tota pulcra"; AHOME, C. VI, 6.4, 1644–1656, "Libro de gastos," fol. 235v. "dieronsele a D Ant[oni]o gualoto treinte p[eso]s con q[ue] se le acabo de pagar el Retablo q[ue] doro en chillo"; and AHOME, C. VI, 6.4, 1644–1656, "Libro de gastos," fol. 233r. "dieronsele a D Ant[oni]o gualoto quatro patacones y dos R[eale]s, por estofar y Renobar el Retablo de S. Ramon."

70. "d[on] Ant[oni]o gualoto por dorar tres Retablos del claustro con su oro, y colores, y dorar juntamente tres bultos p[ar]a d[ic]hos Retablos y pintar los lienços del." AHOME, C. VI, 6.4, 1644–1656, "Libro de gastos," fol. 203v.

71. "En mil y seteçientos pesos que se dio al alferez Lorensso de Salazar por mill y ochoçientos y veinte y vn libros de oro que Entrego, y En quatro çientos Y treinta y seis pezos que a pagado al dho don antonio gualoto desde çiete de henero Del año de sesenta y quatro = y reçiuio assi mismo el dho don antonio onze Libras de bol En quarenta y quattro pezos que las dio vn deuoto Y solo se le Restan deuiendo al dho don antonio veinte pezos del conçierto." ANH/Q, Notaría 1a, Juicios, caja 2, expte. 8-VI-1664, fol. 1r.

72. Navarro notes that in the 1660s the Mercedarians undertook extensive construction and decoration in the church and cloisters of their monastery, including "gilding the cloisters." Navarro, *Contribuciones* 2, 28–29.

73. "dorar y pintar dos rretablos que estan en la ygleçia del d[ic]ho conuento y

capilla mayor en los cruzeros con tres arcos y los d[ic]hos arcos a de dar acauados conforme al que esta acauado en la d[ic]ha capilla mayor para fin de septiembre que biene [. . .] en Un mill y noueçientos pesos." ANH/Q, Notaría 5a, vol. 43, 1654–1655, Juan de Arce, fols. 134r–134v.

74. "el oro y todos los gastos de materiales y oficiales [. . .] hechos los andamios de maderaje para dorar y pintar los di[ch]os retablos y arcos." ANH/Q, Notaría 5a, vol. 43, 1654–1655, Juan de Arce, fol. 134r.

75. Again, Gualoto did not sign the contract "porque dixo no sauer escriuir." ANH/Q, Notaría 5a, vol. 43, 1654–1655, Juan de Arce, fol. 134v.

76. For Antonio Gualoto's numerous land acquisitions in the parish, all of which adjoined his own holdings, see ANH/Q, Notaría 5a, vol. 11, 1628, Gerónimo de Castro, fols. 1340v–1341r, 1341v–1342r; ANH/Q, Notaría 6a, vol. 49, 1637, Juan Martínez Gasco, fols. 635v–636r; and ANH/Q, Notaría 5a, vol. 54, 1664–1665, Diego de Betancurt, fol. 12r–13v.

77. For a description of Don Juan Gualoto's residence, which cost one hundred *patacones* (quite a high price for San Blas), see ANH/Q, Notaría 1a, vol. 130, 1629–1631, Juan del Castillo, fols. 402v–404r.

78. ANH/Q, Notaría 1a, vol. 162, 1639, Pedro Pacheco, fols. 182r–183v.

79. ANH/Q, Notaría 4a, vol. 14, 1656, Antonio de Verzossa, fols. 248r–249v.

80. For Pascual Gualoto, a master gilder and silversmith who worked in the neighboring parish of Santa Prisca during the early eighteenth century, see ANH/Q, Religiosas, caja 4, expte. 29-VI-1681, fols. 167v, 169v, 170r; ANH/Q, Religiosas, caja 8, expte. 14-VI-1696, fols. 22r, 23v, 24v; and Navas, *Guápulo y su santuario*, 208. For Cristóbal Gualoto "oficial pintor" in the first half of the eighteenth century, see ANH/Q, Notaría 6a, vol. 85, 1729–1733, Antonio López de Salcedo, fols. 94r–97r. For his work in the Church of Guápulo, see Navas, *Guápulo y su santuario*, 208; Vargas, *El arte ecuatoriano*, 65. For Manuel Gualoto, "escultor y carpintero," in the late eighteenth and early nineteenth centuries, see ANH/Q, Religiosas, caja 58, expte. 20-X-1798, fols. 2v–4v; and AHOME, C. VI, 6.16, 1781–1820, "Libro de gasto de la Mayordomía de Nuestra S[eño]ra de la Merced," fol. 31r.

81. "[en] mancomunidad otorgamos que nos obligamos de dorar un rretablo Para la iglecia de nuestra señora de Guadalupe y estofarlo y Pintarlo y esmaltarlo y acabarlo con toda Perfeccion conforme se nos diere Por orden del lisençiado Joan gonsales gordillo a satisfaction suya y de otras Perssonas oficiales del d[ic]ho arte." ANH/Q, Notaría 1a, vol. 162, 1639, Pedro Pacheco, fols. 182r–183v.

82. For an illustration of the painting, see Justo Estebaranz, *El pintor quiteño*, figure 61.

83. Navas, *Guápulo y su santuario*, 208; Vargas, *El arte ecuatoriano*, 65.

84. ANH/Q, Notaría 1a, vol. 155, 1636–1637, Juan del Castillo, fols. 169v–171r.

85. ANH/Q, Notaría 1a, vol. 188, 1648, Pedro Pacheco, fols. 554r–555v. Díaz made a tidy profit on this land, which he had originally purchased in 1647 for forty *patacones*, selling only a portion of it for fifty *patacones*.

86. ANH/Q, Notaría 6a, vol. 52, 1641, Juan Martínez Gasco, fols. 46r–47r.

87. "un quarto de casa sala baja cubierta de teja con un patio." ANH/Q, Notaría 1a, vol. 175, 1643–1650, Diego Rodríguez Urbano, fols. 513v–515v. During the seventeenth century, a number of other artisans in San Blas bore the surname Pillajo, indicating a dynasty of more varied professions. For example, the master gilder Don Juan Pillajo is documented as "cacique principal" of San Blas in 1652, and in 1665

Vicente Pillajo "yndio maestro platero" sold land in San Blas. ANH/Q, Notaría 5a, vol. 42, 1652–1653, Juan de Arce y Velarde, fols. 466v–467r; ANH/Q, Notaría 1a vol. 210, 1662–1665, Miguel de Ortega, fols. 123r–124v.

88. "dos cabezas manos y pies escultadas de Ntro. P. San Pedro Nolasco y San Ramón." AHOME, C. VI, 6.4, 1644–1656, "Libro de gastos," fols. 240r, 243v. The 1655 reference to sculpted heads, hands, and feet is from Navarro, "Datos tomados del archivo," no. 2, Año de 1654, fol. 59v.

89. ANH/Q, Notaría 1a, vol. 130, 1629–1631, Juan del Castillo, fol. 211r.

90. ANH/Q, Notaría 1a, vol. 129, 1629–1630, Diego Bautista, fols. 183r–184r. Ponce's land was a strategic corner lot, described as bordering on one side with the residence of padre Lucas Atienza, and on the others by two streets.

91. "la vida del señor san françisco conforme a otras veinte y siete estampas finas de papel que an de ser el modelo, segund y como en ellas estan sin que falte cossa ninguna de ellas [. . .] bien pintados con colores biuas y pinzel Delgado, a contento del d[ic]ho Miguel de Aguirre y de personas que lo entiendan." ANH/Q, Notaría 1a, vol. 137, 1630, Diego Rodríguez Docampo, fols. 822v–824r.

92. "cinquenta y quarto varas de melinze y bastidores nesçesarios para la pintura [. . .] por el trauajo, arte y ocupaçion della." ANH/Q, Notaría 1a, vol. 137, 1630, Diego Rodríguez Docampo, fols. 822v–823r. The nearby community of Pomasque housed a Franciscan church and *doctrina*, for which these works might have been intended.

93. "en boz y en nombre de la d[ic]ha cofradía [. . .] todo lo nessesario asi de oro plata colores y manifactura y ofiçiales [. . .] para los liensos que se a de pintar confiessa aber rreseuido de los priostes y mayordomos de d[ic]ha cofradia quatro varas y dos terçias de cotencie [*cotense*: a coarse hemp fabric] para los huecos que an de ser los dos de abaxo = los gloriosos san joan bautista y san bueno = y las tres de arriua la madre de dios de guadalupe en medio y a los dos lados san p[edr]o nolasco y san rramon = y arriba en el frontispiçio la santisima Trinidad y al pie del rretablo la magdalena y en los dos cartilillos de arriua ssanta tereza de jesus y santa joana todo bien dorado y alcauado [sic] de los priostes y mayordomos de la dic]ha cofradia y de personas que entienda del arte." ANH/Q, Notaría 1a, vol. 148, 1633–1634, Juan del Castillo, fols. 270v–272r.

94. For Cristóbal Faizán "yndio pintor" as a native of Lita, see ANH/Q, Notaría 1a, vol. 190, 1649, Diego Bautista, fol. 108r. Diego Arteaga documented the Andean painter Cristóbal Faizán, described as "from Quito," in the city of Cuenca in the 1640s. Diego Arteaga, *El artesano en la Cuenca colonial, 1557–1670* (Cuenca: Casa de la Cultura Ecuatoriana, 2000), 65–66. See also Jesús Paniagua Pérez and Deborah L. Truhan, *Oficios y actividad paragremial en la Real Audiencia de Quito (1557–1730): el corregimiento de Cuenca* (León: Universidad de León, 2003), 83, 256, 579.

95. ANH/Q, Notaría 1a, vol. 151, 1634–1635, Juan del Castillo, fols. 480v–482r.

96. ANH/Q, Notaría 1a, vol. 190, 1649, Diego Bautista, fols. 108r–109v.

97. "oficial pintor morador en Quito mayor que veinticinco años." ANH/Q, Notaría 1a, vol. 147, 1633, Gerónimo de Heredia, fols. 578r–578v. A series of other such loans followed over time. See, for example ANH/Q, Notaría 1a, vol. 191, 1649, Pedro Pacheco, fols. 70r–70v; ANH/Q, Notaría 1a, vol. 193, 1650, Pedro Pacheco, fols. 345r–345v; ANH/Q, Notaría 1a, vol. 202, 1657–1658, Tomás Suárez de Figueroa, fols. 315r–315v.

98. ANH/Q, Notaría 1a, vol. 164, 1639, Juan de Peralta, fol. 288r–288v. The house was located in the heights of Santa Barbara.

99. ANH/Q, Notaría 6a, vol. 55, 1649, Gaspar Rodríguez, fols. 20r–23v.

100. "que me presto en rreales los quales jugue y perdi jugando con el mismo y otras personas." ANH/Q, Notaría 6a, vol. 55, 1649, Gaspar Rodríguez, fol. 21r.

101. "Yten declaro que el padre maestro fray fran[cis]co de la puebla me dio seis p[es]os para un lienço de pintura mando que el d[ic]ho lienço se le entregue en el estado que estuviere

Yten declaro que joan ambroçio negroto me dio quinze patacones para en quenta de un lienço que le estoy haciendo m[an]do que pagando el susd[ic]ho siete p[es]os se le entregue el d[ic]ho lienço en el estado en que esta

Yten declaro que don fernando de vera y flores me entrego quatro rretratos para que se los pintase consertados en quarenta pesos cuya quenta me a dado dies pata-cones mando que se tase lo que esta hecho y se cobre del d[ic]ho don fernando lo que rrestare debiendo y se le entreguen los dichos lienços

Yten declaro que tengo en mi poder doze lienços pequeños y dos grandes de don m[arti]n de fuenmayor mandose le entreguen

Yten declaro que deuo a don felipe de berguete dies pesos para en quenta de una obra que se le auia de hazer la qual no e hecho m[an]do se le pague de mis vienes

Yten declaro que d[ic]ho don felipe de beruete me deue diez pesos del rresto de un lienço que le hize los quales se compesaran [sic] con los de arriua

Yten declaro que tengo e mi poder seis lienços aparexados que son de antonio de la chica mandose le bueluan

Yten declaro que tengo en mi poder dos lienços de m[arti]n de ayala en bosquexo mandose le entreguen." ANH/Q, Notaría 6a, vol. 55, 1649, Gaspar Rodríguez, fols. 21v–22r.

102. Navarro, *Contribuciones*, 4:21.

103. ANH/Q, Notaría 1a, vol. 188, 1648, Pedro Pacheco, fols. 131r–131v. In his *promesa de no jugar*, Salinas declared that "por quanto el jugar ha sido de mucho descredito . . . y disminucion de sus uienes [. . .] hace promessa de no jugar por tiempo de tres anos [. . .] o pagara a la Santa Ynquicission doscientos pesos."

104. Interestingly, although the painter is named in this document as Simón de Valenzuela, he signed his name Simón de los Reyes. For Valenzuela, see especially Justo Estebaranz, *El pintor quiteño*, 292–294.

105. Miguel de Santiago has come to be seen in the modern literature as the most important painter of the later seventeenth and early eighteenth century in Quito (see introduction herein). Justo Estebaranz documented the 1654–1656 establishment of Miguel de Santiago's workshop. Justo Estebaranz, *El pintor quiteño*, 288. Miguel de Santiago also lived in the parish of Santa Barbara.

106. "al Maestro Pintor Salvador Marín por los lienzos de San Pedro y San Pablo para la Sala Real." "Cuentas de la Real Hacienda, 1648–1660," *Boletín del Archivo Nacional de Historia* 2, nos. 3–4 (1951): 104.

107. "tres liensos de la ystoria de santo domingo del tamaño de los que se ban obrando a contento y satisfassion del d[ic]ho padre prior y los a de obrar asistiendo en este d[ic]ho comb[en]to y dar acabados el ultimo dia del mes de nobiembre que biene de este pressente año." ANH/Q, Notaría 4a, vol. 12, 1654, Antonio de Verzossa, fols. 323v–324r.

108. "se obliga a que mientras acabare esta obra no tomara otra ninguna." ANH/Q, Notaría 4a, vol. 12, 1654, Antonio de Verzossa, fol. 323v.

109. The other paintings in this series bear donor inscriptions. That of the *Vi-*

sion of Pope Honorius III reads: "Este lienzo dio Gaspar de Luna el Consejero de su mag[esta]d y su oydor de esta R[ea]l aud[ienci]a." The inscription on *Christ with Three Lances and Saints Francis and Dominic* (also known as *El mundo en tinieblas*) reads: "El C[apitán] Manvel de la Torre Angvlo Caballero D[e] la Orden de Santiago Corexidor que fue en esta C[iud]ad." Both men held their stated positions in the 1680s and 1690s; thus, these cannot be the works commissioned from Marín in 1654. The inscriptions also demonstrate that the paintings are not the work of the late eighteenth-century painter Francisco Albán and his workshop, as published in Stratton-Pruitt, *The Art of Painting*, 257–259.

110. ANH/Q, Notaría 4a, vol. 5, 1651, Antonio de Verzossa, fols. 252v–253v. Marín rented one and one-half *caballerías* of land in Añaquito from Sebastián de Valencia.

111. "el quarto alto de mis cazas donde al presente uiue el susod[ic]ho con dos aposentos vaxos y la guerta que hay en ella por tiempo de quarto años." ANH/Q, Notaría 1a, vol. 197, 1653, Pedro Pacheco, fols. 65r–65v.

112. Fernando Jurado Noboa, *Los Larrea: burocracia, tenecia de la tierra, poder político, crisis, retorno al poder y papel en la cultura ecuatoriana* (Quito: Sociedad Ecuatoriana de Amigos de la Genealogía, 1986), 20–21.

113. ANH/Q, Notaría 1a, vol. 181, 1645–1656, Francisco de Atienza, fols. 462v–463r. Huanacauri was the name of one of the four mountains considered to be huacas (sacred places) in Cuzco. The names of these huacas were applied to the four mountains or hills surrounding Quito, of which the northern hill known as San Juan was named Huanacauri. See Burgos Guevara, *El guamán*, 268–269, 282–288.

114. For the two plots of land, see ANH/Q, Notaría 1a, vol. 215, 1664–1665, Andrés Muñoz de la Concha, fols. 98r–99v; ANH/Q, Notaría 1a, vol. 211, 1663–1665, Tomás Suárez de Figueroa, fols. 309v–311r. For his purchase of the house, see ANH/Q, Notaría 1a, vol. 217, 1666–1667, Pedro Humanes Guisado, fols. 76r–77v.

115. ANH/Q, Notaría 1a, vol. 232, 1670–1673, Miguel de Ortega, fol. 46r–47v.

116. For Miguel de Santiago, see especially Justo Estebaranz, *El pintor*; Justo Estebaranz, *Miguel de Santiago*. For Miguel de Santiago as *hijo natural* of Lucas Vizuete, see Santiago's 1705 testament: ANH/Q, Notaría 4a, vol. 56, 1706, Manuel Cevallos y Velasco, fols. 14r–16v. Justo Estebaranz covers later aspects of Vizuete's life, which complement the material presented here regarding the painter's early activities and artistic commissions.

117. ANH/Q, Notaría 4a, vol. 8, 1652, Antonio de Verzossa, fols. 15r–15v. This document records that in 1650 Lucas Vizuete sold two blocks of land in Cotacache "las quales las huvo y heredo de gernando capaco yndio su padre."

118. ANH/Q, Notaría 1a, vol. 112, 1625–1626, Diego Bautista, fols. 278r–281v.

119. ANH/Q, Notaría 1a, vol. 126, 1629, Diego Rodríguez Docampo, fol. 1097r.

120. ANH/Q, Notaría 1a, vol. 142, 1632, Gerónimo de Heredia, fols. 362r–363v. For Francisca Mendiola, see especially ANH/Q, Notaría 1a, vol. 169, 1640–1642, Juan de Peralta, fols. 552r–553r. In 1656, Vizuete, Mendiola, and their daughter, Leonor Vizuete, "yndios naturales de la parroquia de Santa Barbara," filed a contract for a loan of 112 pesos. ANH/Q, Notaría 4a, vol. 14, 1656, Antonio de Verzossa, fols. 438v–440v.

121. ANH/Q, Notaría 1a, vol. 169, 1640–1642, Juan de Peralta, fols. 549v–550v. Mendiola declared that she had inherited the property from her parents, Diego de Mendiola and Angelina Nuzi, and from her deceased siblings, Lorenzo and Juan de Mendiola.

122. Justo Estebaranz, *El pintor quiteño*, 42.

123. For Bernabé Lobato, see Justo Estebaranz, "El obrador de Miguel de Santiago," 171–173; Justo Estebaranz, *El pintor quiteño*, 294–296.

124. "dos lienços grandes que se han de entregar clauados en sus marcos y en un lienço a de pintar el nasçimiento de nuestro señor jesucristo y en el otro la adoraçion de los tres rreyes magos conforme a las estampas que se le dieren por el d[ich]o andres farfan [. . .] en las quales dos hechuras a de poner todas las figuras que tengan las d[ic]has estampas y buenos colores y las a de dar y entregar acabadas y bien hechas dentro de tres meses [. . .] para que se pongan en el altar mayor de la d[ic]ha yglessia catedral." ANH/Q, Notaría 1a, vol. 117, 1626, Gerónimo de Heredia, fols. 842r–842v. See appendix, part d, for a full transcription of the contract. Costales Samaniego published a quotation from this document that bears little resemblance to the actual text as transcribed above. Costales Samaniego, "El arte en la Real Audiencia," 224. For the patron, Farfán de los Godos, in 1630, see AGI, Quito, 51, N. 4, "Informaciones: Andrés Farfán de los Godos."

125. Two large paintings depicting the *Adoration of the Shepherds* (an anonymous early nineteenth-century copy after Murillo) and the *Adoration of the Magi* (signed by Bernardo Rodríguez in 1801) hang today in the nave of the Cathedral as continuing testimony to those earlier devotions.

126. "quatro lienzos los dos grandes y los dos arqueados el uno del Nacimiento y el otro de la adoración de los Reyes y el otro de San Miguel y el último de la Visitación de mi Señora Santa Ana." Navarro, *Contribuciones*, 4:102n40.

127. "del único que hay recuerdo es de la Adoración de los Pastores que está en el Museo Británico [. . .] Fue adquirido hace 50 o 60 años por Mr. Ludovico Soderstrom, sueco de origen al servicio de Su Majestad Británica, que lo tenía como Cónsul en Quito [. . .] Pues este señor hizo el negocio a los canónigos del cuadro de la Adoración de los Pastores y lo regaló al Museo Británico. Poseemos nosotros un postal atrás de la cual está escrito que el lienzo fue encontrado en Quito y fue material de discusión larga entre los entendidos la adjudicación a Velázquez o Zurbarán, quedando más probable que sea de éste último." Navarro, *Contribuciones*, 4:100–101. In a later publication, Navarro further clarified the origins of this painting in the Cathedral: "De uno de los retablos de la iglesia Catedral salió aquel cuadro La Adoración de los Pastores que hoy se encuentra en el Museo Británico y que fue objeto de discusión, acerca de la paternidad de su autor, pues mientras unos le atribuyeron a Velázquez, otros le ajudicaron a Zurbarán." Navarro, *La pintura en el Ecuador*, 9.

128. Today, no painting corresponding to the abovementioned "Adoration of the Shepherds" is recorded in the collection of the British Museum, yet there is hope that the canvas may yet come to light in other London museums or collections. For an illustration of Bedón's death portrait, see Vargas, *Arte colonial*, 26. For early seventeenth-century Quito examples of tenebrist paintings in the style of Baroque naturalism, see Navarro, *La pintura en el Ecuador*, figs. 15, 20, 28.

129. "un retablo ya hecho para una imagen de sta teresa." ANH/Q, Notaría 1, vol. 126, 1629, Diego Rodríguez Docampo, fol. 1097r. For Cepeda's purchase of the chapel, see fols. 1184r–1186r, 1222v–1223v, 1271v–1276r. For a 1628 report on Cepeda as the nephew of Santa Teresa de Ávila, see AGI, Quito, 50, N.61, "Informaciones: Pedro de Cepeda."

130. José Gabriel Navarro, "El retablo de Santa Teresa de Jesús en la Iglesia de la Concepción," *El Comercio*, Sunday, 9 October 1960. Navarro identified this painting as belonging to the "Escuela Sevillana."

131. ANH/Q, Notaría 1a, vol. 169, 1640–1642, Juan de Peralta, fols. 549v–550v, 552r–553r; Justo Estebaranz, *Miguel de Santiago*, 78.

132. "por Retocar y rremendar los lienzos del claustro." AHOME, C. VI, 6.4, 1644–1656, "Libro de gastos," fol. 251r.

133. ANH/Q, Notaria 1a, vol. 169, 1640–1642, Juan de Peralta, fols. 549v–550v.

134. ANH/Q, Notaría 1a, vol. 192, 1650, Diego Bautista, fols. 112r–113v.

135. ANH/Q, Notaría 4a, vol. 8, 1652, Antonio de Verzossa, fols. 15r–15v.

136. ANH/Q, Notaría 4a, vol. 15, 1656, Antonio de Verzossa, fols. 79r–81v.

137. ANH/Q, Notaría 4a, vol. 14, 1656, Antonio de Verzossa, fols. 438v–440v.

138. ANH/Q, Notaría 6a, vol. 63, 1662–1663, Diego Rodríguez de Mediavilla, fols. 149r–150v.

139. "que joan fonte pintor me tiene un nino jesus de bulto, durmiendo con su peaña que se lo di a adresar [sic] y le di un peso para dorar." Archivo Histórico del Convento de San Agustín, Quito (hereafter AHSA/Q), vol. 4, "Papeles varios," fol. 225r. Alfredo Costales Samaniego misread this document and mistakenly published the artist involved as the Andean painter Miguel Ponce. He also misidentified the testator as "doña Ventura Gaviria." Costales Samaniego, "El arte en la Real Audiencia," 221.

140. ANH/Q, Notaría 1a, vol. 127, 1629, Gerónimo de Castro, fol. 407r–409r. In this contract, Sebastián de Medina and Juan Fonte *dorador* formed a *compañía* in which they each agreed to invest in the establishment of a *pulpería* and share equally the profits that accrued.

141. "dorar y dorara un tabernaculo hecho y acabado de madera que esta oy dia puesto en el altar y Capilla de la dha Cofradia poniendo en el todo el oro nesessario y bastante para la dha obra y dorado [. . .] y asimismo a de dorar El sagrario que se a de hazer de madera para poner en el altar y tabernaculo." ANH/Q, Notaría 1a, vol. 141, 1631–1633, Juan del Castillo, fols. 198r–199r.

142. "Un rretablo de cinco baras de alto y de ancho tres baras con su sagrario dorado y pintado con todas las pinturas que se requieren de cuerpo Entero y en el tablero de arriua un lienço de la açençion del S[eño]r con los onze apostoles y nuestra señora y el Espiritu santo y en el rremate dios padre de cuerpo entero y en la caxa de en medio una santa Ursula con las onze mill virgenes que se entiende en el nicho y a los lados quatro angeles y una santa cristina de bulto de una bara estofada y dorada y el d[ic]ho rretablo todo dorado de oro limpio con algunos esmaltes donde fuere necessario." ANH/Q, Notaría 1a, vol. 159, 1638, Pedro Pacheco, fols. 112r–113v.

143. ANH/Q, Notaría 1a, vol. 157, 1637, Diego Bautista, fols. 383r–383v. The altarpiece commissioned from Olivas for Báez Martínez's family chapel in the church of Santa Catalina was to measure five *varas* high by three *varas* wide, was dedicated to "Santa Cristina virgen y martir," and was to include "una ymagen de la d[ic]ha santa con su peaña y los demas."

144. "El d[ich]o joan fonte a de dorar el Retablo del altar mayor de la yglesia del d[ic]ho conuento y a de poner el oro y todos los materiales y colores que fueren neçesarios para ello todo a su costa y a de pagar los ofiçiales y pinturas y todo quanto fuere neçes[ari]o para el d[ic]ho rretablo a content y satisfaction de la d[ic]ha abadesa y personas del arte eçepto los lienços grandes que son seis que estos no han de pintar ni poner nada en ellos." ANH/Q, Notaría 1a, vol. 160, 1638, Diego Bautista, fols. 97r–98r. The main altarpiece of the church was destroyed by fire in the twentieth century.

145. ANH/Q, Notaría 1a, vol. 104, 1623, Alonso López Merino, fols. 228r–228v.

146. The *Apostolado* series often included images of Jesus, the Virgin Mary, and others, in addition to the twelve apostles. For the theme in Quito, see María José Redondo Cantera and Ximena Carcelén, "Fortuna pictórica del *apostolado* de Juan Antonio Salvador Carmona," *Boletín del Seminario de Estudios de Arte* 75 (2009): 235–246; and Ximena Carcelén (dir.), *El apostolado en el esplendor barroco*, exh. cat. (Quito: Pontificia Universidad Católica del Ecuador, 2001).

147. As mentioned above, Salinas signed a notarized *promesa de no jugar* in 1648, vowing that he would give up gambling for three years or pay a hefty fine to the Santa Inquisición. ANH/Q, Notaría 1a, vol. 188, 1648, Pedro Pacheco, fols. 131r–131v.

148. ANH/Q, Notaría 1a, vol. 231, 1670–1673, Tomás Suárez de Figueroa, fol. 357v. This contract was left incomplete; it bears the rubric "no pasó."

149. Based on earlier accounts, Teresa's Segovia vision is recorded in Serafín Thomas Miguel, *Historia de la vida de Santo Domingo de Guzmán, fundador de la sagrada Orden de Predicadores* (Valencia: Francisco Mestre, 1705), 299. The vision is also reported in texts that were available to Salinas Vizuete in mid-seventeenth-century Quito, including Pedro de Ribadeneyra's *Flos sanctorum* (1599, 1601, and other editions) and Francisco de Ribera's *La vida de la Madre Teresa de Jesús* (Salamanca, 1590).

150. "yndio ladino oficial pintor natural del p[uebl]o de cotacache [. . .] residente en esta çiudad de san fran[cis]co del quito." ANH/Q, Notaría 5a, vol. 18, 1634–1635, Gerónimo de Castro, fols. 180r–181v.

151. The name Agustín was so important to Santiago and Cisneros that they bestowed it on two of their sons, one of whom died at a tender age. See the 1706 testament of Miguel de Santiago in ANH/Q, Notaría 4a, vol. 56, 1706, Manuel Cevallos y Velasco, fols. 14r–16v.

152. "Alexandro de Rivera yndio pintor preso en la carcel publica a pedimento del Capitan don Juan Suares Sores por ochenta pesos [. . .] que dio al d[ic]ho yndio Para unos liensos." ANH/Q, Notaría 1a, vol. 175, 1643–1650, Diego Rodríguez Urbano, fol. 329r.

Chapter 8: Mateo Mexía and the Languages of "Style"

An earlier version of this chapter on Mexía was previously published as Susan V. Webster, "Mateo Mexía and the Languages of Painting in Early Colonial Quito," *Hispanic Research Journal* 17, no. 5 (2016): 409–432.

1. For a trenchant analysis of the historiography regarding applications of Western positivist models of stylistic development to Quito painting, see Carmen Fernández-Salvador, "Historia del arte colonial quiteño: Un aporte historiográfico," in Carmen Fernández-Salvador and Alfredo Costales Samaniego, *Arte colonial quiteño: renovado enfoque y nuevos actores* (Quito: FONSAL, 2007), 11–122. For Miguel de Santiago, see the studies by Ángel Justo Estebaranz, especially *El pintor quiteño*.

2. Mesa and Gisbert, "The Painter."

3. Ibid., 387.

4. For additional assessments of Mexía's style as retardataire, see Soria, *La pintura del siglo XVI*, 100; Enrique Marco Dorta, *Arte en América y Filipinas*, Ars Hispaniae: Historia Universal del Arte Hispánico XXI (Madrid: Editorial Plus-Ultra,

1973), 21:120; and Benajmín Gento Sanz, *Guía del turista en la iglesia y convento de San Francisco de Quito* (Quito: Imprenta Americana, 1940), 67. Mario Monteforte Toledo et al. characterized Mexía's style as literally "Pre-Raphaelite." Mario Monteforte Toledo et al., *Los signos del hombre* (Cuenca: Pontificia Universidad Católica del Ecuador, 1985), 70. José María Vargas allots one clause of a single sentence to Mexía and dedicates seven pages to Miguel de Santiago in his *Arte quiteño colonial*, 116, 117–124. In a subsequent publication, Vargas expands his consideration of Mexía to a single sentence, noting his signature and date on *Saint Francis and Tertiaries*. Vargas, *El arte ecuatoriano*, 88. In his subsequent book, *Patrimonio artístico*, 31–32, Vargas points to the existence of three paintings by Mexía in San Francisco, and then simply quotes Martín Soria on the artist. José Gabriel Navarro relegates a short paragraph on Mexía to a catchall section at the end of his chapter on seventeenth-century painters that includes a lengthy consideration of Miguel de Santiago, in *La pintura en el Ecuador*, 59.

5. Mesa and Gisbert, "The Painter," 391; José Alcina Franch, Jorge Bernales Ballesteros, and Damián Bayón, *Historia del arte hispanoamericano, siglos XVI a XVIII* (Madrid: Alhambra, 1987), 2:222.

6. Soria, *La pintura del siglo XVI*, 100; Vargas, *Patrimonio artístico*, 31–32.

7. "en San Francisco se hallan dos cuadros que llevan los nombres de Mateo Mexía y Francisco Quispe y corresponden respectivamente a los años de 1615 y 1668. Eran indudablemente oficiales secundarios de los talleres de algún buen maestro." José María Vargas, *La cultura del Quito colonial* (Quito: Editorial Santo Domingo, 1941), 245.

8. Mesa and Gisbert, "The Painter," 395.

9. ANH/Q, Fondo Especial/Sentencias, caja 608, 1620–1639, expte. 4, n.p. This document registers the final sentence of a criminal case that was brought by "Mateo Mexia yndio pintor de la una Parte y Miguel y joan alon yndios Hermanos y simon mateos de astudillo de la otra sobre el Hurto que le hicieron." The nature of the crime is not specified in the document; however, it must have been particularly grave, for Miguel Alon was condemned to be taken from prison "en bestia de albarda pies y manos atado y sea traydo Por las calles publicas desta çiudad con boz de pregonero que manifieste su delito y le sean dados cien acotes condenamosle mas en tres anos de seruicio en vn obraxe y su seruiçio se rremate y lo proçedido aPlicamos a la camara de su mag[esta]d y gastos de justiçia por mitad y a que rrestituya lo Hurtado al d[ic]ho mateo mexia en lo que le faltare por enterar y lo que esto montare." I am grateful to Agnieszka Czeblakow for bringing this document to my attention.

10. Rappaport, *The Disappearing Mestizo*, 31–42; Caillavet, *Etnias del norte*, 311–326.

11. ANH/Q, Fondo Especial/Sentencias, caja 608, 1620–1639, expte. 4, n.p. For the legal advantages of being categorized as "indigena," see Caillavet, *Etnias del norte*, 318.

12. For Mexía as a native of Riobamba, see Costales Samaniego, "El arte en la Real Audiencia," 222. Costales Samaniego calls Mexía a "mestizo," although the document in question does not identify him as such. For Mexía and his wife as natives of Puembo, see ANH/Q, Notaría 4a, vol. 8, 1652, Antonio de Verzossa, fols. 2r–3v.

13. ANH/Q, Notaría 1a, vol. 88, 1617–1618, Alonso Dorado de Vergara, fols. 574r–575r; ANH/Q, Notaría 1a, vol. 91, 1619–1620, Gerónimo de Heredia, fols. 740r–741r, 781r–781v, 814r–814v.

14. Rocío Pazmiño Acuña, "La configuración urbana de la Villa de Villar Don Pardo: Riobamba en la época colonial," in *La antigua Riobamba: historia oculta de una ciudad colonial*, ed. Rosemarie Terán Najas (Riobamba: Municipio de Riobamba, 2000), 67.

15. ANH/Q, Notaría 1a, vol. 98, 1622, Gerónimo de Heredia, fols. 320r–320v; ANH/Q, Notaría 4a, vol. 8, 1652, Antonio de Verzossa, fols. 2r–3v; ANH/Q, Notaría 6a, vol. 63, 1662–1663, Diego Rodríguez de Mediavilla, fol. 38v. The category "vecino" (citizen) was typically reserved for Europeans and Creoles, for it conferred certain privileges that included the ability to hold public office, yet the term could also be applied to non-elite members of a community. See Rappaport, *The Disappearing Mestizo*, 8; Tamar Herzog, *Defining Nations: Immigrants and Citizens in Early Modern Spain and Spanish America* (New Haven, CT: Yale University Press, 2008), 1–19.

16. ANH/Q, Notaría 1a, vol. 88, 1617–1618, Alonso Dorado de Vergara, fols. 304r–305v; 574r–575r.

17. ANH/Q, Notaría 1a, vol. 88, 1617–1618, Alonso Dorado de Vergara, fols. 574r–575r. In 1620, Juan Chauca, the Andean painter named in the document with Mexía, employed the same tactic: he purchased land in San Roque and then declared in a later document that he had done so with the money of an Andean woman, and the land was legally hers. ANH/Q, Notaría 1a, vol. 92, 1620–1624, Diego Suárez de Figueroa, fols. 118v–119r.

18. For Pedro Quispe as *alcalde* of San Roque between 1598 and 1601, see ANH/Q, Notaría 1a, vols. 18–19, 1601, Francisco García Durán, fol. 187r. For the master painter Clemente Quispe as Pedro's brother, see ANH/Q, Notaría 1a, vol. 147, 1633, Gerónimo de Heredia, fols. 155r–156v.

19. ANH/Q, Notaría 1a, vol. 138, 1631–1632, Diego Bautista, fols. 204r–204v.

20. For Quispe houses and land in San Roque, see ANH/Q, Notaría 1a, vol. 128, 1629, Gerónimo de Castro, fols. 616v–620v. For Quispe lands in Puembo, see ANH/Q, Notaría 1a, vol. 10, 1598, Diego Bravo de la Laguna, fol. 126r; ANH/Q, Notaría 1a, vol. 79, 1614, Alonso Dorado de Vergara, fols. 129r–130r; ANH/Q, Notaría 1a, vol. 147, 1633, Gerónimo de Heredia, fols. 155r–156v.

21. ANH/Q, Notaría 4a, vol. 8, 1652, Antonio de Verzossa, fols. 2r–3v.

22. ANH/Q, Notaría 1a, vol. 160, 1638, Diego Bautista, fols. 428r–432r; ANH/Q, Notaría 1a, vol. 163, 1639, Diego Bautista, fols. 222r–223v; ANH/Q, Notaría 6a, vol. 63, 1662–1663, Diego Rodríguez de Mediavilla, fol. 38v. Mexía's wife, María Pasña, also acquired land by individual purchase. In 1636, Francisca Pasña, "viuda de Pedro Quispe," sold to her daughter María Pasña a vacant tract of land in San Roque for thirty pesos. The property was surrounded by the residences of elite Andeans, including those of the architect and builder Don Francisco Morocho, and Angelina Palla, a noblewoman of Inca ancestry. ANH/Q, Notaría 1a, vol. 154, 1636, Diego Bautista, fols. 254v–255v.

23. Pazmiño Acuña, "La configuración urbana," 66–67. For his continuing title of "maestro pintor," see ANH/Q, Notaría 4a, vol. 8, 1652, Antonio de Verzossa, fols. 2r–3v; ANH/Q, Notaría 1a, vol. 208, 1662–1663, Juan Martínez de Miranda, fols. 43v–44v.

24. ANH/Q, Notaría 1a, vol. 73, 1611–1612, Alonso Dorado de Vergara, fols. 1518r–1518v.

25. ANH/Q, Notaría 1a, vol. 91, 1619–1620, Gerónimo Heredia, fols. 740v–741r, 781r–781v, 814r–814v. As discussed in chapter 2, *melinze* was another common support for paintings.

26. "nuebe lienços de una bara poco mas de altura en que han de yr pintadas quatro hechuras de la santisima trinidad y cinco exçehomos con pilatos buenos." ANH/Q, Notaría 1a, vol. 98, 1621, Gerónimo de Heredia, fols. 320r–320v. Mexía paid the notary four *reales* for producing the document.

27. In early colonial Quito, pesos and *patacones* were interchangeable in value, and each could be divided into eight or nine *reales*. The sum of twenty *reales* per painting received by Mexía was therefore a very low price indeed, especially considering that he had to pay the notary four *reales* for the contract.

28. ANH/Q, Notaría 1a, vol. 104, 1623, Alonso López Merino, fols. 228r–228v.

29. For the rental contract, see ANH/Q, Notaría 1a, vol. 124, 1628, Diego Juan de Castillo Figueroa, fol. 182v–183r. For the mortgages, which were held by the Hospital de la Caridad and by Ana de Santo Domingo, a Dominican nun in the Convent of Santa Catalina, whose principal totaled 493 *patacones*, see ANH/Q, Notaría 1a, vol. 121, 1627–1628, Diego Bautista, fols. 304r–306v.

30. The published transcription reads: "Dos cuadros de tres varas de largo y dos y media de ancho; Otros dos de a dos varas y media de largo y dos de ancho; Otros dos de tres varas de largo y vara y cuarta de ancho; Otros dos de dos varas y medio de largo y vara y medio de ancho; Otro cuadro de dos varas y medio de alto y vara y tres de ancho; Otros dos de vara de ancho y largo; Otro de vara y media de ancho y largo . . . Que todos doce cuadros han de ser pintados en lienzo de Santos con sus trazos con que cupieren y algunos de media talla cornisas y frontispixcios y remates pintados a prospeccion ademas se ordenan ser pintados a toda perfeccion de escultura y contento del dicho Padre Prior y conforme a la memoria de los Santos que le diere y en la forma de pintura y escultura . . . que tengo que poner todos los tintes y colores a mi costa y la manufactura y los gastos en colocar . . . el padre prior dara todas las maderas para los cuadros." Pazmiño Acuña, "La configuración urbana," 66–67. Pazmiño Acuña recovered the contract in the Archivo Histórico de la Casa de la Cultura/Chimborazo, Protocolos, 1600–1699, s.f. Alfredo Costales Samaniego published an incorrect transcription of this document that bears little resemblance to the direct quotation cited above. Costales Samaniego, "El arte en la Real Audiencia," 222–223.

31. ANH/Q, Notaría 1a, vol. 160, 1638, Diego Bautista, fols. 428r–432r.

32. ANH/Q, Notaría 1a, vol. 163, 1639, Diego Bautista, fols. 222r–223v; ANH/Q, Notaría 4a, vol. 8, 1652, Antonio de Verzossa, fols. 2r–3v; ANH/Q, Notaría 6a, vol. 63, 1662–1663, Diego Rodríguez de Mediavilla, fol. 38v.

33. ANH/Q, Notaría 1a, vol. 208, 1662–1663, Juan Martínez de Miranda, fols. 43v–44v. Ángel Justo Estebaranz believes that the Miguel de Santiago cited in this document is indeed the contemporary painter, although a candle maker (*cerero*) of the same name also lived and worked in Quito during this period. Justo Estebaranz, *El pintor quiteño*, 56.

34. The Franciscan Third Order of Penitence was established in 1289, and its membership was open to all members of secular society, men and women, married or single, of all walks of life. Members did not take vows but followed a rule of life written for them by Francis of Assisi. For the Franciscan Third Order, see for example John Richard Humpidge Moorman, *A History of the Franciscan Order from its Origins to the Year 1517* (New York: Oxford University Press, 1968), chap. 19; Gerald J. Reinmann, *The Third Order Secular of Saint Francis* (Washington, DC: Catholic University of America, 2013); Raffaele Pazzelli, *St. Francis and the Third Order: The*

Franciscan and Pre-Franciscan Penitential Movement (Quincy, IL: Franciscan Press, 1989).

35. "Entre los cuadros del claustro bajo hay uno bastante malo que representa a San Francisco rodeado de muchos santos y reyes de la tercera orden. Lleva la firma siguiente: Mateo Mexía fecit 1616. Sin duda alguna, uno de los tantos pintores de la escuela antigua quiteña." Navarro, *Contribuciones*, 1:79n44.

36. Mesa and Gisbert, "The Painter," 396. The Virgen de la Merced to which the authors refer is now in the private collection of Ivan Cruz.

37. Orpiment is a yellow arsenic sulfide found in volcanic regions such as Quito. See Eastaugh et al., *Pigment Compendium*, 291–292. Quito is singled out as a major source of orpiment in Fourcroy, *Elements of Natural History*, 2:187.

38. See chapter 2.

39. Janeth Rodríguez Nobrega, "El oro en la pintura de los reinos de la monarquía española," in *Pintura de los reinos: identidades compartidas* (Mexico City: Fomento Cultural Banamex, 2009), 4:1343. This essay contains a useful and detailed discussion of techniques of applied gold leaf and *brocateado* on paintings.

40. The association of *brocateado* with the eighteenth century is particularly strong in the literature on the Cuzco School of painting, where it is seen as the hallmark of the style and is linked to indigenous values. The same supposition regarding the eighteenth-century retrofitting of earlier paintings with applied gold is also present in the literature on Cuzco. See especially Mesa and Gisbert, *Historia de la pintura cuzqueña*, 271–274.

41. For this viewpoint with regard to colonial Latin American painting in general, see Rodríguez Nobrega, "El oro en la pintura de los reinos," 1314–1375. In the eighteenth century, gold ornaments, pearls, and jewelry occasionally were added to the surfaces of earlier paintings. See Alexandra Kennedy Troya, "Arte y artistas quiteños de exportación," in *Arte de la Real Audiencia de Quito, siglos XVI-XIX* (Hondarribia: Nerea, 2002), 192.

42. Martín Soria also noted the effect of illuminated manuscripts in Mexía's paintings. Soria, *La pintura del siglo XVI*, 100.

43. Soria, *La pintura del siglo XVI*, 84, 100; Mesa and Gisbert, "The Painter," 388–389; Stratton-Pruitt, *The Art of Painting*, 30–32.

44. Mesa and Gisbert suggest that the male figure is a donor, but do not mention the three other individualized faces in the crowd. Mesa and Gisbert, "The Painter," 389.

45. Héctor Schenone, *Iconografía del arte colonial: Jesucristo* (Buenos Aires: Fundación Tarea, 1998), 32. For Courbes's work, see José Manuel Matilla, *La estampa en el libro barroco: Juan de Courbes* (Madrid: Ephialte, 1991), 140, cat. 153. A very similar engraving adorns the frontispiece of Cesare Baronio's 1586 and 1593 editions of the *Martyrologium Romanum*.

46. A 1585 engraving, *Christ Conquering Satan and Sin* by the Flemish printmaker Jerome Wierix, after Martin de Vos, also bears notable similarities to Mexía's painting; however, the engraving does not include the *arma christi*, the Trinity, or the assemblies of the elect. Instead, it focuses solely on Christ's triumph over the devil, sin, and death.

47. Mesa and Gisbert attribute the painting to Mexía, noting its many similarities to the *Annunciation* in San Francisco and the *Triumph of the Risen Christ*. Mesa and Gisbert, "The Painter," 395–396.

48. Mesa and Gisbert, "The Painter," 395. This print served multiple artists in seventeenth-century Quito. For example, a 1631 mural painting of Saint Michael Archangel in the crossing of the Church of Santo Domingo also employs Wierix's print as its source. For the Santo Domingo murals, see Webster, "Art, Identity," 417–438. Indeed, this print circulated widely and was used as a model by numerous painters in Spain and across Spanish America. See Stephanie Porras, "Going Viral? Maerten de Vos's St. Michael the Archangel," in *Netherlandish Art in its Global Context*, ed. Thijs Weststeijn et al. (Leiden: Brill, 2016): 54–78.

49. Several authors identify this painting as the work of Mexía. Mesa and Gisbert, "The Painter," 395; Navarro, *La pintura en el Ecuador*, 59; Stratton-Pruitt, *The Art of Painting*, 30–33.

50. Mesa and Gisbert, "The Painter," 395.

51. The inscription is the communion antiphon from Isaiah 7:14, which reads: "Ecce, virgo co[n]cipiet, & pariet fil[i]vm & vocabitur nomen eius Emmanvel" ("Behold, a virgin shall conceive and bear a son and shall call him Emmanuel"), to which Mexía adds Isaiah 7:15: "bvty[r]um & mel comedet ut sciat reprobare mala [sic] & eligere bonum" ("he will be eating curds and honey when he knows how to refuse evil and choose good").

52. "no se conoce un solo cuadro semejante en la pintura quiteña del siglo XVI [. . . es] el primero en su clase." Navarro, *La pintura en el Ecuador*, 59.

53. Alfonso of Portugal holds a book inscribed with the date 1607.

54. Mesa and Gisbert, "The Painter," 389–391. For attributions to Sánchez Gallque and others, see José María Vargas, *La Iglesia y el patrimonio cultural ecuatoriano* (Quito: Ediciones de la Universidad Católica, 1982), 38; Vargas, *Patrimono artístico*, 31; Ximena Escudero-Albornoz, *Historia y leyenda del arte quiteño: su iconología* (Quito: FONSAL, 2009), 178ff; Monteforte Toledo et al., *Los signos del hombre*, 70.

55. Mesa and Gisbert proposed the existence of an altarpiece that incorporated the series of tertiary monarchs with the painting of *Saint Francis and Tertiaries* at its center, although they exclude the *Triumph of the Risen Christ*, without recognizing the full extent of the tertiary monarchs series—they referenced only nine paintings. Mesa and Gisbert, "The Painter," 390–394. The main Franciscan monastery possesses fourteen canvases in the series, to which may be added four paintings of tertiary popes of the same form and dimensions in the Franciscan Recoleta de San Diego.

56. Although the *Annunciation* is related to the other paintings in terms of composition and dimensions, its iconography is less directly associated with the penitential, eschatological focus of the other three. Another hypothetical arrangement for the altarpiece would exclude the *Annunciation* and locate *Saint Francis* on the lower register, *Saint Michael* in the center, and *Triumph of the Risen Christ* above. This configuration accounts for a consistent narrative as well as formal relationships among the three.

57. Navarro, *Contribuciones*, 1:90. The earliest documentary reference to the Third Order encountered by Navarro is a 1674 account in which the Franciscans gave to the Confraternity of Our Lady of the Column "la bóveda que antiguamente fue de los terceros." Patricio Guerra references this 1674 document and provides a more complete citation: "la bóveda antigua que fue de los hermanos terceros cuya puerta de madera sale a la capilla del Pilar." Manuel Patricio Guerra, *La Cofradía de la Virgen del Pilar de Zaragoza de Quito* (Quito: Abya Yala, 2000), 40.

58. The Church of San Francisco was substantially transformed and enlarged in

the first decades of the seventeenth century: the locations of the apse and choir were reversed, and a new crossing, presbytery, and sacristy were built, in addition to the construction of the main cloister. See Susan V. Webster, "La desconocida historia de la construcción de la iglesia de San Francisco en Quito," *Procesos: Revista Ecuatoriana de Historia* 35, no. 1 (2012): 37–66.

59. In 1627, the Cofradía de la Vera Cruz de los Españoles signed a contract with the Franciscans in which they traded their chapel for the old sacristy of the Franciscan church, and they set about enlarging and decorating it. ANH/Q, Notaría 1a, vol. 118, 1627, Diego Rodriguez Docampo, fols. 448v–450v; Webster, *Quito, ciudad de maestros*, 69–70. The ca. 1627 chapel of the Cofradía de la Vera Cruz de los Españoles is today known as that of San Buenaventura.

60. Kennedy Troya and Ortiz Crespo, *Convento de San Diego*, 24–26.

61. ANH/Q, Notaría 1a, vol. 8, 1599, Francisco García Durán, fols. 660r–662v. The documents of donation are transcribed in Compte, *Varones ilustres* (1885), 1:81–88.

62. For the genealogy of Plaza, Hinojosa, and their descendants, see Manuel María Pólit Laso, *La familia de Santa Teresa en América y la primera carmelita americana* (Freiburg: Herder, 1905), 281–282. In addition to their daughters Ana and Juana, Plaza and Hinojosa had a son named Pedro, suggesting a link with the figure of Saint Peter depicted in *Triumph of the Risen Christ*.

63. Susan V. Webster, "Las cofradías y su mecenazgo durante la colonia," in *Arte de la Real Audiencia de Quito, siglos XVII–XIX*, ed. Alexandra Kennedy (Hondarribia: Nerea, 2002), 78–82. Numerous engravings of the popular Virgen de los Desamparados circulated during the seventeenth and eighteenth centuries. See Andrés de Sales Ferri Chulio, *Iconografía popular de la Mare de Déu dels Desamparats* (Valencia: Federico Domenech, 1998).

Final Considerations

1. "Pintor. Los artificios pi[n]tor, escultor, entallador, bordador, servicio de dios y de la s[an]ta yglecia." Felipe Guaman Poma de Ayala, "El primer nueva corónica y buen gobierno," ca. 1615, fol. 673v [687v].

BIBLIOGRAPHY

Archival Repositories

AGI Archivo General de Indias, Seville
AGOFE Archivo General de la Orden Franciscana en el Ecuador
AHBCE Archivo Histórico del Banco Central de Ecuador
AHB/T Archivo Histórico de Boyacá, Tunja, Colombia
AHC/Q Archivo Histórico de la Catedral, Quito
AHODE Archivo Histórico de la Orden Dominicana en el Ecuador
AHOME Archivo Histórico de la Orden Mercedaria en el Ecuador
AHSA/Q Archivo Histórico del Convento de San Agustín, Quito
AMH/Q Archivo Metropolitano de Historia, Quito
AMRE/Q Archivo del Ministerio de Relaciones Exteriores, Quito
ANH/Q Archivo Nacional de Historia, Quito
APIC/Q Archivo Privado de Ivan Cruz, Quito
APS/Q Archivo de la Parroquia del Sagrario, Quito
BNE Biblioteca Nacional de España, Special Collections

Published Sources

Acosta Luna, Olga Isabel. "A su imagen y semejanza: un retrato de la Virgen de la An-
 tigua en Bogotá." *Quiroga, Revista de Patrimonio Iberoamericano* 3 (2013): 12–24.
Acuña, Luis Alberto. "Angelino Medoro, pintor andariego." *Revista de la Academia
 Colombiana de Historia Eclesiástica* 4, nos. 15–16 (1969): 325–329.
Adorno, Rolena. "Images of *Indios Ladinos* in Early Colonial Peru." In *Transatlantic
 Encounters: Europeans and Andeans in the Sixteenth Century*, edited by Kenneth
 J. Andrien and Rolena Adorno, 232–270. Berkeley: University of California Press,
 1991.
Alaperrine-Bouyer, Monique. *La educación de las élites indígenas en el Perú colonial.*
 Lima: Instituto Francés de Estudios Andinos, 2007.

Alcina Franch, José, Jorge Bernales Ballesteros and Damián Bayón. *Historia del arte hispanoamericano, siglos XVI a XVIII*. 2 vols. Madrid: Alhambra, 1987.

Alemparte, Julio. "La regulación económica en Chile durante la colonia (II)." *Anales de la Facultad de Ciencias Jurídicas y Sociales* 2, nos. 6–7 (1936): n.p. http://www.revistas.uchile.cl/index.php/ACJYS/article/view/4053/3949.

Almeida, Eduardo. *Apuntes históricos del Valle de Pomasque*. Quito: Abya Yala, 1994.

Altamira, Luis Roberto. *Córdoba: sus pintores y sus pinturas (siglos XVII y XVIII)*. Córdoba: Imprenta de la Universidad, 1951.

Anonymous. "Cuentas de la Real Hacienda, 1648–1660." *Boletín del Archivo Nacional de Historia* 2, nos. 3–4 (1951): 104.

———. *Vocabulario y phrasis en la lengua general de los indios del Peru, llamada quichua* [1586]. Lima: Edición del Instituto de Historia, Universidad de San Marcos, 1951.

Arboleda, Gustavo. *Historia de Cali*. 3 vols. Cali: Carvajal, 1956.

Arenado, Fuensanta. "Nuevos datos sobre el pintor Angelino Medoro." *Archivo Hispalense* 60, no. 84 (1977): 103–112.

Ariza, Alberto E. "Santo Domingo de Tunja (Precisiones y rectificaciones)." *Apuntes: Revista de Estudios sobre Patrimonio Cultural* 15 (1978): 6–62.

Arquidiócesis de Cali, 1910–2010: un alba iluminada. Bogotá: Cargraphics S.A., 2010.

Arte quiteño más allá de Quito: memorias del seminario internacional. Quito: FONSAL, 2010.

Arteaga, Diego. *El artesano en la Cuenca colonial, 1557–1670*. Cuenca: Casa de la Cultura Ecuatoriana, 2000.

Astrana Marín, Luis. *Vida ejemplar y heróica de Miguel de Cervantes Saavedra con mil documentos hasta ahora inéditos y numerosas ilustraciones y grabados de la época*. Vol. III. Madrid: Instituto Editorial Reus, 1948.

Bargellini, Clara. "Consideraciones acerca de las firmas de los pintores novohispanos." In *El proceso creativo: actas del XXVI Coloquio Internacional de Historia del Arte*, edited by Alberto Dallal, 203–222. Mexico City: Universidad Autónoma de México, 2006.

———. "La pintura sobre lámina de cobre en los virreinatos de la Nueva España y del Perú." *Anales del Instituto de Investigaciones Estéticas* 21, nos. 74–75 (1999): 79–98.

Bauer, Brian S., and Jean-Jacques Decoster. "Introduction: Pedro Sarmiento de Gamboa and *The History of the Incas*." In *The History of the Incas by Pedro Sarmiento de Gamboa 1572*, edited by Brian S. Bauer and Vania Smith, 1–34. Austin: University of Texas Press, 2007.

Beatty Medina, Charles. "Caught between Rivals: The Spanish–African Competition for Captive Indian Labor in the Region of Esmeraldas during the Late Sixteenth and Early Seventeenth Centuries." *The Americas* 63, no. 1 (2006): 125–132.

———. "El retrato de los cimarrones de Esmeraldas." In *Ecuador-España: historia y perspectivas*, edited by María Elena Porras and Pedro Calvo-Sotelo, 18–21. Quito: Embajada de España en el Ecuador, Archivo Histórico del Ministerio de Relaciones Exteriores, 2001.

Benson, Elizabeth P., *Retratos: 2,000 Years of Latin American Portraits*. Exh. cat. New Haven: Yale University Press, 2004.

Berenbeim, Jessica. "Script after Print: Juan de Yciar and the Art of Writing." *Word & Image: A Journal of Verbal and Visual Enquiry* 26, no. 3 (2010): 231–243.

Betanzos, Juan de. *Narrative of the Incas*. Translated by Roland Hamilton and Dana Buchanan. Austin: University of Texas Press, 1996.

Bolaños Donoso, Piedad. "Nuevas aportaciones documentales sobre el histrionismo sevillano del siglo XVI." In *La comedia*, edited by Jean Cavanaggio, 131–144. Madrid: Casa de Velázquez, 1995.

Bonnett, Diana. *El Protector de Naturales en la Audiencia de Quito, siglos XVII y XVIII*. Quito: FLACSO, 1992.

Boone, Elizabeth Hill, and Gary Urton, eds. *Their Way of Writing: Scripts, Signs, and Pictographies in Pre-Columbian America*. Cambridge, MA: Harvard University Press, 2011.

Boone, Elizabeth Hill, and Walter D. Mignolo, eds. *Writing Without Words: Alternative Literacies in Mesoamerica and the Andes*. Durham, NC: Duke University Press, 1994.

Bray, Tamara L. "Ecuador's Pre-Columbian Past." In *The Ecuador Reader: History, Culture, Politics*, edited by Carlos de la Torre and Steven Striffler, 15–26. Durham, NC: Duke University Press, 2008.

———. *Los efectos del imperialismo incaico en la frontera norte*. Quito: Abya Yala and MARKA, 2003.

———. "Rock Art, Historical Memory and Ethnic Boundaries: A Study from the Northern Andean Highlands." *Andean Archaeology* II (2002): 333–354.

Brokaw, Galen. "Semiotics, Aesthetics, and the Quechua Concept of *Quilca*." In *Colonial Mediascapes: Sensory Worlds of the Early Americas*, edited by Matt Cohen and Jeffrey Glover, 166–202. Lincoln and London: University of Nebraska Press, 2014.

Bruhns, Karen Olsen. "Vestimentas en el Ecuador precolombino." *Arqueología del Área Intermedia* 4 (2002): 35–36.

Bruquetas, Rocío. *Técnicas y materiales de la pintura española en los Siglos de Oro*. Madrid: Fundación de Apoyo a la Historia del Arte Hispánico, 2000.

Burgos Guevara, Hugo. *El guamán, el puma y el amaru: formación estructural del gobierno indígena en el Ecuador*. Quito: Abya Yala, 1995.

———. *Primeras doctrinas en la real audiencia de Quito, 1570-1640: estudio preliminar y transcripción de las relaciones eclesiales y misionales de los siglos XVI y XVII*. Quito: Abya Yala, 1995.

Burns, Kathryn. *Into the Archive: Writing and Power in Colonial Peru*. Durham and London: Duke University Press, 2010.

———. "Making Indigenous Archives: The Quilcaycamayoc of Colonial Cuzco." *Hispanic American Historical Review* 91, no. 4 (2011): 679–680.

Cabello Balboa, Miguel. *Obras*. Vol. 1. Quito: Editorial Ecuatoriana, 1945.

Caillavet, Chantal. "'Como caçica y señora desta tierra mando . . .': insignias, funciones y poderes de las soberanas del norte andino (siglos XV–XVI)," *Bulletin de l'Institut Français d'Etudes Andines* 37, no. 1 (2008): 57–80.

———. *Etnias del norte: etnohistoria e historia de Ecuador*. Quito: Abya Yala, 2000.

Capua, Constanza di. "Consideraciones sobre una exposición de sellos arqueológicos." *Antropología Ecuatoriana* 2–3 (1984): 79–103.

Carcelén, Ximena, dir. *El apostolado en el esplendor barroco*. Exh. cat. Quito: Pontificia Universidad Católica del Ecuador, 2001.

Caro, Venancio D. *Caleruega, cuna de Santo Domingo de Guzmán*. Madrid, 1952.

Carrera Stampa, Manuel. *Los gremios mexicanos: la organización gremial en Nueva España, 1521–1861*. Mexico City: EDIAPSA, 1954.

Carrillo y Gariel, Abelardo. *Autógrafos de pintores coloniales*. Mexico City: Universidad Autónoma de México, 1953.

Casselman, Karen Diadick. *Lichen Dyes: The New Sourcebook*. 2nd ed. Mineola, NY: Dover Publications, 2001.

Castañeda García, Carmen. "Libros para la enseñanza de la lectura en la Nueva España, siglos XVIII y XIX: cartillas, silabarios, catones y catecismos." In *Lecturas y lectores en la historia de México*, edited by Carmen Castañeda García, Luz Elena Galván Lafarga, and Lucía Martínez Moctezuma, 35–66. Mexico City: CIESAS, 2004.

Castillo Gómez, Antonio. *Entre la pluma y la pared: una historia social de la escritura en los siglos de oro*. Madrid: Akal, 2006.

Castro Morales, Efraín. "Ordenanzas de pintores y doradores de la ciudad de Puebla de los Angeles." *Boletín de Monumentos Históricos* 9 (1989): 4–9.

Chacón Z., Juan. *Historia de la minería en Cuenca*. Cuenca: Universidad de Cuenca, 1986.

Charles, John. *Allies at Odds: The Andean Church and Its Indigenous Agents, 1583–1671*. Albuquerque: University of New Mexico Press, 2010.

Chartier, Roger. *Inscribir y borrar: cultura escrita y literatura (siglos XI-XVIII)*. Buenos Aires: Katz Editores, 2006.

———. "Lectores y lecturas populares. Entre imposición y apropiación." *Co-Herencia* 4, no. 7 (2007): 103–117.

Chichizola Debernardi, José. *El manierismo en Lima*. Lima: Pontificia Universidad Católica del Perú, 1983.

Civezza, Marcellino da. *Storia universale delle missioni francescane*. 11 vols. Roma: Tipografia Tiberina, 1857–1895.

Clavijo García, Agustín. "Pintura colonial en Málaga y su provincia." In *Andalucía y América en el siglo XVIII: actas de las IV Jornadas de Andalucía y América*, vol. 2, 89–118. Sevilla: Escuela de Estudios Hispano-Americanos, 1985.

Clerc de Cuenca, Isabel. "Sigilografía colombina: estudio de sellos de las zonas arqueológicas Quimbaya-Calima y del litoral pacific Colombo-Ecuatoriano." *Universitas Humanística* 33, no. 33 (1991): 38–45.

Cohen, Matt, and Jeffrey Glover, eds. *Colonial Mediascapes: Sensory Worlds of the Early Americas*. Lincoln and London: University of Nebraska Press, 2014.

Colección de documentos sobre el Obispado de Quito, 1546–1583. Transcribed by Jorge A. Garcés. Quito: Talleres Tipográficos Municipales, 1946.

Compte, Francisco María. *Varones ilustres de la Orden Seráfica en el Ecuador: desde la fundación de Quito hasta nuestros días*. Quito: Imprenta del Gobierno, 1883.

———. *Varones ilustres de la Orden Seráfica en el Ecuador*. 2nd ed., 2 vols. Quito: Imprenta del Clero, 1885.

Cornejo Bouroncle, Jorge. *Derroteros de arte cuzqueño: datos para una historia del arte en el Perú*. Cuzco: Ediciones Inca, 1960.

Costales, Piedad and Alfredo Costales Samaniego. *Los agustinos, pedagógos y misioneros del pueblo (1573–1869)*. Quito: Abya Yala, 2003.

Costales Samaniego, Alfredo. "El arte en la Real Audiencia de Quito." In *Arte colonial quiteño: renovado enfoque y nuevos actores*, by Carmen Fernández-Salvador and Alfredo Costales Samaniego, 127–315. Quito: FONSAL, 2007.

Cotarelo y Mori, Emilio. "Noticias biográficas de Alberto Ganasa, cómico famoso del siglo XVI." *Revista de Archivos, Bibliotecas y Museos* 19 (1908): 42–61.

Cuervo, Luis Augusto. "Exposición de arte antigua en Tunja." *Boletín de Historia y Antigüedades* 16, no. 190 (1927): 611–614.

Cuesta, Juan de la. "Tratado de bien y perfetamente escrivir, assi de la verdadera practica para la buena pintura y figura de la letra, como de los aditamentos y particularidades, necessarias para la escritura." In *Libro y tratado para enseñar leer y escrevir*. Alcalá, 1589.

Cummins, Thomas B. F. "Don Francisco de Arobe and His Sons Pedro and Domingo." In *The Arts in Latin America, 1492–1820*, organized by Joseph J. Rishel and Suzanne Stratton-Pruitt, 418. Exh. cat. Philadelphia: Philadelphia Museum of Art and Yale University Press, 2006.

———."Three Gentlemen from Esmeraldas: A Portrait Fit for a King." In *Slave Portraiture in the Atlantic World*, edited by Agnes Lugo–Ortiz and Angela Rosenthal, chap. 4. Cambridge: Cambridge University Press, 2013.

———. *Toasts with the Inca: Andean Abstraction and Colonial Images on Quero Vessels*. Ann Arbor: University of Michigan Press, 2002.

———. "The Uncomfortable Image: Words and Pictures in the *Nueva corónica i buen gobierno*." In *Guaman Poma de Ayala: the Colonial Art of an Andean Author*, 46–59. Exh. cat. New York: Americas Society, 1992.

Cummins, Thomas B. F., Julio Burgos Cabrera, and Carlos Mora Hoyos. *Arte prehispánico del Ecuador: huellas del pasado, los sellos de Jama-Coaque*. Exh. cat. Guayaquil: Museos del Banco Central del Ecuador, 1996.

Descripción inédita de la Iglesia y Convento de San Francisco de Quito [1647]. Lima: Talleres Tipográficos de "La Tradición," 1924.

DICTER: diccionario de la ciencia y de la técnica del Renacimiento. Ediciones Universidad de Salamanca. http://dicter.usal.es/.

Doctrina christiana y catecismo para instruccion de los Indios, y de las demas personas, que han de ser enseñadas en nuestra sancta Fé. Lima: Antonio Ricardo, 1584.

Doyon, Leon G. "Tumbas de la nobleza en La Florida." In *Quito antes de Benalcázar*, edited by Ivan Cruz Cevallos, 51–66. Quito: Centro Cultural Artes, 1989.

Doyon-Bernard, Suzette J. "La Florida's Mortuary Textiles: The Oldest Extant Textiles from Ecuador." *Textile Museum Journal* 32–33 (1994): 82–102.

Dueñas, Alcira. *Indians and Mestizos in the "Lettered City": Reshaping Justice, Social Hierarchy, and Political Culture in Colonial Peru*. Boulder: University Press of Colorado, 2010.

Duviols, Pierre. *La lutte contre les religions autochtones dans le Pérou colonial: "l'extirpation de l'idolâtrie" entre 1532 et 1660*. Lima: IFEA, 1971.

Eastaugh, Nicholas, Valentine Walsh, Tracey Chaplin, and Ruth Siddall. *Pigment Compendium: A Dictionary and Optical Microscopy of Historical Pigments*. New York: Routledge, 2013.

Egido, Aurora. "Los manuales de escribientes desde el Siglo de Oro [Apuntes para la teoría de la escritura]." *Bulletin Hispanique* 97, no. 1 (1995): 67–94.

Escolano, Augustín, ed. *Historia ilustrada del libro escolar: del Antiguo Régimen a la Segunda República*. Madrid: Fundación Germán Sánchez Ruipérez, 1997.

Escudero-Albornoz, Ximena. *Historia y leyenda del arte quiteño: su iconología*. Quito: FONSAL, 2009.

Escudero de Terán, Ximena. *América y España en la escultura colonial quiteña*. Quito: Ediciones del Banco de los Andes, 1992.

Espinosa Apolo, Manuel. *Insumisa vecindad: memoria política del barrio de San Roque*. Quito: Quito Eterno, 2009.

Espinosa Fernández de Córdova, Carlos. "La mascarada del Inca: una investigación acerca del teatro politico de la Colonia." *Miscelánea Histórica Ecuatoriana* 2 (1960): 6–39.

Espinoza Soriano, Waldemar. *Etnohistoria ecuatoriana, estudios y documentos.* Quito: Abya Yala, 1999.

———. "La vida pública de un príncipe Inca residente en Quito, siglos xv y xvi." *Boletín del Instituto Francés de Estudios Andinos* 7, nos. 3/4 (1978): 1–31.

Estabridis Cárdenas, Ricardo. *El grabado en Lima virreinal. Documento histórico y artístico (siglos XVI al XIX).* Lima: Fondo Editorial Universidad Nacional Mayor de San Marcos, 2002.

———. "La influencia italiana en la pintura virreinal." In *Pintura en el Virreinato del Perú*, 109–164. Lima: Banco de Crédito del Perú, 1989.

Estabridis Cárdenas, Ricardo, Rocío Bruquetas Galán, Ana Carrassón López de Letona, Rosanna Kuon Arce, Christhiam Fiorentino Vásquez, and Marisa Gómez González. "Materials and Techniques in Viceregal Painting and Sculpture in Lima—16th and 17th Centuries." *Art Technological Source Research.* Lisbon: ICOM-CC, 2011.

Esteve Serrano, Abraham. "El 'Libro subtilissimo intitulado honra de escrivanos' de Pedro de Madariaga." In *Homenaje al Prof. Muñoz Cortés*, 151–163. Murcia: Universidad de Murcia, Facultad de Filosofía y Letras, 1977.

Estrada, Emilio. *Arte aborígen del Ecuador: sellos o pintaderas.* Quito: Edición Universitaria, 1959.

Estupiñán-Freile, Tamara. "El testamento de Don Francisco Atagualpa." *Miscelánea Histórica Ecuatoriana* 1, no. 1 (1988): 8–67.

Estupiñan Viteri, Tamara. *Diccionario básico del comercio colonial quiteño.* Quito: Ediciones del Banco Central del Ecuador, 1997.

Fernández Rueda, Sonia. "El Colegio de Caciques de San Andrés: conquista espiritual y transculturación." *Procesos: Revista Ecuatoriana de Historia* 22 (2005): 5–24.

Fernández-Salvador, Carmen. "Historia del arte colonial quiteño: un aporte historiográfico." In *Arte colonial quiteño: renovado enfoque y nuevos actores*, by Carmen Fernández-Salvador and Alfredo Costales Samaniego, 11–122. Quito: FONSAL, 2007.

Ferri Chulio, Andrés de Sales. *Iconografía popular de la Mare de Déu dels Desamparats.* Valencia: Federico Domenech, 1998.

Fourcroy, Antoine-François de. *Elements of Natural History and Chemistry.* 4th ed., 3 vols. London: C. Elliot and T. Kay, 1790.

Fraga González, Carmen. "Emigración de pintores andaluces en el siglo xvi." *Anales de la Historia del Arte* 4 (1994): 577–581.

Garcilaso de la Vega, El Inca. *Comentarios reales.* Lisbon: Pedro Crasbeeck, 1609.

Gardner, Joan S. "Pre-Colombian Textiles, Los Ríos Province, Ecuador." *National Geographic Society Research Reports* 18 (1977): 327–342.

———. "Textiles precolombinos del Ecuador." *Miscelánea Antropológica Ecuatoriana* 2 (1982): 9–23.

Garzón, Gloria. "Situación de los talleres; gremios y artesanos. Quito, siglo xviii." In *Artes "académicas" y populares del Ecuador*, edited by Alexandra Kennedy Troya, 13–24. Quito: Abya Yala, Fundación Paul Rivet, 1995.

Gayo, M. D., and Maite Jover. Museo del Prado, Dirección Adjunta de Conservación y Restauración, Reporte No. 00069. 3 May 2012.

Gento Sanz, Benjamín. *Guía del turista en la iglesia y convento de San Francisco de Quito*. Quito: Imprenta Americana, 1940.

———. *Historia de la obra constructiva de San Francisco*. Quito: Imprenta Municipal, 1942.

Giraldo Jaramillo, Gabriel. "Fundación de la Capellanía de los Mancipes." *Repertorio Boyacense* 70 (1924): 1102–1110.

Gómez Jurado Garzón, Alvaro José. "El mopa-mopa o barniz de Pasto, comercialización indígena en el period colonial." *Estudios Latinoamericanos* 22–23 (2008): 82–93.

González del Campo, María Isabel. "Cartillas de la Doctrina Cristiana, impresas por la Catedral de Valladolid y enviadas a América desde 1583." In *Evangelización y teología en América (siglo XVI)*, vol. 1, 181–913. Pamplona: Universidad de Navarra, 1990.

González Holguín, Diego. *Vocabulario de la lengua general de todo el Peru llamada lengua Qquichua, o del Inca*. Lima: Francisco del Canto, 1608.

González Ojeda, Diego. "Rock Art Investigations in South Ecuador." In *Rock Art Studies—News of the World III*, edited by Paul Bahn, Natalie R. Franklin, and Matthias Strecker, 274–279. Oxford, UK: Oxbow Books, 2008.

González Suárez, Federico. *Historia general de la República del Ecuador*. 9 vols. Quito: Imprenta del Clero, 1890–1904.

Graubart, Karen. *With Our Labor and Sweat: Indigenous Women and the Formation of Colonial Society in Peru, 1550–1700*. Palo Alto, CA: Stanford University Press, 2007.

Guaman Poma de Ayala, Felipe. "El primer nueva corónica y buen gobierno," ca. 1615.

Guerrero, Jorge. "El arte ecuatoriano de la colonia (1600–1800)." *Revista de América* 10, no. 30 (June 1947): 331–344.

Gutiérrez, Ramón, and Graciela Viñuales, "San Francisco de Quito." *Trama* 1 (1977): 34–37.

Gutiérrez Usillos, Andrés. *Dioses, símbolos y alimentación en los Andes: interrelación hombre-fauna en el Ecuador prehispánico*. Quito: Abya Yala, 2002.

———. "Nuevas aportaciones en torno al lienzo titulado 'Los mulatos de Esmeraldas.' Estudio técnico, radiográfico e histórico." *Anales del Museo de América* 20 (2012): 7–64.

Gutiérrez Viñuales, Rodrigo. "La pintura y escultura en Hispanoamérica." In *L'Arte Universale*, edited by Joan Sureda. Milan: Jaca Book, 2008. http://www.ugr.es/~rgutierr/PDF1/119.pdf.

Hamann, Byron E. *The Translations of Nebrija: Language, Culture, and Circulation in the Early Modern World*. Amherst and Boston: University of Massachusetts Press, 2015.

Harllee, Carol D. "Pull Yourself Up by Your Inkwell: Pedro de Madariaga's *Honra de Escribanos* (1565) and Social Mobility." *Bulletin of Spanish Studies* 85, no. 5 (2008): 545–567.

Harrison, Regina. *Sin and Confession in Colonial Peru: The Spanish-Quechua Penitential Texts, 1560–1650*. Austin: University of Texas Press, 2014.

Harth-Terré, Emilio. *El indígena peruano en las bellas artes virreinales*. Cuzco: Editorial "Garcilaso," 1960.

Harth-Terré, Emilio, and Alberto Márquez Abanto. "Pinturas y pintores en Lima virreinal." *Revista del Archivo Nacional del Perú* 27, nos. 1–2 (1963): 104–218.

Hartmann, Roswith, and Udo Oberem. "Quito: un centro de educación de indígenas en el siglo XVI." In *Contribuções à Antropologia em homenagem ao Professor Egon Schaden*, 105–127. São Paulo: Fundo de Pesquisas do Museu Paulista, 1981.

Herrera Montero, Lizardo. "Entre el Santo y el Rey: los festejos realizados en Quito en el año de 1603 por la canonización de San Raimundo de Peñafort." MA thesis. Universidad Andina Simón Bolívar, Sede Ecuador, 2003.

———. "La canonización de Raimundo de Peñafort en Quito. Un ritual barroco entre la exhibición y el ocultado." *Procesos: Revista Ecuatoriana de Historia* 32 (2010): 5–30.

Herzog, Tamar. *Defining Nations: Immigrants and Citizens in Early Modern Spain and Spanish America*. New Haven, CT: Yale University Press, 2008.

Holm, Olaf. "El pasado vive aún . . ." In *Lanzas silbadoras y otras contribuciones de Olaf Holm al estudio del pasado del Ecuador*, vol. 1, edited by Karen Stothert, 54–70. Guayaquil: Banco Central del Ecuador and Museo Antropológico y de Arte Contemporáneo de Guayaquil, 2001.

———. "El tatuaje entre los aborígenes prepizarrianos de la costa ecuatoriana." In *Lanzas silbadoras y otras contribuciones de Olaf Holm al estudio del pasado del Ecuador*, vol. 1, edited by Karen Stothert, 272–296. Guayaquil: Banco Central del Ecuador and Museo Antropológico y de Arte Contemporáneo de Guayaquil, 2001.

Hyland, Sabine. *The Quito Manuscript: An Inca History Preserved by Fernando de Montesinos*. Yale University Publications in Anthropology Number 88. New Haven, CT: Peabody Museum of Natural History, 2007.

Imhof, Dirk. *Jan Moretus and the Continuation of the Plantin Press*. Leiden, the Netherlands: Koninklijke Brill, 2014.

Infantes, Víctor. "De cartilla al libro." *Bulletin Hispanique* 97, no. 1 (1995): 33–66.

———. "La imagen gráfica de la primera enseñanza en el siglo XVI." *Revista Complutense de Educación* 10, no. 2 (1999): 73–100.

Infantes, Víctor, and Ana Martínez Pereira, eds. *De las primeras letras: cartillas españolas para enseñar a leer de los siglos XV y XVI*. Salamanca: Universidad de Salamanca, 2003.

Jara, Victoria de la. *Introducción al estudio de la escritura de los inkas*. Lima: Instituto de Investigación y Desarrollo de la Educación, 1975.

———. "La solución del problema de la escritura peruana." *Arqueología y Sociedad* 1 (1970): 27–35.

Jiménez de la Espada, Marcos. "Relaciones geográficas de Indias: Perú," in *Biblioteca de autores españoles*, vol. 183. Madrid: Ediciones Atlas, 1965.

Jouanen, José. *Historia de la Compañía de Jesús en la antigua provincia de Quito, 1570–1774*. 2 vols. Quito: Editorial Ecuatoriana, 1941–1943.

Julien, Catherine. *Reading Inca History*. Iowa City: University of Iowa Press, 2000.

Jurado Noboa, Fernando. *Diccionario histórico genealógico de apellidos y familias de origen quechua, aymara y araucano (Ecuador)*. Quito: Temístocles Hernández, 2002.

———. *Los Larrea: burocracia, tenencia de la tierra, poder político, crisis, retorno al poder y papel en la cultura ecuatoriana*. Quito: Sociedad Ecuatoriana de Amigos de la Genealogía, 1986.

———. *Migración internacional a Quito entre 1534 y 1934*. Quito: Sociedad de Amigos de la Genealogía, 1989.

Justo Estebaranz, Ángel. "La influencia de los grabados europeos en la pintura quite-
 ña de los siglos XVII y XVIII." In *La multiculturalidad en las artes y en la arqui-
 tectura*, vol. I, 305–310. La Palmas de Gran Canaria: Consejería de Educación,
 Cultura y Deportes de Canarias and Anroart Ediciones, 2006.

———. *Miguel de Santiago en San Agustín de Quito*. Quito: FONSAL, 2008.

———. "El obrador de Miguel de Santiago en sus primeros años: 1656–1675." *Revista
 Complutense de Historia de América* 36 (2010): 163–184.

———. *Pintura y sociedad en Quito en el siglo XVII*. Quito: Pontificia Universidad
 Católica del Ecuador, 2011.

———. *El pintor quiteño Miguel de Santiago (1633–1706)): su vida, su obra y su taller*.
 Seville: Universidad de Sevilla, 2013.

Kennedy Troya, Alexandra. "Arte y artistas quiteños de exportación." In *Arte de la
 Real Audiencia de Quito, siglos XVI-XIX*, 185–203. Hondarribia: Nerea, 2002.

———. "La fiesta barroca en Quito." *Anales del Museo de América* 4 (1996): 137–152.

Kennedy Troya, Alexandra, and Alfonso Ortiz Crespo, *Convento de San Diego de
 Quito: historia y restauración*. Quito: Banco Central del Ecuador, 1982.

Klein, Daniel, Ivan Cruz Cevallos, Miguel Angel Cabodevilla Iribarren, Leon Doyon,
 and Richard Lunniss. *Ecuador: The Secret Art of Pre-Colombian Ecuador*. Milan:
 5 Continents Editions, 2007.

Kubler, George. *Arquitectura mexicana del siglo XVI*. Mexico City: Fondo de Cultura
 Económica, 1982.

Lane, Kris. *Quito 1599: City and Colony in Transition*. Albuquerque: University of
 New Mexico Press, 2002.

Lepage, Andrea. "El arte de la conversion: modelos educativos del Colegio de San
 Andrés de Quito." *Procesos: Revista Ecuatoriana de Historia* 25, no. 1 (2007):
 45–77.

Libro de Cabildos de la ciudad de Quito, 1638–1646. Vol. 30. Transcribed by Jorge A.
 Garcés. Quito: Imprenta Municipal, 1960.

*Libro de proveimientos de tierras, cuadras, solares, aguas, etc., por los Cabildos de
 la Ciudad de Quito, 1583–1594*. Transcribed by Jorge A. Garcés. Quito: Archivo
 Municipal, 1941.

Lizárraga, Reginaldo de. *Descripción breve de toda la tierra del Perú, Tucumán, Río
 de la Plata y Chile*. In his *Descripción colonial, libro primero*. Buenos Aires: Li-
 brería La Facultad, 1916.

Londoño Vélez, Santiago. *Arte colombiano: 3.500 años de historia*. Bogotá: Villegas
 Editores, 2001.

López, Juan. *Quinta parte de la historia de Sto. Domingo y de su Orden de Predicado-
 res*. Valladolid: Juan de Rueda, 1622.

López de Villarino, Teresa. *La vida y el arte del ilustre panameño Hernando de la
 Cruz S. J., 1591 a 1646*. Quito: La Prensa Católica, 1950.

Madariaga, Pedro de. *Libro subtilísimo titulado honra de escribanos*. Valencia: Juan
 de Mey, 1565.

Malpartida Tirado, Rafael. "Confluencia de modalidades dialogales en la *Honra de
 escribanos* de Pedro de Madariaga." *Lectura y Signo* 1 (2006): 105–124.

Mannheim, Bruce. *The Language of the Inka since the European Invasion*. Austin:
 University of Texas Press, 1991.

Marco Dorta, Enrique. *Arte en América y Filipinas*. Ars Hispaniae: Historia Univer-
 sal del Arte Hispánico, vol. XXI. Madrid: Editorial Plus-Ultra, 1973.

Martínez Pereira, Ana. "Los manuales de escritura de los Siglos de Oro: problemas bibliográficos." *Litterae: Cuadernos sobre Cultura Escrita* 3–4 (2003–2004): 133–160.

Matilla, José Manuel. *La estampa en el libro barroco: Juan de Courbes*. Madrid: Ephialte, 1991.

Matovelle, Julio. *Imágenes y santuarios célebres de la Virgen Santísima en la América Española, señaladamente en la República del Ecuador*. Quito: Editora de los Talleres Salesianos, 1910.

Maza, Francisco de la. "Fray Pedro de Gante y la capilla abierta de San José de los Naturales." In *Retablo barroco a la memoria de Francisco de la Maza*, edited by Diego Angulo Iñiguez, 43–52. Mexico City: UNAM, 1974.

McAndrew, John. *The Open-Air Churches of Sixteenth-Century Mexico*. Cambridge, MA: Harvard University Press, 1965.

Meggers, Betty. *Ecuador*. New York: Frederick A. Praeger, 1966.

Meisch, Lynn A. "Colonial Costume." In *Costume and History in Highland Ecuador*, edited by Anne Pollard Rowe, 1–10 and 49–69. Austin: University of Texas Press, 2011.

Méndez Casal, Antonio. "El pintor Alejandro de Loarte." *Revista Española de Arte* 12, no. 4 (Dec. 1934): 187–202.

Mendieta, Gerónimo de. *Historia ecclesiástica indiana*. Mexico City: Editorial Porrúa, 1980.

Mendoza Laverde, Camilo. "Restauración de las pinturas murals de Santo Domingo de Tunja." *Apuntes. Revista de Estudios sobre Patrimonio Cultural* (1976): 79–98.

Mercado, Pedro de. *Historia de la Provincia del Nuevo Reino y Quito de la Compañía de Jesús*, vol. 3. Bogotá: Biblioteca de la Provincia de Colombia, 1957.

Mesa, José de and Teresa Gisbert. *Bitti, un pintor manierista en Sudamérica*. La Paz: Universidad Mayor de San Andrés, 1974.

———. "Dos dibujos inéditos de Medoro en Madrid." *Arte y Arqueología* 1 (1969): 19–27.

———. *Escultura virreinal en Bolivia*. La Paz: Academia Nacional de Ciencias de Bolivia, 1972.

———. *Historia de la pintura cuzqueña*. 2 vols. Lima: Fundación Wiese, 1982.

———. *El manierismo en los Andes*. La Paz: Unión Latina, 2005.

———. "The Painter, Mateo Mexía, and His Works in the Convent of San Francisco de Quito." *The Americas* 16, no. 4 (1960): 385–396.

———. "El pintor Angelino Medoro y su obra en Sudamérica," *Anales del Instituto de Arte Americano e Investigaciones Estéticas* 18 (1965): 23–47.

Meyers, Albert. *Los Incas en el Ecuador: análisis de los restos materiales*. Quito: Abya Yala, 1998.

Mignolo, Walter. *The Darker Side of the Renaissance: Literacy, Territoriality, and Colonization*. Ann Arbor: University of Michigan Press, 1995.

———. "Nebrija in the New World: The Question of the Letter, the Colonization of Amerindian Languages, and the Discontinuity of the Classical Tradition." *L'Homme* 32, nos. 122/124 (1992): 185–207.

Minchom, Martin. *The People of Quito, 1690–1810: Change and Unrest in the Underclass*. Boulder, CO: Westview, 1994.

Moffitt, John F. *The Islamic Design Module in Latin America*. Jefferson, NC: McFarland, 2004.

Molestina Zaldumbide, María del Carmen. "El pensamiento simbólico de los ha-

bitantes de la Florida (Quito-Ecuador)." *Bulletin de l'Institut Français d'Études Andines* 35, no. 3 (2006): 377–395.

Molina, Cristóbal de. "Relación de las fábulas y ritos de los Incas" [ca. 1575]. In *Fábulas y mitos de los incas*, edited by Henrique Urbano and Pierre Duviols. Madrid: Historia 16, 1989.

Monroy, Joel L. *El Convento de la Merced de Quito de 1617–1700.* Quito: Editorial Labor, 1932.

Monteforte Toledo, Mario, Lucas Achig, Adrián Carrasco, Claudio Cordero, Juan Cordero Iñiguez, Manuel Chiriboga, Elías Muñoz Vicuña, and Hernán Rodríguez Castelo. *Los signos del hombre.* Cuenca: Pontificia Universidad Católica del Ecuador, 1985.

Moorman, John Richard Humpidge. *A History of the Franciscan Order from its Origins to the Year 1517.* New York: Oxford University Press, 1968.

Morán de Butrón, Jacinto. *La Azucena de Quito, que broto el florido campo de la Iglesia en las Indias Occidentales de los Reynos del Perú.* Madrid: Imprenta de Don Gabriel del Barrio, c. 1724.

Moreno, Agustín. *Fray Jodoco Rique y Fray Pedro Gocial: apóstoles y maestros franciscanos de Quito, 1535–1570.* Quito: Abya Yala, 1998.

Moreno Egas, Jorge. "La cofradía de tejedores de Nuestra Señora de la Presentación." *Revista del Instituto de Historia Ecclesiástica Ecuatoriana* 13 (1993): 105–124.

Muro Orejón, Antonio. *Documentos para la Historia del Arte en Andalucía: pintores y doradores*, vol. 8. Seville: Laboratorio de Arte, 1935.

Murúa, Martín de. *Historia general del Piru: Facsimile of J. Paul Getty Museum Ms. Ludwig XIII 16.* Los Angeles: Getty Research Institute, 2008.

Navarro, José Gabriel. *Artes plásticas ecuatorianas.* Mexico City: Fondo de Cultura Económica, 1945.

———. *Contribuciones a la historia del arte en el Ecuador.* 2nd ed. 4 vols. Quito: FONSAL, 2006.

———. "Datos tomados del archivo de la Merced," No. 2, Año de 1654, fol. 59v, unpublished ms. in the collection of Ximena Carcelén.

———. *La escultura en el Ecuador durante los siglos XVI, XVII y XVIII.* 2nd ed. Quito: TRAMA, 2006.

———. *Guía artística de Quito.* Quito: La Prensa Católica, 1961.

———. "La influencia de los franciscanos en el arte quiteño." *Academia: Boletín de la Real Academia de Bellas Artes de San Fernando* 5 (1955–1957): 67–78.

———. "Un pintor quiteño, un cuadro admirable del siglo XVI en el Museo Arqueológico Nacional, Madrid." *Boletín de la Real Academia de la Historia* 94 (1929): 449–474.

———. *La pintura en el Ecuador del XVI al XIX.* Quito: Dinediciones, 1991.

———. "El retablo de Santa Teresa de Jesús en la Iglesia de la Concepción." *El Comercio*, Sunday, 9 October 1960.

Navas, Juan de Dios. *Guápulo y su santuario, 1581–1926.* Quito: Imprenta del Clero, 1926.

Nebrija, Antonio de. *Gramatica castellana.* Salamanca, 1492.

———. *Introductiones latinae.* Sevilla: Alfonso del Puerto, 1481.

Nieri Galindo, Luis. *Pintura en el Virreinato del Perú.* Lima: Banco de Crédito del Perú, 1989.

Oberem, Udo. *Notas y documentos sobre miembros de la familia del Inca Atahualpa en el siglo XVI.* Guayaquil: Casa de la Cultura Ecuatoriana, 1976.

Ordax, Salvador Andrés. "El monasterio cisterciense de Villamayor de los Montes (Burgos)." *Boletín del Seminario de Estudios de Arte y Arqueología* 58 (1992): 281–300.

Ortiz Batallas, Silvia, ed. *Desde el silencio de la clausura: el Real Monasterio de la Limpia Concepción de Quito*. Quito: Instituto Metropolitanto de Patrimonio, 2014.

Pachacuti Yamqui, Juan de Santa Cruz. *Relación de antigüedades de este reyno del Perú* [1613]. Mexico City: Fondo de Cultura Económica, 1995.

Palmer, Gabrielle G. *Sculpture in the Kingdom of Quito*. Albuquerque: University of New Mexico Press, 1987.

Paniagua Pérez, Jesús. "La cofradía quiteña de San Eloy." *Estudios Humanísticos: Geografía, Historia, Arte* 10 (1988): 197–214.

———. "La enseñanza professional en el mundo colonial: la enseñanza y desarrollo de los oficios." *Historia de la Educación Colombiana* 8, no. 8 (2005): 77–115.

Paniagua Pérez, Jesús and Deborah L. Truhan. *Oficios y actividad paragremial en la Real Audiencia de Quito (1557–1730): el corregimiento de Cuenca*. León: Universidad de León, 2003.

Patricio Guerra, Manuel. *La Cofradía de la Virgen del Pilar de Zaragoza de Quito*. Quito: Abya Yala, 2000.

Pazmiño Acuña, Rocío. "La configuración urbana de la Villa de Villar Don Pardo: Riobamba en la época colonial." In *La antigua Riobamba: historia oculta de una ciudad colonial*, edited by Rosemarie Terán Najas, 51–86. Riobamba: Municipio de Riobamba, 2000.

Pazzelli, Raffaele. *St. Francis and the Third Order: The Franciscan and Pre-Franciscan Penitential Movement*. Quincy, IL: Franciscan Press, 1989.

Pearlstein, Ellen J., Emily Kaplan, Ellen Howe, and Judith Levinson. "Technical Analyses of Painted Inka and Colonial Qeros." *Objects Specialty Group Postprints* 6 (1999): 94–111.

Pérez Sánchez, Alfonso, and Ana Sánchez-Lassia de los Santos. *Las lágrimas de San Pedro en la pintura española del Siglo de Oro*. Bilbao: Museo de Bellas Artes de Bilbao, 2000.

Phelan, John Leddy. *The Kingdom of Quito in the Seventeenth Century: Bureaucratic Politics in the Spanish Empire*. Madison: University of Wisconsin Press, 1967.

Phipps, Elena. *Cochineal Red: The Art History of a Color*. New York: Metropolitan Museum of Art, 2010.

———. "Color in the Andes: Inca Garments and Seventeenth-Century Colonial Documents." *Dyes in History and Archaeology* 19 (2003): 51–59.

Pizarro Gómez, Francisco Javier. "Identidad y mestizaje en el arte barroco andino. La iconografía." In *Barroco, Actas do II Congresso Internacional*, 197–213. Porto: Departamento de Ciências e Técnicas do Patrimonio, 2001.

Pólit Laso, Manuel María. *La familia de Santa Teresa en América y la primera carmelita americana*. Freiburg: Herder, 1905.

Porras, Stephanie. "Going Viral? Maerten de Vos's St. Michael the Archangel." In *Netherlandish Art in its Global Context*, edited by Thijs Weststeijn, Eric Jorink, and Frits Scholten, 54–78. Leiden: Brill, 2016.

Porras Barrenechea, Raúl. "Quipu i quilca (Contribución histórica al estudio de la escritura en el antiguo Perú)." *Revista del Museo e Instituto Arqueológico* 13–14 (1951): 19–53.

Powers, Karen Vieira. *Prendas con píes: migraciónes indígenas y supervivencia cultural en la Audiencia de Quito*. Quito: Abya Yala, 1994.

Puente Luna, José Carlos de la. "The Many Tongues of the King: Indigenous Language Interpreters and the Making of the Spanish Empire." *Colonial Latin American Review* 23, no. 2 (2014): 143–170.

Querejazu Leyton, Pedro. "El arte quiteño y ecuatoriano en la Audiencia de Charcas y en Bolivia." In *El arte quiteño más allá de Quito*, 234–253. Quito: FONSAL, 2010.

———. "The Materials and Techniques of Andean Painting." In *Gloria in Excelsis: The Virgin and Angels in Viceregal Painting of Peru and Bolivia*, 78–82. Exh. cat. New York: Center for Inter-American Relations, 1986.

Radicati di Primeglio, Carlos. "El secreto de la quilca." *Revista de Indias* 44, no. 73 (1984): 11–60.

Rama, Ángel. *La ciudad letrada*. Hanover, NH: Ediciones del Norte, 1984.

Rappaport, Joanne. *The Disappearing Mestizo: Configuring Difference in the Colonial New Kingdom of Granada*. Durham, NC: Duke University Press, 2014.

Rappaport, Joanne, and Tom Cummins. "Between Images and Writing: The Ritual of the King's *Quillca*." *Colonial Latin American Review* 7, no. 1 (1998): 7–32.

———. *Beyond the Lettered City: Indigenous Literacies in the Andes*. Durham, NC: Duke University Press, 2012.

Redondo Cantera, María José and Ximena Carcelén. "Fortuna pictórica del *apostolado* de Juan Antonio Salvador Carmona." *Boletín del Seminario de Estudios de Arte* 75 (2009): 235–246.

Reinmann, Gerald J. *The Third Order Secular of Saint Francis*. Washington, DC: Catholic University of America, 2013.

Relaciones Histórico-Geográficas de la Audiencia de Quito. Transcribed by Pilar Ponce Leiva. 2 vols. Quito: MARKA and Ediciones Abya Yala, 1992.

Rennert, Hugo. *The Spanish Stage in the Time of Lope de Vega*. New York: Hispanic Society of America, 1909.

Rivas, Jorge F. "Breves comentarios sobre el oficio del pintor en Venezuela, 1600–1822." In *De oficio pintor: arte colonial venezolano*, 17–30. Exh. cat. Santiago de los Caballeros de Mérida: Centro León, Fundación Cisneros, 2007.

Robalino, Isabel. *El sindicalismo en el Ecuador*. 2nd ed. Quito: Ediciones de la Ponitificia Universidad Católica del Ecuador, 1992.

Rodríguez Docampo, Diego. "Descripción y relación del estado eclesiástico del Obispado de San Francisco de Quito [1650]." In *Relaciones Histórico-Geográficas de la Audiencia de Quito* 2, transcribed by Pilar Ponce Leiva, 207–322. Quito: MARKA and Ediciones Abya Yala, 1994.

Rodríguez Nobrega, Janeth. "El oro en la pintura de los reinos de la monarquía española: técnica y simbolismo." In *Pintura de los reinos: identidades compartidas* IV, 1315–1375. Mexico City: Fomento Cultural Banamex, 2009.

Rojas, Ulises. "La Capilla de los Mancipes." *Boletín de Historia y Antigüedades* 26 (1952): 559–564.

———. *Corregidores y justicias mayores de Tunja y su provincia desde la fundación de la ciudad hasta 1817*. Tunja: Imprenta Departamental de Boyacá, 1962.

———. *Escudos de armas e inscripciones antiguas de la ciudad de Tunja*. Bogotá: Talleres de la Cooperativa Nacional de Artes Gráficas, 1939.

Romero de Terreros, Manuel. *Grabados y grabadores en la Nueva España*. Mexico City: Editorial Ars, 1948.

Roquero, Ana. "Identification of Red Dyes in Textiles from the Andean Region." *Textile Society of America Symposium Proceedings* (2008). Paper 129. http://digitalcommons.unl.edu/tsaconf/129.

Rowe, Anne Pollard. "Introduction" and "Evidence for Pre-Inca Textiles." In *Costume and History in Highland Ecuador*, edited by Anne Pollard Rowe, 1–10 and 49–69. Austin: University of Texas Press, 2011.

Rubin, Patricia. "Signposts of Invention: Artists' Signatures in Italian Renaissance Art." *Art History* 29, no. 4 (2006): 563–599.

Rueda Ramírez, Pedro. "Las cartillas para aprender a leer: la circulación de un texto escolar en Latinoamérica." *Cultura Escrita & Sociedad* 11 (2010): 15–42.

———. "La circulación de libros desde Europa a Quito en los siglos XVI–XVII," *Procesos: Revista Ecuatoriana de Historia* 15 (2000): 3–20.

———. "Las redes comerciales del libro en la colonial: 'peruleros' y libreros en la Carrera de Indias (1590–1620)." *Anuario de Estudios Americanos* 71, no. 2 (2014): 447–478.

Ruíz Gomar, Rogelio. "El gremio y la cofradía de los pintores en la Nueva España." In *Juan Correa: su vida y su obra; cuerpo de documentos*, edited by Elisa Vargas Lugo and José Guadalupe Victoria, vol. III, 205–215. Mexico City: UNAM, 1991.

Salcedo Salcedo, Jaime. *Los jeroglíficos incas: introducción a un método para descifrar tocapus-quillca; estudio del Quero 7511 del Museo de América de Madrid*. Bogotá: Universidad Nacional de Colombia, 2007.

Salgado Gómez, Mireya, Carmen Fernández-Salvador, and Melissa Moreano. *Estructuración del orden social colonial en la región de Quito: Quito en el siglo XVII*. Quito: Museo de la Ciudad, 2007.

Salomon, Frank. *Native Lords of Quito in the Age of the Incas: The Political Economy of North Andean Chiefdoms*. Cambridge: Cambridge University Press, 1986.

Salvador Lara, Jorge. *Quito en la poesía del período hispánico: discurso de incorporación del académico correspondiente*. Quito: Editorial Ecuatoriana, 1970.

Samaniego, Filoteo. "Determinantes del primer arte hispanoamericano." In *Arte colonial de Ecuador, siglos XVI–XVII*, edited by José María Vargas, 21–36. Quito: Salvat, 1985.

Sánchez, José María, and María Dolores Quiñones. "Materiales pictóricos enviados a América en el siglo XVI." *Anales del Instituto de Investigaciones Estéticas* 95 (2009): 45–67.

San Cristóbal, Antonio. "Gremios de plateros y doradores limeños del siglo XVII." *Revista Sequilao* 3 (1993): 21–31.

Santo Tomás, Domingo de. *Lexicon, o Vocabulario de la lengua general del Peru*. Valladolid: Francisco Fernández de Cordoua, 1560.

Sanz Ayán, Carmen. "Las compañías de representantes en los albores del teatro áureo: la agrupación de Alonso Rodríguez (1577)." In *Mira de Amescua en candelero*, vol. II, edited by Agustín de la Granja, 460–465. Granada: Universidad de Granada, 1996.

Sanz Ayán, Carmen, and Bernardo J. García García. "El 'oficio de representar' en España y la influencia de la *comedia dell'arte* (1567–1587)." *Cuadernos de Historia Moderna* 16 (1995): 475–500.

Sarmiento de Gamboa, Pedro. *Historia de los Incas* [1572]. Madrid: Ediciones Miraguano and Polifemo, 2001.

Sarmiento de Gamboa, Pedro. *The History of the Incas* [1572]. Translated and edited by Brian S. Bauer and Vania Smith. Austin: University of Texas Press, 2007.

Schenone, Héctor. *Iconografía del arte colonial: Jesucristo*. Buenos Aires: Fundación Tarea, 1998.

———. *Santa María*. Buenos Aires: Universidad Católica Argentina, 2008.

Sebastián López, Santiago. "Angelino Medoro policromó una imagen en Cali (Colombia)." *Archivo Español de Arte* 36 (1963): 137–138.

———. *Arquitectura colonial en Popayán y Valle del Cauca*. Cali: Biblioteca de la Universidad de Valle, 1965.

———. "Nueva pintura de Angelino Medoro en Bogotá." *Cuadernos de Arte Colonial* 1 (1986): 105–106.

———. *Album de arte colonial de Tunja*. Tunja: Talleres del la Imprenta Departamental, 1963.

Sebastián López, Santiago, José de Mesa, and Teresa Gisbert. *Arte iberoamericano desde la colonización a la independencia*. Summa Artis, vol. 28. Madrid: Espasa-Calpe, 1985.

Seldes, Alicia, José E. Burucúa, Marta S. Maier, Gonzalo E. Abad, Andrea Jáuregui, and Gabriela Siracusano. "Blue Pigments in South American Painting (1610–1780)." *Journal of the American Institute of Conservation* 38, no. 2 (1999): 100–123.

Seldes, Alicia, José E. Burucúa, Gabriela Siracusano, Marta S. Maier, and Gonzalo W. Abad. "Green, Red, Yellow Pigments in South American Painting (1610–1780)." *Journal of the American Institute of Conservation* 41, no. 3 (2002): 225–242.

Seldes, Alicia, Gabriela Siracusano, José E. Burucúa, Marta S. Maier, and Gonzalo W. Abad. "La paleta colonial andina. Química, historia y conservación." In *Actas del X Congreso de Abracor*, 155–164. Sao Paulo, 2000.

Serlio, Sebastiano. *Tercero y quarto libro de architectura de Sebastian Serlio boloñes*. Toledo: Casa de Iuan de Ayala, 1573.

Serrera Contreras, Juan Miguel. "El eje pictórico Sevilla-Lisboa, siglo XVI." *Archivo Hispalense* 76, no. 233 (1993): 143–154.

Los siglos de oro en los virreinatos de América, 1550–1700. Exh. cat. Madrid: Museo de América, 1999.

Siracusano, Gabriela. "'Copacabana, lugar donde se ve la piedra preciosa': imagen y materialidad en la región andina," presented at the conference *Los estudios de arte desde América Latina: arte y religión*, Salvador de Bahía, 2003. http://www.esteticas.UNAM.mx/edartedal/PDF/Bahia/complets/siracusano_bahia.pdf.

———. "Para copiar las 'buenas pinturas, problemas gremiales en un estudio de caso de mediados del siglo XVII en Lima." In *Memoria del III Encuentro Internacional sobre Barroco: manierismo y transición al barroco*, 131–139. Pamplona: Fundación Visión Cultural/Servicio de Publicaciones de la Universidad de Navarra, 2011.

———. *El poder de los colores: de lo material a lo simbólico en las prácticas culturales andinas, siglos XVI–XVIII*. Buenos Aires: Fondo de Cultura Económica de Argentina, 2005.

———. "Polvos y colores en la pintura barroca andina. Nuevas aproximaciones." In *Actas del III Congreso Internacional del Barroco Iberoamericano*, 425–444. Sevilla: Universidad de Pablo Olavide, 2001.

Soria, Martin. *La pintura del siglo XVI en Sudamérica*. Buenos Aires: Instituto de Arte Americano e Investigaciones Estéticas, 1956.

Stevenson, Robert. "Música en Quito." *Revista Musical Chilena* 16, nos. 81–82 (1962): 172–194.

Stratton-Pruitt, Suzanne, ed. *The Art of Painting in Colonial Quito*. Philadelphia: Saint Joseph's University Press, 2012.

Super, John. "Partnership and Profit in the Early Andean Trade: The Experience of Quito Merchants, 1580–1610." *Journal of Latin American Studies* 2 (1979): 265–281.

Szászdi, Adam. "El trasfondo de un cuadro: 'Los Mulatos de Esmeraldas' de Andrés Sánchez Gallque." *Cuadernos Prehispánicos* 12 (1986–87): 93–142.

Temoche Benítes, Ricardo. *Cofradías, gremios, mutuales y sindicatos en el Perú*. Lima: Editorial Escuela Nueva, 1987.

Terán Najas, Rosemarie, ed. *La antigua Riobamba: historia oculta de una ciudad colonial*. Quito: Abya Yala, 2000.

Thomas, Henry. "Juan de Vingles (Jean de Vingle), a Sixteenth-Century Book Illustrator." *The Library* 18, no. 2 (1937): 121–156.

Thomas Miguel, Serafín. *Historia de la vida de Santo Domingo de Guzmán, fundador de la sagrada Orden de Predicadores*. Valencia: Francisco Mestre, 1705.

Torre Revello, José. "Algunos libros de caligrafía usados en México en el siglo XVII." *Historia Mexicana* 5, no. 2 (1955): 220–227.

———. "Las cartillas para enseñanza a leer a los niños en América Española." *Thesaurus* 15, nos. 1, 2 y 3 (1960): 214–234.

Torre Villar, Ernesto de la. "Estudio crítico en torno a los catecismos y cartillas como instrumento de evangelización y civilización," introduction to *Fray Pedro de Gante, Doctrina Christiana en lengua mexicana*, 13–103. Mexico City: Centro de Estudios Históricos Fray Bernardino de Sahagún, 1981.

Toussaint, Manuel. *Pintura colonial en México*. 3rd ed. Mexico City: Universidad Autónoma de México, 1990.

Tovar de Teresa, Guillermo. *Pintura y escultura en Nueva España (1557–1640)*. Mexico City: Grupo Azabache, 1992.

Valadés, Diego de. *Rhetorica christiana*. Perugia, 1579.

Valdivieso, Enrique. *Historia de la pintura sevillana, siglos XIII al XX*. 2nd ed. Seville: Ediciones Guadalquivir, 1992.

Valverde Ogaller, Pedro Blas. "Manuscritos y heráldica en el tránsito a la modernidad: el libro de armería de Diego Hernández de Mendoza." PhD diss., Universidad Complutense de Madrid, 2001.

Vargas, José María. "Andrés Sánchez Gallque." *Revista de la Universidad Católica* 6, no. 19 (1978): 25–26.

———, ed. *Arte colonial de Ecuador, siglos XVI–XVII*. Quito: Salvat, 1985.

———. *El arte ecuatoriano*. Quito: Editorial Santo Domingo, 1964.

———. *Arte quiteño colonial*. Quito: Imprenta Romero, 1945.

———. *El arte quiteño en los siglos XVI, XVII y XVIII*. Quito: Imprenta Romero, 1949.

———. *Arte religioso ecuatoriano*. Quito: Casa de la Cultura Ecuatoriana, 1956.

———. *Biografía de Fray Pedro Bedón, O. P.* Quito: Editorial Santo Domingo, 1965.

———. *La cultura de Quito colonial*. Quito: Editorial Santo Domingo, 1941.

———. *Historia de la cultura ecuatoriana*. Quito: Casa de la Cultura Ecuatoriana, 1965.

———. *Historia de la Iglesia en el Ecuador durante el patronato español*. Quito: Editorial Santo Domingo, 1962.

———. *Historia del arte ecuatoriano*. Quito: Editorial Santo Domingo, 1963.

———. *La Iglesia y el patrimonio cultural ecuatoriano*. Quito: Ediciones de la Universidad Católica, 1982.

———. *Manuel Samaniego y su Tratado de Pintura.* Quito: Editorial Santo Domingo, 1975.

———. *Nuestra Señora del Rosario en el Ecuador.* Quito: Artes Gráficas Señal, 1983.

———. *Patrimonio artístico ecuatoriano.* Quito: Editorial Santo Domingo, 1967.

Vargas Murcia, Laura Liliana. *Del pincel al papel: fuentes para el estudio de la pintura en el Nuevo Reino de Granada (1552–1813).* Bogotá: ICANH, 2012.

Veliz, Zahira. *Artist's Techniques in Golden Age Spain.* Cambridge: Cambridge University Press, 1986.

Vences Vidal, Magdalena. "El culto a la Virgen de la Antigua en las diócesis hispano-americanas." In *América Latina: las caras de la diversidad,* 253–272. Mexico City: UNAM, 2006.

Vetancurt, Agustín de. *Chronica de la Provincia del Santo Evangelio de México: quarta parte del Teatro Mexicano.* Mexico City, 1694.

Alonso de Villegas, *Flos sanctorum segunda parte y Historia general: en que se escrive la vida de la Virgen sacratissima Madre de Dios [. . .] y la de los sanctos antiguos que fueron antes de la venida de nuestro Saluador.* Zaragoza: Casa de Simon de Portonarijs, 1586 and Toledo: Juan y Pedro Rodríguez, 1588.

Webster, Susan Verdi. *Arquitectura y empresa en el Quito colonial: José Jaime Ortiz, Alarife Mayor.* Quito: Abya Yala, 2002.

———. "Art, Identity, and the Construction of the Church of Santo Domingo in Quito." *Hispanic Research Journal* 10, no. 5 (2009): 430–434.

———. "A British King in Colonial Bogotá: A Portrait of Saint Lucius Attributed to Francisco Pacheco." *Source: Notes in the History of Art* 34, no. 4 (2015): 48–55.

———. "Las cofradías y su mecenazgo durante la colonia." In *Arte de la Real Audiencia de Quito, siglos XVII-XIX,* edited by Alexandra Kennedy, 67–85. Hondarribia: Nerea, 2002.

———. "La desconocida historia de la construcción de la iglesia de San Francisco en Quito." *Procesos: Revista Ecuatoriana de Historia* 35, no. 1 (2012): 37–66.

———. "The Devil and the Dolorosa: History and Legend in Quito's Capilla de Cantuña." *The Americas* 67, no. 1 (July 2010): 1–30.

———. "Masters of the Trade: Native Artisans, Guilds, and the Construction of Colonial Quito." *Journal of the Society of Architectural Historians* 68, no. 1 (March 2009): 10–29.

———. "Of Signatures and Status: Andrés Sánchez Gallque and Contemporary Painters in Early Colonial Quito." *The Americas* 70, no. 4 (2014): 603–644.

———. "'Pintar la figura de la letra': Andrés Sánchez Gallque y la lengua del imperio." In *Memorias de las VIII Jornadas Internacionales de Arte, Historia y Cultura Colonial: Medievalidad y Renacimiento en la América Colonial,* 54–81. Bogotá: Ministerio de Cultura de Colombia, 2014.

———. "La presencia indígena en el arte colonial quiteño." In *Esplendor del Barroco Quiteño/Himmel aus Gold: Indianischer Barock aus Ekuador,* edited by Ximena Carcelén, 36–50. Exh. cat. Quito: FONSAL, 2010.

———. *Quito, ciudad de maestros: arquitectos, edificios y urbanismo en el largo siglo XVII.* Quito: Abya Yala, 2012.

———. "Vantage Points: Andeans and Europeans in the Construction of Colonial Quito." *Colonial Latin American Review* 20, no. 3 (2011): 303–330.

Yciar, Juan de. *Arte subtilissima, por la qual se enseña a escrevir perfectamente.* Zaragoza: Pedro Bernuz, 1550.

INDEX

contracts, 77, 260nn24, 25, 26; lettered painters' signatures on documents, 4–5, 5, 7, 8, 79, 117, 123, 150, 152, 231n5, 231–232n6, 275n142; for painted objects, 64–65; for paintings, xvii, 43, 44, 46, 52, 64, 74, 79, 83–84; parish of residence identified in, 150; for purchases, 3; race and ethnicity recorded in, 5, 186, 281n2; as record of painters' commissions, xiv, xv, 74, 149, 229–230n4; reliability of, 230n4, 275n142; requirements for filing, 4, 84; of Andrés Sánchez Gallque, 74, 129–134, 220–222, 278n31; and subcontracting, 75, 180; and titles of trade, 74, 258nn2, 3, 4; of Lucas Vizuete, 176, 222–223

notarial documents: and Andean plaintiffs' use of legal system, 29; and book trade, 46–51; on Colegio de San Andrés, 28; and evidence of demand for instructional texts, 28; and Angelino Medoro, 100–102, 103; and Mateo Mexía, 186–190, 294n9; painters' signatures in, 213–214; and prints, 46–51; records of Quito market in, 42; and Luis de Ribera, 74, 91, 106, 107, 109–111, 219–220, 258n2, 269n66; and Andrés Sánchez Gallque, 74, 84, 118, 134, 135, 137, 279n39; trade examinations in, 77, 260n27

Orive, Domingo de, 10, 60
orpiment, 57–58, 61, 63, 192–193, 251n108, 297n37

Pachacuti (Inca ruler), 39, 40
Pacheco, Francisco, 83
Pacheco, Francisco (attrib.), *Saint Lucius King of Britain*, 266n29
painting profession: absence of guild structure in early co-

lonial Quito, 72, 73, 75, 76, 77–79, 83, 84–85, 149, 211, 214; apprenticeship contracts in, 77, 260nn24, 26; and art market, xiv, xv, xvii, 43–46, 79, 84, 92–93, 184, 189, 214; and confraternities, 80; as cultural translators, xiv, 4, 41, 153, 209, 215; education and training of, xvii, 4, 8, 9–11, 20–21, 79, 152; gilding techniques used by, 57, 74, 207–208, 210; hierarchy of professional status, 73, 76–77; journeymen of, 73, 74, 76–77, 149; knowledge of materials, technologies, and chemistry of painting, xiv, 52–53, 57, 58, 72, 73, 214; and languages, xiii, xiv, xvii, 134, 212–213; lettered status of, xiii, 8; masters of, 57, 73, 76–77, 79, 87–88, 147, 149, 152, 160, 260n23, 261n31; and mutability of professional titles, 57, 74–75, 258nn2, 3, 4, 5; and painters as general contractors, 74–75, 79; and pre-Columbian cultures, xvii, 40–41, 59; and professional collaborations, 77, 79, 85; and public shops, 78; and signature inscriptions, xiii, xvii, 7–8, 79, 149, 150, 261n31; structure of, xvii, 72, 73, 76, 85, 88, 149, 160, 162, 183; stylistic pluralism of, 184, 212–213, 214, 215; titles of trade, 73–75, 77, 147, 214, 215; and urban geography of first generation, 85–88, 214; and urban geography of later generation, 150–151, 183; and *voz del anonimato*, xiv
paintings and painted objects: and art market, 43–46, 79, 183, 184, 189, 214; clothing and dress in, 69, 110, 196–197, 213, 275–276n2; colonizing role of, 9; commissions for, xiv, xv, 46, 52, 53–54, 57, 58, 65–66, 74, 79, 83–85, 147, 149, 184, 229–

230n4; early colonial objects of painting, 63–72; easel paintings, 51, 52, 64; *estampas* as models for, 45, 46, 48, 50, 51, 70, 83, 184, 191, 196, 197–199, 200, 202–203, 208, 209, 273n112, 298n48; gold and silver leaf used on, 51, 54, 56, 57, 194, 208, 213, 297n41; and Inca education, 33–34; and Inca languages of empire, 31, 213; interrelationship between painting and script, 64; material composition of, 44, 45–46, 51–57, 58; mural paintings, 115, 116, 166, 206–207, 272nn107, 109; northern Andean painted objects, 59–63; painters' signing of, 79; and *quilca*, 38–41; subject matter of, 43, 44–46, 68, 124, 204, 243–244n14; supports for, 51, 52, 184, 188, 247n65; text incorporated in, 3–4, 8–9, 138, 143, 194

paños azules (blue Quito cloth), 53, 249n82
Pasña, María, 156, 187, 189–190, 283n28, 295n22
Paucar, Luis, 83, 127, 276n9
Paul, Saint, 45, 47, 105
Peña, Pedro de la, 10, 64
Peña (cacique), 71, 257n58
Peñafort, Raimundo de, 68–69
Pérez de Moya, Juan, *Philosophía secreta de la gentilidad*, 49
Pérez Sanguino, Francisco: artistic commissions of, 57, 159–160, 284n44; pulpit, Church of the Convent of the Immaculate Conception (plate 19), 159; residence in San Roque parish, 158–160; titles of trade, 65, 74, 158–159, 258n5
Peter, Saint, 105, 127–128, 129, 132
Philip II (king of Spain), 50, 67–68, 70, 256n56
Philip II (anonymous), 70, 71
Philip III (king of Spain), 124, 125, 138